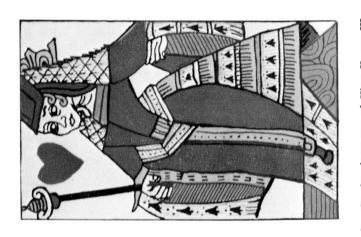

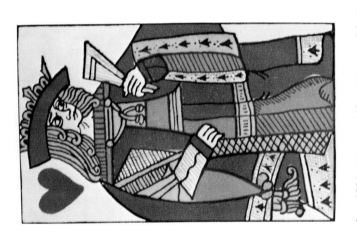

1. 1581, January 15. Treasonable Lyon Playing Cards--lampoon of King Henry III of France and the Queen

ART CENSORSHIP

A Chronology of Proscribed and Prescribed Art

by

JANE CLAPP

The Scarecrow Press, Inc.
Metuchen, N. J. 1972

ISBN 0-8108-0455-7

Library of Congress Catalog Card No. 76-172789

CONTENTS

714596

Art Censorship brings together from scattered sources a record of suppression, restriction and restraint of visual communication in the plastic arts--painting, sculpture, graphic arts, architecture--and the decorative arts. Photography, including motion pictures, is not considered in Art Censorship. "Censorship" has been broadly construed to include artists or art works restricted for economic, social, political, moral or aesthetic reasons by state and church officials, and also by citizen or other groups, individuals, or society as a whole. Incidents of censorship cited include any form of abridgment of "Artistic Freedom" (as defined by the American Federation of Arts in its Statement of Artistic Freedom, adopted October 22, 1954):

> the artist's right to create, exhibit, publish, reproduce, sell or otherwise use his work; and corresponding rights of institutions and individuals to use his work.

Limitations on art critics, art museums and galleries, art sellers, and art viewers, as well as famous art controversies and art causes célèbres, have also been considered.

CHRONOLOGY OF CENSORED ART: Incidents of art censorship, reported in factual and anecdotal form, are arranged in brief entries by date in the Chronology of Censored Art, and the Index provides access to details of information by reference to the year and date of the chronological listings. The examples of censored art describe, as a record, not an evaluation, typical, significant, interesting, or well-known incidents in the positive and negative controls of art. The examples selected--obviously a limited sampling only--show art prosecuted, suppressed, and modified by social and other controls, in a variety of categories, including such non-exclusive areas as:

Art and State and Politics--Social criticism; political satire;
 lese majeste; "engaged" art; "official" art identified with
 political ideology or authority; administrative controls of li-
 censure, customs administration, postal administration.

Art and Society--Tribal and other art style, "Canons" of art;
 taste and fashion in art; artists' "revolts"; mass marketing
 and merchandising of art; class distinctions in censorship of
 men--women, upper class--lower class, educated--uneducated,
 rich--poor, cultivated--vulgar, children--adults; obscenity;
 art and morals; nude in art; sex in art; violence; vandalism.

Art and Law--Legislative reports, bills, and debates; statutes
 governing censorship; judicial decisions in libel, sedition,
 blasphemy, obscenity, and other cases with art or artists in
 court.

Art and Religion--Aniconic prosciptions; Art Codes; Iconography;
 church council edicts and rulings; heresy; blasphemy; sacrilege;
 Clergy in Art; Pope in Art.

Art and Aesthetics--Art Academies; art "dictators"; Artists' Hand-
 books and Manuals, or other, prescribed and proscribed subject
 matter and techniques of art; public opinion as art arbiter;
 imagination and originality; avant-garde.

Art and Individual Rights--"Free Speech" for artists; manifestoes;
 citizen right of privacy; self-censorship; individuals and citizen
 and other groups guarding public morals and conduct; art
 organizations, guilds, trade unions.

INDEX: The Index provides a key to information given in the
Chronology of Censored Art. Listed are artists' names, titles of
works of art, and a variety of subjects, including geographic loca-
tions, art forms, themes and motifs in art, and reasons for censor-
ship, such as Blasphemy, Heresy, Sacrilege, Lese Majeste, Treason
and Sedition, Libel, Nude, Obscenity, Scatology, Sex in Art, Violence.

 Index references are to date of listing in the "Chronology of
Censored Art." Listings are arranged in order of date from

general to specific, as:

century	19th c.
range of decades	1860's-1870's
decade	1860
range of years within decade	1860-1867
approximate year	c 1860 (or 1860?)
year	1860
month	1860 My
day	1860 My 1

Identical dates are distinguished by letters in parentheses following the dates, as:

1860 My 1 (A)
1860 My 1 (B)
1860 My 1 (C)

SOURCES OF INFORMATION: Some 650 references are listed in the Bibliography, and documentation is shown in the Chronology of Censored Art by parenthetical reference to cited sources:

(143:38) refers to publication 143 in bibliography, page 38

(179 V:396) refers to publication 179 in bibliography, volume V, page 396

(410, F 8 1951 3:5) refers to publication 410 (a newspaper) in bibliography, issue of February 8, 1951, page 3, column 5.

References to art censorship were located by search of newspaper and periodical indexes (Readers' Guide, Art Index, Index to Art Periodicals, Social Sciences and Humanities Index, New York Times Index, London Times Index, Legal Periodicals Index) and of various general and special library catalogs. With few exceptions, references consulted and listed are in English, and published since 1900.

ILLUSTRATIONS: A selection of illustrations shows some of the works of art repeatedly censored, or censored in famous instances.

vii

ACKNOWLEDGMENTS: Appreciation is expressed to the many librarians, libraries, museums and art galleries, and other organizations and individuals who suggested instances of art censorship, provided information, and made publications and pictures available.

ABBREVIATIONS

Ag	August
Ap	April
c	circa (before date)
	century (following date)
D	December
ed	edition; editor
F	February
Ja	January
Je	June
Jy	July
LAT	Los Angeles Time
LT	London Times
Mr	March
My	May
N	November
NYH	New York Herald
NYHT	New York Herald Tribune
NYT	New York Times
NYW	New York World
O	October
p	page
S	September
vol(s)	volume(s)

ILLUSTRATIONS

ILLUSTRATION ACKNOWLEDGMENTS

Each illustration was supplied by the owner or collection credited under the illustration, except for those listed here

Illustration
No.

1. Illustration from Playing Cards: The History and Secrets of the Pack, by W. Gurney Benham, c. 1931. Reprinted by permission of Ward Lock Limited.

4. Illustration from Gregg International Publications Limited Newsletter, vol. 2, no. 1, p. 2, October 1964.

7. Scottish National Portrait Gallery; Tom Scott Photo, Edinburgh.

12. Los Angeles County Museum of Art Photo.

20. Illustration from Illustrated Sunday Magazine, Albright-Knox Art Gallery.

22. Cartoon, Montgomery, Alabama, Advertiser, February 3, 1915.

23. Cartoon, The Masses, September 1917, page 7.

24. Julius Shulman Photo, Los Angeles.

26. Illustration from Hintergrund, by George Grosz, 1928. Library of Congress.

27. Illustration from Paintings of D. H. Lawrence, London, Cory, Adams & McKay Ltd, 1964. Reproduced by permission of Laurence Pollinger, Ltd., and the Estate of the late Mrs. Frieda Lawrence.

29. Julius Shulman Photo, Los Angeles.

30. Illustration from The Rabbits' Wedding, by Garth Williams, 1958. Reproduced by permission of Harper & Row, Publishers.

32. Illustration from Little Black Sambo, by Hazel Bannerman. Reproduced by permission of J. B. Lippincott Company.

34. Compix, UPI Photo.

CHRONOLOGY OF CENSORED ART

3400-2900
B.C.

The definite conventions and set formulae, rigid and simple, of Egyptian art were determined "probably by the end of the Third Dynasty" (386:91-92) and in persisting relatively unchanged for over 3,000 years, through 30 dynasties, represent the "ultimate expression of obedience to politico-religious authority" (420: 31). While the rules governing Egyptian art were not written out, they were followed so strictly that they are referred to as "The Canon." There is no word for "art" or "artist" in Egyptian hieroglyphics (a sculptor was indicated by the word-sign for "bow-drill"), and workmanship, not artistic imagination, characterized the visual arts (633:73); whether in sculpture, relief and in-the-round, or in tomb painting, figures were represented according to a geometrical plan, determined by a finely meshed network of equal squares (442:62; 600).

Plato (457, Laws II:656) praised Egyptian art as an instrument for preserving culture (314:40) because "no painter or artist is allowed to innovate... or to leave the traditional forms and invent new ones."

As determined from a study of art objects, papyri, artists' models, and unfinished work in progress, the rules Egyptian artisans followed seem to include:

Color: Standard tones, flat with no shading, are black and white, and yellow, red, blue, green. Specific colors are used uniformly--red or brown for men, yellow or white for women, zigzag blue lines for water (608:3).

Design: Representations drawn and corrected before being painted or sculptured. Scale drawings made and transferred to the work (179, VII:666).

Figure Convention: "Descriptive Perspective" dictated profile (310:13) presentation--like Magdalenian drawings, Bushman painting, Eskimo engraving (314:145)--head in profile with "frontal" eye, "frontal" shoulders, abdomen in 3/4-view, legs and feet in profile with both right feet, male figure with left foot forward, female, with feet together. According to the system of squares ("Lepsius' Canon"), the proportion of the human figure is always the same: "ankle on the first horizontal level, knee on the sixth level, shoulder on sixteenth level" (442:60).

15

c3300 B.C. - The visualization of the Hindu artist followed a canon
A.D. 600 "which stipulated proportion, pose of body, and ges-
 tures of limbs and hands, which constituted a kind of
 language." By the mudra (Sanskrit for "sign") artists
 conveyed in standard arrangement of hands and body
 specific concepts, such as "teaching," "meditating,"
 "not-fearing" (209:197).

c2625 B.C. In the limestone relief from the Saqquara tomb of
 Ptahhotep, "first of the priests of the Pyramids of
 Asosi, Ne-userre and Menkauhor," on the north side
 of the sacrificial chamber depicting Ptahhotep at the
 offering table is an "almost obliterated figure" under
 the chair. Such deliberate erasure of figures of
 relatives "in consequence of quarrels is frequently
 found" in tombs of the Fifth and early Sixth Dynasties
 (322:206).

1900 B.C. Among the civil matters dealt with in the Babylonian
(?) legal code, Code of Hammurabi, was the regulation of
 seal designs, the commercial art of that day (110:41).

1481-1447 In the time of Thutmose III, one of the greatest
B.C. Pharoahs of Egypt, ruled alone after the death of his
 aunt Hatshepsut, who as his "co-regent" had usurped
 and held the throne of Egypt against his will for
 twenty-two years; he obliterated her memory from the
 rolls of history by causing "wholesale destruction" of
 her name, pictures, statues, and stelae. Hatshepsut's
 titles and portraits were erased from the walls of
 temples, as at Dier el Bahri, where her many statues,
 too, were found broken and dumped into a quarry pit
 before the temple. The great obelisks at Karnak were
 sheathed in masonry at Thutmose's order to cover up
 the hieroglyphics "Hatshepsut" and the queen's "proud
 inscription." Even the images and names of the
 queen's followers--royal architect, Senmut, and high
 priest and vizier Habusoneb--were erased and destroyed
 throughout Egypt (386:180-181; 633:155).

1375-1358 In the brief interval of the Eighteenth Dynasty "Amarna
B.C. Period," when Ikhnaton ruled Egypt, "art was tempor-
 arily freed from the bonds of religious convention"
 (608:3). Monotheism represented by the disk of the
 sun god (Aten, the One God) replaced polytheism, and
 Ikhnaton erased evidence of the old gods, as when he
 had the tomb of his father, Amenhotep III, opened to
 cut the name of Amen, greatest primeval diety in the
 Egyptian pantheon, from the royal sarcophagus.
 Artists were forbidden to write the word: "Gods," and
 representations and names of the old divinities were
 systematically chiseled and chipped from tombs,
 temple walls, and statues (386:231-234, 260).

13th c. B. C. Jewish ritual restrictions on the delineation of hu-
man or animal figures by conforming Jews, reflect
"a definite religious (or magico-religious) attitude"
(179, VII:798, 801) and, while Jewish attitudes and
interpretations have varied from land to land and
from one generation to another, the inhibition was
generally maintained for three dimensional "graven
images" of human beings (busts and statues) until
the seventeenth or eighteenth century (509:18).
 Certain exceptions to these strictures are seen
in Rabbinical commentaries ("sealing rings in the
form of intaglios" are acceptable "because the nega-
tive shape is not an image in the forbidden sense")
and in some Jewish households in Poland statuettes
were admissible "provided they are not quite com-
plete--if, for instance, a finger is missing" (230:
112-113). As a monotheistic religion, with more
spiritualized religious conceptions than polytheism,
the Jewish proscription of "graven images" combat-
ted iconism (images) as idolatry by permitting no
representations of their single God--a defense
against the profusion of local dieties worshipped by
their polytheistic neighbors (43; 260, II:260), and al-
lowing Jewish breaking of the idolatrous images of
neighboring pagan tribes (604:127). The ban dates
back to Exodus (XX 4), the "initial commandments
of the Decalogue" (Second Commandment: "Thou
shalt not make unto thee a graven image, nor any
manner of likeness, of anything that is in the heaven
above or that is in the water under the earth") (179,
VII:808), and to the Old Testament (Deuteronomy IV,
17-18 prohibits: "the likeness of male or female,
the likeness of any beast that is on the earth, the
likeness of any winged fowl that flies in the heaven,
the likeness of any thing that creepeth upon the
ground, the likeness of any fish that is in the water
under the earth, " and Matthew XXIV, 1-2; Mark XIII,
1-2; Luke XXI, 5-6 set forth other bans).
 Resistance to these anthropomorphic and zoomor-
phic proscriptions in art are reported in the "episode
of the golden calf" and in the "incident of the sanc-
tuary of Micah (Judges) where a likeness of the God
of Israel himself was raised" (179, VII:808). This
Old Testament banning of images (because of pagan
idolatry--worship of the false God) and worship of
the one true God by means of images (44:17) was not
always interpreted as an outright prohibition of the
representation of human or animal form, but the
tradition of Judaism agreed ("Thou shalt not bow
down to them and shalt not serve them") that no im-
age must be made for the purpose of worship, either
as representing or substituting for the Divinity (509:
18). Judaic prohibition of images in art, "not only

with the fear of idolatry but with the more universal
fear of encroaching on the creator's prerogatives"
(230:112-113), was similar to the monotheistic ban
of Islam in this respect.

1200 B. C. The famous sculpture of the god Amen protecting
King Tutankhamon of Egypt, now in the Louvre, was
partially destroyed by mutilation of the King's figure,
supposedly at order of his successor Horemheb "who
wished to prevent the divine protection of Tutank-
hamon by breaking the contact between Amen and
the former ruler" (278).

c 1000 B. C. The god Seth, originally one of the supreme dieties
of Egypt, became violently hated as evil because he
was involved in the Osiris myth as the "envious
brother and treacherous assassin" of the benign
Osiris. Seth "was banished from the circle of
Egyptian dieties and it became an act of piety to
destroy representations of him wherever found"
(312:30-31).

8/6th c. B. C. Under Zoroastrianism, the religion of Iran previous
to the spread of Islam, "images as representations
of the godhead" were forbidden. This aniconic dic-
tate was shared with other Indo-European religions:
God could be represented only by symbols (179, XIV:
966).

720-692 B. C. Hezekiah (Ezikias), King of Judah, "brake in pieces
the brazen serpent which Moses set up: because
the people, contrary to the precept of the Law,
burnt incense to it" (275, I:122).

7th c. B. C. Assyrians melted down captured Urartian bronze
statues (493:57).

6th c. B. C. The canon of proportion, based upon "preordained
geometrical schemes, " of archaic Greek sculpture
was so strict that sculptors Telekles and Theodorus
each made one part of a two-part statue while the
first sculptor was at Samos, and the other at Ephe-
sus "without the statue's being misformed or mal-
proportioned, " according to Diodorus Siculus in his
book Bibliotheca historica (179, VII:666).

c 549 B. C. The sumptuary laws of Solon, one of the first eco-
nomic and constitutional reforms initiated in Athens
after his election as archon to combat the severe
Athenian economic problems (101:134), were directed
against such extravagances as apparel--females were
forbidden to wear more than three garments out of
doors (330:81)--and funerary sculpture, referred to

by Cicero in de Legibus II, 26, 24. Because of
this anti-luxury law few Attic grave reliefs date
from the sixth century B. C. (although, by contrast,
they are common in other states of Greece in this
period), and their ban continued until the Parthenon
epoch (357:75).

5th c. B. C. The sculptured male nude "Apollo," "dominant sub-
 ject matter of the representational Greek arts,"
 represents the "conventionalized and idealized type,
 of young citizen-soldier-athlete" in Athens and other
 city-states of Greece, where gymnastic training was
 a civil obligation for the younger men of good fami-
 lies but was expressly forbidden to the lower ranks,
 including slaves. The class structure was reflected
 in the rigidly prescribed style of human art subjects
 "headed by the elite citizens of good birth, descend=
 ing to lesser citizens, tradesmen, slaves, and bar-
 barians" (581:474-475).

480 B. C. The citadel of Athens was destroyed by the Persians,
 and the Greeks used the fallen statues to fill in the
 soil for rebuilding the temple (570:15). This level-
 ling course for the Parthenon, according to some
 authorities, owes its unique geometric shape and
 the interplay of the various elements of the facade
 to the "divine proportion," with geometric progres-
 sions of the "golden sector order" (432:189).

453-448 B. C. When the two pupils of sculptor Phidias--Alcamenes
 and Agorakritos--made marble statues of Aphrodite
 for a competition in Athens, "Alcamenes received
 the prize, not from the merit of his work, but be-
 cause the Athenians voted for their fellow-citizen
 against a foreigner" (458:191).

443 B. C. Censorship was officially instituted in Rome, with
 the Lex Canuleia establishing the office of Censor
 (Comita Centuriata) commissioned to take a census
 of citizens and property--to institute a systematic
 classification of each according to his "censes,"
 that is to say "his fortune" (240:147, 367). Cen-
 sors--only patricians were eligible for the office--
 gradually assumed control over public morals (cura
 morum) and punished "offenses not only against
 morality, but against the conventional requirements
 of Roman custom" (98:33).

c 440 B. C. Greek sculptor Polykleitos developed "The Canon"
 ("Polykleitos Canon"), the rule of proportions for
 representation of the human figure, in his statue
 "Doryphoros" ("The Spearbearer"). This "rule of
 art," "a visual declaration of artistic principles"

(114:36), is not recorded--"the rules of proportion
which have come down to us in Pliny, Gauricus and
other ancient writers are of the most elementary
kind" (113:18-21).

"The Canon" is a geometric proportion (according
to Galen: "the proper proportion of finger to finger,
finger to hand, hand to forearm, forearm to arm,
and finally each limb to the entire body"). It is a
relationship, not an absolute module (442:65). Most
simply expressed in traditional elementary rules,
"The Canon" is the proportion of head to total fig-
ure--reported variously as 1:7 (572:185-186), 1:7
1/2 (114:67), or 1:6.84 (432:231). Sculptors called
"The Doryphoros," "The Canon," and the statue's
accepted correct proportions became a standard from
which they could learn the first rules of their art
(458:43), and "a mathematical demonstration of the
proportions that produce beauty in the human form"
(296:xvii).

440? B. C. When sculptor Alcamenes (Alkamenes) of Lemnos
and Athens executed his statue of Hephaestus at
Athens "the lameness of the god was so tactfully
suggested that it was patent without amount to de-
formity," because "nothing but the traditional per-
fect was allowed" in Greek sculptures of this time
(101:93).

438 B. C. Phidias, greatest of ancient Greek sculptors, was
brought to trial in Athens for peculation and impiety
(367:21). He was charged with embezzling the pre-
cious materials of the Parthenon statue of Athena,
which reportedly required more than a ton of gold
and a great quantity of ivory, and of committing
sacrilege by representing himself and Pericles in
the figure's shield. These charges made by politi-
cal enemies of Pericles were especially aimed at
Pericles. Phidias was acquitted of the theft of the
gold, since the gold on the statue was detachable
and its weighing showed the falsity of the charge.
He was, reportedly, convicted of "misappropriation
of public funds avowedly expended on ivory," and of
sacrilege for introducing his own likeness and that
of Pericles upon the shield of goddess Athena.
Some accounts say that Phidias was sentenced to
prison where he died, others report he was exiled
(330:186;367:21). (ILLUSTRATION 2.)

4th c. B. C. Ku K'ai-Chih wrote How to Paint the Cloud Terrace
Mountain, earliest known treatise on the art of
Chinese landscape painting, that influenced genera-
tions of artists.

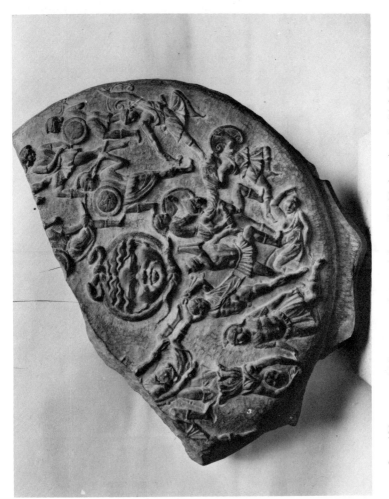

2. 438 B. C. Phidias. Parthenon Athena Shield (copy). British Museum

c 387 B. C. Plato counted art as a form of imitation and classed
 the artist with the sophist--as a maker of images
 against whom the government must be on its guard
 (518:232; 570:13). Art, according to Plato, "is not
 a collection of canons of criticism, but rather a
 subtle influence which pervades all things animate
 as well as inanimate" (457, Republic, III, 400, 401).
 He judged art by one test, "simplicity, " and made
 the State enforce the morality of art--in The Repub-
 lic he places sculpture and architecture under the
 same rigid censorship which he applies to poetry
 and music (457, Republic III, 401A). Disliking the
 "illusions" of painting (457, Republic X, 602)--the
 most dangerous of the arts (31:13)--and the "false
 proportions" given by sculptors to their subjects
 (457, Sophist, 235-236) as a kind of magic, or de-
 ception, Plato approves the Egyptian hieratic fash-
 ion of art, sanctioned by authorities (457, Laws II,
 657A), which had not changed for thousands of years
 (31:13). Though little "is said of the plastic arts
 expressly" in Plato's writing, they--like literature
 and music--"must be submitted to the regimen of
 the State, if the purity of the moral message is to
 be preserved, " and he "throws upon the State the
 impossible task of supervising the content and form
 of all artistic production" (26:129, 132). Because
 art has the power to intensify--not just to purge--
 emotions, a "drastic censor" should control it (632:
 4, 107).

364-361 B. C. Cnidian Aphrodite, the bigger-than-life marble
 statue by Praxiteles, most renowned sculpture of
 antiquity, was probably the first nude representation
 of the goddess of love and beauty in Greek sculp-
 ture--if not the first female nude in the round (597:
 101). "Ancient traditions of ritual and taboo" dic-
 tated that no sculpture of nude women dates from
 the 6th century B. C. , is rare in the next century,
 and even into the 4th century B. C. "the naked
 Aphrodite was embarrassingly associated with Orien-
 tal cults" and so subject to religious disapproval--
 not for moral reasons, but because the beauty of
 her body might seem an inducement to heresy (114:
 112). Cos, an island city, had arranged to purchase
 an Aphrodite from Praxiteles and, given a choice of
 the nude figure or a draped duplicate showing "severe
 modesty" (458:lxxxvii, 193), chose the clothed god-
 dess as more dignified. The rejected nude statue
 bought by the city of Knidos (Cnidus) became known
 throughout the ancient world as the "Aphrodite of
 Cnidus, " the first and greatest representation of
 the Venus Pudica--"a figure posed in the act of at
 once covering and indicating sexual attributes that

primitive art realistically exhibited and emphasized" (179, VII:669). "Multitudes sail to Knidos to look upon the statue," Pliny reported (458:lxxxvii, 193). Set in a circular temple high on a bluff looking westward over the Aegean, Aphrodite safeguarded passing ships and sailors. This sculpture was destroyed, probably in the seventh century by Arab invasion, but survives in some 52 copies, among the best-known of which is the "Cnidian Aphrodite" in the Vatican, the figure "obscured with painted iron drapery, added by the papal authorities long ago" (330:248-249).

351 B. C. Plebians were admitted to serve as Roman censors, in addition to patricians. The office continued to the time of the Emperors. Vespasian and his son took the title; and the last who bore it was the brother of Constantine. Censorial power was generally assumed by the Emperor "under the title of Morum praefecti" (98:33).

335-322 B. C. Aristotle urged that special care be taken to protect the immature from pictures as well as talk and books: "We must forbid looking at unseemly pictures" (14, The Politics, Book 7, 297).

330 B. C. Alexander the Great plundered Persepolis and its palace built by Darius the Great as the easternmost capital of the Persian world empire.

328-325 B. C. "Emperor Alexander issued an edict that none but Apelles might paint his portrait, none but Pyrgoteles engrave it, and none but Lysippos cast his statue in bronze" (458:219).

317-307 B. C. Demetrios of Phaleron enacted sumptuary legislation forbidding the erection of sculptured gavestones in Attica. Under this anti-luxury law, stelae depicting the scenes of daily life were no longer allowed in Athens as memorials of its citizens (330:321; 497: 150; 617:17).

c 200 B. C. - 500 A. D. In the Ajanta cave paintings, which served as a "mother school" for Chinese and Indian representations of Buddha, Indian proportions "were faithfully followed, as were the texts telling how the various scenes must be arranged" (597:746). Transfers were used to prick outlines in red or black chalk on the rough plaster in preparation for the pigment (597:692).

2nd c. B. C. "The type for each deity or class of person" was set

by "a greater artist" in Greece. This canon was "unashamedly followed by lesser artists" (330:64).

2nd-1st c. B. C. (A)

During the reigns of the Hasmonaean Kings, a dynasty of independent rulers, ancient Jewish prescriptions were followed by changing numismatic subjects to discontinue the use of human likenesses on coins, and to substitute ritual symbols, and plant and fruit motifs (509:127).

2nd-1st c. B. C. (B)

While the chronological order of Buddhist sources shows "every shade of opinion from a prohibition as final as the Semitic to the fullest iconolatry" (403: 115), in earliest Indian Buddhist bas-reliefs, which illustrate the life of Buddha, representations of Buddha himself are forbidden, so that he must be shown symbolically--as two footprints, or as an empty throne--while other persons in the scenes are shown in bodily form (44:102-103).

In other aspects of Indian art, dance and hieratic poses of the Bodhisattvas are rigidly prescribed by dogma. Each gesture and posture (mudra) of feet, fingers, eyes, and torso is a symbol of a phase of dogma, and the faithful could read these emblems much as the symbols on medieval cathedrals could be read by their congregation. Among such gestures of Buddha and Bodhisattvas recognized by viewers of sculpture and painting are:

"Do not fear"--Hand up, palm out;
"Charity"--Hand pendant, palm out, extended;
"Contemplation"--Palms up;
"Discussion"--One hand raised, thumb touch-
 ing second finger;
"Resistance to temptation"--Palms on Earth,
 as Buddha under the bodhi tree (597:684).

Silpa Sastras (traditional manuals for artists) also set forth the details of acceptable dress and ornament (407:156).

184 B. C.

"Cato the Censor, " Roman statesman, became Censor in Rome. He was a model "for patriotic zeal, inflexible moral severity, and primitive simple frugality" (81:18), and stopped all building operations and repair of public temples in Rome. After the Battle of Cannae, laws Cato proposed were passed against luxury--for example: No woman should wear gold ornaments or embroidered cloths. By legislation he tried to force a return to the "high morality and simplicity" of the early days of the Republic, and said he preferred that it should be asked why he had not a statue than why he had one (102:284-285). When a statue was raised to Cato, the inscription read:

"In honor of Cato, the Censor, who, when
the Roman Commonwealth was degenerating
into licentiousness, by good discipline and
wise institutions, restored it" (101:53).
Cato "protested against the statues set up to Roman
women in the provinces, and yet he could not pre-
vent their being set up in Rome itself" (458:27).

158 B. C. In the second consulship of Marcus Aemilius and
Gaius Popilius, the censors Publius Cornelius Scipio
and Marcus Popilius "removed all the statues of
magistrates standing round the Roman forum, ex-
cept those which had been set up in accordance with
a decree of the people or the Senate" (458:25).
Pliny's report of the statue removal and melting
down is questioned by other authorities.

1st c. B. C. De Architectura, by Roman engineer and architect
Vitruvius, set the standards in architecture for
many centuries. The "Vitruvius Man, " serving as
a model of proportion for sacred edifices, with
arms and legs extended fitting "into those 'perfect'
geometrical forms, the square and the circle, " is
expressed in Leonardo da Vinci's most famous draw-
ing (113:18-21). "Psychological and physiognomic"
categories of the orders of ancient architecture are
contained in the specific recommendations of Vitruvius
(Book I, Chapter II):
 Doric temples for Minerva, Mars, and Hercu-
 les; Corinthian temples for Venus, Flora, and
 Proserpina; Ionic temples, between the two ex-
 tremes, for Juno and Diana (230:373).

88 B. C. Art was proscribed by Marius, Roman general and
political leader, when he accused his rival for power,
Sulla, of corrupting his soldiers in exotic and volup-
tuous foreign lands: "for there it was that the army
of the Roman people first learned to indulge in
women and drink, to admire statues, paintings,
and chased vases..." (101:44).

87 B. C. Roman soldiers of Sulla, at his order that every
building and fortification in Piraeus be levelled,
completely destroyed the city. All that remained
of the famous port for 2, 000 years was a "mound
of rubble and a ten-foot marble statue of a ·lion
overlooking an empty harbour" (236:18).

22 B. C. The last regular censors were elected in Rome.
Later Emperors assumed censorial powers--func-
tioning in guardianship of the public morals (regimen
Morum), breech of which resulted in a stigma
(infamia). Claudius (47-48) and Vespasian (in 73)

took the title, "Censor," and Domitian (81-96) was "Censor for Life" (177, V:160-161).

1st c. (A) Laesae magistatis was incorporated in the jurispru-
dence of Rome under the Caesars. It was a fore-
runner of medieval and modern statues--"The majes-
ty that doth hedge round the king"--to protect execu-
tive officials of high rank from disparaging remarks
or representations on the part of subjects or citi-
zens (255:30).

1st c. (B) Later Roman Emperors decorating immense public
monuments--temples and baths, aqueducts and mar-
kets, amphitheaters, stadiums, and triumphal arch-
es--with pillaged Greek statues frequently removed
the original head of the figures and substituted their
own likeness (236:25). Among famous classical
Greek buildings destroyed for their building mater-
ials was the Temple of Zeus in Athens, known as
"a limeburner's quarry for centuries" (236:13).

30 A planned effort to erase all memory of Nero Caesar
and Drusus Caesar through widespread destruction of
their images and commemorative figures in Rome
and other areas was carried out (damnatio memo-
riae), according to one art authority (S. Stucci).
Nero and Drusus, sons of Germanicus and Agripp-
ina, were heirs to the Roman empire, but were
banished during the reign of Tiberius (32:175).

60's St. Paul denounced the silversmiths of Ephesus for
making figurines of Diana (Bible. Acts XIX-XX)
(403:110).

96 Sculptured portraits of Roman rulers were as com-
mon in Roman times as color prints of sovereigns
and leaders of states today. There were thousands
of figures of the Emperor in every town in the Ro-
man empire, but "when a detested ruler died, many
of these sculptures were destroyed during an out-
burst of popular wrath." Such a destruction of por-
traits was carried out after the death of Domitian
(Titus Flavius Domitianus Augustus), Third of the
Flavian Emperors of Rome, who was murdered by
a freedman (227:10).

190-203 An early critic of idolatry in Christian art, Clement
of Alexandria, Greek theologian and Father of the
Christian Church, as head of the catechetical school
in Alexandria--the most famous center of learning
in the ancient world--"unleashed a tirade against
paganism" in his Exhortation to the Greeks. This
writing, "hostile to images on philosophical grounds,"

led to the "rejection of images as objects of wor-
ship" and to "the denigration of painting and sculp-
ture themselves" (179, VII:810).

c 200 The earliest Christian painting in the Catacombs of
Rome "shied away from painting Christ, " "under
the impact of the Old Testament prohibitions"--
Exodus, XX, 4 (2:2).

212 (A) The booty of Greek statuary, pictures, and plate
that Marcellus brought back to Rome when he cap-
tured and sacked Syracuse was criticized by Roman
and Greek writers as one of the "aesthetic indiscre-
tions" that initiated the decline of Rome (102:284).

212 (B) An example of the official efforts to erase all im-
ages of a Roman public figure (damnatio memoriae)
occurred in the removal or damaging of images of
Geta (189-212), one of the two sons of Septimius
Severus, whose short joint rule with his brother
Caracalla (211-212) ended when Caracalla caused
his murder. In a scene inside the eastern pier of
the Arch of the Argentarii in the Forum Boarium,
Rome, showing Septimius Severus and his wife Julia
Domna sacrificing, Geta--a third figure who stood
on the right--has been deliberately cut out following
a damnatio memoriae. In another relief showing
Septimius Severus receiving a group of Senators,
the head of Geta has been removed, along with the
head of one of the Senators (561:111-112).

240? Origen, Christian writer and teacher of Alexandria,
noted as one of the Greek Fathers of the Church,
in his writing Contra Celsum explains that Chris-
tians repudiate images for definite religious reasons,
following the Mosaic prohibition of such religious im-
ages. He found "one of the Jews' great contributions
to pure religion" their expulsion "from their state
'all painters and makers of images... an art which
attracts the attention of foolish men, and which
drags down the eyes of the soul from God to earth' "
(131, II:429).

273 Mani--founder of Manichaeism, a dualistic religious
system based on light and dark, and a combination
of Gnostic Christianity, Buddhism and Zoroastrian-
ism--was seized by the Zoroastrians as he was re-
nowned as a painter who "used his paintings to en-
force his teachings, " and was crucified (178:380;

3rd-4th c. Ladies of Rome were attacked by the moralists be-
cause they wore "robes of Chinese silk. " Such
garments were transparent, and "good Roman gold

was exported to pay for them" (388:195).

4th c. (A) The classic canons of Roman architecture broke
 down when the systems of proportion followed by
 designers of the first and second centuries and the
 purpose and relationship of architectural elements
 were abandoned for liberty in combination of arch
 and column (597:135).

4th c. (B) Lactantius Firmianus, tutor of one of the sons of
 Emperor Constantine the Great, spoke out in the
 Christian belief that such images as the statues of
 ancient Rome were "open instruments of demons,"
 and found that "there is no religion wherever there
 is an image" (519:133).

4th c. (C) The Cappadocian Fathers made the "first formal
 Christian defense of the visual arts" against charges
 of idolatry over the icons of the church by formulat-
 ing the pragmatic designation of church art as the
 "books of the unlearned" (179, VII:812).

300-900 Content and form of Mayan sculpture, an integral
 part of Mayan architecture, was prescribed by the
 priests in the official hierarchy, and the "clergy
 kept close watch to see that the designs, the attri-
 butes, and even the techniques of the artists should
 be preserved" (17:32).

306 "Called to deal with disciplinary rather than doctri-
 nal questions," the Synod of Elvira in Spain pro-
 hibited--in Canon 36--all painting in churches:
 "Pictures of what is reverenced and adored must
 not be painted on the walls of the church." The
 same council also prohibited dicing--in Canon 79--
 not because gambling was disapproved by the Church,
 but because "the dice bore the images of pagan gods"
 (44:114; 93:151; 260:151; 416, I:45, V:290).

313 Christianity "took on doctrinal and institutional form"
 beginning with the Edict of Milan (367). From the
 fourth century on, the arrangement, form, symbol-
 ism of form and color in religious paintings was
 imposed by "sacred dogma," and was "fixed and
 absolute," having been early decided by Church
 authorities: The Virgin Mary and John the Baptist
 come first after the Trinity; A Donor and Family
 must be shown small and out of proportion to con-
 vey "lowliness and self-abasement"; color proscrip-
 tions included: Christ after Resurrection must be
 shown in white, Virgin in Assumption in blue, St.
 John the Evangelist in blue tunic and red mantle;
 among the only acceptable symbols that could be

used: Holy Ghost--a Dove (since the sixth century),
God--a hand issuing from clouds (until the twelfth
century) (228:64-65).

314?
Lorenzo Ghiberti in The Commentaries reported that:
"Idolatry was persecuted in such a way that all the
statues and pictures of such nobility, antiquity and
perfection were destroyed and broken to pieces...
the drawings and the rules for teaching... eminent
and noble arts were destroyed." Severe penalties
were ordered for "anyone who made any statue and
picture." It was decreed "that all the temples
should be white... and the temples remained white
for about six hundred years" (275, I:152-153).

c 399
St. Augustine expressed the Puritan ethic against
art in his Confessions when he spoke of "pictures
and divers images," among other arts, as "far ex-
ceeding all necessary and moderate use and all pious
meaning," and made to "tempt men's eyes" (102:7).
According to a canon or proportion of the human fig-
ure represented in art, derived from Augustine, the
numbers that ought to recur are "6" and "10," since
"upon them is supposedly based the proportional
structure of Noah's Ark and Christ's Body" (179,
VII:674).

5th c.
Two colossal Buddhas carved in stone cliffs over-
looking the valley at Bamiyan, Afghanistan, were
later damaged by Moslems offended by these images--
the faces were destroyed in target practice from
across the valley (597:685-686).

c 400
The Talmud--Abodah Zarah (Talmud), 5, 2--the
collection of Jewish law and tradition, prescribed
that "you may use, for sealing, a signet ring with
the raised image of a man upon it, because when
you seal with it, the figure in the wax will be con-
cave and therefore not be so much an image as a
hollow. The signet with raised figure on it may not,
however, be worn. On the other hand, it is permis-
sible to wear a signet with the figure sunk upon it,
but you must not use such a signet for sealing" (44:
53).

404
Among few explicit proscriptions against anthropo-
morphic representations of Buddha in Buddhist texts,
are the aniconic--"rejection of the human image"
(179, VII:799)--statements in the Shih sung lu (a
Chinese version by Punyatara and Kumarajiva in
the Sarvastivadin Vinaya, which originated at least
three centuries earlier): the elder Anathapinadada
turning to the Buddha says: "Lord of the World,

since it is not permitted to make a likeness of the
Buddha's body, I pray that the Buddha will grant
that I make likenesses of his attendant Bodhisattvas.
Is that acceptable?" (179, VII:807). The represen-
tation of Buddha symbolically, as by footprints, fol-
lows the proscription, and differs from other sym-
bols of gods--sun god Surya by the sun--which is "a
simple symbolic representation" (179, VII:808).

410, August Alaric, king of the Visigoths, besieged, captured
24 and plundered Rome, and "would not raise the siege
until every single object of gold and silver and all
the household utensils of the city had been handed
over" (583A:19). To meet his demands for an addi-
tional 5,000 pounds of gold and 30,000 pounds of
silver, ornaments belonging to statues of the gods--
"objects of priceless artistic value"--were melted
down (583A:19).

426 Theodosius II, Emperor of the Eastern Roman Em-
pire, issued a decree calling for the destruction of
all remaining pagan temples (532:118).

431 The Council of Ephesus by proclaiming the Virgin
Mary mother of God (Theodokos) influenced artistic
representation from the sixth to the twelfth century
with set forms of the Virgin, generally accepted as
prototypes for Christian art everywhere:
 Hodegetria--she who points the way: Standing,
 holding Child in left arm, right arm held out
 in prayer;
 Kyriotissa--mistress: Standing, holding Child
 close;
 Blachernitissa--name of church in Constan-
 tinople: Bust length, arms raised as in orant.

445-452 During the great persecution of Buddhism in China,
wall paintings and sculpture were destroyed in the
complex of Buddhist cave-temples hollowed out of
the cliffs at Tun-huang, a town in Kansu province
that was a station on the Silk Route from China to
Turkestan and India (354:16).

455 Rome was sacked by Vandals (the term "vandalism"
meaning "willful or ignorant destruction of some-
thing beautiful or of value" derives from these
"followers of Vandal, the German, who in the fifth
century ravaged Western Europe") with enormous
damage to accumulated treasures of art and litera-
ture (274:52). "After Rome fell to the Huns, the
villas of Roman colonizers through Europe were de-
spoiled, and statues in formal allees and colonnades
were burned for lime to be used as fertilizer" (570:35).

6th c.

The iconographical system in religious art that had received approval of the Church continued "with little change, in spite of Iconoclasm in the seventh and eighth centuries, until the end of Byzantine culture" (492:53-54).

500

Hsieh Ho, Chinese painter and critic, formulated the "Six Canons of Chinese Painting" in his writing Ku Hua P'in Lu (Record of the Classification of Painters). These criteria for judging paintings summarized the practice of earlier generations of artists and became the basis of art criticism in the Far East for centuries (564:40-41). In the Six Canons--"general standards of painting rather than practical advice to painters" (106, I:46)--Chieh attempted "to set down everything that could not be reduced to rules and formulas" (106, II:xi). In this "Tao of Painting, " each rule consisted of six characters--phrased in four characters, followed by two words: shih (to be) and yeh (so, such, thus):

> Canon 1. Ch'i yun sheng tung--rhythmic vitality, Vital Breath or Force revolving life stirs; Spirit-resonance, or life-movement;
>
> Canon 2. Ku fa yung pi--anatomical structure, Brush creates structure; Bone method, or the use of the brush;
>
> Canon 3. Ying wu hsieh hsing--conformity with nature; Correspondence to the Object, which means the depicting of forms; Conformity with nature, or correspondence to the thing or the depicting of forms;
>
> Canon 4. Sui lei fu ts'ai--suitability of coloring, Suitability to Type, which has to do with the laying on of colors; Suitability of coloring;
>
> Canon 5. Ching ying wei chih--Artistic grouping, Division and Planning; placing and arrangement;
>
> Canon 6. Chuan mo i hsieh--Copying of classical masterpieces, Transmission by Copying, that is copying of models; Transmitting models, or reproducing and copying" (106, I:46).

c 529

Among the total of 30 types of craftsmen mentioned in the Craftsmen's Charter issued by Cyrus, King of Persia, at Uruk, were highly skilled gild members who had special obligations and regulations: "You shall make repairs and do the work involving silver, gold, bronze, gems and wood... " (618:56, 103).

572 Listed as favored gild workers--"Enterers of the
Temple"--qualified to enter holy places, according
to the cuneiform tablet notice promulgated by Nebu-
chadrezzar II at Uruk, are: wood-workers, gem
cutters, metal workers, and goldsmiths. A type of
work permit issued to each artisan in these skills
was to be kept on his person (618:52, 54).

590's Christ appeared to the Bishop, according to Gregory
of Tours, in a dream and commanded that "His Body
be covered with drapery" in a painting of a "naked
Christ upon the Cross" at the Cathedral of Narbonne
(114:307-308).

590-604 Pietro Aretino wrote in a letter to Michelangelo that
Pope Gregory the Great (Gregory I, known as St.
Gregory) "stripped Rome of the superb statues of
idols the better to improve the reverence due to
the humble images of the saints' (101:48). About
this same time Pope Gregory, in a famous letter,
rebuked Bishop Serenus of Marseilles for the "bish-
op's removal of images from churches. " While
sympathetic to Serenus' indignation against "excess
of image adoration, " the Pope opposed "wholesale
elimination of religious imagery" because of its
"didactic value, particularly for the illiterate" (44:
13; 179, VII:812; 260:262).

c 600 The Iconoclastic movement in Armenia began with
the destruction and mutilation of Christiam images
(2:263).

622? The doctrinal basis of Muslim opposition to repre-
sentation in art "from an early period in the history
of Islam... effectively prevented the admittance of
painting into any part of the religious life of the
Muslim world" (15:4). A "common superstition in
the East, that an image is not something apart from
the person represented, but is a kind of double"
(15:12), made painting blasphemous--as the artist
rivalled the Creator in making living figures--and
called for the damnation of painters, who fashion
forms of life, but cannot breathe life into anything.
The Arabic word for painter (passed from Arabic
into Persian, Turkish, and Urdu), musawwir--liter-
ally "forming, fashioning, giving form"--applies
equally to painters and sculptors. According to
tradition, "The angels will not enter a house in
which there is a picture or a dog" (15:5-6).
 While there is no specific mention of pictures in
the Koran (The Word of God), the real object of
the Koran's proscription is the avoidance of idolatry:
"O, believers, wine and games of chance and statues

and (divining) arrows are an abomination of Satan's
handiwork; avoid them" (Koran, V, 92).

The Traditions of the Prophet, another theologi-
cal source of the Mohammedan world condemning
pictorial art, reports that the Prophet says "those
who will be most severely punished by God on the
Day of Judgment will be the painters" (Bukhari, ed.
Juynboll, vol IV, p. 104, no. 89). Since the rep-
resentation of human and animal figures was pro-
hibited in religious art and architecture, "although
it was allowed in the embellishment of domestic ar-
ticles and secular texts" (569:24), Islamic artists
became supreme masters of arabesque ornament,
of interlacing, and of calligraphy. While there are
no illustrations in the Koran, it is "ornamented with
superb calligraphy, marginal medallions, and title
pages" (569:25). Decorative writing became charac-
teristic of Persian, as well as other Eastern art--
Kufic, with its contrasting angularity, and Neskhi,
with flowing curves and arabesques (209:292). Manu-
scripts were illuminated with beautiful portraits, pic-
tures, and medallions--the most frequently illustra-
ted were the two great poets, Firdusi and Nuzami--
but even some secular volumes show faces and fig-
ures painted out, following the "orthodox religious
sentiment active in the destruction of pictorial rep-
resentation of human beings" (15:4). When the Mus-
lim religious proscription against representational
art was disregarded, "pious hands carried on the
work of destruction and mutilation" of such trans-
gressing art, even up to recent times (15:10).

692 The Trullan Council in its eighty-second canon pro-
hibited the symbolic representation of Christ as the
Lamb, and ordered his portrait in human form (2:
263):

> Canon 82 of Quinisextum: "In order that perfec-
> tion be represented before all peoples even in
> paintings, we ordain from now on that the human
> figure of Christ our God, the Lamb...be set up
> even in the images instead of the ancient lamb..."
> (380:99).

695 With increased Islamic proscription against figural
depiction in art, "Muslim coinage ceased to display
any figural designs, and was, with few exceptions,
decorated with inscriptions only" (179, VII:816).

721, July Ommiad Caliph Yazid II issued an iconoclastic edict,
soon after he took over the government, forbidding
religious images, in strict conformity to Moslem
law, and extending "the prohibition to the Christian
Churches of the empire" (602:46-47). All Christian

and Jewish images in religious art--wall mosaics,
paintings on tablets, images on sacred vessels, and
altar coverings--were systematically destroyed as
representations of "living things" (2:6). The Byzan-
tine church at Main (Transjordan) shows in the floor
mosaic of the nave and annex how violently the decree
was carried into effect: animals, including the lion
and ox, and fruit were destroyed; while geometric
designs, Noah's Ark, hunting scenes, Palestinian
church buildings were allowed to remain (2:7).

Years later, the Second Ecumenical Council of
Nicaea (787) attributed the origin of the Iconoclastic
edict of Yazid II "to a Jew" (179, VII:816).

730 Through the Council of Constantinople, Ruler of the
Eastern Roman Empire Leo III--called "Leo the
Isaurian"--issued iconoclastic edicts, nine years
after his accession to the throne, forbidding religious
image making and ordering religious images to be
destroyed. The decree, enacted to prevent the ven-
eration of images as a relapse to heathenism--the
various saints represented in images were considered
minor gods in pagan hierarchy--and the worship of
realistic religious statues and pictures for themselves
rather than as symbols (260, II:264, 271), also had
economic aspects in aiming to control "the prolifera-
tion of monks who lived from the sale of icons"
(225:49).

This official ban ushered in the "Iconoclastic
Controversy" of the late Ancient and early Byzan-
tine Periods--a dictation of style and content in
religious art imposed by law for more than a cen-
tury (492:76), the long struggle between Iconoclasts
and Iconodules (the image destroyers and the image
worshippers) ending only with the restoration of im-
ages by Theodora in 843 (532:283-284). Leo's pro-
scription was first carried out in Constantinople with
the destruction of icons, mosaics, pictures, and
carvings (140:60-61). Sacred images were burned
in public places and picture-covered walls were
whitewashed (474:53). The systematic destruction
of figural religious art was resisted by the populace--
"when some servants of the Emperor destroyed the
figure of the Lord over the great brass gate, they
were killed"--but the Emperor carried on the de-
struction of all images in human form of Christ and
His Mother, and of His saints and angels, punishing
"many for... adhesions to the images with mutilation,
blows, and exile" (260, II:373).

731 November Pope Gregory III called a Roman synod that decreed
1 protection of images in churches, condemned to de-
struction by Leo III's decree, providing that:

738

"If anyone... shall take away, destroy, dishonour,
or revile the pictures of the Lord or His Mother,
he shall be excluded from the body and the blood
of the Lord and the Communion of the Church"
(260, II:303).

738

Following the traditions of Mohammed proscribing
figures in religious art, a governor of Medina had
figures on the censer which 'Umar had presented
to the mosque of that city erased (15:9).

754, August
27

The Council of Hiereia, in one of the "repressive
measures against image supporters" under Ruler of
the Eastern Roman Empire Constantine V--described
by his enemies as "archheretic" and referred to by
the insulting epithet "Copronymus"--excommunicated
"images and image-worship, " in an edict that drove
many sculptors and mosaicists, in danger of their
lives from the iconoclasts, out of the city of Con-
stantinople to residence in Italy and to the Court of
Charlemagne (8:153, 160; 299, I:88). The synod, at-
tended by 338 bishops of the Church assembled under
the presidency of Thedosius of Ephesus (474:55),
"anathematized those who venerated or produced
religious images" (179, III:589). Painting was con-
demned as blasphemous art whenever it ventured to
represent Christ, the Virgin, or saints; sacred pic-
tures and images were removed from churches, and
murals and mosaics were smeared over with chalk.
Churches extensively redecorated with landscapes,
trees, and birds were criticized by the opponents of
iconoclasm as "bird-cages" and "fruit magazines"
(260, II:307-316). Patriarch Germanus was anathe-
matized under the harsh strictures of the synodal
decree as a "wood worshipper" (179, VII:8, 2; 602:
27).

764-765

A "harsh wave of oppression" was directed against
the supporters of images in the Christian church by
Emperor Constantine V who imposed "an oath re-
nouncing images... on all imperial subjects" (179,
VII:812).

787, October
13

The Second Council of Nicaea, under Pope Hadrian
I, in twenty-two disciplinary canons of its seventh
session, laid down the rules for artists making holy
images in colors, mosaics, or other materials in
all Christendom (93:45), that lasted nearly 500 years
until the late Renaissance (82:90; 302:105-106). The
excommunication for making images and image-wor-
ship imposed thirty-seven years before by Leo the
Isaurian, and the anathemas of Hiereia of 754 were

repudiated with the new decrees. The Council ruled
that "the production of holy images was thereafter to
be regulated both in choice of subject and in execu-
tion" (179, VII:813), and that icons could be honored
by "relative worship" (kissing, offerings), "but not
with the supreme worship due to God alone" (178:
241). The artist was allowed to paint and to adorn
churches any place he willed, but the principles of
his art and the arrangement and disposition of his
painting lay with the Fathers of the Church (291:250).
The decree accepting images read in part:

> "We define with all accuracy and care that the
> venerable and holy ikons to be set up like the
> form of the venerable and life-giving Cross, in-
> asmuch as matter consisting of colours and of
> small stone and of other material is appropriate
> in the holy church of God, on sacred vessels and
> on vestments, on walls, on panels, in houses and
> on roads; both the image of our Lord and God and
> Saviour Jesus Christ and that of our undefiled
> Lady the Holy Mother of God and those of the
> Angels-worthy-of-honour and those of all holy
> and pious men. . . " (101:5-6; 380:103-104).

According to the decree, art alone belongs to the
painter, its organization and arrangement to the
church (101:16; 348:98). Artists carried out orders
(140:59)--". . . the substance of religious scenes is
not left to the initiative of the artist, it derives
from principles laid down by the Catholic church
and religious tradition" (101:16; 348:98). Among
the detailed, elaborate, and unbreakable rules gov-
erning the representation of religious images (302:
105-106) are: Jesus on the Cross had to be shown
with His Mother on his right and St. John on the
left; the centurion pierced his left side, not the
right; only God, the angels, Jesus Christ, and the
apostles could be represented with bare feet--it was
heretical to depict the Virgin or the saints with bare
feet (348:98-99). The didactic purpose of religious
art--to illustrate and emphasize the teachings of the
Church--influenced composition as well as subject;
The place occupied by any figure with relation to the
center of the design had specific meaning--the higher
the position, the more honor; the right hand of
Christ, more distinguished than his left, as in "The
Last Judgment" where the elect must be shown on
Christ's right, the damned on his left (597:195-196).

The Edict of the Council of Nicaea was promul-
gated at the Magnaura Palace "in the Imperial pres-
ence"--Empress Irene and her young son Constantine
VI (380:103-104)--and was ratified by both the Greek
and Roman churches (140:59).

790-793 The Libri Carolini, a four-volume work, was issued
"stating in Charlemagne's name, the objections of
his circle of theologians to the restoration of images
by the Second Council of Nicaea" (416, VIII:729).
According to these authoritative instructions, the
purpose of an image in church art was confined
"almost entirely to stimulating the memory by its
content" (42:265).

794 The General Council of the West called by Charle-
magne at Frankfurt--attended by bishops of all
Frankish realms, two legates of the Pope, and
bishops from England--rejected the decrees of the
Council of Nicaea, issued in 787, allowing images
in the church, on the grounds that the decrees were
not ecumenical (292:54). The synod formally con-
demned the decisions of the Nicaea Council, possible
because--through a very literal translation of certain
Greek expressions in the decrees that Pope Adrian
sent to Charlemagne in 788--the Frankish bishops
thought the Council advocated "absolute adoration of
the images" (93:143).

 "The most inviolable Carolingian tenet" with re-
gard to church art was the injunction, "Deus pingi
non posset" ("God the Father cannot be depicted")
(179, VII:814).

9th c. (A) The codified Hadith--a "collection of genuine and
apocryphal sayings and accounts of Mohammed and
his companions"--reinforced previous Islamic pro-
scriptions against figural art, objecting to the "mak-
ing images of living things" through "fear of idola-
try" and "an encroachment upon the creative powers
of God." It relegated the painter to the lowest level
of society, and held painters would merit the punish-
ments of hell on the Day of Judgment because they
could not breathe life into the forms they fashioned--
"angels of mercy would not enter a house in which
there were images" (179, VII:816). In Islamic art,
however, there was "at all times... a great discrep-
ancy between official dogma and private practice,
especially since there were no religious or public
bodies capable of enforcing the iconoclastic stric-
tures in the inaccessible private rooms of palaces
and houses" (179, VII:817).

9th c. (B) The Buddha, lesser deities and attendants painted in
the Amitabha Paradise on the walls of the Tun-huang
cave were laid out according to Indian formulas using
chalk on a string, and the outlined figures were
drawn freehand or by using pounces, each according
to assigned colors, hand gestures, attributes and
garments (597:754).

813 Emperor Leo the Armenian disregarded the 787 de-
 cree of the Council of Nicaea (299, I:88), renewed
 the times of iconoclasm. His soldiers "destroyed
 images in all directions" (260, II:393, 397).

815 The iconoclastic Council of St. Sophia "rejected ar-
 tistic representations of Christ and the saints" (2:
 237), and while it ordered the destruction of icons,
 it "avoided denouncing them as idols, 'because there
 are degrees of evil'" (179, VII:813). From the ninth
 century on, Byzantine painting "portrayed the offi-
 cial dogma of the Eastern Orthodox Church," and--
 after the triumph of the iconodules or pro-icon
 party--became "more purely biblical and liturgical"
 (178:64).

820 Emperor of the Eastern Roman Empire Theophilus,
 a strong iconoclast, "did his utmost to root out im-
 age-worship" (260, II:397).

825 The Paris synod condemned Pope Eugenius II for
 image-worship (299, I:88-89).

843, March The iconoclast ban on "imaging" in religious art
 was finally brought to an end when the iconodules
 came into power and the Church Triumphant at the
 Council of Constantinople declared the "binding and
 ecumenical authority of the Iconodule Decree issued
 by the Council of Nicaea on October 13, 787."
 That decree was now interpreted in the light of the
 teaching of the chief Iconodule controversialist, St.
 John of Damascus: the picture was considered "a
 magical counterpart of the prototype," and had "a
 magical identity with it."
 With this official Church recognition of the "won-
 der-working ikon" (380:103-105) and the authoriza-
 tion that "effigies of Christ and the saints contained
 a spark of divine energy," "making their contempla-
 tion beneficial to the soul," there was a great in-
 crease in pictures and sculptures of sacred subjects
 (235:25-26; 492:62). The "heresy of the Iconomachi"
 was suppressed (260, II:398), and with the lifting of
 the ban on images, "only perhaps in Mesopotamia
 was the aniconic style retained among Christians"
 (492:77).
 Official manuals for painters, "laying down the
 choice of subject and the manner of composition of
 images" were compiled, and "remained in use in
 the Eastern Church after its separation from Rome
 in the eleventh century (and are still in use today)"
 confining "the freedom of inspiration and expression"
 of artists "within strictly defined limits" (225:49).

845 Great persecution of the Buddhist church in China
 resulted in the destruction of the Buddhist paintings
 on the walls of churches and other religious buildings
 at the T'ang capital, Ch'ang-an (354:14). Among art
 works lost at this time, or in subsequent upheavals,
 are the paintings of the most celebrated of all T'ang
 court painters, the great Wu Tao-yuan, better known
 as Wu Tao-tzu (354:18).

858 The Christian church in Chartres, on the site of a
 Druid shrine and the present-day site of the Chartres
 Cathedral, was destroyed by pagan Normans.

867 This year, considered by some authorities the date
 ending the "iconoclastic epoch, " because "ceremon-
 ious public installation of icons was apparently re-
 sumed"--23 years after the imperial restoration of
 icons in 843--was followed by "pronouncements
 against iconoclasm and anathemas against notorious
 iconoclasts" even "as late as 869, in the proceedings
 of the Ignatian Council of Constantinople" (179, VII:
 914).

869-870 The Fourth Council of Constantinople, in its 7th
 Canon, forbade those anathematized to paint images
 in the churches (93:164).

10th c. Theophilus' De Diuersis Artibus (The Various Arts),
 publication of "most comprehensive range, orderly
 presentation, and logical development and attention
 to detail" of medieval sources for art and techniques,
 was issued. The Diversarum Artium Schedula (Essay
 Upon Various Arts) included "all that Arabia displays
 on casting or hammering or chasing metal, " and all
 that "industrious Germany approves in cunning work
 of gold, silver, copper, iron..."

10/11th c. The Byzantine guide to painting, first system of
 Christian iconography providing the framework for
 artists' representation of the Deity, was issued
 (158, II:191). This "Bible of Art" showed the sub-
 jects and manner of presenting images in art, and
 as it preserved in "a crystallized, stereotyped fash-
 ion" the Greek style of painting (178:65), the compila-
 tion prepared by monk Dionysius, is referred to as
 the Painter's Manual of Mount Athos (179, VII:667,
 674).

10-12th c. The color employed in Byzantine paintings did not
 imitate the natural hues of objects, but followed a
 fixed color scheme for specific persons represented
 in religious art, enabling the spectator to know at
 once who was portrayed: Christ was identified with

blue and cherry-red, sometimes picked out with
gold; the Virgin was shown in all shades of blue;
St. Peter was assigned yellow and light blue; St.
Paul, blue and claret-red; and Emmanuel-Logos,
yellow streaked with gold (235:43).

907-1279 "Some Ch'an (Zen Buddhist) masters are pictured as
burning images of Buddha and tearing up the sacred
scriptures" (403:92) because Ch'an Buddhism in the
Five Dynasties and Sung periods denied the value of
orthodox Buddhist rituals, deities, scriptures, and
holy images in favor of individual enlightenment.

11th c. Kuo Hi in his essay on Chinese painting, Lin ts'iuan
Rao che, "first laid down the symbolism of colours--
wind being... yellow... and water blue in autumn and
black in winter." Chinese painters down to the pres-
ent day have drawn the titles of their pictures from
the list of themes given in the manual's third chap-
ter (175:10).

1072 Peter Damiani, trusted advisor to several popes,
presided at the Council of Milan, attacking "all the
arts and learning as incompatible with Christian
life" (367:42).

1083? Brother Agnellus deprived a brother of his hood be-
cause he had decorated a pulpit with pictures (130:
334).

12th c. (A) Traditional Indian painting principles were set forth
by Hindu writer Yasodhara, recorded as a Sanskrit
couplet describing the six "limbs," or component
parts, of painting (Book I, Chapter II of a commen-
tary on the second-century Kama Sutra of Batsayana,
that may be dated from the sixth or seventh century):
 "Differentiation of types, canons of propor-
 tion, embodiment of sentiment and charm,
 correspondence of formal and pictorial ele-
 ments, preparation (literally 'breaking,'
 'analysis') of pigments; these are the six
 limbs of painting."
These "limbs" refer to: subject, composition, ar-
tist's response during the process of painting, that
which is grasped by the spectator, content, mechan-
ics of production. "Breaking" in the sixth point re-
fers to preparation of pigments, and also to the
three "breakings," or bends, of the body in the
classical dance pose (403:40).

12th c. (B) The authoritative Sepher Hassidim (Book of the
Pious) "categorically expressed" Jewish disapproval
"of pictures of animate beings in the synagogue,

especially before the Torah-shrine" (509:24).

12th c. (C) The "Catholic Principle" broke the ban on paintings
 and statues on the altar of a church--a proscription
 that had been "repeatedly imposed by synods, and
 approved by liturgical writers"--through its encourage-
 ment of "art as a bridge to the invisible." The rel-
 iquary, free-standing figure of a Saint or the Virgin,
 and a retable (which grew in German gothic into a
 triptych and a winged altarpiece, and in Italy, into
 a tall picture) could now be used to enrich the altar
 (78:XIX).

12th c. (D) Maimonides, Rabbi of Cairo, condemned asceticism
 and interpreted the Jewish proscription of human or
 animal figure representation in art and decoration
 (in Mishnah Torah--Second Law--Hilkhoth Avodat
 Kokhavim, III, 10-11) as forbidding only the human
 (not animal) form in the round, while permitting it
 in painting and tapestries (509:24).

1115 From their founding by Bernard of Clairvaux, Saint
 and first abbe of the Cistercian monastery in France,
 the order of Benedictine nuns and monks removed
 everything from their chapels "which might flatter
 curious eyes and charm weak souls"--painting, carv-
 ing, fine tissues, and precious metals--all "vain
 things that were good for worldly folk" (102:9), ac-
 cording to St. Stephen Harding of Sherbourne's
 Carta Caritatis (Charter for Charity), the constitu-
 tional foundation-stone of the order (130:330).
 St. Bernard spoke of "the profusion of paintings
 and carvings in monastic churches as little short of
 heathenism" (132:62), and in reaction--"with strong
 puritan notes, common to the great monastic re-
 forms of the time" (131, I:281)--"against the decadent
 luxury of the Order of Cluny," the Cistercians "for-
 bade not only all 'graven images' but also all colour
 in their churches" (225:51):
 No crosses of silver or gold, only of painted
 wood;
 Candlesticks and censers of plain iron or
 copper;
 Vestments of linen or fustian;
 Altar cloths of unembroidered linen;
 No "curious carving," no stained glass, no
 paintings on wall or pillar (131, I:281).
 "While the puritanism of Carta Caritatis could not
 finally be enforced... it did foster a spirit of se-
 verity and restraint" in church art (131, I:339).

1125 (A) Bernard of Clairvaux, abbe of the Cistercian
 monastery, in a famous letter to Guillaume de

St. -Thierry, spoke against the "decorative richness"
of churches, and the "extravagances of early twelfth-
century monastic art" (130:53). "To what purpose
these ridiculous monsters and astonishing deformi-
ties? These unclean apes, these ferocious lions,
these centaurs, these spotted tigers, these huntsmen
sounding the horn; why are they here? You see
several bodies united in a single head or several
heads to a single body; a quadruped with the tail of
a serpent beside a serpent with the head of a quad-
ruped; a monster half horse and half dog, and a
horned animal with the body of a horse... The Church
is resplendent in her walls, beggarly in her poor;
she clothes her stones in gold and leaves her sons
naked; the rich man's eye is fed at the expense of
the indigent" (130:331; 572).

1125 (B) Sung Dynasty Emperor Hui Tsung, painter, collector
 of paintings, and patron of artists, founded and di-
 rected the Imperial Academy in China, in which he
 specified the subjects to be portrayed by artists and
 rewarded the best competitors, but this control rep-
 resented relative freedom in painting compared to
 previous strict formality of composition dictated by
 the Indian Sutras (597:763-768).

1192 According to General Chapter Records of the Cister-
 cian Foundation in France, two abbots were punished
 by the Chapter for "over-costly and superfluous"
 buildings. There was some relaxation of previous
 strictures against church decoration, however, as
 Cistercian authorities decreed by this time "that,
 in the frequent cases where a Benedictine house
 joined the Order, the existing stained glass might
 be retained in the church" (131, I:339).

13th c. (A) Rabbi Meir of Rothenberg "prohibited the illumina-
 tion of festival prayer books with pictures of ani-
 mals and birds... on the grounds that they distracted
 the attention of the worshipper, " but judging by the
 number of existing illuminated manuscripts his order
 was not effectively enforced (305:17).

13th c. (B) Custom decreed that medieval church art had "cer-
 tain determined laws" ("viae certae et determinatae)
 in Europe, and was governed "by almost mathemat-
 ical rules":
 "In the building of cathedrals the north porch
 invariably was dedicated to the Old Testament,
 the south porch to the New Testament, the
 west to the Last Judgment" (291:250).

13th c. (C) St. Francis of Assissi "banished from his Order all

painting and nearly all architecture" (225:52).

13th c. (D) The Jewish writing Sepher ha-Hinnukh, ascribed to
 Aaron of Barcelona, emphasizes that it was forbid-
 den to make likenesses of a human being out of any
 material even for ornament--**XXXIX**, 12 (509:24).

13th c. (E) Dislike of church ornament was so marked among
 the friars of St. Bonaventura's school that "high of-
 ficials in the Order were disgraced for permitting a
 painted window or a painted pulpit in their church-
 es... Multitudes of beautiful works of art were muti-
 lated, and noble buildings destroyed, by the vandal-
 ism of the very ages which gave them birth" (132:
 62).

1203, Decem- The Byzantine populace, rioting in protest against
ber an order that they provide food for the Crusaders
 encamped outside Constantinople, and the high taxes
 imposed by city ruler Alexis, destroyed a thirty-
 foot ancient bronze figure of Athena because its
 right arm "pointed to the West from whence the
 barbarians (Crusaders) had come. " The statue--
 identified by some writers as the famous sculpture
 of Phidias formerly on the Acropolis of Athens--had
 been "visible on a clear day to ships rounding the
 Cape of Sounion, " and was the "first of hundreds of
 classical sculptures to be destroyed as a result of
 the Fourth Crusade" (236:32-33; 275, I:83; 330:185).

1204, April 12 The capture of Constantinople by the Fourth Crusad-
 ers "was followed by one of the most appalling rav-
 ages of a city in the history of warfare. " Fifty
 thousand French and Venetian rioters in a week
 stripped and sacked the "vast collection of ancient
 sculpture which Constantine the Great and his suc-
 cessors had imported" to adorn the capitol. Treas-
 ures from palaces, churches, monasteries and li-
 braries were destroyed or stolen, and according to
 a Byzantine historian:
 "Mobs ransacked the great Byzantine palaces,
 smashing chandeliers for their silver, chisel-
 ling the gold and silver from the columns,
 gouging the gilt from the walls, tearing apart
 the inlaid furniture to retrieve their jewels. "
 Crusaders "brought horses and mules into the main
 body of St. Sophia" to carry off the loot of "sacred
 vessels, silver chalices, chandeliers, pieces of
 bronze doors.... " The relics that were sent to
 Venice and to France, included "many pieces of
 the Cross... and at least ten authentic heads of
 John the Baptist" (236:34-36; 275, I, 80).

1213 The Cistercian Chapter in France "forbade all
 painting (or possibly carving, since the same word
 is often used in both senses) of all images except
 the crucifix... An existing painted altar was ordered
 whitewashed; permission was needed even to paint a
 door white" (131, I:339).

1235 A tesselated pavement of a Cistercian church in
 France was ordered destroyed because St. Bernard
 had condemned such pavements in his Letter to
 Guillaume de St. Thierry, written in 1125 (131, I:
 340).

1240 The Cistercian Foundation in France decreed that
 carved reredoses must be destroyed because they
 violated the puritanism of church decoration.
 "Stone bell towers on churches were forbidden;
 bells (generally two in number) might not exceed
 five hundredweight; and the number of lamps in the
 whole church was restricted to five" (131, I:340).

1250/1260 The series of eight bas-reliefs on the Martyrs Por-
 tal of Notre Dame in Paris, secular scenes showing
 student life at the University of Paris--including
 trials and examinations, struggles with the police,
 lectures, modes of study, artisans at work--were
 "cut off from public view for a very long time, "
 encouraging "far-fetched interpretations" giving
 them some religious significance (LAT Ja 10 1968
 V:6).

1254 The Speculum Majus by Vincent of Beauvais--French
 Dominican scholar nicknamed "librorum helluo"
 ("Devourer of Books")--was completed. As the
 "most complete scientific encyclopedia of the thir-
 teenth century, " aimed to reflect "all things of all
 times, " the work included a basis for medieval art
 subjects and iconography (177, VIII:365; 373:23-25).

1270's According to al-Hilli's standard work on the law of
 Shiah--one of the two great sects of Mohammedanism
 --pictures are included among the articles which
 cannot be bought or sold "because making of them
 is an act intrinsically unlawful" and a breach of
 Sacred Law (15:12).

1275 The Legenda Aurea (Book of the Golden Legend)--a
 collection of many centuries of Christian legend--
 was assembled to help develop a scheme of emblems
 by which each saint could be recognized and his
 story read (275, III:141).

1286 Rationale Divinorum Officiorum, written by William

Durand the nobleman of Languedoc called "The
Speculator, " on the origin and symbolism of the
Christian ritual, included one book on the meaning
of the Church and its parts, following the thirteenth
century "penchant for symbolism and Gothic accep-
tance of every artistic detail of a church as a token
of some aspect of Catholic dogma": Pictures and
ornaments in churches are the lessons and the scrip-
tures of the laity (374, I:121).

1293, January
18

Ordinamente della Giustizia, Gianno di Bello's law
in Florence, made membership in a guild a compul-
sory obligation for every native man over sixteen
years of age, further extending the power of the
Craft-Guilds (558:50).

1297

Florentine painters dependent "for their supplies of
pigments to the Apothecaries and their agents in
foreign lands" placed themselves under the banner
of the Guild of Doctors and Apothecaries (L'Arte de'
Medici e Degli Speziali). Before this time the paint-
ers--as all workers in the decorative arts: archi-
tects, builders, mosaicists, gold and bronze work-
ers, carvers in wood and stone--formed a branch
of the Comacine Guild, and Magistri Pittor (master
painters) formed a branch of the famous guild until
the beginning of the fourteenth century, when painter
communities were founded outside the parent group
(558:269).

1298

After his defeat of Sir William Wallace, King Ed-
ward I of England, as one of his acts to "extirpate
the Scots, " "destroyed the antique monuments of
Scotland erected by the Romans or the early Scots"
(223, I:15).

14th c.

The art of stained glass making in much of Europe
was destroyed by "the decline in technique resulting
from the disastrous effects of the Black Death, to-
gether with the Cistercian ban on pictorial windows"
(178:458).

1304

Giovanni Pisano, chief Italian sculptor of the Middle
Ages, "was forced by Pisan authorities to submit to
an inquiry" in connection with the Pisa Cathedral
pulpit (4:193) he had contracted for, which "was a
failure in the opinion of his contemporaries" (4:190).
Master craftsman Pisano recorded the acceptance of
his guilt of failure in the carved inscription surround-
ing the pulpit: "Giovanni has encircled this, the
rivers and the parts of the earth. Attempting much,
learning and preparing all with great labour, he now
proclaims: I have not taken care enough. Though

I achieved much, I have been much condemned. Yet
with a coward heart I bear the penalty with humility.
That I may avert malice from this (the monument)
mitigate my sorrow and seek glory (I say): Join
your tears to these verses. Let him who reproves
(this work) prove himself, unworthy one, worthy of
a crown. Thus he who is reproved, proves himself
and proves (also) the worth of him who reproves
him" (4:194).

1311 Guillaume Durand, bishop of Mende, recommended
 in his memorial to the Pope and the General Coun-
 cil of Vienne that church authorities should destroy
 "all ill-formed images and all which deviate from
 the truth of things as they happen. " (131, I:51).

1339 In Florence the Guild of Painters (L'Arte de Pittori)
 became incorporated as an affiliate of the Guild of
 Doctors and Apothecaries (L'Arte de' Medici e Degli
 Speziali). At this time the Society of Sculptors and
 Architects was affiliated with the Guild of Masters
 in Stone and Wood and of Retail Cloth-Dealers and
 Linen Manufacturers (L'Arte de' Maestri di Pietra
 e di Legname, e de' Rigattieri), and goldsmiths
 were added to the Guild of Silk and Cloth of Gold
 Manufacturers (L'Arte della Seta e di Drappi d'Oro,
 e Degli Orafi) (558:225). Detailed strict require-
 ments--aimed mainly at fixing technical tradition
 (403:31)--governed the training and work of guild
 members. For example, goldsmiths were authorized
 to work in all metals, "but every article made had
 to be submitted for approval to appointed inspectors, "
 and each article passed required identification by
 maker's name stamp and his trade mark. Mater-
 ials were regulated--gold employed "had to be of
 equal value to that used for the gold florin"--as
 was place of work--"no goldsmith was allowed to
 exercise his craft outside his own dwelling-house
 or workshop" (558:229).

c 1340 Following the Islamic proscription against represen-
 tation of living things, al-'Umari "abstained from
 having the zoological section of his encyclopedia
 illustrated, but not the botanical" (179, VII:817).

1341 Many of the sixteen reliefs in the civic allegory de-
 picted on the Tarlati Monument were mutilated when
 the ruler, brother of Bishop Tarlati, was expelled
 from the city of Arezzo. These narrative reliefs,
 in the democratic tradition of Tuscan sculpture, had
 celebrated the good government of Tarlati as con-
 trasted with the bad rule of his predecessors (465:
 189-190).

1349 The Florence Guild of Painters was enrolled as
 "Compagnia e Fraternita di San Luca" under the
 special protection of the Virgin Mary and St. John
 the Baptist, St. Zenobbio, and St. Reparata. The
 membership fee was 5 lire, and religious duties
 imposed--in addition to apprenticeship and work
 standards--included: "go to Confession and to Com-
 munion at least once a year and recite daily five
 Paternosters and five Aves. " Records show that
 these requirements were enforced--complaints of
 remissness in religious duties (in 1406) resulted in
 "durance in Guild House with money fines, ranging
 from twelve denari, for each dereliction of duty"
 (558:270).

1357, Novem- By public decree of the city of Siena, a statue of
ber 7 Venus in the Fonte Gaia, the center of town--which
 had been exhumed some years earlier to the delight
 of the populace at finding such a treasure, signed
 by Lysippus and showing Aphrodite on a dolphin--
 was taken down and buried in Florentine territory
 to bring bad luck to the Florentines, enemies of
 the Siennese. This action was taken after "a citi-
 zens group made a patriotic speech pointing out the
 disasters that had befallen the city ever since the
 figure had been discovered. " "Since idolatry is pro-
 hibited... by faith, " there was no doubt that the
 Venus was the cause of the disasters in Siena (114:
 94).

1370 (A) Cennino Cennini, Giotto's pupil and "inheritor of the
 traditional practices of the fourteenth century Italian
 art workshop, " wrote Libro dell'Arte (The Crafts-
 man's Handbook) to provide "the student of painting
 with medieval precepts and examples. " For the
 first time since antiquity, "artistic fantasy is recog-
 nized, " establishing a distinction between "mechani-
 cal" and "fine arts" (275, I:136).

1370 (B) Pope Urban V buried a statue of Hercules and other
 objects of pagan art under the foundation of the pal-
 ace he was building "in order to abolish the memory
 of idolatry" (130:447).

1377-1384 In an attack on the hierarchical system, corruption,
 and worldliness of the church, John Wycliffe--Eng-
 lish religious reformer and theologian, called "The
 Morning Star of the Reformation"--considered "im-
 age-worship" unlawful, and forbade representations
 of the Trinity:
 "Hit semes that this offrynge ymages is a
 sotile cast of Anti-christe and his clerkis
 for to drawe almes fro pore men... Certis,

these ymages of hemselfe may do nouther gode
nor yvel to mennis soules, but thai myghtten
warme a man's body in colde if thai were
sette upon a fire" (334, II:440).

1389 — Mathias of Janow in the Synod held "that images of
Christ and the saints gave rise to idolatry, and
that they ought to be banished from the church and
burned" (334, II:437).

15th c. (A) — King Louis IX of France tore "out the first page of
his Bible, because the Bible story of the first trage-
dy of humanity was shown there in its naked truth, "
according to Dominican Bernard d'Auvergne in his
text, Put on Clothes, Therefore in the Elect of God
(130:119). Artists of this time avoided picturing
nude figures, and when such figures were shown in
scenes of Creation of the World, Adam and Eve,
the Resurrection, and the Last Judgment, the "fig-
ures were rendered on small scale like puppets"
(597:201).

15th c. (B) — St. Bernardino of Siena (d. 1444) spoke against the
arts, including as "most mortal sin" "wanton pic-
tures exciting to vanity or lust" (130).

c 1400 (A) — Jean Gerson criticized a Vierge in the church of the
Carmelits in Paris as "anti-dogmatic because it
visualized the Trinity as incarnate. " (42:282-284).

c 1400 (B) — In Venice, Pier Paolo Vergerio ordered the removal
of the images of Saints Christopher and George (179,
XI:908).

1400 — As an indication of the power of tradition in art rep-
resentation, and in religious symbolism, by 1400 it
had become "exceptional to find the Virgin without
a blue mantle. " Until about 1300 it is "the excep-
tion for her to appear in a blue cloak. " Red and
green with gold were the two most aristocratic col-
ors of dress in the Middle Ages--these were the
only colours "definitely forbidden" by ecclesiastic
disciplinarians for wear by the clergy--so that ar-
tists, wishing to regally array the Queen of Heaven,
clad the Virgin in these colours (130:264).

1400-1430 — The guilds in Italy regulated the course of instruc-
tion for painters and sculptors. They not only
"regulated apprenticeships and manufacture, " but--
by restrictions particularly hampering to painters
and sculptors--"also controlled the movements of
their workmen outside their town walls" (225:26).

1426 Papal authorities gave a company of lime-burners
leave to destroy the Basilica Julia, claiming half
the produce of the kilns (130:441). A host of Ro-
man monuments were destroyed during the time of
Pope Martin V who restored sanctuaries in the city
by "systematic spoilation of pagan monuments."
Succeeding Popes continued the destruction of classi-
cal monuments for contemporary building projects,
then issued "laws protecting the very buildings they
had stripped" (570:86).

1434 Filippo Brunellesco, not a member of the Florentine
guild of freemasons or the painters guild, was given
the commission to complete the lantern of the Flo-
rence Cathedral--he had already won the competition
held in 1418 for the erection of the dome of the Ca-
thedral. While Brunnellesco belonged to the Silk
Merchants Guild (Arte della Seta, which he joined
in 1398) and to the Guild of Goldsmiths (Arte Degli
Orafi, a subordinate corporation of the Guild of Silk
and Cloth of Gold Manufacturers and Goldsmiths--
L'Arte della Seta e di Drappi d'Oro, e degli Orafi--
in which he enrolled in 1404), the Mason's Guild
(Masters of Stone and Wood Guild) were so offended
at this breach of their monopoly--through employ-
ment of Brunellesco, a nonmember--that they in-
sisted the artist join their guild. When he ignored
the guild protests, refused to join their group, and
would not pay his guild dues, the Masters of Stone
and Wood Guild sued him for debt of fees owing,
and the court imprisoned him as guilty of the charge.
Brunellesco was released from prison only with the
help of Por Santa Maria and the guilds of which he
was a member (299,I:126; 558:334-335).

1436 Della Pittura (Treatise on Art) by Leon Battista Al-
Berti was published as "an expression of the Renais-
sance point of view," and had enormous influence
for centuries on such subjects as perspective, re-
lief, light and shade, and use of color (229:32).
The work emphasized the importance of economy
in art, a reflection of the ideal of self-control in
the society of the High Renaissance: "...just as
princes enhance their majesty by the shortness of
their speeches, so a sparing use of figures increas-
es the value of a work of art" (257, II:91-92).

1448 Pope Nicholas V who launched the great building
programs of the Renaissance Popes records the
vandalism of antiquities in his grand building pro-
gram. According to his accounts, he had 2,500
cartloads of stones taken from the Colosseum in
a single year, razed the Arnicia Chapel and the

Temple of Probius in the Vatican, and melted down
all the coins found in the tombs to make a gold
chalice (277:40).

1462, April
28

Pope Pius II promulgated the first papal bull "for-
bidding further destruction of ancient monuments"
(416, XI:394). Later in his Commentaries (c 1482)
the Pope charged Sigismondo Malatesta of Rimini,
patron of art and letters, with having "paganized"
the Franciscan church San Francesco by introduc-
ing pagan gods into the church because the structure
was "surrounded with mausolea and triumphal ar-
cades, and the interior chapels were fitted with
balustrades and fluted pilasters to give each the
look of an ornamental screen surrounding some
proud tomb" (534:134-135). Later the Pope ignored
his own edict against the quarrying of ancient stone
or using any fragment of antiquity in new construc-
tion by plundering the Villa of Hadrian at Tivoli for
his building in Rome, Siena, and his birthplace, Cor-
signano (570:89). It was during the time of Pope
Pius II that an artist (Paolo Romano) was first ad-
mitted to the great dining-hall to eat as an equal,
rather than being relegated as an artisan to eat with
the servants.

1464, Septem-
ber 29

During the third year of his reign King Edward IV
of England issued a protectionist edict forbidding
the importation of playing cards (Cardes a Juer),
"The Devil's Picture Books, " into his realm "from
this Michaelmas Day" (37:25).

1471

Pope Paul II forbade the decoration and sale of amu-
lets and charms, but at the same time he discussed
the Agnus Dei, the consecrated figure of a lamb
stamped in wax remaining from paschal candles,
pointing out its efficacy in "preserving from fire
and shipwreck, in averting tempests and lightning
and hail, and in assisting women in childbirth" (334,
III:410).

c 1475

Sienese artist Francesco di Giorgio Martini "left a
mystical interpretation of proportions and was tried
as a heretic" (179, XI:908).

1477?

St. Antonius, Archbishop of Florence, "condemned
the errors of artists not only contra fides (as, for
instance, the representation of the Trinity with
three heads), but also those against morality:
'quando formant imagines provocativas ad
libidinem, non ex pulchritudine sed ex dis-
positione earum, et mulieres nudas et hujus-
modi'" (179, XI:899; 416, I:647).

1480's Federigo de Montefeltro, Duke of Urbino, allowed
 no printed book, with its woodcut illustrations, to
 to enter his library. He preferred manuscripts
 beautifully written by a scribe, and illuminated by
 hand-painted miniatures because these "addressed
 his eyes and mind in a personal way" (632:69).

1485 Leone Battista Alberti's treatise De Re Aedifica-
 toria (more commonly known as the Ten Books of
 Architecture) was published in Latin. Modelled on
 the ancient architectural manual of Vitruvius, the
 treatise was an up-to-date guide to architecture
 discussing "every aspect of building--history, siting,
 design, construction, city-planning, and engineering. "
 By this work, Alberti "did much to establish archi-
 tecture, formerly considered a mere trade,... as an
 equal of any of the arts. " First presented as an
 incomplete Latin manuscript to Nicholas V in 1452,
 the Ten Books was published in Italian in 1550.
 (277:134).

1485-1500 Florentine painter Francesco Botticini's "Assumption
 of the Virgin" which had been inspired by the writ-
 ings of Matteo Palmieri, was covered, for religious
 reasons, between 1485 and 1500 (179, XI:899).

1488 "Adam and Eve, " frank studies of the nude by Baccio
 Bandinelli, was made to stand behind the high altar
 of the Florence Cathedral, but the painting so
 shocked the clergy that it was removed, and today
 is in the Bargello.

1490's Isabella d'Este, Marchioness of Mantua, renowned
 beauty, patron of the arts. and skilled diplomat,
 wrote to artist Luca Liombeni with specific instruc-
 tions concerning certain decoration in the palace at
 Mantua:
 "Enclosed herewith is a list of the devices which
 we want you to paint on the frieze. We count on
 you to arrange them as nicely as possible so
 that they will be most effective. You can paint
 what you like inside the closets, provided that
 you do it skillfully. If not, then you will re-
 paint them at your own expense and you will
 spend the winter in the dungeon. " (369:249).

1494 When the armies of the King of France entered
 Florence, and Piero de' Medici, son of Lorenzo,
 fled the city, a mob sacked the Medici palace and
 destroyed Botticelli's frescoes on the walls of the
 Bargello (254).

1498 In his effort to burn paganism and idolatry in the

public square of Florence (569:51), Savonarola,
Dominican friar religious reformer, substituted "for
the profane mummeries of the carnival" a "Bonfire
of Vanities, " and the objects confined voluntarily to
the flames were supplemented by his followers
("Piagnoni, " or "Weepers")--boys who entered
houses and palaces of the city and carried off what-
ever (558:512) they "deemed fit for the holocaust"--
precious illuminated manuscripts, ancient sculptures,
pictures, rare tapestries, and other priceless works
of art along with mirrors, musical instruments,
books of divination, astrology, and magic (334, III:
212-213).

In his sermons to reform the Church and society
of his day (133:260), Savonarola had criticized the
vanity and immorality in art:
> "...you paint the faces in your churches, which
> is a great profanation of divine things...you fill
> your churches with vain things (130:316). Take
> away from your room and your house these im-
> proper paintings....You have filled your house
> full of vanities and images" (225:53-54).

Savonarola had issued "strict injunctions not to in-
clude portraits of real people in altarpieces" (179,
XI:899), and had spoken out, not against art itself,
but against nudity in art (152:16). Among many
Florentine painters who "suddenly stopped painting
nudes and pagan subjects and brought their works
to be burned (225:53-54) in the "Bonfire of Vanities"
were Lorenzo di Credi, and Sandro Botticelli, who
is reported to have burned drawings of the nude and
of his famous painting "Venus" (114:157;254).

16th c. (A) "The sacro-pictoral code of Interian de Ayala" was
detailed and strict in its rules for Spanish painters.
Painters who exposed the feet of their Madonnas
were censured; the Cross, in a painted Crucifixion
scene, had to be represented as "precisely fifteen
feet by eight, " "the timber had to appear cut flat,
never rounded; and four nails, not three, had to be
depicted. Deviation from these rules was heresy, "
and merited the attention of the Familiar of the In-
quisition (539:237).

16th c. (B) Artists--sculptors, goldsmiths, painters--received
from the guild a technical training that enabled them
to practice their art, but in the sixteenth century
the painter and sculptor became separated from the
crafts of "stone carver, the tapisser, the goldsmith,
the engraver" because they received training in art
as a profession at an Academy of Fine Arts, newly
established by kings and princes for that purpose
(275, III:414-415).

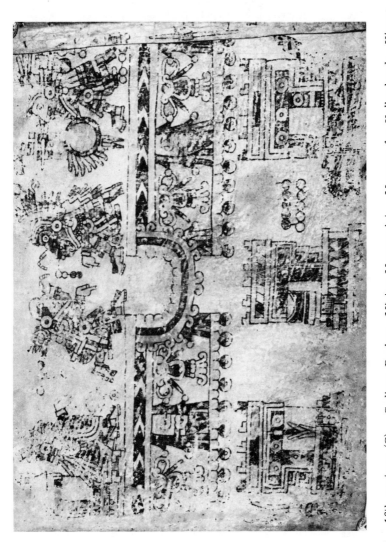

3. 16th century (C). Codices Becker, Mixtec Manuscript. Museum fur Volkerkunde, Vienna

16th c. (C) The Codices Becker, one of the pictorial Mixtec
 manuscripts offering a wealth of information on re-
 ligious beliefs, tribal history, and everyday life
 (Vienna Ethnographical Museum--Museum fur Volker-
 Kunde Wein--Inv. No. 60306 and 60307), add little to
 other factual accounts of Mixtec dynasties of the
 eleventh century in Mexico, but are valued for their
 "exceedingly beautiful" painting depicting in great
 detail Mixtec ceremonies and life, such as Temple
 visits. They exist only in fragments, destroyed--
 not only by time, but by "intentional erasure" (90;
 116). (ILLUSTRATION 3)

16th c. (D) During the high point of Venetian glassmaking on the
 island municipality of Murano--located in the lagoon
 about a mile north of Venice--glassmakers were for-
 bidden to leave the islands and were imprisoned in
 their workshops lest they reveal the secrets of their
 craft.

16th c. (E) In the Protestant Reformation "all the heretical
 movements of the Middle Ages were fundamentally
 iconoclastic....The Albigenses and the Waldenses,
 as well as the Lollards and the Hussites, condemned
 the profanation of the faith by the glamour of art"
 (257, II:124). Reformation leaders Martin Luther,
 John Calvin, John Knox, and Huldreich Zwingli re-
 kindled the ancient suspicion of "image-worship" and
 "banished all religious imagery from its churches"
 (43). During this religious revolution, more medieval
 art in Europe was destroyed than had been destroyed
 up to this time "among orthodox populations by
 Jesuits and rococo rebuilders" (131, I:322). The
 Protestant hatred of images made a distinction in
 church art media and content, directing the icono-
 clastic destruction and proscription mainly "to idols,
 that is, sculptured images (with constant reference
 to the Biblical golden calf)." The print, on the other
 hand, as an illustration of events in the Gospel was
 saved by the fact that "it was a narrative and not
 an anthropomorphization of the divine," and, too, it
 played an important function "in the educational ac-
 tivities... vigorously carried on by the reformers"
 (179, XI:902).
 While the Catholic Church in the West had been
 almost consistently in favor of religious art, "which
 it regarded as a means for educating men toward a
 better understanding of the creed" ("by acquainting
 the illiterate with images of the things they could
 not read about, but also by instilling in all the habit
 of proper devotional attitudes"), early Protestants
 expressed their opposition to church authority "by
 smashing all the altarpieces on which they could

lay hands" (43). Statues of the Virgin were demol-
ished, crucifixes burned, images of the saints trans-
pierced with swords (374:167). "Almost all pictures
of Christ and the Saints in Greek Orthodox Churches
were destroyed" (43).

Calvinists, Huguenots, Puritans, and Lutherans
each destroyed art in the church. In the space of
half a century, sculpture, glass, tapestries, wood
carving, metalwork, and illuminations were "prac-
tically obliterated" (140:95). Because Puritans "did
not like Art"--fine arts were "indelibly associated
with the old church and the old nobility" which they
rejected--they "discouraged the arts of architecture
and decoration in their barnlike churches" and in
general "distrusted the higher pleasures of art" (66:
226-227). In England, the Puritan iconoclastic move-
ment was strong, resulting in the wanton destruction
of organs, stained glass windows, and statues (555:
250). Also proscribed were illuminated manuscripts
in England, where they "made a holocaust... to feed
furnaces, " or were sent over to the Low Countries
in shiploads to be used for various base commercial
purposes" (140:71).

Martin Luther condemned the "idolatry" of the
Catholic Church, just as he condemned pagan image-
worship, and "saw 'idolatry' in the mere adornment
of churches with pictures" (257, II:124). His follow-
ers forbade religious paintings, and confiscated
existing paintings (141:32-34). In Switzerland,
Zwingli "fostered the campaign for the destruction
of sacred art" (179, XI:900).

16th c. (F) "In the general collapse of humanism of the later
sixteenth century, the nude survived as an instru-
ment of pathos"--subjects of Christian art in which
"nude figures are appropriate or permissible": The
Expulsion, the Flagellation, the Crucifixion; the En-
tombment, and the Pieta (114:312). For about a
hundred years, "the death of Our Lord and the suf-
ferings of saints were... almost the only way in
which the naked human body could be represented
without official disapproval" (114:340).

16th c. (G) Rabbi David ibn Zimra objected to a family crest
embodying a lion over the Torah-shrine at Candia--
then under Venetian rule--because it was contrary
to ritual rule against representing animate beings
in Jewish holy art (509:25).

1502 Officials in Spain considered establishing an im-
primatur for woodcuts and prints to control the con-
tent and presentation of these "easily saleable" pic-
tures (179, XI:907).

1505 (A) When the Belvedere in the Vatican was turned into
a museum, the carved inscription over the entrance
read:
"PROCUL ESTO PROFANO" ("LET THE IGNO-
RANT STAY AWAY") (227:45).

1505 (B) Lucas Cranach, a leading German artist of the
Reformation period and friend of Martin Luther,
ceased painting nudes for almost thirty years be-
cause his first patron, Frederick the Wise of Saxony,
did not approve of "erotic art" (560:64).

1507-1519 Much of the idolatrous stone sculpture of the Aztecs
was "smashed by Catholic priests or broken into
building-stones" (598:74), and most of the native
goldwork "found its way to the Spanish melting-pot"
(598:149). "Temples torn down for the greater
glory of God" (598:260) were to provide a 20-foot
foundation for the Cathedral of Mexico City.

1509 The destruction of English Gothic painting, begun by
Henry VIII, was considered necessary as part of the
King's "attack on the Church organization to suppress
alleged exploitation of the people by the Church, and
to nationalise the Church's wealth. " "Images were
credited with magic powers by ignorant peasants, "
according to royal critics, "relics vying with each
other in grotesque pretensions... to mislead the
people" (630:44). The King's injunction that "all
images which had been worshipped or to which idle
pilgrimmages had been made should be taken down
and removed from the churches" resulted in the loss
of many valuable works of English sculpture (73:44).

1510-1535 The Bernese army--advocates of the Reformed
Church--"smashed all the statues of saints on its
way to Geneva" to show that it had "embraced the
Gospel" (559:315-316), and when the army reached
Geneva the soldiers went to the church and "des-
troyed all the fine paintings on the high-altar,
burned all the carved-wood statues, and smashed
the great, rich stained-glass window behind the
high-altar" (559:317).

1514? Raphael wrote a letter of protest to Pope Leo X
"against the continual destruction of Roman relics. "
He declared that contemporaries had done more
damage to the statues and marbles of ancient Rome
than the Goths and Vandals, and that "far too many
people" had "allowed Roman edifices to be ruined...
by permitting the excavation of pozzolana (clay) from
the ground upon which their foundations rest" and
"the daily burning in ovens" of marble ornaments

and statues "to turn them into mortar" (274:55).

1515-1547 Literary and artistic protest diminished in France
when King Francis I "consolidated royal preroga-
tives and further extended royal control over the
Church. " With the interests of State and Church
identical, censorship became severe and effective.
"In one case, the King condemned to death an au-
thor, a printer, and an illustrator for passages de-
faming the king" (538:33).

1518 "The first picture in the history of painting to cre-
ate a scandal"--"Sacra Conversazione" by Giovanni
Battista Rosso--shows the Virgin and Child en-
throned with Four Saints. Its style provoked lively
criticism because it abandoned the "serenity of
classicism, " and it was "found too extreme for
church decoration. " Rosso painted the picture for
Santa Maria Novella in Florence, but when Monsig-
nor Buonafede, church administrator saw "all the
diabolical saints... he fled from the house and re-
fused to accept the panel, declaring that he had
been cheated...." (31:131-132).

1521 (A) German Protestant reformer Karlstadt (Andreas Ru-
dolf Bodenstein) "had pictures of the saints burnt in
Wittenburg" (257, II:124), "with the enthusiastic as-
sistance of the crowd" (179, XI:900).

1521 (B) The Church's Edict of Worms "made vain efforts to
stem the flow of antipapal propaganda from the Lu-
therans, and explicitly forbade the publication of
satirical matter" (538:15).

1522 Florentine sculptor Pietro Torrigiano died, aged
fifty-six, on a hunger strike in the dungeons of the
Inquisition in Seville. The artist has smashed a
statue of the Madonna commissioned by the Duke d'
Arco because he considered the payment offered by
the Duke for the completed work "ridiculously small. "
Torrigiano, brought before the Inquisition on a
charge of sacrilege, was found guilty and condemned
to die, but he avoided execution of the extreme pen-
alty by starving himself to death in his prison (73:
43; 179, XI:908; 232:39).

1522, Sep- After the first issue of Martin Luther's new Bible--
tember with cuts by Luther's friend Lucas Cranach derived
from the "Book of Revelation"--Frederick the Wise
revised the illustrations to change the tiara of the
Scarlet Woman or Whore from the papal tiara
(which was also worn by the Beast with Seven
Heads whose number was 666) to "Harmless

Crowns. " In the issue of 1534 the "insulting papal tiaras" were restored (216, I:5).

1523 (A) According to the account of Weininger, an "aniconic outbreak" in which sacred art was destroyed occurred in Germany (179, XI:900).

1523 (B) Jacopo Pontormo's painting "The Deposition" was labelled "a blasphemous work"--"which in tottering composition, piles up tiers of androgynous wild-eyed creatures, one of whom, in the foreground, has adopted an indecent stance" (31:134).

1524 The Diet of Nuremberg confirmed and strengthened the censorship laws against political and religious literature and prints (538:15).

1525 (A) Huldreich Zwingli, Swiss religious reformer who established the Reformation in Zurich, persuaded "the Zurich city council to have works of art removed from the churches and destroyed" (257, II:124). After his written diatribe against images, and at his instigation, the Zurich magistrates proclaimed that the majority of each parish should decide whether the images that were an object of worship should be removed and destroyed. "The result was a very considerable destruction" (130:410).

1525 (B) Matthias Grunewald, master of the Isenheim altarpiece, sided with rebel peasants, and for this he was forced to leave a lucrative post as court painter to Cardinal Albrecht of Brandenburg, patron of many of Germany's leading artists, to seek "a miserable refuge in Saxony" (538:39).

1525 (C) In Germany, three of Durer's disciples--Georg Pencz, and the brothers Barthel and Hans Sebald Beham--were banished from Nuremberg for sympathizing with the peasants (538:39).

1526-1530 Corregio's decoration of the dome of Parma Cathedral so departed from acceptable church art--it was labelled "a hash of frogs' legs"--that cathedral authorities "broke their contract with the artist" and refused to let him paint the apse. The ceiling composition "seemed so audacious to Corregio's contemporaries, that the commission for the decoration of the choir, which was to have followed decoration of the cupola" was also cancelled (31:139).

1527 (A) During the sack of Rome, bonfires were lit in the Sistine Chapel in an attempt to destroy the frescoes (179, XI:897).

1527 (B) Pope Clement VII condemned and suppressed every
 edition of Pietro Aretino's Sonetti Lussurioi and the
 artist who illustrated the "indelicate" book, Giulio
 Romano, was compelled to leave Rome in order to
 avoid prosecution and imprisonment (525:174). Ro-
 mano's illustrations--"Posizioni" showing various
 positions of sexual intercourse--were made into a
 set of engravings by Marcantonio Raimondi, which,
 as Aretine's Postures, became "the best known work
 of erotic literature in Renaissance Europe" (450:289;
 576:17).
 After publication of the Sonetti in 1524, Aretino--
 self-designated "censor of a proud world"--too, was
 expelled from Rome, as was Marcantonio Raimondi,
 leading line-engraver of the Renaissance, said to
 have been "banished from Rome" for engraving the
 set of "licentious illustrations" (46A:121).

1528-1533 Juan de Zumarraga, Franciscan first Bishop of Mex-
 ico, zealously gathered and burned collections of Az-
 tec manuscripts as heretical books. Earlier in the
 tenth century under the Toltec empire, a meeting of
 priests and nobles had decreed that most of their
 books should be destroyed for fear that the hieratical
 caste would lose power if their books fell into the
 hands of the common people. One great magical
 work was retained: The Tonalpohualli (The Count
 of Fate), a system of prognostication based on calen-
 dar periods of 260 days.
 When the Spaniards arrived in Mexico, many of
 the surviving Aztec manuscripts were of a poetic
 and semi-religious nature, and it was these that
 fell under the ban of Bishop Zumarraga. The pic-
 ture-writing of the manuscripts, although it depends
 on a strictly observed code of proportion and rigid
 adherence to a fixed convention, is regarded as art
 of a high order (77).

1528, May 31 A band of Huguenots destroyed the statue of the
 Madonna in Paris, at the corner of Rue du Roi de
 Sicile (179, XI:900).

1530 The Diet of Augsburg confirmed and strengthened the
 censorship laws against political and religious litera-
 ture and prints (538:15).

1536 (A) John Calvin, French theologian and reformer most
 active in Geneva, gave impetus to the Puritan
 ethic against art that had existed long before
 him in the writings of St. Augustine, Savonarola,
 and other European religious reformers. He gen-
 erally condemned art in the church as "popish"
 and "idolatrous": "sculpture and painting were

particularly suspect because they served the popish
adoration of the saints" (379:47), and wrote in
Institution Chretienne (Christianae religionis insti-
tutio; Institutes of Christian Religion) against two
kinds of false art:
> Art that is against Christ (the use of images in
> the church);
> Art for art's sake (art which exists only for
> enjoyment).

Calvin disagreed with Gregory, who had found church
art the books of the illiterate, because he saw art
as "a doctrine of vanities"--Jer. X. 8--and "a teach-
er of lies"--Hab. II. 18. He held that the Christian
church for its first 500 years had not used images,
introducing them only when the church began to de-
cline. Because art is immoral (it is sensual and
deals with immoral subjects) and a waste of time (it
interferes with work and industry, and pleasure--as
from art--is a form of idleness), Calvin prohibited
any representation of God, Christ, or the angels:
"Nothing should be painted or engraved but objects
visible to our eyes" (555).

1536 (B) The Ten Articles, attempting in the last years of
Henry VIII's reign in England to simplify Christian
doctrine and reduce it to a few essential points,
condemned the veneration of pictures and of saints
(280:266).

c 1536 After Hans Holbein the Younger's religious paintings
in Germany were destroyed by iconoclastic mobs,
he "concentrated upon portraiture, an art which
could offend neither Catholic nor Protestant" (68:9).

1540--1541 Because Biagio da Cesena, papal master of cere-
monies, told Pope Paul III--when they viewed the
three-quarters completed Sistine Chapel fresco,
"The Last Judgment," by Michelangelo ("the most
distinguished artist in the Christian world" (257, II:
116):
> "that it was a very improper thing to paint so
> many nude forms, all showing their nakedness...
> in shameless fashion," and that the picture was
> "better suited to a bath-room," or a road-side
> wine-shop, than to a chapel of the Pope,"
the angry artist represented his critic in the paint-
ing as a figure in Hell--Minos, snake-entwined judge
in Hades, at the lower right-hand corner of the
painting (515).
> Biagio complained to the Pope about Michel-
angelo's libel in portraying him as one of the
damned. He was told:
> "Had the painter sent thee to Purgatory, I would

have used my best efforts to release thee, but
since he hath sent thee to Hell, it is useless to
come to me, as I have no power there" (369:
255; 601, IV:140).

1540, July 22 By edict Pope Paul III gave all the monuments of
the Forum and of the Sacra Via to Fabbrica di S.
Pietro (St. Peter's Church at Rome). Pope Paul's
prior regulation had decreed that any person who
destroyed ancient statuary could be put to death,
but according to this new pontifical grant the pow-
dered Parian marble and lime from the statues and
monuments was disposed of at great profit, much
Graeco-Roman art disappearing in the lime-kiln and
as building material (130:441-442).

1541, October When Michelangelo finally "revealed to the eyes of
31 his disconcerted admirers the fresco of 'The Last
Judgment' in the Sistine Chapel above the altar, "
his contemporaries were shocked by "the indecency
of this display of colossal nude figures in a church"
(31:144). The "superb nudes" whose "heroic pro-
portions and nobility of spirit seem to us passion-
ately pure" (515) were condemned as unclothed hu-
man bodies. Pietro Aretino, Italian satirist known
as "The Scourage of Princes" for his attacks on
powerful rulers of his day, wrote Michelangelo a
letter containing "a tirade on the licentiousness and
impurity" he found in the painting, which made him,
"as a baptized Christian, " blush (515).

1545-1563 To work for purification of the church from within,
devout men in the Catholic Church formed the
"Oratory of Divine Love, " during the time of world-
ly Pope Leo X. The reforms they effected were
marked by The Index, the Council of Trent, and
the Dominican Inquisition. The Inquisition--"evolved
in the Middle Ages as an effective means of coping
with the problem of heresy"--found the heinousness
of the sin of heresy (the literal meaning of the
word "heresy" is "choosing, " "selecting") was "se-
lecting beliefs instead of obediently accepting the
whole faith of the Church" (585:1-2). The "Special
Office, " or "Holy Office" of the Inquisition--"an in-
evitable evolution of the forces at work" in the
thirteenth century--was in art, as for other expres-
sions and activities it supervised, "far less censor-
ious of morality than of doctrine" (133:305).

1546-1556 "Violent accusations of heresy were made in writing"
against mannerist painter Jacopo Pontormo's "Last
Judgment" in the choir of S. Lorenzo in Florence,
because the iconography of the picture alluded to

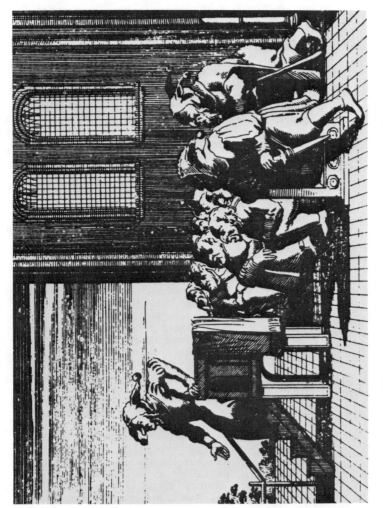

4. 1550. Engraving from Erasmus, In Praise of Folly

"salvation by faith alone" (179, XI:907), and the pic-
ture--last work of the artist--was eventually painted
over (in 1742) because it was "so advanced for its
time" (178:398).

1547, March
11
Don Juan, cacique of Teutalco, was fined by the
Mexican Inquisition on charges of idolatry and sacri-
fice because he kept the figure of a carved god of
wine (Ometochtli) in his home (238:80).

1549
As the Church and artists "were at loggerheads"
over the "wide-scale use of the nude" in religious
art, the discovery of Baccio Bandinelli's "Adam and
Eve, " undraped figures, in S. Maria del Fiore in
Florence "provoked enraged correspondence, " and
Michelangelo, who was blamed for having provided
the model for this particular work, was denounced
as "the inventor of filth" (179, XI:910).

1550
Opera Omnia by Erasmus of Rotterdam, Dutch
scholar and leader of the renaissance of learning
in northern Europe, illustrated with engravings by
Hans Holbein, was condemned by The Index in Spain,
1550; and in 1559 was again condemned by The Index
"more harshly than the works of Luther or Calvin"
(245:10-11). Holbein's engravings for In Praise of
Folly, work of Erasmus reissued in the famous
1603 edition are an example of the "antipapal propa-
ganda conducted largely by means of prints and il-
lustrated books" (179, XI:902). (ILLUSTRATION 4)

1551
Russian Czar Ivan the Terrible "virtually destroyed
secular art in Russia. " To effect strict social con-
trol, rules were set down "for everything from icon-
painting to shaving and drinking. " The Church Code
of 1551 "proscribed secular material in the arts"
(545:7).

1552
When, under Henry VIII, Mass in the English church
service had been changed to Communion, Thomas
Cranmer encouraged destruction of religious art and
decoration: "The images were removed from the
churches, and the walls whitewashed, and adorned
with the royal arms" (559:349).

c 1554
Renata di Francia (Renee de France), French prin-
cess notable in the history of the Reformation, deco-
rated her chapel in Castello Extense, Ferrara, with
nothing but geometric designs. This austerity rep-
resented the Reformation opposition to the use of
sacred images by private individuals in private and
family chapels, and the Inquisition, aware of this
trend, distrusted and even prohibited "the use of

private chapels and the tombs in them. " Renata di Francia had been briefly imprisoned by the Holy Office for heresy (177, XIX:142; 179, II:901).

1558-1559 Acts of barbarism with "smashing, hacking, and defacing" of church art was a sign of the "elect, " and the iconoclasts of the second and third years of Queen Elizabeth's reign produced headless statues to be seen in the abbeys and cathedrals throughout England (559:375).

1558 (A) The Vicar of Farra (Aquileia) removed all images from the churches (179, XI:901).

1558 (B) Daniele da Volterra, Italian artist and follower of Michelangelo, was instructed by Pope Paul IV to paint draperies over those naked figures which appeared "to be especially provoking" in Michelangelo's Sistine Chapel fresco, "The Last Judgment" (31:144; 178:497; 257, II:123). These "corrections" over those parts of the figures which (in Alberti's words) "porgono poco gratia, " in conformity with the newer puritan taste of the Counter Reformation (178:497)-- when "nudity as such became suspect" (532:618)-- earned for Daniele da Volterra the nickname "The Breeches-Maker" ("Il Braghettone"). Further veils, draperies, breeches, skirts, and clouds were added by later artists commissioned to carry the process of "correction" in the mural further, under succeeding Popes (515).

1558, September 7 Censorship under the Spanish Inquisition, "a most elaborate machinery of repression" (134) began in earnest with a decree issued by regent Dona Juana in the name of Philip II: The introduction of all foreign books in Spanish was banned; printers were obliged to seek licenses from the Council of Castile, granted control in 1544 over such permits; strict procedures for the operation of censorship were laid down, and punishment for "contravention of these points" set as "death and confiscation. " The first official Index of forbidden books in Spain had been drawn up in 1547 and published in 1551--a reissue of the Index issued by the University of Louvain in the Netherlands, and at least five Indexes were issued by tribunals of Toledo, Valladolid, Valencia, Granada, and Seville--all differing slightly in content. Among the prohibited works were "All pictures and figures disrespectful to religion" (304:88-92).

1559 For the first time an official list of books prohibited for the whole world was printed in Rome, and was

to go through about three hundred editions (134:380).

1560's-1650's The Counter-Reformation--deep-rooted reaction in
the Catholic Church--largely the outcome of the
Council of Trent (1545-1563), "affected the arts as
essential tools in spreading the prestige and teach-
ings of the Church. " The heated debate over peren-
nial religious themes--images, devotions, cult of
the saints--influenced esthetics, artistic theories,
art criticism, style and iconography.

The traditional alliance between the artist and
the Church (chief and most faithful patron of the
arts for over 1000 years) was disrupted. Violent
controversies were directed against the use of im-
ages inspired by ancient art, and associated--par-
ticularly the nude figure in heroic and mythological
themes--with representations of an erotic nature
(179, XI:899). Church reformers put into effect such
a strict set of rules for painting and sculpture that
many artists were driven out of ecclesiastical em-
ployment (219:22).

1560's Fray Diego de Landa, the second Bishop of Yucatan
and "leading authority on the ancient Maya, " in his
book, Relacion de las cosas de Yucatan, of 1566--
the "principal Spanish source for late (New Empire)
Maya history"--explains why only three of the Maya
codices (native books in hieroglyphic manuscript
treating of history, chronology, astronomy and dif-
ferent aspects of religion, and of value as art as well as
history) survive--
(Codex Dresdenis, 39 leaves of 8x3 1/2", total
length: 11-3/4'--treatise on astronomy, with
horoscopes and some ritualistic material--in
State Library, Dresden;
Codex Tro-Cortesianus, 56 leaves of 9 1/4x5",
total length: 23 1/2'--textbook of horoscopes to
assist priests in divinations--in Museum of Ar-
cheology and History, Madrid;
Codex Peresianus, 11 leaves of 9 1/4x5", total
length of fragments:4-3/4'--ritualistic, as katun
sequency and corresponding patron deities and
ceremonies; with some horoscopes--in Biblio-
theque Nationale).
In Bishop Landa's words:
"We found a great number of books... and as they
contained nothing in which there was not to be
seen superstition and lies of the devil, we burned
them all, which they regretted to an amazing de-
gree and caused them affliction" (398:295-297).

1560? (A) Carlo Borromeo, cardinal and archbishop of Milan,
had "all pictures which seemed indecent to him

removed from the sacred places" (257, II:123).

1560? (B) Anthonis Mor--Dutch portrait painter born in Utrecht
 and famous as an "international court painter" known
 in Spain as Antonio Moro and in England as Sir An-
 thony More--had been brought to Spain in 1552 by
 Cardinal Granvella, but "quarreled with the Inquisi-
 tion and returned to Antwerp" (539:237).

1560 At S. Spirito in Florence, the monks destroyed a
 priceless fresco by Simone Martini (Simone Memmi),
 one of the leading Siennese painters of the fourteenth
 century. The prevailing taste in religious art was
 strongly anti-medieval and frescoes of these earlier
 times (130:446).

1561 The Eton College barber "was paid six and eight-
 pence 'for wypinge oute the Imagery Worke upon
 the walles of the Church'"--Eton Chapel frescoes
 painted by William Baker between 1479 and 1488--
 with plaster or whitewash (630:42).

1562 In a wave of destruction of papal imagery, cam-
 paigns organized by citizens from various social
 classes, including artists converted to the Reforma-
 tion, were conducted in Switzerland, Germany,
 France, and England. In many parts of France,
 widespread drives against religious art in the icono-
 clasm of the Reformation "blotted out centuries of
 religious sculpture"--extending even to the "decapi-
 tation of statues on porches and facades, breaking
 up of the screens and choirs that cut off the faith-
 ful from the altar, culminated in firing and destruc-
 tion of entire churches. " Paintings were burned,
 and generally "statues heads were thrown into wells"
 (179, XI:900). Civil wars in France intensified the
 image-breaking--Protestant iconoclasts were marked-
 ly active in Lyon; Catholic leaders at Dijon and
 Chartres melted down the Church plate and ornaments
 (130:411).

1563 When a royal ecclesiastical visitation was conducted
 by Elizabeth I in England to give effect to the "Thir-
 ty-nine Articles"--guaranteeing the queen supremacy
 in religious and ecclesiastical questions--church of-
 ficials "removed pictures and relics root and branch,
 destroyed shrines, pictures, and paintings. Altars
 were replaced by tables" (280:269).

1563, January "To free painters and sculptors from the bondage of
13 the Mechanical Arts and establish them in the Liber-
 al Arts, " Cosimo de' Medici approved the statutes of
 the Academy of Art in Florence, and accepted the

title of their protector. The thirty-six painters and
sculptors nominated for membership in the Academy
"escaped from the control of the guilds," the mas-
ter-apprentice relationship was replaced by master-
pupil, and the artist became "an intellectual and not
a manual worker." "The Academy offered the artist
social prestige and security. But in exchange for
these it deprived him of his liberty" (225:46).

1563, Decem- In decrees comparable to the restrictions of the
ber 4 Second Council of Nicaea, of 787--eight centuries
 before, the leaders of the Counter-Reformation in
 the twenty-fifth, and last, session of the Council of
 Trent limited the freedom of the artist (225:48),
 through promulgation of official rulings concerning
 liturgical art (179, XI:908). The Church "restates
 its old argument in favor of images and paintings--
 that they were 'the Bible of the illiterate'--and at
 the same time insisted that religious art should be
 the servant of the Church (275, II:65). Church offi-
 cials spoke out against false images that would mis-
 lead "simple folk" and the "unlearned multitude" and
 warned that "all wantonness be avoided, so that im-
 ages be not painted or adorned with provocative
 beauty" (130:381; 452:237).
 A Bishop must approve "any unusual image... so
 that nothing new or anything that has not hitherto
 been in use in the Church shall be decided upon with-
 out having first consulted the most holy Roman Pon-
 tiff" (42:284; 275, II:65).
 In general, after the decrees of the Council of
 Trent, nudity was objected to in sacred subjects
 (114:376), and although "nudity in religious art," as
 in the case of Michelangelo's "Last Judgment" was
 proscribed, heroic and mythological nudity was toler-
 ated (275, II:62-63). Because of this restriction--and
 the denunciation of "unseemly mythology," allegory in
 art became "more than ever a means of avoiding cen-
 sure--a sort of expedient for vindicating pagan im-
 agery and licentious tales" (534:266, 271). These
 stern decrees--described with regard to art as "the
 birthday of prudery"--required "exact conformity to
 canonic form of Biblical stories and to official in-
 terpretation of questions of dogma," and the icono-
 graphy of Church art became so fixed and schema-
 tized (as in the Annunciation, the Birth of Christ
 the Baptism, the Ascension, the Carrying the Cross,
 the Woman of Samaria, Christ as the Gardener) that
 the forms "still hold good today as the standard
 model of the devotional image" (257, II:122-123, 183).
 Rules for painting and sculpture set forth by the
 Council of Trent ("He who is gifted with a heavenly
 knowledge of faith is free from an inquisitive

curiosity" (384:14)) were put into effect by the In-
quisition through its "rigorous supervision of every-
thing relating to morals and religion"--including art
(229:103).

1564
Following the rules regarding religious art set forth
by the Council of Trent (152:243), theologian Andrea
Gilio da Fabriano published Dialogo degli errori dei
pittori (Dialogue on the Errors of Painters) support-
ing and clarifying the directives laid down by the
Council (225:57). "Against all forms of nudity in
ecclesiastical art"--"even in cases where a charac-
ter could be portrayed in the nude in full accordance
with the Biblical record" (237, II:122), the work dis-
cussed the moral and religious values of Michelan-
gelo's Sistine Chapel fresco, "The Last Judgment, "
including in its serious criticism of the painting:
 Representation of Christ--He was shown unbearded;
 he was shown standing, not as He should be:
 Sitting on His throne of glory;
 Charon ferry--a theme taken from mythology;
 Angels--represented without wings; Apocalyptic
 Angels, contrary to Scripture, shown standing
 next to each other instead of being assigned to
 the four corners of picture;
 Saints--gestures show them "as if they were at-
 tending a bullfight";
 Draperies of some figures--shown blowing in the
 wind, when on the Day of Judgment the wind
 should have stopped blowing (225:57;257, II:122).

1566 (A)
The question of the indecency of the nudes in Michel-
angelo's Sistine Chapel fresco, "The Last Judgment, "
was raised under Pope Pius V, and El Greco, who
was in Rome at the time, urged its destruction, pro-
posing to replace it with a fresco that would be
"modest and decent and no less well-painted than
the other. " The Pope did not efface the "sacri-
legious decoration" (31:145), but had further offen-
sive portions (257, II:123) painted over with additional
draperies (225:57) in the interest of modesty (182:
169).

1566 (B)
A "terrible outbreak of Iconoclasts" made it neces-
sary to replace destroyed sculpture (in Brussels?)
(507:201).

1568
The Venetian ambassador recorded that in Amandola
"the exiles, who are said to have been accompanied
by a number of unfrocked clergy, got in and cruelly
burned the churches and tore down and broke the
images, displaying great contempt for all things
sacred" (179, XI:901).

1569-1599 The preference of printers in France for copper-
plate illustrations to wood or other metal engravings
was due largely to "restricting regulations within the
craft and to royal censorship for two centuries,"
and made illustration "the chief glory of French
books" (215:45-46).

1569 (A) "Fanatical mobs roused by Protestant preaching
broke into churches in the Low Countries and de-
stroyed tapestries, paintings, and sculpture" (68:8).

1569 (B) The Bishop of Cortona informed the Grand Duke
(Florence, Archivio di Stato, Cosimo Records, No.
198) of a widespread rumor in Cortona that it was
forbidden to possess crucifices or images, so these
were being either hidden or destroyed (179, XI:901).

1570's Nicholas Hilliard, limner to Queen Elizabeth of
England, was guided in his portraits of the Queen
by her "pronounced views on portrait painting."
She "objected to the new-fangled use of shadows...
and... made this plain to the portrait painters in
her court," forbidding accomplished artist Hilliard--
a leading miniaturist of the court--to experiment
with shadows because the Italians, she said," 'had
the name to be the cunningest and to drawe best,
shadowed not'" (82:92; 630:47-48).

1570 Johannes Molanus clarified "the position of the
Catholic church" toward religious art in his theo-
logical work, De Picturis et Imaginibus Sacris, pub-
lished in Louvain, specifying that "what was forbid-
den in print, was also forbidden in images" (42:284-
285):
 "Let us tolerate and permit some things for the
 sake of the weak....That which the Church toler-
 ates in books, let us also, with her, tolerate in
 pictures, which the Fathers have justly named
 the Scriptures of the Simple" (452:237).

1572 Il Marescalco (Giovanni Buonconsiglio), Vicenza
painter, "was brought to trial because he did not
want to depict purgatory" (179, XI:908).

1573 In Lombardy, St. Charles Borromeo, carrying out
the regulations of the Council of Trent concerning
art, combined positive instructions with prohibitions
for liturgical structures and decoration by issuing
"instructions governing the construction of churches"
(179, XI:909). Nearly four hundred years later, Pope
Paul VI in discussing liturgical arts (in 1964) re-
ferred to Borromeo's manual "describing the perfect
artist and builder of churches" as setting forth

5. 1573 July 18. Veronese. Feast in the House of Levi. Gallerie dell'Accademia, Venice

"norms extremely restricting as to form, measure-
ment, material, and location" (446:38-39).

1573, July 18 Veronese, master painter of the Venetian school
whose real name was Paolo Cagliari, was summoned
before the Inquisition--the Tribunal of the Holy Of-
fice--in Venice and accused of sacrilege in his paint-
ing, "The Last Supper that Jesus Took with His
Apostles in the House of Simon," a 17x39 foot can-
vas painted for the refectory of SS. Giovanni e
Paolo (208:85; 257, II:122; 325). Veronese had "ig-
nored the instructions of the Council of Trent con-
cerning subjects and manner of treating religious
paintings" because he had introduced in his picture
"human and animal figures--other than Christ and
the Apostles" (which were allowed as they followed
the Bible narrative). He showed German pikemen,
servants, a dwarf, jesters, a parrot, a dog (225:
58-59). The artist spoke to his accusors, explain-
ing his introduction of these "frivolous and extrane-
ous" secular figures (515):

> "The commission was to decorate the picture as
> I thought fit. It is large and can hold many fig-
> ures... If there is any space left in a picture I
> decorate it with invented figures. We painters
> claim the license that poets and madmen claim..."
> (225:58-59).

He had refused the request of the Prior of SS.
Giovanni e Paolo to substitute Mary Magdalen for
the dog in his painting: "I did not feel that the fig-
ure of the Magdalen would look good there." When
Veronese, defending his painting on the ground of
"artistic license," cited the nudity of the figures in
Michelangelo's "Last Judgment" fresco in the Sistine
Chapel, the Inquisitors pointed out that there were
no buffoons or dogs in Michelangelo's painting (515),
and the Chief Inquisitor told him:

> "Do you not know that in these figures by Michel-
> angelo there is nothing which is not spiritual?"
> ("non vi e cosa se non de spirito?") (113:71; 114:
> 52).

The Inquisition ordered Veronese to "improve and
change his painting within a period of three months
from the day of this sentence, under such penalties
as the Sacred Tribunal might impose" (229:108).
The ordered alterations were only partially carried
out--the servant with the "bleeding nose" was de-
leted, but the dog, the dwarf, the jester, the parrot,
and the German halberdiers remained in the paint-
ing--but the artist satisfied his accusers by changing
the name of the picture to "Feast in the House of
Levi," freeing the painting from the religious pro-
scriptions imposed if the scene were either "The

Last Supper, " or "Feast in the House of Simon"
(275, II:65-70). (ILLUSTRATION 5)

1576 John Northbrook in his publication Spiritus est
Vicarius Christi attacked card playing in England,
as well as plays and dramatic performances--"vain
Playes or Enterlude, with other idle Pastimes. "
He criticized the court cards as examples of idola-
try, even though the names were changed (King of
Hearts, became Charlemagne; Knave of Diamonds,
Hector; Knave of Clubs, Lancelot):

"The play of Cardes is an invention of the Deuill,
which he founde out that he might the easier
bring in Ydolatrie among men. For the Kings
and Coate cardes that we use nowe were in olde
time the ymages of Idols and false Gods: which
since they woulde seem Christians have changed
intu Charlemane, Launcelot, Hector, and such
like names, because they would not seeme to
imitate their ydolatrie herein, and yet maintaine
the playe itself, the very inuention of Satan, the
Deuill, and would disguise this mischief under
the cloake of such gaye names (37:26-27).

1579 El Greco's "Espolio, " a picture commissioned for
the priests of Toledo Cathedral Chapel, was refused
by the Fathers when the artist refused to make
changes they suggested--removal of "certain im-
proprieties" (485:184). El Greco sued for payment
and won an arbitration which decided, with the award
of the price he had demanded, that "Espolio" was
"one of the best pictures ever seen" (382).

1581 Artist Passignano (Domenico Cresti) was sentenced
to exile as a heretic (179:XI:908).

1581, January Playing cards made in Lyons, France, were suppres-
15 sed because they satirized Henry III, King of France,
as a weak ruler by showing the King carrying a fan,
and the Queen holding the scepter. The Parliament
of Paris promulgated an Ordinance prohibiting cari-
catures to control lampoons and attacks on the King,
of which packs of cards were one of the chief ex-
amples (37:82). (ILLUSTRATION 1. FRONTIS-
PIECE)

1582 When El Greco presented to Philip II of Spain the
large picture which the King had commissioned,
"Martyrdom of St. Maurice and the Theban Legion, "
destined for a chapel in the Escorial, although the
artist had spent two years completing the work "the
king who was not pleased by what he saw did not
hand the painting over to the prior of the monastery

until 1584. " The prior, too, hesitated to install the painting in the chapel, and the King finally commissioned a substitute picture from an obscure Italian artist, Romulo Cincinnati. Because of "difficulties" arising from "some question of iconographic orthodoxy rather than aesthetic considerations, " "St. Maurice"--deprived of its sacred function, rather than refused--was "given a home in the rooms of the Escorial set aside for a museum" (31:159-160).

1582, August 22

"I confess publicly, write down, and make known to all... how gravely I have sinned and how sorely I grieve and repent, " wrote seventy-one year old Bartolommeo Ammanati, well-known Florentine sculptor and architect, in a letter to the Accademia del Disegno in Florence, as he was "seized with remorse for those nudes--vain and lascivious--naked statues, fauns, satyrs, and the like" which he had carved in his youth (225:57; 299:99-100). Reflecting the Counter Reformation "new prudery and emphasis on decorum" (276:252-257), he pointed out that figures and statues exhibited in public places were "seen and looked at by everyone" and so reached far more people than "profane... books and writings which cannot be read by all" (276:252-257), and "urged members of the Accademia ...to depict only clothed figures" (179, XI:910).

1583

Scipione Pulzone's painting, "The Assumption, " in the Bandini Chapel in S. Silvestro al Quirinale in Rome, on the advice of Bolognese liturgical art arbiter Gabriel Paleotti (which Pulzone had requested), shows the Apostles "not looking at the Virgin assumed into Heaven" (179, XI:909).

1584 (A)

Giovanni Paolo Lomazzo of Milan published Tratto dell' Arte Pittura, scultura, ed architettura (Treatise on the Art of Painting) presenting the principles of classicism as a definite academic system. The work, most important writing to appear in Northern Italy on the theories and iconography of Mannerism, was widely read and used as a guide in the nineteenth century. Its seven books "treat the theory of proportion, motions as they reflect the emotions, color, light and shade, and linear perspective, the practice of painting, and subject matter, or iconography" (275, II:74).

1584 (B)

Cardinal G. Paleotti in his book Discorso intorno alle immagini sacre e profano stated "images of the gods are 'filthy and criminal'. " Book III, of which only a summary was published, "was to have been directed entirely against 'lascivious paintings'--

against the world of Fable, natural habitat of nudes and sensual images" (534:266-267).

1590's Carrying out the strictures on church art of the Fourth and Fifth Provincial Councils of Milan, one bishop ordered "The Visitation, " painting by Andrea Sabatino (Andrea da Salerno), removed from a church because the features of the sacred personnages represented were copies of recognizable contemporaries ("parceque les traits des personnages sacres y avaient ete copies sur des contemporains") (152:256).

1590-1593 When Michelangelo Caravaggio delivered his portrait of "St. Matthew and the Angel, " painted as a public commission for the Contarelli Chapel in S. Luigi dei Francesci, the Roman church rejected the picture "for its general realism and specifically low-class characterization of the saint" (178:68). St. Matthew--shown with "a bald head and bare, dusty feet, awkwardly gripping a huge volume, anxiously wrinkling his brow under the unaccustomed strain of writing" (231:12)--scandalized church authorities and congregation because of its "unconventional representation, " including the saint's "vulgar display of his feet" (225:58).

1590 (A) Bartolommeo Ammanati, Florentine sculptor, wrote when he was nearly eighty years old to his Patron, Grand Duke Ferdinand of Tuscany, requesting that the Duke allow him to clothe the nude statues he had made for the Duke's father at Pratolino "artistically and decently, " and give them the names of virtues. The petition was not granted (229:101).

1590 (B) The painters guild in Genoa brought suit against artist Giovanni Battista Paggi to prevent him from painting in Genoa "because he had not undergone the prescribed seven-year course of instruction there" as an apprentice (257, II:57). Paggi, of noble birth, had made his reputation as a painter by "studying from drawings, casts, and books without any training in a local master's workshop (454:67-68).

 The guild asked for official sanction of its old rules requiring seven year's apprenticeship. These same rules also limited each master to the employ of one apprentice--so surplus work "could be passed to less busy masters"--and forbade the "import of pictures and the immigration of painters. " Paggi argued, against this "outmoded code, " that art should be an honored profession "based in part on natural gift which is unteachable and the study of the work of great masters" (454:67-68). In a fundamental decision, which allowed "the right to

practice as a professional artist" and freed the ar-
tist from conditional apprenticeship under a guild
master, the court held "that the guild statutes were
not binding on artists who did not keep an open
shop. " By this judgment, the influence of the guilds
and the craft tradition, developments of nearly two
hundred years, were broken (257, II:57, 63).

1590 (C) Giovanni Paolo Lomazzo, "greatest authority of the
time in matters of art theory, " set forth in his
book Idea del tempio della pittura explicit rules
for painters, including the requirement "that the
painter should seek the advice of theologians in the
representation of religious subjects" (257, II:121).

1591 Divine Proportion (De divina proportione), treatise
by Fra Luca Pacioli, inspired the painter Piero
della Francesca to set forth the canons of art by
geometric proportion, describing the proportions of
Roman letters in diagrams based on proportions of
the human body (432:194).

1594 Cardinal Gabriele Paleotti issued orders that all
religious representations (tableaux de piete) be in-
spected, and--as needed--be retouched, reworked,
or removed from churches. He prescribed redoing
of paintings that were obscene or depicted nudes,
and severe punishment for the artists whose com-
positions did not meet the requirements of the Coun-
cil of Trent and the inspection commission of the
church (152:256).

1596 Pope Clement VIII considered destroying Michelan-
gelo's Sistine Chapel fresco, "The Last Judgment, "
because of the "obscenity" of its figures, and the
painting was saved only upon petition from the Ac-
cademia di San Luca (31:145; 225:157; 257, II:123).
He also inspected book illustrations for conformity
to church doctrine concerning art and proscribed
unacceptable works--among which were two editions
of Roland Furieux, that of Valgrisio in 1558 and
that of Francisco de'Franceschi in 1584, in which
the illustrations of Chapter VIII were proscribed
(152:257).

1598, Decem- By decree papal delgate Cardinal Montalto of Bolog-
ber 28 na, recognized the art of painting as a "nobile e
virtuosa professione, " and allowed a separate guild
of painters to be established. Painters had be-
longed to the guild of sword-cutlers, saddlers, and
scabbard-makers until 1569, and since that time to
that of the calico merchants (Bombasari) (454:69).
Not until the Academies of Art were established in

Rome and Florence, would the next step be taken
in solving "the problem of the artist in the Renais-
sance": Freedom of the artist from the fetters of
medieval guild organization (454:109).

17th c. (A) Jacinto de la Serna's famous treatise on Indian idola-
try, Manuel de Ministros de Indios para el Cono-
cimiento de sus Idolatrias ye Extirpacion de ellos,
was used in the Mexican Inquisition as a guide for
destruction of pagan art (238:177, 189).

17th c. (B) Nudity continued "the great issue" between the
Church and artists: Popes Innocent X and Innocent
XI "were leaders in the campaign to cover nudes. "
In France, Michelangelo's "Leda" and other works
"were burned at the French court on moral grounds"
(179, XI:910).

17th c. (C) Spanish painting was required to follow the "strict
rules" of the Catholic priesthood, and one decree,
quoted by Palomino, "issued by the Inquisition for-
bade the making of nude statues and pictures, under
penalty of excommunication, a fine of fifteen hundred
ducats, and a year's exile" (539:237).

17th c. (D) The monk-painters of Tibetan scrolls or banners
followed traditional iconography and painted as an
act of devotion, with the rules of subject matter
and method of presentation handed down unchanged
from generation to generation. Transfer patterns--
in the form of pounces, or pricked patterns--were
used over and over again for the main figures to
preserve traditional representation. Colors--flat
and strong blues, reds, greens, yellow, and gold--
were prescribed by law (178:469; 597:726-727).

17th c. (E) Rabbi Samuel Aboab of Venice expressed--in Re-
sponsa, 247--disapproval of illustrated Bibles be-
cause he considered it improper for angels to be
delineated according to the inadequate human imagi-
nation (509:25).

17th c. (F) Art forms of Negro Africa, primarily sculpture--
figures, masks, ceremonial and utilitarian objects,
maintained traditional tribal patterns in a "conser-
vation common to tribal culture. " The prescribed
designs or form patterns that were traditional with
each village or group could not be modified by the
artist "without incurring the unmitigated criticism
or even wrath of the leader of his village or tribe"
(597:546-548, 552-553).

1600 (A) In this Holy Year, when three million pilgrims

visited the tombs of the Apostles and an <u>auto-da-fe</u>
on Campo dei Fiori burned Giordano Bruno at the
stake, art with a mythological theme was taken from
the papal palaces and the "nude figures above high
altars which Aretino had cited in his attack on
Michelangelo were banished (570:293).

1600 (B) "Medieval Painters' Guilds still ruled in French cit-
ies" and among their jealously guarded privileges
were: control over training by apprentice system;
control over number of practicing painters; exclu-
sive right of members to sell paintings, or to es-
tablish shops with workers (625:12).

1600 (C) George Abbot, Vice-Chancellor of the University of
Oxford in England, undertaking "to destroy the in-
fluence of what he feared might be exerted in favor
of Romanism, by pictorial representation, " had a
"number of such pictures... burned in the market
place of the university town" (223:8).

1601-1625 Puritanism, with its "habit of taking pleasure sadly"
(described as typically English by foreigners), came
into fashion in England in the reign of James I (379:
91). "Asceticism descended like a frost on the life
of 'Merrie Old England'" (614:168), and the icono-
clastic movement was strong for a time--organs,
stained glass windows, and statues "were wantonly
destroyed" (555:250). Although the Puritans may
not have found much to suppress in pictorial arts,
their "attitudes hostile to beauty in art go back to
Isaiah and the 22nd Psalm" (613:272-273). "Suspic-
ious and often hostile to the aspects of culture with-
out any immediate religious value" (614:168), they
generally disapproved of art, just as, in Macaulay's
well-known epigram, they stopped bearbaiting in
England when they were in power, not because it
gave pain to the bear, but becamse it gave pleasure
to the spectators.

1605 Caravaggio's painting "Madonna of the Serpent"
("Madonna del Serpe") was taken down from the
Pala Frenierei, one of the minor altars of the
Vatican Basilica, because the Virgin and the nude
Christ Child were "too indecently portrayed" (206:
253). The painter had failed to follow the church
edict that "religious work must treat scriptural fig-
ures with nobility, " and his picture was rejected
for church display because the "scene was repre-
sented in a base manner" (225:58). (ILLUSTRATION
6)

1607 Caravaggio's "plebian naturalism" "so horrified

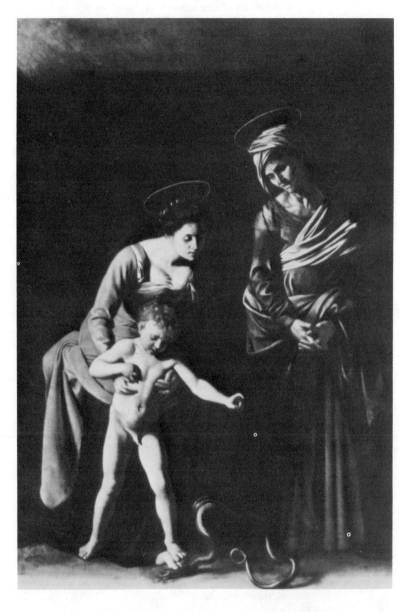

6. 1605. Caravaggio. Madonna of the Serpent.
Galleria Borghese, Rome

certain parishes and confraternities" in Italy that
they turned down some works they had commissioned
simply allowing the artist to keep them. One such
refused painting was "Death of the Virgin, " com-
missioned for the church Sta. Maria della Scala in
Trastevere. Because the artist "had indecorously
depicted the Madonna swollen and with bare legs"
the church rejected the painting, but it was bought--
on the recommendation of Rubens--by Vincenzo Gon-
zaga, Duke of Mantua (31:9; 206:xxvii, 235). "Death
of the Virgin" was delivered to the Duke only after
a week's viewing of the painting by Romans who
wished to look at the "scandalous picture" before it
left the city (31:163).

1607, May "A landmark in the history of the social emancipa-
tion of artists" is "the final resolution of the law-
suit" El Greco engaged in against the confraternity
of the Hospital de la Caridad, Illescas, when it con-
tested the price of the altar he had painted and
sculpted for the hospital. The case dragged on for
many years, through appeals, but finally the Coun-
cil of the Archbishopric of Toledo brought the broth-
ers' defeat by seizing all their church's precious
objects, including the Virgin's mantles and jewelry,
in judgment (31:161).

1614? Guido Reni--Italian painter in Rome, greatly ad-
mired by his contemporaries--"encountered diffi-
culties" with the Church "over the addition of an
illicit iconographic detail that he refused to remove
and was forced to flee Rome, " returning to Bologna
(179, XI:912).

1622 The Guild of Painters in Paris succeeded in obtain-
ing another confirmation of its privileges. These
rules of 1260 for the "Paintres et Tailleors" had
been confirmed by Philip the Fair, and again in
1391, 1430, 1548, 1555, 1563, 1582. According to
the Guild regulations--registered again by the Parlia-
ment of Paris in 1639--"compulsory duration of ap-
prenticeship was fixed, importation of works of art
was regulated, and the privilege of keeping an open
shop limited to members of the Guild" (454:82-83).

1623-1644 The indifference to, or active encouragement of,
destruction of antiquities in Rome by Pope Urban
VIII (Maffeo Barberini)--he "declared the Coliseum
a public quarry, where the citizens might go for
stones they needed for new construction" (274:55),
and used "the bronze girders of the Pantheon in
the making of guns" (416, XIV:482)--prompted the
epigram concerning such wanton vandalism in Rome:

"What the barbarians did not do, the Barberini
did. "

1624? According to Bernini, sculptor protege of Urban
VIII and succeeding popes, his sensual figures
"Apollo and Daphne" escaped the censure of the
scandalized prelate by acquiring at the last moment
its still extant Latin distich, which transformed it
from a highly erotic myth into a morality fable:
 'Quisquis amans sequitur fugitivae gaudia formas.
 Fronde manus implet, baccas seu carpit amaras' "
(179, XI:905).

1628 Pope Urban VIII forbade representations of the Trini-
ty that had scandalized English reformer John Wy-
cliffe two hundred and fifty years earlier, by pre-
scribing, under penalty of anathema, that "all fig-
ures should be burnt which portrayed the Three Per-
sons in the shape of a man with three mouths, three
noses, and four eyes" (130:380).

1633 Florentine-born artist Vicente Carducho, working in
Spain, published his book Dialogues on Painting, Its
Justification, Origin, Essence, Definition, Classes,
and Distinction (Dialogos de la pintura, su defense,
origen, essencia, definicion, modos y diferencias)
in Madrid. Written as a dialogue between master
and pupil, the book attacked naturalistic painters
and realists, such as Caravaggio and Velazquez,
and stressed the moral purpose of art, "insisting
on the necessity of prayer and inner preparation
for the artist about to paint a religious picture. "
Carducho also set down the proper subjects for
church art, stressing decorum, propriety and
gravity, and for royal palaces--historical paint-
ings (276:437-441).

c 1635 Because of religious controversy and possible charg-
es of heresy--he was a Protestant and was im-
prisoned by the Roman Inquisition (178:52)--Sebastian
Bourdon, French painter known chiefly for his his-
torical scenes, "limited himself, for religious rea-
sons, to landscape, bambocciades, and portraits"
(179, XI:908).

1642 (A) Rembrandt completed his painting "The Night Watch"
and received a high fee (about 1600 guilders) for the
picture. "It is a myth that this picture was refused
and that Rembrandt's unorthodox treatment of the
group portrait was responsible for a shift in his
reputation" (275, II:198). "Contrary to common opin-
ion, the painting was recognized from the first as
remarkable, and was given a prominent position in

the club house of the group" commissioning the work (597:390).

1642 (B) At the beginning of the Civil War in England, the equestrian statue of King Charles I by Hubert Le Soeur of Lyons "was sold to a brazier named John Rind, with accompanying orders to break it in pieces." Rind buried the figure--first and one of the best equestrian statues in London--"and kept it concealed until 'The Restoration' when it was placed in its present position"--at the entrance to Whitehall (73:48).

1642, Febru- Troops of the Parliament of England, following the
ary 23 order of February 23 (and ignoring contradicting orders issued about a fortnight later on March 4 and 7 for protection of Cambridge University, its schools, colleges, chapels, and libraries) seized pictures of "all sorts... were they but paper prints of the twelve Apostles" from Cambridge University "every market-day to burne them openly in the market-place, proclaiming them the Popish Idols of the University" (223:8-9).

1644-1912 The style of Ch'ing Dynasty painting in Chinese art is characterized by some critics as "academic and lifeless" because copying of Ming period paintings was popular, and brush-stroke types were classified and made into copybooks for the study of apprentice painters (597:778-779).

1644, January The Committee for Demolishing Superstitious Images,
16 Pictures and Monuments of the Long Parliament in England was ordered to burn art objects gathered in Camden House: "Ordered... do take care to deface or burn such... as are seized on"; and to search the city of London "Thursday next (January 18) to seize such objects, place and time of the burning" to be at the discretion of the Committee (223:9).

1644, March 9 The Long Parliament in London ordered "Whitehall and all other places of the king's Houses and Chapels" searched for "Popish art objects" by the Committee for Demolishing Superstitious Images, Pictures and Monuments (223:9).

1644, May 9 An ordinance bearing on the subject of seizing and burning superstitious Images, Pictures and Monuments was adopted by the Long Parliament in London and "sent to the Lords for concurrence" (223:9).

1645-1649 During the Civil War in England, when paintings and

other works of art belonging to Charles I and the
Cavalier nobles were offered for sale, Colonel John
Hutchinson--Puritan soldier who signed the death
warrant of Charles I--was one of the few English-
men ready to purchase them and keep them in Eng-
land (379:108). The Puritans--spoken of by Cava-
liers as "Roundheads" and described in 1599 by Ben
Jonson:
 "Religion in their garments, and their hair
 Cut shorter than their eyebrows" (379:115)--
after gaining "possession of the royal collection of
paintings... burned all that contained representations
of Jesus or of the Virgin Mary" (379:114). But Oli-
ver Cromwell "preserved many of the important
royal paintings," and refused to acknowledge the
many protests about the statues of Venus, Cleopatra,
Adonis, and Apollo in the gardens of Hampton Court
(according to a "zealous Puritan lady they were
'monsters which are set up in privy gardens' "),
allowing the figures to remain where they were
(379:121).

1645 In a "puritanical crusade upon the art treasures of
 York House," any art objects "that could be con-
 sidered as favoring the doctrine or worship of the
 Roman Church" were ordered seized and burned
 (223:9).

1645, July 23 An ordinance of the English Parliament ordered any
 picture which fell within one of the following four
 categories burned:
 "(1) The Second Person of the Trinity,
 (2) God the Father,
 (3) the Virgin Mary, and
 (4) the Holy Ghost" (223:9-10).

1648, Febru- In Paris the Academy of Art (Academie Royale de
ary 1 Peinture et de Sculpture) held its foundation meet-
 ing. Painters and sculptors of France, following
 the example of artists in Italy, organized "to sepa-
 rate the 'arts noble' from the 'arts mecaniques'...
 by establishing a body to supersede the guilds of
 the bourgeoisie" (454:84-85). Artists rejected the
 term "artisan" as designating manual workers in
 the mechanical arts, and to "achieve a status com-
 parable to that of the university 'artes'" (225:4-5),
 the Academy's initiating memorandum of January
 20, 1648 exempted all real artists from the trade
 rules of the guild, and aimed to caution the mast-
 ers of guilds who ran open shops against producing
 any figure-pictures, portraits, landscapes, statues
 or reliefs either for private or clerical patrons."
 This petition submitted to Lousi XIV compared

the "honorable place" of painting and sculpture, pro-
fessed "freely and nobly" under the Greeks and Ro-
mans, with the place of these arts in France for
several centuries, where they "had been in a state
of extreme abasement... subjected to a gang of ig-
norant and grasping jurors, low artisans without
elevation or merit" (225:68). Included in the found-
ing statutes "was a rule forbidding any Academician
to open a shop for the sale of his works or to ex-
hibit them in the windows of his house" (625:13).

The Paris guild of artists did not easily give up
its monopoly, and ten days after the publication of
the new Academy's constitution, Paris police
"searched the studios of members of the Academy
and confiscated articles of value as a fine for break-
ing the laws of the guilds" (454:84-85).

While "at first merely independent of the guild, "
the Academy--founded by Jean Colbert under Royal
protection--"soon dominated and replaced it in power
and prestige" (625:6-7). Charles LeBrun, as its
Rector, prescribed the rules for art, "instructing
the artist what he should paint as well as what he
should not paint" (82:92), and in a "despotism of
one monarchy and one aesthetics" (102:96) obtained
a monopoly on teaching of drawing from life, forced
all "free" painters into its organization, and "laid
down a rigid hierarchy of subject matter of cultural
importance: 'Classical and Christian themes are
the only proper subject matter' " (625:6-7). "His-
tory painting was at the top of the scale; landscape
and still life were relegated to lower positions"
(128:3). "An artist was expected to use certain de-
signs, certain colors, and... certain types of out-
lines... Cut-and-dried principles... tabulated as pre-
cisely as mathematical rules" regulated the artistic
life of France (128:3).

1649 Francisco Pacheco, Spanish portrait and religious
painter, father-in-law of Velazquez and advisor to
the Inquisition in Spain on matters of art, provided
conventions and rules to be followed by Spanish ar-
tists in his manual Art of Painting (Arte de la Pin-
tura), first published in Seville. He included in the
specific iconographic and compositional standards
such details as:
 In pictures of the Immaculate Conception, the
 Virgin must be painted in blue and white dress,
 because "she appeared in this guise to Dona
 Beatrix da Silva, the Portugese nun who founded
 the Silvestrines";
 Our Lady must be represented with her eyes
 turned to Heaven, her arms folded across her
 bosom, the sun behind the figure in a bright

golden light, the moon, "a crescent with down-
ward pointing horns";
A cord of St. Francis must be shown around the
Virgin's waist, because she so "appeared in 1511
to the foundress of the Order of the Conception
at Toledo" (539:237).

1650-1680 The Holy Office (Inquisition) in Spain, occupying it-
self in censoring Art to prevent corruption of mor-
als, carried out its duties in a more extensive and
delicate manner than the "suppressing of blatant
pornography"--"books were deprived of objectionable
illustrations, snuff-boxes would be submitted to scru-
tiny, lest the pictures on their covers should offend
good taste. " "In the twilight of its days, the Madrid
Tribunal ordered all hairdressers in the city to re-
move from their windows, or reduce to decency, the
wax busts which they exhibited to advertise their art,
on the ground that the over-exuberant display of
their charms might prove too tempting to the adoles-
cent mind" (510:194).

1651 The Massachusetts legislature called attention to the
"excess of Apparell" unsuitable to people of "mean
condition. " "Most Puritan restrictions on dress in
England were imposed for purposes of class differ-
entiations rather than for ascetic reasons"--long
hair was acceptable on upper-class Puritans like
Oliver Cromwell or John Winthrop, "but was a sign
of vanity on the head of a person of lower social
status. " Colonial legislators in these sumptuary
laws of Massachusetts maintained class distinctions
in dress as they expressed:
"our utter detestation and dislike, that men or
women of mean condition should take upon them
the garb of Gentlemen, by wearing Gold or Sil-
ver Lace, or Buttons, or Points at their knees,
or to walk in great Boots; or Women of the
same rank to wear Silk or Tiffany hoods or
Scarfes, which tho allowable to persons of great-
er Estates, or more liberal education, is intol-
erable in people of low condition" (150:10).

1652-1660 The opposition of Russian rulers of church and state
to the "Western School" religious paintings was ex-
pressed by Patriarch Nikon when he "hurled icons
painted in the Latin style onto the church floor and
pierced the eyes of their saints before ordering
them burnt (545:10).

1653-1658 To incite rebellion in England when Cromwell was
Lord Protector, treasonable playing cards published
in Holland by English exiles were smuggled into the

country. Among such cards--possession of which was punishable by death--is one showing Cromwell praying while Charles II is being decapitated (506:5).

1655? Queen Christina of Sweden, patroness of the arts and militant in the protection of personal freedoms, during a visit to Rome stayed in the Palazzo Farnese, owned by the Duke of Parma. Immediately upon occupying the Palazzo, "the Queen removed with her own hands the white draperies with which the nude statues had been decorously swathed..." (570:307).

1655 Forty-eight artists in The Hague applied for exemption from the existing Guild of St. Luke, in which they were grouped with wood-carvers, embroiderers and "lower grade painters." After one year, they were permitted to establish a "confrerie" of their own with the name of "Pictura." The rules of this company were patterned on those of the medieval guilds: No artist from outside the area was to be allowed to practice in The Hague, unless he paid a fee to the "Pictura" company; none but "Pictura" members were to sell pictures during Fairs--but this was a first-step in Holland toward the liberation of artists from guild regulations (454:129-130).

1655, June 23 The enlarged code of rules of the French Academy of Art (Academie de Peinture et de Sculpture), registered with the Assembly, included the provision that life-drawing courses were a monopoly of the Academy. Nowhere outside the Academy was a publice life-drawing course allowed, even as private life-drawing circles in artists' studios (454:86-87). In the seven years since its founding in 1648 as a "free society of members all entitled to the same rights and granted admission in unlimited numbers," the Academy "was transformed into a state institution with a bureaucratic administration and a strictly authoritarian board of directors" receiving a royal subvention (257, II:194). Students found one of the main advantages of Academy membership the exemption from military service (454:97).

c 1657 Velazquez, court painter to Philip IV of Spain and son-in-law of puritanical Francesco Pacheco--who as Grand Inquisitor of the Inquisition in Spain acted as censor of Spanish painting for the Holy Office--dared paint "only one nude Venus... and her in secret": "Venus and Cupid" (the "Rokeby Venus" in the National Gallery, London) (178:369; 364:235). During this time, J. Luzan y Martinez also served as Artistic Censor to the Holy Office in Spain (510:195).

c 1660 Bartolome Murillo, one of the most popular Spanish
 religious artists of his time and founder and first
 president of the Academy of Painting in Seville,
 "was rebuked by the Inquisition for suggesting
 that the Madonna had toes" (364:235).

1661 (A) Upon inheriting a share of Cardinal Jules Mazarin's
 art treasures through his wife, Hortense Mancini,
 the Duke de la Meilleraye "mutilated with an axe
 all the male statues. " "His prudish aggression,
 eccentric in his time, by the nineteenth century
 would have been orthodox and commonplace" (103:
 178).

1661 (B) By the Edict of St. Jean-de-Luz, Louis XIV of
 France "declared engraving to be one of the liberal
 arts, and allowed engravers to exercise their craft
 without serving an apprenticeship. "

1662 (A) Anti-clericalism and satirical contempt for the Pope
 under Pope Alexander VII were focused in the
 "Fortune" picture by Salvator Rosa painted for
 Carlo de' Rossi. "Allusions of the picture too ob-
 vious to pass unnoticed" when it was exhibited at
 S. Giovanni Decollato ("Fortune seated at the top
 of the canvas with a great cornucopiea, indifferent-
 ly pouring out her riches to a gathering of pigs,
 wolves, foxes, wild birds, and beasts of prey")
 caused the subversive significance of the work to
 be pointed out by authorities. Painter Rosa was
 saved from imprisonment only by intervention of
 Don Mario Chigi, the Pope's brother, and one of
 the clericals "obviously implicated in Rosa's sa-
 tirical interpretation of Fortune" (256:153-154).

1662 (B) Jan Cossiers, member of the Antwerp Painters'
 Guild and a resident of Antwerp, worked for seven
 years in his studio to complete a 29-foot-high three-
 panel mural, "Golgotha, " on a commission signed
 in 1655 for the Malines Beguinage. When Cossiers
 wished to install the panels and to complete them
 in their final position, the Malines Painters' Guild
 "refused permission. . . on the grounds that nonresi-
 dents were not allowed to paint in the town, " and
 maintained the refusal in spite of testimony of
 Antwerp artists--present or former officials of the
 Antwerp Guild--"that it was customary in Antwerp,
 Brussels, Louvain, Ghent, and Bruges for nonresi-
 dent artists to adjust or finish such commissions
 in situ" (316:F 9 1960 14b)

1663, Febru- Jean Colbert, who had been elected Vice-Protector
ary 8 of the powerful and influential Academie de Peinture

et de Sculpture of Paris in 1661, obtained an Arret
du Conseil "ordering all privileged painters of the
court of Henry IV to join the Academy, failing
which they would lose their privileges." Colbert
wanted to sever art from the guild, but "his only
aim in carrying this out was to tie art more firmly
to the court and the central government" (454:109),
and the absolutism of his dictatorship in art--a logi-
cal continuation of the life-drawing monopoly--"de-
feated the very independence of the individual artist
for which, less than a hundred years earlier, the
first academies had been founded." The line of de-
marcation drawn between court artists and the ar-
tists of the bourgeoisie left the painter and sculptor
with less freedom than they had found under the
rule of the guild, or the privileges for artists under
previous French kings (454:88).

1664　　David Teniers the Younger founded the Academy of
Fine Arts in Antwerp to "oppose and limit the con-
trols" of the guilds regulating workers in the "Liber-
al Arts," as distinct from the "Mechanical Arts."
Teniers and his artist friends expressed their vexa-
tions with the strictures of the guild, which had pro-
ceeded against Teniers in Brussels "for breaking a
rule when selling his own and other painters' works
at auction." Also, many of his colleagues were
angered by the treatment of Jan Cossiers by the
Malines Painters' Guild in 1662 (316:F 9 1960 14b).

1666　　Andre Felibien published Conversations on the Lives
and Works of the Most Eminent Painters, a work
that remained a valid guide "through the eighteenth
and much of the nineteenth century" for art theory.
The scale of values he assigned the various subjects
of painting "widely influenced the generations to fol-
low":

> "Still-lifes are at the bottom of the scale, land-
> scapes are slightly preferable; pictures of ani-
> mals range higher by another grade, because
> they treat of a higher form of life. As superior
> as humanity to the world of animals, is the por-
> trait to the animal pieces. Histories... are of
> necessity far more valuable than the realistic
> presentation of individual beings" (454:92, 95).

1667　　Colbert enlarged the royal tapestry enterprise in
France, Manufacture Royale des Gobelins, into the
Manufacture des Meubles de la Couronne, including
craftsmen of many kinds--sculptors, goldsmiths,
joiners, cabinet-makers, weavers, artists in pietra
dura, and painters in specialties such as genres
mineurs (animals, battles, costumes), thus freeing

these craftsmen from dependence on the guild (454: 243). This further separation of "Fine Art" from "Applied Art" "tended to deprive the craftsmen of all creative work as it raised a wall between design of the artist and the execution of the artisan" (454: 244).

1673 Charles Alphonse Dufresnoy, one of "the pedantic interpreters of art in seventeenth century France," wrote a didactic poem in Latin, De Arte Graphica, issued in a first French edition that set forth "principles," with "all the importance of dogmas until far into the eighteenth century for every academic theorist" (273:71).

1674 Some members of All Souls College, Oxford University, used the University press to prepare an edition of Aretino's Sonnets illustrated by "Giulio Romano's celebrated drawings of sexual postures," suppressed by Pope Clement VII when they were first published in 1527. Dr. John Fell, responsible for the Press then housed in Sheldonian Theatre appeared unexpectedly the night the prints were being run, and "the angry Dean seized the printed sheets and plates," threatening "the owners of them with expulsion" (279:96).

1675 Sir Christopher Wren's design for rebuilding of St. Paul's Cathedral--a domed church in the form of a curved Greek cross--was so radical in concept that he had to design a more moderate version. Traditionalists of the clergy, still unsatisfied with the revised plans, insisted on a medieval-style church with a long nave. Wren, impatient to get the building started, then presented a mediocre design which was promptly accepted by authorities, but once under way with construction, he "felt no compunction to adhere to the accepted plan" (Life 50:105 Je 2 1961).

1676? Carlo Maratto, most famous Italian painter of his day, was employed by Pope Innocent XI--in this period of "great austerity"--to cover an over-exposed breast of the Virgin Mary, as painted in the Quirinal by Guido Reni at the beginning of the seventeenth century (256:162).

1679 The Mustard Seed Garden Manual of Painting (Chieh-tzu-yuan hua-chuan) of Mai-mai Sze, the handbook of Chinese painting that traditionally motivated and governed Chinese painting was issued. This "most widely used" manual of painting in China consisted of 13 books arranged in three parts. Part I, on

landscape painting, consisted of five books: One on general principles and standards, with historical notes and a section on colors; Book of Trees; Book of Rocks Book of Jen-wu (People and Things); and a book of additional plates of landscape painting.

Part II contains four books: Book of the Orchid; Book of the Bamboo; Book of the Plum; Book of the Chrysanthemum.

Part III contains four books: Book of Grasses, Insects, and Flowering Plants; Book of Feathers-and-Fur and Flowering Plants; and two books of additional examples (106, I:vii).

The illustrations of brushwork range "from a single stroke of a blade of grass to the composition of a whole scene, " and are "copied mainly from parts of works by established painters" (106, I, vii).

"Colors were related to Seasons, the Five Ch'i (Atmospheric influences of rain, sunshine, heat, cold and wind), and Five Planets and the Five Points marking the Five Regions of the Heavens, each presided over by a supernatural creature and associated with a number:

Wood	Green	Dragon	East	Spring	Jupiter	8
Fire	Red	Phoenix	South	Summer	Mars	7
Metal	White	Tiger	West	Autumn	Venus	9
Water	Black	Tortoise	North	Winter	Mercury	6
Earth	Yellow	Dragon	Center		Saturn	5"

(106, I:68).

These specimens of wood-block printing became "part of the traditional education of a scholar" (106, I:5) as they set forth "not a personal way, nor the mannerism of a school" in painting, but the Chinese tao ("Way") of painting (106, I:3).

1680

Henri Testelin set art standards in France in his elaborate Table of Rules, a book of lectures given at the Academy and published under the title, Sentiments des plus habiles peintres sur la pratique de la peinture et sculpture mis en table de preceptes (Opinions of the ablest painters on the practice of painting and sculpture arranged in tables of rules) (276:381).

1680, March 19

Authorities in Rome ordered the police to seize two of the pictures exhibited at the annual exhibition of art, held each year in the Pantheon on March 19 to celebrate the feast day of Saint Joseph--most famous and well attended of all the regular art exhibitions in seventeenth-century Rome, on the grounds that the paintings were indecent (256:126-127).

1687, September 26

The Parthenon, best known of all the monuments of ancient Athens, that had survived intact for more

than eighteen centuries, was destroyed when mortars
of the troops of Venetian Admiral Francisco Moro-
sini scored a direct hit on the structure, which was
being used by the Turkish for storing munitions
(236:55, 63-64).

1693 England's Chief Justice Holt--in the case of Cropp
 v Tilney (1693, 3 Salk, 226)--touched on the effects
 of caricature:
 "Scandalous matter is not necessary to make a
 libel; it is enough if the defendant induces an
 ill opinion to be had of the plaintiff or to make
 him contemptible and ridiculous" (88:12).

1695 The Licensing Act in England lapsed and, with it,
 the system of "pre-censorship to which the Britsh
 press had been subject for most of the sixteenth
 and seventeenth centuries" (575:225).

1698 Charles Le Brun, Peintre du Roi and co-founder of
 the French Royal Academy in 1648, published in
 Paris a detailed guide for artists, Methode pour
 apprendre a dessiner les passions proposee dans
 une conference sur l'expression generale et parti-
 culiere (A Method of Learning to Draw the Passions
 as Proposed in a Lecture on Expression, in General
 and in Particular). The work gives examples of
 two basic principles of art as practiced by the Aca-
 demy--drawing and expression: "For aid in the
 correct depiction of expression, the various facial
 expressions, of anger, fear, etc., are drawn" (275,
 II:159-160).

18th c. When a copy of Corregio's painting "Io" passed into
 the possession of Louis d'Orleans in France, accord-
 ing to report (which may be apochryphal, although
 it appears in such standard works as Ricci's Corre-
 gio) "he at once ordered its destruction and is said
 himself to have struck the first blow with a knife"
 because of the nudity and immorality of the subject
 (114:384-385, 517).

1704 To work in Nuremberg, painters were required to
 belong to the guild in that city, and to quality for
 such membership each painter was required to sub-
 mit a masterpiece and to maintain his membership
 by paying regular contributions to the guild (454:117).

1714 The Accademia di S. Luca, art academy, in Rome
 issued new rules prohibiting any nonacademic artist
 from producing work for any but private purposes
 unless it was examined and accepted by the Acca-
 demia. Because of an overwhelming protest from

both academic and nonacademic artists against this
restriction--on behalf of freedom of art--this rule
was never enforced and later was cancelled (454:8).

1726 (A) Jacob van Schuppen modelled the rules of the revived
Vienna Academy of Art on those of the Paris Aca-
demy, founded in 1648: Suppression of life-courses
outside the Academy, and exemption of all academi-
cians from the regulations and membership require-
ment of the guild (454:121).

1726 (B) In the case of Rex v Curl, the court found the defen-
dent, Curl, guilty of exhibiting corrupting pictures,
as "what tended to corrupt society was held to be
a breach of the peace, and punishable by indictment. "
The judgment stated that "the courts are the guard-
ians of public morals, " and when considering "the
corruption of the public mind in general, and de-
bauching the manners of youth in particular, by lewd
and obscene pictures exhibited to view... courts of
justice are, or ought to be, the schools of morals"
(120:16).

1729 The legal liability of the cartoonist in England "who
attacks his victims through 'caricatura' or 'allegori-
cal painting' was explained in the book State Law:
or, The Doctrine of Libles Discussed and Examined:
 "If a man draws a Picture of another, and
 paints him in any shameful Posture, or igno-
 minious Manner, 'tho no name be to it; yet if
 the Piece be such, that the Person abused is
 known by it, the Painter is guilty of a Libel...
 They that give Birth to Slander are justly pun-
 ished for it" (575:225).

1734 Engravers were held in "poor repute" in England,
but their status was improved by the Act of 1734
for the Encouragement of the Arts of Designing,
Engraving and Etching Historical and other Prints
(known as Hogarth's Act), which "led to the dating
of prints. " They were still regarded as artisans
rather than artists when the Royal Academy was
founded, thirty-four years later, as "membership
was denied to engravers or etchers" (46A:220).

1737 "With establishment of the Salons, or annual expo-
sitions, in France, art theory was freed from the
guardianship of the Academy and opened to the pub-
lic. " "Art criticism by men more or less informed
on the subject" was one of the results of this change
(276:514).

1742 The painting of Pontormo (Jacopo Carrucci, who

worked in the style of Florentine Mannerism) in the
choir of S. Lorenzo, completed in 1745-1746, was
painted over because it was "so advanced for its
time" (178:398).

1745 Pope Benedict XIV, "foe of freedom of art beyond
 the formulation of the Council of Trent" (42:288),
 recalled and confirmed the condemnation that Pope
 Urban VIII made in 1628 of representation of the
 Trinity "in the shape of a man with three mouths,
 three noses, and four eyes" (130:380). However, he
 did approve the representation of the Trinity showing
 Christ dead, sanctioning this motif because the ar-
 tist would be complying with the Council rule "that
 God should be represented as seen by human eyes
 (42:288).

1747 William Hogarth was arrested for sketching in Calais
 at the seaport's gate. His picture "The Gate of
 Calais, " one of his masterpieces, was painted from
 these sketches done on the spot (141:64).

1748 The Chinese Lamaist text, Tsao Hsing Liang-tu
 Ching, established precise rules for Lamaist icono-
 graphy. Included in this "classical text of measure-
 ments" were standards for representing such figures
 as Avalokitesvara--11-headed and 1000-armed Bod-
 hisattva--specifying dimensions, location, color,
 and expression of heads (242:194-198).

1750 Jean Jacques Rousseau "attacked the mythological
 motifs in the art of galleries and public gardens of
 France as corruptive of public morals" (451:125).

1758-1769 According to German art historian Adolf Michaelis,
 the interest in art of Pope Clement XIII "limited
 itself to providing the naked angels in his pictures
 with clothes, and the antique statues in the Belve-
 dere with tin fig-leaves" (570:316). At his direction
 more draperies were added to the figures in Michel-
 angelo's Sistine Chapel fresco, "The Last Judgment"
 (31:145; 225:57; 443:13) by artist Stefano Pozzi.

1765 In Paris, members of the Royal Academy "obtained
 the passage of an ordinance requiring art critics to
 sign their real names to their articles" of criticism
 (625:10).

1768-1790 The Discourses, art lectures by arbiter of English
 painting Sir Joshua Reynolds, delivered each year
 as Academy President at the prize-giving of the
 Royal Academy, contained specific instructions to
 be followed by painters. In these exact canons of

proportion--published as a textbook--"a young woman
should have the proportions of the goddess Diana,
and her height should be exactly ten times the
length of her face... the hand should be the same
length as the face, and the big toe should be as
long as the nose. " In clothing--also the subject
of detailed rules--only inferior painting distinguish-
es varieties of material and fabrics in paintings
should be "neither woollen, nor linen, nor silk,
satin, or velvet: it is drapery; it is nothing more"
(127:4-6).

1768 The Eastern Church had admitted sacred images,
but made a distinction between sculpture in the
round, which was too real for admission, and
painted icons. The distinguishing test of accepta-
bility was whether you could take the image by the
nose (44:148).

1769 (A) A classic law case--Villers v Mousley (1769, 2
Wilson 403)--laid down the rule "that to publish
anything of a man that renders him ridiculous is
a libel, " which includes caricature (87:12).

1769 (B) The Archbishop of York and Sir Joshua Reynolds
tried to persuade painter Benjamin West to depict
the figures in Roman dress in his painting to com-
memorate the "Death of Wolfe, " showing the scene
at the Battle of Quebec twelve years before. West
refused this instruction and painted Wolfe and the
other soldiers in the costumes that they had actually
worn.

1769, January 2 The Royal Academy in London was opened by royal
proclamation, Sir Joshua Reynolds was chosen the
first president, and the initial exhibition was held
in the same Spring. Not all English artists favored
the Academy--William Hogarth, although he had
fought for recognition of the artist, opposed the es-
tablishment of a Royal Academy, saying:
"Though academies sometimes improve genius,
they never create it" (570:468).
The primary purpose of the Academy was as a
teaching institution. Among the strict rules govern-
ing classes, were those concerning women models
in life classes ("disapproved of by the morality of
the day"):
"No person under twenty should draw from the
female model, unless he was married";
"No one--the Royal family excepted--is admitted
into the Academy during the time the female
model is sitting" (570:473).

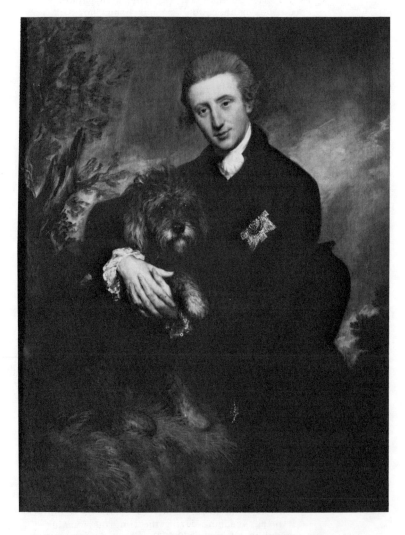

7. Thomas Gainsborough. Henry, Third Duke of Buccleuch.
Collection of the Duke of Buccleuch at Bowhill, Scotland

1770	The Academy in Edinburgh refused to show Thomas Gainsborough's portrait of Henry, Third Duke of Buccleuch, as he was portrayed with his favorite dog, a Dandie Dinmont Terrier. "Most undignified," according to the judges, who rejected the "too informal" portrait because the subject matter included a dog. Sir Joshua Reynolds, five years Gainsborough's senior, still painted such well-known sitters in Greek and Roman costume (500:37). (ILLUSTRATION 7)
1773 (A)	By explicit exceptions members of Academies of Art in Vienna and Berlin, Copenhagen and Stockholm, Madrid, and the Netherlands were released from obligations to and restrictions of the guilds. This professional freedom of artists, following that of the original Paris program, was expressed in a letter from the Secretary of the Vienna Academy to its protector Count Kaunitz: "It must not only be deeply degrading in general, but also detrimental to the impression which foreign visitors receive from the national mentality of a State, if skill in art is restricted by the guilds" (454:167).
1773 (B)	Sir Joshua Reynolds and Benjamin West tried in vain to carry through a scheme for the decoration of St. Paul's, London, with pictures, but were defeated by the then Bishop of London, Dr. Richard Terrick. Reynolds commented on this inhibition determined by the ideology of puritanism: "It is a circumstance to be regretted, by painters at least, that the protestant countries have thought proper to exclude pictures from their churches; how far this circumstance may be the cause that no protestant country has ever produced a history-painter may be worthy of consideration" (480:64).
1773 (C)	Claude Nicolas Ledoux, Royal Architect of French King Louis XV, was imprisoned for two years by the Revolutionary government of France (275, III:228).
1773 (D)	Empress Maria Theresa issued an Ordonnance pour affranchir les Arts "which gave all painters, sculptors, engravers, and architects the right to exercise their arts and sell their works... provided that the artist took no part in ouvrages mecaniques or the trade operations of the métiers." One of the sources of this decree was the prosection of Cornelis Lens--several years before--"for gilding the frames of some of his own works." Lens, an artist specializing in painting coach panels and flower pieces,

did not belong to the union whose members gilded frames. Andreas Cornelis Lens, the artist's son, eager for revenge of this guild affront to his father, had "petitioned Prince Charles of Lorraine to enlist the Empress's... authority to secure full freedom for all artists in the Austrian Netherlands. " The Ordonnance was the result (316:F 9 1960 14b).

1774 (A) Louis XVI denounced the erotic pictures painted by Francois Boucher for the cabinet secret of Pompadour at the arsenal where she received Louis XV-- "done in the best tradition of the menus plaisirs of the Renaissance"--and "in a fit of moral indignation" ordered the paintings destroyed. Rene Nicolas de Maupeou, to whom the order was given, hid the paintings, so that some of them are now preserved (570:366).

1774 (B) Comte d'Angiviller wrote to the French Academy, when he was appointed Directeur general des batiments in France, to inform them of the official view on art in his administration: Subjects were to express a civic virtue and teach a moral lesson as "the true function of art was to combat vice and preach virtue" (340:77). As Commissioner of Public Works, Angiviller also eliminated "indecent and licentious little pictures" from the Salon in Paris (451:126).

1776, July 9 An equestrian figure of King George III, first statue ever erected in New York City, was pulled down by a mob of Washington's soldiers and rebellious citizens "stirred to patriotic frenzy" by the news of the Declaration of Independence. The gilded lead monument, standing in the center of Bowling Green, was the work of English sculptor Joseph Wilton, and had been set in place August 16, 1770. His Majesty, represented in the garb of a Roman Emperor with a laurel wreath on his brow, was melted into bullets and used as ammunition by the American revolutionaries (516:161).

1776, November A marble statue of William Pitt, Earl of Chatham, that stood at the intersection of Wall and William Streets in New York City, portraying the advocate of the American colonists in the British Parliament in the flowing toga of a Roman Senator, was decapitated and otherwise mutilated by British soldiers in retaliation for the destruction of New York City's equestrian figure of George III four months before. Pitt's figure, the work of English sculptor Joseph Wilton, stood on its pedestal headless and handless until 1788. Eventually the statue was placed in the

New York Historical Society (516:162).

1777 Canons of the Cathedral of Auxerre removed the fifteenth century tapestry of the "Legend of St. Stephen" trom the Cathedral because its mixture of history and legend of their patron saint--based on the imaginative Golden Legend of Jacobus de Voragine--was considered "too fanciful" for display in the church. The series of weavings were ceded to the Hotel-Dieu of the town, where they safely spent the years of the Revolution, passing finally in 1897 from the local poorhouse to the Cluny Museum.

1782 When Thomas Gainsborough exhibited his pictures at the National Gallery in London, "Lady Waldegrave's portrait, set in the opening of a fireplace, was not even mentioned in the catalogue" (500:58). At the time the same portrait was sent to the National Academy for exhibit, Sir Joshua Reynolds, Academy President, "refused to hang the painting... because of Lady Waldegrave's scandalous reputation." Gainsborough, irritated by this slight, asked that all of his paintings sent for exhibit be returned immediately (500:40).

1784 (A) The first plaster cast of an antique statue seen in the United States was the "Venus de Medici," brought from Paris by the well-known English portrait painter Robert Edge Pine to Philadelphia. After the attempt to exhibit the statue publicly had "brought moral wrath down upon him" (379:477) because the undraped figure so "outraged the prevailing sense of decency" (247:177), Pine showed the classical "Venus" "only privately to friends he could trust" (247:177; 262:3).

1784 (B) According to a contemporary account--W. de Archenholz's A Picture of England, London, 1797, p. 167--Samuel Johnson, English author and lexicographer, "on his death bed, is said to have asked Sir Joshua Reynolds to promise him not to work on the sabbath" (207:107).

1784 (C) Englishman William Hutton protested the many restrictions "hedged about" admission to view the few portraits and some sculpture at the British Museum (627:1).

1787 King George II of England issued a proclamation against vice, urging the suppression of "all loose and licentious prints, books, and publications, dispensing poison to the minds of the young and unwary," and punishment of "the publishers and vendors

thereof" (279:164).

1790 "The first manual from which the godheads... in the
 Lamaistic pantheon could be identified" (242:193)
 was completed as a guide for Tibetan artists. This
 famous iconographic handbook made in Peking con-
 sisted of "a small book of 100 folios, on each of
 which three gods are shown with their names in
 Tibetan." Other manuals for Tibetan artists gave
 exact physical proportions of the body, especially
 for the face and hands and the attitude of the human
 figure, that must be conformed to as a formal di-
 rective in representing man and gods in the sacred
 tradition. The Navatala ("nine-span system of draw-
 ing laid out an ideal figure from Buddhist texts and
 artist's practice manuals")--a grid (horizontal and
 vertical lines) takes a tala (span) as the unit of
 length, as: "Span between tip of thumb and tip of
 index finger of an outstretched hand corresponds to
 the distance from the hair line to the chin."
 According to this system--related to the nine-
 fold division of the world, with an "analogy between
 the macrocosmos and the microcosmos"--"the stand-
 ing body is divided into nine portions, each one
 span in height" (242:190).

1790, June Revolutionary leaders of the French National Assem-
 bly, in a relentless war "on every symbol, every
 emblem, every reminder of royalty" (261:263, 265),
 "called on artists to devote their talents to serving
 the Revolution" (340:99-100). A group of artists
 petitioned the Assembly to remove the chained
 slaves at the base of the statue of Louis XIV in
 the Place des Victoires, "as an insult to equality"
 (261:263, 265). The offending statues were taken
 down and sent to the Musée des Monuments. Ar-
 tists were warned by the President of the Assembly
 that they would have to devote themselves to na-
 tionalistic themes:
 "C'est a des sujets nationaux que vous conse-
 crerez vous talens; par-la vous saurez expier
 les antiques erreurs de la flatterie" (340:99-
 100).
 Formal decrees of the Assembly later ordered that
 "all monuments raised to pride, prejudice, and tyr-
 anny," all "statues, bas-reliefs, inscriptions, and
 other memorials erected in public squares, temples,
 gardens, parks..." related to royalty be removed
 (261:262-265).
 To carry out Revolutionary proscriptions, "the
 huge equestrian statue of Louis XIV in the Place
 Vendome came crashing down." Even playing cards
 had to be changed because the "court cards" were

contrary to Equality. Kings, Queens, and Knaves
were replaced in new packs by Fraternities, Virtues,
and Reasons (65:145); or by:
> Four Geniuses--War, Art, Commerce, Peace;
> Four Liberties--Worship, The Press, Profes-
> sions, Marriage... and Divorce;
> Four Equalities--Duties, Ranks, Colours, Rights
> (261:263-265).

1790, Sep- The Club of Revolutionary Artists in Paris (Com-
tember 29 mune des Arts)--formed by Jacques Louis David
who was known as the "Robespierre of the Brush"
because of his active participation in political events
that lead to the overthrow of the monarchy (275, III:
2)--drafted a memorandum at its first meeting de-
manding that the National Assembly dissolve the
Academie Royale de Peinture et de Sculpture (454:
198). David, as a member of the Committee of
Public Instruction, was to completely dissolve the
Royal Academy--suppressed in 1793 (170:26)--and
replace it with his own autocratic control of the
arts, "as narrow, relentless, and intolerant as
that exercised later in Germany and Russia" (550:
30-31).

Art became "a confession of political faith... to
teach and improve, spur on to action, and set an
example" in the program of the Revolution for "the
alteration of society" (257, III:148). Revolutionary
influence appeared in dress and personal grooming--
wigs were generally discarded as reminiscent of
royalty, men "turned to mustaches, which became
a definite... symbol of patriotism and virility. " In
the decorative arts, "miniature guillotines were
sold as souvenirs or toys, " "patriotic beds stand-
ing sturdily on legs decorated with fasces, posts
capped with liberty bonnets" appeared (65:144-145).
This was the era when popular names for children
were: "Libre Petion, Constitution, Montagne,
Marat, " and the Revolution's effect on language
was seen in various changes, including the attempt
"to transform the reine abeille (queen bee) into the
abeille pondeuse (laying bee)" (65:145, 146).

1791 The Legislative Assembly in France "abolished the
privileges of the Royal Academy" and "gave all ar-
tists the right to exhibit at the Salon" (257, III:159-
160). Guilds, too, were prohibited by the Revolu-
tionary government (215:53).

1791, Novem- Revolutionary official Liquinio spoke at the Jacobin
ber Club in Paris urging that pictures show the Revolu-
tion to the common man (three-fourths of the popu-
lation in France could not read or write):

"You know the evils that fanaticism caused by
spreading pictures throughout the country. I
propose that the Society undertake to engage all
artists to labour in opposition to this by making
pictures that have to do with the Revolution"
(261:vi).

1792 (A) In England--because it was libellous, under law, to
incite hatred, ridicule, or contempt for any man--
Joshua Baldrey was fined and sent to prison for
three months after caricaturing an Essex magistrate
(575:227).

1792 (B) As part of the Inquisition in Spain, "censors were
placed at customs houses to screen the influx of
republican propaganda" (538:98).

1793 The Council of the Commune of Thiers, a card-
making French town renowned for its paper-making,
issued a notice to "fellow-citizens" concerning the
pictures on playing cards:
EQUALITY -- DEATH TO TYRANTS -- LIBERTY
"All emblems which denote royalty, scourge of
the human race, are proscribed... If card playing
(le jeu) is permitted for relaxation it must at
least be required that those who engage in it
shall not have continually in their hands or be-
fore their eyes the emblems of our ancient slav-
ery. Packs of cards consist partly of cards
known under the names of Kings, Dames, Valets.
The former show fleurs-de-lys, sceptres, crowns.
The Republican should reject such emblems.
They must be removed from those who do not
blush to encounter them and to have them before
their eyes. All manufacturers of cards in this
commune are forbidden to manufacture and sell
them with the figures and emblems here before
set forth, and all the citizens are forbidden to
buy and make use of such cards, either for
themselves or for use in playing in their houses"
(37:139).

1793, July 4 The Commune des Arts--"a free and democratic art-
ists' association without special groups, classes,
and privileged members" (257, III:161)--was recog-
nized in France as the only official organization of
artists, and in another month all existing Academies
of Art were abolished (170:26;454:199). The denun-
ciations poured out against the guilds by the first
Academies were the same as "those heaped by Revo-
lutionary artists on the Academies": "trade, not
art; compulsion, not freedom; routine, not genius"
(454:204).

The Commune des Arts survived only until the Terror of the Revolution abated, and when it was dissolved--in 1794 as a "reconstituted Academy" for its restrictions on art--the Societe Populaire des Arts became the officially sponsored organization for artists (454:199).

1793, November

Jacques Louis David, "Pageant Master of the Republic," proposed a "national jury of the arts" made up of artists and expert laymen in the Convention of the Revolution, as a substitute for the old French Royal Academy, "to contribute forcefully to the education of the public" and to award palms of glory to "Republican artists" (229:205-206; 275, III:3-4).

1794 (A)

Portrait painter Adolph Ulrich Wertmuller, a Swedish artist who had studied in Paris, came to Philadelphia and achieved notoriety, not fame, when he attempted to introduce the French studio nude. His painting of the unclothed "Danae," a success in Paris, caused a scandal when it was publicly exhibited and was looked upon as "a peep show" (142: 23; 495:125).

1794 (B)

The Societe populaire et republicaine des Arts replaced the Commune des Arts--established the previous year--as "the more or less official art organization during the 'Terror'" (170:36), to take over the functions of the suppressed Academy (457, III:161). At the end of 1794 the Institut de France "was set up, with new academies organized under its control in a national system more... centralized than ever before" (170:26).

1794, November 24

Carrying out Revolutionary strictures against religous images, the City of Strasbourg in northeast France gave an order "to have cast down within the week all the stone statues around the Temple of Reason" (179, VII:820).

1796?

Objection on the ground of propriety was made to the presence of a cast of the "Apollo Belvedere" in the Royal Academy Galleries in London (627:263).

1796

"At Murcia, Spain... a statue of Venus and (presumably) Adonis in one of the public thoroughfares" was criticized by clerics as "libidinously naked," but "a Professor of Sculpture certified that, as far as the more important areas were concerned, they were modestly covered" (510:194-195).

1796

Wall-papers, with mythological figures, received from Barcelona caused the Commissioner of the

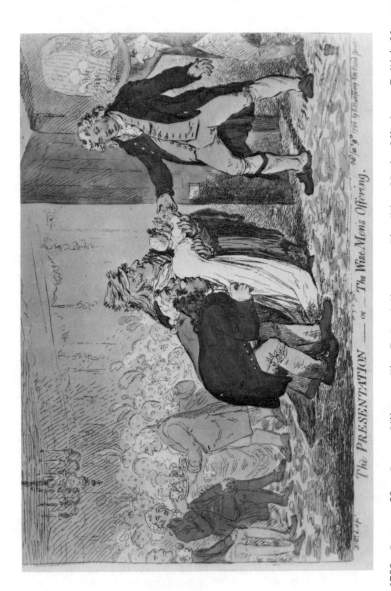

The PRESENTATION — or — The Wise Mens Offering.

8. 1796, January 23. James Gillray. The Presentation--or--The Wise Men's Offering. British Museum

Holy Office at Buenos Aires to be "much exercised" by the "questionable nature and questionable attitudes" of the figures (510:194).

1796, January 23

On this Saturday James Gillray, famous Victorian caricaturist, was arrested for his publication on January ninth of the print "The Presentation--or-- The Wise Men's Offering, " recording the birth on January 7, 1796 of the Princess Ann to the Prince of Wales and his wife, Princess Charlotte. The Prince, who had married Caroline of Brunswick "in return for settlement of his financial problems, " was at the time of this royal bribe "involved with Lady Jersey, but still in love with Mrs. Fitzherbert" (269:118).

The offending picture--"satire comparatively mild by Gillray's standard"--"shows the infant princess in the hands of an unidentified stout woman. Fox and Sheridan, fawning obsequiously, are associated with the child's introduction to her royal father, who lurches tipsily into the room. " Gillray was charged with selling the print, and admitted to bail. Certain issues of the press considered the matter in nearly "a religious light": "Vile... most obscene" (The Oracle); "decency is shocked by the subject. "

The action against Gillray was dropped, perhaps by intercession of British statesman George Canning, or it "died a natural death" (269:61-62). (ILLUS- TRATION 8)

1798-1800

The Alien and Sedition Acts passed by the United States Federalist Congress, "as measures to control opposition to America's war policy and to the Fed- eralist majority party, " specified in the Sedition Act that:
"it was a crime to publish or utter false, scan- dalous, or malicious criticism of the President, Congress, or the government with the intent to defame them or bring them into disrepute. "
The unpopular Acts were allowed to lapse in early 1801 (415:27-28, 39).

1798

Mrs. Grundy remains an "energetic and persistent old person, who wants to retain her influence over people's lives" (207:15)--the original Mrs. Grundy was a neighbor, in Thomas Morton's play of 1798, Speed the Plough, --an invisible off-stage character "of whom it was continually asked, 'What will Mrs. Grundy say'" (207:257).

1799, February 6

Los Caprichos--Francisco Goya's most famous work-- eighty etchings satirizing Spanish "life and manners, ridiculing the vices, prejudices, follies, and guiles

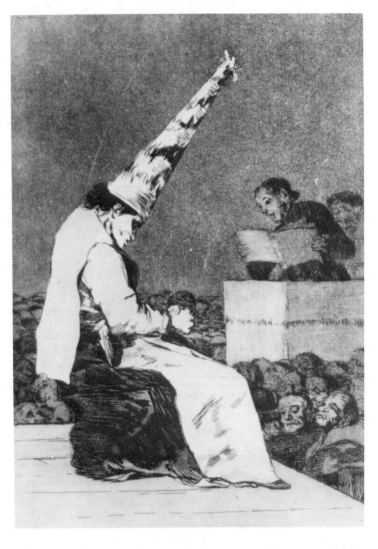

104

9. 1799, February 6. Francisco Goya. At the Moment of Judgment, plate 23 Los Caprichos. National Gallery of Art, Washington, D. C. Rosenwald Collection

of women, lawyers, physicians, priests, and monks,"
were issued. Announcement of their sale, describ-
ing the prints as criticism of "human errors and
vices" appeared in the Diario de Madrid of this date.
Only twelve days after publication (538:101), during
which time twenty-seven sets of prints were sold
(219:178), the series was withdrawn and later (in
1803) the copper plates and the remaining 240 sets
of prints were given to the Spanish King, Charles
IV. The prints had "caught the eye of the Inquisi-
tion" (628), and the Holy Office was "looking into the
matter and preparing material for a trial" (219:178)
of the artist. Goya's scathing social indictment in
portraying the "symbol of authority and hierarchy on
the back of the common man" (629:3) is not clarified
or interpreted by his written comments on the plates,
and the cryptic nature of his notes--"captions that
do not clarify"-- "is ordinarily explained away by
the anti-clericalism and lese-majeste of the etchings"
(629:3).

"In a letter written a quarter of a century later,
Goya said that 'it was because of Los Caprichos that
I was accused by the "Santa"'--an abbreviation of
the full title of the Inquisition" (538:101). (ILLUS-
TRATION 9)

19th c. (A) "English Customs authorities destroyed a set of pic-
 tures which François Boucher executed for the Pom-
 padour." Louis XVI ordered these paintings removed
 from the Arsenal palace in 1774, with the command,
 "Il faut faire disparaitre ces indecences" (137:100).

19th c. (B) In France most censorship of prints, engravings,
 lithographs, and drawings was carried out in cases
 against booksellers, but also named as defendants
 in such legal actions were a journeyman carpenter
 and a public crier.

19th c. (C) The doctrine of "Freedom of Art" became a funda-
 mental tenet of nineteenth-century aesthetics. Schil-
 ler, Goethe, Humboldt had preached the "sacredness
 of art," and the "Romantic movement emancipated
 the artist and made service to society degrading."
 Independent artists regarded themselves "as the
 bearers of a message superior to that of State and
 Society" (454:240).

1800 Lord Elgin, Great Britain's Ambassador to Constan-
 tinople, shipped famous marbles from the Parthenon
 in Athens to England--the first shipment was lost in
 a shipwreck--causing the term "Elginism" to appear
 in the French language: Larousse, III, 1930--"par
 allusion a Lord Elgin, Depecage des monuments

prives ayant un caractere artistique. " Sixteen years
later, the English Parliament approved purchase of
the sculptures for 36 thousand pounds sterling (274:
52-53).

1802

The Society for the Suppression of Vice was founded
in England, with the main purpose of "initiating
criminal proceedings against the publishers of ob-
scene books and prints" (279:165; 367:28). Witty
clergyman Sydney Smith, editor of the Edinburgh
Review, described the group as "a society for sup-
pressing the vices of those whose incomes do not
exceed £500 per annum" (279:166).

1802, March

The English Treasury "appointed seven gentlemen
to act as a Committee of National Monuments. "
In addition to allocating money, and authorizing
payments for commissions, they were responsible
for selecting designs, and "determined such matters
as size and projection from the wall. " The Com-
mittee influenced public monuments in London, as
in Westminster Abbey and St. Paul's. In the large
"Monument to Captain Richard Burgess" by Thomas
Banks at St. Paul's, they required that "the scanty
... drapery be lengthened to satisfy the demands of
decency (623:199).

1804 (A)

When Napoleon had himself crowned Emperor of the
French, the Gothic arches of the Cathedral of Notre
Dame in Paris were covered, by Imperial order,
with cardboard and plaster to represent the classic
style.

1804 (B)

Roman authorities denied an export permit for An-
tonio Canova's statue "Perseus"--commissioned in
1801 by a Polish noblewoman for 3, 000 sequis
($120, 000)--because they admired the figure so
much. (National Sculpture Review. Fall 1967),
p. 6)

1805

The Pennsylvania Academy of Fine Arts was es-
tablished--one of the first institutions in the United
States devoted to art (the New York Academy of
Fine Arts had been founded in 1802)--the "first
formally organized art institution" (582:26). Charles
Willson Peale, a distinguished naturalist as well as
a prominent portrait painter, was one of the found-
ers of the Academy, and "for nearly fifteen years"
he fought "a running battle with local prudery" over
public exhibition of the cases of classical sculpture,
purchased by the Academy Trustees, because of the
nudity of the figures (360:12; 495:135).
 When Peale proposed that the Academy should

include life classes, in which students could draw
from the nude, as part of the Academy's curriculum,
"a large contingent of dilettantish young men" en-
rolled as students "walked out," after a written pro-
test "highly disapproving of the inconsistent and in-
decent" suggestion (360:12).

1806, March The Pennsylvania Academy of Fine Arts was for-
mally opened to the public in an initial exhibition--
fifty plaster casts of famous nude antique statues
in the Louvre--with an admission charge of twenty-
five cents. After criticism of the undraped figures
exhibited from the public and artists, one day a
week (Monday) was set aside (597:567) "with tender
gallantry" (262:13) to admit "ladies only," and on
this day the "'indecent statues' were prepared for
such visits by carefully draping them" (379:477).

1807, April The Society of Artists in Philadelphia condemned
the Pennsylvania Academy of Fine Arts for their
public exhibition of casts of nude antique statues
in the Louvre as "extremely indecorous and alto-
gether inconsistent with the purity of republican
morals" (252:97). Lay members of the Academy,
slightly less conservative, had influenced the de-
cision to "exhibit the statues one day a week ex-
clusively for ladies" (262:1).

1808 In the earliest recorded judicial pronouncement on
the subject of caricature and the law of libel, Lord Ellen-
borough in England held that if the book My Pocket Book,
or Hints for a Ryghte Merrie and Conceited Tour,
in quarto, to be called 'The Stranger in Ireland in
1805, by a Knight Errant', "only ridiculed the
plaintiff as an author, the action could not be
maintained." Travel writer Sir John Carr had
brought suit, alleging libel, in the frontispiece
of the book, picturing a Knight leaving Ireland "in
the form of a man of ludicrous appearance holding
a pocket handerchief to his face, apparently weep-
ing or bending under a heavy load of three books
carried on his back" (Sir John Carr, Knt. v. Hood
and another 1 Camp. 345 n.). The judgment ac-
cepted "ridicule...as a fit weapon of criticism"
(87:12), and truth as a defense (187).

1809 (A) William Rush, Philadelphia sculptor commissioned
to carve a symbolic representation of the Schuyl-
kill River as a decorative figure for the Philadel-
phia waterworks, worked from a nude model. The
artist's daring in sculpting from an undraped model
became a source of scandal in Philadelphia. Years
later when Thomas Eakins recorded the event in his

painting of 1877, "William Rush Carving His Alle-
gorical Figure of the Schuylkill River, " he included
a "knitting chaperon" (174:143).

1809 (B) "Varnishing Days, " instituted by the Royal Academy
 in England, allowed "three days or more to all
 Members of the Royal Academy for the purpose of
 varnishing or painting on their pictures in the places
 to which have been allotted to them, previous to the
 day appointed for the Annual Dinner in the Exhibition
 Room. " This law, which remained in force for
 more than forty years, was "deeply resented" by
 exhibiting artists who were not members of the
 Academy, and who never saw their work until the
 exhibit was opened to the public. The unfairness
 of "Varnishing Days" to the "outsider" was recog-
 nized by Academy members, but the rule was kept
 in force until 1851--the time of Turner's death--in
 which year Turner's influence allowed "Varnishing
 Days" to be discontinued for seven years. When
 restored in 1858, "the benefits were extended to
 artists at large" (627:149).

1810 (A) The old system of admissions to the British Museum
 --"admitting only by ticket, and of conducting through
 the rooms the parties of visitors, none of whom was
 allowed to linger or to separate himself from the
 others"--was abolished (267:262).

1810 (B) A uniform design on playing cards was prescribed
 for the whole of France. After Napoleon had been
 proclaimed and crowned Emperor of the French in
 1804, royal emblems on playing cards came back
 into favor, and all the old Republican patterns on
 cards were suppressed by government decree (37:
 147). The "official pattern" adopted and announced
 for playing cards in France was engraved by Jean-
 Bertrand Andrieu from designs by Jacques Louis
 David (37:107).

1810, Novem- The law excluding water-colour painters from candi-
ber dature for the A. R. A. (Associate of the Royal Aca-
 demy) in England was repealed by the Royal Aca-
 demy as "no longer necessary to the welfare, but
 repugnant to the honour and interests of, the Royal
 Academy" (627:177).

1810, Decem- In a London trial (Du Bost v Beresford, 1810, 2
ber 6 Camp. 511), the judge--Edward Law, Lord Ellen-
 borough, as Lord Chief Justice the highest law of-
 ficer in England--declared "that the plaintiff was
 both civilly and criminally liable for having exhibited
 the picture, " "La Belle et la Bete. "

Antoine Du Bost, French painter and lithographer, had brought suit against Reverend J. Beresford, a young clergyman, for cutting the painting to pieces on June 20, 1810, as it hung on exhibit in a Hyde Park gallery. "Beauty and the Beast" was a caricature of Thomas Hope, "one of the plainest men in London" shown with his wife, "one of the handsomest women in London" (627:176). Hope had hired artist Du Bost to paint Mrs. Hope's portrait some time before, but quarreled with the painter over the picture; Du Bost's destroyed painting showed Mrs. Hope in the same dress as her portrait, with the label from the fable:

"All this I will give thee,
Beauty, to marry me."

The exhibited painting, an immediate succes de scandale, drew "great crowds daily" eager to see "a scandalous libel upon a gentleman of fashion and his lady" (369:250-254). When Beresford, brother of Mrs. Hope, viewed the picture, he considered it "a scandalous libel on his sister and her husband," and destroyed it as it hung in the gallery.

The Lord Chief Justice in summing up said: That as the picture was "a libel upon the persons introduced into it, the law cannot consider it valuable as a picture... The Jury, therefore, is assessing the damages must not consider this a work of art--[valued by the artist at L500]--but must award the plaintiff merely the value of the canvas and paint which formed its component parts" (369:250-254), and that if application had been made an injunction would have been issued "to prevent the picture ever being exposed for sale" (627:176). Judgment for damages returned by the jury: L5.

Du Bost v Beresford gave authority to the rule that "however much men in public life may have to submit to caricature, persons who are not in the public eye can claim protection if they are openly held up to ridicule in this way. "and such a libelled person may even "take the law into his own hands by destruction of the offending work" (88:12).

1811? Because of its violent subject matter, there were "strong objections" when English painter James Ward's "The Serpent of Ceylon"--showing with "studied cruelty" a boa constrictor winding himself around a Negro on a horse--was hung in a public exhibit "between the portraits of two Ladies" in London (451:130, 137).

1811, May 6 The Annual Exhibition of the Society of Artists of Philadelphia at the Pennsylvania Academy of Fine Arts considered the question of the exhibition of

undraped antique statue casts, and "moved to appro-
priate one day in the week for the exclusive admis-
sion of ladies. " Some antique statue casts had been
included in the Exhibition, but after it had been
open a few days, "the Committee of Arrangements
found it expedient to remove the antique figures
from public view" (262:31-32).

1814-1829 The battle and Napoleonic-hero-worship canvases of
Antoine Jean Gros, French historical painter, made
for Napoleon were "banned by the Restoration, but
could again be exhibited publicly in 1830" (451:34).

1814 (A) Francisco Goya was "called upon to defend his paint-
ing Maja Desnuda (The Nude Maja), " which had been
"discovered with other carnal paintings of the same
description among the goods sequestered from a
convent" (510:195). (ILLUSTRATION 31. 1959)

1814 (B) "The flesh-tinted wax female nude" sculpture exhi-
bited by Rembrandt Peale "in the back room of his
Peale Baltimore Museum" for twenty-five cents ad-
mission could be viewed--as was the custom--only
by gentlemen "on certain days, only by ladies on
other specified days" (142:117).

1814, May 3 William Hazlitt, famous English essayist and art and
dramatic critic for the Morning Chronicle, London,
was dismissed by Chronicle owner James Perry for
his criticism of Sir Thomas Lawrence's painting ex-
hibited in the Royal Academy show: Perry was
being painted by Lawrence, and "chose to have him
praised, " not denounced in a "damaging critique":
 "LAWRENCE (23) Portrait of Lord Castlereagh,
 is not a likeness. It has a smug, smart, haber-
 dasher look, of which there is nothing in Lord
 Castlereagh. The air of the whole figure is di-
 rect and forward, and there is nothing, as there
 ought to be, characteristically circuitous, in-
 volved, and parenthetical in it... " (627:225).

1814, June 23 Obscene drawings made and sold in Paris by Madigne
and the married couple Marchal were ordered de-
stroyed by the Cour d'Assises de la Seine (92:98).

1815 "Ariadne, " American artist John Vanderlyn's "fine
nude" (379:477) painting, the "most skillful nude yet
exhibited by an American " (174:45) was admired
when he showed the work in Paris, but when the
picture of the sleeping, undraped figure was put on
public display in New York, the painting's indecency
--"the undraped condition of the subject" (379:477)--
shocked American gallery-goers (142:23), who de-

nounced the work "as a deplorable example of
European depravity" (174:45).

1815, "Filthy conduct," ruled the Supreme Court of Penn-
March 1 sylvania (Eastern District, December Term, 1815)
 in its guilty judgment of the first obscenity case
 tried in the courts of the United States (Common-
 wealth v Sharpless, 2 Serg & Rawle, Pa 91, 1815).
 The trial concerned a picture, and the law was in-
 voked for the first time "to keep the dignity" of the
 community. Although there was no statute on the
 books to enforce, certain "yeomen" of Philadelphia--
 Jess Sharpless, the defendant, and five associates--
 were found guilty under the common law (judge-made
 decisions that serve as precedents for future cases)
 of the "manifest corruption and subversion of youth
 and other citizens" of Philadelphia, and "offending
 the peace and dignity of the commonwealth of Penn-
 sylvania."
 It had been charged that the defendants "in a
 certain house... did exhibit, and show for money... a
 certain lewd, wicked, scandalous, infamous, and ob-
 scene painting, representing a man in an obscene,
 impudent, and indecent posture with a woman" (181:
 11-15).
 The defense claimed that the court lacked juris-
 diction because the offense was one of private morals
 that in England would have been dealt with "in an
 ecclesiastical court" (404:8), but the court "laid
 down the sweeping rule that under the common law
 the courts are obliged to pass upon all questions of
 public morals, a rule that became the basis for pub-
 lic censorship not only of the pornographic, but of
 classical works..." (247:177; 447:334). The exhibi-
 tion of paintings for money was considered in law
 "publication" (151:35-40), and--according to this
 Sharpless decision--"any offense which in its nature,
 and by its example, tends to corruption of morals,
 as the exhibition of an obscene picture, is indictable
 at Common Law" (120:15).
 The picture in question is not represented or de-
 scribed in the court records, and the judge answered
 the contention of defense that the offending picture
 was not adequately designated and named, by saying
 that he considered further identification of the indic-
 table picture a "circumstance" that "could well be
 omitted," as he was "for paying some respect to
 the chastity of the records" (181:11-15). English
 courts later refused to accept this American rule--
 "Chastity of Records"--pronouncing it "fanciful and
 imaginary"--Bradlaugh v Queen, QB 607-620 (523:227).

1815, May "Le Bijou de Société," obscene engraving, was or-
19 (A) dered destroyed in Paris by the Cour Royale de
 Paris (92:90).

1815, May "Monuments du Culte Secret des Dames Romaines,"
19 (B) judged a publication with obscene engravings, was
 ordered destroyed in Paris by the Cour Royale de
 Paris. This same publication was also ordered de-
 stroyed by the same court eleven years later, on
 September 19, 1826 (92:113).

1816 With the fall of Napoleon and the restoration of the
 monarchy, Jacques Louis David, who had arbitrarily
 directed art affairs under the Republic and whose
 paintings "had been an incitement to revolution,"
 was exiled by the Bourbons to Brussels (48:90).

1817 Artist William Hone was able to demonstrate the
 weakness of the British government's moral position
 in prosecuting him in three trials on charges of
 having published impious and seditious libels, by
 producing in his defense "copies of parodies which
 were just as extreme as his own, though the art-
 ists had not been prosecuted." After Hone showed
 in exhibit James Gillray's "Impious Feast of Bal-
 shazzar" and "Apotheosis of Hoche"--pointing out
 that "Gillray was pensioned by His Majesty's min-
 isters when he published the first cartoon, and had
 published the 'Apotheosis of Hoche' to serve the
 purposes of the administration"--he was acquitted
 by the jury at each of his three trials (575:227).

1818 (A) The United States Congress--after viewing the extent
 to which American artist John Trumbull's large
 painting, "The Declaration of Independence," one
 of four pictures they had authorized for the rotunda
 of the Capitol at $32,000, departed from "safe
 mediocrity"--did not give Trumbull the commission
 to fill the remaining three spaces. Factual objec-
 tions to the scene and composition--"X was not there,
 but is represented; Y was there, and not in the pic-
 ture" were also "loudly expressed" (495:133).

1818 (B) The North Carolina legislature asked Thomas Sully
 to paint two full-length portraits of George Washing-
 ton, but Sully proposed instead that he paint a his-
 torical scene of Washington crossing the Delaware.
 The completed picture, too large to suit the North
 Carolina legislature, was sold to a frame dealer
 for $500 (468:33).

1818, June "L'Enfant du Regiment" was judged an obscene en-
30 graving and ordered destroyed in Paris by the Tri-

bunal Correctionnel de la Seine (92:101).

1819 (A)　　　　French artists considered Gericault's "Le Radeau de
la Meduse" ("Raft of the Medusa") such a sensation,
when the painting was exhibited at the Paris Salon,
that "they were at once divided into two rival fac-
tions: The 'Classiques' and The 'Romantiques' "
(311:20). The picture--"a pile of corpses on which
some dying figures raise themselves in a final ap-
peal for help"--depicts an episode in a disastrous
expedition to Senegal, beginning July 17, 1816, when
surviving crew members of a mutiny on the French
Frigate "Medusa" spent thirteen days and nights on
a raft in the open sea (422:241).

Critics "almost unanimously condemned the
painting" (422:241), and Gericault was accused of
criticizing the French government "which seemed
partly responsible for the disaster" (597:496-497).
Government officials apparently considered the ship-
wreck subject matter "a pretext for depicting the
struggle of humanity for freedom" (422:241), pre-
judicial to the administration, because although the
painting was purchased by the French Government,
it "was not hung because of its political implications"
(451:132).

1819 (B)　　　　The caricatures of American genre painter David
Claypoole Johnston, "called the American Cruik-
shank," were "too strong to print"--caricatured lo-
cal celebrities threatened libel suits so that Phila-
delphia print and book sellers refused to handle his
work (495:180-181)--and the artist became an actor
to earn his living (178:281).

1819 (C)　　　　A Frenchman visiting England commented on the
class differences in England, "There is another
thing peculiar to England. The pleasures of the
fine arts are enjoyed here only by the well-to-do.
Why are the common people excluded from them?"
The Englishman answered by saying that the French
people had "a cultivated taste...but that it might be
dangerous to admit a London crowd to a gallery"
(627:297-298).

1819, Decem-　　The Libels Act of 1819 (later known as "The Crimi-
ber 30　　　　nal Libels Act") was adopted by special session of
the English Parliament--a "gagging bill" to control
the "unstamped press and its cartoons" (216, II:184).

1820　　　　　With the backing of the Duke of Wellington and the
approval and support of William Wordsworth, Dr.
John Stoddart, editor of the New Times in London--
called by his numerous enemies "Dr. Slop"--set up

"Great offices will have
Great talents."

This is THE MAN—all shaven and shorn,
All cover'd with Orders—and all forlorn;

10. 1820, May. George Cruikshank. The Dandy of Sixty--
Caricature of King George IV of England. British Museum

the Constitutional Association "to provide an organi-
zation which could unobtrusively work on behalf of
the government in enforcing political censorship by
appearing with clean hands before a jury and by
bringing private prosections for cartoons and other
ridicule of government officials" (575:227).

1820, April Engravings representing many obscene representa-
27 tions, offered for sale by Jacques Bignon, were
ordered destroyed in Paris by the Cour d'Assises
de la Seine, and Bignon sentenced to prison for
two months (92:133).

1820, May To suppress a caricature of himself by George
Cruikshank, King George IV of England purchased
the drawing, "The Dandy of Sixty..." A receipt
for £70, signed by Robert Cruikshank, the artist's
elder brother, shows payment "for copyright of a
caricature titled 'The Dandy of Sixty...' At the
same time relinquishing the same subject in the
shape of caricature" (216, II:185). (ILLUSTRATION
10)

1820, May 25 Obscene engravings, offered for sale in Paris by
Jean François Carlier, a journeyman locksmith,
were ordered destroyed by the Cour d'Assises de
la Seine, and Carlier fined 10 francs (92:105, 140).

1820, June 22 "Famille Imperiale, " seditious print offered for sale
by Parisian print dealer Augustin Emmanuel Dauty,
with the inscription: "Pour le père et le fils, " was
ordered destroyed by the Cour d'Assises de la
Seine, and Dauty fined 600 francs (92:17, 148).

1820, July 4 Obscene engravings and works (ouvrages), offered
for sale by Barat, Parisian wax vendor, were or-
dered destroyed by the Cour d'Assises de l'Orne,
and Barat sentenced to four months in prison and
fined 16 francs (92:106).

1821 (A) Sir Francis Freeling, concerned about the absence
of draperies in Victorian artist William Etty's
"Cleopatra's Arrival in Cilicia, " when the painting
was to be exhibited at the Royal Academy in Lon-
don, induced the painter to make some additions,
to insure the picture's acceptance by a public "in a
period of squeamishness and ultra-sensitiveness in
matters of sexual morality. " Purchasers of Etty's
nudes "were disturbed to find the paintings wrongly
interpreted by relatives and friends; and the request
for more drapery was frequent" (211:22-23).

1821 (B) In the enforcement of political censorship against

caricatures, the Constitutional Association, formed
in December, 1820 to prosecute seditious libel,
brought charges against William Benbow for libelling
King George IV in two cartoons--"The Brightest
Star in the State... or.. A Peep Out of a Royal
Window, " and "The Royal Cock and Chickens, or
The Father of His People. "

Juries having proved reluctant to convict defen-
dants on complaint of libel by the Association be-
cause of its "bad reputation, " this case was even-
tually dropped. Later, "the Association collapsed
and with it the hope of the British government to
convict men for publication of cartoons" (575:228;
576:ix, 168).

1821 (C) The Massachusetts court in its judgment against
 Peter Holmes--indicted under common law for sel-
 ling an obscene print (Commonwealth v Holmes, 17
 Mass R. p. 337)--repeated the ruling concerning
 "Chastity of Records, " made in the Sharpless case
 in 1815, when it found that in the case of Holmes:
 "obscene matter need not be set out in the indict-
 ment lest the court should give permanency and
 notoriety to indecency" (120:15).

1821, Sep- "Les Sentinelles en Defaut, " was ordered destroyed
tember 14 (A) as an obscene engraving by the Cour Royale de
 Paris (92:119).

1821, Sep- "Vous Avez le Clef" was ordered destroyed as an
tember 14 (B) obscene engraving by the Cour Royale de Paris
 (92:123).

1821, Decem- "Reception d'un Homme Illustre aux Champs-
ber 18 Elysées" was ordered destroyed as a seditious
 print by the Tribunal Correctionnel de la Seine
 (92:29).

1822, Janu- "Le Chat Cheri" was ordered destroyed as an ob-
ary 14 (A) scene engraving by the Cour d'Assises de la Seine
 (92:95).

1822, Janu- "L'Embarras du Crois" was ordered destroyed as
ary 14 (B) an obscene engraving by the Cour Royale de Paris
 (92:100).

1822, Janu- "L'Indescret" was ordered destroyed as an obscene
ary 14 (C) print by the Cour d'Assises de la Seine (92:107).

1822, Janu- "Le Songe Trompeur" was ordered destroyed as an
ary 14 (D) obscene engraving by the Cour Royale de Paris
 (92:120).

1822, January 14 (E)	Three obscene engravings--"L'Amant Heureux"; "L'Amant Pressant"; "Les Amants Surpris"--were ordered destroyed by the Cour d'Assises de la Seine (92:87).
1822, June	The Society for the Suppression of Vice accused William Benbow in London of publishing "two obscene and indecent pictures representing the persons of men and women in indecent postures, attitudes, and situations." The offending pictures--Mars, Venus, and Vulcan," and "Leda"--had been used as frontispieces for the January and February, 1822, issues of Rambler's Magazine: or, Fashionable Emporium of Polite Literature. The jury acquitted Benbow (576:ix).
1822, November 16 (A)	"Academie des Dames," a work offered for sale by Jean Baptiste Rousseau, Parisian bookseller, was ordered destroyed because of the obscene engravings it contained by the Cour Royale de Paris, as an outrage of good morals (aux bonnes moeurs). Because of failure to notify the defendant to appear for trial, he was acquitted (92:87).
1822, November 16 (B)	"Les Amours du Saint-Père Le Pape," a work offered for sale by Jean Baptiste Rousseau, Parisian bookseller, was ordered destroyed because of the obscene figures it contained by the Cour Royale de Paris. Because of failure to notify Rousseau to appear for trial, he was acquitted (92:88, 191).
1823, March 4	"Chambre des Deputes," engraving representing la séance of March 4, 1823, was ordered destroyed by the Cour d'Assises de la Seine (92:12).
1823, March 7	"L'Attente Volupteuse" was ordered destroyed as an obscene engraving by the Tribunal Correctionnel de la Seine. This same picture was again ordered destroyed nearly twenty years later, on August 9, 1842, by the Cour d'Assises de la Seine (92:89).
1823, August 26 (A)	"Apotheose de Bonaparte" was ordered destroyed as a seditious engraving by the Cour Royale de Paris (92:7).
1823, August 26 (B)	"Apotheose des Quatre Condamnes de la Rochelle," with the inscription: "Pro Patria," was ordered destroyed as a seditious engraving by the Cour Royale de Paris (92:7).
1823, December 11	The Cour Royale de Paris confirmed the judgment of the Tribunal Correctionnel de la Seine of November 10 of this year declaring lawful the seizure of

busts showing the Duc de Reichstadt in a caricature so extreme as to upset public peace (106:xxxv).

1824 England's Vagrancy Act was passed. Section 4 of the Act provided that "Persons committing certain offenses shall be deemed rogues and vagabonds and may be imprisoned for three months with hard labour, " including "every person wilfully exposing to view, in any street, road, highway, or public place any obscene print, picture, or other indecent exhibition" (23:109).

1825, Febru- "Le Songe" was ordered destroyed as a seditious
ary 25 (A) engraving by the Tribunal Correctionnel de la Seine (92:31).

1825, Febru- "L'Aretin Français, " a book with engravings, was
ary 25 (B) ordered destroyed as outraging decency, public morals, and religion by the Tribunal Correctionnel de la Seine. This same work was also twice ordered destroyed--March 2, 1832 and February 9, 1842--as outraging decency by the Cour d'Assises de la Seine (92:89).

1825, Febru- "Extases de l'Amour" was ordered destroyed as an
ary 25 (C) obscene engraving by the Tribunal Correctionnel de la Seine (92:103).

1825, Febru- "Lanterne Magique" was ordered destroyed as an ob-
ary 25 (D) scene engraving by the Tribunal Correctionnel de la Seine (92:108).

1826 Religious paintings on tanned buffalo hides, painted with native vegetal dyes, were used by the Franciscans--from soon after the reconquest of New Mexico through the eighteenth century--to decorate their chapels. These sometimes crude pictures "of the Crucifix and of Mary, Joseph, St. John the Baptist, and the principal Franciscan saints " offended Ecclesiastical visitors from Mexico who commented "on the unseemliness of animal hides as backgrounds for holy images. " "Secular clerks, after Republican Mexico was established, ordered the removal of what was left of the offending material... Today, just over forty paintings of this class are known, some of which are only fragmentary" (59:21).

1826, Sep- "Monuments de la Vie Privée des Douze Cesars, "
tember 19 a work with obscene engravings, was ordered destroyed by the Cour Royale de Paris (92:113).

1828-1838? When William Etty--famed Victorian painter of nudes, usually in Mythological scenes--"prepared a scheme

of decoration for a garden house at Buckingham Palace, Queen Victoria and others concerned could not quite bring themselves to approve his 'immodesty'" (379:262) shown in the undraped figures.

1828, November 22 (A)
"Le Sommeil du Lion," engraving offered for sale in Paris by Gramain, was ordered destroyed as seditious by the Cour Royale de Paris (92:31).

1828, November 22 (B)
"Le Songe de Marie-Louise," engraving offered for sale in Paris by Gramain, was ordered destroyed as seditious by the Cour Royale de Paris (92:31).

1829
John Duncombe was fined L50 and imprisoned for six months for publishing in the New London Rambler's Magazine a picture, "The Guard of Honor," illustrating a story of the same title. The indictment described the offending illustration as "representing a dog and the person of a woman partly naked in a most indecent posture and attitude" (576: ix).

1831 (A)
James Fenimore Cooper ordered a sculpture from American artist Horatio Greenough, "the first instance of one American commissioning another to make a statue group in marble" (142:103). Greenough made the "Chanting Cherubs"--supposed figures copied after Raphael's painting "Madonna del Trono" (shown with a letter from Cooper in the New York American, April 30, 1931)--in fulfillment of the commission. When the work was publicly exhibited in New York City "their nude baby forms" so shocked "Puritan decency" (568:44) that the naked infants "were forced to wear little aprons for the sake of modesty" (142:103-104). In addition to causing "great moral indignation" (379:516), the open-mouthed marble group "disappointed crowds because they did not sing."

A conservative assessment of nude art was made at this time by George W. Hilliard, author of the period's most popular guidebook to Italy for American tourists: No subject ought to be put on canvas "which a man would hesitate to look at in the presence of his children, or of the woman he loves"; and American sculptors living in Italy always referred to undraped figures "as 'the nudo'" (578:46).

1831 (B)
Delacroix's painting "Liberty Leading the People," exhibited at the Salon in Paris, so "outraged bourgeois opinion" that the picture, although officially bought by the French Government to decorate the Throne Room at the Tuileries... in fact... had been acquired solely so that it could be withdrawn from

circulation" because of its "glorification of the revo-
lutionary spirit" (31:223).

1831, May 5 Charles Philipon, French journalist and caricaturist,
 edited and published La Caricature, a weekly sati-
 rical sheet that appeared in Paris each Thursday
 after the July Revolution of 1830, and carried one
 page of text and two pages of lithographs (225:106).
 La Caricature, first issued November 4, 1830, car-
 ried such "ferocious political cartoons" as a "weapon
 in the fight for the people and for liberty" in France
 that during the four years it was published govern-
 ment authorities seized the paper twenty-seven times.
 English novelist William Thackeray, observing
 the French people's fight for social, political, and
 economic reforms--as reflected in La Caricature--
 described the contest sympathetically: "half a dozen
 poor artists on one side, and His Majesty Louis
 Philippe, his august family, and the numberless
 placemen and supporters of monarchy, on the other"
 (444:219). These "poor artists" whose work appear-
 ed in La Caricature included the leading French
 painters and printmakers: Honoré Daumier, Denis
 Auguste Raffet, Grandville (Jean Gerard), Henri
 Monnier, Charles Travies de Villers, and Pigal
 (273:148). Philipon's cartoon "Soap Bubbles"--
 showing bursting bubbles as the French government's
 promises for social and political reform vanishing
 in thin air--appeared in La Caricature on May 5,
 and caused Guisquet's men (he was Chief of Paris
 Police) to seize the offending picture in a raid on the
 Aubert shop where the lithograph was printed (607:18).

1831, June 30 The paper La Caricature was ordered seized in
 Paris when Charles Philipon printed a cartoon show-
 ing King Louis Philippe refacing the July 1830 signs
 (that is, forgetting old promises) (607:20).

1831, Novem- "Le Poire," a symbol invented by Charles Philipon
ber 19 to represent French Emperor Louis Philippe as a
 large Burgundy pear, was published frequently in
 his Paris papers La Caricature and Le Charivari--
 issued daily from 1832 to 1842, including a six
 month's period when the censors refused publication
 of many drawings and only the framed page appears
 in the paper, empty except for complaint about the
 censorship.
 "Le Poire," as a symbol for "Le Roi Bourgeois,"
 took its meaning from French slang (a "fathead"),
 and it became identified with and succeeded in ridi-
 culing the King--and the French government--by
 associating them with "bourgeois stupidity" when-
 ever it appeared in Philipon's satirical papers, or

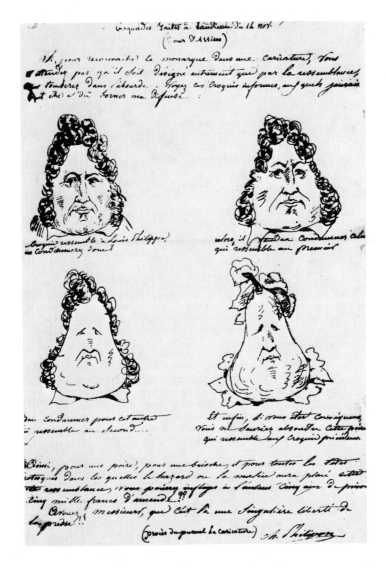

11. 1831, November 19. Charles Philipon. Metamorphosis of
the Pear. George Longstreet Collection, Los Angeles

was chalked on walls and buildings by passers-by to attack the regime.

When Philipon was brought to trial November 14, 1831 "for crimes against the person of the King" (225:106) for his insulting drawing, he denied "Le Poir" was a libel and claimed he had drawn only what he saw. As his defense in court against the charge of lese majeste, the artist drew a pear (in the manner of his friend caricaturist Grandville), converting it with a few strokes into a likeness of the King: "The first looks like Louis Philippe, the last looks like the first, yet this last one...is a pear! Where are you to draw the line? Would you condemn the first drawing? In that case you would have to condemn the last as well, since this resembles the first and thus the King, too!..." (273:29-30). "Can I help it if His Majesty's face is like a pear"? (265:81).

The court found Philipon guilty, on November 19, 1831, and sentenced him to six months in prison--a term he began January 13, 1832--and fined him 2,000 francs. The famous sequence, "Metamorphosis of the Pear," Philipon drew in court--an analysis of the process of caricature--was published in La Caricature--the first time on November 24, 1831--and, in a variation, as a woodcut supplement to Le Charivari, on January 17, 1834. (ILLUSTRATION 11)

1832 (A) At the annual exhibition of the National Academy of Design in New York City, "The Chanting Cherubs" by American sculptor Horatio Greenough--"two children innocently nude in a marble sculpture about three feet high"--was assailed for its "impropriety," by 'Modistus' an anonymous critic. This moral controversy had been reflected in the school of the Academy where the antique statue casts had suffered "conspicuous mutilation." Portrait painter Charles Cromwell Ingham's resolution in an Academy meeting "that a plaster leaf be placed in lieu thereof," although opposed by some members, was adopted (112:22-23).

1832 (B) Among foreign comments on the prevailing American prudery of this time was that of Frances Trollope, mother of the famous English novelist Anthony Trollope, who reported in her book Domestic Manners of the Americans, based on her stay in Cincinnati, that the owner of a garden (beer garden?) in that city "where people go to eat ices and look at roses" was nearly ruined because his advertising sign representing a Swiss peasant girl showed her skirt so "indecently short" as to reveal her ankles.

12. 1832, February 23. Honore Daumier. Gargantua. George Longstreet Collection, Los Angeles

The garden owner saved his business by having "a
sign painter add a flounce to the petticoat" (379:517).

1832, Febru- In the atmosphere of repression and censorship of
ary 23 the July Monarchy in France--when prints required
 official approval prior to publication, and newspapers
 had to deposit bonds to be forfeited if they criticized
 the government (503:142)--artist Honoré Daumier
 was brought to trial for his lithograph "Gargantua, "
 along with the lithographer--Delaporte--and the
 printer--Aubert.

 Lese Majeste was charged, an offense to King
 Louis Philippe, and Daumier was also accused of
 "fomenting disrespect and hatred of His Majesty's
 Government" (607:28-29). Scatalogical "Gargantua"
 drawn in December, 1831 for an issue of the Paris
 weekly La Caricature did not appear in the paper be-
 cause police seized the stone (according to a Decem-
 ber 29, 1831 article) before the picture could be run.
 Twenty-three-year-old Daumier had caricatured the
 King as Rabelais's giant Gargantua--gorging on the
 wealth of France: Seated on a throne (chaise per-
 cée--toilet seat) Louis Philippe devours the wealth
 of France--taxes represented by baskets of gold
 brought up a ramp to his mouth by tiny men, his
 ministers--and passes it on as favors, commissions,
 privileges and monopolies to the business classes
 and French peerage (225:106; 538:159; 597:519-520;
 607:28-29), in whose interest the government is
 conducted.

 Daumier had already received one warning from
 French authorities for a "rash lithograph" (503:134),
 and the court found him guilty as charged for draw-
 ing "Gargantua, " sentencing him to six months im-
 prisonment--to begin August 27, 1832--and fining him
 500 francs (607:28-29). He spent five months in
 cell 102, Sainte-Pelagie Prison, Rue de la Clef,
 Paris. Political caricatures were forbidden by
 French censorship from 1835 to 1848, dictating a
 change in Daumier's subject matter from govern-
 ment to social comment. (ILLUSTRATION 12)

1832, Novem- Two lithographs by Dreuille--"La Chemise de la
ber 27 Grisette" and "La Chemise de la Courtisane"--pub-
 lished by Ligny et Dupaix in Paris were ordered
 destroyed as outraging public decency by the Cour
 d'Assises (92:96).

1833, Janu- "Autopsie, " a lithograph with an accompanying arti-
ary 28 (A) cle, published in La Caricature were ordered de-
 stroyed in Paris for allusions offensive to the gov-
 ernment by the Cour d'Assises de la Seine (92:38).

1833, Janu- Charles Philipon, and his editor Gabriel Aubert,
ary 28 (B) were tried in Paris for publication of a caricature
 (lithograph and article), "Project for a Monument,"
 in La Caricature, No. 84, as an "offense against
 the King." The defendants were acquitted by the
 jury, but the article and lithograph were ordered
 destroyed (92:42, 68, 126, 182; 166:69).

1833, March Engravings hostile to decency (attentatoires aux
23 bonnes moeurs) published by Felix Alexander Col-
 lette and offered for sale in a public place by
 Bouilly, were ordered destroyed by the Cour d'
 Assises de la Seine, and Bouilly was condemned
 to three months in prison and fined 150 francs.
 Earlier, on January 23, 1833, Collette had been
 condemned to six months in prison and fined 500
 francs by order of the Cour d'Assises de la Seine
 for publishing many engravings offensive to the per-
 son of the King and members of the royal family,
 and an outrage against public morals and decency
 (92:136, 145).

1833, April 23 "Album Anecdotique, N. 16"--attacks against the
 constitutional rights of the King (les droits constitu-
 tionnels du roi), offered for sale by Fonrouge, Pari-
 sian printer-litographer were ordered destroyed by
 order of the Cour d'Assises de la Seine, and Fon-
 rouge was condemned to three months in prison and
 fined 1,000 francs (92:34, 137).

1833, October Engravings outraging decency, offered for sale by
29 Parisian engraving dealer Edme Desmaisons, were
 ordered destroyed by the Cour d'Assises de la
 Seine, although Desmaisons was acquitted of the
 charge (92:105, 150).

1833, October "L'Interieur d'une Grille," published by Gabriel
31 Aubert et Besnard, was ordered destroyed as an
 obscene print by the Cour d'Assises de la Seine
 (92:107).

1834 Charles Philipon, publisher of the Paris papers La
 Caricature and Charivari, with six judgments against
 him and three convictions adding up to thirteen
 months in prison and 6,000 francs in fines for pic-
 tures--and some articles--appearing in his publica-
 tions, founded L'Association Mensuelle, a lithograph
 supplement to La Caricature (170:180), in order to
 pay his fines and publication losses from the govern-
 ment censorship. French officials effectively "eli-
 minated print-sellers"--including L'Association Men-
 suelle--"by voting a stamp act, requiring that all
 loose prints have a government stamp placed directly

on them" which defaced the print and destroyed its
value (607:59).

The last print in the series of La Caricature
supplements, Daumier's "La Rue Transnonian, le
14 Avril 1834, " depicted the scene where twelve
working people had been shot in an apartment by
soldiers, after a sniper's bullet from the building
killed an officer of the troops mobilized to prevent
a workmen's uprising stimulated by the "insurrection
of the silk workers in Lyons" earlier in the year
(170:180). The lithograph--showing "furniture and
bodies littering the moonlit floor in...still disorder
(called by Baudelaire "trivial and terrible")--attrac-
ted queues of spectators, and French government
agents "immediately seized the stone and all availa-
ble prints" (607:59).

1835 A law case to test an artist's claim--not uncommon--
that his work was displayed unadvantageously was
brought to legal decision when an exhibitor removed
his picture from the walls of the National Academy
of Design annual exhibition in New York City because
he was displeased with the disposition of his work.
The Academy "brought suit to determine the principle
involved, stating to the court that it was not seeking
damages. " When the judge upheld the Academy's
action, "the picture was replaced and the artist
fined six cents" (112:22).

1835, Septem- French "September Laws, " aimed at censorship of
ber 9 the press, including caricatures and political satire,
such as Daumier directed against King Louis Philippe
and government officials, were passed (192:8) "com-
pletely silencing political criticism" (607:50) in
France. Liberty of the press--suppressed by King
Charles X, an abridgment of freedom instrumental
in his downfall--had been reestablished by Louis
Philippe at the beginning of his reign in 1830, but
from 1832 on the king had sought to curb diatribes
in the press, and the September Laws "totally sup-
pressed adverse comment and caricature" (11:10).

Under these laws, as passed by the French As-
sembly and lasting thirteen years until abolished
March 8, 1848 (607:118) after the overthrow of
Louis Philippe in the Revolution of February 1848
(170:180), insults to the king were to be regarded
as threats to the public security:

"Any sketch, any engravings, lithographs, medals
and prints, any emblems of any sort or kind
whatsoever they may be, may not be published,
shown, or offered for sale without the authoriza-
tion of the Minister of the Interior in Paris and
the Prefects of the Department. In case of

offense...[they] may be confiscated and the pub-
lisher will be condemned by a correctional tri-
bunal to imprisonment of from one month to a
year and a fine of from 100 to 1,000 francs"
(607:67).

1835, Novem- Engravings publicly displayed and offered for sale
ber 27 in July 1835 by Jean Marie Mandement were ordered
 destroyed as outrages against public morals, relig-
 ion, and decency by the Cour d'Assises du Gard,
 and Mandement was condemned to six months in
 prison and a fine of 16 francs (92:105, 175).

1835, Decem- Philipon's satirical Parisian paper, Charivari, won
ber a case at trial when its editors "demolished the
 government's charge" of lese majeste against an
 illustration it printed, by showing that the picture
 had previously appeared "in a book by Louis Adolphe
 Thiers, one of Emperor Louis Philippe's favorite
 ministers" (607:249).

1836-1840 Captain Marryat, English author, visiting Governor
 Edward Everett of Massachusetts--first man in the
 United States to receive a PhD degree (from Gottin-
 gen University), and President of Harvard Univer-
 sity--reported that he "saw in the Governor's house
 a cast of the Apollo Belvedere [nude antique Greek
 state in the Vatican] which was ordinarily covered
 'in compliance with general opinion'" (379:517).

1838 Modification of England's Vagrancy Act was passed,
 providing that--Section 2--"Persons exposing ob-
 scene prints, etc. in shop windows are liable on
 conviction to punishment" (23:110).

1839 The 1839 Portland Vase--first general edition in a
 Wedgwood copy of the famous Greek Barberini Vase
 of cameo-glass, with white classical figures carved
 in bas-relief in two scenes on a deep blue ground--
 was "remarkable" only for the drapery which "Vic-
 torian taste" added to the figures. The original--
 probably the most famous vase in the world--made
 by Greek glass workers in Alexandria about 50 B.C.,
 is in the British Museum and its nude figures are
 "indecently undraped" (377:82).

1840's (A) Tableaux Vivants--lightly draped young women and
 men giving the illusion of nudity--became popular
 in New York City. Looking through gauze at ad-
 vertised "naked ladies"--in reality clothed in tights--
 cost up to $1. Sharper "Dr. Collyer" had exploi-
 ted the prevailing interest in art and "attracted the
 public in droves" to such displays--"aesthetics

sweetened with sex"--as a "new movement in the
fine arts, " introduced at Palmo's Opera House, ad-
vertised:
 "Living men and women in almost the same state
 in which Gabriel saw them in the Garden of Eden
 on the first morning of Creation" (360:19-20).
Criminal prosecution and "indignant moral mobs"
caused showmen to tone down their exhibits--at
least their advertising--so that by 1848 the New
York Sunday Mercury asked what had become of:
 "Those nice tableaux vivants
 Of beautiful young ladies, sans
 Both petticoats and pants,
 Who, scorning fathions's shifts and whims,
 Did nightly crowds delight,
 By showing up their handsome limbs,
 At fifty cents a sight" (379:497).

1840's (B) During the 1840's--as well as the 1850's--the Penn-
sylvania Academy in Philadelphia continued to drape
its plaster casts of undraped antique Greek figures
on "Ladies' Day " (247:177). "Prudery, Ignorance,
and Self-consciousness, the three Philistine fates, "
whose motto is 'I don't know anything about art but
I know what I like, ' were the enemies that those
who were interested in educating and refining the
public taste saw all around them" (360:11).

1840's (C) The French Academy, lacking a female model until
the time of Ingres, "employed an old soldier to
stand duty as both Apollo and Venus" (361:164).

c 1840 In England, the Cupid on a valentine was covered
with a skirt (207:pl 20).

1841-1842 At the art academy in Berlin, students were per-
mitted to view nude Heroes of classic sculpture
"with salmon-colored trunks, " and the Venus de'
Medici "with a shawl" (454:231).

1842 The Cerne giant--180-foot-long outline figure above
the Dorset village of Cerne Abbas, an ancient club-
swinging giant Saxon god or Phoenician Hercules--
is never represented in his full "ithyphallic vigour"
because even though the villagers scour and fill with
fresh chalk the outline trenches of his figure every
seven years, he is castrated in drawings, such as
those included in John Sydenham's Baal Durotrigensis,
of 1842 (207:193).

1842, March 4 Obscene engravings exhibited and offered for sale
by Victor Peru, street peddler ("marchand ambulant")
and Ambrose Felix Bourguin, Parisian copper en-

graver, were ordered destroyed by the Cour d'
Assises de la Seine. Bourgin was condemned to
five months in prison and fined 50 francs; Peru was
condemned to six months in prison and fined 16
francs (92:105, 156, 182).

1842, August "Album Heretique, " a work offered for sale by
9 (A) Regnier Becker, was ordered destroyed as outraging
 public morals and religion by the Cour d'Assises de
 la Seine (92:87).

1842, August "Les Apprets du Bel, " engravings offered for sale
9 (B) by Regnier Becker, were ordered destroyed as out-
 raging public morals and decency" (92:89).

1842, August "Le Don du Mouchoir, " a lithograph, and "Douze
9 (C) Sujets du Jour, " a collection of drawings, offered
 for sale by Regnier Becker were ordered destroyed
 as outraging public decency by the Cour d'Assises
 de la Seine (92:99, 100).

1842, August "Le Coup de Vent, " obscene engraving offered for sale
9 (D) by Regnier Becker was ordered destroyed as outraging
 decency by the Cour d' Assises de la Seine (92:96).

1842, August "Galerie des Gardes Françaises, " folio of six draw-
9 (E) ings--each entitled "Garde française"--offered for
 sale by Regnier Becker were ordered destroyed as
 outraging public morals and decency by the Cour d'
 Assises de la Seine. This same collection offered
 for sale by Bon was ordered destroyed for the same
 offense by the Cour d'Assises de la Seine-Inférieure
 on September 8, 1844 (92:104).

1842, August "Les Moeurs de Paris per Arrondissement, " folio
9 (F) of a dozen drawings offered for sale by Regnier
 Becker and by Bon, were ordered destroyed as out-
 raging public morals and decency by the Cour d'
 Assises de la Seine. This same folio was ordered
 destroyed for the same reasons by the Cour d'Assises
 de la Seine-Inférieure on September 8, 1844 (92:113).

1842, August "La Rosee, "obscene engraving offered for sale by
9 (G) Regnier Becker, was ordered destroyed by the Cour
 d'Assises de la Seine (92:119).

1842, August "Saint-Simoniens, " a collection of obscene engravings
9 (H) offered for sale by Mayer, was ordered by the Cour
 d'Assises de la Seine (92:119).

1842, August Engravings and collections of engravings, offered
9 (I) for sale by Regnier Becker, were ordered destroyed
 as outraging decency by the Cour d'Assises de la

Seine (92:106).

1842, August "Une Veilée de Jeune Fille, " licentious engraving
9 (J) offered for sale by Regnier Becker, journeyman
carpenter of Meru (Oise), was ordered destroyed
by the Cour d'Assises de la Seine (92:122, 188).
Regnier Becker was condemned to six months in
prison and fined 200 francs for outraging public
morals, religion and decency in 1839, 1840, 1841,
and 1842 through the sale of obscene prints, engrav-
ings, and lithographs (92:122, 188).

1842, August In the United States Tariff Law of 1842, Congress
30 enacted the first national censorship statue as a
"federal obscenity law" concerned with pictorial art
alone, and not with the printed word (279:vii; 414:
li). Enough traffic in indecent pictures had warranted
forbidding their import into the United States (72:79):

> "The importation of all indecent and obscene
> prints, paintings, lithographs, engravings, and
> transparencies is hereby prohibited" (181:19-
> 20; 415:327).

"Without any debate" Congress had inserted into
the Tariff Act authorization for Customs officers
to confiscate prints or pictures if they considered
them "obscene or immoral, " and "to bring court
proceedings authorizing their destruction" (447:12).

1843 (A) The first reported case of the United States Customs
seizure of obscene matter, under the provisions of
the Tariff Law of 1842 making the importation of an
indecent and obscene painting cause for forfeiture
of the entire invoice (447:341), was tried in the
district court of New York (United States v Three
Cases of Toys, 28 Fed Cas 112, No. 16499 S. D.
N. Y.). The law was found applicable although the
painting in question "was not a distinct article, but
was affixed to another article. " The indecent paint-
ings were attached to nine snuff boxes, included in
three boxes of toys imported from Germany in
September, 1842. On each snuff box was painting--
under a false bottom--"an indecent scene or figure,
of so very obscene a character that they were unfit
to be produced in court, and only one of them was
exhibited, having been first defaced with ink to hide
its obscenity, for the purpose of showing in what
manner the paintings were attached the boxes. "

 The jury, without leaving the courtroom, brought
a verdict for the government, with confiscation of
the entire shipment--valued at about $700. The
fact that the importers were unaware of the charac-
ter of the paintings did not exempt the balance of
the invoice, which belonged to another firm, from
confiscation.

1843 (B) "The public was horrified by Horatio Greenough's
 Zeus-like statue of George Washington, " undraped
 to the waist--but "half-draped in something like a
 bed sheet" (360:13), when the figure (10 1/2 feet
 high and weighing 20 tons (326:182)) was set opposite
 the eastern front of the Capitol in Washington. The
 artist, after laboring eight years on the figure, had
 written:
 "I have sacrificed the flower of my days and the
 freshness of my strength" (360:13),
 only to have "purblind squeamishness" awake "with
 a roar at the colossal nakedness of Washington's
 breast" (379:516).
 Washington suffered "waves of outraged purity
 and patriotism"--one public group went on record:
 "The general would never have shown himself
 bare-chester in public" (607:231);
 and a Washington reporter described the Father of
 His Country as saying, while he pointed in two oppo-
 site directions:
 "My body is at Mount Vernon, my clothes are
 in the Patent Office (568:51).
 In 1908 the statue was removed to the basement of
 the Smithsonian Institution for protection from
 weathering (597:566-567).

1843, April "Bibliothèque des Romans, " folio of obscene engrav-
11 (A) ings offered for sale by Mayer, was ordered de-
 stroyed by the Cour d'Assises de la Seine (92:90).

1843, April "Le Jour et La Nuit, " folio of engravings offered
11 (B) for sale by Mayer, was ordered destroyed as out-
 raging decency, public morals, and religion by the
 Cour d'Assises de la Seine (92:108).

1843, April "Rosee de Toutes les Saisons, " folio of obscene en-
11 (C) gravings offered for sale by Mayer, was ordered
 destroyed by the Cour d'Assises de la Seine (92:119).

1843, April Obscene engravings, offered for sale by Mayer in
11 (D) Paris, were ordered destroyed by the Cour d'Assises
 de la Seine. Mayer was condemned to prison and
 fined 500 francs for outraging public morals and
 decency in 1842 by the public sale of obscene draw-
 ings and engravings, and of a playing-card box re-
 vealing obscenities when viewed as a transparency
 (92:105, 177).

1843, May The National Academy of Design at its eighteenth
 annual exhibition in New York City, at the Society
 Library on the corner of Leonard Street and Broad-
 way, was accused of excluding one painting by New
 York artist William Page--"Cupid and Psyche"--"on

the score of indecency." In an angry exchange of
published letters, critics of the banning pointed out
that the picture was based on ideal subjects and
had been shown at the Boston Athenaeum in 1834
(495:183), and the defender of the Academy's cen-
soring action said that the picture was returned to
the artist because it was "a known copy," but added
that if the picture had been rejected because of its
"offense to delicacy," the directors of the National
Academy were only upholding their trust as guard-
ians of public morals "not to be prostituted to
please the 'salacious' cravings of libertine fancies"
(488; Life 51:155 O 6, 1961).

1843, August "Panorama des Paillards," obscene engraving offer-
11 ed for sale by Mayer, was ordered destroyed by the
 Cour d'Assises de la Seine (92:115-116).

1844, Septem- "Je M'Abandonne à Toi," a collection of six draw-
ber 8 ings with a green paper cover bearing an obscene
 lithograph, offered for sale by street peddler Pierre
 Bon, was ordered destroyed by the Cour d'Assises
 de la Seine as outraging public morals, religion, and
 decency, and Bon was condemned to five years in
 prison and fined 6,000 francs (92:103, 134).

1845, April 25 Engravings of obscene subjects offered for sale by
 Parisian lithographer Louis Jules Guerrier were
 ordered destroyed by the Cour d'Assises de la
 Seine (92:105).

1845, April Drawings of obscene subjects offered for sale and
29 (A) exhibited by Louis Jules Guerrier in Paris were
 ordered destroyed by the Cour d'Assises de la
 Seine, and Guerrier was condemned to one year
 in prison and fined 500 francs for outrages against
 public morals and decency by selling prints, draw-
 ings, lithographs, engravings and book covers
 (cartonnages) with obscene subjects (92:98, 161).

1845, April Claude Balthasar Manuel Marechal was condemned
29 (B) to six months in prison and fined 500 francs by the
 Cour d'Assises de la Seine for the sale in Paris of
 obscene prints, drawings, engravings, and litho-
 graphs (92:176).

1845, Novem- "Après la Victoire," immoral engraving offered for
ber 28 sale by Louis Victor Deshayes, Parisian print
 dealer, and his wife Goin, was ordered destroyed
 by the Cour d'Assises de la Seine as an outrage to
 public morals and decency, and the Deshayes were
 condemned to five months in prison and fined 500
 francs (92:89, 150).

1847-1851 "Naked, but not corrupting, " was the unanimous
 opinion of a group of Cincinnati clergymen called
 to view Hiram Powers' statue "The Greek Slave, "
 "the darling of her day" that had already won the
 American sculptor an international reputation when
 she was exhibited at the 1851 Crystal Palace Exhi-
 bition in London (387). "The Slave"--a gentle Greek
 Christian woman taken by the Turks, stripped and
 manacled (379:516; 568:61)--might be considered
 political propaganda (her tour of New York and
 other cities netted $23, 000), but she could not be
 displayed in Cincinnati until the clergymen commit-
 tee upon critical examination of the figure gave her
 a 'character' (568:61), "since her hands were
 chained, her undraped condition was beyond her
 control, and she would not endanger public virtue"
 (597:567). Unitarian minister Reverend Orville
 Dewey wrote a pamphlet defending sculptor Powers'
 work:
 "The chasteness in this statue is strongly con-
 trasted with the usual voluptuousness of the an-
 tique... the helpless constraint... in the Greek
 girl... was clothed all over with sentiment,
 sheltered, protected by it, from every profane
 eye. Brocade, cloth of gold could not be more
 complete protection than the venture of holiness
 in which she stands" (360:19-20; 578:47).
 Men viewing the figure took off their hats, and gal-
 lery visitors spoke "in hushed tones" (578:47).
 Among poets moved to song by "The Greek Slave"
 were an anonymous writer, in Knickerbocker Maga-
 zine of October 1847:
 "Naked yet clothed with chastity she stands
 And as a shield throws back the sun's hot rays,
 Her modest mien repels each vulgar gaze"
 (578:47);
 and Elizabeth Barrett Browning:
 "Appeal, fair stone,
 From God's pure heights of beauty against man's
 wrong!
 Catch up in thy divine face, not alone
 East's griefs, but West's, and strike and shame
 the strong
 By thunder of white silence overthrown" (568:62;
 578:47). (ILLUSTRATION 13)

1848 (A) John August Ingres, celebrated French painter, in
 a report to the French Government "demanded ac-
 cess to the salons for all artists on condition only
 that their work did not offend the canons of public
 morality" (282:109).

1848 (B) The contemporary press in London criticized Thomas

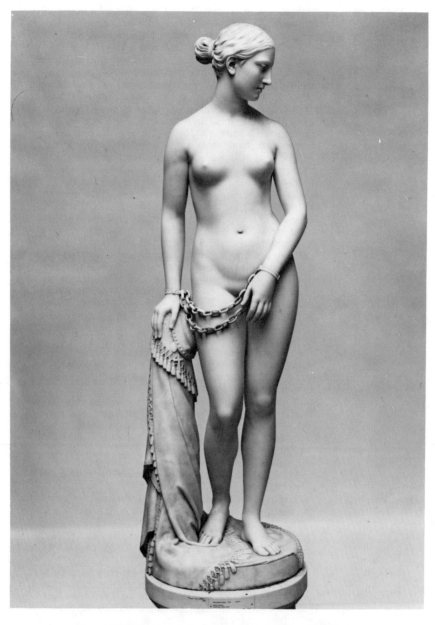

13. 1847-1851. Hiram Powers. The Greek Slave.
Corcoran Gallery of Art

Thornycroft's figures "Queen Victoria's Children as
Seasons, " writing of "Autumn":
"To connect childhood with intoxicating wine is
repugnant to our feelings" (351).

1848 (C) The "freedom from restrictions of government
censorship" began in Germany, so that caricature
could again take part in political questions. "Herr
Piepmeyer" by Adolf Schroedter--a "noisily officious
Mr. Nobody, zealous representative of the people as
a member of the legislature" in the publication The
Life and Opinions of Herr Piepmeyer--became an
"example of how German pictorial satire tackled
political questions of the day" (273:120).

1850's (A) In Thai art the iconography of a Buddha image was
set in regard to anatomy, dress, posture (57:38).
In the aniconic symbol of Buddha's presence--
"Sukhodaya Footprints"--the prints must conform
to measure--about two yards length--with "a check-
erboard pattern of 108 symbols, as listed in the
Pali texts, " that "perhaps derive ultimately from
the ancient podoscopic charts in which the 108 signs
were labels of auspicious skin formations" (57:98).

1850's (B) Because of Orthodox Jewish prohibitions against im-
ages, Abraham Palagi, Rabbi of Smyrna, refused
to admit to the Synagogue a portrait sent by Moses
Montefiore (509:23).

1850's (C) Displays of nude figures in art exhibits aroused
"the ire of a significant number of Americans, "
and when casts of classical sculpture were shown
in American galleries, separate hours, according
to the dictates of convention, were arranged for
men and women (70; 142:23).

1850 (A) Harriet Hosmer, famous American sculptor of the
nineteenth century, had to leave her home in Boston
to study in St. Louis in order to include anatomy
in preparation for her art work (379:518). Public
opinion in Watertown, her home, considered sculp-
ture a "much too unladylike occupation" because of
the physical labor involved and the necessity to
learn human anatomy. Miss Hosmer studied anato-
my as an individual student with Dr. J. N. Mc-
Dowell, professor of Anatomy at the medical school
in Columbia, Missouri--an acquaintance of Miss
Hosmer's physician father who agreed to instruct
her, but "could not allow her to enter the all-male
class" in anatomy at the medical school (142:326).

1850 (B) Crowds gathered at the Salon in Paris before Gustave

Courbet's painting "Funeral at Ornans," and "a
deafening roar of protest" greeted the picture be-
cause it attacked the prevailing aesthetic prejudice
and convention, and affronted public pictorial and
social taste in depicting "the pageantry of a peasant
funeral" (637:8).

1850 (C) Publisher Henry G. Bohn, publisher of York Street,
Covent Garden, London, issued a separate volume
of James Gillray plates because the subject matter
of these forty-five pictures "shocked nineteenth-
century art historians and critics"--"blatantly inde-
cent" including scatalogical and flagellation pictures
(224; 515:175).

1850 (D) Millais's painting "Carpenter Shop" intended as a
presentation of a sacred subject caused public and
press outcry, and was denounced as blasphemy be-
cause of the dirt and disease of the Holy Family
represented--even Punch carried a doctor's diagno-
sis of the ills of Joseph, Mary and other figures:
"scrofular or strumous diathesis" (435:162).

1851 (A) With the coup d'état in France, establishing the
Second Empire under Napoleon III, Count Nieuwerk-
erke was given authoritarian powers as head of the
administration of the Beaux-Arts and imposed "a
state-controlled aesthetic. " "All honors and awards
were reserved for official artists and academicians,
members of the Institute;... they used their power
ruthlessly to discriminate against any artist who
showed the least originality" (462:43).

1851 (B) When Edmond Texier, a French visitor to London,
asked his hostess why chairs and pianos wore more
clothes than some ladies he saw in the Haymarket
at the Covent Garden, she replied: "Wouldn't you
be shocked, Monsieur, if you could see the legs of
these chairs"? (207:181).

1851 (C) After Archbishop John Baptist Lamy arrived in his
newly created diocese of New Mexico, one of his
reforms was an order to discard the santos--in-
digenous folk art figures of colonial New Mexico
representing carved and painted patron saints and
members of the Holy Family, in the form of
"retablos" (flat panels or figures in relief) and
"bultos" (figures in the round).
To Bishop Lamy's European eyes these saints
made by native craftsmen were grotesque, and "he
directed that they be replaced with conventional
plaster images and colored prints which were im-
ported. " At order of the Bishop--whose career

14. 1851 (C). San Rafael, bulto. Museum of New Mexico, Truman Mathews Collection

in the Southwest forms the basis of Willa Cather's
novel Death Comes for the Archbishop--"most of
the santos were destroyed" (60; 315: D 20 1959, V:
6). (ILLUSTRATION 14)

1851, April 17 Charles Vernier, artist of the engraving "Actuali-
ties" which appeared in the Parisian daily Charivari
with the legend: "Le prix de l'adresse aux Champs-
Elysees. Celue qui la renversera tout a fait sera
son ministre, " was sentenced for his offense against
the President of France to two months in prison and
fined 100 francs. The plate of the engraving was
ordered destroyed May 27, 1851 (89:166).

1851, May 1 The Great Exhibition opened at the Crystal Palace,
Hyde Park, London. Hiram Powers' "Greek Slave, "
"one of a forest of marble nudes, " was the only
sculptured nude to cause "a scandal, not because
of her body, which was a blameless pastiche on
the Knidian Aphrodite, but because her wrists were
handcuffed" (114:221). When the Crystal Palace was
moved to Sydenham, "a number of protests were
published" concerning the figure (114:499).

1851, Decem- Censorship in France was resumed with the coup
ber 2 d'état of Louis Philippe. The Emperor was taboo
for caricature. Daumier's caricatures for Chari-
vari were "often returned as unsuitable for publica-
tion by the censor" (607:154).

1853 (A) In Mannheim, Germany, "Venus de Milo, " nude
classic statue, was tried in court of law for her
nudity, and "was convicted and condemned" (142:
117-118).

1853 (B) The Parliament in England passed its first legisla-
tion against obscenity--authorizing the Customs to
seize "indecent or obscene prints, paintings, books,
cards, lithographic or other engravings, or any
other indecent or obscene articles" (355:132).

1853 (C) English Queen Victoria proved that she "was not as
puritanical as many of her contemporaries" when
"she was not shocked by but openly admired and
wished to purchase one of William Mulready's nude
studies, which the directors of the art school of
the Royal Academy had been warned against letting
her see" (451:145).

1853 (D) Gustave Courbet's "Bathers, " exhibited at the Salon
of 1853, received Imperial censure when Napoleon
III "struck with his crop across the buttocks" of the
figures, "and called them 'draught mares'" (225:108).

1853, April Auguste Cinquini was condemned to 15 days in pris-
24 on by the Tribunal Correctionnel de la Seine for
 offering for sale in Paris plaster figures of "Italy,"
 and other women nude in indecent poses, as "out-
 rages aux bonnes moeurs" (166:xxxvi).

1854 (A) A picture by an official artist with Admiral Matthew
 Galbraith Perry, commander of the United States
 Navy squadron to Japan sent to negotiate a treaty
 which would open that country to commerce, "caused
 a Congressional furor and was later suppressed"
 because it showed Japanese men and women bathing
 together (79:138).

1854 (B) A New York court "dealt naturally and realistically"
 with a statue when it decided that "the colossal
 statue of George Washington, specially carved and
 mounted to lend the finishing touch of perfection to
 a Gothic castle with landscaped grounds, formed an
 insufficient ensemble to turn 'chattel to land'" in
 the case, Snedeker v Warring (1854) 12 N.Y. 170;
 Warren, Cases on Property, n. p. 665 (369:248).

1854, July 8 William Peters published a pamphlet, typical of the
 time's "troubled contemporary moralists, against
 the use of models in art schools": The Student
 Question... and An Appeal Against the Practices of
 Studying from Nude Human Beings by British Artists,
 and in Public Schools of Design. In such publica-
 tions anti-nudery was "usually combined with anti-
 popery, chauvanism, and bourgeois democracy"
 (114:499).

1855 (A) Adolf Zeising published in Aesthetische Forschungen
 a report on the Golden Section (variously referred
 to as Section Dorée, Goldene Schnitt, Nombre d'
 Or, Law of Numbers, Divine Proportion, Gottliche
 Proportion), a mystic measurement found in the
 human body, nature painting, and architecture--and
 with a long history in technology and philosophy of
 arts. The report included findings of measuring a
 variety of objects "adjudged beautiful," and implied
 that the proportion "constituted a perfect mean be-
 tween absolute unity and absolute variety."
 The proportions of the Golden Section approach
 Fibonacci numbers (each number is the sum of the
 two preceding numbers--1, 1, 2, 3, 5, 8, 13, 21, 34, 55,
 89...) which have a "natural" significance, that is,
 they appear in natural forms of growth, such as
 conch-shells, proliferation of seeds in growth areas
 (432:179-187). Zeising's study of the Golden Section
 was continued by Gustave Theodore Fechner, founder
 of psychophysics, in his experiments asking people

to choose the most pleasing shapes on white cards,
and to judge articles in common use for preferred
proportion: books, envelopes, confectionery, bricks,
doors and windows, picture dimensions.

1855 (B) Sir Joshua Walmsley's Common's motion for opening
the British Museum and the National Gallery after
Sunday morning service was defeated in the English
Parliament by a heavy majority (207:113).

1855 (C) A School of Design, recently established in a "pro-
vincial town" in the United States, inaugurated its
operation by holding a conversazione in the class-
rooms. Following the suggestion of the Committee
of Management, the School concealed its many casts
of nude antique statues by surrounding the figures
with growing plants so that the unclothed figures of
gods and goddesses would not scandalize the citizens
assembled for the soiree (584:303).

1857 (A) "The Gleaners" painted by Jean François Millet, was
refused by the Salon in Paris because its "message
was dangerous. " The picture of peasants--"revolu-
tionary... in a sentimental, Victorian way" (178:342)
--was criticized as social propaganda depicting "the
underprivileged oppressed by exploitation of the upper
classes" (597:508-509). Although the Salon of 1850
had accepted Millet's "The Sower" and "The Binders, "
"it was these paintings which first aroused hostile
critics to accuse Millet of being a socialist" (177, XV).

1857 (B) "Georges Rouault's graphic illustrations, after Baude-
laire's Les Fleurs du Mal were banned" by the
French police at time of publication (529).

1857 (C) The United States Tariff Law of 1842 forbidding the
importation of indecent "pictures" and "prints" was
amended to "more effectually accomplish the purpose
for which the provision was enacted" (72:79) by add-
ing the word "articles" to the categories "of items
that could be seized" by the Customs authorities.
Also added to banned art were "images and figures"
to cover three-dimensional representations of sculp-
ture, indecent daguerreographs, and photographs
(181:21; 447:17).

1857 (D) "Lord Campbell's Act" ("The Obscene Publications
Act") became law in England. It provided for
searches and seizures of offending obscene books
and prints that were "for the single purpose of
corrupting youth, " and "of a nature to shock the
common feelings of decency of any well-regulated
mind" (103:80). During the Parliamentary debate

as to the purpose of the law and the definition of
"obscenity, " Lord Lyndenhurst--eighty-five year old
former Chief Justice in England, who opposed the
bill that would regulate obscene books, pictures,
and statues--speaking in the House of Lords, saw
"staid... art dealers being marched off to jail for
selling great masterpieces, " and described "im-
proper paintings by celebrated painters" (447:14).
Among the works of recognized artistic merit
jeopardized by the proposed Act, he cited the
famous painting of Corregio, "Jupiter and Antiope, "
in the Louvre, pointing out that "according to the
Bill" a copy of this painting--generally recognized
as a great work of art--could be seized as obscene.
Lord Lyndenhurst also reported United States Cus-
toms' seizure of a catalog picturing the figures,
principal statues, and paintings of the Royal Museum
of Naples (Museo Barbonica Reale), and destruction
of the publication under the United States obscenity
law; he noted that the same book was at that time
in the Library attached to Parliament (181:21; 182:
116-117, 120-121).

"Lord Campbell's Act" "turned the average Eng-
lish magistrate into a censor of artistic and literary
morals by leaving it to him to say whether... any
particular work was obscene, and, if it was, to
order its destruction" (279:171). Shortly after the
bill passed, the Chief Justice reported that the new
law provided for "assaults" and final "victory" over
the vicious Hollywell peddlers of pornography, but
when Lord Lyndenhurst challenged him to produce
samples of the confiscated "abominations" for in-
spection, the Chief Justice excused his refusal to
produce seized obscenities on the grounds that they
would "alarm" the "modesty" of England's peers
(447:14).

1857, August 30	Engravings offered for sale in Paris, September 1856, by Augustin Emmanuel Dauty were ordered destroyed as obscene by the Cour d'Assises de la Seine, and Dauty was sentenced to one year in prison and fined 500 francs (92:105, 148).
1859 (A)	American artist John Rogers, whose statuettes graced the parlor tables of nineteenth century America, hired a street salesman--a Negro--to sell his sculptured group "The Slave Auction" because the representation had "incurred the censure of Southern sympathizers" and "New York City shopkeepers refused to put the figures on sale in their establishments" (142:361).

1859 (B) When eight pieces of statuary were added to the
 Tennessee Capitol building in Nashville, around the
 entrance lampposts, Samuel D. Morgan, state offi-
 cial, chose the figures from a catalogue published
 by Wood & Perot of Philadelphia, agreeing to pur-
 chase the sculptures (including two undressed maid-
 ens representing "Morning" and "Noon", and an un-
 clad boy depicting "Night") only if some clothing
 were added--total cost: $3, 600. Legislators, view-
 ing the statues when they arrived in Nashville, were
 shocked into publicly denouncing "such lightly clad
 figures. " Governor Andrew Johnson, later President
 of the United States, was reportedly "so mortified"
 by the nudity of the lampposts that "he refused to
 approve an appropriation for the works of dubious
 art" (410, Jy 8 1956 26:1).

1860-1880 Some of the "best works" of English landscape paint-
 er Joseph Mallord William Turner are lost, if
 Frank Harris correctly reported Ruskin's conversa-
 tion concerning the paintings--in his book My Life
 and Loves, 1823, volume II, page. 263.
 When Turner died in 1852 his unsold paintings,
 left to the English nation, were stored--unsorted
 and unviewed--in boxes in the National Gallery, Lon-
 don. Ruskin offered to put the paintings in order
 as Turner had been one of the artist he most ad-
 mired. In sorting these works of genius lying un-
 appreciated in the National Gallery cellars, he came
 across a portfolio filled with "painting after painting
 ... of the most shameful sort--the pudenda of women. "
 Ruskin found, upon inquiry, that Turner had left
 his house in Chelsea on Friday afternoons to live
 among the sailors' women at Wapping until Monday
 mornings, painting these women "in every posture
 of abandonment. " After some weeks of indecision,
 Ruskin decided that he was "the one man capable of
 coming in this matter to a great decision":
 "I took the hundreds of scrofulous sketches and
 paintings and burnt them where they were...
 burnt all of them... " (525:176).

1860's Reproductions of the "Venus de Milo" were accepted
 into some homes in the United States--but only after
 the figure was renamed "Goddess of Liberty" (247:
 318). During this same period, a visitor to the
 Boston Art Museum told the young lady attendant
 that she should make aprons for all the nude statues
 in the galleries, and before the end of the century
 public libraries from Brooklyn to Denver removed
 Tom Sawyer and Huckleberry Finn from their
 shelves as unsuitable reading for the young.

1860 (A) The problem of nudity in art continued to trouble
puritan spirits in the United States, among these
Nathaniel Hawthorne whose character Miriam in
the Marble Faun points out that while "the human
body had been a familiar experience for the Greeks
... nowadays 'people are as good as born in their
clothes'; the artist cannot therefore sculpture nudity
without guilty glimpses at hired models" (326:160).

1860 (B) The Summer Palace in Peking was looted when the
Europeans made their triumphal entry into Peking.
"English and French, officers and other ranks,
joined the populace of Hai-tien and... coolies" in
destroying and carrying off "accumulated treasures
of art... the tradition of centuries" (583A:200-208).

1862 "The first open revolt of artists" against the dicta-
torship of the St. Petersburg Academy occurred in
Russia--the serfs had been freed two years before.
In "a political revolt about the subject matter"
thirteen students objected to the theme of the Gold
Medal Competition Award announced by the Academy
as "Odin in Valhalla" ("The Banquet of the Gods in
Valhalla"), "demanding instead a Slav theme" (41:
25). The protesting students were expelled from
the Academy, the official organization for Russian
artists, and in order to survive formed a Fellow-
ship of Wanderers (Predvizhniki), that circulated
travelling exhibits of their work in the Russian
provinces, with the subject matter of their paint-
ings "realistic, critical of social injustice" (545:17),
and "the realities of everyday peasant life" (368:74).

1863 (A) Gustave Courbet's painting of two drunken priests on
the way from from a feast ("Return from the Meet-
ing"; "Return from the Conference") was rejected by
the jury of the Paris Salon "as an assault on reli-
gion and morality" (300:416). Courbet participated
actively in the anticlerical movement of his day
(607:186), and this painting--with its "moral message"
showing parish priests who were "active supporters
of the Imperial regime" drunk--after being banned
from exhibit by the police (225:109) was "bought by
a Catholic who wished to destroy the painting be-
cause of its subject matter" (Art News 54:37 Ja 1956).

1863 (B) The sensation of the Salon des Refuses--an exhibit
of 4, 000 works refused admission to the official
Paris Salon by the jury of the Beaux Arts Academy
(608:191), and hung for public viewing in the Paris
Palais de l'Industrie through the intervention of
Napoleon III (275, III:367)--was Edouard Manet's
painting "Dejeuner sur l'herbe" ("Picnic, " or

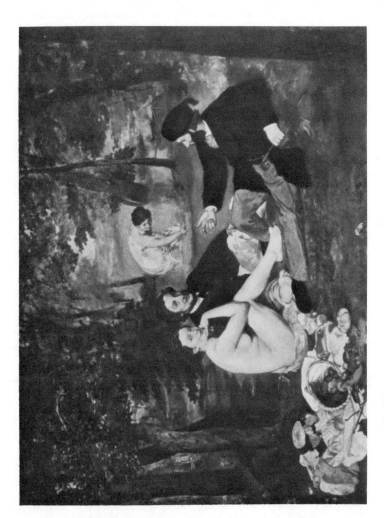

15. 1863 (B). Edouard Manet. Dejeuner sur l'herbe. Louvre, Paris

"Luncheon on the Grass, " as the public had desig-
nated the picture titled by the artist "Le Bain"
("The Bathing Party"). "Luncheon on the Grass"
seemed to be "a signal for the condemnation of the
whole group of impressionists in the name of mo-
rality" (31:241). Emperor Napoleon was shocked
by the picture, when he visited the gallery, and
the Empress pretended not to see it because of the
"vulgarity" of depicting fully dressed males and a
nude female (189). Viewers branded the work
"shameless" and "immoral" "since it showed a
nude woman not the least embarrassed in the pres-
ence of two clothed gentlemen"--furthermore, the
figures were obviously taken from real life, and
the woman is "undressed" as her clothing is spread
on the ground indicating that nudity is not her natural
state (she is not a wood nymph) and her male com-
panions are shown in modern dress. As one gallery
visitor commented:
> "How awkward to be caught in a situation like
> this !" (290:8-11).

The scandal seemed "not so much that the two young
ladies were nude... but that the two gentlemen were
fully clothed" (315, Ag 13 1969 IV:1).
Art critic Louis Etienne evaluated the painting:
> "A commonplace woman of the demi-monde, as
> naked as can be, shamelessly lolls between
> two dandies dressed to the teeth... This is a
> young man's practical joke, a shameful open
> sore not worth exhibiting" (342:13).

Among artists who commented adversely on the
nudes was Odilon Redon, who recorded in his
Journal on May 18, 1888, his favorable opinion
of "intellectual" painters who painted a nude woman
so that she looked as though she were not going to
get dressed again right away:
> "But there is one, in Manet's 'Picnic, ' who
> will hurry to dress herself, after her boring
> ordeal on the cold grass, among those gentle-
> men without ideals who surround her and talk
> to her. What are they saying? Nothing inno-
> cent, I suspect" (229:359-360). (ILLUSTRATION
> 15)

1863 (C) After Napoleon Joseph Charles Paul Bonaparte--
 called "Prince Napoleon"--purchased the Ingres
 picture "Le Bain Turc" ("The Turkish Bath"),
 painted in the decade of the nineteenth century
 which was "the high-water mark of... prudery"
 (114:220-221) in the artist's eighty-second year,
 and including two hundred nudes, his wife Clothilde
 insisted that the Prince exchange the scene for a

self-portrait, as she found the baths "scandalously
overful of nudity" (New Yorker Ja 13 1968, p. 96).

1865-1867 "A moralism of long standing, a distrust of the
merely physical...prudery of the middle class...a
furtive and self-contradicting modesty" influenced
the form and style of American art. Joel Tanner
Hart's nude female statue--his ideal work, never
finished: "Woman Triumphant"--was first called
"Venus," then "Purity," and finally "The Triumph
of Chastity." The Ladies' Academy of Art in Cin-
cinnati hired a Mr. Fazzi "to make fig-leaves for
the statues" which they had imported from Europe,
and Antonio Canova, sculptor of the day was quoted
regarding the propriety of depicting the nude:
> "always in purity and with that veil of modesty
> which indeed nature did not need in the inno-
> cence of first creation, but does so now in her
> perverted state" (326:178).

1865 The first postal obscenity law was passed in the
United States, barring obscene "books and pictures"
from the United States mails (72:79; 414:lii; 447:
17), and making such mailing a criminal offense--
a "misdemeanor punishable by a fine of not more
than $500 or imprisonment for not more than one
year or both (404:75). The law had been passed as
a result, at least in part, of "complaints about the
reading materials mailed to many soldiers who
served in the Civil War," including Cleland's no-
torious Memoirs of a Woman of Pleasure (415:327).

1865, May 1 Although Edouard Manet's painting of a reclining
nude, "Olympia," was accepted for hanging by the
Paris Salon, under a barage of public and critical
attacks on "Olympia" (275, III:367) as an offense to
both art and morals (229:311), gallery officials
found it necessary to have the picture guarded at
all times by two policemen to protect it from angry
assault with knives and canes of gallery visitors
(364:234; 603:11; 619). Midway during the exhibit,
the painting was rehung from its "place of honor"
on the stairs to a remote location "above a huge
door" "at a height where even the worst daubs had
never been hung" (249:7). Its "display of nakedness
was considered altogether scandalous"--critics and
public alike were insulted by the "flatness of...the
shapes" (189) as well as the nudity. Shocked re-
porters compared "Olympia" to "a stripped fowl"
(189), called her "a yellow-bellied odalisque," a
"parcel of filth," a "tinted tart," and--one of the
most vehement--Edmond About demanded that the
gallery be fumigated to free it from the painting's

1868 (A) corruption (619).

1868 (A) According to an English legal decision--Scott v
 Wolverhampton Justices (1868) 32 J. P. 533--in de-
 termining whether pictures are obscene, the court
 needs to hold in mind not only "the nature of the
 pictures complained of," but also "the type of prem-
 ises in which they were found, and the type of per-
 son for whom they were intended" (430).

1868 (B) The "Hicklin Rule"--so named although it was exactly
 opposite of what Benjamin Hicklin, the Recorder of
 London, ruled--became a test of "obscenity" in
 England and in the United States--this same year
 public hanging was abolished in England. The "Rule"
 --set forth in the decision of Sir Alexander Cock-
 burn, Lord Chief Justice of England, when the prose-
 cution appealed the case Regina v Hicklin from the
 Hicklin verdict--states:
 "...the test of obscenity is this, whether the
 tendency of the matter charged as obscenity
 is to deprave and corrupt those whose minds
 are open to such immoral influences and into
 whose hands a publication of this sort may
 fall" (181:34-35).
 Subsequent judgments found that according to the
 "Hicklin Rule" "ancient works of art...are in their
 proper place in a Museum, but their photographs
 may not be sold in the streets" (375:49).

1869 The vigor of movement and intense vitality of the
 dancing nude women in Jean Baptiste Carpeaux's
 sculpted facade for the Paris Opera House, "The
 Dance," was not appreciated by "conservative opin-
 ion of the period" (278:57), and the work was severe-
 ly criticized as immoral because the dancing figures
 were "perfectly transcribed naked women."

1870's-1880's "Only a daring person, even in New York high so-
 ciety, ventured to hang a nude in his drawing room,
 or in any room of his house where it might be seen
 by casual visitors" (379:560). This attitude toward
 nude art persisted in the United States. Early in
 the century, American painter John Vanderlyn,
 asked by a wealthy New Yorker to choose some
 famous old painting and copy it for him, reproduced
 Corregio's "Antiope" but the patron refused the
 finished work:
 "What can I do with it? It is altogether in-
 decent. I cannot hang it in my house, and my
 family reprobate it" (379:478).

1870's? Under the United States postal censorship law, an
 edition of Harvard's Lampoon--burlesquing in a
 picture on page 1 the painting "Washington Crossing
 the Delaware" and presenting "a nude young lady"
 on another page--was banned from the mails (447:
 48).

1870 (A) Winslow Homer's "work was at first considered
 quite radical by the critics" because of the Ameri-
 can painter's homely subjects, his color, and the
 unfinished state of his pictures (234:20), but the
 subject matter of his picture "High Tide" was ob-
 jected to on moral grounds. It was found "perhaps
 not quite refined" as it depicted women emerging
 from the ocean "in voluminous bathing suits" in
 days when bathing as subject matter "was still a
 little risque" (234:15).

1870 (B) When Harper's Weekly brought charges of corruption
 against William Marcy Tweed, head of New York
 City's notorious "Tweed Ring"--which after gaining
 control of the city's finances swindled the municipal
 treasury of "sums estimated variously from
 $30,000,000 to $200,000,000" (582:18)--it was the
 cartoons of Thomas Nast that of all public criticism
 most touched Boss Tweed:
 "I don't care what they print about me--most
 of my constituents can't read anyhow--but them
 damn pictures"! (266:23)
 Tweed offered Nast "a half million dollars to stop
 caricaturing him" (182:29), but the cartoons contin-
 ued and were influential in the collapse of the corrupt
 regime the following year.

1871, May 16 The Vendome Column, erected in Paris to commemo-
 rate Napoleonic victories, was torn down by a mob
 of Communards when, on order of the Commune,
 they toppled the "hated symbol of Bonapartism" onto
 a bed of straw with a block and tackle (Life 0 10
 1969, p. 109; 538:196). Gustave Courbet, as Presi-
 dent of the Commission of Fine Arts--he had "saved
 the Louvre and the Arc de Triomphe from a like
 destruction" (48:90)--was arrested several days
 later on May 21 when government troops entered
 Paris, and accused of the Column's destruction.
 Courbet spent three months in prison awaiting
 trial, and was sentenced to an additional six months
 in St. Pelagie prison (637:15) and a heavy fine, but
 illness shortened his term (538:196). Two years
 after the artist's release from prison in 1874--dur-
 ing which time he was refused the right to exhibit
 his paintings (637:15)--a court held Courbet per-
 sonally responsible for the demolition of the Column

and sentenced him to pay the cost of rebuilding it
(275, III:347; 538:198)--323, 091 francs 68 centimes
in annual installments of 10, 000 francs (637:15).
Courbet fled to Switzerland (311:22) because he had
been ordered to turn over everything he received
from the sale of his work to the State, as he had
no money to pay the fines. A "comparison of the
dates" of Courbet's "brief term at the Commune
and of the passage" of the decree ordering the Ven-
dome Column's destruction proves that Courbet could
not have voted for the monument's removal (637:15).

1872 James Abbott McNeill Whistler's picture "Arrange-
ment in Gray and Black" (more generally known as
"Whistler's Mother") was the last portrait "he ever
got past the outraged admissions committee of the
Royal Academy" in London, and this painting was
hung "only because Sir William Boxall, Whistler's
friend, argued himself hoarse on its behalf."
Shown in Philadelphia and New York in 1881-1882
the picture found no purchasers at the price of
$1, 000, but in the course of time "Whistler's
Mother" became one of the most famous paintings
by an American artist. Since 1926 it has hung in
the Louvre, where it was placed by the French
government after they bought the portrait for 2, 000
francs-- $400--in 1891 (80).

1872, March 3 In his first publicized act as guardian of the moral
purity of youth, Anthony Comstock, accompanied by
a police captain and a reporter for the New York
Tribune, bought from two New York City stationery
stores books and pictures which he declared were
obscene. He presented his purchases as evidence
to the policeman who arrested six employees of the
stores... Three were convicted and sentenced to jail
for terms ranging from three months to one year.
Comstock's forty-year campaign for decent literature
and art under the slogan, "Morals, Not Art Or
Literature" had begun (121:xi).

1873 (A) Charles Hazeltine reported the seizure of a nude
statuette by the City Marshal of New Bedford,
Massachusetts, the trial of the figure's owner,
and his suit against the Marshal (259).

1873 (B) Walter Pater, British essayist and critic, published
Studies in the History of the Renaissance, a book he
had suppressed for fifteen years because he feared
his conclusion--claiming autonomy for art and aesthe-
tic experience--"might possibly mislead some young
man into whose hands it might fall" (513:45, 74).

1873 (C) Edgar Degas' most famous scene of cafe life--
 "Absinthe, " "a disenchanted picture of Parisian
 existence"--created a scandal when it was shown
 in London. "Outraged Puritans of the day con-
 sidered the painting a study in alcoholism, " but
 in reality the man and woman seated at a cafe
 table "were not degenerates of the period, but
 were friends of Degas--the woman an actress,
 the man a distinguished etcher--posed by the
 artist" (494).

1873, March 3 "The Comstock Act"--Section 1461, Title 18, United
 States Code--lobbied through both houses of Congress
 by Anthony Comstock "with less than a total of one
 hour debate" (279:191) became the "Obscenity Law"
 of the United States, that Comstock, "as Special
 Agent of the United States Post Office Department,
 defended and enforced for four decades" (121:vii).
 President Grant signed the bill June 8, 1873 (404:
 9), strengthening the 1865 law by giving severer
 penalties and extending the list of materials pro-
 hibited from the mails to include contraceptives or
 information about where they could be obtained
 (121:xii).
 A "decisive role in the enactment of the law was
 played by pictures, not books" (180:134), and An-
 thony Comstock's activity in passing the statute--
 "obscene matter is non-mailable matter"--brought
 the term "comstockery" into use as "a convenient
 synonym for prudery, Puritanism, and officious
 meddling" (72:122).

1873, May The Society for the Suppression of Vice was for-
16 mally organized in New York City (72:125), sup-
 ported by such prominent and wealthy citizens as
 William E. Dodge, Jr., Morris K. Jessup, J.
 Pierpont Morgan, and Robert B. McBurney. A
 special act of the New York State Legislature gave
 the Society "a monopoly of vice, and its agents the
 rights of search, seizure, and arrest" which up to
 this time had belonged exclusively to publicly con-
 stituted police authorities (121:xiv; 182:10-11).

1873, July 8 By judgment of the Tribunal Correctionnel de la
 Seine, Antoine Charubino was condemned to a month
 in prison and 100 francs fine, and François Michel
 to six days in prison for offering for sale statuettes
 representing "La Republique" in a phrygian bonnet
 (166:xxxvi).

1874-1877 A writer, who called himself Touchatout, amused
 Paris by a series of satirical biographies, each

preceded by a burlesque portrait. When the son of
Louis Napoleon was the subject of such an article,
the Bureau of Censure "endeavored to protect" the
young man by forbidding the publication of the por-
trait. Touchatout printed the biographical sketch
headed--not with the portrait--but with the notice:

RÉPUBLIQUE FRANÇAISE.

LIBERTY, EQUALITY, FRATERNITY,
AND CENSURE.

THE PUBLICATION OF THE PORTRAIT OF

Vélocipéde IV.

HAS BEEN FORBIDDEN BY THE CENSURE.

IT CAN BE FOUND AT ALL THE PHOTOGRAPHERS'.

(444:237).

1874 (A) Among the artists with work in the first "Impres-
 sionist" exhibit, held on the vacated premises of
 the photographer Nadar in Paris, were Degas,
 Renoir, Monet, Pissarro, Cezanne, Sisley, and
 Berthe Morisot. The "Impressionist" label--from
 Monet's picture "Impression--Sunrise"--was a de-
 risive designation of the critics for this "revolt
 against the official art of the Salon, the neo-
 classicism of the Academy, the elaborate set of
 iron-clad rules which enslaved most of the artists
 of the day. " They said the work was "outlandish, "
 "insults to the painter's craft, " and--in the words
 of Louis Leroy in Charivari--"hostile to good artis-
 tic manners" (615).

1874 (B) Anthony Comstock reported in the Y. M. C. A. pam-
 phlet Private and Confidential that he had seized
 and destroyed 194, 000 obscene pictures and photo-
 graphs (72:153; 279:vii), from March 1872 to this
 date. He found that "in the guise of art the foe
 to moral purity comes in its most insidious, fas-
 cinating and seductive form" (72:224), and had two
 standards for "nude art": It could be displayed
 properly in a museum where the display could be
 appreciated by "cultured minds"; but such display
 "must be kept in its proper place out of the reach
 of the rabble" (72:224)--in a "saloon, a store win-
 dow, or where it reached the common mind. "

Such pictures were a different matter because of
their "appeal to passion" and serving as "a fan to
the flame of secret desires" (121:xxv). Reproduc-
tions of pictures, according to Comstock, were
more objectionable than the originals (72:240), pri-
marily because the photography of the day showed
them in black and white rather than in the colors
in which the artist had painted them. Comstock's
campaign against "immoral" art was vigorous and
unceasing, but among the half-million pictures he
eventually "pounced on" there were few reproduc-
tions of "well-known or worthy pictures" (72:17).
As vice crusader in New York City, he "forced a
Broadway garment maker to take from a display
an insufficiently clad wax figure (28:355-356), and
had people "arrested, tried, and imprisoned for
sending through the mails photographs and prints
of statuary like Powers' "Greek Slave" (39:1031).
One account of the triumph of "Morals, Not Art"
closes with enthusiasm and a sense of mission the
arrest of the guilty:
 "Then, Ho, for the Charles Street Jail" (28:362).

1875 (A) August Rodin's first exhibited work "L'Age d'Airain"
("Age of Bronze")--a male nude, modelled from the
figure of a young Belgian soldier--occasioned so
much adverse comment, especially from fellow
sculptors "who accused him of trying to palm off
a life cast as an independent work" (579:515-516),
that the figure was withdrawn from the show (299,
II:683-684).

1875 (B) Thomas Eakins in his painting "The Gross Clinic"
attempted to bring science and technology into the
world of art by representing "one of the outstanding
surgeons of the day... lecturing to a class during the
performance of an operation" at Jefferson Medical
College (495:318-319). This surgical demonstration
subject of his first major canvas was considered
"too bold"--not just the scene's "unpleasantness,"
but Eakins' "unblinking attention to facts--for in-
stance the blood on the surgeon's hands" (174:139).
The picture was refused admission to the American
section of the Centennial Exhibition, although the
jury had accepted five other works of the artist
and Eakins was "able only with difficulty to have
it hung in the medical section" (495:318-319).

1875 (C) Police were summoned to quell violent demonstra-
tions at the Impressionists group auction sale at
the Hotel Drouot in Paris (615).

1876 The New England Watch and Ward Society was
 formed as a guardian of public morals, with activi-
 ties including suppression of books and censorship
 of art (72:149; 634:78).

1877, October An English clergyman who visited the Bordeaux
 picture gallery reported that he came away:
 "'as I could hardly look in any direction without
 being distressed and disgusted by seeing on the
 walls paintings of females in a state of perfect
 nudity. More or less all men at such sights
 do "think evil"... Such exhibitions must tend to
 corrupt the sight-seers, and especially so the
 young of both sexes'" (207:114, 295).

1878, Novem- The trial of an action for libel which painter James
ber 25 Abbott McNeill Whistler sought to recover damages
 from critic John Ruskin in a London court was de-
 cided in the plaintiff's favor--Whistler was awarded
 one farthing in damages, but the libel suit "ruined
 him financially" (275, III:389). In 1887 Whistler had
 exhibited a group of nine pictures at the Grosvenor
 Gallery, including "Carlyle, " two other important
 portraits, and four of his most famous and success-
 ful "Nocturnes"--"pictures from memory in a chosen
 color harmony"--including "Nocturne in Black and
 Gold: The Falling Rocket, " "a night piece that
 represents the fireworks at Cremorne" (275, III:393).
 Ruskin, attacking the exhibit with "insane violence"
 (495:270-271), wrote of "Nocturne in Black and Gold
 ... " and of Lindsay, founder of the Gallery:
 "For Mr. Whistler's sake, no less than for the
 protection of the purchaser, Sir Coutts Lindsay
 ought not to have admitted works into the Gallery
 in which the ill-educated conceit of the artist so
 nearly approaches the aspect of wilful imposture.
 I have seen, and heard, much of Cockney impu-
 dence before now; but never expected to hear a
 coxcomb ask two hundred guineas for flinging a
 pot of paint in the public's face" (Fors Claviga,
 July 2, 1877, Letter 79).
 On the stand, Whistler testified that he had "knocked
 off possibly in a couple of days" the criticized
 "Nocturne, " but he was applauded when he said
 that the 200 guinea price for the painting was not
 for the two days labor, but "for the knowledge
 gained through a lifetime" (275, III:393). (ILLUSTRA-
 TION 16)

1880-1888 The French government cancelled the commission
 awarded Auguste Rodin for "a decorative door rep-
 resenting an ensemble of bas-reliefs drawn from

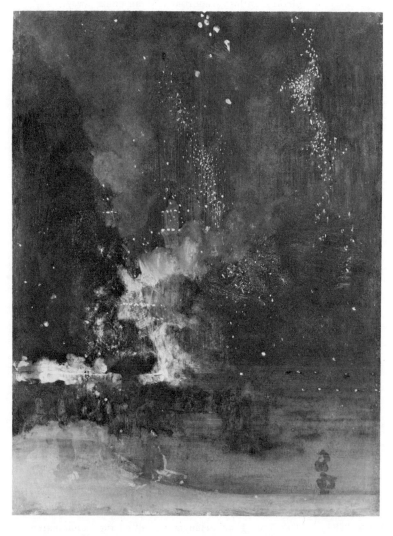

16. 1878, November 25. James Abbott McNeill Whistler.
Nocturne in Black and Gold: The Falling Rocket.
Detroit Institute of Arts. Gift of Dexter M. Ferry, Jr.

Dante's Divina Commedia" for the Museum of Decora-
tive Arts in Paris, when the sculptor's preliminary
"Gate of Hell"--limited to depicting the Inferno--
exceeded the theme, becoming "a manifestation of
all imaginable forms of human tragedy" (297:178).

1880's? At the trial of Silas Hicks in the General Sessions
 Court, New York City, upon an indictment for sell-
 ing an obscene picture, Judge Gildersleeve charged
 the jury:
 "Look at that picture and say if it should come
 into the hand of young children... if the impres-
 sions it would be likely to create would be pure
 and moral... or would they be likely to create
 lewd, lascivious, and immoral impressions"
 (120:21).

1880 The Prince of Wales "argued in vain that the British
 Museum and the National Gallery should be opened
 on Sundays. " The House of Lords voted in favor
 of such a proposal in 1886, but the House of Com-
 mons remained opposed to such Sunday activities
 "for a decade more" (379:347). The Lord's-Day
 Society--one of a group of "sabbatarians" objecting
 to opening these institutions because it would "in-
 volve the labour of a great many attendants and
 transport workers" on the Sabbath--was ultimately
 defeated on this issue, and "working people" were
 given "an opportunity to see the nation's historical
 and artistic treasures" (207:112).

1881 (A) The French law pertaining to "outrage aux bonnes
 moeurs" (equivalent of the English "Obscene Libel"
 law) made a distinction--in Loi du 29 Juillet, Art.
 28--between drawings, prints, engravings and paint-
 ings and other mediums of offensive publication. Of-
 fenders under pictorial representations "were triable
 at Police Correctionelle (paid magistrates sitting
 without jury) and were treated as common criminals"
 (137:138).

1881 (B) The Metropolitan Museum of Art's school, organized
 the previous year, added courses in "drawing and
 design, modeling and carving, carriage drafting,
 decorating in distemper, and... plumbing" (582:62).

1881, April A furious correspondent to the London World com-
 mented on a picture depicting the interior of Slade's
 School of Art in London because he found "the idea
 of chits of children studying from undraped statues...
 simply repellent. " He called on Parliament to enact
 a law "for the welfare and morality of the rising

generation" forbidding instruction of drawing in
art school "mixed classes," attended by men and
women (410, April 11, 1881 3:3).

1882-1884 Governor Benjamin Franklin Butler of Massachusetts
 "recommended that the Massachusetts State Legisla-
 ture abolish the Massachusetts State Normal Art
 School because, he claimed, it had demonstrated its
 'uselessness' by the fact that the students modeled
 'nude human figures in clay'" (360:150-151).

1882 After a five month's trial in the longest libel case
 in English legal history--Belt v Lawes--and the
 second longest English trial next to that in the Tich-
 borne case, the jury awarded the largest libel judg-
 ment (£5,000) in England against the sculptors, who
 were alleged to have hired a "ghost." The verdict
 was reinstated in appeal, when impropriety was
 argued of B. Huddleston's charge to the jury, quot-
 ing Aristotle:
 "...the public are better judges of art and
 literature than artists and men of letters them-
 selves. Artists and men of letters are some-
 times jealous, sometimes narrow-minded. The
 public are impartial and come to better conclu-
 sion" (613:173).

1882, Novem- Objection was made to the Rules and Regulations of
ber the Royal Academy in London because they gave
 "undue prominence to the works of members"--
 many of whom are "not very good artists":
 Members' works are exhibited without any jury
 selecting them for hanging;
 There is no limit on the number of works a
 member may exhibit in a show;
 Preference is given to the works of members
 when placing pictures for display (410, D 11
 1882 2:1).

1883 Anthony Comstock published his second book about
 his adventures in suppressing vice in New York City,
 Traps for the Young. In half-dime novel format
 and style, Comstock was the hero who single-handed
 watched the "sewer-mouth of society" to bring pur-
 veyors of obscenity to justice. He always won
 (121:xv).

1884 (A) "Too daringly décolleté" was the criticism of the
 shocked public, the press--and more important--
 of the Gautreau family when they viewed in the
 Paris Salon John Singer Sargent's full-length portrait
 of Virginie Gautreau, celebrated figure in French
 society.

Sargent had painted her in a black evening gown,
contrasting with what the artist called "lavender or
blotting-paper colour skin, " but because of the
"scandal" resulting from the revealing painting,
the Gautreaus requested removal of the portrait
from public exhibition. The artist left Paris soon
after the controversy over this portrait to work in
London, and the painting hung in his Paris studio
as "Madame X" until 1915 (142:421; 495:281).

1884 (B) The plate on p. 441 of Samuel L. Clemens Life on
the Mississippi, published in 1883, showing the
author in flames, "was omitted from later printings"
at the request of Mrs. Clemens (306:19).

1884, Octo- The case of People of the State of New York v
ber 7 August Muller was decided in the New York Supreme
Court by a unanimous affirmation of the judgment of
a lower court--made March 28, 1882--that defendant
August Muller was guilty of selling indecent and ob-
scene photographs "representing nude females in
lewd, obscene, indecent, scandalous, and lascivi-
ous attitudes and postures. " Muller--22-year old
clerk in the New York City book and picture
store owned by Edmund F. Bonaventure, was
convicted by the testimony of vice-crusader Anthony
Comstock, and the evidence of nine Comstock-
seized photographs of paintings from the art store.
 The original paintings, represented by the photo-
graphs judged "lewd and disgusting, and offensive
and destructive of good morals, " were by French
artists of the "modern school"--including "La
Asphyxie" by Cherubino Pata, "After the Bath" by
Joseph Wencker; "La Baigneuse" by Leon Jean
Basile Perrault; and "La Repose" by Chambord.
Eight of the nine pictures had been exhibited at
the Salon in Paris, and the remaining canvas at the
Centennial Art Exhibition in Philadelphia.
 The prosecution conceded the claim of the de-
fense that the pictures had been publicly exhibited
in Paris and in Philadelphia. Six expert witnesses--
artists, critics and art historians--ready to give
opinions that the photographs were "pure art" and
not "unmitigated obscenity, " as charged under Sec-
tion 317 of the Penal Code of the State of New York,
were not allowed to testify.
 The court held:
 "The object of the law was to protect public
 morals, especially as to that class of the com-
 munity whose character is not so completely
 formed as to be proof against the lewd effects
 of pictures, photographs, and publications

prohibited" (People v Muller 32 Nun 209-215;
People v Muller 96 N.Y. 408-414).
Comstock felt that his great victory in this case was
not in the fine imposed, or in the destruction of 768
pictures he had seized, but in the court's definition
of "obscenity"--Court of Appeals: "It would be a
proper test of obscenity in a painting or statue
whether it is naturally calculated to excite in a
spectator impure imaginations"--and the refusal of
expert opinion concerning the obscenity of the seized
photographs--expert testimony is not required to de-
termine obscenity and indecency in art, but falls
within the range of ordinary intelligence: "testimony
of experts is not admissable upon matters of judg-
ment within the knowledge and experience of ordinary
jurymen" (120:22-24; 121:xxvi; 151: 42-44; 408, D
18 1883)

1885 The "great frost of Victorian prudery" reached its
 height in England: Legs of human beings or furni-
 ture were called "limbs, " and were always expected
 to be covered; the favored term for the white meat
 of chicken was "bosom. " Prudery dogged the nude
 painter--when critic J. C. Horsley read an attack
 on nude painting at a church congress, he earned
 himself the nickname "Clothes Horsley, " and
 Whistler's comment: "Horsley soit qui mal y pense"
 (361:164).

1886 (A) Thomas Eakins, outstanding American painter of the
 nineteenth century, was forced to resign from his
 post as instructor of life and anatomy at the Penn-
 sylvania Academy of Art, which he had held for ten
 years, "because of a scandal resulting from posing
 a nude male model before a mixed class" (178:162;
 229:353; 495:319).

1886 (B) At the New York City "International Exhibition, "
 Georges Petit Gallery, over 300 impressionist pic-
 tures shown by Durand-Ruel, including 32 canvases
 by Renoir, was appraised by the New York Sun art
 critic, who specified that Renoir's paintings were
 "lumpy and obnoxious creations" (439:17).

1886, March The National Vigilance Association was founded in
 England, with purity of art and literature as one of
 its aims (576:258).

1886, April Artist William T. Trego sued the Philadelphia Acade-
19 my of Fine Arts to compel the Jury of Awards to
 give him the Temple Prize--$3,000 donated by art
 patron Joseph E. Temple for the best historical
 painting of the American Revolution. The Jury had

judged Trego's painting best of the four pictures
entered in the competition, but "held that his work
did not reach the standard of merit which called
for the first prize," and awarded him a silver
medal instead of the prize money. Trego, disagree-
ing with the prize jury on the merits of his paint-
ing, demanded the recognition and money of the
Temple Prize Award.

The Academy "obtained judgment on the demurrer"
when the case came to court, and the Supreme Court
in review dismissed Trego's appeal and approved the
judgment of the lower court, holding that the Acade-
my's Jury of Awards was to "constitute the tribunal
to pass on the merits of the paintings and to decide
which prizes should be awarded" (410, Ap 20 1886
5:2).

1886, May 1 In the case of Rice, Sharpley & Company, Montreal
jewelers, "charged with exposing in their windows two
statues of Michael Angelo's [sic] 'Night' and 'Morn-
ing'"--the original figures of which are in the Medici
Chapel, Florence--the Recorder "found the prisoners
guilty, but did not pass sentence as they may have
acted in good faith, and in the position of those of
whom it was said by a very high authority, 'For-
give them, for they know not what they do'".

The judge in reaching his decision, pointed out
that the statues were proved nude as "the drapery
did not half cover the figures," and that, although
art experts testify such figures are common in
European museums, viewing such figures would
"familiarize the people with sensuality." Even if
nude figures are seen in church decorations in
Rome, the judge said, these are "remnants of the
pagan elements in Christianity," and "the Pope
caused draperies to be placed on the more revolt-
ing nudities of Michael Angelo's [sic] 'Last Judgment'"
(410, My 2 1886 1:6).

1887-1893? Anthony Comstock ordered a candy-dealer in New
York City to remove a reproduction of "The Triumph
of Charles the Fifth" (521:49) from his shop window
on Fulton Street. The painting by the well-known
Austrian historical and figure artist Hans Makart
(425:459)--showing Charles riding into Antwerp, his
horses led by nude boys--was taken from the con-
fectionery window, but the picture was then repro-
duced in Life, a magazine of the time, "as Com-
stock would like to have it": All the horses wear-
ing pantaloons (72:225).

1887, Novem- Anthony Comstock, acting for the New York Society
ber 12 for the Suppression of Vice, raided the forty-year

old art gallery of Herman Knoedler (M. Knoedler &
Co. , 170 Fifth Avenue, New York City--"the oldest
and most distinguished firm of dealers in paintings
and pictures in America") (274:52), and seized 117
photographs and engravings of "masterworks of
French art" of the "modern French school" as "ob-
jectionable, lewd, and obscene, " and charged the
firm with endangering the youth of the United States
(363:134) and being "a bad influence on public morals"
(120:31).

Many of the original paintings by foremost living
French artists, in the seized reproductions, had
been exhibited or now hung in galleries open to the
public, as the Salon in Paris. The raid roused
much public protest, and artists rallied to the de-
fense of the nude in art. The Society of American
Artists at their regular semi-annual meeting passed
a resolution protesting the action of the Society for
the Suppression of Vice, and condemning Comstock's
censorship. It was signed by such leading American
artists as William Merritt Chase, president; Augus-
tus, Saint-Gaudens; Kenyon Cox; J. Alden Weir;
E. H. Blashfield; Eastman Johnson. Comstock
brushed aside all criticism: "Fifth Avenue has no
more rights in this respect than Centre Street or
the Bowery. "

The final decision as to how far the case for the
human figure depicted nude in art--"the most pro-
foundly classical of pictorial and sculptural sub-
jects"--had advanced from the "medieval aspect of
nudity in art as a badge of shame" with its repre-
sentation restricted to such scenes as the Expulsion,
the Crucifixion, and the Damned (311:7) was not
given until some months later--on March 23, 1888
(120:31; 274:52; 311:7; 363:134).

1888 (A) The Crispus Attucks Memorial on Boston Commons,
erected to commemorate the American leader of
the mob in the Boston Massacre and one of three
men killed by the fire of British troops, was sub-
ject to "official censorship and modification made
upon" it as "a public statue (The Attucks Shaft)"--
recounted in Angela F. T. Heywood's Sex-symbolism
--The Attucks Shaft (267).

1888 (B) Anthony Comstock's defense and explanation of
"ridicule, sneers and misrepresentations" in the
daily press concerning his censorship activities for
the New York Society for the Suppression of Vice
was published in his booklet Morals vs. Art. The
crusader wrote expressly that "pure morals are of
the first importance... protected by Law" and singled
out "lewd French art--a foreign foe" as "sugar-

coated strychnine. " He based his activities on the
premise that nude art is not in its "proper place"
if it is exhibited "before the eyes of the uncultivated
and unexperienced" in the "cheap and indiscriminate
sale" of photographs of pictures, shown in the "cold
reality of black and white, " lacking the "sweet
harmony of blended colors and tints" of the original
paintings (120).

1888, January 24

On a flying visit to Philadelphia--November 29, 1886
--Anthony Comstock accompanied by an assistant
had visited a number of stores dealing in artists'
materials, and, after purchasing pictures from
them, indicted the employees and the owners of
the stores on charges "of exhibiting and selling
obscene, lewd, and indecent pictures to the mani-
fest corruption of the good citizens of the Common-
wealth. "

After a jury trial, in which evidence showed that
the seized pictures were imported and had passed
Customs and were not displayed in the stores, but
"kept in a box at the rear" for sale "only to per-
sons seriously interested in art, " Judge Biddle
promptly acquitted all defendants, and critized Com-
stock's censorial visit to Philadelphia. When Com-
stock attempted a word of explanation, the judge
said, "You do not require a justification, " and when
the vice-crusader persisted that he had visited Phila-
delphia to "discharge a sacred duty, " Judge Biddle
commented that, "Perhaps there is a higher standard
of virtue in New York than we have here in Philadel-
phia" (410, Ja 25 1888 5:3).

1888, March 23

Justice Kilbreth, in a New York City court, decided
that two out of the thirty-seven pictures authorities
seized--November, 1887--from M. Knoedler & Co. ,
New York City art gallery which had "furnished
respectable citizens with good pictures for more
than a generation, " "are objectionable" and fined
the defendants--Edward L. Knoedler and George E.
Pfeiffer, clerk in the gallery--$300 each for "Traf-
ficking in Improper Pictures, " Anthony Comstock's
charge (520).

The pictures in question--photographs and engrav-
ings of original paintings by well-known artists of
the "modern French school" such as Alexandre
Cabanel, William Adolphe Bouguereau, Jean Leon
Gerome, Jules Joseph Lefebvre, Jean Jacques
Henner--had been removed from the Knoedler gal-
lery by the police on November 12, 1887, after
complaint by Comstock, representing the Society
for the Prevention of Vice. Artists, museum di-
rectors, art critics, and the press spoke out

against Comstock's censorship before and after the
decision. The New York Telegram on November
16, 1887 had covered its front page with reproduc-
tions of the seized paintings of "nude women," ask-
ing Comstock what he was going to do about it (410,
N 13 1887 3:3; N 17 1887 9:1, 9:3; N 24 1887 3:2;
Mr 24 1888 4:3, 8:5).

Judge Kilbreth--commenting, "I should have liked
to let them go altogether, but couldn't quite see my
way clear"--returned thirty-five of the thirty-seven
seized pictures to the gallery, but gave Anthony
Comstock a victory in his famous "Knoedler Art
Case" by finding that the two remaining pictures
("Rolla," and "Entre Five et Six Heures en Breda
Street") "clearly seem to come within the description
of lewd and immoral pictures" (408 Mr 24 1888).

c 1889 (A) Paul Gauguin painted his "Vision After the Sermon"
on the theme of the wrestling Jacob, but when he
offered it to the little church in Brittany, where he
painted the picture, the priest refused to accept it
(315 N 18 1962).

c 1889 (B) Alfred Choubrac, poster artist of the 1890's, added
a French touch to the fig leaves, conventional cor-
rector of immodest art, when in protest to censor-
ship he produced a poster showing vine leaves to be
added to offending illustrations: Grand Choix de
Feuille de Vigne pour affiches Illustrées (499:37).

The term "figleaves"--with Biblical backing
(Genesis III:7): "then the eyes of both [Adam and
Eve] were opened and they knew that they were
naked; and they sewed fig leaves together and made
themselves aprons"--was recorded in use in England
in the sixteenth century (439), citing Coverdale, in
1535: "sowed fygge leaues together," and Latimer,
in 1553: "all but figge-leaues."

1889, June A deputation of artists in Australia asked the Vic-
torian Ministry for Customs to impose a protective
duty on imported paintings of £10 per painting (118:
145).

1890-1893 The "prize medal" for the Columbian Exposition de-
signed by Augustus Saint-Gaudens on commission
from the United States Government showed Columbus
landing in America on one side, with "the figure of
a nude boy holding a shield on which the prize-
winner's name would be engraved" on the other
side. Saint-Gaudens' son reports why the medal
was never used:
 "Previous to the striking of the medal, the Page
Belting Company of Concord, New Hampshire

improperly obtained a copy and printed a carica-
ture of it so villainous that the boy, who on the
original stood as a bit of artistic idealism, ap-
peared in all the vulgar indecency that can be
conveyed by the worst connotation of the word
nakedness. At once the morality for which the
nation is notorious took fire. The Government,
sensitive to the 'hue and cry,' took the path of
caution and had a decorous substitute for the of-
fending boy run up by one of the medalists at
the mint" (366:150).

1890's? William Hogarth, English painter and engraver, took
 a 'moral' view of the vices he depicted in his fam-
 ous series of prints--"The Harlot's Progress, " "The
 Rake's Progress, " "Marriage-à-la Mode"--and the
 "new species of painting... the moral comic" he
 created is "like the conscience of his time" (605:
 28, 31), yet Victorian England made alterations in
 some of his prints "in the interest of prudery":
 "Industry and Idleness" series, print No. IX--
 "in which a soldier has drawn a male genital
 organ on the wall";
 "Marriage-à-la Mode" series, print No. V--"in
 which the wife's lover is shown escaping half
 naked through the window after they have been
 surprised by her husband" (279:110).

1890 The United States Attorney General declared the
 power of the United States Post Office to use the
 Comstock Act of 1873 as a censorship statute.

1890, May 9 Mixed classes for drawing from the nude were dis-
 continued in mid-term at the Art Students' League,
 New York City, by a 6 to 6 vote of the Board of
 Control--the League's rules required a majority
 vote to resume the classes regularly scheduled.
 The action--prompted by "objection" made to holding
 the class of three men and nine young women draw-
 ing together from the nude figure, and one girl
 leaving the school on account of the class--followed
 an immediate stopping of the class. Augustus
 Saint-Gaudens who, as Instructor in Sculpture at
 the League, taught the life drawing course, denied
 rumors that he would resign from the teaching staff
 of the school over the incident, but he did not con-
 tinue his teaching at the League the following term
 (410, My 10 1850 5:1; My 15 1890 8:1).

1890, Novem- Art censorship became an "international question"
ber 8-14 when an English court decided that twenty-one of
 Jules Garnier's paintings, illustrating the work of

Rabelais in a London exhibition at the Art Gallery
in Pall Mall, were "immoral"--as charged by the
National Vigilance Association--and ordered that
they be destroyed. French citizens in Paris "with
an interest in the paintings, " which had been seized
by London police, urged the French government to
take action through diplomatic channels to prevent
the ordered destruction of the censored French
paintings in London (410, N 9 1890 1:2, N 15 1890
2:6; 576:x, 258).

1891, March A group of ladies in Philadelphia petitioned the Penn-
15 sylvania Academy of Design not to hang nude pictures
 "like those of Alexander Harrison, Kenyon Cox, and
 Will H. Low" as such paintings were "flagrantly in-
 delicate, " "ruthlessly assailing" the modesty of view-
 ers, and a direct attack upon the delicacy of their
 daughters and the morality of their sons. The Hang-
 ing Committee of the Academy, after considering
 the complaint, replied that there would be no change
 in the Academy policy of presenting the "serious
 works of eminent professional artists, " and that
 the "exhibited paintings did not injure the morals
 of the community" (410, Mr 15 1891 12:5).

1891, May 16 A curious historical blunder caused "a great row to
 spring up" over the painting "St. Elizabeth of Hun-
 gary" by English artist Philip Calderon, "one of
 the best-known and most capable Royal Academi-
 cians, " given the place of honor in the current Lon-
 don display of the Academy. Calderon based his
 picture--depicting a beautiful young woman kneeling
 in profile "absolutely naked" before a stone altar--
 on the legend of St. Elizabeth chronicled by German
 historian Dietrich von Niem. Niem reported that
 St. Elizabeth "stripped herself bare of all her pos-
 sessions" to take the vow of poverty, and follow in
 the footsteps of the Saviour, but a translation error
 described the saint as "taking off her clothes. "
 "St. Elizabeth, " bought by the English Government
 under the Chantrey Bequest, was criticized by church
 writers, including Jesuit Father Clarke who labelled
 the picture "grossly insulting" by showing the Saint
 in "an act of indecency" (410, My 17 1891 1:3).

1891, July 28 In a revival of "a rigid construction" of the Act of
 Congress on March 3, 1879, the United States
 Treasury Department issued a ruling instructing
 Customs officers to seize prints, photographs, and
 other reproductions of artistic or natural objects
 when sent through the mail from abroad as "not
 mailable. " Artists, industrial designers, architects,
 and art dealers petitioned--on October 28, 1891--

for a change in this procedure that made foreign art
reproductions dutiable and admissable by the Customs
only when sent by express. Secretary of Treasury
Charles Foster took no immediate action on the pro-
tests to this embargo on mailed art from abroad,
although many teachers and artists condemned the
ruling as bringing undue hardship on art and art
schools (410, Ag 16 1891 20:3; Ag 20 1891 8:6; O
29 1891 1:6).

1892

A United States court held--United States v Perry
146 U.S. 71 (1892)--that not all art was entitled to
free entry into the United States, but only fine arts
defined as "intended solely for ornamental purposes,
and including paintings in oil and water, upon can-
vas, plaster, or other material, and original statu-
ary of marble, stone, or bronze." The decision
set forth a four-fold division of art: "fine arts,
minor objects of art, objects of art, and objects
designed primarily for useful purposes" (154:1236,
1241).

1892, April 27

Some of the artists and art critics who crowded the Bow
Street Police Court in London to hear the proceeding
against painter Rudolf Blind, summoned for exhibit-
ing "an obscene painting of a female," testified as
expert witnesses for the defense. Frederick Good-
all, John MacWhirter, Sir Lawrence Alma-Tadema,
David Christie Murray, Ford Madox Brown, all de-
fended Blind's picture because they regarded this
court action as an attack on the nude in art, declar-
ing that if the nude painting in question were in-
decent, "then three-quarters of the pictorial treas-
ures of the world ought to be destroyed." The de-
cision--greeted with loud applause: "Summons dis-
missed" (410, Ap 28 1892 2:1).

1893 (A)

Lady art students were admitted to life drawing
classes at the Royal College of Art in London, pro-
vided the model was "partially draped" (454:231).
Female models in life-classes had already been in-
troduced in nineteenth-century Art Academies: Ber-
lin in 1875, Stockholm in 1839; Naples in 1870. At
the Royal College of Art in London, they were not
yet allowed in 1873-1875.

1893 (B)

When Chicago staged its first World's Fair, the nude
figures of men and women adorning the buildings
were criticized as the very "apotheosis of brutality"
because they were placed indiscriminately about the
Fair buildings "where they must be seen by modest
maidens, whether they will or no." According to
one press account, the viewing of female nudes by

women in "mixed multitudes" and of male nudes--
"few western or southern men would countenance
this"--is "an outrage upon divine modesty" (345:13).

1894 | Several of Aubrey Beardsley's drawings in the set
he made for the illustrated edition of Oscar Wilde's
Salome were "suppressed" by the publisher as too
risqué. Beardsley--not unfamiliar with such censor-
ship--revised his drawings to make them acceptable
to the publishers, commenting in verse on the mar-
gin of one drawing:
"Because the figure was undressed,
This little drawing was suppressed.
 It was unkind,
 But never mind--
Perhaps it all was for the best" (279:112).

1894, January | The case of defamation through a wax model dis-
played in an ante-room to Mme. Tussaud's "Chamber
of Horrors" in London was heard in a trial for libel
before Lord Coleridge, the Lord Chief Justice, and
a special jury--Monson v Tussaud 1894 1 QB 671.
The plaintiff, Alfred John Monson, had been tried
the previous year for murder and attempted murder
in the sensational "Ardlamont Mystery," but released
on both counts with a verdict of "Not Proven."
When Madame Tussaud's Wax Works exhibited his
likeness in "Scene of the Tragedy," representing the
"Ardlamont Mystery," Monson sued claiming the
representation was libel. Although the original hear-
ing and appeal courts "were of the opinion that the
exhibition was prima facie libellous" (344)--as Mon-
son was a private citizen rather than a public man--
on evidence "that Monson had... consented to the ex-
hibition," the court dissolved the interlocutory in-
junction that had been issued (88:12; 344) when Tus-
saud's testified that they had paid Monson for the
privilege of exhibiting his effigy. The jury awarded
Monson damages of one farthing and required Tus-
saud's to remove his figure from their exhibition
(149:149-153).

1894, October 22 | Colonel John M. Wilson, Superintendent of Public
Building in Washington, D. C., denied that he had
decided that "Love and Life," painting by English
artist George Frederick Watts, was "too immoral
to be hung in the White House." The picture after
being exhibited at the World's Fair had been presen-
ted to the American nation, and accepted by Congress.
Colonel Wilson explained that the painting which was
stored in the basement of the Executive Mansion,
had never been uncrated since he agreed to the
State Department's request to house the gift picture.

"Love and Life" was later sent to the Corcoran
Gallery (410, 0 23 1894 9:4).

1894, Decem- Councillor Barry requested that the Cork Corporation
ber 1 Council in Ireland remove the posters in Western
 Road showing the Bovril bull because their number,
 their character, and their disfigurements were "not
 at all suitable to the eye. " When "asked to de-
 scribe the placards, and their offending appearance,
 Mr. Barry replied: 'I should be ashamed to tell
 you'" (499:40-41).

c 1895 (A) Theophile Steinlein was required by the Paris cen-
 sor to revise his cover for the paper Le Journal--
 an illustration for the serial The White Slave Traf-
 fic (La Traite des Blanches)--by drawing a covering
 on the bare bosom of one of the women depicted
 (499:42-44).

c 1895 (B) Alfred Choubrac's poster for the Folies-Bergère
 showing Ilka de Mynn in a costume consisting of a
 star pendant and a decorative transparent gauze was
 removed from Paris billboards after it attracted
 "official disapproval" (499:9).

1895 Auguste Rodin won a sculpture competition for a
 statue commemorating the heroism of a 14th-cen-
 tury Calais citizen, Eustache de St. Pierre, and
 his companions, who offered their lives during the
 Hundred Years War to redeem the city. Nine years
 passed between the completion of the memorial,
 "The Burghers of Calais, " and its unveiling in
 front of the Calais Town Hall because the Munici-
 pality opposed acceptance of the work on the grounds
 that the figures were "not sufficiently heroic" (410,
 Mr 20 1955 VI, 28:3; 512:226). Rodin's plan for
 installation--"on a low plinth advancing in space in
 the anonymity of sacrifice"--was rejected as too
 unconventional, and the figures were installed
 "grouped together elevated above the ground" (275,
 III:405). The sculptor's later work, too, was re-
 jected by critics and the public: "The Kiss" (1886/
 98) criticized as "obscene, " and his figure of "Bal-
 zac" (1898) called "formless lava" and "a cow"
 (410, Mr 20 1955 VI, 28:3).

1896 (A) In Germany, where censorship was relatively rigid,
 the entire first run of the Bavarian National Exhi-
 bition poster was scrapped because the publicity
 committee "thrown into consternation at the naked-
 ness of the artisan-children" required Riemerschmid,
 the artist, to "amend the original drawing to provide
 discreet concealment" (499:19, 23).

1896 (B) Of 208 towns in England possessing museums, art
 galleries, and libraries, only 46 had opened them
 on Sundays--and 15 of these closed them again. It
 was generally felt "that the contemplation of paint-
 ings led to immorality," as one writer observed:
 "That modern city which has been distinguished
 above all others for the studious cultivation of the
 arts--Munich--is also distinguished by this ter-
 rible fact--that one out of every two births is
 illegitimate."
 Reverend John Gritton, secretary of the Lord's-Day
 Society--dedicated to keeping the Sabbath as a day
 of rest--expressed the views of the Society, that
 collections of statuary and paintings were "quite as
 likely to inflame the passions as to purge the life"
 (207:113).
 In the United States, the Boston Art Museum had
 begun Sunday opening hours for the public in 1877,
 and the Metropolitan Museum of Art in New York,
 in 1891.

1896 (C) A poster showing Zaeo, "star of an acrobatic troupe"
 appearing in London at the Royal Aquarium--an en-
 tertainment centre from which "the fish had disap-
 peared shortly after it opened"--was castigated by
 Mr. Coote of the National Vigilance Society, in a
 hearing of the Theatre and Music Hall Committee
 of the London County Council concerned with the
 renewal of the license of the Royal Aquarium, "as
 an affront to all right-thinking people" because of
 Zaeo's form-revealing flesh pink tights and "her al-
 legedly acrobatic posture."
 In a "spectacular victory" for the Society, the
 London County Council made the license renewal
 conditional upon removal of the offensive posters
 (499:25, 27).

1896 (D) The United States Supreme Court applied the "Hicklin
 Rule" in the Rosen Case and found New Yorker Lew
 Rosen guilty of obscenity because he had issued a
 twelve-page paper, Broadway, in which a page of
 the gazette contained pictures which the Court called
 "females in different attitudes of indecency." As
 printed, these figures received considerable publicity
 because the lampblack obscuring them could be
 erased with a piece of bread (181:45-46). The sen-
 tence for this publishing of "photographs of people
 almost nude": 13 months in prison (501:21).

1896 (E) French artist Felicien Rops' self-advertising poster
 for his one-man show of paintings, drawings, water-
 colors, pastels, and a variety of graphic arts--with
 attention-drawing elements of a reclining undraped

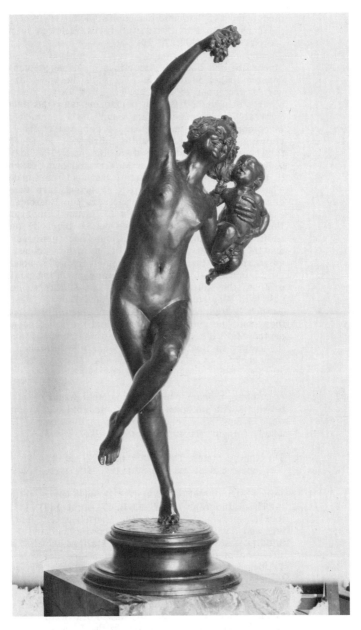

17. 1896 (F). Frederick MacMonnies. Baccante and Infant Faun.
Metropolitan Museum of Art. Gift of C. F. McKim, 1897

model and two "uninhibited cupids"--"fell foul of
the censor" in Paris, but was finally allowed to be
posted "as is" (499:27, 29).

1896 (F) "Inebriate and blatantly licentious," "a naked woman
dancing in her shame" (302:17), was the way Har-
vard's professor of art Charles Eliot Norton and
other distinguished Boston petitioners saw the bronze
figures "Baccante and Infant Faun" by Frederick
MacMonnies when they demanded removal of the
statue from the Boston Public Library.
 The sculptor had offered the original "Baccante"
to architect Charles Follen McKim and had consented
to its placement in the fountain basin of the Garden
Court of the Library, a neo-Renaissance structure
designed by McKim and his partners for Boston's
Copley Square. The Women's Christian Temperance
Union joined the fight, shocked not so much by the
nudity of the dancing Baccante, as "her tipsiness
and the fact that she held an infant in her arms...
an outrageous insult to pure American motherhood."
 Responding to the continued, and mounting public
protest, the Library trustees "asked McKim to con-
sult with Augustus Saint-Gaudens and Daniel Chester
French," highly respected American sculptors, but
they made no public statement, and the trustees ac-
cepted McKim's offer to remove the Baccante, and
the outcry of Boston residents over her "drunken
indecency" was stilled (142:423-424; 157:108; 182:
20; 387:82-84). (ILLUSTRATION 17)

c 1897 A number of Manichaean manuscripts found by a
peasant, with pictures decorated in gold and colors,
were dumped in five cart-loads into the river, "as
unholy things" (15:40).

1897 The United States Tariff Act of 1897 levied a 20%
duty on works of art (30 Stat 194, 1897) (154:1229).

1897, April James Abbott McNeill Whistler through court action
--"The Lithograph Case" (Q. B. C. April 1897)--
forced George du Maurier (the British artist, novel-
ist, and satirist of fashionable upper-class and
middle-class English life on the staff of Punch) "to
alter the pictures and description of Joe Selby in
Trilby, famous novel written and illustrated by du
Maurier, "as insulting to Whistler" (369:270).

1897, April When Thomas Platt, influential politician in the
22 Republican party machine in New York state, had
an anti-cartoon bill presented in the New York
legislature, cartoonist Homer Davenport compared
him to "Boss" Tweed--drawn in the Nast manner--

	in the New York Journal and Advertiser (266:47-48, 181). This bill was killed.
1897, June 8	"American aversion to the exposure of flesh in public places" caused New York City Superintendent of Parks Samuel Parson to reject George Grey Barnard's figure of "Pan," and a newspaper to record the incident:

"So who wants these statues?
Wont anyone remark?
There ought to be a place for them
Somewhere in Central Park"

Some years later--in 1908--"Pan" was given to Columbia University, where it was placed on the northeastern corner of the campus (157:108, 113).

1897, October	"She is here to stay," announced Metropolitan Museum Director General Louis P. di Cesnola, after Frederick MacMonnies bronze statue, "Baccante and Infant Faun" was formally accepted by the trustees of the Museum and placed on display in a place of honor in the entrance hall.

Architect Charles McKim, the donor, had been forced by adverse public comment to remove the statue the previous year from Boston Public Library, and the Metropolitan's adoption of "The Two Orphans" did not go unmarked in the press or by civic groups interested in guarding the public morals. Both the American Purity League and the Social Reform League circulated petitions against the Museum's acceptance of the controversial figure, and even after the sculpture was installed di Cesnola's correspondence contained protests against the gift and its public display from Reverend W. F. Crafts, Superintendent of the Reform Bureau, Washington, D. C.; Aaron M. Powell, President of the American Purity Alliance; and Mrs. Harriet S. Pritchard, State Superintendent of Women's Christian Temperance Union in New York (142:423-424; 157:108; 410, 0 29 1897 6:5, 12:2). (ILLUSTRATION 17. 1896 (F))

1897, December	James Abbott McNeill Whistler, famous American artist living in London, considered the judgment of the First Chamber of the Court of Appeal in Paris an important victory in the fight for freedom of artists (Whistler c Eden, Dalloz, Jurisprudence Generale (1898) 2nd part, p. 465), when the Avocat-General de la Republique--highest law officer in France--ruled that Whistler did not need to deliver a picture--portrait of the wife of Sir William Eden, "wealthy English gentleman." The painter, in the judgment affirming that of a lower court, must

"return the purchase price of the picture with interest plus 100 francs," but--contrary to the lower court's ruling--did not need to hand over the portrait to Eden. The contract between painter and patron was "an obligation to execute," so that the portrait had never ceased to be the artist's property, and could not be taken from him without his consent. This case became the subject of a book, The Baronet and the Butterfly, and Whistler noted in his Resumé that this judgment: "Established the ABSOLUTE RIGHT of the Artist to control the destiny of his handwork" (369:256-260).

c 1898 (A) Adolphe Willette's poster advertising La Revue Déshabillée ran into censorship trouble in Paris--where censorship as compared with British standards was "easy-going"--"not so much because of the nudity of the girl on the poster, but the presence of the male silhouette" looming in the background (499:19, 21).

c 1898 (B) Alfred Choubrac satirically corrected his cover for the Parisian illustrated literary journal Fin de Siècle, after the censor objected to the unclothed state of a girl sitting on a new moon, by the addition of a "strategically placed dominating legend" in red:
 "Cette Partie du Dessin a été Interdite."
As a further barb to the censors, Choubrac "designed, printed, and posted all over Paris" a small poster advertising the devices of the censor: Scissors and Vine Leaves ("Feuilles de Vigne"--French variant of fig leaves) "offered in a wide range of sizes, specifically for use on posters" (499:34-35, 37).

1898 (A) Among the obscene articles the Post Office Act of India, just enacted, prohibited transmitting were any "indecent or obscene painting... lithograph, engraving" (375:3).

1898 (B) Aubrey Beardsley, on his death bed in the South of France, wrote to Leonard Charles Smithers, who had published Beardsley's erotic drawings for an edition of Lysistrata of Aristophanes in 1896, imploring him to "destroy all copies of Lysistrata and all bad drawings... By all that is holy, all obscene drawings" (279:112; 379:321).
 After Beardsley's death, the "jackals" who had "egged him on to base ends" "published works he had been trying to keep from publication in his lifetime." In 1956 the United States Government in its cross examination of Samuel Roth and in its

1898 (C) summation to the jury in the Roth Case (United
States v Roth, 237 F. 2d 796 (2d circ. 1956)), used
Haldane McFall's biography of Beardsley in an ef-
fort to establish that the artist's "Venus and Tann-
hauser," included in Roth's periodical American
Aphrodite, was "shamefully obscene" (349:20).

1898 (C) Book illustrations were brought within the scope of
the French law relating to l'outrage aux bonnes
moeurs, in Loi du Mars 1898 (137:138).

1898 (D) "Architecture--not a work of art";
"Cannot be a work of art if adapted to a useful
purpose"--
these were the contentions of the United States
Government in a case--Morris European and Ameri-
can Express Company v United States, (1898) 85 Fed
Rep 964--Cir. Ct. So. Dist. N.Y.--considering the
customs classification of an importation under the
United States Tariff Act--a church altar and reredos
designed by "a leading American artist" imported in
1896 into the port of New York, for presentation to
the Trinity Episcopal Church in Binghampton, New
York.

The Customs collector had classified the work as
"dressed stone, not specifically provided for"--para-
graph 106, Act of August 27, 1894--and therefore
dutiable at 30%. The Board of General Appraisers
sustained the collector's classification, and refused
the altar and reredos free entry as a work of art,
or as statuary--dutiable at 20% of value--although
expert testimony that the work was "Art" had been
given by leading artists (J.Q.A. Ward, Augustus
Saint-Gaudens, Jonathan Scott Hartley, Frederic
Wellington Ruckstahl) (399).

Appeal Judge D. J. Townsend in considering the
problem, found that:
"The work as an entirety falls within the accepted
definition of a 'work of Art.' It represents the
work of an artist; it embodies something more
than the mere labor of an artisan; it is 'a skil-
ful production of the beautiful in visible form'...
The further contention that it cannot be a work
of art if adapted to a useful purpose would ex-
clude the Ghiberti doors of Florence, or the
fountains of Paris or Versailles" (274:9).
He held that the altar and reredos are: "'a work
of Art' within meaning of Act August 27, 1894,
paragraph 686, and entitled to admission free of
duty" (399).

1898 (E) The editor of the German satirical periodical

Kladderadatsch was imprisoned for three months and
the issue of the Berlin paper containing Brandt's
cartoon lampooning Kaiser Wilhelm II was confis-
cated. The drawing--"News From the Camp of the
Heavenly Hosts" ("Aus dem Lager der himmlischen
Heerscharen")--found insulting to majesty (Majestats
beleidigung) ridiculed the Kaiser's publicized state-
ment that no one could be a good soldier who was
not a good Christian.
 Section 95 of the German Imperial Criminal Code
governed such offenses--including caricature and
political satire--and defined "insult to the Emperor"
as: "to say or do, either in public or in private,
with or without intention to offend, anything deemed
irreverent..." (71:71). In the first ten years of
Kaiser Wilhelm's reign--1888-1898--offenders "on
charges of adverse criticism of the royal person
or of the affairs of government," under Section 95,
received sentences totalling more than 1000 years
(71:71).
 State trials on such charges were frequent during
this period, with the dicta--"The greater the truth,
the greater the libel" (255:30).

1898 (F) Kaiser Wilhelm II of Germany vetoed the Gold Medal
 art judges voted to a set of six prints, "The Weav-
 ers" by Kathe Kollwitz, when the series--a land-
 mark of socially conscious art--was shown at the
 Great Exhibition at the Lehrter Bahnhof in Berlin
 (219:234; 538:255). The artist, inspired by the
 Gerhart Hauptmann drama The Weavers about an
 abortive strike of textile workers in 1840, spent
 four years preparing the etchings to show the plight
 of the worker and his struggle to better his position.
 The six prints in spite of their verboten social con-
 tent--termed by the Emperor "gutter art" ("Rinn-
 steinkunst")--won foreign honors for Kollwitz at
 later exhibits--a gold medal in Dresden (1899), and
 a prize in London (1900).

1898 (G) The audience was outraged when the completed
 statue of "Balzac" by Auguste Rodin was unveiled
 in Paris. "The raw emotion and grotesqueness of
 the image"--a far cry from the "official art" of the
 day (462:45)--created an enormous uproar (352:25),
 proving too unconventional for the public, who were
 unanimously unfavorable in their views (421:51), and
 dividing critics in their opinion as to the figure's
 artistic merit. The Societe des Gens de Lettres
 had commissioned the work as a memorial in 1881,
 but they refused to accept the finished statue, and
 engaged another sculptor to create a more decorous
 "Balzac" for the destined site (421:51). Over forty

years were to elapse before Rodin's ten-foot stand-
ing figure was erected as a public monument in
Paris--in 1939--at the intersection of the boulevards
Raspail and Montparnasse, after the work had been
"rediscovered as a precursor of twentieth century
aesthetic movements" (7, 1956:570).

1898 (H) Leo Tolstoy's book What Is Art?, published in
Russia was "mutilated by the Censor"--according
to Tolstoy's preface to the first English Edition of
1930 translated by Aylmer Maude; so that he re-
quested all readers interested in his views on art
judge his work by its English Edition:
> "After the legal term of four days had already
> elapsed, the book was seized and... handed over
> to the Spiritual Censor... one of the most igno-
> rant, venial, stupid, and despotic institutions
> in Russia. "

Only after "correcting" the book did the Spiritual
Censor allow it to be issued, Tolstoy reports,
fortifying his opinion of censorship "as an immoral
and irrational institution" (580:65-66).

1899 (A) The California legislature--many of whose members
had not been treated kindly by San Francisco car-
toonists (265:47)--added section 258 to the California
Penal Code, prohibiting the publication of "any
caricature... which... will in any manner reflect
upon the honor... manhood... virtue... or business
or political motives of the person so caricatured"
(369:269). The same legislature passed bills for-
bidding publication of portraits without consent of
the subject (401:588). About this time similar laws
were proposed in other states, including New York
(401:588).
 Although these California laws were carried in
the Code until they were repealed in 1915 (369:269),
they were never enforced.

1899 (B) The book Kalogynomia, or The Laws of Female
Beauty was suppressed in England because of its
illustrations. Originally published in 1821 and
freely circulated, the reprint of 1899 was censored
because of the 25 plates issued with the book (525:
178).

1899, June 16 Six Chicago Art Institute girl students, studying
with sculptor Lorado Taft, unveiled their graduation
exercise--a plaster fountain with ten nude plaster
nymphs splashing plaster water--on a grassy plot
adjoining the Institute. An immediate furor de-
veloped over the morality and propriety for public
display of these undraped figures. The Women's

Christian Temperance Union found the work "Shock-
ing!" The Social Purity Section of the Civic Founda-
tion considered the fountain "Awful!" and papers as
far away as Pittsburgh carried headlines:
 "The Morals of Chicago Gone to the Bow-Wows."
When a police guard had to be established to keep
observers from writing their appraisals of the
sculpture on the nymphs, Mayor Carter Harrison
rode down from the City Hall on his bicycle to see
the fountain for himself. "It is beautiful and artis-
tic," was his verdict, but as the summer rains
threatened to dissolve the plaster of the statues,
the work was dismantled. A newspaper poem,
dedicated to the Chicago Commissioner of Public
Works reported the controversy:
 "Commissioner McGann, he's the man
 Who won't have statues sans clotheses.
 He's honest and true, a good man for you,
 Who'll take 'em from under our noses." (284)

1900, January Well-known American landscape artist Henry W.
24 Ranger had David C. Preyer, art writer and publish-
 er of The Collector and Art Critic, arrested on
 charges of criminal libel for an editorial in the
 January 17, 1900 issue of his art journal. Critic
 Preyer alleged in the editorial that Mr. Ranger,
 whose works were shortly to be exhibited in England,
 "was less representative of American art than others
 specified" and sharply analyzed Ranger's style, casti-
 gating his paintings as "counterfeit."
 Art critics, wondering if "criticism is to be muz-
 zled by threat or fear of the stigma of arrest," fol-
 lowed the proceedings as a test case to determine
 whether they might be prosecuted for adverse notices
 and speaking disparagingly about an artist's work.
 Magistrate Hogan dismissed the charges (410, Ja 25
 1900 7:2; Ja 27 1900 60:3; Ja 28 1900 9:5).

1900, Decem- Carry Nation--America's most uninhibited individual
ber 27 crusader against drink, tobacco, sex, the Masonic
 Lodge, and political figures such as William Mc-
 Kinley and Theodore Roosevelt--partially destroyed
 with an arsenal (consisting not of her usual "famous
 hatchet," but of rocks, an iron rod, and a cane) a
 life-size painting over the bar of the Hotel Carey in
 Wichita, Kansas. The painting--showing Cleopatra
 reclining on a couch attended by Roman and Egyptian
 handmaidens and two loincloth-clad eunuchs--was the
 work of John Noble, titled "Cleopatra at the Bath."
 It had been painted and circulated in carnivals,
 honky-tonks, and peep-shows as "The Temptress
 of the Nile" (573:130-133). (ILLUSTRATION 18)

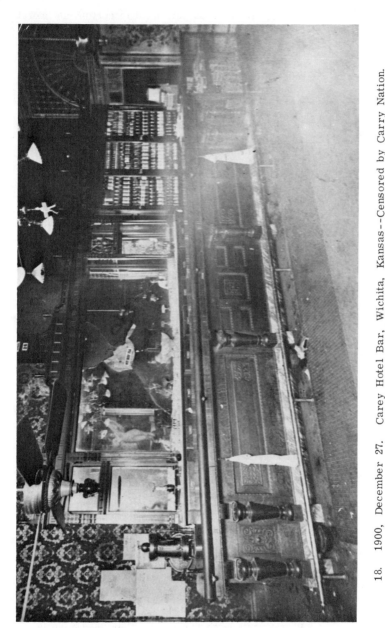

18. 1900, December 27. Carey Hotel Bar, Wichita, Kansas--Censored by Carry Nation. Kansas State Historical Society

1901 (A) "Indecently nude, as calculated to corrupt the morals
 of the populace, and unfit to figure in a public
 place, " read the clerical consiglieri pronouncement
 against four naiads on the Fountain dei Termini in
 Rome. Riots greeted this announcement. The
 naiads--commissioned by the Roman Waterworks
 Company from Sicilian artist Mario Rutelli for the
 Fountain, at the head of Via Nazionale close to the
 ancient baths of Diocletian--were playfully disport-
 ing themselves--one on a sea horse, two on dol-
 phins, and one "toying with a fabulous bird, half
 swan, half eagle. "
 A Fountain dei Termini Committee of artists,
 laymen, and clerics was quickly appointed to con-
 sider whether the water-nymphs needed more drapery
 (201).

1901 (B) A "Reserved Room" is recommended as a solution
 to exhibits of museums not wishing to affront public
 taste by public display of undraped classic works of
 art. Because "a considerable number of sincere
 persons" find nudity in art offensive--even in casts
 of famous Greek and Roman works of antiquity such
 as the "Discobolus"--best-known statue of a discus
 thrower by Myron, 5th century B.C. Greek sculptor,
 with replicas in the Vatican and the British Museum
 --such displays should be segregated from general
 exhibits and put in a special room where they may
 be viewed by public visitors seeking them out (426:
 286-288).

1902 The poster advertising the play "White Slave Traffic"
 --showing a victim stripped to the waist and a figure
 with a cat-o'-nine-tails--was banned in England when
 it was submitted to the Censorship Committee of the
 British Poster and Advertising Association. It was
 banned again nine years later when it was submitted
 to the same Committee to advertise another dramatic
 performance, "Pleasures of a Gay City" (499:14).

1902, October When Charles Nelan, cartoonist of the Philadelphia
19 North American, depicted Samuel Whitacker Penny-
 packer, the Governor of Pennsylvania, as a parrot
 in a series of cartoons, Judge Pennypacker "respond-
 ed to this attack on his dignity by prompting a friend-
 ly legislator (Assemblyman Frederick Pusey) to in-
 troduce a bill in the Pennsylvania legislature prohibit-
 ing "the depicting of men... as birds or animals"
 (265:48, 180; 366).

1903 Pennsylvania Governor Pennypacker discussing the
 arrogance of political comment in caricatures, an-
 nounced to the Pennsylvania legislature:

"In England a century ago the offender (cartoon-
ist) would have been drawn and quartered and
his head stuck upon a pole without the gates.
In America today this is the kind of arrogance
which 'goeth before a fall'" (265:47, 180).

1903, May 9 After the death of Gauguin on May 9, 1903, a gen-
 darme of Atuana destroyed Gauguin's cane--carved
 by the artist in the image of two lovers--because he
 considered it indecent (548:244).

1905? "The Surprise, " a painting that hung in the galleries
 at "South Kensington, " London, was removed as not
 suitable for public exhibition. Although the picture
 was "admirable as a piece of painting, " it "repre-
 sented a woman in the act of dressing hastily draw-
 ing her clothing around her at the approach of an
 unexpected intruder"--"who had no business being in
 the lady's dressing room" (584:305).

1905 (A) Anthony Comstock, vice crusader, requested William
 Macbeth to remove from the window of his art shop,
 237 Fifth Avenue, New York City, a painting, "The
 Explorers, " by Bryson Burroughs. The picture--
 showing five small nude children wading in a brook
 --caught Comstock's eye, and he stepped into the
 shop to say that it must be taken out of the window,
 although he did not care how prominently it was dis-
 played inside the gallery (72:238; 180:135).

1905 (B) Aristide Maillol's heroic female nude, "L'Action
 Enchainee, " commissioned by Puget Theniers to
 celebrate the French village's famous native son
 Louis Auguste Blanqui (1805-1881)--fiery revolution-
 ist who lead France toward constitutional republican-
 ism--so shocked village officials when they received
 the completed buxom figure, "that they did all they
 could to hide it on a very high pedestal surrounded
 by railings and trees (512:238).

1905 (C) "Les Fauves" ("The Wild Beasts")--Matisse, Rouault,
 Vlaminck, Derain, Van Dongen--enraged the public
 by the paintings they exhibited in the Salon d'Automne
 (Autumn Salon), and critics commented: "A pot of
 paint has been thrown in the face of the public" (Life
 48:89 F 8 1960).

1905, March 4 The picture, "The Bath of Psyche, " a Richmond,
 Virginia, Police Justice Crutchfield decided, was
 immoral. The original of the painting was on dis-
 play in London's Tate Gallery, and the artist, Sir
 Frederick Leighton was famous for the draftsman-
 ship of his classical paintings.

Justice Crutchfield fined the proprietor of the
Richmond Art Company $25 and sentenced him to
one day in jail for exhibiting reproductions of "The
Bath of Psyche," and other similar paintings in his
store window on Broad Street (410, Mr 5 1905 1:4).

1905, June 9 The Chamber of Deputies in France voted into law
provisions for "The Separation of Church and State,"
labelled by critics "brutal impiety." The legisla-
tion provided for the removal from public monu-
ments each religious sign or emblem--potential
order for the general demolishment of crosses and
of religious statues all over France on roadways,
city halls and other public buildings. Opponents of
the bill predicted that this Vandalisme Legal might
result in a destruction of art works never before
seen in France during the violent epoch of the
Revolution, or even of the Barbarian invasions,
and never matched in any other country at any
time (599).

1905, Septem- Anthony Comstock and George Bernard Shaw ex-
ber changed verbal blows over the New York Public Li-
brary's removal of Shaw's play Man and Superman
from the public shelves of the Library to the "re-
serve section." Shaw struck first in an interview,
coining the work "comstockery":
 "Comstockery is the world's standing joke at
 the expense of the United States. Europe likes
 to hear of such things. It confirms the deep-
 seated conviction of the old world that America
 is a provincial place, a second-rate country
 town civilization after all."
The Library had put Shaw's play on "restricted
circulation," explaining that "it was necessary to
restrict the work to adults because Shaw's attacks
on social conditions would be misunderstood by
children" (121:xxvii).
 Comstock responded to Shaw's jibe:
 "I had nothing to do with removing this Irish
 smut-dealer's books from the Public Library
 shelves, but I will take a hand in the matter
 now."

1906 (A) Kathe Kollwitz, "socialist, feminist, and pacifist,"
much of whose "reporting of proletarian life was
published in the communist Eulenspiegel (1921-1928)
(170:628-630), was distinguished by having her litho-
graph, "Deutsche Heimarbeit-Ausstellung" (German
Handicraft Exhibition) poster banned by the German
Empress. (ILLUSTRATION 19)

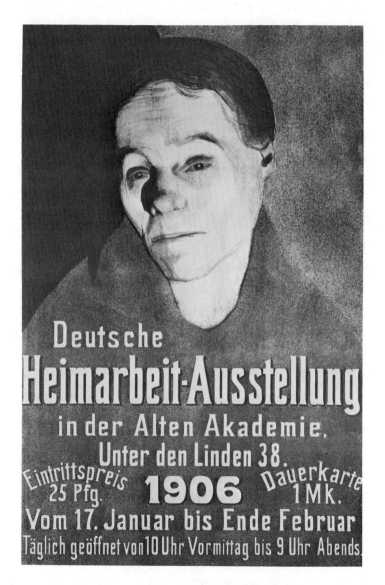

19. 1906 (A) Kathe Kollwitz. German Handicraft Exhibition Poster.
National Gallery of Art, Washington, D. C., Rosenwald Collection

1906 (B) Belgian artist Constantin Meunier intended his work,
 "Monument au Travail, " as an "artistic tribute to
 the laboring masses, " but when he offered it to the
 Belgian government, officials refused his gift of the
 sculpture, unless they could scatter the individual
 segments in various museums, fearing, perhaps,
 that "Monument au Travail" would become "a focus
 for socialist manifestations" (264:197).

1906 (C) English novelist Marie Corelli objected to picture
 postcards "depicting imaginary incidents in her life,
 though... not necessarily exposing her to ridicule
 and contempt. " Although Judge J. Swinfden Eady
 stated on hearing her case--Corelli v Wall (1906),
 22 T. L. R. 532--"It is well settled that a person
 may be defamed as well by picture or effigy as by
 written or spoken word, " he refused to issue an
 interim injunction stopping distribution of the post-
 cards (344).

1906, March Censorship of the public display of paintings--and
10 even statuary--dealing with political subjects was
 announced in Russia. Imposition of the ban was
 brought to public attention by Russian artist M.
 Amphitriatroff, formerly of Rossys and a public
 figure since his publication several years ago--Janu-
 ary 1902--of a pamphlet "reflecting" on the Russian
 imperial family. Amphitriatroff, exiled to Siberia
 for his critical pamphlet and now resident in Paris,
 has just published copies of Russian paintings "deal-
 ing with political subjects, which have been excluded
 from the Annual Art Exhibition" in St. Petersburg,
 Russia (410, Mr 11 1906 5:4).

1906, August "My God, what are we coming to?" sculptor Gutzon
2 Borglum replied to a reporter who asked his opinion
 of Anthony Comstock's confiscation of the latest is-
 sue of The American Student of Art, official maga-
 zine of the Art Students' League of New York, be-
 cause the paper contained reproductions of student
 sketches made in life classes (72:17). Although
 Washington, D. C. postal authorities had declared
 the magazine "mailable, " sixty-two year old Com-
 stock characterized the offending pictures as "worse
 than naked" (390:286-287). Newspapers ridiculed
 the censorship action, and there was much adverse
 comment from artists and the general public (521:
 49), but the offending publication was destroyed as
 obscene (72:219).

1907 (A) Chief Inspector Edward Drew of Scotland Yard wrote
 to the Paris police that the book, Illustrated Artistic
 Encyclopedia, published in Paris by Keary contained

obscene pictures by English standards--"An obscene, as opposed to an indecent, picture was one in which 'the hair is clearly shown on the private parts'" (576;289).

The Chef de Surete explained in an answering letter to the Assistant Commissioner at Scotland Yard that "pubic hair was not considered obscene by the French and, therefore, no action could be taken against Keary" (576:289).

1907 (B) Charles H. Caffin, art historian wrote in The Story of American Painting that publishers of art books, wary of shocking their public--"overwhelmingly composed of young girls"--avoided the use of the nude in art, thus producing "a flaccid condition of self-consciousness and insincerity" in painting, and--by false moral standards--bringing about a false art based "on sentimentality and facile prettyness" (379:621).

1907, January The "first example of revolutionary mid-nineteenth century art" to be hung in the Louvre in Paris entered that museum at the personal order of France's Premier Georges Clemenceau. The picture--Manet's "Olympia, " "perhaps the most reviled painting in history"--was transferred from the Luxembourg Museum, which had accepted the work in November 1890 from Monet with the stipulation that the canvas would eventually be hung in the Louvre (410, Ja 13 1957 VI, 76:2).

1908 (A) The first--and last--exhibition of "The Eight" (Robert Henri, Maurice Prendergast, Everett Shinn, John Sloan, William Glackens, George Luks, Arthur B. Davies, Ernest Lawson) was hung at the Macbeth Gallery, New York City. The group--banded together in revolt against "popular academic pretty pictures, " "Venus in Cheesecloth, " and similar themes of sentimentality embodying the philosophy of William Dean Howells ("the smiling aspects of life were more American")--had won the derogatory labels of "Ashcan School, " and "Revolutionary Black Gang" with their social protest and realistic subject matter (608:233).

1908 (B) Drawings were brought within the scope of the French law relating to l'outrage aux bonnes moeurs--Loi du Avril 1908 (137:139-140).

1909 (A) The United States Customs "duty on art over twenty years old was removed, " but a 15% duty was placed on all art less than twenty years old, with minor

exceptions for museum purchases, exhibitions, and
art gallery exhibitions (154:1232).

1909 (B) The United States Customs--under section 28 of the
law passed by Congress in 1842 forbidding import
of any obscene prints, pictures and drawings--at-
tempted to prevent the Field Museum, Chicago,
from importing Chinese pictures and manuscripts
that the Museum considered important to their col-
lection for professional study. These materials,
after being detained "temporarily" on the grounds
that they were obscene, were released to the Field
Museum (182:75; 616:20).

1909-1910? American sculptor George Grey Barnard's symbolic
figures for the Pennsylvania State Capitol in Harris-
burg, representing the most important commission
of his career, had taken eleven years to complete--
from December 12, 1902, when the contract was
signed, to October 4, 1911, the official unveiling
when that day was designated "Barnard Day," the
band played "The Barnard March," and school
children sang the specially composed song, "The
Barnard Groups." To avoid offending public taste
by the nudity of the large number of symbolic fig-
ures--arranged in four areas at the main entrance
facade, the main and the wing entrances--the statues
had been "ordered draped" (Buffalo Courier, Mr 7
1911; 142:446-448).

1910-1940 "The Attila of art history"--Austrian critic and
historian Professor Josef Stzygowski--during the
last thirty years of his life expounded racist views
of art with "bitter hatred of all that Mediterranean
civilization implies." "Nothing good could come
from the Aegean and from the South. Only in the
North was there art, and that art was Aryan and
Germanic, owing nothing to races tainted with
Negroid blood as were the Greeks and Semites"
Stzygowski founded an Institute devoted to propaganda
for his views, carried on by his "devoted Viennese
followers."
 As a "prophet of aniconic art, with its patholo-
gical horror of the nude or... of the draped figure,"
racialism, and Septentrionalism, Stzygowski--and
his "devastating doctrines" "had more influence in
France, England, and America," than in Italy or
in Germany itself (40:27).

c 1910 (A) A Lysoform Antiseptic advertising poster was banned
on the Berlin Underground Railway "because of a
nude figure." Police objections to the poster were

withdrawn--a background figure of a skeleton sym-
bolizing death was also officially criticized--when
the figure was draped, in a re-issued edition (499:
16-17).

c 1910 (B) Julius Price's poster for the Daly's Theatre review
"An Artist's Model" was censored in London, until
the artist made the picture of the scantily clothed
model acceptable by "a much-enlarged palette" (499:
26-27).

c 1910 (C) The censor in Vienna required revision of Gustav
Klimt's poster advertising the Seccession Art Ex-
hibition (Kunstavssteillung Secession), and found the
picture acceptable for public display only after "a
bit of stylised forestry" was added to partially con-
ceal the nudity of Theseus, who was portrayed bat-
tling the Minotaur (499:27, 31).

1910 (A) William Scawen Blunt--the English poet, traveller,
and anti-imperalist critic of white exploitation of
native races--wrote in his diary after examining
post-impressionist pictures sent from Paris to Lon-
don that he could see in such paintings only "that
gross puerility which scrawls indencies on the walls
of a privy" (379:337).

1910 (B) After the Carnegie Trust presented to the Carnegie
Institute's Museum of Art Sir William Orpen's "Ven-
us and Me, " representing the painter in a studio
with a large reproduction of the "Venus de Milo, "
the title of the work was modestly changed to
"Portrait of the Artist" (182:20).

1910 (C) Chief of Washington, D. C. , police Major Sylvester--
"renowned as an authority on police and criminal
questions in the United States"--came into conflict
with Mrs. Albert Clifford Barney--"Washington's
professional eccentrique" who insisted on "being
recognized as an esthete"--over a question of pro-
priety in art. The Major instructed his officers to
drape in a heavy canvas the statue of a reclining
nude woman displayed on Mrs. Barney's lawn, be-
cause it was exhibited "within easy view of the gap-
ing crowds" attracted by the figure.
 Mrs. Barney, from her residence in Paris, vigo-
rously protested the Chief's prudish action and ex-
plained that the sculpture, carved by her daughter
Laura, was exposed not to shock viewers, but to
weather and acquire an antique tone. An art critic
studied photographs of the figure before, and after,
draping, and commented that Sylvester might not

have been all wrong, as the sculpture "was shock-
ing bad art" and "greatly improved by its shrouding"
(621:328).

1910, Febru- Umberto Boccioni wrote in the Manifesto of the
ary 11 Futurist Painters in Italy that the group would
 "fight relentlessly... the religion of the past" and
 "rebel against... everything moth-eaten" (1:376):
 "The nude in painting is as nauseous as adultery
 in literature. There is nothing immoral in our
 eyes; it is the monotony of nudity that we fight
 against. Painters possessed of the desire to
 display on canvas the bodies of the women with
 whom they are in love have transformed picture
 exhibitions into galleries of portraits of disrepu-
 tables. We demand for the next ten years the
 absolute suppression of the nude in painting"
 (178:189; 364:238).

1910, October Vice crusader Anthony Comstock had George Bauer
28 arrested in New York City for mailing to him an
 "immoral and obscene" drawing--a memorial picture
 of anti-religious and anarchistic Spanish freethinker
 Francesco Ferrer. Bauer was released when the
 jury refused to indict him on the charge of sending
 an obscene picture through the mail:
 "The immoral and obscene character of the draw-
 ing was discovered in a symbolic figure rep-
 resenting humanity. A symbol without woolen
 trousers... " (203).

1910, Novem- George Bauer was arrested by Anthony Comstock in
ber New York City for the "obscenity" of a picture--
 "Montjuich"--because in the center of the 19x24 inch
 painting there was a three-inch high figure represent-
 ing Humanity--a nude female form (203).

1911 (A) A group of more than 120 German artists... issued
 a Protest deutscher Kunstler--a "manifesto assail-
 ing Cezanne, van Gogh, Gauguin, and their German
 disciples, and demanding their boycott" (620:59).
 Their Kaiser, Wilhelm II, had also "found the Im-
 pressionists and van Gogh too depraved for the Prus-
 sians" (205).

1911 (B) Although the poster for the International Exposition
 in Rome had been accepted for posting in half a
 dozen language versions in as many countries, the
 United Billposters Association Censorship Committee
 in London found the advertisement too offensive for
 British taste and forbade its display in England.
 The same Committee gave qualified approval to the
 poster for the Turin International Exhibition of In-

dustry and Labour by allowing its public display,
with the stipulation that the advertisement--"showing
male nudes"-- be "posted as high up as possible"
to prevent possible mutilation (499:44-45).

1911 (C) Upon the unveiling of the Sather Gate to the campus
of the University of California in Berkeley, "a lurid
discussion began to find space in the newspapers"
concerning the gateway. The gate columns, decorated
with bas-relief panels by sculptor Earl Cummings,
showed eight undraped figures, and these caused "a
furor of public criticism" led by "a few religious
fanatics and several mis-guided coeds. " Newspaper
reports that the Regents of the University had given
the sculptor an ultimatum to either remove his nude
reliefs from the gateway or to model new ones fully
clothed to take their place were proved unfounded.
The University Regents never considered removing
Cummings' panels because of press criticism (384:
9).

1911 (D) An Indian court decided that "religious books, prints,
or sculptures may become obscene" if the reproduc-
tions of such religious art are "hawked in the streets"
--Kherode, 1911 39 Cal 377 (375:43).

1911, March 6 In an "elephantiasis of modesty, " the Board of Al-
dermen in Buffalo, New York, adopted a resolution
offered by Alderman John P. Sullivan "to the effect
that statuary in the Albright Art Gallery should be
either draped or segregated. " The modesty of the
Aldermen, adopting the resolution "unanimously
without comment" requested the directors of the Al-
bright Art Gallery "to consider and report on the
advisability of draping the nude statues there on ex-
hibition, or placing them in a room to be designated
and used for that purpose. " As the censored stat-
ues--figures known to generations of artists, stu-
dents, and the general public--were mostly from
the "Golden Age of Greek Art, " of the fourth to
fifth century B. C. , including the Venus de Milo,
Doryphoros, Apollo, Laocoon, Venus de'Medici,
much comment in the press about the resolution
was critical and facetious--but not all. Rt. Rev.
Charles H. Colton, Catholic Bishop of the diocese
of Western New York, other members of the Catho-
lic clergy in the area, and lay members of the
church felt that such action should be taken because
the public exhibition of nudity "was demoralizing and
harmful especially to the immature. " Bishop Col-
ton, whose study of the nudity question inspired
the resolution adopted, said in a prepared statement
that as the "great majority of people" viewing the

188

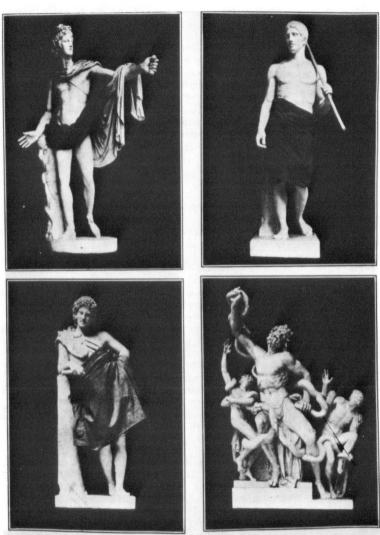

TIMES PHOTOGRAPHER'S IDEA OF HOW THE STATUES WILL LOOK DRAPED ACCORDING TO ALD. SULLIVAN'S RESOLUTION.
No. 1, Apollo Belvedere. No. 2. The Doryphorus. No. 3, A Satyr. No. 4. An Undraped Statue, Laocoon Group. The Original of This Letter Will Be Found
in the Vatican at Rome.

20. 1911, March 6. Albright Art Gallery Statues a la Sullivan

nude figures in the Gallery were "untrained in mat-
ters artistic" they failed to "grasp the true import"
of the display, and "pure thoughts may suffer
blight. " He recommended a special exhibit room
for the undraped figures "so that those who enjoy
that kind of art may have it all to themselves. "
Pictures of the statues carefully draped, "and
Buffalo's sense of humor" saved the day for classi-
cal art. The statues remained unclothed (Albright-
Knox Art Gallery newspaper files; 456:240-241).
(ILLUSTRATION 20)

1911, May A representative of the Purity Society astonished
guests of Bellevue-Stratford in Philadelphia when he
attempted to censor-by-drape two marble statues by
the famous American sculptor William Wetmore
Story: "Cupid" and "Delilah, " which had been
carved by Story in his Roman studio in the 1860's
(165).

1911, June The June issue of the American Journal of Derma-
tology was suppressed "on account of an illustrated
article by Dr. W. P. Carr on scrotal surgery" (429).

1911, Septem- "Children from 9 to 12 years are taken through
ber rooms of filth at the Art Museum of Boston, " Rev.
Lawrence B. Greenwood charged, as spokesman for
the recently organized School Protective League,
whose purpose is to "close the public Art Museum
against public school children. " A mass meeting
of 500 parents of school children had met in Dor-
chester last month for the purpose of keeping their
children from "questionable art that has such a bad
effect on the morals and manners of children as
well as upon people of mature years. "
Rev. Greenwood observed that if the offensive
pictures and sculpture in the museum appeared in
a newspaper, the paper would be unmailable; if
they were displayed to the street, the owner would
be arrested; and "if the paintings or statues were
found in a house of ill repute, during a police raid,
they would be thrown into the dump heap, or where-
ever the poker chips and other rubbish... are thrown. "
He urged Museum authorities to drape nude figures
and to remove offensive paintings and sculptures
from exhibition in order to make the Museum an
acceptable place for school children to go for lec-
tures, and to increase general attendance.
The School Protective League plans to continue
its fight, in the hope of arousing public sentiment
to the peril (Boston Morning Herald, S 18 1911;
520).

1912 (A) Canova's Living Porcelains poster--calling attention
 to "Magnificent Reproductions of the World's Famous
 Porcelains" depicted in a series of beautiful tab-
 leaux: Artistic, Chaste, Classic, Unique"--was
 banned in England because of the undraped female
 figures shown in the advertisement (499:13, 15).

1912 (B) For decency reasons, the Dutch, British, and Chin-
 ese versions of Swedish artist Hjortzberg's design
 for the Stockholm Olympics poster--depicting an ath-
 lete classicly nude--required modification by a con-
 trived placement of "flying streamers" (499:52-54).

1912 (C) The Manifesto of the Blue Rider, published in Ger-
 many as part of the movement of Expressionism,
 had as its "underlying drive and purpose...freedom
 in art" (191).

1912 (D) Austrian painter Egon Schiele, pre-cursor of the
 Expressionist School, was sentenced to twenty-four
 days imprisonment at Neulengbach, Lower Austria,
 for turning out "pornographic drawings" (392:13).

1912, October Postcard dealer O. Fulda scored Moral Censor An-
 thony Comstock for "confiscating" his stock of post-
 cards, and then refusing to return them after Fulda's
 case was dismissed--New York Call, October 9, 1912
 (520).

1913? When Berlin police condemned a poster designed by
 Kathe Kollwitz for the Greater Berlin Propaganda
 Council--showing "ragged children, victims of over-
 crowded slums and squalor"--it was withdrawn from
 circulation (499A:16).
 Kollwitz, although not a member of the German
 Communist Party, was "one of the venerated
 'People's Artists'" (171:39) who had allied herself
 "with the German left in the decades preceding Hit-
 ler's seizure of power," and her pictures of the
 suffering and deprivation of the poor--especially of
 women and children--had been banned and suppressed
 a number of times by the German authorities (410,
 N 5 1967 II, 33:1).

1913 (A) A reproduction of Paul Chabas' nude painting "Sep-
 tember Morn" was ordered removed from public dis-
 play in the window of Jackson and Semmelmeyer's
 Photographic Store on Chicago's Wabash Avenue by
 Chicago police, and His Honor the Mayor supported
 this censorship. The picture--showing a young girl
 bathing on the shores of Lake Annecy, Upper Savoy--
 had been well-received at the 1912 Salon in Paris
 (418), and that same year it was published in Town

and Country (433:90). Critics condemned the un-
warranted "persecution" of the police in banning the
picture (finding "September Morn" "as unconscious
as a bathing bird which seeks refreshment in the
water left by a passing shower"). Alderman "Bath
House John" Coughlin, Chicago political boss, de-
creed that "September Morn" must not be displayed
publicly anywhere in Chicago (247:322), but a jury
after hearing testimony from both sides of the ques-
tion (Superintendent of Schools Ella Flagg Young
found that the picture "wasn't lewd, " but felt that
nude art should not be shown to children before the
age of 14; W. W. Hallam of the Chicago Vice Com-
mission observed that the picture "was lewd" be-
cause it showed a girl bathing in a public place--
"definitely against the law"; and an art critic found
"September Morn" "nude, not naked") returned a
verdict of "Not Guilty" (284; 588).

1913 (B) Anthony Comstock condemned Jean François Millet's
 painting "Goose Girl" as obscene, because it "might
 arouse in young and inexperienced minds, lewd or
 libidinous thoughts" (121:xxviii).

1913 (C) An unsuccessful attempt was made to pass anti-
 cartoon legislation in the Indiana state legislature
 (265:47).

1913 (D) Mexican military dictator Victoriano Huerta--known
 as "The Wolf" for his rapacious search for power,
 which involved deposing, arresting and arranging
 the death of Mexican president Francisco Madero--
 became so enraged, according to report, when he
 saw the engraving Mexican graphic artist Jose
 Guadalupe Posada made, "Calavera Huertista, "
 portraying him as "a revolting spider, crawling
 with maggots, holding the bones of his victims, "
 that he ordered the printing house releasing the
 print razed (538:375-376).

1913 (E) Auguste Rodin's famous sculpture "Le Baiser" ("The
 Kiss"), on loan to the Corporation of Lewes from
 the Tate Gallery, London, was securely hidden be-
 neath a heavy tarpaulin because its theme was con-
 sidered "too daring" for public viewing (342:12-13).

1913, Febru- Tyranny of majority opinion in America was a worse
ary 17-March censor than the Inquisition, Alexis de Tocqueville
15 reported in his 1831 book Democracy in America,
 and it was the Armory Show held in New York City
 that by changing public opinion produced a "revolu-
 tion in art" in the United States. Because this
 "International Exhibition of Modern Art" was a

"decisive point" in overthrowing nineteenth century
taste in America it created "public shock, " press
ridicule and critical attack (178:19). This first
public exhibit in the United States of French Dada
and Impressionist art carried "on the revolt of 'The
Eight' against the intolerance of their own profession"
(495:373) to allow new talent in American art to gain
a viewing. Paintings, prints, sculpture of the new
French artists--some 400 works: Cezanne, van Gogh,
Redon, Gauguin, Matisse, Lehmbruck, Picasso; and
1, 112 works by 307 American artists of the "Ash
Can School" (495:373) served to "start riots, alert
vice squads, and be burned in effigy by art stu-
dents" (360:201, 205-206, 210).

The pine-tree flag of the American Revolution
with the words, "THE NEW SPIRIT, " printed below
it was the symbol of the exhibit that public and crit-
ics greeted with "fury and bewilderment, amaze-
ment and amusement. " "A colossal joke of eccen-
tricity, that won't bear repeating, " one critic wrote
(329:140). The New York Times assessed the show:
"The Armory show is pathological. It is hideous";
and New York Herald critic Royal Cortissoz com-
mented: "Unadulterated cheek. "

The most talked about work at the 69th Regiment
Armory was Marcel Duchamp's painting, "Nude De-
scending Stair, " but it was Constantin Brancusi's
cubist sculpture "The Kiss" that inspired poetry:

"He clasped her slender cubiform
In his rectangular embrace...

He kissed her squarely on the lips" (512A:215).
Among the few observers sensing the changes that
the Armory Show heralded was Joel Spingarn of
Columbia University, who said he "felt for the first
time that art was recapturing its own essential mad-
ness" (360).

1913, May 14 In the first application of techniques of modern pub-
licity to an object in the visual arts, Harry Reichen-
bach--master promoter and public relations hoaxer
of the early twentieth century--engineered an inves-
tigation by Anthony Comstock of an "innocuous nude
painting" "September Morn, " so that the picture be-
came the "talk of the world. " Reichenbach bought
the picture, painted by Paul Chabas in 1912 and al-
ready the object of limited notoriety by a Chicago
police banning, and displayed the nude in the window
of Braun & Company, 13 West Forty-sixth Street,
New York City, after hiring for $45 "a small gallery
of urchins to gather before the window, and point,
grimace, and remark. " An anonymous telephone
call brought vice-crusader Anthony Comstock to the

21. 1913 May 14. Paul Chabas. September Morn. Metropolitan Museum of Art. Gift of Mr. and Mrs. William Coxe Wright, 1957

scene. While Comstock termed the bather "sala-
cious," and was later quoted in appraisal: "There's
too little morning and too much maid in that pic-
ture" (418), he decided immediately that the painting
was "not actionable" as obscene or immoral.

Newspaper publicity of his visit--and other public
actions and controversy over "nudity, art, and mo-
rality": postcard reproductions of "September Morn"
were forbidden in the United States mail, and a New
Orleans art dealer was arrested for displaying a
copy of the painting (410, Ag 10 1913 11, 1:6)--made
"September Morn" the most popular picture of the
day (Life 21:90 D 23 1946) with an estimated
7,000,000 reproductions sold, rivalling the public
acceptance of the works of Maxfield Parrish, and--
at a later date--van Gogh's "Sunflowers." The nude
bather appeared in dolls, statues, calendars, um-
brella and cane handles, sailors' chest tatoos, and
amateur drawings on barroom floors (365:252-253).
From an artistic standpoint, the painting was "the
last gasp of the now discredited School of Bouguer-
eau and the Paris Salon artists of the pseudo-Classi-
cal period" (55:4), but Americans bought it on candy
boxes, cigar bands, and watch fobs (True, Jy 1964
p. 71).

Chabas, the painter, died rich and famous in
1937. Shortly before his death, he revealed that
the model who posed for "September Morn" had
"made a fortunate marriage" and was the mother
of three children. The gallant artist never dis-
closed her name. After the "September Morn"-
vogue began to pass, a novelty dealer introduced
a burlesque of the figure in which a burglar con-
fronts the nude young bather, saying, "Hands Up!"
and the bather obeys. Comstock's proceedings
against two dealers who sold this reproduction re-
sulted in their arrest and conviction for selling an
obscene picture (72:238-239).

Another twenty years was to pass, before "Sep-
tember Morn" went on public exhibition--September
1, 1957--in the Metropolitan Museum of Art, which
had accepted the picture as a gift from William
Coxe Wright of Philadelphia, after it had been re-
fused by the Philadelphia Museum of Art (365:252-
253; 410, My 11 1913 II, 1:4; My 12 1913 5:4; My 15
1913 7:2, 10:4; Jy 23 1913 4:3). (ILLUSTRATION
21)

1913, June? When the International Section of the Armory Show
moved from the National Guard Armory in New York
City to Chicago's Art Institute, it became the sub-
ject of an Illinois State vice inquiry--sparked spe-
cifically by two paintings: "Prostitution," a mo-

rality picture pointing out the evils of vice; and
Marcel Duchamp's "Nude Descending Staircase."
Another work--abstract painting by Francis Picabia,
"The Dance of Spring"--was publicly denounced by
the Mayor of Chicago.

Arthur Charles Farwell, president of the Chicago
Law and Order League, bothered by the Matisse
nudes, commented on the exhibit's "degeneracies":

"Why, the saloons could not hang these pictures.
There is a law prohibiting it... The idea that
people can gaze at this sort of thing without it
hurting them is all bosh. This exhibition ought
to be suppressed."

Some fellow-artists and art students were equally
violent in their condemnation. Students at the Art
Institute of Chicago burned Matisse in effigy for his
"betrayal of art" with his painting "Blue Nude"
(512A:216). An instructor in art at Waller High
School publicly complained that the exhibition was
"nasty, lewd, immoral, and indecent," and the di-
rector of the Chicago Art Institute, A. M. R. French,
evaluated Cubism displayed in the exhibit as a "toss-
up between madness and humbug" (360:219; 610:117).

1913, Sep-
tember

"In a campaign of prudery raging in Prussia and
Saxony," several German courts condemned cheap
copies of nude works of art. "The court in each
case asserted that an original nude statue or pic-
ture might be harmless... but that cheap copies of
it, circulated among the profane public, were de-
moralizing."

The First Prussian Land Court banned a photo-
graph of the well-known statue, "The Archer," by
Professor Nikolaus Geiger because it was nude--al-
though the original figure was bought by the Kaiser
and is displayed in Sans-Souci Park.

In another recent court case, an art work belong-
ing to the Kaiser was judicially condemned when a
court found the reproduction of a French Rococo
eighteenth-century painting--the original of which is
in the Royal Collection--indecent. At Dresden re-
productions of two pictures by Titian and Giorgione,
the originals of which are owned by the King of
Saxony, were condemned; and the Land Court in
Berlin has forbidden circulation of a photography
of a statue on view in a public square of that city:
"The Washer Girl" by Professor Bruno Schmitz
(410, S 28 1913 IV, 2:2).

1913, October
3

The United States Tariff Act passed providing free
entry for specified art (Paragraph 652):

"All original paintings whether... in oil, mineral,
water or other colors, and pastels, drawings and

sketches in pen and ink, pencil or water colors,
unbound artists' proof etchings, engravings, and
woodcuts, and original sculptures or statuary
(including not more than two replicas or reproduc-
tions of the same) should be admitted free of
duty" (154:1234).

c 1914 "When theological savants pointed out Gutzon Borg-
 lum's grave heretical error in representing some
 angels as females" in his works ornamenting the
 Cathedral of Saint John the Divine in New York City,
 the sculptor deliberately smashed the criticized fig-
 ures (387:101).

1914 Lawton Parker's painting "La Paresse" ("Idleness")
 was "quietly removed and... excluded from the offi-
 cial catalogue" at the Carnegie Institute invitational
 exhibit in Pittsburgh. An International Jury had ac-
 cepted "La Paresse" for exhibit and it was hung "as
 a first line picture. " The painting, depicting a re-
 clining nude girl, had already been exhibited in
 the United States and abroad--it won the Gold Medal
 of the French Society of Artists--and had been shown
 at the Chicago Art Institute and at the Pennsylvania
 Academy. When artist Parker investigated the ban-
 ishing of his picture, he found that the painting had
 been rejected by Director Beatty of the Fine Arts
 Department of the Institute, who had overruled the
 appointed International Jury because "he did not
 think the public sufficiently enlightened in art to
 accept the work properly. "
 The Art Committee of the Carnegie Institute
 viewed the picture in a private gallery--Wunderly
 Galleries--and ordered it restored to the Institute
 exhibition (562:347-370).

1914, Febru- Anthony Comstock objected when the Chautauquan,
ary official organ of the Chautauqua Institute--devoted
 to furtherance of a program of education--showed a
 photograph of an antique statue of a naked faun on
 its cover. The faun, an archeological find from
 Lake Nemi, Italy, was in the University of Penn-
 sylvania Museum, and was one of a series of art
 objects from various Museums in the United States
 used on the cover of the Chautauquan. Although
 Comstock considered the faun "a most indecent
 thing to send into homes where there may be young
 girls, " he "decided not to prosecute if the offense
 were not repeated" (72:251).

1914, March 3 Tyomies Publishing Company and John Nummivouri--
 the Company's business manager--were convicted for
 distributing in the mail 3, 000 copies of the Finnish

language magazine <u>Lapatossu</u>, published in Hancock,
Michigan, because <u>two issues</u> (April 24, 1912, and
December 13, 1912) contained caricatures found "ob-
scene, lewd, filthy and indecent" pictures. The de-
fendants, convicted under Section 211 of the Penal
Code of the United States--forbidding the mailing of
obscene and filthy matter--found their conviction up-
held by the United States Circuit Court of Appeals
for the Sixth District (520; 586).

1914, March 6 The postmaster of New York City temporarily sup-
pressed the <u>Metropolitan Magazine</u>, New York, for
reproducing <u>Paul Manship's works</u>: "Wood Nymph
Dance" and "Playfulness" (49).

1914, March 8 Karl Maria Stadler's poster advocating votes for
women on "Frauen Tag"--part of the propaganda of
"Red Week" of the "left" political group--did not
appear in Berlin as the police in the city described
it as "offensive to authorities" (499A:16).

1914, March "Though I am not a saint, I blushed at the exhibi-
11 tion of garmentless paintings and statuary...," Al-
bert Kuelling, real estate agent and member of the
Vanderveer Park Taxpayer's Association, told the
Association at its Tuesday night meeting, in describ-
ing his visit last Sunday to the Brooklyn Institute of
Arts and Sciences. Kuelling reported that if such
a display were "conducted privately it would be
raided as a disorderly house," and criticized parti-
cularly "the untailored condition of the statuary."
After considering Kuelling's complaints, the As-
sociation "decided that many statues and paintings
in the Institute are vulgar and immoral," and ap-
pointed a committee of three to demand that Frank-
lin W. Hooper, president of the Institute put such
works of art "where the public can't see them."
In their discussion, other members of the Associa-
tion recalled that nude statues were exhibited at
Erasmus Hall High School in Brooklyn, and--al-
though no sculpture was specified--members later
admitted that one offending figure was Frederick
MacMonnie's "Baccante," which should be censored
because it "has too much Baccante and too little
dance in it."
Principal of Erasmus Hall High School Walter B.
Gunnison was unmoved by the Association's com-
plaint: "There are always persons ready to argue
that exhibition of the nude in art is immoral and
dangerous. The question was settled long ago" (411,
Mr 12 1914).

1914, May 16 Nudity in art is not indecent, the judge and jury
 agreed in Berlin's criminal court, after "a demon-
 stration of the difference between decency and in-
 decency in art" by one of Germany's famous paint-
 ers of nude pictures.
 Berlin police in one of their "periodic raids" on
 shops displaying copies of famous nude pictures and
 "suggestive postcards" had seized a number of "in-
 decent" pictures and plates, and the public prosecu-
 tor demanded that they be destroyed. The defense
 called one witness--a well-known German artist--
 who exhibited a large canvas he had painted of a
 nude female figure. The judge, the prosecutor, and
 the jury indicated that they did not consider the
 painting indecent. The artist then left the court-
 room with the canvas, and a few minutes later again
 exhibited the picture from the witness stand. "Dis-
 gusting! Take it away!" judge, attorneys, and jury
 are reported to have "shouted as one."
 The artist had added a pair of stockings to the
 figure in his painting, and as a result of his demon-
 stration the court released all pictures and postcards
 that had been "under suspicion" (41, My 17 1914).

1915 (A) "Have you seen Stella?", famous greeting originat-
 ing at the Panama Pacific Exposition in San Fran-
 cisco, arose from public "delight and shock" at the
 nude painting "Stella" by Italian artist Alver Regli,
 shown at the Exposition.

1915 (B) New York attorney John Quinn, "the twentieth cen-
 tury's most important patron of living literature and
 art" at the time of his death in 1924, "almost single-
 handedly got the United States Tariff Law changed
 and was largely responsible for its definition of
 art," but when he tried to bring into the United
 States "some ceramic plaques and jars" by French
 artist Georges Rouault, "the Customs officers looked
 at the official definition of art and--finding no men-
 tion of ceramic sculpture--declared that these jars
 were not works of art," and, therefore, dutiable.
 Although Justice Waite in the Customs Court upheld
 the inspector's ruling that the jars and plaques were
 not works of art, Quinn won a reversal in a higher
 appeal court (512A:209-210).

1915 (C) The California state legislature repealed the "Anti-
 Caricature Law"--Cal Stats. (1915) 761--carried in
 the state code since its passage in 1899 (369:269).

1915, Febru- Frank Spangler's drawing, the "Cartoon Mirror,"
ary 3 in the Montgomery, Alabama, Advertiser, reported
 an attempt to pass anti-cartoon legislation in the

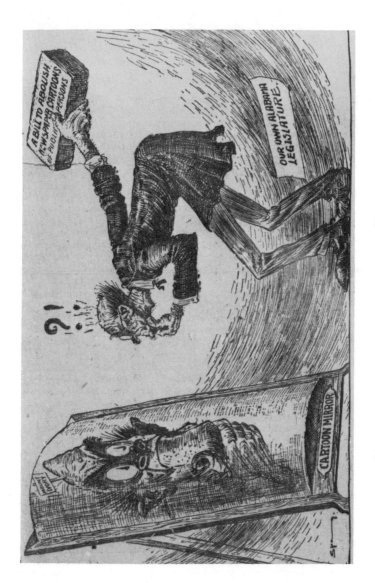

22. 1915, February 3. Frank Spangler. Cartoon Mirror

Alabama state legislature (265:47). (ILLUSTRATION 22)

1916 (A) W. H. Barribal's poster for "Who's Who," farcical comedy review of Harry Norris and Herbert Clayton, "ran into bosom scandal" in London, which was dispelled only after the two female figures shown were clothed in dresses in a "corrected" drawing (499:24-25, 48).

1916 (B) The Art Institute of Chicago moved the larger-than-life bronze nude man, "Sower" by Chicago sculptor Albin Polasek, from its location "just outside the front door" to a new site "just inside the front door" because some Michigan Avenue strollers complained that they were "bothered by the undraped condition of the figure" (182:20; 284).

1916 (C) A United States Court in New York granted an artist exclusive property rights to his creations, outside, and even "in spite of," the copyright law, when it ruled that "Bud" Fisher--Harry C. Fisher--creator of the cartoon "Mutt and Jeff" had exclusive right to the use of the name and characters of the cartoon, and exclusive right to continue to publish and syndicate the cartoon, although his employer for six years--New York American which was owned by the Star Company claimed these exclusive rights because they held the copyright and had made the cartoon famous through syndicating it "in almost every city and town in the United States"--Star Company v The Wheeler Syndicate, Inc. 160 N. Y. Supp 689 (1916). The American had sued Fisher, who left their employment to establish his own syndicate (Wheeler Syndicate) to restrain him from drawing the cartoon for any other newspaper or syndicate, or using the name "Mutt and Jeff," and Fisher counter-sued. According to the court decision, Fisher had exclusive right to use the names because--as in trademark law--exclusive right belongs not to the inventor or the creator of a trademark, but to the first to use it in a business, and Fisher was "considered in the business of producing cartoons," and had derived exclusive right to use the name as his trademark through the sale of the right to publish cartoons to the American. The court also granted Fisher exclusive right to produce future cartoons of "Mutt and Jeff"--"from the standpoint of Unfair Competition"--otherwise the public would be deceived into thinking that further cartoons were the "genuine productions of Mr. Fisher" (307).

1916 (D) When the question of a United States Custom's

inspector denying an "art" classification to a marble
font, marble boxes, stands and seats came before
the Court of Customs Appeals, the Court--using the
definition of sculpture copied from The Standard
Dictionary and The Century Dictionary: "that branch
of free fine arts which chisels or carves out of
stone or other solid material, or models in clay
or other plastic substances for subsequent repro-
ductions by carving or casting, imitations of natu-
ral objects, chiefly the human form, and represents
such objects in their true proportions of length,
breadth, and thickness, or of length and breadth
only"--concluded that Congress never intended to
incorporate "all beautiful artistic objects" within
the duty-free range of "works of art. " The appeal
to recognize the marble objects as art for tariff
purposes was refused--United States v Olivetti &
Co. 7 Ct. Cust. App. 46 (1916) (154:1236).

1916, Febru- Hearst's Magazine arrest on account of the pictures
ary-April used in the issues of February, March, and April
 1916 was dismissed by the judge (520).

1917-1940 Swiss architect Robert Maillart (1872-1940), a bridge
 designer, "had mastered the arch in its purest and
 most sweeping forms" by using "the tensile and
 compressive properties of reinforced concrete to
 the ultimate. " The lightness and elegance (221:86)
 of his bridges "seemed to offend the tastes of lay-
 men and specialists alike--they were "so radical in
 theory to the engineers (one commented: "We have
 had enough of this puff pastry" (221:86)) and so un-
 usual in form to the public--that they were "con-
 fined to remote Alpine valleys" (221:84).
 "In Berne, where his bridge spanned the Aare
 River, he was forced to disguise the arches in heavy
 granite, thus destroying their original lines" (610:
 114; 221:86).

1917 (A) Some sixty unframed watercolors and pastels by
 Orozco were "torn into bits" at the American Cus-
 toms House on the Mexican-American border at
 Laredo, Texas, and the artist was informed that
 it was against the law to bring immoral prints into
 the United States. Orozco denied that the prints
 were immoral, and claimed that "the figures were
 not even nude" (485:75).

1917 (B) According to the Frankfurter Zeitung, after a "dis-
 graceful denunciation" a Daumier exhibit in Berlin was
 "interdicted" (218:27).

1917 (C) A photograph of Giorgione's "Sleeping Venus, " the

original of which hung in the Dresden Museum, "was held to be indecent"--Clarkson v McCarthy, 1917 NZLR 624--when it was exhibited in a shop window in New Zealand (118:40).

1917 (D) In "one of the most heated controversies of early 20th-century American art" (142:449), George Grey Barnard's $100,000 memorial figure of Abraham Lincoln was rejected in the English Parliament for placement in London--now in Manchester, England-- and its replica in Cincinnati's Lytle Park was "attacked from all sides" as a portrait showing Lincoln "as a coarse, imbecilic dolt" (142:449), with "anthropoidal hands and feet" (161A:75). Sculptor Barnard, wishing to create a realistic and moving memorial, had used the life mask Leonard Volk made in 1860 for his Lincoln's head, and modeled the body, "after a two-year search for the right figure, from a six-foot-four-inch forty-year old farmer who had been splitting rails all his life near Louisville, Kentucky" (142:449).

1917 (E) As part of its control of public expression in wartime, the United States Government established a Bureau of Cartoons, and sent out a bulletin to guide cartoonists in propaganda favorable to the war effort. Among topics suggested for cartoonists were: "Liberty Bonds, recruiting, saving food and fuel" (34:310). With these restrictions, most cartoonists "concentrated their efforts on Uncle Sam buckling on armor, or the Kaiser with a bomb, pistol, or knout" (34:310).

1917 (F) Leopold Zborowski, friend of Amedeo Modigliani, tried hard to bring Modigliani's work to the attention of the public, but "his most ambitious attempt during Modigliani's lifetime... a show he arranged at the Berthe Weil gallery in Paris" lost its strongest drawing card when the police ordered him to remove four eye-catching paintings of reclining nudes from the gallery window, where they had been placed to attract the public (347).

1917, May 27 The Code of Canon Law (Codex Juris Canonica), the code of law governing the Catholic Church, was completed and approved by Pope Benedict XV, who decreed that the rules should have the force of law on May 19, 1918. The Code, containing 2414 canons divided into five books, in Canon 1385 "presents general norms for prior censorship" and includes sacred pictures as a class of publication always subject to examination and censorship before their publication:

"Without prior Church censorship even laymen
are not allowed to publish:

3. Sacred pictures, no matter by what process
 they are printed, whether they are issued
 with or without prayers" (76:8, 10).

Approval is required of "printed images or repre-
sentation of the Blessed Trinity, Jesus Christ, the
Blessed Virgin Mary, angels, or saints; or images
that represent a religious mystery, a sacred scene,
biblical events, or emblems of religion" (76:12).
This provision governs "only printed pictures," and
does not include medals, paintings, and statues (76:
31), but part of the clergy's duty is "to see that
artists conform to the laws of the church":

"robes, furniture, and other articles of churchly
use conform to liturgical description, ecclesias-
tical tradition and the law of religious art" (301:
23).

1917, August- "Having Their Fling," Art Young's cartoon, was
September "Exhibit F" in the United States Government's case
when seven staff members of The Masses, socialist
monthly magazine published in New York City, were
brought to trial under the Espionage Act for "ob-
structing the war effort" (34:309-310; 538:325, 333).
This picture, appearing in the September 1917 issue,
shows bankers and clergymen dancing in a shower
of gold--"a blast at figures of corruption and war
mongering" (34:309-310).

After two juries disagreed "by a very narrow
margin" (171), the five editors and two artists--
Young and Henry J. Glintenkamp--indicted were
freed (538:325).

Under the United States Espionage Act of 1917,
and its amendment of 1918 to include sedition, "pro-
scribed and prosecuted statements were those that
were construed to cause insubordination or disloyalty
in the armed forces, or to obstruct enlistment or
recruiting" (415). The Masses--one of "possibly
100 newspapers and periodicals barred from the
mails" under the Act (some 1,900 persons were
also proscribed for speech) (415)--was suppressed
by A. R. Burleson, Postmaster General in August
1917 (538:333) as "seditious without specifying any
particular portion as objectionable" (100:154). The
publisher offered to delete any passages pointed out
by the Postmaster, but only after suit was started--
because the "whole purport" of the issue was unlaw-
ful in "encouraging the enemies of the United States
and hampering the war effort"--was objectionable
content specified: four cartoons ("Liberty Bell,"
"Conscription," "Making the World Safe for Capital-
ism," "Congress and Big Business"), "a poem, and

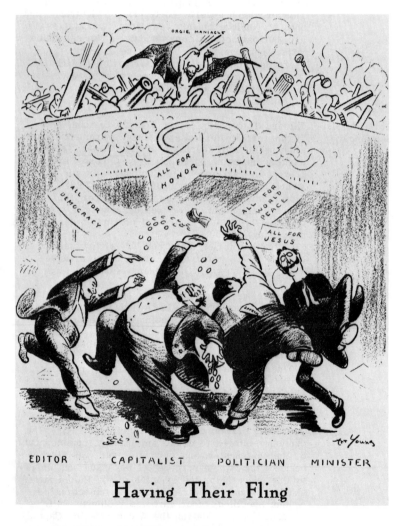

EDITOR CAPITALIST POLITICIAN MINISTER

Having Their Fling

23. 1917 September. Art Young. Having Their Fling

three articles praising Emma Goldman and Alexander Berkman, who were in prison for conspiracy to resist the draft" (100:42-43). Postmaster Burleson after suppressing the August 1917 issue of The Masses refused to admit the September and subsequent issues to second-class mailing privileges on the grounds that the publication had skipped a number (that is, the August issue he had suppressed) and was therefore "not a periodical since it was not regularly issued" (100:98). Judge Learned Hand upheld the magazine's injunction against the Post Office for this action (Masses Publishing Co v Patten, Postmaster, 244 Fed 535 (1917)), but the Circuit Court, in appeal reversed Judge Hand on a point of administrative law--that "the Postmaster's decision must stand unless clearly wrong" (100:42-51)--and found The Masses unmailable (Masses Publishing Co v Patten, Postmaster, 246 Fed 24 (1917)), forcing the publication--no longer entitled to second-class mailing privileges--out of business (258:158-159). (ILLUSTRATION 23)

1919 In the District of Columbia, N. M. Berthelot Moens, ethnologist, was arrested as a German spy. His collection of photographs and paintings of nude men, women, and children, which he had gathered over a number of years to demonstrate the significance and value of the study of topographical characteristics in the matter of detecting racial mixture, had been brought by anonymous report to the attention of the police authorities effecting his arrest, and these offending illustrations were seized with the rest of his belongings. When Moens was finally brought to criminal court it was on the charge of having "obscene pictures" in his possession.

Although expert witnesses in the field of anthropology and ethnology testified for the defense--including United States Army Officers, sculptors and artists, surgeons and physicians, Congressmen and Senators--giving evidence that Moens' photographs and paintings "were in no way 'lewd and obscene'", the defendant was convicted and sentenced to a fine and imprisonment. The Washington Court of Appeals reversed this verdict (541).

1920's (A) Soviet artist P. Filonov suffered "abject poverty and official censure" under the Russian official art policy and was unable to exhibit or sell his pictures because of government strictures. Filonov--spurning the illustrative approach and obvious subject matter of official Soviet art--wished to paint "in the native Russian tradition of imaginative expression" (368:76).

1920's (B) "In the early 1920's the authorities in Moscow closed
 the doors of 'Vchutemas,' one of the most advanced
 art schools in existence" (551:82).

1920's (C) The Communist Party in Russia expelled artists
 Naum Gabo (originally Naum Pevsner) and his
 brother Antoine Pevsner from the Central Soviet of
 Artists and deprived them from earning a living
 through their arts. They had published the Mani-
 festo of Constructivism and taught painting and
 sculpture at the State Art School in Moscow, and
 the Russian government chose this method to show
 that the modern movement in art--of which they were
 a part, along with Chagall, Kandinsky, and Malevich
 --was officially condemned. U. S. S. R. censorship
 replaced the works of this Russian School of modern
 art with paintings in the manner of Ilya Efimovich
 Repin (1884-1930), whose better-known paintings in-
 clude "Mist Over the Volga," "The Return to Si-
 beria," and "The Cossacks" (27:22; 368:75).

1920 (A) Sculptor Constantin Brancusi's "Princess X" ("Prin-
 cess Bonaparte") was removed by the police from
 the Salon des Independants in Paris "in the interest
 of decency," as a phallic representation, although
 the artist stated that it was merely an abstract tor-
 so and head. "Princess X" was later exhibited in
 New York and in Chicago, but Brancusi was so of-
 fended by the Salon's censorship that he never again
 showed his work in a group exhibition (Life. Letters
 to the Editor. Ap 10 1970 68:26; 368:276).

1920 (B) German artist George Grosz, arrested and tried for
 attacking the Reichswehr in his portfolio Gott Mit
 Uns through drawings showing profiteers, prostitue
 and militarists, was fined 5, 000 marks. Grosz
 stated that the German army "was most irked by
 the fact that he had purposely misdrawn the uni-
 forms, giving them the wrong number of buttons
 and subtly distorting them in other ways" (30:21-22;
 538:293).

1920, January R. W. Shufeldt, M. D. , was so incensed at the
 treatment of ethnologist N. M. Berthelot Moens in
 Washington, D. C. , in 1919, when Moens was ar-
 rested and tried for possessing "obscene pictures"
 and his scientific illustrations confiscated, that he
 proposed in an article to found a Society for the
 Protection of Science and Art in the United States.
 This Society, composed of professionals in the sci-
 ences and the arts, would prevent such "infamous
 treatment" of scientists and artists by acting as an
 impartial advisor to the courts in the United States

on the "value and propriety" of referred "sculptures, pictures, photographs, and the like" (541).

1920, April 20 The "First Dada Event" in Cologne, organized by Max Ernst--founder of the local Dada group--and his old friend Hans Arp (108:368;212, I:237), caused a riot and such a scandal that the show was "closed by the police upon order of the magistrate who was Ernst's own uncle" (108:368). Authorities had been warned "that the Dadaists were worse than Communists," and police who closed the exhibition "more or less assumed it to be a gathering of homosexuals" (498:162).

The Event could be entered only through the pissoir of a beer-hall--the Winter Beerhouse (609:7) and "innocent beer drinkers... attracted by the din which came from the other side" of the wall curiously walked through to find themselves in the "Dada-Fair" "crammed with all sorts of suggestive objects, collages, and photomontages." After closer police inspection showed "that the only morally objectionable object in the exhibition was by a certain Albrecht Durer... the Fair was re-opened" (498:162).

1921 Because "concrete got too big a preference," no building permit could be issued for Frank Lloyd Wright's Millard House ("Miniatura") in Pasadena, California--"the first concrete block house to employ the textile-block system," invented by the architect several years before, although the building ("a hollow wall formed of 3-inch thick concrete blocks... reinforced in the joints both ways; steel cross ties placed every third course; joints poured with cement grout") was, according to Wright's report, "an earthquake-proof light construction" (544). (ILLUSTRATION 24)

1921, April 28 Louis Van Brink, New York City art dealer and auctioneer, was arraigned in Jefferson Market Court on complaint of John Sumner, agent for the Society for the Suppression of Vice, charged with "displaying in his window obscene and lewd pictures and prints either nude or partly nude." As penalty for the offense--a compromise suggested by Magistrate Joseph E. Corrigan--those pictures "declared most objectionable were destroyed" (410, Ap 29 1921 20:3).

1921, May 21 Giving an officer of the German army a pig's face caused the five promoters of last year's Berlin Dada art exhibit--advertised as the "First International Dada Fair"--to be charged (April 21, 1921) with insulting the Reichswehr, Germany's new army.

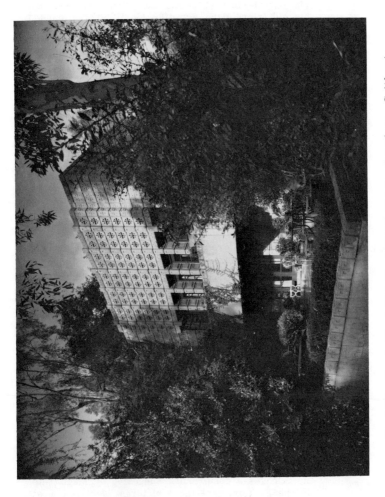

24. 1921. Frank Lloyd Wright. Millard House. Pasadena, California

Primary subject of the complaint was a stuffed fig-
ure in the field gray uniform of a German officer
hung from the roof of the exhibit hall--with the mask
of a pig's head.

Among other art exhibited, which was specified
by authorities as "offensive": The mutilated figure
of a woman, a knife stuck in her breast and an iron
cross on her back; a volume of sketches by George
Grosz--Gott Mit Uns--described by the prosecution
as "gross insults to officers and soldiers" of the
German army. The defense attorney claimed that
the satire was directed not at the new German army,
but the old German militarists, and said that the
entire exhibit was a "joke, " giving as an example
of Dada humor the posters that covered the exhibit
building for some days before the opening of the
Fair:

"ATHLETES WANTED FOR GUARDING THE ART
EXHIBITION. "

A verdict of "guilty" against two of the Dadaists--
artist George Grosz was fined 300 marks for his
part in the exhibit--"saved the honor of the German
army" (410, Ap 22 1921 17:4; My 22 1921 II, 5:1).

1921, Decem- The Brooklyn Society of Artists at a meeting con-
ber 13 sidered the letter from Professor Walter Scott Per-
ry, Director of Fine Arts of Pratt Institute, in
which he demanded that the pictures of the Society
exhibited next year at their third Annual Salon--to
be held as usual at the Institute--be censored be-
cause Pratt Institute had "a right to demand true
color and idealism" from exhibited artists.

The Society decided to stand by provisions of
their constitution and continue to "hang the pictures
of all members" (410, D 19 1921 13:2).

1922 (A) "Artists of the Revolution" in Russia issued a mani-
festo:

"It is our duty to mankind to perpetuate the
revolution, the greatest event in history, in
artistic documents. We render a pictorial rep-
resentation of the present day: The life of the
Red Army, the life of the workers and peasants,
the leaders of the Revolution, and the heroes of
labor" (126:12).

1922 (B) In Mexico City the "Revolutionary Syndicate of Tech-
nical Workers, Painters, and Sculptors" issued its
broadside Manifesto for a new monumental art of
social purpose, written by Jose Clemente Orozco,
Diego Rivera, and David Alfaro Siqueiros (108:461--
English translation from Laurence E. Schmeckebier,
Modern Mexican Art, University of Minnesota Press,

1939, page 31, and Bernard S. Myers, <u>Mexican</u>
<u>Painting in Our Time</u>, Oxford University Press,
1956, page 29).

1922, Febru-
ary 10

The switch George Bellows made from his last
year's painting "Old Lady in Black"--first prize
winner in 1921--to his this year's work "Nude Girl
with Shawl" proved too much for the viewing public
and some members who saw the undraped figure in
"Nude Girl" in the National Arts Club Exhibit, on
display since January 1.

The Arts Committee of the Club considered pro-
tests against the painting--a seated young woman
whose "black silk gown covers the lower part of the
body, but above the waist she is nude except for an
airy white shawl. " Members complained that the
nude was "immoral, " one formal letter demanded
that the painting be removed from the Exhibit, and
one member--a friend of Bellows--criticized the
portrait as "too décolleté. " The Club officially
approved the controversial painting, and made a
public announcement that it would continue to be
on display until the Exhibit closed (410, F 7 1922
10:2; F 9 1922 18:2).

1922, Febru-
ary 11

John S. Sumner, executive of the Society for the
Suppression of Vice, complained that the "moral
backwash" resulting from reaction to the reform
wave that carried prohibition through "interfered
with the Society by making it more difficult to ob-
tain convictions" for public display in show windows
of "indecent art. " He pledged that the Society will
continue its fight against indecent photographs
"flaunted as art" (410, F 12 1922 II, 2:4).

1922, March

Frederick MacMonnies' sculpture "Civic Virtue"
caused such a public outcry in New York City, that
Mayor John F. Hylan held several public hearings
in the City Hall to decide whether the statue should
be installed in City Hall Park. The allegorical
group--"derided by most of the general public, "
and ridiculed as "The Fat Boy"--showed a nude
youth with club on shoulder vanquishing a recum-
bent female nude, representing the siren of tempta-
tion to political corruption.

The statue was denounced by the WCTU and other
women's organizations as "degrading to American
womanhood" because Civic Corruption was represen-
ted by a woman:

"We do not believe that the human race regards
man as a symbol of virtue and woman as a
symbol of vice. Neither has a monopoly on
virtue. "

MacMonnies attempted to defend his figures by ex-
plaining that there was "no truth that man is trampl-
ing on woman, " and that the man's foot was planted
"on a rock not a lady's back. "

In the face of mobbed meetings, weeks of contro-
versy, and obstruction by women's groups who main-
tained that "women would have to turn their eyes
away when they walked by" "Civic Virtue, " the sculp-
ture was installed in the Park--on April 20, 1922--
but as criticism continued, the statue was removed
to Foley Square, and then moved again to the front
of Queens City Hall (142:427-428; 182:20, 410, Ap 1
1922 14:5; Ap 2, 1922 II, 1:6; Ap 6 1922 19:8; Ap 7
1922 10:2; 16:6; Ap 21 1922 13:3).

1922, April
9 (A)

Civic virtue did triumph in New York City--at Coney
Island on Palm Sunday, the first day of the season--
when Police Inspector Bryon Sackett ordered three
nude plaster figures of women, placed in front of
the new Bowery attraction "Love Nest, " "to be
draped or removed from public view. "

Although the owners of the group contended that
it was a copy of a famous sculpture--"The Fallen
Angel"--Sackett found the statues "too realistic, "
particularly as the figures had been tinted from
"chaste white" to a delicate skin tone (410, Ap 10
1922 6:2).

1922, April
9 (B)

Elizabeth Elliott, in a letter to the New York Times,
reported that "many years ago" a statue of Apollo
had been placed on view as "the pride of the Frank-
lin Literary Society" at the Normal School in Ada,
Ohio. At that time an official of the Society vigor-
ously denied the press rumor that the nude figure
wore tailored trousers. What had really happened,
he explained, was that a viewing committee con-
sidered the propriety of "Apollo, " when the figure
was uncrated, and had "a satin sash tastefully draped
around it" before it was placed on display (410, Ap
10 1922 14:6).

1922, May 8

"A Dr. Jekyll and Mr. Hyde personality, " Justice
Herbert commented in Special Session Court, New
York City, upon sentencing Lorenzo Dow Covington
--writer, lecturer, explorer, archaeologist, Fellow
of the Royal Geographical Society in England, and
"one of the world's foremost Egyptologists"--to an
indeterminate sentence of from six months to three
years in the penitentiary, following Covington's con-
viction of having obscene pictures and literature in
his home.

After his arrest on March 27 on complaint of
John S. Sumner, Secretary of the Society for the

Suppression of Vice, Covington had spent ten days
under observation in Bellevue Hospital before he was
released as "sane." Sumner had seized 240 pictures
from Covington's home on a search warrant, issued
after two men who had been convicted of possessing
obscene pictures reported that they had bought them
from Covington.

The Egyptologist explained in court his reason
for purchasing the material--from a friend who
brought them from Spain:

> "I felt that these pictures and the literature
> would help me in my studies of human nature"
> (410, My 9 1922 2:4).

1923 (A) On a charge of "defaming public morals"--specifically
of "corrupting the inborn sense of shame and virtue
innate in the German people"--George Grosz was
brought into court in Germany (30:21-23), for his
"satirical book on jungle sex morals, Ecce Homo"
(538:293). The 16 colored lithographs and 84 mono-
chrome lithographs of the publication, in biting so-
cial comment on Berlin of the 1920's showed apo-
calyptic scenes of moral depravity--crime, lust,
murder and hypocrisy in "slum brothels and elegant
hotels, the criminal hangouts and the taxi dance-
halls, the red light districts, the worker's hovels
and fancy apartment houses." "Although the emi-
nent journalist Maximilian Harden" was among those
testifying in his defense, Grosz--found guilty--was
fined 6,000 marks, and "some twenty-four plates
(including one of a prostitute wearing a cross) were
confiscated from unsold copies of the portfolio" (30:
21-23).

1923 (B) In an outbreak of student violence and other antago-
nism in Mexico "fostered by the church against art-
ists of the Syndicate of Painters and Sculptors who
condemned superstition and ecclesiastical rule in
their murals on public walls" (485:30), the Jose
Clemente Orozco frescoes in the National Prepara-
tory School in Mexico City were attacked by religious
groups as sacrilegious. Damas Catolics (Catholic
Ladies) shrouded the panel in the school's patio in
sheets, sacks and leaves to hide its subject--"Ma-
ternity," called the "Nude Madonna" by the censor-
ing group. The first and second floor panels, de-
faced by students with sticks, rocks, and knife
gashes, pictured Christ as a laborer chopping down
his own cross, and Franciscan monks feeding the
hungry and caring for lepers (485:9-11). Orozco
restored the defaced frescoes in the years following
--1924 to 1928--at the invitation of Dr. Alfonso
Pruneda, rector of the National University, with

the support of Mexican President Plutarco Calles,
and Secretary of Education Dr. Puig Casaurano
(485:30).

1923, January An architect, Irving K. Pond, spoke out against "the
legal straight-jacket" being applied to United States
architecture from state licensure requirements, and
from the review of proposed structures by architec-
tural commissions--24 of the 48 states had enacted
laws that prohibit the practice of architecture to
those "not qualified, under a prescribed examination,
as a structural and as a sanitary expert," according
to Pond's complaint, and architectural commissions
have been established "to pass upon the artistic
merit of the design of a building intended to be
erected by a private owner upon private property,"
with power to forbid construction (461:4-5).

1923, Febru- "On the ground of indecency," Paris police removed
ary 10 Raymond Duncan's painting "Maternity"--"dealing
with the subject of childbirth"--from the Salon of
the Independent Artists 34th Annual Exhibition on
the opening day of the art show. "Maternity," one
of about 5,500 works of art by more than 1,600 art-
ists on display, had "shocked the bourgeois," a feat
that the Independent Artists had achieved from time
to time--especially as "Les Fauves"--since their
founding in 1884, but which the Salon "finds more
difficult in recent years."

 Duncan carried the banned picture away under his
Greek robes, but when he attempted to capitalize on
the publicity of his work being censored at the Salon
by arranging a private showing of the painting in his
home with a charge of a franc for each viewer, the
Prefect of the Seine barred this private exhibition of
"Maternity" "on charge of outraging public morals,"
and ordered him to appear before the State's attorney
(410, F 11 1923 3:5; My 16 1923 22:4).

1923, August "Venus and Adonis," a statue by American sculptor
18 Frederick MacMonnies whose public commissions had
made him both rich and famous, was placed on view
at New Rochelle Public Library in New York. When
the figures--recently purchased by and on loan from
the Metropolitan Museum of Art in New York City--
were condemned by groups in the community as "im-
moral," exhibition authorities ordered them draped.
After the curious, attracted by a deluge of newspaper
publicity of the censoring, crowded to see "Venus
and Adonis," the sculpture was returned--on August
23--to the Metropolitan Museum (410, Ag 19 1923 13:
1; Ag 21 1923 6:5, 36:6; Ag 22 1923 15:5; Ag 23
1923 9:2).

1923, August Vogue magazine, published in New York City by
24 Conde Nast, was sued by Mrs. Therese Lind on
 charges that the magazine published a reproduction
 of a statue by A. S. Calder consisting of a bust
 for which she had posed and a naked torso of an-
 other woman. Mrs. Lind alleged she posed for the
 statue with the understanding that it was to be draped
 (410, Ag 25 1923 11:1).

1923, Decem- According to George Creel, Chairman of the newly
ber 16 organized National Council to Protect the Freedom
 of Art--an enlargement and reorganization of the
 Joint Committee for the Promotion and Protection
 of Art and Literature--the purpose of the National
 Council (consisting of various groups of authors,
 actors, playrights, musicians, motion picture pro-
 ducers, and artists--such as the Guild of Free
 Lance Artists) is a "nation-wide fight on all kinds
 of censorship." The organization urged repeal of
 existing censorship laws, as it considered censor-
 ship of one form of expression a threat of regula-
 tion and banning in all forms (410, D 17 1923 11:1).

1924 (A) Since its founding in 1873, the New York Society for
 the Suppression of Vice had "confiscated" "on an
 average of nearly 65,000 obscene pictures and post-
 cards each year," and in fifty years activity, "the
 total of such confiscations was three million" (182:
 265).

1924 (B) Leon Trotsky published Literature and Revolution,
 defining the place of art in a revolutionary society
 as "one of relative freedom under 'watchful revolu-
 tionary censorship'". He visualized art in the serv-
 ice of the revolutionary state, and discussed "Our
 Marxist conception of the objective social dependence
 and social utility of art..." (108:457, 462).

1924 (C) From 1923 to 1925 Salvador Dali was interested in
 scuola metafisica, the Metaphysical School, founded
 by Giorgio de Chirico and Carlo Carra in Ferrara
 in 1915-1916. Suspended from the Madrid School of
 Fine Arts--in 1924--"for a year on a charge of inciting
 the students to insurrection against the School authori-
 ties," he returned to the School for a time, "but was ex-
 pelled permanently in October, 1926, presumably on the
 grounds of extravagant personal behavior" (552:4-5).

1924, May Editor Francis Crowninshield of Vanity Fair decided
 that "fashion in the obscene" had changed from 1917
 so that he ran a picture by Rockwell Kent, showing
 a humorous attic scene with a woman standing in a
 tub with her back to the reader, draped only by a

towel. This same drawing when it was submitted to the editor seven years earlier had been censored, and was included in the magazine at that time only when the artist had added "a corset, a pair of bloomers, and high-laced boots" to cover "objectionable" parts of the woman's anatomy (182:261).

1924, August 7 The provisions of the resolution of the International Convention for the Suppression of the Circulation of and Traffic in Obscene Publications--meeting under the auspices of the League of Nations at Geneva--made it "a punishable offense" to trade, distribute, or publicly exhibit "obscene... drawings, prints, paintings, pictures, posters, emblems... or any other obscene objects," including the importing or exporting, or advertising such "obscene matters or things" (283).

1924, November 10 After spending nearly a month on parole or in jail, Earl Carroll--showman famous for his Vanities in New York City--was freed. An allegedly "improper poster" advertising the musical, Vanities, caused Carroll's arrest on October 7, and--in an effort to "show-up" the city's "self-appointed censors"--he had refused bond and was taken to prison, on October 30. A week later--November 4--he accepted freedom on bail, and authorities finally dropped the charges in a highly publicized case (410, 0 8 1924 1:2; 0 17 1924 23:5; 0 18 1924 14:6; 0 31 1924 1:5; N 1 1924 17:3; N 4 1924 14:1; N 11 1924 6:2).

1924, November 29 A New York Appellate Division Court reversed (People v Baylinson) a lower court's conviction of A. S. Baylinson, Secretary of the Society of Independent Artists, for permitting the painting, "Marriage of Cana, or Father, Forgive Them, For They Know Not What They Do," by J. François Kaufman to hang in the Society's annual exhibition at the Waldorf-Astoria Hotel in New York City--as one of the 800 works of art shown beginning February 22, 1923. The picture--a satire on prohibition depicting prohibitionists William Jennings Bryan and United States Congressmen Andrew J. Volstead and William H. Anderson--had been objected to by the public, but Society president John Sloan and Baylinson refused to remove the painting. Not all observers were offended by the painting--Father McGinnis made a public announcement that it should be distributed throughout the United States--but when Magistrate Ryttenberg considered the charge that the picture violates the Penal Code, he recommended for trial as "outraging public decency." Raylinson was arrested, on May 23, for allowing the picture

to be publicly exhibited (410, F 23 1923 6:4; F 25
1923 1:5; F 26 1923 12:5; F 27 1923 40:3; F 28
1923 12:2; Mr 11 1923 IV, p 12; Mr 16 1923 4:4;
My 26 1923 8:4; My 29 1923 14:4; My 30 1923 14:6;
N 29 1924 15:2).

The court found that while the artist might be
guilty of sacrilege or blasphemy--not a crime under
New York state laws--or of "bad taste" in his car-
toon against enforcement of the existing laws pro-
hibiting the sale and manufacture of intoxicating
liquors, there was no evidence of "willful intent"
on the defendant's part in display of the picture,
no proof of disturbance or outrage of public decency
at the exhibition. Baylinson's conviction was re-
versed, the information dismissed, and the fine
paid by the defendant remitted to him (151:74-76).

1925 (A) When sculptor Jacob Epstein's "contorted female
nude" relief memorial to English naturalist William
Henry Hudson--showing "Rima," the bird-girl hero-
ine of his novel Green Mansions--was unveiled by
Prime Minister Stanley Baldwin in the Bird Sanctuary
in London's Hyde Park, he was heard to exclaim as
he pulled the cord revealing the figure, "My God"!
(575, 1959:173). The figure described as "bovine in
form with tremendous sagging muscles" was called
by press and public "grotesque" and "horrible."
Londoners joked that "Rima" "scared the birds
away," and showed their disapproval of the sculpture
more concretely by painting it green, and later by
tarring and feathering the bird-girl (575, 1929:176).

1925 (B) The Indian Penal Code set forth, in Section 292, the
Obscene Publications Act containing the main provis-
sions against obscenity in the general law of India:
"reasonable restrictions upon the freedom of speech
and expression... in the interests of decency or mo-
rality" of the country. It prohibited the sale, dis-
tribution, import or export of "obscene drawings,
painting representation or figure," as well as of ob-
scene books. Specifically exempted from the stric-
tures are "any... drawing or painting kept or used
bonafide for religious purposes or any representa-
tion sculptured, engraved, painted or otherwise rep-
resented on or in any temple or any car used for
the conveyance of idols or kept or used for any re-
ligious purpose" (375:1-2).

1925 (C) President Calvin Coolidge answered an official invi-
tation to send an American representation to the Ex-
position des Arts Decoratifs held in Paris this year:
"America has no art to send" (495:393).

1925 (D)	Gutzon Borglum--upon being dismissed from his commission to carve the rock wall of Stone Mountain near Atlanta, Georgia, with Robert E. Lee and other figures representative of the Confederacy-- destroyed his designs and models for the "Confederate Memorial. " The project was plagued with dissension because (according to the artist) the state of Georgia demanded inclusion of Klansmen among the memorial figures, and the great expense (estimated at $2,000,000) which exceeded any estimates. Georgia sued sculptor Borglum for his destruction of the designs and models, but the artist won his case by testifying that these designs and models were his personal property to be disposed of as he pleased, and that only the carvings on the mountain wall were the project commissioned by and belonging to the state of Georgia (142:490-491).
1925, February 4	The National Council for the Protection of Literature and the Arts was formed, with the purpose: "To oppose all forms of Censorship" (410, F 5 1925 21: 7).
1925, May 7	"A set of fossils, " a hostile critic called the officers of the National Academy of Design in New York City, because they stood "for strongly biased censorship in their own exhibitions, " and were "a group of men who want to standardize their own work and dictate to the country what shall and shall not be accepted as art. " This criticism of the groups' "academic system of censorship" had been called forth by Edwin Howland Blashfield's proposal as President of the Academy that the organization raise $6,000,000 in an expansion drive (341:303-304).
1925, August 15	The newly installed statues--symbolizing Rhine and Moselle wine and champagne--unveiled a week ago on the Wine Auction Building in Coblenz, Germany, were found "unacceptable" by the Censorship Committee on account of the nudity of the figures. When the censors demanded that the sculptor dress the undraped statues, he "saw no possibility of carving garments on the figures. " Official decision: This year's wine auction will be carried out before sheeted symbols (410, Ag 15 1925 10:8).
1926	In France "a publisher was imprisoned for issuing a brochure containing articles and drawings from the magazine Le Cupidon" (137:156).
1926, March 26	The New York Society for the Suppression of Vice issued its annual report decrying the deluge of "indecent pictures and immoral literature" now flooding

the country, and finding Magistrates, Courts and Press, and the United States Post Office and Justice Departments all remiss in the fight against indecency (410, Mr 27 1926 9:1).

1927-1928 The "Venus de Milo," appearing on a Palmolive Soap advertising poster, was shown in Montreal, Canada, with a "white patch across the breasts" due to local censorship regulations (16:134).

1927 (A) When he returned to Cedar Rapids, Iowa, after studying at the Academie Julian in Paris, artist Grant Wood received a $10,000 commission for the stained glass window in the Grand Rapids Memorial Building, housing the local American Legion post. Wood arranged for the window to be made in Munich --"where the best stained glass workers were to be found"--but the finished window was rejected by the Legion "because it was made in Germany" (495:399).

1927 (B) Among the first of German sculptor Ernst Barlach's major public works of art removed or destroyed by Hitler as "un-German" art, was "Hovering Angel," in the church at Gustrow. Other Barlach monuments "removed during the Third Reich," because they were outside "conventions of traditional sculpture" and marked by public antagonism whether on public display in museums or commissioned memorials to World War I, were: "Fighter of the Spirit," memorial honoring the soldier dead of the University of Kiel--removed in 1928; "Three Soldiers," memorial in Magdeburg Cathedral--removed in 1929; "Mourning Mother and Child," relief stele, Hamburg--removed in 1931. These monuments were set up again after World War II, and the figures for the facade of St. Catherine Church in Lubeck--three of which were completed by 1933--could at last be installed with the collapse of the Nazi regime and its proscription against Barlach's work (405:150).

1927 (C) "Prudery caused certain nudes to be removed by the police" from the Annual Exhibition of California, at the Oakland Art Gallery (7, 1929:68).

1927 (D) The United States Customs Division "was given the status of a bureau by Congress, with direct control over its own investigative force" (626:87).

1927, January 28 "The Censorship Mania," New York Times' comment editorially on the proliferation of bills banning and limiting a variety of arts in the New York State legislature at Albany, attributed such evidence of "a mounting desire in this country to control and stand-

ardize everything" to the Anglo-Saxon character
trait "earnestness," that is an "overwhelming im-
pulse to make everybody exactly like yourself" (410,
Ja 28 1927 16:3).

1927, Febru- "Not Art," was the decision announced by United
ary 23 States Customs spokesman F. J. H. Kracke, after
 an "extensive investigation" as to whether the works
 of Rumanian sculptor Constantin Brancusi were ad-
 missable as duty-free art, or were dutiable at the
 rate of forty percent as "mere merchandise." The
 Customs decision meant that eight works sold by
 Brancusi in the United States for about $10,000
 were subject to government tariff charge of $4,000.
 The ruling followed the unanimous opinion of art ex-
 perts--"several men high in the world of art"--that
 Brancusi's work was not art because it "left too
 much to the imagination," and that none of the ex-
 amined sculpture, in their judgment as art authori-
 ties, could come under the duty-free category as a
 work of art. Informal comments of individual ex-
 perts included:
 "If that is art, then I'm a bricklayer."
 "Dots and dashes are quite as artistic as
 Brancusi's work." (410, F 24 1927 23:1).

1927, Febru- Marcel Duchamp, famed French cubist painter of
ary 26 the controversial picture "Nude Descending a Stair-
 case" the sensation of the Armory Show of 1913,
 carried fifteen bronze statues by his friend Constan-
 tin Brancusi with him when he left on the liner
 "Paris" for France. The works--refused admittance
 to the United States by the Customs Service who
 said they were "not art," and therefore dutiable--
 are to be exhibited in Berlin. Duchamp, interviewed
 in New York before his departure, said that Bran-
 cusi had not given up his efforts to have the Customs
 recognize his works as art, and was appealing the
 decision barring their free admittance:
 "To say that the sculpture of Brancusi is not
 art is like saying an egg is not an egg" (410, F
 27 1927 I, 14:1).

1927, March 4 Budapest police in "a frenzy of morality" banned the
 showing of a photograph of the "Venus de Milo"--
 Greek statue on display in the Louvre--from a shop
 window in the Hungarian capital (410, Mr 5 1927
 12:2).

1927, March 7 Assessment of the censorship situation in Europe,
 as reported in the New York Times, indicates that
 not only in Puritan-conscience America, but also
 in "the higher culture of Europe" the censor did

not hesitate in suppression:
 Active censorship in Central Europe, including
 Germany--Reichstag action on the far-reaching
 "Trash and Smut" bill;
 Italy--Mussolini vies with the Vatican "as a
 censor of morals" (410, Mr 7 1927 18:5).

1927, March "In a political bid for the support of ecclesiastical
23 authorities, " the Fascist Chamber of Deputies in
 Italy is considering a drastic censorship bill to wipe
 out pornography and sedition in all artistic expres-
 sion--press, stage, art, motion pictures, phonograph
 records, and advertisements. The proposed censor-
 ship administrative agency of the Government--"Cen-
 tral Pornographic Office"--will decide which works it
 considers "offensive to public order, morality, or
 religion, " with the penalty for convicted offenders
 three years imprisonment (410, Mr 24 1927 1:2).

1927, May 17 The Reichstag finally passed Germany's long-con-
 sidered morality law on the third reading of the
 bill "protecting youths of both sexes up to the age
 of eighteen from... art shows, " and other perform-
 ances and exhibitions which would taint their morals
 (410, My 18 1927 18:5), "undermine culture, " and
 purvey "moral dirt" (61:266).
 The "Trash and Smut Bill" ("Schund und Schmutz")
 (7, 1928:142) was adopted "through the efforts of the
 clerical and reactionary elements, " and aimed
 against offensive art, including "indecent prints and
 pictures. "
 German artists almost "unanimously opposed the
 measure, " and the Prussian Academy of Fine Arts
 issued a manifesto when the censorship law was under
 consideration, saying that the statute "contains im-
 measurable damage for 'intellectual' freedom of the
 German Republic, and might occasion tremendous
 damage to genuine works of art" (410, N 26 1926
 7:1). On its second reading November 29, 1926,
 the bill failed to pass in its entirety--the section
 providing for creation of national and state censor-
 ship boards being defeated 181 to 191 (410, N 30
 1926 8:4; D 8 1926 26:2). Herr von Kendel, Minis-
 ter of the Interior, championed the bill as "merely
 an extension and completion of the law prohibiting
 painting and selling of obscene and trashy matter, "
 and a law "necessary to guard the innocent" (410,
 My 18 1927 18:5).
 Police under the measure are given wide powers
 of enforcement--supervision of dancing in homes,
 entry into private homes, protection of children
 from parents--and the law, as proposed, provides
 for delegates of Protestant and Catholic churches

to have seats on the art commission of Berlin's Po-
lice Headquarters. Examples of the acts "verboten"
--a term "made notorious throughout the world" by
the paternal dominance of the last Kaiser (410, Ja
3 1927 18:5; F 27 1927 II, 1:2)--are:
> No admittance of youths under
> 18 to art exhibitions "not certi-
> fied as pure by boards of police
> censors";
> No participation of girls and boys under 18 in
> "Life Classes" in art academies. "

The general climate of art censorship in Germany
is demonstrated by a recent incident in Cologne when
official exception was taken to the reproduction of a
classic picture of the naked Christ Child in Koel-
nische Volkszeitung, the paper of the Catholic Cen-
tre Party.

1928 (A) Professor Paul Schulze-Naumberg, noted German
architect and city-planner, published a book, Art
and Race, explaining "hereditary determinism" in
art, and showing that "the artist cannot help but
reproduce his own racial type in his creations. "
This publication marked "the birth of the concept
of 'degenerate art'" in Nazi aesthetics (126:52).

1928 (B) Surrealism--"without question the greatest artistic
commotion of the twentieth century" (125:133)-- pro-
duced a silent film "Un Chien Andalou, " the work
of Salvador Dali and his fellow Spaniard Luis Buñ-
uel, that was an immediate succès de scandale when
it was shown in Paris. This first surrealist motion
picture, one of the classics of experimental cinema,
caused riots and extensive public and press comment
because of the subject matter and the "crystalline
intensity" (125:166) of its treatment--as in the pro-
logue when a "razor-blade passes through a girl's
eye, slicing it in two" (actually an ox-eye, bought
from a butcher). "L'Age d'Or, " second master-
piece of surrealism in cinema--and also the work
of Dali and Buñuel--caused a similar scandal when
it was shown in Paris in 1930.

1928, January By an act of "pre-censorship" the Oakland, Cali-
fornia, Library Board took up the cudgel for the
sake of morality when they informed William H.
Clapp, Director of the Oakland Art Gallery, that
all future exhibitions (which were held in a Library
building) must be pre-approved by a "reconsideration
jury. " This ultimatum was sparked by a display of
thirty modern European paintings "containing not on-
ly nudes, but distorted nudes. "

The press and artists--both those painting in
radical and conservative style--attacked the Library
Board's edict, with no effect. The problem of art
censorship in Oakland was solved by moving the Art
Gallery from the Library building to a new location
beyond the jurisdiction of the Board (7, 1929:68).

1918, July 9 Two nude paintings were seized from the lounge of
the Fifth Avenue Playhouse in New York City by
John S. Sumner, Secretary of the Society for the
Suppression of Vice, on the grounds that they were
"indecent pictures, " and the manager of the theater
was arrested for their display. The two pictures,
previously exhibited at the Weyhe Galleries, New
York City, were among some fourteen on display in
the theater lounge and their painter, Arche Bonge,
six-foot-six doorman of the Paramount Theater, was
a young artist who recently worked his way through
the Art Institute of Chicago as a theater doorman.

Sumner said his action was taken on "three or
four complaints" about the painting made to his of-
fice. The manager of the theater explained that it
was his policy--of some years standing--to allow
artists to use the lounge as a display are for their
works, and that Sumner had insisted on going to
trial over the charge, although he had offered to
remove the offending paintings (410, Jy 10 1928 17:
4; Jy 27 1928 23:3).

1926, Novem- In the most famous legal challenge of the United
ber 26 States Customs Service classification of art works
by "representational and utilitarian tests" (154:1240),
the case of Constantin Brancusi to recognize his
"Bird in Space" as duty-free art rather than a
"manufacture of metal" taxable at 40% of value--
which was $210 of its declared value of $600 as
art, although its tariff category, according to Cus-
toms, was as "hardware, " with kitchen utensils and
hospital supplies (558A)--was concluded with "a stun-
ning victory for modern art" in a landmark Customs
Appeal Court decision by Judge Byron C. Waite,
with Judges George N. Young and Genevieve R.
Cline concurring (Brancusi v United States T. 43063
54, Treas Dec 428, Cust Ct 1928).

The trial had opened in the United States Cus-
toms Court, Third Division, on October 21, 1927.
Expert witnesses for the plaintiff testifying that the
sculpture was fine art included Capt. Edward
Steichen, U. S. N. R. , photographer and purchaser
of "Bird in Space"--that became known by the popu-
lar title "Bird in Flight" (558A)--Frank Crownin-
shield, editor of the magazine Vanity Fair, sculptor
Jacob Epstein, Forbes Watson, editor of The Arts,

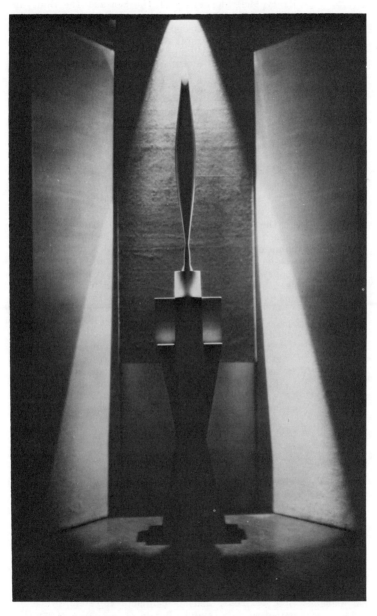

25. 1928, November 26. Constantin Brancusi. Bird in Space.
Captain Edward Steichen Collection

Henry McBride, critic of The Sun and The Dial, and
William Fox, Director of Brooklyn Museum. Two
academic sculptors appeared as government witnes-
ses: Robert Ingersoll Aitken, and Thomas H. Jones
(410, 0 23 1955 VI:26).

In order to prove that "Bird in Flight" was a
work of art--not a "manufacture of metal" dutiable
at $240 on its $600 valuation--it was necessary to
fit the work into the 1916 Treasury Department dic-
tionary definition of sculpture (an "imitation of natu-
ral objects... in their true proportions of length,
breadth, thickness"), and to show that:

1. It was not an object of utility (although the
 government counsel "insinuated... it might
 be suitable for a kitchen or hospital");
2. Brancusi was a professional sculptor;
3. The bronze figure was an "original sculp-
 ture" (410, 0 23 1955 VI:26).

The "true proportions" of the "Bird" were dis-
cussed (481:80; 531:241-242; 626:226-227)--Steichen
admitted that if he "would see it in a forest... he
would not take a shot at it (512A:210); Judge Waite
observed that "the importation... is characterized...
as a bird... It has neither head nor feet nor feathers, "
and found the sculpture so difficult to describe ver-
bally that he "ordered a photograph" of "Bird in
Space" attached to the court opinion. He concluded
his decision:

"It is beautiful and symmetrical in outline, and
while some difficulty might be encountered in
associating it with a bird, it is nevertheless
pleasing to look at and highly ornamental, and as
we hold under the evidence that it is the original
production of a professional sculpture, and is in
fact a piece of sculpture and a work of art ac-
cording to authorities... We sustain the protest
and find that it is entitled to free entry... " (592).

Although Judge Waite intended in his decision "to
strike down the representation test for determining
what qualifies as art" in the United States Customs
classification (154:1240)--through his "liberal inter-
pretation of sculpture in the tariff law" (512A, 210):

"to be art, a work by a recognized sculptor
need not bear a striking resemblance to a natu-
ral object, "

the old outdated "articifial representational standard
prevailed" for almost thirty years more (154:1240)
(ILLUSTRATION 25)

1928, Decem- George Grosz, and his publisher Herzfeld, were
ber 10 called to face trial in Berlin on a charge of sacri-
 lege because of two satirical drawings by Grosz in
 the portfolio Hintergrund (Background), which con-

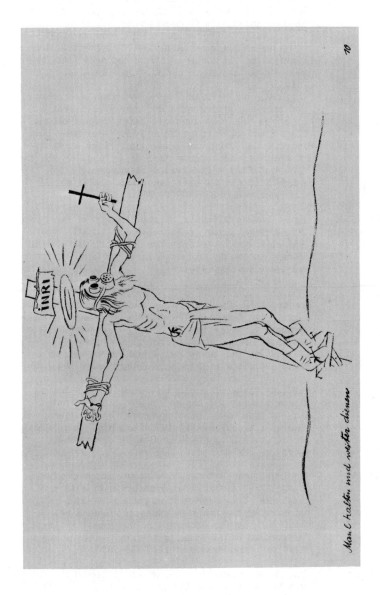

26. 1928, December 10. George Grosz. Christ in a Gas Mask, illustration from Hintergrund

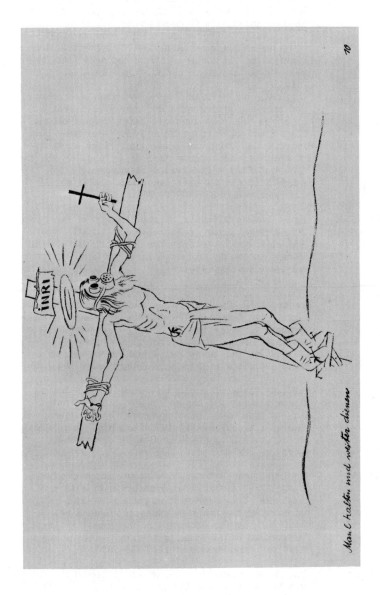

225

sisted of stage sets for the play by Jaroslav Hasek
The Good Soldier Schweik. " "The offending plates
were the famous ones of Christ in a gas mask and
another depicting a German pastor balancing a cross
on his nose. " Church authorities indicated they
were pressing their suit against Grosz, whose bit-
ter drawings of social comment had seen him "re-
peatedly summoned to court... but always let off"
(410, D 7 1928 10:6).

Grosz and Herzfelde were convicted of blasphemy
and sacrilege and fined 2, 000 marks each, but on
appeal in the following year, Judge Siegert of the
State Court of Berlin reversed the conviction "hold-
ing that the artist had 'made himself the spokesmen
of millions who disavow the war' by showing how the
Christian Church had served an unseemly cause
which it should not have supported" (30:21-23, 64;
538:293). (ILLUSTRATION 26)

1929-1933? Ernst Ludwig Kirchner, German leader of Die Brucke
(The Bridge) group of Expressionist artists, was
commissioned to decorate the Folkwang Museum at
Essen, but Nazis prevented Kirchner from carrying
out these murals (448).

1929? "On complaint to the police department that a well-
known, first-class bookstore was selling dirty post-
cards, two female police officers were sent to make
purchases. " The nude they bought--extended full
length in the painting reproduction--was by "Gior-
gione, " but that name meant nothing to them or to
their superiors in the police department. When the
offending bookseller was brought to court, he "was
not only exonerated, but was made to feel that the
law was sorry for having annoyed him. " The pic-
ture at trial was "Sleeping Venus" by Giorgione,
famous fifteenth century Venetian artist, displayed
in the original in the State Gallery in Dresden,
Germany (199:21).

1929 (A) The American Artists Professional League, with
about 2000 members, tried unsuccessfully to have
the United States government put a protective tariff
on contemporary foreign works of art in a new
tariff bill, on the grounds that the American artist
"is entitled to the same protection as the American
steel or textile manufacturer" (7, 1930:75).

1929 (B) The D. H. Lawrence book of his Collected Paintings
was banned from the United States by the Customs
Department (245:91; 306:10).

1929 (C) The "Censorship of Publications Bill" was enacted

by the Irish Free State. Its five-member Board of
Censorship, chosen by the government, proscribed
publications and the official register of books and
periodicals banned exceeded 150 pages. The roster
of thousands of authors was so extensive, that a
critic of the Board of Censorship said their motto
might be:
"If its good, we've got it" (163:378-379).

1929, March Eighteen leading societies of culture in Germany
11 held a protest meeting in Berlin against the attempt
 to re-establishment of censorship of the creative
 arts in Germany. The meeting heard a letter from
 Gerhart Hauptmann read ("... We will fight until
 the last breath for the liberty of art"), and listened
 to speeches by Kathe Kollwitz and other artists and
 writers, before establishing as permanent their
 "fighting committee against censorship" (410, Mr
 12 1929 5:1).

1929, April 5 A well-known firm of booksellers in London refused
 to stock a book--Leon Feuchtwanger's Ugly Duchess
 --because (according to report of The Daily Mail)
 they "banned the book jacket, which bore a reproduc-
 tion of the famous portrait of Margarete, Duchess
 of Carinthia and Tyrol by Quintin Matsys, sixteenth
 century Flemish artist. Messrs. Martin Secker
 Ltd, Ugly Duchess publishers, refused to produce
 a different jacket (525:178).

1929, July 5 "A fragment of human pudenda" was the test police
 used (332:670; 505:923) in determining which of the
 25 paintings by D. H. Lawrence, on exhibit in Lon-
 don at the Dorothy Warren Gallery since June 14,
 they would seize, according to the artist. Law-
 rence's single, brief exhibition of pictures, made
 since he started to paint in 1926 at forty years of
 age, had "opened amid the repercussion of the scan-
 dal created by the appearance of Lawrence's novel,
 Lady Chatterly's Lover" (143:40). After the show
 had been open for six weeks--during which time it
 was viewed by more than 12,000 persons, and at-
 tacked by art critics "on both aesthetic and moral
 grounds" (333:22-23)--two policemen--an inspector
 and a sergeant--"expressed horror at what they saw
 in the Gallery," and returned later this same day
 with reinforcements to remove 13 paintings, and
 four copies of the Mandrake Press book of repro-
 ductions of the paintings, as indecent. At this
 same time they also "impounded a volume of draw-
 ings by George Grosz" (333:22-23).
 Herbert G. Muskett--prosecutor in the case
 heard August 8 at Marlborough Police Court before

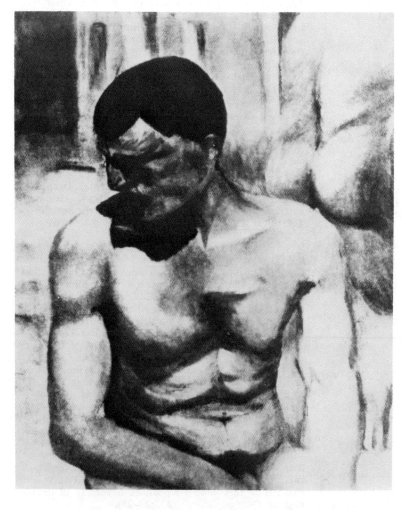

27. 1929, July 5. D. H. Lawrence. Contadini--"idealized
self-portrait. " Whereabouts unknown since World War II

Magistrate Frederick Mead, aged eighty-two--
characterized the pictures as "gross, coarse, hide-
ous, unlovely, and obscene" (248:16-17). Experts
whom the defense wished to call--Arnold Bennett,
Augustus John, Sir William Orpen--were not allowed
to testify--later, Rebecca West called the impound-
ing of Lawrence's paintings "an appalling indiscre-
tion" (in the September Bookman), and Aldous Huxley
attacked the suppression of the pictures (in the No-
vember Vanity Fair).
 Magistrate Mead found that "it is utterly im-
material whether they are works of art or not.
The most splendidly painted picture in the universe
might be obscene, " and should be "put an end to,
like any wild animal which may be dangerous. "
He returned the censored pictures to the defendants
(Mr. and Mrs. Philip Trotter, the persons respon-
sible for the exhibit), with the provision that the
paintings would not be shown publicly again, and
ordered the four volumes of reproductions of the
paintings destroyed (333:23-24; 410, Jy 6 1929 4:4;
Jy 7 1929 VIII, 10:1; Ag 9 1929 6:7). (ILLUSTRA-
TION 27)

1929, Sep- A London periodical used "a few strokes of the re-
tember touching brush" to make the stone figure of a nude
 little boy "publishable, " when it pictured sculptor
 Jacob Epstein's "Day, " recently unveiled in London
 as an over-entrance figure at the London Under-
 ground Railway Office (335:5).

1930-1959 Because they "flouted the convention of wall paint-
 ing, " the murals of Thomas Hart Benton--two in
 New York City, one in Indiana, and one in Missouri
 --were 'storm centers' of controversy. " "The ac-
 tual scenes and living characters" they depicted in
 "crime and violence, agrarian occupations, industrial
 activities, night life in the cities" (141:126) caused
 "public and critical clamor. " The pictures in the
 New School for Social Research, New York City,
 were criticized as "degrading America. " The In-
 diana murals--including Ku Klux Klan members, and
 a rioter throwing a rock at a soldier--were labelled
 "utter depravity" and "pictures of infamy. "

1930's (A) The Nazis in Germany found "the flat roofs and un-
 compromising lines of the 'International Style' in
 the work of such internationally renowned architects
 as Gropius and Ludwig Mies van der Rohe" anathema,
 and "forced modern architects to construct gabled
 roofs on houses which had been designed with flat
 ones so that they might appear more echt deutsch"
 (27. Existing structures and figures not conforming

to the Nazi official aesthetic were selectively de-
molished--as the memorial at the Berlin-Lichten-
berg Cemetery, designed by Mies van der Rohe for
Rosa Luxemburg and Karl Liebknecht, who were
"murdered by right-wing radical officers," which
was destroyed (487:15), an official order.

1930's (B) Self-denominated pressure groups "presented a well-
organized attack on the Dallas Museum of Fine
Arts," complaining of "female nudity in pictures
and sculpture" in the Dallas Museum as "immoral"
art (508:200).

1930's (C) Judge John E. McGeehan, a Roman Catholic, attemp-
ted to have a portrait of Martin Luther removed from
a New York City courtroom mural illustrating legal
history.

1930's (D) The "International Style" of architecture was con-
demned in Russia as "formalist" and "Western"--
although during the preceding decade a "considerable
number of buildings of this style under the influence
of Le Corbusier and Gropius had been designed"--
and urged Russian architects to "look backward" for
inspiration to Imperial Rome and Imperial Russia
(27).

1930 (A) Some artists in San Francisco objected to the com-
mission awarded Diego Rivera to paint one of the
murals for the New Stock Exchange Building in the
city on the grounds that he was a Communist (7,
1931:577). Rivera's "most controversial and pole-
mical murals" belong to this period--after his ex-
pulsion from the Communist Party in 1929--among
them, the panels he painted in the Hotel Reforma,
Mexico City, that "satirized dictatorship in a poster-
like manner" (204:145-146).

1930 (B) Alfred Rosenberg, German Nazi leader and writer,
published the book, Myth of the Twentieth Century
(Der Mythus des 20. Jahrhunderts) which "became
the accepted Bible of Nazi ideology." About one-
third of the publication "deals with the Nazi doc-
trine of art," and elevates Professor Schultze-
Naumberg's racial art teachings, of 1928, "to the
rank of official Nazi party doctrine" (126:52). Hit-
ler, as Fuhrer, dictated Germany's art--along with
other cultural expression. He had taken an exami-
nation to enter Vienna's Academy of Fine Arts
twenty-three years before, but was rejected--accord-
ing to the Academy's Classification List: "Test
drawings unsatisfactory." On a second try a year
later, his drawings had been judged so poor that

he was not even admitted to examination for en-
trance to the art school (620:59).

One of the first Nazi official actions--when they
gained power in Thuringia, a state of the Weimar
Republic--"was to eliminate works by expressionists
from the Schlossmuseum in Weimar (620:59), be-
cause in Hitler's words (270:352-362) they considered
such art "an expression of a mankind subnormal
from the racial point of view. "
 Professor Paul Schultze-Naumberg--whose racial
art teachings published in the book Art and Race in
1928, became official Nazi doctrine--was appointed
director of the Weimar Art School. He explained
in one of his lectures that race dictated response
to art, and "anyone who found esthetic pleasure in
Expressionism was not a German" (270:352-362).
 Nazi proscription in art extended to architecture,
and resulted in the destruction of works not meeting
their standard--as the monument to the Revolution
for the city of Weimar, designed by Walter Gropius
in 1921/1922 in memory of those killed in the sup-
pression of the 1919 putsch (487:15).

John S. Sumner of the New York Society for the
Suppression of Vice had Timothy Murphy, owner of
a picture gallery near Longacre Square in New York
City, arrested on a charge of exhibiting indecent
pictures. The reproductions of nudes in Murphy's
store were mostly by famous artists such as Rem-
brandt and Goya, and when the complaint was heard
in the Magistrate's Court, it was dismissed (180:
135).

Of 740 books on the United States Customs list to
be kept out of the country, "at least half are in
Spanish. " Some books prohibited in Spanish are
not prohibited in French, and some books prohibited
in English are not prohibited in their original French
(148:985).

The International Bureau of Revolutionary Artists in
Russia issued "encyclicals, circulars, instructions,
syllabuses of errors, " and as a central board of
foreign missions in the arts defined the role of art
in the Communist State:
 "Art must be a class weapon" (299, II:825-826).
 Prior to the dictatorship of Stalin, Russian art
had been under less specific structures--Lenin had
held that the function of art is "to relieve and re-
store. " With Commissar for Education A. V. Luna-
charsky's encouragement of art expression, pro-
duction, and education there was as yet no detailed

censorship of art. Trotsky, in his History of the
Russian Revolution, said that Marxism is not a club,
but a philosophy which disciplines the artist.
 Among the currently sanctioned programs for
Communism in other countries was "a program of
action for the United States of America" labelled:
"Guide to Every Phase of Our Work" (299, II: 859).

1930 (G) Members of one of the African Christian churches
 burnt "most of the carvings" at Efon in Ondo Pro-
 vince, southwest Nigeria, thus ending the town's
 activity as one of the centers of Yoruba carving
 (188:92).

1930 (H) Frank C. Pape's drawings for an Urquhart and
 Monteaux edition of Rabelais' Gargantua and Panta-
 gruel caused this edition to be the only one still
 banned by the United States Customs Department be-
 cause of its "so-called obscene illustrations" (245:
 17).

1930, March The United States Senate, after twelve hours of dis-
18 cussion of the censorship of imported obscene books
 and pictures, adopted the Smoot Amendment "extend-
 ing the present law, to make district courts the
 final arbiters of obscenity in literature, art and
 treasonable publications" (410, Mr 19 1930 1:3)
 sent into the United States. The new Tariff Act
 takes from Customs Officials and the Treasury
 Department their absolute authority in censorship
 in banning or admitting books and art (250:23) at
 over three hundred ports of entry into the country.
 By its provisions, authority to decide what is ob-
 scene or immoral in the appraisal and rejection,
 the seizure and destruction of pictures and sculpture
 was removed from the final jurisdiction of the Cus-
 toms and transferred to a regular federal district
 court, with a jury trial, whenever a seizure was
 contested (47:46). "Two items were stricken from
 the class of non-importable works:
 (1) treasonable matter;
 (2) obscene books--
 but the ban on pictures was retained" (447:57).

1930, April Jose Clemente Orozco's proposed mural of Pro-
 metheus at Pomona College in California--planned
 in the heroic size of some 100 square yards--was
 the subject of a special service at the principal
 church in the area, when several local ministers
 denounced the mural on three grounds:
 (1) Prometheus was an unsuitable subject for
 a college wall because the myth symbolized
 rebellion;

(2) The painter was a Mexican, and Mexicans were without respect for established institutions;

(3) Interpretation of a theme as daring as Prometheus should not be entrusted to a foreign artist, unfamiliar with American customs and beliefs (485:179).

1930, May 6 The Cardinal Patriarch of Venice, Italy, "issued a circular to the clergy instructing them to urge their parishioners not to attend the Venice Biennale, " because "paintings have been admitted which offend good taste and decency" (410, My 7 1930 10:5)

1930, June Englishman Yorke, a professional football player, recovered Ł200 damages from Lincoln Newspapers Ltd. for a cartoon which appeared in the Lincolnshire Chronicle, according to a report in the London Times of June 25. Although the artist who drew the cartoon "testified that he had no particular player in mind... the crowd watching a match... identified the plaintiff with the picture, and damages were awarded" (344).

1930, August 9 The German Ministry of Art barred the use of nude models at the Weimar Art School (410, Ag 10, 1930 18:2).

1930, November The Kharkhov Congress in its meeting for "mass organization of Art and Literature" defined "art as a class weapon"--in the motto of the John Reed Clubs (167:8). Leopold Auerbach, in an official report, set forth the USSR plan for artists:
"Artists are to abandon 'individualism' and the fear of strict 'discipline' as petty bourgeois attitudes;
"Artistic creation is to be systematized, 'collectivized,' and carried out according to the plans of a central staff like any other soldieriy work;
"Every proletarian artist must be a dialectic materialist. The method of creative art is the method of dialectic materialism" (167:9).
The slogans of the "Artists' International" expressed the same State use of art as propaganda:
"Art renounces individualism
Art is to be collectivized
Art is to be systematized
Art is to be organized
Art is to be disciplined
Art is to be created 'under the careful yet firm guidance' of a political party
Art is to be wielded as a weapon" (167:215).

1930, Decem- The New South Wales police objected to the publica-
ber tion of Norman Lindsay's paintings in the December
 1930 issue of Art in Australia--after a newsdealer
 had advertised the issue of the magazine as "Pictures
 for Men Only. Wonderful Art Book," and "Deluxe
 Edition of New Art Book Containing 30 Nudes" (118:
 39).

1931 (A) The American Artists' Professional League's fight
 to obtain Congressional legislation "making it man-
 datory for American artists to be employed in paint-
 ing official portraits, when such portraits are to be
 paid for with public funds" was not successful. The
 League will continue these efforts to "protect Ameri-
 can artists," and is seconded in this action by a
 resolution of the American Federation of Arts,
 passed in May at their annual meeting (7, 1932:76).

1931 (B) Professor Lionello Venturi, internationally known
 Italian art historian, refused to take an oath of
 loyalty to the Fascist Mussolini regime in Italy,
 and went to the United States in "voluntary exile,"
 where he was to live the rest of his life.

1931 (C) The Paris gendarmes closed "L'Age d'Or," famous
 surrealist film by Salvador Dali and Luis Buñuel--
 reported to contain "more shocking material: erotic,
 blasphemous, or anti-social (i.e. kicking the blind)
 than any picture ever made"--and the scandal of
 this motion picture "reverberated as far as the
 Vatican" (Art News Annual 21:133-162 D 1952; 125).

1931 (D) The United States Customs Bureau in New York
 City banned a postcard displaying nude frescoes by
 Michelangelo in the Sistine Chapel of the Vatican.
 The law at this time considered all pictured nudity
 indecent (501:73).

1931 (E) "Socialist direction of the creative arts in Russia
 had been consolidated," and a three-fold lexicon
 set forth the "official standard and measure of the
 worth of a work of art":
 partynost--party character
 ideinost--Socialist content
 narodnost--national roots (545:30-31).

1931, Janu- Jose Clemente Orozco's murals at the New School
ary 19 for Social Research in New York City were rejected
 as "unpleasing" by the financial backers of the mu-
 ral project, when they were viewed by officials
 upon completion. Subscriptions to the New School
 Building Fund--according to artist Orozco--were
 refused because he had depicted a Negro presiding

at the panel, "Table of Brotherhood, " and Lenin--
along with Ghandi and Felipe Carillo Puerto, "mar-
tyred governor of Yucatan"--symbolizing "main
political philosophies of the era" (485:205-213).

1931, Janu-
ary 29

Immorality and bad taste in "an obvious attempt to
ridicule" the "Forty Immortals" of the sacred Insti-
tute of France caused a scandalized police censor
in Paris to order "Second Childhood, " a painting
by Anne Marie Carner, removed from the Salon des
Independants at the Grand Palais. The picture--a
"life-sized portrayal of a member of the dignified
French Academy adorned with regulation tailcoat,
sword and cocked hat... but minus trousers" (along
with another painting, "Awakening From the Sleep
of Innocence" by Rumanian artist Georges Florian)
was taken out of the exhibition.

Last year a picture of "Communist tendencies, "
showing the "sorrows of war, contrasted with the
pleasures of profiteering, " had been removed from
the same annual show. One of the attractions of
these annual Salons Vernisages, for "people who
like to be shocked, " is viewing the unjuried works
with "the possibility of seeing a few revolutionary
or immoral canvases before they are condemned"
(410, F 1 1931 III, 4:5).

1931, June 30

On June 2, 1931, after 5, 000 copies of the Decem-
ber 1930 issue of the magazine Art in Australia had
been sold, the Crown Solicitor of Australia raided
two bookshops and the office of the publication in
Sydney to seize all of that issue--containing nude
paintings by Norman Lindsay--and "all blocks and
stereos. " After issuing a summons to the three
companies "to show cause why the material seized
should not be destroyed and to answer a charge of
selling obscene material, " authorities dropped the
case against the booksellers. The case against the
publishers--Sydney Ure Smith and Leon Gellert--was
dismissed by the newly-appointed Attorney-General
of Australia Joseph Lamoro, who pointed out that
Art in Australia could not be branded as obscene be-
cause the publication had been in existence for sev-
eral years, it was artistic and aimed at encouraging
Australian art, it had devoted a special number to
each of "the great Australian artists, " with whom
Norman Lindsay was included "on the score of
ability" (118:40-41).

1931, Octo-
ber 22

"Art assumed new vitality" and New Yorkers dem-
onstrated a stimulated appreciation of the work of
Venetian master Jacopo Robusti Tintoretto (1518-
1594) when John Sumner, Secretary of the Society

for the Suppression of Vice, asked the E. and A.
Silberman Galleries on 57th Street to remove a re-
production of Tintoretto's life-size "Susanna" dis-
played in their second-story window. The Silber-
mans refused to remove the painting, and rejected
Sumner's charge that they were guilty of "moral
turpitude" in exhibiting the reproduction of the four-
century-old picture, which showed Susanna "clothed
exactly as the Bible had described her when certain
prurient minded elders gazed on her. "

Police were required to direct the crowds that
rushed to see "Susanna, " and the Silbermans had
their gallery window washed in order not to dis-
courage an interest in art (410, 0 24 1931 1:2, 0
25 1931 23:7; 0 29 1931 22:8; 427:17; 566:16).

1931, Novem- Anthony Czarnecki, Collector of Customs in Chicago,
ber held up the entry into the United States of three etch-
 ings of nudes by well-known artists--"Three Sisters"
 and "Shallow" by Anders Zorn, and "Venus" by
 James Abbott McNeill Whistler--on the grounds that
 they were obscene and barred from entry under a
 tariff law banning "importation of obscene etchings
 for commercial purposes. "

 The prints, consigned for public sale to Franklin
 J. Maine, manager of the Chicago Book and Art
 Auctions, Inc. , had hung in art galleries all over
 the world for years, but when the case was re-
 viewed in Washington, D. C. , upon Maine's appeal,
 the government upheld the Customs' ban, deciding
 that "while the etchings might be proper in art col-
 lections, both public and private, they were unfit
 for sale. "

 Substitute copies of these prints--already "ad-
 mitted" to the country--were found and sold, among
 a total of 365 prints, by the Auctions as scheduled
 (3:32; 199:21; 410, N 12 1931 27:7; 547:12)--"Three
 Sisters" for $80; "Shallow" for $100; "Venus" for
 $85 (199:21).

1931, Novem- Mrs. Harry C. Fisher, former Countess of Beau-
ber 21 mont and former wife of cartoonist "Bud" Fisher,
 ordered Gerald Cavanaugh, manager of the Hotel
 Marguery where she resided in New York City, to
 remove the painting "Friendship, " depicting two re-
 clining nude figures, by Louis G. Ferstadt, from the
 invitational art exhibition in the hotel's second-floor
 gallery because she found the picture, which had
 been publicly displayed many times since it was
 painted in 1923, "too offensive" (410, N 24 1931
 27:5; 547:12).

1932 John Sloan resigned as president of the Art Students

League in New York City over a controversy concerning the invitation of George Grosz to teach at the League the summer of 1932. The Board of Control of the League reversed its approval of Sloan's invitation to Grosz after it had been tendered, and after accepting Sloan's resignation, the Board reversed itself again and confirmed the appointment of Grosz as instructor (30:23-24).

1932, March 26 The only nude figure ever produced by noted American sculptor Augustus Saint-Gaudens was "Diana" (1892), "a svelte, graceful image of the godess" that "reigned over the Manhattan skyline" atop Stanford White's Madison Square Garden tower until the Garden was demolished in 1925. Seven years later, when the figure came out of her retirement in a Brooklyn warehouse to be installed in Fairmont Park near the new Museum of Art in Philadelphia, Reverend Mary Hubbert Ellis, Primitive Methodist church pastor who led a "youth protection committee" and was "a crusader against pornography" tried "to block Diana's entry into the Quaker City, " on the grounds that she was immoral (142:389-390). Although Reverend Ellis complained that the Pennsylvania Academy and the Art Museum were "as bad as the burlesque theatre for nude pictures, " she and her committee were unavailing in their effort to "stop their putting such things around in the open. " "Diana" was placed in the Park as planned (410, Mr 27 1932 2:5).

1932, April 17 Barse Miller's prize-winning painting "Apparition Over Los Angeles"--depicting Angelus Temple topped by figures floating in clouds--was taken out of the annual Los Angeles County Museum exhibition, according to Museum Director Dr. William Alanson Bryan, because the picture's subject matter was "too controversial for exhibition in a county institution. " One of the floating figures shown by Miller was easily identified as red-haired Aimee Semple McPherson-Hutton, Temple evangelist, while other elements of the composition included Venus, a man in a business suit, and a cloud-bourne dollar sign (410, Ap 18 1932 2:2).

1932, April 23 To carry out Stalin's dictate that "All art must be propaganda, " the Association of Soviet Artists was formed in the USSR (299, II:852-856), assuming centralized control of painting and sculpture in Russia (41:47). The Central Committee of the Communist Party--Bolshevik C. P. S. U. --by final resolution-- "On Reconstruction of Literary-Artistic Organizations"--brought "Party control" over the visual arts

by ordering liquidation of all independent and unoffi-
cial art groups, and their "replacement by unions
'with a Communist faction' carrying out Party policy"
(545:42-43). All Russian artists who practice pro-
fessionally are required to belong to the Union (41:
77), and to carry out the Committee policy making
Social Realism the basis for all Soviet art (67, 1965:
38).

1932, August Two Toronto police officers, acting under instruc-
17 tions of the Morality Department, visited the Cana-
 dian National Exhibition Gallery to inspect the nude
 paintings. Presumably as a result of this visit,
 Fred Haines, Curator of the Gallery, told eminent
 Canadian artist John Russell that he had submitted
 more paintings--12 canvases in all--than could be
 hung, and that Russell's painting of a nude young
 girl was not going to be exhibited.
 "All or none," was Russell's ultimatum, and he
 pointed out that American nude paintings were being
 displayed, and that his picture had already won a
 prize at the Paris Salon.
 This "nude picture controversy" was over in a
 few days--on August 22--when authorities found
 room in the Exhibition for all of Russell's paintings,
 including that of the undraped figure (410, Ag 23,
 1932 7:2).

1932, Sep- The Hungarian Minister of Education sent instructions
tember 23 to the Director of the Art Academy in Budapest for-
 bidding nude models from posing before student art
 classes. According to the ban, all models were to
 wear bathing trunks in the future (410, S 24 1932
 4:5; 0 16 1932 II, 3:3).

1932, Octo- After the Nazis won a plurality in the Dessau City
ber 1 Council, the Council dissolved the Bauhaus, Ger-
 many's influential art school, "because of its sup-
 posed political radicalism" as a cause of "the fall of
 the City's Social Democratic government" (170:658).
 The "discharging of faculty and students" from the
 Bauhaus carried out the campaign promises of the
 Nazi candidates for the Council "to disperse the
 school... as one of the most prominent centers of
 the Jewish-Marxist art program," housed in Dessau
 in its "oriental glass palace" (170:658).

1932, Novem- At the inauguration of the new Pinakothek in the
ber (A) Vatican, Pope Pius XI condemned "modern forms
 as unhealthy and dangerous and demanded conformi-
 ty of images and architecture to the venerable tradi-
 tion" of the Catholic Church. He banned "modern
 forms" from the altar, and laid upon Catholic artists

the duty to avoid novelty and to repeat formae e
traditione receptae (303:137).

1932, Novem- The United States Customs seized two woodcuts of
ber (B) nudes by British artists Eric Gill and Blair Hughes-
 Stanton, and refused to admit them to the country
 on grounds of "obscenity. " The pictures--part of a
 collection of 116 prints sent from Redfern Galleries
 in London on behalf of the Society of British Engrav-
 ers to the National Alliance of Art and Industry--
 were to have made a two-year tour of the United
 States.
 The Alliance has requested the Customs Bureau
 in Washington to release the censored prints so that
 they may be sent back to London (410, D 9 1932
 24:5).

1932, Decem- Observers asked whether "prudery or publicity" dic-
ber 12 tated the "funniest event in the year of art in the
 United States": The banning from Radio City Music
 Hall, in Rockefeller Center, New York City, by
 Roxy--S. L. Rothafel, variously described as an
 "impresario, " and "the prosperous exploiter of
 near-nude chorus girls"--of three statues com-
 missioned for the theater in 1932.
 The offending figures--big aluminum nudes by
 Robert Laurent ("Goose Girl"), Gwen Lux ("Eve"),
 and William Zorach ("Spirit of the Dance")--were
 sent to the basement storage area of the theater,
 rather than the places of honor in the foyer, speci-
 fied in the artists' contracts. Roxy explained that
 he was sure the undraped figures would shock his
 patrons, and cause box-office losses. When twenty-
 four-year-old Nelson Rockefeller protested the re-
 moval of the figures, Roxy told him, "I'll put the
 statues back, if you agree to pay for the empty
 seats in the Music Hall. " After weeks of publicity
 and adverse comment from artists (who labelled the
 banning "an undignified publicity stunt") and critics
 (Edward Alden Jewell of the New York Times said
 that the issue of morality of the figures was "too
 silly" to discuss in an art column), the ban was
 suddenly lifted (7, 1933:71; 142:578-579; 410, D 13
1932 21:6; D 14 1932 24:4; D 15 1932 22:5; D 16 1932
 18. 5; Ja 1 1933 IX, 9:1; 449:149; 635:7).

1933 "Buy American" became a significant theme in
 American art in the midst of the United States
 economic Depression when the American Artists
 Professional League "carried through one part of
 its program and obtained legislation" which forbade
 "the decoration of Government owned buildings with
 any other works than those created by American

citizens" (7, 1933:66).

1933, Janu-
ary 28

British Industries Fair officials withdrew a poster
advertising the forthcoming Fair from circulation
in Egypt, Turkey, and Syria because certain authori-
ties considered the presentation of "Britannia" beck-
oning the world to the Fair "might offend Eastern
sensibilities. " According to Eastern standards--ex-
perts conversant with such customs pointed out--the
figure pictured could be construed as "acting in less
than perfect modesty" (410, Ja 28 1933 1:2).

1933, Febru-
ary 14

After being judged "obscene" and detained four days
by the New York office of the United States Customs,
a series of pictures reproducing Michelangelo's "The
Last Judgment" frescoes in the Sistine Chapel of the
Vatican were released. The pictures--copies by 16th
century artist Marcello Venusti of Michelangelo's
heroic nudes before Daniele da Volterra painted loin-
cloths on the figures at Pope Paul IV's order--in
ten pamphlets of thirty rotogravure reproductions
were ordered by the Weyhe Gallery in New York
City. A form letter sent from Customs asked that
the Gallery waive rights to the reproductions and
consign them for destruction:

> "There is being detained...a package addressed
> to you, containing obscene photo books, 'Ceiling
> Sistine Chapel,' Filles-Michel Angelo, the im-
> portation of which is held to be prohibited under
> the provisions of the Tariff Act..."

When the question of banning these pictures was
brought to the attention of Customs Assistant Solici-
tor Brewster, he ordered immediate release of the
reproductions of one of the world's most famous
murals (137:126; 245:13; 180:132-133; 410, F 15
1933 19:3; F 18 1933 14:7).

1933, March

"Sacreligious parody, " said Detroit clergymen when
Diego Rivera's murals at the Detroit Institute of
Arts--$25, 000 gift of Edsel Ford (7, 1934:67)--were
unveiled after eight months work by the artist (who
lost 125 of his 310 pounds in the process--aided by
an albumin and thyroid extract diet). "Some clergy-
men were critical of a small panel ("Vaccination
Panel") high on one wall--"showing a child being
vaccinated in a serum laboratory"--scandalized by
the detail, which was publicized as vaccination of
the "Divine Infant" (485:159), depicted in "vivid and
lurid symbol, " and "typical strident Mexican colors"
(7, 1934:67). Serum-giving animals in the panel's
foreground--a horse, a bull and sheep--were found
traditional beasts of Holy Nativity pictures, and "the
nurse's white cap and the child's yellow hair looked

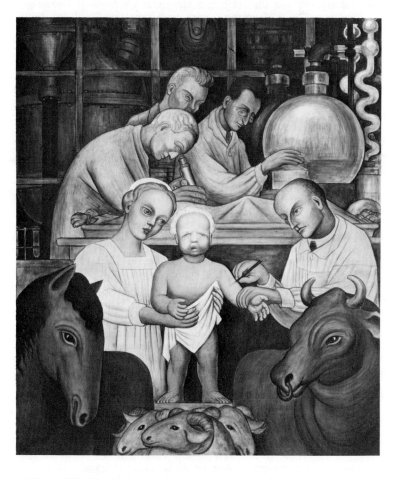

28. 1933, March. Diego Rivera. Vaccination Panel, mural.
Detroit Institute of Arts. Gift of Edsel B. Ford

like halos. " Certain elements in Detroit demanded
that the wall be whitewashed because the painting
represented "art for propaganda's sake" and was
"too Communist and too Mexican. "

Museum Director William R. Valentiner and Mr.
Ford--who believed Rivera "was trying to express
his ideas of the Spirit of Detroit"--resisted these
community efforts to return the walls of the garden
court to plain white plaster, because the murals
were "a slander to Detroit workingmen" (557:26).
(ILLUSTRATION 28)

1933, March 12 After the State and Municipal elections in Germany,
Nazi Hermann Göring took over the Prussian Minis-
try of the Interior, and within two weeks Martin
Wagner and all his associates in Berlin--who had
administered the capital's public housing program--
were discharged, and in Frankfurt the building ad-
ministration was replaced. Purges of architects
not in sympathy with the Nazis continued from March
to May 1933 so that during these three months "the
entire administrative staffs of all the Prussian build-
ing societies were discharged and new men who
could prove their sympathy with the party were
'elected. '" "Radical architects" received no new
commissions after 1933, and Germany's famous ar-
chitects--Walter Gropius, Erich Mendelsohn, Lud-
wig Mies van der Rohe, Martin Wagner, Ludwig
Hilberseimer--emigrated to England or America
(321:173, 184).

1933, April 11 The Bauhaus--"most influential design school in
modern times" (410, S 14 1969 VI, p. 34)--was
"provisionally" shut down by the Nazi government
in Germany three months after Adolf Hitler's ap-
pointment as German Chancellor. The school had
moved from Dessau--when it was closed on October
1, 1932 by the Dessau City Council--to Berlin, and
it was finally dispersed on August 10, 1933, after
"the Gestapo staged a raid on Bauhaus quarters and
arrested a number of the students for possessing
'illegal communist propaganda material'" (321:171-
172).

Nazis closed the school as a "breeding place of
cultural Bolshevism" producing architecture fit only
for factory buildings: "the house with the flat roof
is oriental--oriental is Jewish--Jewish is bolshevis-
tic" (170:663). It was the Bauhaus that was the
first target of Nazi purges against creators of "the
new architecture, " who were deprived "of their jobs
in schools, building societies, and municipal govern-
ments, and of their positions of leadership in the
national professional organizations" (321:169).

Among the architects and artists associated with
the Bauhaus who went into exile to escape Nazi pro-
scriptions were Walter Gropius, Ludwig Mies van
der Rohe, Herbert Bayer, Laszlo Moholy-Nagy, Paul
Klee, Lyonel Feininger, and Marcel Breuer (604:
144).

1933, April
20

"All right in their place"--a museum, that is, but
not outdoors in a park--Park Commissioner Browne
said, as he ordered the nude watercolors by John
Rivolta taken down from the art sale display by
"needy artists" at the Grand Army Plaza entrance
to Prospect Park in New York City, where there
were "too many mothers and children around" for
this type of art display (410, Ap 21 1933 19:2).

1933, April
24

On the order of Boston Museum of Fine Arts direc-
tor Edward Jackson Holmes, "Mater Dolorosa"--the
six-foot-square canvas of a modernistic conception
of the Madonna and Child--painted by Henri Burk-
hard was removed from the New England Society
of Contemporary Art Exhibit, where it had hung
for three weeks, because contributors claimed the
picture was "irreligious" (410, Ap 26 1933 6:8).

1933, April
30

Complaints over nude sketches closed the annual
Spring Exhibition of the Van Emburgh School of Art
at the Plainfield Public Library in New Jersey.
"Conventional nude studies." among some 400 works
by students at the School, were exhibited for the
first time in the seven years that the Exhibit had
been given in the Library.
 Librarian Mrs. Lawrence M. Bowman said--ac-
cording to the New York Herald Tribune--that those
protesting "felt that a public building where children
were allowed to go was not the proper place for ex-
hibition of the nude." One critic of the show--quoted
in the New York Times--pointed out that "it may be
all right to hang such pictures in New York, but not
in a little city like Plainfield (population 40,000). I
dislike mentioning the matter, but there actually are
paintings of men and women in the nude, and they
have used living models."
 Van Emburgh School continued the censored show
in its own studios (410, Ap 30 1933 33:6; My 1 1933
17:8; 470:21).

1933, May

"Total control over the arts" in Germany was es-
tablished by the creation of the Reich Chamber of
Culture under Dr. Joseph Goebbels' Ministry of
Propaganda and Popular Enlightenment. Every art-
ist who wanted to make a living by his art in Ger-
many had to belong to the Art Chamber--separate

divisions were set up for "every branch of creative
and commercial activity"--but "racially inferior...
and politically unreliable artists were excluded"
(126:54). Banned artists were forbidden to exhibit
or to sell their works, and even to paint in the pri-
vacy of their own homes. The decree was enforced
--in some instances by surveillance and periodic
inspections--by Gestapo agents. Carl Hofer, Profes-
sor at Berlin Academy until he was dismissed by the
Nazi regime, reported that Gestapo agents felt his
brushes to see if they were wet, when they checked
to see that he had not broken the official order ban-
ning him from painting (126:58). Minister Gobbels
took time away from other duties--for example, the
famous Book Burning taking place on May 10--to en-
unciate the aesthetic principles of the Nazis:
 "Only that art which draws its inspiration from
 the body of the people can be good art in the
 last analysis and mean something to the people
 for whom it has been created. There must be
 no art in the absolute sense, such as liberal
 democracy acknowledges. An attempt to serve
 such art would end in the people's losing all
 internal contact therewith and the artist's be-
 coming isolated in a vacuum of art for art's
 sake (472).
The Nazi SS man who replaced the director of
the Folkwang Museum in Essen interpreted the
party's philosophy of culture:
 "the most perfect object created in the course
 of the last epochs did not originate in the studios
 of our artists. It is the steel helmet" (108).
In advancing the official ideology of the totali-
tarian state, art with "cosmopolitan or bolshevist
tendencies" was taken from museums and collec-
tions (108:474), and among artists restricted offi-
cially were:
 Fritz Winter--prohibited from exhibiting his
 paintings, so forced to earn his living as an
 artisan (406:52-55);
 Ewald Matare--sculpture proscribed by the Nazis
 (604:128);
 Arnold Zadikow--sculpture destroyed as "Jewish, "
 including "Wrestler" and "Motherhood" (524:pl 25,
 26);
 Hans Uhlmann--forced to earn his living as an
 engineer, after his release as a political prisoner
 (406:10, 46);
 Ernst Barlach--referred to in official Nazi pub-
 lications as a Jew and a Bolshevik: "a distorter
 of the most evil manner, " asked to withdraw
 from the Academy, forbidden to exhibit in Ger-
 many, all public commissions cancelled (197;

287:38-41)
George Grosz--"branded by the Nazi regime
'Cultural Bolshevik No. 1'" (30:24), his graphics
and books burned (197), deprived of German citi-
zenship (30:24);
Heinrich Campendonk, youngest member of the
German Blue Rider Group of Expressionist
painters--discharged from his teaching post at
Dusseldorf Academy (178:66);
Paul Klee--drawings called "a menace to the
State" (197);
Ernst Ludwig Kirchner--639 works confiscated
as "degenerate" (448);
Emil Nolde--officially barred from painting
(604:128).

1933, May 22 Rental Manager Hugh Robertson, followed by twelve
uniformed guards, called Diego Rivera--"world's
foremost living fresco painter"--down from his
scaffold before his unfinished mural on the wall of
the Great Hall facing the doors in Rockefeller Cen-
ter's RCA Building, and handed him an envelope
containing a check for $14,000 (last payment on the
$21,000 due the artist for his work), and a notice
that he was fired.
 Within half an hour, the unfinished 63x17 foot
fresco was covered with tarpaper and a wooden
screen. Rivera had celebrated May Day (May 1)
by painting a small head of Vladimir Ilyich Lenin,
hero of the Russian Revolution of May Day, near
the center of the fresco. The original sketches
for the mural--"portraying human intelligence in
control of the forces of nature"--left a place for
"a great leader," which turned out to be not Lin-
coln, but Lenin. When Nelson Rockefeller asked
Rivera "to substitute the face of some unknown man
where Lenin's face now appears," Rivera offered
to balance Lenin with a portrait of Abraham Lincoln,
but refused to take Lenin out of the mural, respond-
ing to the criticism that the head of the Russian
leader, with certain "revolutionary symbols or pro-
letarian insignia," was Soviet propaganda: "All art
is propaganda."
 Rivera was told by his lawyer that while "he
might sue to establish an artist's dubious right
under an 'implied covenant' to force exhibition of
his work," he had sold the fresco and had no legal
right to the painting. Later the mural was chipped
off the wall, and replaced by one painted by Spanish
artist Jose Marie Sert (7, 1934:68; 83:5; 320:196;
410, F 13 1934 21:1; 485:272; 579, 1933:186-187).

1933, June The National Commission to Advance American Art,

formed May 10 "to promote American art, " held a
stormy protest meeting of artists to score the em-
ployment of "mediocre foreigners" to carry out pub-
lic and institutional art commissions in the United
States. Particular criticism was directed to Dart-
mouth College for engaging Jose Clemente Orozco,
one of Mexico's famed muralists, to paint frescoes
at the College's Baker Library. At least one critic
friendly to Orozco maintained that the Commission
had been organized to prevent the artist from com-
pleting the Dartmouth frescoes he was then at work
on (410, Je 10 1933 15:8; Je 18 1933 VIII, 8:4; 485:
263).

1933, Sep- Twenty-five architects had been excluded from the
tember ? BDA (Bund deutscher Architekten)--German profes-
 sional organization similar to the American Institute
 of Architects--"primarily on the basis of political
 and racial clauses in the new membership require-
 ments" (321:174).

1934 (A) The restrictive "Hicklin Test" of obscenity was re-
 jected by the Second United States Circuit court of
 Appeals in the case United States v One Book Called
 "Ulysses. "

1934 (B) "Social Realism" slogan was introduced with new art
 policy in the USSR recognizing that "the masses are
 the final arbiters of taste. " "Timid conservatism...
 true to life" is the Soviet ideal in painting and sculp-
 ture, with any work that is unusual or difficult to
 understand attacked as "formalistic" (67, 1939:497).

1934 (C) Denver city officials announced that a commission for
 a $100, 000 memorial to former Mayor Robert W.
 Speer had been given to famous Yugoslavian sculptor
 Ivan Mestrovic, but "such emphatic protest was
 raised in the local press and by local artists, that
 Denver withdrew the invitation to the foreigner, and
 later gave the commission to Arnold Ronnebeck, a
 Colorado artist" (7, 1935:541).

1934 (D) Huntington Cairns, a lawyer and a classical scholar,
 began advising the United States Treasury Depart-
 ment and the Customs Bureau in their decisions as
 to what constitutes obscenity in imported books and
 art. As Special Legal Advisor--Cairns' name had
 been produced when Secretary of the Treasury Mor-
 genthau, annoyed at continued problems with Customs
 censorship, ordered, "Find me a lawyer who has
 read a book"--the art and literature Counsel barred
 imported art only occasionally as obscene or grossly
 scatological, and during his twelve years work in the

Treasury Department (1934-1946) only one importer
of works banned by Customs carried his case to the
courts--and that single case was lost by the importer
(47; 626:237-238).

1934 (E) George Biddle's sketch for a mural by one of the
United States Justice Department staircases, sent
to the Commission of Fine Arts for its approval by
the Section of Painting and Sculpture (later called
the Section of Fine Arts) of the Treasury Department,
was disapproved.
 The Commission, created by Theodore Roosevelt,
"passes on all schemes proposed for official Washing-
ton: buildings, monuments, painting, sculpture, and
landscaping... Although it was set up to advise, in
practice, its disapproval had always been accepted
as a final veto. " In this instance, the Section de-
cided to "buck the Commission, " and authorized
George Biddle to proceed (164:73-74).

1934 (F) Huntington Hartford in his book Art or Anarchy?
warned that the art of Abstract Expressionism was
a "gigantic communist plot against America. "

1934 (G) Although three art experts testified that French sculp-
tor Henry Navarre's glass vases--molded into non-
representational designs with wooden spatulas and
hammer--were "works of art, " the Court of Customs
and Patents Appeals hearing the case (United States
v Ehrich, 22 CCPA (Customs) 1(1934)) held that
the vases "could have been made by an artisan as
well as an artist, " and so were not art, but "duti-
able importations"--citing the Perry decision of
1892. In spite of strenuous objections by two dis-
senting judges--Bland and Garrett--the decision re-
mained the law until 1958 (154:1240-1241).

1934 (H) Shore-leave sailors of the United States Navy "gam-
boling with floosies, " depicted in Paul Cadmus'
painting "Sailors and Floosies, " caused the picture's
removal from a Public Works of Art Project Exhi-
bition at Washington's Corcoran Gallery, after Ad-
miral Hugh Rodman, U. S. N. , complained:
 "It represents a most disgraceful, sordid,
 disreputable, drunken brawl wherein apparently
 a number of enlisted men are consorting with
 a party of streetwalkers. This is an unwarran-
 ted insult" (579, 1940:179).

1934, February "Oh, little picture on the wall,
 Ain't you got no clothes at all?
 Ain't you got no shimmie shirt,
 Ain't you got no petty skirt,

Ain't you got no silk brassiere
Or cloak to hide you where it's bare,
Ain't you go no shoes or hose,
Or hanky for to blow your nose,
Ain't you, little girl"?

so a writer on the Orlando, Florida, Reporter-Star
covered the nude-paintings controversy over the pic-
tures by Elsie Cowan, graduate of Chouinard Art
School in Los Angeles. The three "immoral" fig-
ures were ordered removed as obscene from Miss
Cowan's exhibition in the Chamber of Commerce
Building, upon demand of the W. C. T. U., and the
Reverend Morris Butler Book. The Orlando Art
Association, sponsor of the art show, continued to
take a favorable view of the works, and before the
paintings were banned from exhibit, two of the three
nude studies were sold (196:9).

1934, March 29 In surprise orders issued today by Austria's Doll-
fuss government, all nude statues were ordered re-
moved from the streets of Austrian cities. Govern-
ment workers in Vienna, after receiving the instruc-
tions, began tearing down a number of statues con-
sidered as falling within the ban. Among the sculp-
tures eliminated from the thoroughfares, was the
Tabor Street figure of a farmer sowing grain, which
had been erected by the former Socialist city govern-
ment--most of whose members are now in jail (410,
Mr 30 1934 14:2).

1934, June 15 Austrian censors, introduced by the counter-revolu-
tion of last February, invaded a Vienna cemetery
to drape in sackcloth the sculptured monument by
a famous Viennese artist that marked the grave of
prima donna Selma Kurz--the recumbent figure of
a woman with undraped torso, representing "Aida,"
one of the singer's most famous roles. The statue
considered insufficiently clad is close to the tomb
of former Chancellor Mgr. Seipel, "spiritual father
of the present-day clerical fascists in Austria," and
repeated threats to blow up the monument and com-
plaints in "certain clerical newspapers" dictated
"Aida's" sackcloth clothing--"bound tightly around
the neck of the figure and weighted down with stones
lest an incautious breeze should lift a corner and
shock the public."

Relatives of Mme. Kurz had been ordered to re-
move "Aida" from the cemetery at once (410, Je 17
1934 IV, 3:4).

1934, August A "Mrs Grundy in trousers" caused removal of a
nude painting, one of fifteen art works displayed in
various store windows in Hartford, Connecticut,

according to Albertus E. Jones, head of the Hartford
School of Fine Arts. Jones predicted the necessity
of removing from public view, or of clothing all un-
draped figures in paintings and sculptures, because
of the complaint of a "self-appointed custodian of
public morals. " The censored picture was painted
by Mrs. Harry M. Gann, a pupil at the Hartford
School (546:15).

1934, Sep- John Smiuske, an alien house painter from Latvia,
tember so resented a satirical mural, "The Nightmare of
1934, " lampooning President Franklin D. Roosevelt
and his family, that he threw varnish remover over
the painting and touched the canvas with a match,
destroying the caricature, which was on view in the
Westchester Institute of Fine Arts in Tarrytown,
New York, at 25 cents a look.

 Jonas Lie, President of the National Academy,
was so impressed with this act "of American patri-
otism" and critical of the six months sentence
Smiuske received for malicious mischief, that--act-
ing as a private citizen--Lie posted $500 bail for
Smiuske, releasing him from four weeks of incar-
ceration in the Tarrytown county jail where he was
held pending an appeal from the sentence. Hugo
Gellert, chairman of the Artists' Committee of
Action, "a left-wing group" in New York City, in
a published letter equated Lie's action to the en-
dorsement of Nazi book burning:
 "You have openly endorsed the destruction of
 the work of a fellow artist... We uphold our
 right to decide the form and content of our
 work" (436).

1935? One of the Ben Shahn murals on the theme of pri-
sons, accepted for installation on the walls of Ri-
ker's Island Penitentiary, contrasted old prison
methods--with their punishments of flogging--to
the new ones of prison trade schools. The Com-
missioner of Corrections and Mayor La Guardia of
New York City approved the series, but they were
rejected by Jonas Lie, speaking for the New York
Municipal Art Commission, "because their pictured
realities might arouse discontent in the minds of the
prisoners" (108:470; 449:118, 120).

1935 (A) Regulations were issued in Italy "which absorbed
the artist into the texture of the corporate state, "
but with "little, if any, direct destruction or perse-
cution of modern art, " as is found in Germany (126:
61).

1935 (B) Adolf Hitler in a speech at Nuremberg referred to

modern artists in Germany censored under official
Nazi policy:

> "One will no longer discuss or deal with these
> corruptors of art. They are fools, liars, or
> criminals who belong in insane asylums or
> prisons" (108:474).

1935 (C) The Duchess of Marlborough sued five news agents
for importing the American magazine Hooey into
England (Marlborough v Gorringe's Travel & News
Agency Limited) in an issue that contained a cartoon
she found libelous: Two roses, closely intertwined
in a garden bed and each bearing a single rose,
bend toward each other and touch as though they
were kissing, while a gardner is saying (in the
caption) to a "stout lady" in front of a mansion,
"I guess we shouldn't have planted the Duchess of
Marlborough and the Rev. H. Robertson Page in
the same bed. "

The Register of the National Rose Society con-
tains the names of the two roses given in the car-
toon caption. This case was settled by the defen-
dants "offering an unqualified apoligy, " and "contri-
buting a fixed sum toward damages and costs" (149:
158-160).

1935 (D) Although sculptor Gaston Lachaise considered his
late works before his death in 1935 "very signifi-
cant, " the Museum of Modern Art did not exhibit
these "violently sexual works" in the Lachaise re-
trospective exhibit, and the sculptures remained
"uncast, unexhibited, and largely unknown to the
public" because of lack of public acceptance of "the
radically explicit nature of the artist's vision. "
Lincoln Kirstein, in his catalog of the retrospec-
tive exhibit, explained the lack of these "difficult"
late works in display:

> "If they were to be shown today... they might
> give offense and precipitate scandal obscuring
> the importance of the rest of his creation"
> (25:45).

1935, April 10 In an inquisitorial interrogation at a session of the
Art Commission of the Russian Vsekolkhudoshnik,
the picture "Old and New" by artist Nikritin came
under debate when the artist "was summoned to the
bar for 'disputation' in his work. " The Commission
--consisting of prominent Russian professional art-
ists with the exception of one art critic, Beskin--
was unanimous in condemning Nikritin and in reject-
ing his painting. Among individual comments were
those of:

> Skolov-Skalya: "Such a peculiar man! And so

individualistic!"
Critic Beskin: "A deeply pathological, erotic
picture"
Mashkovzev: "Could a party man and young
Communist create such a picture, and would he
do it?"
Lecht: "This piece must be unmasked as inad-
missable. If the artist were uneducated we
might think that he had become such an introvert
that he could make this picture outside the world.
Yet he reads a lot--unfortunately not what is
necessary..." (20:37).

1935, May 6 Tokyo police seized prints of Naruto Strait by
Hiroshige, nineteenth century master of the Japan-
ese print and famous for his landscape series, be-
cause they depicted a section now fortified (410, My
7 1935 21:2).

1935, August The American magazine Vanity Fair was banned in
Japan because William Gropper's cartoon "Japan
Emperor Getting the Nobel Peace Prize" was "re-
garded as insulting to the Japanese Emperor," ac-
cording to a Foreign Officer spokesman. Gropper
included this picture in a group of drawings: "Not
on Your Tintype--Five Highly Unlikely Historical
Situations By One Who Is Sick Of The Same Old
Headlines" (Vanity Fair Ag 1935, p. 39) (Editor
and Publisher Ag 10 1935, p. 10; 265:214).

1935, Novem- "Morals have nothing to do with it, but the paintings
ber 7 are trash," Mrs. Frank Granger Logan--1150 Lake
Shore Drive, Chicago--commented. This opinion of
Mrs. Logan, for years one of the chief patrons of
arts and struggling artists in Chicago, was echoed
by a Chicago newspaper in its report of the 46th
Annual Exhibition of American Painting and Sculpture
at the Chicago Art Institute as "obscene and indecent."
The Exhibition jury's awarding of the Logan Prize to
a modern painting, "Thanksgiving Day" by Doris Lee,
precipitated Mrs. Logan's war on "modernism" in
art through an organization, "Sanity in Art," and a
book of that same title published in 1937 (7, 1939:
596).
 The goal of "Sanity in Art," according to the
founder, was
 "to help rid our museums of modernistic,
 moronic grotesqueries that were masquerading
 as art,"
and
 "to reestablish authentic art in its rightful
 place before the public" (350:10, 23).

1936 (A) The Modern Art Section of the Kronpinzenpalat,
 Berlin (126:54), was closed by Nazi order, and
 16, 550 works of "undesirable" art purged from
 museums all over Germany (620:62).

1936 (B) At the Berlin Academy's jubilee show of "Three
 Centuries of Berlin Sculpture, " Ernst Barlach's
 three works were removed, along with those of
 Wilhelm Lehmbruck and Kathe Kollwitz, as "not
 conforming to the Nazi aesthetic policy" (287).

1936, Febru- The American Artists Congress organized with the
ary purpose of bringing artists of the United States into
 a trade union comparable to the CIO (Congress of
 Industrial Organization). Many professional artists
 criticized the Congress's purposes and tactics as
 "a proletarian fad, " because of the group's social
 reform activities and their interest in international
 politics (7, 1937:534).

1936, Febru- Russian newspapers launched a general attack on the
ary 14 whole front of "Leftist" art--including sculpture and
 painting--and in the new line Soviet critics scored
 Leftist "tricks and distortions" as having no relation
 to Communism, and being rooted in "petty bourgeois
 Westernistic formalism" (410, F 15 1936 17:2).

1936, Febru- "Morals" involved in the nude and semi-nude figures
ary 28 in a mural painting displayed at the Richmond, Vir-
 ginia, Academy of Art led to the arrest of John
 Stewart Bryan, vice chairman of the Academy, when
 F. M. Terrell--a Richmond Sunday school teacher
 and "leader of a self-appointed morals committee
 of six local citizens"--swore out a warrant charging
 Bryan with violation of the Virginia Code making it
 a "misdemeanor to keep, sell, distribute, or dis-
 play any obscene book, pictures... which tend to cor-
 rupt the morals of youth. "
 Terrell had threatened such action if the mural,
 painted by New York City artist Mordi Gassner,
 were not removed from the Academy "by noon. "
 Terrell had tried to let the matter drop by withdraw-
 ing the warrant, when he found that he could not ex-
 tradite Gassner from New York City on the charge,
 but the warrant had already been served.
 Next day in police court hearing, lasting less
 than a minute, charges of displaying an "indecent"
 painting were dismissed when the complainant refused
 to press charges (410, F 29 1936 13:8; Mr 1 1936
 I, 34:6; Mr 8 1936 37:3).

1936, March The painting of a saloon Venus lying on a seashore
19 which hangs above a bar in Paterson, New Jersey,

need not be removed, according to the ruling of
Frederick Burnett, New Jersey State Commissioner
of Alcoholic Beverage Control. The "plump Venus"
had outraged Mrs. William Burd, wife of the local
Methodist minister, and she had demanded that
Burnett order the picture taken down because it
was "obscene," and might corrupt the morals of
women and children passing by the cafe and view-
ing the painting through the window.

 Commissioner Burnett wrote to the complainant--
admitting that the painting was bad art: "The paint-
ing is mediocre, the color flat, the style eclectic,
and the subject trite"--holding that

 "there is no reason why places for the consump-
 tion of liquor should not be made comfortable
 and decorative. Pictures, as well as flowers,
 may brighten a corner... The picture is not ob-
 scene. Therefore, I shall not order it removed"
(180:139; 410, Mr 20 1936 25:5).

1936, April 5 Patriotic Texans objected to William Zorach's memo-
rial "The Pioneer Woman" because the woman in the
family group wore no wedding ring and the figures
were nude. A pioneer family "going around that
way would have been strung to the nearest tree,"
one critic commented. Zorach's sculpture was one
of about 120 models that artists had submitted for
fourteen monuments at various locations throughout
Texas, being commissioned to celebrate the Texas
Centennial. An Advisory Committee, including art
museum directors and heads of college art depart-
ments, had selected 13 monuments, with second
choices for each. Zorach's commission for "The
Pioneer Woman"--the single biggest contract at
$25,000--was voted unanimously by the Texas State
Centennial Commission, to be placed at the Texas
State College for Women, Denton, Texas. His
model, the jury insisted, was a "symbolic memorial
to, not of, the Pioneer Woman--an exception to the
themes of other models in competition, which were
either a "sunbonnet woman with skirts whipped by the
wind, or an amazon in blue denim on horseback,
bearing a rifle in one hand and a child in the other."
Bowing to overwhelming criticism, Zorach agreed to
drape the figures in "The Pioneer Woman" (142:578;
410 Ap 6 1936 3:6; 574:48).

1936, Novem- Rumors circulated that Pope Pius XI had expressed
ber 7 a desire to "see the covering-up process continue"
on Michelangelo's Sistine Chapel fresco "The Last
Judgment" were confirmed in a dispatch from Vatican
City--released by the United Press and printed in
the New York World Telegram:

"The Vatican City announced today that Pope Pius
XI had ordered draperies painted on several nudes
in the famous Michelangelo frescoes in the Sistine
Chapel, considering them daring and offensive to
Catholic morals. Biagio Diagetti, artist, has
started painting flowing veils around parts of the
nudes and expects to finish his task by Christmas
(443:13).
These innovative murals have been bitterly criti-
cized from the moment of completion--October 31,
1541--until the present day--generally "until the end
of the sixteenth century... in the name of decorum or
the appropriateness of the image to its subject."
"Many Catholics continue to veil their faces" in
front of the painting, and "many lovers of art con-
tinue to find it 'in bad taste'" (31:145).

1936, Novem- Charged with carrying five pistols, Diego Rivera
ber 21 was arrested for entering the not-yet-opened Hotel
 Reforma in Mexico City--along with "twenty other
 shouting Communists"--in protest of the retouching
 of four of his satirical frescoes in the hotel's "Hall
 of Diplomats." Rivera accused the hotel of modify-
 ing the features of a figure resembling ex-President
 Plutarco Elias Calles in his mural, erasing some
 colors of a composite flag of countries that the art-
 ist considers under dictators (including the United
 States), and retouching the depiction of a Mexican
 army officer dancing with an Indian squaw.
 Rivera said that this changing of his Mexico City
 work was a "worse crime against art than the Rocke-
 feller affair," because when the Rockefeller Center
 mural was destroyed in 1933 after he refused to re-
 move a portrait of Nicolai Lenin from the composi-
 tion, Rockefeller had paid him for his work, and if
 he wished to destroy it that "was his legal right."
 Here at the Hotel Reforma when his work was
 changed "surreptitiously" "over his signature," this
 falsification of work which he had signed was "just
 like forging a check." Three days later the murals
 were removed because the management said that it
 found them "offensive." The construction syndicate
 to which Rivera belonged petitioned for a Senatorial
 investigation of the painting's removal, charging
 that hotel owners Alberto Arturo and Mario Pani
 censored the work because they "are enemies of
 the social ideology that these paintings exalt" (410,
 N 22 1936 1:4; N 24 1936 9:6).

1936, Novem- Dr. Joseph Paul Goebbels, Nazi minister of Propa-
ber 27 ganda and National Enlightenment, formally an-
 nounced abolishment of all art criticism in Germany.
 From now on, German critics must give descriptive

reports on exhibits and objects based on Nazi standards (410, N 28 1936 1:5; N 29 1936 31:3; IV, 8:4; D 4 1936 24:4).

1936, December 16
"Bubble Girl," painted by Edwin F. Beemer, an art instructor at De Witt Clinton High School in New York City, was withdrawn from the exhibit of the Westchester Arts and Crafts Guild and the Westchester Workshop Annual Show of over 500 art works at the County Center, White Plains, New York, when the hanging committee decided that the nude--standing with a bubble held in her upraised hands--was "undesirable for a public exhibition attracting many school children." Edmond F. Ward, vice president of the Arts and Crafts Guild, said that one reason the painting--previously displayed in the independent artists show at the Grand Central Terminal in New York City--had been turned down was its size--about four by eight feet--because as it was the only nude received for exhibit and "occupied so much space, it probably would have attracted attention wherever it was hung" (410, D 17 1936 25:2).

1937 (A)
Painter Winold Reiss, whose work on a mural at Longchamps Restaurant, 253 Broadway, New York City, was stopped by Building Trades Council No. 9 because the artist was not a union member, surrendered to pressure for joining the trade union only after the Council called 80 mechanical workers out on strike. Reiss paid his union initiation fee to Mural Artists Guild (Local 829 of A. F. L.) (7, 1938:520).

1937 (B)
Germany's invitation to British painters to exhibit in Berlin, "with specified reservations as to race and political faith," was "promptly rejected" (67, 1938: 500).

1937, March 15
German art critics--after being forbidden to criticize and instructed to devote their writing to description by Joseph Goebbel's Propaganda Ministry decree on November 27, 1936--were directed to resume criticism "from the standpoint of what is National Socialist is good, and what is not National Socialist is bad. "

A fortnight ago, the Ministry had relaxed strictures on art cricism by repealing their requirement that writers on the arts must be at least thirty years old, provided that the critic under that age was a member of the National Socialist Party. Captain Wilhelm Weiss, head of the Reich Press League and Chief Deputy in the Ministry, announced the

new policy for art critics at a meeting of the Cen-
tral German Press Chamber at Dessau:
"The press policy of the National Socialist State
is merely an extension of its political policy into
the realm of public opinion... Art criticism is
not primarily an aesthetic question, but a poli-
tical one" (410, Mr 16 1937 15:4; Mr 17 1937
24:4).

1937, July George Grey Barnard, internationally famous Ameri-
can sculptor of the nineteenth century, whose work
is in the Metropolitan Museum of Art and adorns many
buildings of that era, including the New York Public
Library, brought embarrassment to Kankakee, Illi-
nois, School Board in his seventy-fourth year.
Upon his gift to Kankakee Central High School of
some fifty pieces of his statuary--valued at $100,000,
the School Board Committee on Statuary when view-
ing the figures was so shocked by the nudity of the
statues that it immediately ordered the whole sculp-
ture collection--which up to this time had been on
display in a Madison Presbyterian church where
Barnard's father had formerly been pastor--under
lock and key. George Leuehrs, a sculptor from
New York, was hired by the School Board to tailor
plaster pants for the male nudes--Barnard having
agreed to this "compromise" draping, but insisting
that the female nudes be left as he had sculpted
them (456:450).

1937, July 7 "Haus der deutschen Kunst" ("House of German Art")
in Munich was dedicated by Adolf Hitler in a 90-
minute speech, to an audience of about 30,000, in
which he set artistic standards, banned art in Ger-
many not obvious to all (410, Jy 19 1937 8:2), and
castigated "degenerate half-wits who... see blue
fields, green sky, and sulphurous clouds" (620:63).
"Grosse deutsche Kunstausstellung," the initial
exhibition of 850 works, had been selected from art
completed since the Nazi Party came into power to
demonstrate the superiority of "true German art"
over what the Nazis called "degenerate Bolshevik
and Jewish art." The German art approved by
party leaders "was in a pallid academic style verg-
ing on illustration," and was "concerned with Nazi
themes of heroism, familial duty, and work on the
land" (108:474). The subjects--"happy German
family, motherhood, heroism, farm life, smiling
landscapes and female nudes" "appealed to all feel-
ings... religious, patrioic, cranial... except the
aesthetic" (620:64).
A satirical quatrain--parodying a poem by Goethe--
"described the collection of Nazi art, with many

"bland Aryan nudes" by Professor Adolf Ziegler,
head of the Reich Chamber of Art:
> "Kennst du das Haus, auf Saeulen ruht sein Dach,
> Von Blut und Boden stretzet das Gemach,
> Und Zieglers nackte Maedchen sehn dich an,
> Was hat man dir, du Arme Kunst, getan?"

freely translated:
> "That high-roofed columned mansion, long ago,
> Today with Blood and Soil is all aglow;
> And Ziegler's naked wenches stare at you.
> O, Art, poor thing, what have they done to you"
> (620:63).

For contrast with this "true German art, " the
second official Nazi art exhibit--that of "Entartete
Kunst" ("Degenerate Art") was opened in Munich on
July 18.

1937, July 8 Germany's nation-wide drive to eliminate "degenerate
art" was begun at the Municipal Art Gallery of Man-
heim by Professor Adolf Ziegler, President of the
Reich Chamber of Art--referred to by his bitter cri-
tics as "The Master of Pubic Hair" because of his
"meticulously detailed nudes. " By special decree of
the Fuhrer, expressed in an order signed by Goeb-
bels, Professor Ziegler was authorized "to secure"
all paintings and sculpture of "degenerate" German
art "since 1910 which were in possession of the
Reich, and any of the Lander, or individual munici-
palities. " The 16, 000 works of art "by nearly 1, 400
artists gathered up" from all over Germany included
paintings, prints and sculpture of foreign artists--
Andre Derain, Edvard Munch, Alexander Archipenko,
Marc Chagall--as well as of German artists--Wil-
helm Lehmbruck, Franz Marc, Max Beckmann, Carl
Hofer, Willy Baumeister (126:55).

1937, July 18 The exhibit "Entartete Kunst" ("Degenerate Art")
opened at the art center of the Third Reich in Munich
as a demonstration of "Jewish-Democratic" and
"Kultur-Bolshevistic" influences in the art banned
by the Nazis (410, Jy 20 1937 15:5; Jy 25 1937 IV,
4:7).

The terms "Degenerate Art" and "Decadent Art"
(Kunst der Verfallszeit") were applied by the Nazis
to "all art other than the most commonplace natu-
ralism" (604:127). Examples of work forbidden
listed schools of: Impressionism; Expressionism;
Cubism; Futurism; and the roster of German artists
officially condemned by the Nazis "included virtually
all...modern German artists who are important in
the history of art" (108:474); and a number of pro-
scribed foreign artists: Alexander Archipenko,
Ernst Barlach, Max Beckmann, Heinrich Campendonk,

Lovis Corinth, Otto Dix, Lyonel Feininger, Gauguin,
van Gogh, George Grosz, Erich Heckel, Alexej von
Jawlensky, Wassily Kandinsky, Ernst Ludwig Kirch-
ner, Paul Klee, Oskar Kokoschka, Wilhelm Lehm-
bruck, Franz Marc, Emil Nolde, Karl Schmidt-
Rottluff, and many others including Otto Mueller,
Braque, Chagall, Ensor, Laurencin, Munch, and
Picasso (478:79-81; 620:58). Otto Freundlich--whose
sculpture "New Man" was the cover illustration of
the exhibition catalog of "Degenerate Art"--died six
years later in a concentration camp in Poland, to
which he had been deported by the Nazis.

Hitler had denounced modern art as the product
of "morbid and perverted minds"--reportedly shout-
ing at one painting, "There are no blue horses"
(197)--and pledged to rid Germany of "esthetic
atrocities" (83:82). Any German artist who demanded
the prerogative of free expression was threatened
with punishment, including sterilization:

"They would be the object of great interest to
the Ministry of the Interior of the Reich, which
would then have to take up the question of whether
further inheritance of such gruesome malfunction-
ing of the eyes cannot at least be checked. If,
on the other hand, they themselves do not believe
in the reality of such impressions by trying to
harass the nation with this humbug for other
reasons, then such an attempt falls within the
jurisdiction of the penal law" (108:459).

Public attendance at the "degenerate" exhibit was
three times that at the "True German" exhibition,
held at the same time in Munich (410, Ag 6 1937
15:8).

1937, August General Hermann Goering ordered removal of all
4 modern art from German museums and exhibits
 with disregard of legal forms and property (410,
 Ag 4 1937 6:4), and in this "cleansing" by the Nazis
 thousands of paintings and other workd of "degenerate
 art" were confiscated and destroyed. To further
 control unacceptable German art, "Official Notices"
 sent out by Nazi authorities to all art dealers in
 Germany forbade "all commerce in works by inter-
 dicted artists. "

1937, Septem- The Kansas State Art Commission, appointed to ar-
ber range for the painting of the State Capitol murals
 by John Steuart Curry, met in Topeka to insist upon
 "safe and sane" restrictions in subject matter in the
 paintings. The Commission wanted Curry--a native
 son and leading American regional painter--to com-
 plete the murals, but they demanded assurance that
 the finished work would be "art within reason, " and

not "too, too modern" (18:13).

1937, October In response to the first German newspaper protests
14 against the several anti-German caricatures in a
 Prague art exhibit opened by the Czechoslovak Minis-
 ter of Education, the Czech government "immediately
 hastened to remove some of the more offensive pic-
 tures, " but the press throughout Germany continued
 to denounce "Czechoslovak brazenness" (410, 0 15
 1937 2:2).

1937, Decem- The second annual American Artists Congress closed
ber 19 its meeting at the New School for Social Research in
 New York City with a series of resolutions ("some
 pertaining to art") condemning infringements on civil
 liberties, criticizing censorship in art--including the
 censorship of Rockwell Kent's murals in the United
 States Post Office Department Building in Washing-
 ton, D. C.--attacking discrimination against Negro
 artists, urging complete unionization among the art-
 ists of America with all artists becoming members
 of the trade union movement (410, D 20 1937 25:4).

1938 (A) Mural and sculpture work at the New York World's
 Fair was controlled by the Mural Artists Guild (Lo-
 cal 829 of A. F. L.) because the union had success-
 fully battled for a closed shop among mural painters
 (7, 1939:593).

1938 (B) Manifesto: Towards a Free Revolutinary Art was
 issued by Andre Breton and Leon Trotsky calling
 for the foundation of a Marxist International Federa-
 tion with the aims:
 "The independence of art--for the revolution;
 The revolution--for the complete liberation of
 art"
 (text of English translation by Dwight McDonald,
 Partisan Review 4:49-53 Fall 1938) (108:483-486).

1938, January Peggy Guggenheim honored Jean Cocteau with the
 initial exhibition at her London gallery, "Guggen-
 heim Jeune, " at the Gallery's opening, January 24,
 1938, and when Cocteau sent his art objects--draw-
 ings, furniture, plates, and two sheets, one of the
 sheets portraying "arch, slithering creatures with
 pubic hair... conspicuously covered with fig leaves"
 was released by the English Customs "only on the
 condition" that Miss Guggenheim "confine it to in-
 timate showings in her private office" (512A:329-330).

1938, Janu- United States Treasury Department officials pre-
ary 28 pared to obliterate from a $3, 000 mural in the
 new Post Office Department Building in Washington,

D. C. , artist Rockwell Kent's exhortation to the
Puerto Ricans to "change chiefs. " Kent painted
two panels for the Building--one showing the carry-
ing of mail in Alaska ("Mail Service in the Arctic"),
and the other in Puerto Rico ("Mail Service in the
Tropics"). In the center of the Puerto Rican mural
a postman in a tropical scene hands a Puerto Rican
an airmail letter from Alaska, and on this letter is
a suggestion--in "an obscure Eskimo dialect"--that
the Puerto Ricans revolt, or declare their independ-
ence. Kent "tipped off" a journalist friend the mean-
ing of the inconspicuous and untranslated message,
and when the story was published in a Washington
newspaper, Secretary Morgenthau was "deluged with
thousands of letters critical of the paintings. " Dur-
ing the past two months--because the artist did not
cash his final payment check for $2, 000--authorities
had delayed painting out the message, as a Post Of-
fice spokesman explained:
> "While the check was uncashed, there remained
> a doubt about the ownership of the mural. Now
> Mr. Kent has cashed the check and we can do
> as we please with the mural. "
The objectionable message was soon painted out by
another artist (164:74-75; 410, Ja 29 1938 2:6).

1938, Febru- Twenty local sculptors "working undisturbed with the
ary architects" for the 1939 Golden Gate Exposition in
San Francisco (123:10) were ordered by Harris Con-
nick, new Director and Chief of the Exposition, to
redo nudes destined for the fair. Connick--chief
engineer for the 1915 San Francisco World's Fair,
and later finance chairman for Famous Players
Lasky Corporation--was undisturbed when the sculp-
tors showed him pictures of nudes that "got by"
him when he had directed the World's Fair nearly
a quarter of a century ago.
 Describing the current crop of figures, he said,
"They're terrible, " and told the Fair's Architectural
Commission that "Strong men would blush" at some
of the statues, asking for additions and subtractions
on the figures "until they satisfy the rules of good
taste. " Describing individual figures, he considered
David Slivka's nude male figure representing "the
bounty of the West... more like a failure of the fig-
leaf crop, " and called a companion female figure
"Fertility" "embarrassing. " The San Francisco Art
Commission was so impressed with Connick's criti-
cism--"It's not a question of sex at all... We want
only genuinely artistic pieces... figures that are
beautiful, and correct anatomically"--that they de-
cided to destroy "several rather frank pieces of
sculpture" from the 1915 Exposition that had been

stored in the basement of the San Francisco City
Hall for twenty-three years (473:8; 526:14).

1938, May Mrs. Josephine Hancock (F. G.) Logan's book Sanity
in Art was published to carry on her crusade against
"modern art humbug. " Mrs. Logan, patron of art
in Chicago, set forth the views of the society "Sanity
in Art, " which she founded in an attempt to change
the taste of the American public with respect to
contemporary painting and sculpture. Her campaign
against surrealism and similar "more eccentric"
art exhibitions, which she regards as "an affront...
to America, " is supported by other art patrons and
some groups--including the American Penwomen--
all documented by forty pages of signed testimonials
in her book (86:8; 410, S 4 1938 X, 7:1; S 11 1938
X, 7:1).

1938, May 16 Belgian sculptor Georges Minne's "Mother and
Child" monument to Belgian Queen Astrid, who died
in 1935, "drew violent reaction from the public and
press" when it was placed in Koningin Astridplaats,
and was transferred because of this criticism to the
Central Park, Amsterdam on July 13, 1949 (29:163).

1938, June 3 Hitler ordered confiscation, without compensation,
of "degenerate art in Germany accessible to the
public and owned by German citizens" (410, Je 4
1938 5:2).

1938, July Peggy Guggenheim's contemporary sculpture show at
her London gallery, "Guggenheim Jeune, " caused a
"row with British customs procedure" over the clas-
sification of the work of such "recognized masters"
as Brancusi, Arp, Gabo, Pevsner, and Calder.
The decision as to whether the works were "art"--
and so exempt from duty--or "simply so much
stone- and wood-carving"--subject to custom fee--
was made in England by the director of the Tate
Gallery--then fifty-eight year old James Bolivar
Manson. When Manson rejected as art two sculp-
tures by Constantin Brancusi and Jean Arp, the
press and liberal members of Parliament made
such protest, "that he rescinded his decision"
(512A:330).

1938, August John Sumner, head of the New York Society for the
Suppression of Vice, published an article in defense
of his twenty-five years work devoted to "fighting
commercialized vice, " including "tawdry, vulgar,
and degraded 'objets d'art'... supplying an illegiti-
mate thrill to old fools and to young boys and girls. "
The 65th year of operation of the Society--founded

by Anthony Comstock whose motto was "Morals, Not Art"--occurred on May 16 of this year (565:26-27).

1938, August 22	The Governor of Puerto Rico, Blanton Winship, asked for an appropriation of $3,000 to pay the commission of another artist to paint the Puerto Rican panel in the Post Office Department Building in Washington, D. C. to displace that of Rockwell Kent, which he said "is in bad taste...and conveys a false impression of conditions in this beautiful island." The Kent mural shows Puerto Ricans-- "as Negroes"--with one of their group receiving an airmail letter from Alaska marked with "a strange-looking message" (said by the artist to be Eskimo dialect), that "liberally translated" is "a plea for Puerto Rican independence." Post Office officials, according to report, had already--on January 28, 1938--ordered the message painted over by another artist (410, Ag 23 1938 15:3).
1938, October	Although lampooning of living public officials is forbidden under the British libel law, appurtenances of the famous are not protected. The law is silent about umbrellas. For this reason since September 30--when Prime Minister Neville Chamberlain met with German officials at Munich to work out the compromise "Munich Pact"--Chamberlain's "instrument for inclemency" (as an umbrella is referred to in court circles) has become an increasingly popular cartoon subject, as "a symbol of appeasement" (389:30-31).
1938, November	This issue of the Annals of the American Academy of Political and Social Science, edited by Edward P. Cheney, was devoted to "Freedom of Inquiry and and Expression." The Social Sciences Research Council appointed Dr. Cheney "to organize and edit, with the assistance of competent scholars and of an advisory committee, a series of studies regarding freedom and the expression of freedom." Among the reports were "Freedom and Restraint: A Short History," by Dr. Cheney, and--with most significance for the visual arts--"Freedom of Expression in Literature," by attorney Huntington Cairns, considered the "official censor" of the United States for fifteen years (1934-1949) in his work as Assistant General Counsel in the United States Treasury Department, advisor to the United States Customs Office.

Cairns defined "obscene" as "The class of sexual stimulants which is not generally brought into public view," and mentioned certain limitations on presenting visual arts:

"In the field of art it is impossible in the Anglo-
American world at all events, to exhibit or print
for the general public, complete portfolios of
the works of such artists of the first rank as
Leonardo da Vinci and Rembrandt, to say nothing
of artists of the second, third, or lesser ranks,
such as Boucher and Lawrence" (104:84).

1938, November 17 — Art experts from the Reich Chamber of Culture,
accompanied by members of the German Secret
Police, toured homes of Munich's formerly wealthy
Jews and removed works of art, transporting paint-
ings and other art objects in trucks to the city's
National Museum. The confiscation, officially de-
scribed as "preservation of works of art for the
Reich," was expedited by Hermann Goering's decree
of last April, by which Jews were required to regis-
ter their property, including declaration of such art
as antiques, paintings, china (410, N 18 1938 3:8).

1938, November 26 — Nazi financial officials in Berlin established special
"Pawn-brokerage" offices, to be put in operation
next week, for buying--at their own valuation--
jewels and other art objects from Jews, including
banned Jewish art in the form of "priceless heir-
looms that have been in Jewish families for genera-
tions" (410, N 27 1938 46:1; N 28 1938 25:1).

1938, December — The Bruenn German Association of Arts and Scien-
ces, in Czechoslovakia, "demanded proof of mem-
bers' Aryanism," and the Moravian Artists Associa-
tion forbade Jewish members to exhibit (410, D 11
1938 50:7).

1939? — "An issue of the non-profit, graphic arts magazine,
PM, was stopped by the New York Postmaster on
the grounds that its nudes--including figures by
Abner Dean and Peter Arno--were 'obscene.'"
Upon protest to the Solicitor of the Post Office,
the magazine was released for distribution (447:71).

1939 (A) — One of Maurice Sterne's series of twenty mural
panels--"The Struggle for Justice"--painted for the
law library at the United States Department of Jus-
tice in Washington, D. C., "caused unfavorable com-
ment among Roman Catholics" (46:137-139) when the
paintings were exhibited in New York City, prior to
installation. The panel in question--"Cruelty"--
showed "with a crude symbolism" (46:137-139) trial
by fire: A man carrying two red hot irons collap-
ses at the altar where he was placing them, while
a group of medieval churchmen look on at this scene
of the Inquisition.

A Roman Catholic priest campaigned against this
painting "as being offensive and untrue" (164:79),
and the controversy over its installation in Washing-
ton, fed by press accounts, dragged on, preventing
placement of the entire series. John Michael Car-
mody--administrator of the Federal Works Agency,
in charge of effecting the installation of the paintings
--became "unavailable to letters and telephone calls,"
but when the problem was called to the attention of
Monsignor Michael Joseph Ready, assistant general
secretary of the National Catholic Welfare Conference
in Washington, his influence on the critics allowed
immediate placement of the murals, as planned (46:
137-139).

1939 (B) On the order of Colonel Brehon Somervell, WPA
administrator in New York City, "a series of murals
painted in the Federal Art Project for the administra-
tion building at Floyd Bennett Airfield were destroyed,
because of "their obvious Communist propaganda and
their inferior aesthetic quality. " The artist, a WPA
employee for four years during which he received a
total salary of about $5, 000, "had been a Commun-
ist candidate for Congress before his employment on
the WPA" (468:62).
 Criticism of subversive activities in the Federal
Art Project centered on the New York program--
Federal Project No. 1--and the art project--except
for the relief program--was abandoned (468:63).

1939 (C) President Franklin D. Roosevelt, in a speech at the
opening of the new building of the Museum of Mod-
ern Art in New York City expressed the artists' and
the American ideal of freedom in the arts:
 "The arts cannot thrive except where men are
 free to be themselves and to be in charge of the
 discipline of their own energies and ardors...
 What we call liberty in politics results in free-
 dom in the arts... Crush individuality in the
 arts, and you crush art as well" (620:67).

1939 (D) Stalin defined the role of the artist in Soviet Russia
at the Eighteenth Party Congress as active participa-
tion "in the political guidance of the Country. " The
artist in Soviet society had to be--in Stalin's favorite
term--"an engineer of men's souls. " Subject as well
as style in art was restricted "almost entirely to
the 'new Soviet man' and the 'new Soviet society'
depicting scenes of industry, construction, and col-
lective farm work. " Even landscapes, "seemingly
nonpolitical... were only permitted if they showed the
countryside in 'Socialist transformation' using such
devices as dams or electric power stations" (545:

44-45). The Russian artist was expected to accept
and guide himself by "kritika i samokritika" ("cri-
ticism and self-criticism")... "to become his own
personal state censor" insuring an "art national in
form and socialist in content" (545:45).

1939, Febru- The February issue of Studio--"venerable English-
ary American publication" devoted for nearly half a cen-
 tury "to serious enquiry into what is significant" in
 fine and applied art, was banned by the United States
 Post Office in New York City (447:71) as "obscene"
 because it contained nudes by contemporary artists
 (186:185). The censored pictures--Matisse, "Hindu
 Rose"; Eric Gill, "Apocalypse" a woodcut; Aristide
 Maillol, Ovid illustrations; Demetrius Galanis,
 "Three Graces"; H. M. Williamson, "Vanity," and
 "Toilet" two prints (180:137-138)--caused the Post
 Office to revoke the magazine's second class mail-
 ing permit (563), and to tell the publishers that
 future issues of Studio would have to be sub-
 mitted to postal authorities in advance for a
 decision as to whether they would be carried in the
 mails. The publisher must agree to this "prior
 censorship, " a Post Office spokesman said, before
 any application for a magazine mailing rate for the
 publication would be considered (180:137-138), and
 that "there was no reason an art magazine should be
 permitted to reproduce figures under the name of
 art, while other publications reproducing pictures
 of nudes should be classified as obscene" (622:56).
 Vigorous protest to this restriction by Bryan
 Holmes, Studio American representative and grand-
 son of the magazine's founder--supported by Ameri-
 can art organizations and art authorities (Juliana
 Force of the Whitney Museum of American Art, and
 Alfred Barr of the Museum of Modern Art)--brought
 a reversal of the Post Office decision. In considera-
 tion of the publication's reputation and "serious ap-
 proach to art, " Studio magazine mailing privileges
 were restored, and the February issue released for
 distribution.

1939, March By treaty with Germany, signed in Vienna, Czecho-
18 slovakia's cultural activities as well as territory were
 absorbed in the Reich, with the result that Czech
 Prime Minister Rudolf Beran announced in the offi-
 cial Czech policy toward art:
 "We must put an end to the modern scribble and
 smear artists. "
 Under the new art policy, prominent state art
 and museum officials were dismissed from their
 positions, including Vincenc Kramar, Director of
 the State Gallery of Old Art in Prague, and carica-

tures of "brilliant satirical draughtsmen, " such as
Antonin Pelc and Adolf Hoffmeister, could no longer
be published because of the new censorship (67, 1940:
515).

1939, June (A) The Union of Soviet Artists was formed in Russia,
and by 1941 there were 3, 724 painters, sculptors,
graphic artists, theater and film actors, and art
critics in the Union (545:51).

1939, June (B) "Adam, " latest "shocker" of sculptor Jacob Epstein,
"bad boy of the English art world, " whose "bull-
bold virility" in a seven-foot, three-ton alabaster
figure, "made pulpits seethe, strong men blush, and
the public flock to look" when it was unveiled in Lon-
don, grossed $250, 000 from an exhibit at Blackpool,
English summer resort (67, 1940:60; 579, 1940:178-
179).

1939, June 22 A fig-leafed copy of Michelangelo's "David" was put
in display at Forest Lawn, the Glendale cemetery
made famous by Evelyn Waugh's novel, The Loved
One.

1939, June 30 The Nazi government sold in Lucerne, Switzerland,
the "degenerate" art removed from Germany's galler-
ies and museums, in a giant auction--"Gemalde und
Plastiken Modernor Meister aus deutschen Museen. "
The entire sale of 125 paintings realized only 600, 000
Swiss francs (one franc quoted at that time in New
York City at 22. 525 cents), not much more than half
the anticipated amount. A van Gogh self-portrait
brought the highest price (175, 000 Swiss francs), and
"Three Women" by Matisse, the second highest
(4, 200 Swiss francs). A Belgian syndicate, rep-
resenting museums in Brussels and Antwerp, bought
most of the paintings, including two by Picasso:
"The Soler Family, " and "Two Harlequins" (51; 410,
Jy 2 1939 4:2).

1939, July ? The "degenerate" art--paintings, prints, sculpture--
collected by Professor Adolf Ziegler in Germany that
was not sold in the Lucerne auction--on June 30,
1939--or "bartered off against examples of German
Romantic painting" was burned by the Berlin Fire
Brigade (126:55).

1939, Octo- Hitler's art policy:
ber "Germany forbids any work of art which does not
 render an object faithfully, or which derides such
 Nazi ideals as War and Women, "
 while it approved "explicit nudes, " forbade "modern
 art, " including such figures as Lehmbruck's "Kneel-

ing Woman" (198:55).

1940 (A) The Gestapo interrogated Thomas Theodore Heine--
 German graphic artist whose satires "needled two
 generations of Germans" and who was co-founder of
 Simplicissimus, a "lively satirical weekly magazine
 of political and social protest"--in Oslo, where he
 had fled the Nazi regime that took over Simplicissi-
 mus in March 1933. They asked him, "Were you a
 Socialist or a Communist in Germany"? "Impres-
 sionist, " Heine replied (538:269).

1940 (B) The United States Congress passed the first peace-
 time sedition law since the Alien and Sedition Acts
 of 1798. This "Alien Registration Act" (54 U. S.
 Statues 670)--known as the "Smith Act, " for Rep-
 resentative Howard W. Smith of Virginia who intro-
 duced it--"made it a crime to advocate forcible or
 violent overthrow of the government, or to publish
 or distribute material advocating violence with in-
 tent to overthrow the government. " An estimated
 100 persons were fined or imprisoned under the
 Alien Registration Act in the twenty years from 1940
 to 1960. Prosecutions under the Act died out in
 1957, with the decision of Yates v United States, in
 which the Supreme Court reversed the conviction of
 fourteen Communist Party leaders under the Smith
 Act--but the law is still on the books (415:39).

1940 (C) Court cases in India and the United States (Sreeram
 Saksena v State A. I. R. 1940 Cal 290; and Parmele v
 United States 1940 113 F 2d. 729) found that "the
 nude is not per se obscene" in art "unless there is
 something which shocks or offends the taste of an
 ordinary or decent-minded man. " "For pictures,
 as well as sculpture... the surroundings, circum-
 stances, pose, the posture and suggestive elements"
 must be considered. "Public good taste cannot be
 transgressed... in the name of encouraging art" (375:
 49).

1940, January With the opening of the new May Ormerod Harris
 Hall, as offices and classrooms for the College of
 Architecture and Fine Arts at the University of
 Southern California in Los Angeles, nude models
 were banned in life drawing or other art classes by
 the University Art Committee (122:27). It was not
 long before student and public complaint of this re-
 striction caused the decree to be rescinded, so that
 advanced sculpture and painting classes once again
 worked from a nude model (394:27).

1940, Janu- At a meeting of the Trustees of the Milwaukee Art
ary 25 Institute, the "Resolution on Freedom of Exhibition"
 passed set forth the policy of the Institute "with re-
 gard to exhibitions generally, " including the state-
 ments:
 "... that freedom of expression in art is akin to
 the freedom of speech, of the press, and of
 teaching vouchsafed by the federal and state
 constitutions, "
 and that
 "it shall continue to be the policy of the officers
 of this corporation to guarantee that freedom in
 connection with its exhibitions... " (490).

1940, April 3 A Vatican broadcast condemned an art exhibit staged
 in Berlin by the German government in the famous
 Kaiser Friedrich Museum during the Christmas holi-
 days, December 15 to January 1, 1939, and now on
 a tour of Germany--this month in Leipzig. The
 Church spokesman criticized the art show, "Wife
 and Mother--the Source of the Nation's Life, " dedi-
 cated to the glorification of the German woman, as:
 "permeated by contempt and hatred for Christianity
 and all its ideals of womanhood. "
 Among the works described as demonstrating
 "contempt for the Church and for women" were a
 statue--"Frau Welt" ("Mother Earth") from the ca-
 thedral at Worms--showing a woman whose back is
 covered with toads and worms; and a figure from
 Trier--"St. Eucharius Sets His Foot Upon a Naked
 Woman in Labor, " which in reality symbolizes "the
 crushing of idolatry with all her offspring" (410, Ap
 4 1940 8:1).

1940, June 12 The United States withdrew from participation in the
 Venice Biennale art exhibit, after having sent the
 American collection for the show, several months
 before, on April 19. Indication of Fascist domina-
 tion of the Biennale--evident since the planning com-
 munique of the Italian government on April 15 an-
 nounced Mussolini's conference with the press on
 this year's program--was followed by the withdrawal
 from participation by some European countries--
 Britain on May 4, France on May 12--and the in-
 creased participation by others--Germany increased
 their number of exhibited works on May 12 (410, Ap
 16 1940 4:2; Ap 20 1940 15:5; My 12 1940 37:5; Je
 13 1940 21:2).

1940, August Dr. Walter Heil, head of the San Francisco Golden
 Gate International Exposition's European and United
 States Exhibitions took down from the United States
 Art Show a painting by Paul Cadmus, "Sailors and

Floosies, " after the United States Navy made com-
plaints about the picture. When Dr. Heil's superior
ordered the painting hung again, because of the fur-
or over its censorship in the San Francisco press,
the Navy spokesman commented on the incident:
"What fools we'd be to order it removed. It
merely gives the artist publicity" (579, 1940:
179-180).

1940, October The British censor at Bermuda removed three cases
7 of art objects of more than 500 items, including
paintings and rare books, from the "strong room"
of the American Export liner Excalibur as "enemy
exports. " Worth "hundreds of thousands of dollars"
the art treasure was held by British authorities as
"an obvious German ruse to secure dollar exchange"
for art objects which had been looted from museums
in Paris.

Among the seized paintings were 270 works by
Renoir, 30 paintings by Cezanne, 12 by Gauguin, 7
by Degas, and pictures by Manet, Monet, and Pic-
asso. The consignee, Martin Fabiani, an art expert
in Paris--according to reports from London--was
being used as a German agent. The shipment was
addressed to the Bignou Galleries in New York City,
and Duncan Macdonald of these Galleries tried to
get the British to release the shipment which, he
said, Fabiani had purchased earlier this year in
Paris, and shipped from Lisbon, with the approval
of the United States Consul there.

The Bermuda Supreme Court--in session at Hamil-
ton on November 8--rejected an application for hear-
ing on the condemned art treasures. When counsel
representing Fabiani told the Court that sending the
art to London to be dealt with by the Prize Court
there would be damaging to the objects in the collec-
tion, the Bermuda Attorney General indicated that
climatic conditions in Bermuda "would be harmful"
to the art, and precluded its being held there.

Later--on December 9--the shipment seized from
the SS Excalibur was sent to Canada (410, 0 8 1940
27:6; 0 10 1940 3:7; 0 11 1940 13:5; N 9 1940 5:5;
D 10 1940 10:5).

1941, Janu- After its publication of the cartoon "Their Gallant
ary 21 Allies"--ridiculing British allies by showing the
Free French, Dr. Antonio Salazar of Portugal, and
Polish leader Wladyslaw Sikorski--"described as
fascist"--holding a banner: "War on USSR. Peace
with Italy"--in the issue of January 20, 1941, offices
of the Daily Worker in London were raided by Scot-
land Yard Special Branch. The Home Office an-
nounced that the publication had been suppressed

under the Regulation 2D of the Defense (General)
Regulations. This ban remained in force until the
Soviet Union had been involved in the Second World
War (575:228).

1941, June A band of unfriendly Cheyenne braves "in complete
tribal regalia" picketed the United States Post Office
in Watonga, Oklahoma, because they objected to the
decorative mural inside the post office. Chief Red
Bird, age 71, explained the Cheyenne's opposition
to the painting, which depicted Cheyenne ancestors
in the time of Chief Roman Nose:
 "Breech clout too short, look like Navajo. Roman
 Nose's baby look like stumpy pig. No good. It
 stinks" (579, 1941:178).

1941, July 2 The New York Times Sunday Magazine section for
June 8 was banned in Tokyo, Japan, because the
supplement contained a page of Chinese war art--
woodcuts portraying the Chinese Army and the ef-
fects of Japanese bombing on villages, as in one
print titled "Homeless After a Japanese Raid, " de-
picting a refugee fleeing from a burning village (410,
Jy 21 1941 5:5).

1941, August After the murals in San Francisco's Coit Tower had
28 been installed for seven years, the San Fancisco
Park Commission discovered that they were "Com-
munistic, " and adopted a resolution asking the city
Art Commission "to remove from the walls of Coit
Tower three murals" alleged by the Park Commission
to engender class hatred (117:10).
 The Park Commission had investigated--and con-
firmed--the original complaint made last month by
San Francisco taxpayer Leo Sullivan "that the murals
were communistic and tended to breed class hatred"
(117:10)--in one panel, workers' faces were found to
"epitomize hatred, " and in another there was repre-
sented a "non-patriotic volume"--a book by Karl
Marx (400:12).

1941, Septem- Jose Clemente Orozco's Mexico City mural decorat-
ber ing the walls facing the main floor of the Supreme
Court of Justice angered several Supreme Court
Justices when they viewed a panel "showing blind-
folded Justice in a compromising position. " The
Justices demanded removal of the offensive panel,
and while the Mexican government refused to remove
the picture, as a compromise they commissioned
American painter George Biddle to paint a mural
on the floor below (485:291).

1941, October "Progress, " a nude "Rodinesque" statue group sculp-

ted by Tony Noel in 1906, caused distress in Lin-
iers, a Buenos Aires suburb, when it was moved
from the downtown theater section of the central
city of Buenos Aires to a "quiet little plaza" near
Father Jose McDunphy's church of Corpus Domini.
Father Jose--already known as "the scourge of nude
statues of Buenos Aires"--protested to the Mayor of
the suburb:

> "Not everything which is good in the heart of the
> city is suitable for every street. This is the
> quarter where a man lives with his own--the
> happiness of his wife, the sanctity of his home,
> the innocence of his children... If anyone wants
> to sin, let him go downtown to the port."

"Progress" is now draped in newspapers by "Father
Dunphy's flock" (13:144-147).

1941, Decem- After the Japanese attack on Pearl Harbor, the or-
ber 7 der was issued to artists of the Federal Art Project
in Los Angeles to paint only war subjects for hang-
ing in army camps. The portrait of General Doug-
las MacArthur became a favorite subject (67, 1943:
524).

1942 (A) The London Daily Mirror "came close to suppression"
under Regulation 2D of the English Defense (General)
Regulations for its publication of Donald Zec's car-
toon showing a torpedoed sailor on a life raft, with
the caption: "The price of petrol has been increased
one penny--Official." The Mirror claimed the car-
toon "was merely a warning to its readers against
wasting petrol," but "the British government inter-
preted the cartoon as a comment on the profits of
the petroleum companies." Home Secretary Herbert
Morrison, summoning the offender to his office, told
the owner and editor of the Mirror that "further in-
discretion would result in suppression of the paper"
(575:229).

1942 (B) American artist John Steuart Curry, famed regional
painter of his native Midwest, was forced to repaint
part of his mural for the Kansas Capitol in Topeka
because of the complaints of "crusty Kansans" upon
viewing Curry's gigantic painting depicting the history
of Kansas. The artist was informed "that pigs' tails
do not curl when they are eating, and that he had
them curled the wrong way anyhow" (579, 1942:172).

1942, March Life magazine was "banned in Boston" "because it
(A) reprinted six nude pictures then on public exhibition
at the Dallas Art Museum" (54).

1942, March Elmer Plummer's painting "The Climax"--showing
(B) a burlesque stripper in a bump--was not hung when
 the 21st Annual Exhibition of the California Water-
 color Society moved from San Francisco to the Los
 Angeles County Museum. The picture--"mysteriously
 ... secluded from the public eye"--could be viewed
 only in a back room. The work had been selected
 by a jury for public viewing, Plummer pointed out,
 in his objection to this "peep show" display of his
 painting (353:12).

1942, April 15 War restrictions on artists who summer on New
 England's picturesque coastline forbid--according
 to Frederick Bundy, president of the Gloucester,
 Massachusetts, Chamber of Commerce--including
 "any lighthouse, any area set aside for defense use,
 or any government craft or structures in sketches,
 drawings, or paintings. " In addition, artists may
 be required to exhibit their works to an authority
 in the government for approval, but the details of
 this surveillance have not yet been determined (410,
 Ap 6 1942 15:2).

1943 (A) The United States Treasury Department Section of
 Fine Arts (1933-1939) purchased 539 murals, selec-
 ted on the basis of merit in regional competitions,
 for the decoration of federal buildings. The WPA
 Federal Art Project spent an estimated $35 million
 for 2, 500 murals, 18, 000 sculptures, and 100, 000
 paintings (12:88). Protests by American artists
 failed to deter "determined laymen" from whitewash-
 ing unwanted WPA murals, including Emerson Burck-
 hart's painting in Columbus, Ohio, and Rudolph
 Weisenborn's decoration in Chicago (7, 1944:550).

1943 (B) William Dobell, widely-known contemporary Austral-
 ian artist, received an award for his work, although
 academic painters criticized his prize-winning pic-
 ture and attempted to prevent the honor being given
 to him (178:151).

1943, April An issue of Life magazine was "banned in Boston"
 because it reproduced in full-color works of well-
 established American artists represented on view at
 the San Francisco Museum of Art in the Contem-
 porary American Figure Painters Exhibit. Among
 the artist represented--not all by nudes--were:
 Henry Varnum Poor, Guy Pene du Bois, Waldo
 Peirce, James Chapin, Raphael Soyer, and Leon
 Kroll (467:4-5).

1943, Septem- Argentina extended her "war" on communism to the
ber arts, and in a "police campaign, decreed by the

government for the extermination of Communism
throughout Argentina," government officials prohibited
artist Antonio Berni--winner of this year's Argentine
National Prize for painting, highest distinction of its
kind in Argentina--from receiving the award, "on the
grounds that he was a Communist and therefore in-
eligible. "

At this same time, one of Berni's paintings was
banned from the Municipal Art Gallery in Buenos
Aires, and General Pertine, Mayor of Buenos Aires,
removed Luis Falcini from his post as curator of
the Gallery. The dismissal of Falcini--"reliably
reported to be not a communist but a man of demo-
cratic ideas"--was caused by his painting for a local
trades union several years ago "a picture showing a
man saluting with upraised arm and clenched fist"
(316, S 27 1943 3:c; 410, S 27 1943 9:2).

1943, Octo- "I wonder how they will protect our boys from those
ber nude statues and paintings when they reach Rome, "
 wounded artist Umberto Romano asked. He had
 been approached in the summer of 1943 by represen-
 tatives of the Trenton, New Jersey, branch of the
 U. S. O. with the request that he paint free a large
 mural to decorate the U. S. O. Clubhouse, in the old
 auditorium of the Y. M. C. A. in Trenton. After the
 artist agreed to supply the labor and the U. S. O. the
 materials for painting, Romano produced a 14x11
 foot mural, his own conception of "The Spirit of
 Freedom, " a nude figure.

 The picture was returned to Romano uninstalled
 because U. S. O. officials said that they objected to
 soldiers "being exposed to nudity" (469:15).

1944 "Disgraceful" was the word, according to Peyton
 Boswell, editor of The Art Digest, for the final un-
 dignified liquidation of the Federal Art Project in
 New York City, when "thousands of destrecherized
 paintings were auctioned to a junk dealer as 're-
 claimed canvas'" (7, 1945:561).

1944, January The United States Post Office in New York City
 found the December 1943 issue of View magazine
 "non-mailable under Section 598, Postal Laws and
 Regulations, " because it contained "objectionable
 matter" in the form of pictures. Charles Henri
 Ford, editor of the publication, contested the un-
 mailable decision when hearing was granted, pointing
 out that the nudes the Post Office found obscene were
 paintings by Michelangelo, Picasso, and Leon Kelly.
 (596:19). The Postmaster released the sequestered
 issue for distribution (447:71).

1944, August 25	The Allies finally achieved liberation of Paris from German occupation, during which time artists--such as Picasso--had been forbidden to exhibit their works. Occupation authorities were planning to remove the sculptured historical figures and monuments of the city--a list of 150 had already been compiled--and to reduce their metal for the manufacture of munitions. All but a few of these marked sculptures--which had disappeared from the parks and the boulevards of Paris--were found and saved (67, 1945:525, 625).
1944, October 8	Fleeing as the police intervened, unidentified rebels consisting of "several score" of painters protested the prominence given to Pablo Picasso and his followers at the Autumn Salon--referred to as the "Liberation Salon" because it was the first art show in Paris after the city was freed from German occupation. The protestors, whose own works had been rejected for hanging in the show, demonstrated in front of Picasso's work--74 paintings and 5 sculptures, given the place of honor in an entire room--and tore fifteen of his paintings from the walls, but did not damage them, before the police arrived (410, 0 9 1944 4:7).
1944, November 20	Berlin police offered a reward for information about the anti-Nazi posters that had heralded the advance of the Allies into Germany (410, N 21 1944 8:4).
1945 (A)	The American Commission for the Protection and Salvage of Artistic and Historic Monuments worked in Europe to save frescoes and other art objects from further damage by exposure, and to make a careful survey of the destruction of art and architectural monuments as a result of bombing, land mines, and other military action (67, 1946:75).
1945 (B)	When Sergeant Bill Mauldin was awarded the Pulitzer Prize for his Stars and Stripes cartoons, General George S. Patton called him to headquarters and accused him of "undermining the morale of the Army, destroying the confidence in the command, and making soldiers unsoldierly" (265:22).
1945, March	The citizens of elm-shaded Kennebunkport, Maine, "seethed in mounting anger for four years" over a mural painted for their post office for the Federal Works Agency by Guggenheim Fellowship winner Elizabeth Tracy, depicting bathers at a resort beach near town. Led by the vocal oppostion of two novelists--native son Kenneth Roberts ("The painting's an

eyesore, and the whole town is ashamed of it") and Booth Tarkington, summer resident ("It's dismal... a combination of Coney Island and Mexican realism"), the town's citizens chipped in $1,000 to buy a substitute mural, Maine artist Gordon Grant's painting of Kennebunkport harbor in 1825. The United States Senate voted to accept and install Grant's mural, ending a long controversy (372:34).

1946 (A) New York publishing company Farrar & Rinehart at the same time that they published Gerald Butler's "kill-&-thrills murder shocker" Kiss the Blood Off My Hands "simultaneously achieved the all-time high of art expurgation in Abner Dean's It's a Long Way to Heaven (a collection of pictures imitated from William Steig), in which are included drawings of three hundred and twenty-three--323--naked men, not one of them anatomically male" (336:68).

1946 (B) A United States court found (Hannegan v Esquire 327 U.S. 46) that "A requirement that literature or art should conform to a norm prescribed by an official smacks of an ideology foreign to our system" (375: 4).

1946 (C) "Too extreme," exclaimed shocked Catholic officials, upon viewing the new church in a city-financed resort at Belo Horizonte, Brazilian state capitol 375 miles from Rio de Janeiro. The church, designed by famous Brazilian architect Oscar Niemeyer and decorated with modern murals--"St. Francis Preaching to the Birds"--remained unconsecrated by local bishops, and after three years the building was designated a national monument to preserve it for other-than-religous use (587:76).

1946, May 13 The Allied Military Government ordered all Nazi memorials in Germany be destroyed before 1947 (7, 1947:125).

1946, October 2 Mayor J. M. Curley of Boston halted the Copley Society Exhibit of eleven modern paintings on the theme of "The Temptation of St. Anthony" as "an insult to the Catholic Church" (410, 0 3 1946 29:6).

1946, November 25 The "morally vigilant police of Fall River, Massachusetts," prohibited the distribution of the tenth anniversary issue of Life magazine (3, 1946-1947: 42) because "two reproductions illustrating rustic romance"--Noon" by Doris Lee, and "Lovers in the Cornfield" by Angelo di Benedetto--appeared in an art section. Allied Chiefs of Police of the Southeastern District of Massachusetts "were instructed

to banish" this issue of Life "under penalty of im-
prisonment or of fine, or both" (52:3). Douglas
Gilbert, in his article in the New York World Tele-
gram, assessed this art censorship:
"No age has a copyright on damn fools" (52:3).

1947 (A) Exhibition authorities at the Regina Fair in Canada
"refused to hang a nude painting by the well-known
English painter Matthew Smith, " even though it was
one of the works in the Massey Collection of Modern
English Painting, presented to Canada by the Right
Honourable Vincent Massey, and was on tour of
Canada before being hung in the National Gallery
of Canada.
Winnipeg Art Gallery later "condemned" the same
painting on the grounds that it would offend "the re-
spectable families" of that city (402:78).

1947 (B) "I don't like the family Stein:
There is Gert, there is Ep, and there's Ein;
Gert's poems are bunk,
Ep's statues are punk,
And nobody understands Ein. "
Trustees of the Tate Gallery in London considered
Jacob Epstein's gigantic statue--11-feet high--"Luci-
fer" so "punk" that they refused to accept it for ex-
hibit. The sculptor, controversial since his first
work in 1909--"brazenly nude" figures to decorate
an office building--had been attacked by public and
critics alike for his distorted "often misshapen"
statues, categorized as "vile" and "obscene. " The
figures were splattered with red paint, censored
with fig leaves, and sent on tours "as a kind of
peep show" advertised as "the world's greatest
shocker" (557A). Even Epstein's drawings were
found offensive, and were seized by the United States
Customs as obscene (363).
Fifteen years after refusing to house "Lucifer, "
the Tate Gallery accepted the figure for display, and
honored Epstein--in November 1952--with a retro-
spective exhibit (557A).

1947 (C) The encyclical Mediator Dei of Pope Pius XII set
forth official Catholic attitude toward modern Chris-
tian art: "Modern pictures and statues, whose style
is more adapted to the materials in use at the pres-
ent day, are not to be condemned out of hand. "
Such art "should steer a middle course between ex-
cessive realism... and an exaggerated symbolism, "
and "take into account more the needs of the Chris-
tian community than the personal taste and judgment
of the artist" (179, III:594).

1947 (D) In disciplinary action for "a comrade who thinks he
 can conduct a revolution in apples," the USSR offi-
 cially declared the art of Pablo Picasso "decadent,
 bourgeoise, and generally baneful." "Long-time
 earnest left-winger" Picasso joined the Communist
 Party in 1946, declaring: "It is not necessary to
 paint a man with a gun. An apple can be just as
 revolutionary" (48).

1947 (E) Professor Vladimir Kemenov, Director of Moscow's
 Tretjakov Gallery, attacked modern art as "decadent,
 anti-humanist, and pathological," and expelled Rus-
 sian artists working in the style of "hideous and re-
 volting" modernism from Soviet art guilds and un-
 ions. The State had sponsored exhibits of Construc-
 tivists and Suprematists and other "progressive art-
 ists" after the Revolution, sanctioning such diverse
 expression as that of Kandinsky and Chagall, but
 from the 1920's--when the "narrow and restrictive"
 doctrine of Socialist Realism evolved as official Rus-
 sian art--"bourgeois taste prevailed and academic
 artists regained supremacy."
 Soviet authorities "aware of the possible conse-
 quences of the assertion of nonconformity," now re-
 fer to "personal and searching or imaginative state-
 ments" by Russian artists as "subjective anarchy"
 (108:457, 459).

1947 (F) The "Maple Leaf"--soap flakes trademark--baby,
 shown on a Quebec streetcar as an advertising card,
 was dressed with a loin cloth, a covering insisted
 upon by Quebec censors (402:76).

1947 (G) According to "truly Catholic criticism of the visual
 arts," "grand Blasphemy" lies in advanced painting
 that is an exhibition of "private pleasures in shape-
 less and distorted forms." In such work nature is
 represented "not as a hymn to the glory of God,"
 but as "a diabolical creation reproducing man's own
 depravity." If the subject of a picture--according
 to the writer on Modern Heresy--is "blasphemous,
 indecent, or frankly pagan, its very success is its
 own indictment" (115:79-80).

1947, Febru- Because "morality squads in Quebec have to approve
ary 11 all posters and illustrations before they can make a
 public appearance," "Buste de Femme"--a drawing
 by outstanding French painter Pierre Bonnard, whose
 work is known for its "charming decorative effect"--
 appeared "propertised" in the Canadian edition of the
 French art weekly Carrefour, on February 11. This
 Canadian edition, a Montreal reprint of the Paris-pub-
 lished magazine--printed in Canada by L'Action

Catholique--blotted out most of the drawing with "a
white stripe across the breasts, " because the uncor-
rected drawing would have proved "offensive to the
public" (16:134).

1947, April Two art exhibits sent abroad by the United States
State Department, under the Cultural-Cooperation
program begun in 1938 for developing better cultural
relations with other nations, caused such a political
controversy that they were recalled and the program
using art curtailed (468:84-85).

The exhibits--"Contemporary Americans, " selec-
ted from a collection of 79 oil paintings purchased
with the advice of art authority Leroy Davidson (7,
1948:502) by the State Department for $49, 000--were
entitled "Advancing American Art, " and had been
sent on tour for a five-year period to Europe--49
paintings--and to Latin America--30 paintings. The
collection had been shown in Paris, and in Cuba, and
gone as far as Prague and Port au Prince, Haiti
(410, Ap 13 1947 II, 10:3), respectively, when con-
servative art groups (notably the American Artists
Professional League) protested (298:245; 376:47) the
"esthetically radical character" (468:84-85) of the
paintings, publicizing their criticism in the press,
in Look magazine, and over the radio.

After a "flood of letters were received by Con-
gressmen" criticizing the expenditure of public funds
for art that was "Communist propaganda"--President
Truman on seeing one of the pictures ("Circus Girl"
by Yasuo Kuniyoshi) reportedly said, "If that is art,
I'm a Hottentot"--Secretary of State George Marshall,
and other officials, indicated doubts as to the value
of the exhibition, not uninfluenced by Congressional
criticism raised at hearings on the State Depart-
ment's appropriation bill (410, My 18 1947 53:8),
and recalled the exhibits. Later the paintings--79
oils and 38 watercolors--were sold by the War As-
sets Administration (410, My 23 1948 II, 8:3), as
"war surplus, " netting "little over $5, 000" (7, 1948:
502)--about "ten cents on the dollar" for the collec-
tion, which was purchased in sealed bids by public
institutions, including colleges, high schools, muse-
ums, and public libraries (410, My 18 1947 53:8).

1947, May "Lovers, " a statue by Mitzi Solomon, was expelled
from the National Association of Women Artists
Exhibit at the National Academy of Design in New
York City, at the request of Hobart Nichols, presi-
dent of the Academy (393:6), although the figure had
been awarded a $50 prize in the Women Artists Ex-
hibit and had previously been shown at the Whitney
Museum. "Pressure exerted by... fellow artists and

the ridicule of the press" caused "Lovers" to be re-
turned shortly to public view at the Exhibit, after
Grace Treadwell, president of the Association, and
Nichols issued "a joint statement asking the artist to/
return her statue to the Exhibit and inviting her and
her friends to rejoin the Association" (53:7).

1947, August The first one-man show of Icelandic art ever held
12 in England opened at the London gallery of the Royal
Society of Painters in Water Colors, but the artist--
Asgeir Bjarnthorson--was forbidden to make a single
sale. A Board of Trade spokesman explained Great
Britain's ban on sales in England by foreign artists:
 "We do not allow pictures into this country ex-
 cept for exhibition" (410, Ag 13 1947 21:6).

1947, October Art critic Eric Newton reported that Pravda recently
19 reiterated an old creed--Russia's "Art for Marx's
Sake"--in which the Soviet artist is told what and
how he must paint, and the critic is informed of
what he must say about "realistic art." Under sup-
pression of modern art in totalitarian states (410, D
14 1952, VI, p. 22), "Realistic Art... in the service
of the people" and "ideologically sound and cheerful"
is the only officially approved expression (419).

1947, Novem- Lieutenant Colonel Dymschitz laid down the rules for
ber Social Realism in East Germany's art in his lecture,
"Soviet Art and its Relation to Bourgeois Art," at
the Soviet Haus der Kultur in East Berlin. These
strictures cast "an authoritarian pall" over art in
the Eastern Sector, where students "can compensate
for scholarly and academic weaknesses" in their art
work by "political activity" (339).

1948 (A) Josef Stalin "cracked down on Soviet artists... who
violated his standards of 'Social Realism'". Many
offenders "vanished suddenly... Some were never
heard of again" (67, 1965:38).

1948 (B) The last edition of the Index Librorum Prohibitorum
--published in Rome at Typis Polyglottis Vaticanus--
was issued.

1948, Febru- The Russian magazine Moscow Bolshevik reported
ary 25 that Soviet painters examining their work in the light
of the recent--February 11--Central Committee of
the Communist Party censure of composers (both
Soviet composers and painters are under the direc-
tion of the Council of Ministers' Art Committee)
found a "spirit of decadence and bourgeois estheticism"
in their own visual arts (410, F 26 1948 3:8).

1948, March The United States Supreme Court decision in the
29 Winters case (Winters 294 N.Y. 545) was one of
 several (Strohm 160 Illinois 582 34 L (KB 11);
 McKee 73 Connecticut 18) in prosecutions for the
 publication of pictures or stories of deeds of blood-
 shed and crime (336:18).

1948, Novem- The Hotel del Prado in Mexico City covered a con-
ber 19 troversial Diego Rivera mural. Early in June of
 this year, Archbishop Martinez had refused to bless
 the painting, one in the "Sunday in the Almeda"
 series, unless artist Rivera removed the "atheistic
 phrase" ("God Does Not Exist") painted into the de-
 sign.
 Rivera had refused to censor his painting, and
 when students effaced the phrase, he painted it again
 as it was originally (410, Je 3 1948 27:6; Je 6 1948
 16:l; Je 8 1948 23:3; Je 13 1948 30:4; N 20 1948 5:3).

1949 (A) Because of the United States Post Office's "rigid
 policing of nudity in photographs," Eastman Kodak
 "set up... a private censorship operation of materi-
 als sent to it for processing," and expressed in
 writing the company's policy on censorable material
 (447:108). Following these criteria, applied when
 a customer sent to Eastman an undeveloped color
 picture of a copy of Goya's painting "Duchess of
 Alba," the company returned a developed picture
 only after "a vigorous protest was filed" by the
 customer. Eastman explained in an accompanying
 letter:
 "In our judgment, confirmed by rulings we have
 had from the Post Office Department in similar
 cases, we cannot legally return such pictures
 without a satisfactory explanation of the circum-
 stances surrounding the taking of the pictures
 and their intended use" (447:280).

1949 (B) Diego Rivera censored his own murals, when he
 supplied photographs to supplement his retrospective
 exhibit in Mexico City, by holding back three of the
 panels of the 21-section "Portrait of America," he
 had painted in the New School for Social Research
 in New York City after the Rockefeller Center mu-
 ral was destroyed.
 The artist designated these plates "unsuitable,"
 because "he was trying for reinstatement in the
 Communist Party," which "had ousted him after
 one of their several quarrels," and considered the
 "paintings possibly offensive to Party authorities"
 (410, Jy 6 1969 II, 19:1).

1949 (C) Showing of paintings in the "Gallery of Wheels"--

an art exhibit assembled from the work of 19 artists
from various galleries in New York City by Mr. and
Mrs. Carroll Aumont "for the pleasure and therapeu-
tic benefit of paraplegics at St. Alban's Naval Hospi-
tal on Long Island"--ceased when Congressman
George A. Dondero, Republican from Michigan,
criticized the exhibit's artists: "Radicals all. They
had a great opportunity not only to spread propaganda,
but to engage in espionage" (213:88-89).

Six of the artists whose works were in the St.
Alban's show also had paintings in the United States
State Department exhibits censored in 1947.

1949, Febru- ary 1	Claiming an artist's "proprietary interest in his work to protect his honor and reputation," Alfred D. Crimi sued the Rutgers Presbyterian Church in New York after they covered with "a coat of buff-colored paint" his 35x26 foot fresco on the rear chancel wall, eight years after he had completed the painting.

A committee appointed to commission the fresco
in 1937 had unanimously selected the Crimi design--
in a nation-wide competition under the auspices of
the National Society of Mural Painters (144; 155:42)
--over those of 19 other competitors. Continued
criticism by parishioners, who objected to the bared
chest of the figure of Christ depicted in the painting
--"the chest of Christ was so bare it placed 'more
emphasis on His physical attributes rather than on
His spiritual qualities'" (274:94-95)--prompted the
redecoration, without notice to the artist. Crimi
sought to force the Church either to remove the ob-
literating paint they had placed over his mural, and
permit him to remove the fresco at Church expense,
or to pay damages for effacing the mural. Crimi
had been paid $6,800 for his painting, and his con-
tract contained no provision against obliteration of
the work (81:199-201).

The New York State Supreme Court decided the
case (Crimi v Rutgers Presbyterian Church 89 N.Y.
S. 2d. 813, 194 Misc 570 (1949)) against the artist
plaintiff, holding that an artist retains no rights in
his work "after it has been unconditionally sold
where such rights are related to his artistic reputa-
tion" (274:94-95). "The law protects the right of
the artist... to the integrity of his work. No change
can be made without his consent, whether by sub-
traction, or addition such as covering nudity. The
buyer of a picture may totally destroy it, but he
may not change it" (274:71).

1949, March- October	Politics entered the art field in the United States when Congressman George A. Dondero, Republican from Michigan, "filled many pages of the Congres-

sional Record with attacks on modern art, under the
false premise that modern art... and Communism...
are synonymous" (7, 1950:523; 337:240). He sug-
gested that guilds of artists should be checked for
"heresy" (370:121-133), and attacked established mu-
seums--Museum of Modern Art, Art Institute of
Chicago, Fogg Art Museum at Harvard University--
and professional art organizations--Artists Equity
Association (410, Mr 18 1952 24:7)--for the display
of modern art, which he labelled "degenerate."
Dondero demanded that art associations--including
the National Academy of Design, American Artists
Professional League, Allied Artists of America,
Illustrators Society, American Watercolor Society--
expel communist members, and reward the "hard-
working, talented, reserved, patriotic proponents
of academic art." Although his charges were op-
posed by other Congressmen--Jacob Javits of New
York and Charles Plumley of Vermont--and many
artists, art organizations, and "interested citizens,"
"as a result of his speeches and charges a number
of exhibitors returned paintings to artists named as
'subversive,' a number of members resigned from
Artists Equity Association, and artists lost mural
commissions and were expelled from conservative
clubs" (370:121-133).

Congressman Dondero's speeches on art in the
Congressional Record include:

March 11, 1949	"Modern Art as Communist Heresy"--noting that 17 of 28 artists loaning paintings for New York City "Gallery on Wheels" exhibit to government hospital patients were mentioned in the Dies index.
May 17, 1949	"Communism in the Heart of American Art--What To Do About It"--described as expressing "traditional hatred of modern art... harnessed to fear of Soviet aggression" (162:84). When art critic Emily Genauer interviewed Dondero in Washington the following month, she quoted him as expanding his views on art:

"Modern Art is communistic
because it is distorted and
ugly, because it does not
glorify our beautiful country,
our cheerful and smiling peo-
ple, our great material pro-
gress. Art which does not
portray our beautiful country

in plain, simple terms that
everyone can understand breeds
dissatisfaction. It is therefore
opposed to our government, and
those who create and promote
it are our enemies" (213:89).

August 16, 1949 "Modern Art Shackled to Com-
munism"--pointing out that the
Armory Show of 1913 was a "red
plot, " and that foreign "isms"
"representing weapons of destruc-
tion" to America's "priceless cul-
tural heritage" include a "role of
infamy" of modern art: "Dadaism,
Futurism, Surrealism, Cubism,
Expressionism, Abstractionism"
(370:121-133).

1949, July 18 In replying to a letter from C. E. Plant, commander
of a San Francisco American Legion post regarding
the removal of "communist art" in Federal Buildings
--specifically the Refregier Post Office murals in
San Francisco--Richard M. Nixon, as a member of
Congress, wrote:
"I realize that some very objectionable art, of
a subversive nature has been allowed to go into
Federal buildings in many parts of the country...
At such time as we may have a change of ad-
ministration and in the majority of Congress, I
believe a committee of Congress should make a
thorough investigation of this type of art in Gov-
ernment buildings with a view to obtaining re-
moval of all that is found to be inconsistent
with American ideals and principles" (298:247;
537:20; 590).

1949, Septem- The attack on modern art in both Russia and the
ber 11 United States was discussed in the New York Times.
Cubism--as an example of such art opposing the
"traditional, merely pretty, academic and illustra-
tive, " and that is not propaganda or anecdotal--is
called degenerate and its suppression and censor-
ship demanded in Russia--where it is labelled
"bourgeois"--and in the United States--where it is
described as "Communistic" (410, S 11 1949 II, 6:3).

1949, Novem- Protests by a group of students made public a con-
ber 22 troversy over an unfinished mural--10x27-foot "One
World" by graduate student Harold Collins--on the
ground floor of La Guardia Hall, the student lounge
at the New York University's School of Education.
Some students, upon viewing the preliminary char-
coal sketch of the painting, charged that the picture

was "communistic propaganda" because American
workers were compared unfavorably with Russian
workers--figures in the mural representing the
world's people reaching toward each other through
the medium of the United Nations, contrast "horrible
United States" ("bemedaled generals, a hooded figure
carrying a rope, and a shouting politician") with
"glorious USSR."

The Republican Club of Washington Square College,
among student groups asking for removal of the paint-
ing, called the work "the epitome of Stalinism."

School authorities removed the sketches from the
wall--on November 24--but after a week--November
31--the unfinished painting was returned to its
planned site and Collins resumed his work to finish
it (410, N 23 1949 14:6; N 24 1949 36:3; N 25 1949
24:2; N 29 1949 24:5; D 1 1949 33:6).

c 1950 An American Customs official declared paintings by
 Maurice Utrillo, being imported into the United
 States, were "dutiable products"--rather than duty-
 free "art"--because "the paintings had been done
 with the aid of picture postcards" (620A).

1950, March Concerned with the "conflict of aesthetic ideologies,"
27 in which modern art is attacked as "radical and sub-
 versive" (7, 1951:521), three museums in the United
 States issued a Manifesto on Modern Art, defending
 modern art, affirming the belief in freedom of ex-
 pression in the arts, and the Museum's duty to foster
 it. These leading institutions--devoted primarily
 to the art of our time (Museum of Modern Art--
 represented by Rene d'Harnoncourt, Director, Al-
 fred H. Barr, Jr., Director of Museum Collec-
 tions, and Andrew C. Ritchie, Director of Painting
 and Sculpture; Whitney Museum of American Art--
 with Director Hermon More, and Associate Director
 Lloyd Goodrich; and the Institute of Contemporary
 Art, Boston--whose spokesmen were James S. Plaut,
 Director, and Frederick S. Wight, Director of Edu-
 cation)--in "an interesting and important cultural
 document" rejected "the notion that all esthetic in-
 novations... are politically subversive and 'un-Ameri-
 can,'" pointing out that "almost all the art of the
 past hundred and fifty years now generally accepted
 as good was originally misunderstood, neglected, or
 ridiculed not only by the public but by many artists,
 critics, and museum officials."

 "We deplore the reckless and ignorant use of
 political and moral terms in attacking modern art,"
 the Manifesto concluded, after stating that the wide
 and varied diversity in modern art was "a sign of
 vitality and freedom of expression inherent in a

democratic society, " and that "free speech" for art-
ists was necessary so that "art may grow, change,
and serve the human spirit" (7, 1951:521).

1950, April The Richmond Press in Richmond, Virginia, demand-
ed that Virginia State funds be cut off from Rich-
mond's Virginia Museum of Art because the Museum
exhibited the painting "Female Corpse, Back View"
by Hyman Bloom, succès de scandale of the current
art show, "American Painting, 1950, " which had
been selected by Special Director of the Exhibition
James Johnson Sweeney, to present "a unified twen-
tieth century style" (7, 1951:521).

1950, April 30 The American Association of Museums sought clari-
fication of the United States Customs law on import
of abstractions in art. Although the Customs Com-
mission chairman "saw hope of a Customs simplifi-
cation Bill, " another nine years were to pass before
the Customs Law was revised to admit duty-free im-
ported "abstract sculpture...the orphan of law and
precedent" into the United States as art.
 The Museum of Modern Art and art dealers had
contested the Customs appraisals made under the
turn-of-the-century definitions--legal (Underwood &
Grundy Tariff Acts) and judicial (requirement that:
"sculpture represent nature, or the human or animal
form in the actual proportions of the natural object. ")
Among the cases brought over Customs classification
and duty on imported sculpture were:
 "Development of a Bottle in Space"--bronze
 sculpture by Futurist Italian artist Umberto
 Boccioni--ruled dutiable at 20% of value be-
 cause it did not "represent, even in abstrac-
 tion, " a "natural" object. The Customs in-
 spector commented on the work: "Good Lord,
 why didn't they guy put an apple in there some-
 where--that would have let it in";
 "The Bull"--work by Italian artist Mirko
 (Mirko Basaldella), imported duty-free only
 because Catherine Viviano of the Viviano Gal-
 lery in New York City was able to persuade
 the Customs appraiser that "the intricate in-
 volutions" of the sculpture represented "ani-
 mal life";
 "Bird in Flight"--ruled by Judge Waite on
 November 26, 1928 a work of "art, " reversing
 the previous classification given the sculpture
 by Constantin Brancusi;
 "Fish"--Constantin Brancusi's "streamlined
 abstraction without fin or scale...veined in
 gray marble, " most recent importation of
 the Museum of Modern Art, admitted by

Customs "only under bond" (410, My 1 1950 27:5).

1950, June An "important declaration of principles" asserting
 freedom of the artist was passed by acclamation at the
 meeting in Venice, Italy, of the International Associa-
 tion of Art Critics (Association Internationale des Cri-
 tiques d'Art)--founded in 1949 to promote international
 cooperation in the plastic arts (painting, sculpture,
 graphic arts, architecture), with 783 individual mem-
 bers and 44 national sections (67, 1951:537):
 "In view of continued sporadic attacks on art, espec-
 ially on unfamiliar expression in pictures and sculpture,
 the members of the A. I. C. A. unanimously feel it an
 urgent duty to publish the following statement:
 "1. We believe that the artist is entitled to the same
 freeom in creation, exhibition, and publication
 of his work as is enjoyed by writers in the tradi-
 tion of the free press;
 "2. We believe in the right of free individuals to dis-
 agree on matters of taste and that this right im-
 plies a reciprocal obligation of tolerance toward
 explorations in the arts which may provoke such
 disagreements;
 "3. With examples in mind of art under political re-
 strictions, we deplore the imposition on the artist
 or on the exhibition of his work on restraints or
 threats of restraints based on considerations ex-
 traneous to art" (410, Je 25 1950 II, 9:2).

1950, Septem- Pope Pius XII in a speech--reported in the Vatican news-
ber 3 paper Osservatore Romano on September 5--to the First
 International Congress for Catholic Artists, with 200
 Catholic artists from 23 countries in attendance, con-
 demned all immoral and existential art and the theory
 "Art for Art's Sake. " The Pope said that while the func-
 tion of "condemned art is to drag itself on the same
 plane as sensual and material things, " the function of
 true art is "to bring man nearer to God. " "Art" and
 "immoral" are contradictory terms in the Church's
 view, and "immoral art... lowers and enslaves the soul
 to carnal passions" (410, S 6 1950 36:6).

1950, Octo- "Mother Earth's Fertility"--a reclining female nude
ber 6 bas-relief by sculptor William Longley--was chipped
 from the wall of an annex of New Mexico's Capitol
 in Santa Fe after a bitter fight between artists and
 churchmen over the morality of the figure. Three
 clergymen led by the head of the local Ministerial
 Alliance, a Protestant group, complained to 65-year-
 old Governor Thomas J. Mabry that the sculptured
 figure was "extremely suggestive. " The sculptor
 had insisted that "Mother Earth"--nicknamed "Miss

Fertility" by the newspapers--was "wholly without
sex appeal, " and his supporters, including famed
artist John Sloan, cited the nudes in the Sistine
Chapel as precedent for undraped public figures.
"No artist, " Sloan said, "would find the sculpture
pornographic. "
 When the building's architect, given the decision
as to whether the figure would remain by Governor
Mabry, removed the nude, a "Committee for the
Preservation of Cultural Freedom" tried to get it
put back on the grounds that since the sculpture was
a public work paid for by taxpayers, the architect
did not have the authority to take it down. Whether
the nude was artistically good or morally bad, the
Committee said, the issue was now one of censor-
ship. One taxpayer in a letter-to-the-editor summed
up his views:
 "I think the work in question looks like hell.
 But principles are principles" (315, O 7 1950;
 381:25).

1951 (A) Alexander Jendov, "best-known and most talented
 Bulgarian Communist painter, " led an artists' re-
 volt in Bulgaria when he wrote a letter to the Prime
 Minister and Communist Party boss Valko Cervenkov
 to protest "barracks discipline, inane censorship,
 and administrative terror" inflicted on Bulgarian
 artists, who were compelled by the government--
 he said--"to recite hollow phrases about Soviet art. "
 Jendov was immediately expelled from the Bulgarian
 artists' union and the Communist Party, and two
 months later he was arrested (410, F 10 1952 VI,
 26:3).

1951 (B) One of the sculptures of Canadian artist Robert
 Roussil was "broken by indignant visitors" to the
 exhibition in the Agnes Lefort Gallery in Montreal.
 Roussil's first show--after he stopped his training
 at the Art Association in Montreal in 1948--was
 marked by controversy--"one of the works had to
 be withdrawn because of the scandal it caused"--
 and "the frankness and vitality, particularly of his
 nudes, have caused Roussil's art to be attacked
 for immorality, even obscenity" (371:263).

1951 (C) The United States Customs refused to allow a bio-
 grapher of D. H. Lawrence to import a copy of the
 privately printed Paintings of D. H. Lawrence on
 the grounds that the book was obscene (355:39).

1951, March 7 Under cover of early morning darkness, a crew of
 city workers removed the nude statue, "The Family"
 by Enrique Alvarez, from the outside front of the

new Municipal Courts Building in New Orleans, and
transported it to a warehouse. The life-size bronze
group--father, mother, and son--had created "rag-
ing argument" since it was installed three weeks ago,
and after complaints from outraged passers-by was
draped with a tarpaulin. Three city judges and a
priest supported expressed public criticism by tak-
ing the view that the figure was "pornographic rather
than artistic. "

Later in the year "The Family" was sold at auc-
tion to a New Orleans art dealer, whose price for
the statue gave the city $600 more than the $2,400
that they had paid. The sculptor, watching the auc-
tion stoically as he sat under a magnolia eating
watermelon, commented only: "It's their statue"
(410, Mr 8 1951 41:7; Ag 25 1951 8:8).

1951, June? The United States Post Office took action against
Gershon Legman's "sensational attack on double-
standard censorship, " the book Love and Death,
as they considered the publication obscene "because
of the presence of a few objectionable four-letter
words" (3, 1950/1951:43). These probably escaped
folklorist Legman's attention, as experts have desig-
nated him "the greatest living authority on the bawdy
limerick" (W. S. Baring-Gould. The Lure of the
Limerick).

1951, June 24 A "nude chair" caused a violent controversy when
the new Municipal Art Gallery of Long Beach, Cali-
fornia, first opened. It was one of the exhibits--
designed by Charles Eames and decorated with a
line-drawing of a woman by Saul Steinberg, artist-
cartoonist whose work is known from the New York-
er and Harper's Bazaar--"selected by artists and
designers with expert knowledge of contemporary
art, " according to City Librarian Edward Castagna,
director of the opening of the Gallery in the $150,
000 Municipal Art Center. Mrs. Dean E. Godwin,
chairman of the Long Beach Municipal Art Commit-
tee--scheduled to take over administration of the
Center on July 1--designated the offensive chrome
and plastic chair "vulgar... not art, " and said that
the "nude chair" "must go" from the exhibit, "De-
sign for Today's Living. "

Mrs. Godwin and her Committee demanded that
Librarian Castagna remove the chair. He refused.
During the opening exhibit the chair in question was
turned to the wall by Committee members to con-
ceal the Steinberg outline drawing of the undraped
woman, and just as frequently it was turned back
with the drawing in public view by members of
Castagna's staff.

The question of the censorable chair was brought
to the attention of the Long Beach City Council and
City Manager Samuel E. Vickers by Mrs. Godwin,
and as they found the chair "Humorous, whimsical,
and witty" art, it remained on view until the exhibit
closed (351A Je 25 1951 2:1; Je 26 1951)

1951, August The "Victorian" police in Australia prosecuted Rosa-
leen Norton, Australian artist--"well known...for
her belief in 'black magic,'" for exhibiting obscene
articles for gain at Melbourne University--that is,
"three paintings of females with male genitals and
one of a youth in the grip of a panther." When the
case came to hearing, "the magistrate dismissed
the charge, and laid Ŀ4 4/-costs against the Police
Department" (118:58).

1951, Novem- "I started with the usual base, then despite myself,
ber in the grip of a driving force, my hammer hit on
my chisel. I was haunted by a rhythm in the form
of a cross, and I had to obey orders which were
not of my own inspiration," so explained Chilean
sculptor Juan Luis Cousino in excusing his produc-
tion in a four-ton block of marble of "an abstract
creation of the Virgin Mary," rather than a conven-
tional portrait of Empress Eugenie, which the city
of Biarritz had commissioned him to make.

Biarritz, fashionable resort on the southwest
coast of France, had contracted with Cousino last
spring to replace the bronze figure of its greatest
patron--Empress Eugenie, whose Biarritz memorial
had been melted down for armaments by the Ger-
mans during World War II. Cousino's model for
Eugenie submitted for city approval--"an ingratiating
...figure with wasp waist, swan neck and billowing
crinolines"--had been promptly accepted, and offi-
cials anticipating the sculpture's completion had re-
cently sent out invitations for a grand unveiling of
the long-sought replacement.

When they assembled to view the Empress a few
days before the installation ceremony, they found a
"stony-eyed Sphinx...her mouth open in a stifled
cry of the world's sufferings" substituted for the
pleasing model, and immediately cancelled the un-
veiling ceremony, ordered the statue to the city
dump, and demanded that Cousino refund the 35,000
francs already paid him for the Eugenie monument.
Cousino offered half-payment refund, but Biarritz
officials refused to exhibit his "pyramidal Virgin"--
or even to return it until the sculpture refunded
their money (45:163).

1951, Novem- In a French Government-ordered action, Paris police
ber 6 (A) seized seven pro-Communist paintings from the Au-
 tumn Salon, biggest art show of the current Paris
 season. French President Victor Auriol had re-
 fused to preside at the opening of the exhibit unless
 the canvases were removed. Ce Soir, Communist
 newspaper in Paris, reported that it was "the first
 time since Napoleon III that the French police have
 censored a big art show. "
 The banned pictures showed a Communist cell
 meeting, a political parade, a portrait of a petty
 officer who had been jailed for spreading Communist
 propaganda in the French Navy, and happy Parisians
 buying a Communist newspaper picturing Thorez,
 French Communist leader on the front page, with
 the legend "Maurice Thorez Doing Fine" (410, N 7
 1951 10:6).

1951, Novem- After alarmed citizens agitated in the Los Angeles
ber 6 (B) City Council against "communist infiltration" at the
 city-sponsored Municipal Art Exhibition in Griffith
 Park, the Council--after hearing testimony "from
 both sides"--adopted a resolution (Edward Roybal
 dissenting) stating "in effect, that any kind of paint-
 ing or sculpture other than illustrative realism is
 suspect of subversion or sacrilegion. "
 The Council's attention had been called to the
 Exhibition, when one of the displayed paintings,
 "Surge of the Sea" by Rex Brandt received a sec-
 ond prize, and observers reported the picture con-
 tained "a sailboat bearing an emblem thought to re-
 semble the hammer and sickle. " Councilman Har-
 old Harby--upon visiting the art show--found com-
 munist propaganda and blasphemy in several of the
 entries in addition to Brandt's painting: he criticized
 an exhibited abstract crucifix by Bernard Rosenthal
 as "a travesty on religion because it made Jesus
 look like a frog, " and attacked a canvas painted by
 Gerald Campbell because "its red hues" showed
 Kremlin controls (528).
 Brandt explained, in the hearing of the Council's
 special investigation of his picture, "that the insig-
 nia on the sail was the racing class symbol of the
 boat"--"the traditional Island Clipper insignia" (528)
 --a standard symbol used and known by all but land-
 lubbers (298:245; 320:197).

1951, Decem- Police in Pittsfield, Massachusetts, banned the No-
ber 1 vember 26 issue of Time magazine from the city's
 newsstands because the 400-year old masterpiece by
 Pieter Breughel the Elder, "The Wedding Dance, "
 reproduced in the art section was found "objection-
 able" by police censors (410, D 2 1951 38:3).

1952 (A) A minority of the membership of the National Sculp-
 ture Society--without consulting and not speaking for
 the Society members as a whole--sent an "open let-
 ter" on the Society letterhead to hundreds of "promi-
 nent community leaders attacking the Metropolitan
 Museum of Art's 1951 exhibition of Contemporary
 American Sculpture" as furthering "aesthetic leftism, "
 which the attackers equated with political leftism.
 This unauthorized action was repudiated by many
 Society members (including Paul Manship, former
 Society president, James Earle Fraser, and Cecil
 Howard), and denounced by such responsible art
 groups as the Whitney Museum of American Art and
 the American Federation of Arts (7, 1953:537). The
 National Sculpture Society statement--protected by
 such conservative artist members as Wheeler Wil-
 liams, Don de Lue, Mrs. Katharine Thayer Hobson
 (298:245)--critized the "systematic indoctrination" of
 students in schools and colleges "in the philosophy
 of imaginative anarchy in the creative arts, " and
 repudiated--"in the name of the sound, normal
 American people"--"'modern' artists' claim of a
 New Age in art" (571:59).

1952 (B) A book illustrated by Australian artist Rosaleen
 Norton won the distinction of becoming a "stateless
 book" when sample copies air-freighted to America,
 soon after its publication in Australia, were seized
 by the United States Customs and not permitted to
 enter the country, and these same copies were re-
 fused readmittance by the Australian Customs when
 they were returned to Australia. These "stateless
 books... presumably were burnt by the Australian
 Customs. "
 This same book was banned by the Australian
 Post Office for transmission in the mails because
 of "a number of diabolistic paintings" considered by
 Postal authorities "too obscene or too blasphemous
 without further qualification, " although at the price
 of Ł8 8/-, the book was outside the purchase range
 of most young people.
 The New South Wales Police, also critical of
 the publication, went to magistrate trial against the
 publisher-salesman of the work. Two drawings
 were judged "obscene and offensive to chastity and
 delicacy"--two symbolic male nudes, one--represent-
 ing creative force and fertility--"with a goat's head
 clutching an egg in one hand and balancing a swas-
 tika in the other"; the second "with a serpent on
 his head, and a small figure moving toward him
 with a sword in his hand" (118:58-59).

1952 (C) The Indian court ruled that:

"reproductions of ancient Indian architecture, as
those at Khajurao or Konarak, on the exterior
of some ancient Hindu temples or... erotic sculp-
ture or painting in temples or churches... re-
moved from their religious setting and made the
theme to delight the vulgar and to arouse lewd
thoughts" are then obscene--Sukanta Haldar v
State A. I. R. 1952 Cal 214 (375:57).
The pictures at issue were included in three issues
of the Bengal monthly magazine Nari Nari, in an
article dealing with "ancient Indian architecture ex-
hibited on the walls of old Hindu Temples" describ-
ing and picturing "statuary representations of co-
habiting couples." The original court held that
pictures were "not best from the artistic point of
view," and "not explained for the sake of art," but
were those figures "which are indecent and more
aphrodisiac" (375:103).

The Appeal Court, too, found that the "pictures
were selected with the sole object of exploiting the
base instinct in human nature... a naked attempt to
exploit sex neurosis," and reaffirmed the sentence
"to rigorous imprisonment for two months and a
fine of Rs 200/" (375:101, 105).

1952 (D) The Instructio de arte sacra was issued by the Su-
preme Congregation of the Holy Office to indicate
the attitude of the Catholic Church toward modern
art by summarizing existing laws and giving general
directions on the building of churches and their orna-
mentation, without attempting to set styles (179, III;
594).

1952 (E) Although "libel" by its Latin derivation means "a
little book" (149:14), a subsection of England's De-
famation Act of 1952 made it clear that "a libel or
slander may be conveyed in any shape or form":
"any reference in this Act to words shall be
construed as including reference to pictures,
visual images, gestures, or other methods of
signifying meaning" (149:149).
In the United States, about one-fifth--31 out of 148--
criminal libel cases brought in the 50 years after
World War I "grew out of charges made against offi-
cials" (415:284). The "fair comment" defense in li-
bel was recognized as "comment on the work of an
artist if the work is offered for approval of the pub-
lic," and "on acts of public men or institutions"
(415:140). "Truth of the defamation" in libel cases
has been argued as "a complete defense" (415:111).

1952, March Alan D. Gruskin, director of Manhattan's Midtown
Galleries, when he put on a show "The Nude"--

many of the paintings "old-fashioned" in avoiding
representation of the figure with abstractions of
cubes, triangles, criss-crosses and cones--com-
mented on the theme of his exhibition:
> "Nudes have never sold too well. A lot of mu-
> seums are leary of buying them because their
> trustees are conservative businessmen. Even
> bars have been giving them up for mirrors.
> One nude we displayed in a bar had to be taken
> down because the drinkers objected" (423A).

1952, March
24

In Detroit, a controversy again flared up over the
work of Mexican muralist Diego Rivera at the De-
troit Institute of Arts when Eugene L. Van Antwerp,
former mayor of the city, led a campaign to have
Rivera's "Age of Steel" frescoes at the Institute
"removed or covered up. " The "art purgers charged
that the murals--executed in 1922 on the commission
of the late Edsel Ford--contained Communist propa-
ganda, represented Detroit workingmen as ugly, and
were blasphemous and decadent. The city's Council
let the paintings stand after the Detroit Art Com-
mission in a special report refuted the complaints,
and--although they attacked Rivera's behavior--de-
fended the frescoes as among the best of Rivera's
work" (320:195-196; 410, Mr 25 1952 25:3).

1952, April

The book jacket cover commissioned from artist
Cornelius van Roemberg for the Dutch edition of
Satan--a collection of essays on the theology of evil
and the influence of the devil in the world today,
edited by Father Bruno de Jesus-Marie, a French
Catholic priest--was a design showing a portrait of
the devil. This Dutch publishers found the cover
so "repugnant, " "stupid and sly" that they replaced
the cover design with a new book jacket. Sheed and
Ward, the publisher in the United States, issued the
book with two covers--Roemberg's and the "corrected"
cover (502:96).

1952, April 24

Pablo Picasso in a letter to Secretary General M.
Thorez, Communist Party leader in France, pledged
"devotion to the Communist art line" (410, Ap 25
1952 5:5).

1952, May?

The deletion from a large exhibition of Mexican art
organized by the Mexican government for display at
the Musée National d'Art Moderne in Paris of the
mural Diego Rivera painted for the show was an ex-
ample of "a purely political" art controversy. Mexi-
can government officers responsible for the display
thought Rivera's painting--showing Joseph Stalin and
Mao Tse-tung as "near saints" and the western na-

tions as "money-grubbing war-mongers"--might prove
"offensive to certain countries" (7, 1953:393; 410 F
7 1953 17:4).

1952, May 10 "Poor Policy, " to exhibit Ward Mount's painting
 "Freedom From Dogma, " Edward W. Miller, Presi-
 dent of the Jersey City Museum Association, wrote
 on May 10--two days before the preview of an exhi-
 bition of the Painters and Sculptors Society of New
 Jersey, to Mrs. Mount, president of the Society.
 Because of the probability that the picture would
 "arouse religious discussion, " the trustees of the
 Association would not hang Mrs. Mount's painting--
 the subject was "of such a controversial nature, "
 and they considered it "an undisguised attack upon
 the Christian Church. "
 Artists Equity, of which Mrs. Mount was a mem-
 ber, informed President Miller--in a letter from
 Harold Black, corresponding secretary for Equity--
 that "a committee of prominent artists" who examined
 a photograph of the banned painting... "found nothing
 offensive to any single group, religious or otherwise, "
 and that "summary removal" of the picture was "an
 act of unreasonable censorship and suppression" (463:
 5).

1952, July 7 The United States Foreign Service Journal urged that
 the United States State Department "do away with" a
 massive mural stretching the width of the Depart-
 ment's main first-floor lobby in its Washington of-
 fice because the painting might be "misinterpreted
 by foreign diplomats. " The painting--according to
 the Journal--should be immediately "erased, eradi-
 cated, expunged, deleted, and destroyed--or at least,
 decently veiled" as "too belligerent. "
 The mural--inherited by the State Department
 from the United States Defense Department when it
 moved into the old War Department Building in 1947,
 shows gas-masked, heavily armed soldiers, bombers
 with bombadiers fixing their sights, and hovering
 "hysterical eagles" with "flexed talons. " "In the
 interest of diplomacy, " a bloody battle scene in
 the reception room of the Secretary of State's fifth-
 floor office was hidden by drapes "some time ago"
 (410, Jy 8 1952 5:4).

1952, July 19 The Vatican cautioned prelates on "corrupt and er-
 rant" art invading churches (410, Jy 20 1952 16:4).

1952, Septem- "The International Conference of Artists, held at
ber Venice from the 22nd to the 28th of September, was
 attended by over 200 delegates, representing 44
 countries and 11 international associations of artists,

and by over 150 artists who came as observers. "
Among problems in the literary and artistic world,
that the Conference had assembled to discuss, at
the invitation of UNESCO, was "excessive interfer-
ence on the part of those in authority" with the per-
formance of the artist's function (282:7).

1952, October
11

A victory of Mexican artists over the "Social-Mes-
sage" School of Mexican Art was seen when painter
Rufino Tamayo was permitted--after a long struggle
--to paint a mural in Palacio de Bellas Artes, Mex-
ico City (410, 0 12 1952 VI, 18:3).

1952, Decem-
ber

Shiek Abdullah al Salimal Sebah banned the govern-
ment of Cyprus Tourist Office posters sent to his
oil-rich kingdom of Kuwait to drum up trade. The
"Venus de Milo" pictured on the posters did not of-
fend Moslem modesty, the Shiek explained, but be-
cause Islamic law says a thief shall be punished by
having his hands cut off, his subjects--viewing the
armless "Venus"--would think that "all the girls of
Cyprus are thieves" (Life D 8 1952).

1953-1955

Mrs. Myrtle G. Hance attempted to "save the city
from Communism" by exposing--as a former officer
of the Minutewomen of America--subversive material
in the public library of San Antonio, Texas. Included
in her proscribed list of about 600 books on the pub-
lic library shelves, indicated as written or illustra-
ted by Communist-front affiliated authors or artists,
were Moby Dick and Canterbury Tales because they
had been illustrated by Rockwell Kent.
 Under Mrs. Hance's plan for controlling Com-
munism, subversive books would not be banned from
the library, but would be plainly labelled (47:65-69).

1953 (A)

"One For the Road, " British artist Lynes' poster
showing a driver whose face was part skull--"one
of a series of shock designs put out during the 'for-
ties and 'fifties in the interests of Road Safety" by
the Royal Society for the Prevention of Accidents--
was banned by a number of local English authorities.
While "blood, death, and destruction" were "greatly
in demand for entertainment value, " they made road-
safety posters on this theme probably the most banned
advertisement during a twenty-year period in England
(499:60).

1953 (B)

The State portrait of Queen Elizabeth II in coronation
robes caused a controversy in England when it was
exhibited, and was criticized as "failing entirely to
convey the queen's beauty and vigor. " Sir James
Gunn, the artist and one of the highest paid British

portrait painters of the century, defended his picture
of Queen Elizabeth, his most noted painting:
"What they want is a grinning picture showing all
the queen's teeth. I am painting for posterity"
(315).

1953 (C) Although "modern art since Impressionism" is still
 forbidden public exhibition in Russia "on purely ideo-
 logical grounds" because of its "distortions, bourgeois
 formalism, and international cosmopolitanism," the
 collection of the Museum of Modern Western Art in
 Moscow was placed on view in the Pushkin Museum,
 Moscow. This exhibition is the first instance, known
 to official United States sources, where a Soviet gov-
 ernment-sponsored exhibition showed to the Soviet
 people "works of art which have no direct relation
 to Communist ideology" (Art News 53:17 My 1954).

1953, January David Dempsey reported in the magazine Atlantic
 Monthly that the paperback art book, The Pocket
 Book of Old Masters, was seized in Dubuque, Iowa,
 "as obscene and offensive to public morality because
 of the nudes that were reproduced in it" (153:76).

1953, Febru- The Nationalist Party, a Catholic political group
ary 6 with two seats in the Congress of Mexico, issued
 a statement saying that Diego Rivera had "exceeded
 the limits of human tolerance" by insulting the Vir-
 gin of Guadalupe--patron saint of the Americas--in
 the new outdoor mural he is finishing over the mar-
 quee of the Insurgente Theater in Mexico City.
 "Sacrilege" was the only term the Party found fit-
 ting to describe Rivera's "deliberate insult to the
 Church and to the Mexican people's religion"--all
 part of the Communist Party line to step-up harass-
 ment of the Church throughout Mexico. The huge
 (538-square-foot) controversial painting shows the
 history of the theater in Mexico, and the central
 figure--Mexico's favorite comedian Cantinflas (Mario
 Moreno)--is depicted in his famous tramp outfit--
 but the cloak, bearing the image of the Madonna, is
 that "traditionally associated with Juan Diego, the
 poor Indian who had three visions of the Virgin in
 the sixteenth century. "
 After a month of continued public criticism, Ri-
 vera changed the theater mural--on March 6--paint-
 ing out the Virgin of Guadalupe on the actor's cloak,
 and replacing it with the comedian's familiar torn
 garment (410, F 7 1953 17:4; F 10 1953 14:2; Mr
 7 1953 8:5).

1953, March British sculptor Reg Butler's first prize-winning fig-
15 ure in the London Contemporary Art Institute Inter-

national Sculpture Competition on the theme of "The
Unknown Political Prisoner"--selected by judges over
3, 500 designs from 75 countries (487:16)--was
smashed by I. Szilvassy, as it stood on exhibition
in Tate Gallery, London (511:170).

This destruction of Butler's work--described as
"a scaffold of execution" (487:16)--which had been
selected by a jury of art experts (museum directors,
art critics, and professors of art history) seemed
to demonstrate that the public and the artist are
separated by "infinite and apparently unbridgeable"
distance (482:81).

Szilvassy, who had spent considerable time as a
political prisoner in a Nazi concentration camp, was
placed on probation (410, Mr 16 1953 9:6; 17:1; Mr
22 1953 VI, 66:2; Mr 23 1953 25:3; Ap 18 1953 6:3).

1953, May 1 The United States House of Representatives' Com-
mittee on Public Works (chairman: Dondero) held
a subcommittee hearing on the resolution introduced
March 5 by Representative Herbert Scudder, a Re-
publican from Sebastopol, California, to remove the
Anton Refregier murals from the Rincon Annex of
the new San Francisco Post Office building (410, My
2 1953 13:1; My 10 1953 II, 13:3). Refregier had
won the $26,000 commission for the work in a com-
petition conducted by the United States Section of
Fine Arts, and his casein tempera 27-panel mural--
painted on the walls of the 208-foot main lobby and
the 34-foot "L"-shaped lobby opening in to it--told
the story of San Francisco and of California (67,
1942:503). The murals, unveiled in 1949, had taken
five years to complete, during which time the Gov-
ernment had approved stages of the work after 91
conferences or inspections (298:245-247).

Congressman Scudder, backed by patriotic and
civic organizations in San Francisco, including the
American Legion, Native Sons of the Golden West,
the Associated Farmers, and the Association of
Western Artists (61:3), charged that Refregier's
pictures were "artistically offensive and historically
inaccurate, and... cast a derogatory and improper
reflection on the character of the pioneers and histo-
ry of the great State of California (320:197). The
four panels found controversial by patriots' criticism
showed: Anti-Chinese riots of 1870's, the Mooney
Case, San Francisco Water Front strike of 1934,
the founding of the United Nations (298:245-247).

Among the arguments advanced at the hearing by
mural critics was: "Our ancestors did not have rec-
tangular heads" (410, Ap 27 1955 II, 13:4). The
"subtle ridicule" observed in the paintings by Rep-
resentative Scudder through picturing the United

States representatives at the United Nations founding
disappeared when "the green asses ears" he saw in
the mural proved to be part of canopies of laurel
depicted in a Fortune magazine sketch made at the
meeting (298:247-248).

After the American Federation of Arts, individual
museums in the United States--and even the London
Times--expressed concern or disgust at the proposed
"act of vandalism" in the demand to remove all pan-
els of Refregier's painting, the resolution to censor
the Post Office mural was finally shelved.

1953, May 21 One panel of the four-panel mural painted by Mexi-
can artist Jose Clemente Orozco in 1930 at the New
School for Social Research, New York City, was
covered--at the insistence of the governing board of
the School, and agreed to by by the alumni socie-
ties and the Graduate Faculty. As a "temporary
solution" for "a disturbing internal problem" at the
school, a white monk's cloth curtain was placed on
the west wall of the School dining room to conceal
the "Soviet Panel" on the mural--"Revolutionary
Violence" "depicting great social movements astir
in the world": "the Mexican Revolution, Gandhi's
non-violent movement to free India from British
rule, the Chinese Revolution led by Sun Yat-sen,
and the Russian Revolution with portraits of Lenin
and Stalin" (320:195).

Since 1951 school authorities had been "harassed
with protests" against the "Russian painting, " and
had previously installed a copper plaque saying that
"the sentiments expressed in the picture were exclu-
sively Orozco's. " This present curtaining was made,
officials explained, during "a period of great unease
about Russia. " The draping was subsequently modi-
fied by uncovering the portrait in the mural of Car-
illo Puerto (320:195; 410, My 22 1953 29:5; 485:213).

1953, June "Pocahontas was our first conservationist. She
saved Captain John Smith, didn't she?" the director
of Louisiana State Museum in New Orleans asked,
in his defense of the seated figure of Pocahontas--
nude to the waist--in the Louisiana State Wildlife
and Fisheries Commission Exhibit. The Museum's
Board of Curators, considering the question of the
controversial undraped statue, voted unanimously to
move "Pocahontas" to an inconspicuous spot in the
infrequently visited "Mississippi River Room" at the
back of the Museum, where some 50,000 school
children, who visited the Exhibit each month, could
no longer see or touch the Indian figure (459:61).

1953, August 16

Several months ago architect Daniel Laitin re-modeled the narrow lobby of 30 Central Park South, New York City, a building occupied by medical specialists--psychiatrists, allergists, dentists, and "heart men, " among others--and crowned by the Penthouse Club, a restaurant providing romantic piano music and "a fairy-tale view of Central Park. " As part of the redecoration to "enlarge and enliven" the limited space of the lobby, specially commis-sioned abstract mosaics by artist Max Spivak were installed, and this art work has occasioned violent and vocal tenant and patient reaction.

The most articulate opposition to Spivak's mosaic has come from two dentists, but a psychiatrist ob-jects to the art because he is afraid of its adverse effects on his patients while they wait for an eleva-tor, and certain doctors say that their reputations will be damaged because the mosaic lacks "a con-ventionally dignified professional look" (410, Ag 16 1953 II, 4:6).

1953, August 29

The Hungarian Communist Youth newspaper reported that in Hungary fees of artists depend on canvas size and number of persons portrayed in paintings (410, Ag 30 1953 13:2).

1953, November 4

The French Secretary of State for Arts ruled that the anti-United States paintings by Communist A. Fourgeron were "unembarrassing to the French Government, and that the Paris exhibit of the work of Fougeron is to continue, despite public criticism of the political message in the art (410, N 5 1953 41:8).

1954 (A)

The United States Post Office banned from the mails the illustrated book Anthropometry and Anatomy for Artists, published in London, although it had been cleared for importation by the United States Bureau of Customs the previous year (355:39; 447:107).

1954 (B)

The court in an Indian case--Rammoorty v State of Mysore (A. I. R. 1954 Mys. 164)--observed that "works of art are never considered obscene" (375: 40).

1954 (C)

Osservatore Romano, Vatican newspaper, "called attention to the immoderate use of nude models" and issued "a prohibition to certain classes of persons from attending schools of art where nude models pose" (441:85).

1954 (D)

The poster advertising "The Million Pound Note"--the Rank Organisation's film of Mark Twain's story

--was banned for showing Gregory Peck chasing a
million pound note. After the advertisement had
been placed "all over" London's Underground, the
Bank of England--consulted only then by the Rank
group--said that the poster was illegal--"a breach
of Section 9 of the Forgery Act, 1913, and Section
38 of the Criminal Justice Act, 1925" making it a
criminal offense "to reproduce bank notes of any
description. "
 "Black paste-over slips" were quickly added to
each poster in the Underground, until the picture
could be covered entirely by a substitute advertise-
ment showing no English money (499:54-55).

1954, August The United States Post Office Department locked up
 as "obscene, lewd and lascivious" the famous satire
 of Aristophanes, Lysistrata--illustrated by Norman
 Lindsay--the "high priest of aestheticism in Aus-
 tralia"--because, according to the Department attor-
 ney, the book contained "numerous passages which
 are plainly obscene, " and that its effect was "inten-
 sified and heightened by the indecent and lascivious
 character of the illustrations. " The plaintiff's at-
 torney (Harry Levinson v Arthur E. Summerfield,
 U. S. District Court, D. C.)--in combination with the
 American Civil Liberties Union and established pub-
 lishers--caused the Department to release the book
 without trial (47:45).

1954, August The Long Buckby, England, Town Council voted to
25 censor tombstone inscriptions, after finding one "of-
 fensive, " but soon reversed itself, canceling the
 previous ruling (410, Ag 26 1954 2:4).

1954, August American Legion officials were silent about the re-
31 moval of poster paintings by Marcel Colin of Washing-
 ton from the meeting room of the Legion's National
 Security Commission at the Statler Hotel in Washing-
 ton, D. C. The satirical posters--showing President
 Truman (as a red herring initialed "H. S. T. "), the
 Americans for Democratic Action, labor unions, the
 World War II Lend-Lease Program, and the British
 Empire as favoring the Communist cause--has been
 castigated by Edward D. Hollander, national director
 of Americans for Democratic Action:
 "scurrilous back-fence art... as insulting to the
 American intelligence as it is degrading to the
 Legion" (410, S 1 1954).

1954, October The New York Times rejected artist Al Hirschfeld's
(A) drawing--a copy of a painting--as an advertisement
 for the Broadway comedy "Reclining Figure, " as
 "too nude, " because the line sketch Hirschfeld made

did not conceal the navel or breasts of the figure,
since the original painting did not.

The artist modified the drawing to make it ac-
ceptable in the advertisement by inking in a bras-
siere with "eye-catching voluptuously multiple cir-
cles. " When the next issue of Life magazine brought
the censorship to public attention by showing "before"
and "after" drawings together, the Times printed the
figure as originally drawn (Life 37:42 0 25 1954).

1954, October President Eisenhower, in his address on the occasion
(B) of the twenty-fifth anniversary of the Museum of Mod-
ern Art in New York City, stated the principle of
Freedom of the Arts:

"... a basic freedom, one of the pillars of liber-
ty in our land... As long as artists are at liberty
to feel with high personal intensity, as long as
our artists are free to create with sincerity and
conviction, there will be healthy controversy and
progress in art. "

He contrasted artists under freedom with artists
under tyranny:

"When artists are made the slaves and tools of
the state; when artists become the chief propa-
gandists of a cause, progress is arrested and
creation and genius are destroyed" (172).

1954, October Expressed dislike in public opinion--an estimated
15 75% of tenants--caused the removal of "King and
Queen" by English sculptor Henry Moore from the
lobby of a twenty-four-story office building in New
York City--at 380 Madison Avenue, "the space where
the Ritz-Carlton Hotel used to be. "

Percy Uris, president of the group that owns the
building, commented that the sculpture "apparently
was too much of a museum piece for a commercial
building, " and returned the "King and Queen" to the
Curt Valentin Gallery, who had agreed to the sale
on condition that the figure "prove satisfactory" in
the tryout of a month's installation (410, 0 16 1954
19:2).

1954, October The American Federation of Arts at its 45th Annual
22 Convention issued a statement regarding the freedom
of the artist from political or other governmental
investigations and oppressions. The Federation's
Board of Trustees draft held that:

"Freedom of artistic expression in a visual work
of art, like freedom of speech and press, is
fundamental in our democracy" (Art News 53:8
Ja 1955).

"This fundamental right exists irrespective of
the artist's political or social opinions, affilia-

tions or activities. The latter are personal mat-
ters, distinct from his work" (Art News 54:7 F
1956).

1954, Novem- Painter George Biddle, United States Fine Arts Com-
ber 16 mission member, scored the United States govern-
 ment security check on artists before they are grant-
 ed commissions for painting and sculpture in fed-
 eral buildings (410, N 17 1954 30:6; N 22 1954 12:4):
 "Outside the orbit of the Soviet totalitarian states,
 our Federal Government is the only nation I know
 that employs a secret organization to investigate
 the political background of artists before granting
 them commissions" (Art News 53:8 Ja 1955).

1954, Decem- "Radio," a seventeen-ton figure memorial to Gugliel-
ber (A) mo Marconi, inventor of the wireless, once graced
 the approach to the Italian Pavilion at the 1939-1940
 New York World's Fair, but today the nude--really
 half-nude, "with drapery over her hips"--holding
 "the heart of the world" in one upraised hand, is
 welcome nowhere with open arms.
 Rejected by New York City, when offered by the
 Italian government, and by Jersey City, when offered
 by Jersey City attorney Edward F. Zampella, its
 present owner-custodian, "Radio" was to have
 found a home in Lodi, New Jersey, sponsored by
 service clubs--including the Kiwanis and the Rotary
 --but acceptance was halted when the sisters of Im-
 maculate Conception Convent in the city protested to
 the Borough Council in a letter that they did not
 want "statues of nude women in Lodi." The sisters'
 objection was seconded by Pastors of St. Joseph's
 and St. Francis Roman Catholic Churches in Lodi.
 Lodi officials decided that they would view "Radio"
 by visiting the Bishop Street warehouse in Jersey
 City housing the figure--where the workers fondly
 refer to the statue as "the old girl" and there is
 no charge for storing the unwanted allegory--before
 voting on whether or not to accept the gift statue,
 but the offer of "Radio" was withdrawn before the
 question could come to a vote (410, D 28 1954).

1954, Decem- The Fairfield County Council in Darien, Connecticut,
ber (B) passed a motion "that the council protest any presen-
 tation of murals or gifts to any public buildings or
 functionings by any known Communists or subver-
 sives," and--after a "prolonged and ill-tempered de-
 bate"--decided "to give the Norwalk, Connecticut,
 Board of Education authority over works of art in
 school buildings." The controversy sparking this
 move was the Veterans of Foreign Wars of Fair-
 field County--spokesman Alfred Beres, commander

of Norwalk Post 603--"who came out against art
works that 'any known Communists or subversives'
offer for display in public buildings" because Mrs.
Anita Parkhurst Willcox, commercial artist and il-
lustrator, offered to paint four panel murals in the
Honey Hill School, Norwalk, "illustrating harbor
scenes from Norwalk history. " The Veterans, and
other patriotic groups, objected to the paintings be-
cause Mrs. Willcox "had attended a peace conference
in Communist China, had had her passport seized by
the United States State Department, and was 'a known
subversive'" (320:197-198). The rejected painter
said that two years ago when she and her husband
went to China--because they were pacificsts--they
signed affidavits to the State Department that "they
are not communists" (410, D 23 1954 21:7; F 2 1955
23:2).

1954, Decem- Debora Marcus, chief editor of Coraddi, literary
ber 17 publication of the Women's College of the University
 of North Carolina--biggest all-girl college in the
 United States with its present enrollment of 2, 404--
 resigned in defense of "art, " when the editors of
 the publication were given an official reprimand by
 Chancellor Edward K. Graham over the full-page
 drawing of a nude male figure by graduate student
 Lee Hall, appearing in the fall issue of Coraddi.
 Editor Marcus rejected the official attitude that
 "such art should be confined to galleries, " and
 Chancellor Graham's charge that the magazine staff
 had confused "license with freedom, " and were
 guilty of "bad taste. " She refused to censor the
 material in the magazine for "political expediency, "
 according to her 300-word resignation statement,
 and said that "the magazine staff felt that anything
 suitable for drawing and writing in the field of the
 fine arts was suitable for printing and exhibiting"
 (409, D 17 1954).

1954, Decem- The Convention for the Protection of Cultural Prop-
ber 31 erty in the Event of Armed Conflict, dated May 14,
 1954, the Hague--after being signed by fifty attend-
 ing countries as of May 14 1954--became effective
 as "the first comprehensive international agreement
 for protecting cultural property in history" (274:23-
 24).

1955 (A) In the Museum of the University of San Marcos,
 Lima, Peru, the collection of ancient Peruvian
 sculpture--Inca, Chimu, Nazca, and other--portray-
 ing, through in-the-round portrait jars, incidents of
 their daily life--including "styles of coitus and other
 sexual acts, grotesquely ithyphallic drinking jars"--

are segregated in a "reserved section," and this col-
lection is "shown only to qualified persons" (318:533-
534).

Ten years were to elapse before this erotic art
of pre-Columbian Peru became the subject of a ma-
jor art publication: R. Larco Hoyle. Checan, 1965.

1955 (B) Reverend Denis K. O'Regan, O. P., Department of
Philosophy, Providence College in Providence, Rhode
Island, in his essay "Freedom in Relation to the Ex-
pression of the Beautiful" expressed the Aristotelian-
Thomistic view of Art and Morality:
"...if in Michelangelo's "Last Judgment" the bod-
ies of the just, while more strikingly beautiful
unclothed, nevertheless distract in that state
from the awe which the representation is intended
to convey, then the end requires that they be
clothed. Thus art, while not free to misrepre-
sent reality any more than one is free to lie, is
further not free, even if it is representing reality,
to represent it in a way which detracts from,
rather than induces to, virtuous action" (241:405).

1955 (C) Art International was accepted for import by the
United States Customs, but banned by the United
States Post Office as "indecent according to the
moral standards of the nation" (355:39).

1955 (D) Anthropologist Weston La Barre in an article, "Ob-
scenity: An Anthropological Appraisal," "attempted
to show, through comparative examples the anthropo-
logical relativity of obscenity" in artistic represen-
tations, as well as in words, nudity of various parts
of the body, or publicly prohibited acts (318).

1955, Febru- The United States District Court, Maryland (United
ary 15 States v One Unbound Volume of a Portfolio of 113
Prints... 128 F Supp. 280 (D. D. Maryland) (1955))
found the portfolio of 113 prints imported from Ger-
many, entitled Die Erotik der Antike in Kleinkunst
und Keramik, by Gaston Vorberg were: mounted
prints, in sepia, on cards 11x14 inches showing
"Greek, Roman, Etruscan, or Egyptian statues,
vases, lamps or other artifacts which are decorated
with, or otherwise display, erotic activities, features,
or symbols. Many of them show acts of sodomy and
other forms of perverted practice...." The court
concluded that the portfolio was not "a scientific or
scholarly work in the field of archeology"--as the
claimant contended--and entered the judgment: "I
find the portfolio obscene..." (593).

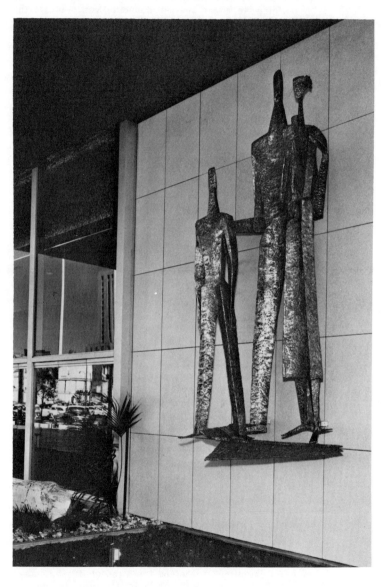

29. 1955, March. Bernard Rosenthal. The Family. Police Administration Building, Los Angeles

1955, Febru- The Nebraska State Legislature Budget Committee
ary 22 reflected in its appropriation consideration for funds
 for additional murals in the Nebraska State Capitol
 building its anger against Kenneth Evett's mural in
 the Capitol. The detail in Evett's painting that
 "most outraged" the legislators--according to report
 --was a "square bull" (410, F 23 1955 29:2; Mr 27
 1955 II, 13:4).

1955, March In an outpouring of criticism over the $10,000 14-
 foot 1,000 pound brass and bronze sculpture "The
 Family" ("The American Family") by Bernard Rosen-
 thal--main-entrance facade decoration on the new 7
 million dollar Police Facilities Building in Los An-
 geles--groups demonstrated (Christian Nationalists
 picketed (7, 1956:567)), issued public statements
 (Native Daughters of the Golden West: "The statue
 is not representative of our culture..."; Leo Fried-
 lander, president of the National Sculpture Society:
 "...a metallic monstrosity...an outrageous
 violation of the Fine Arts" that would "surely prove
 deleterious to morality" (410, Mr 21 1955 24:6)),
 and six citizens petitioned the Supreme Court--on
 February 15, 1955--to force removal of the sculp-
 ture as a public nuisance (410, F 27 1955 85:1;
 Mr 27 1955 II, 13:4). Members of the City Council
 joined the controversy:
 "Here we have a 'typical American family' that
 has no eyes, no ears, no nose, and no G-U-T-S
 ..." "This shameless, soulless, faceless, raceless
 monstrosity will live in infamy...probably the most
 scandalous satire and caricature of the American
 people I have ever seen," councilman Harold Harby
 (323; 410, Mr 21 1955 24:6; 528:12).
 Rosenthal's stylized group, in keeping with the
 design of architect Welton Beckett for the Police
 Facilities Building, had been commissioned under a
 building contract awarded by the Department of Pub-
 lic Works--with the approval of the Los Angeles
 City Art Commission, who found the figures--father,
 mother, son, and infant daughter "symbolizing the
 objects of police protection"--preferable to statues
 of "a policeman and policewoman realistically mod-
 elled from members of the force," which had been
 suggested more appropriate than Rosenthal's sculp-
 ture by citizen and conservative artist groups. The
 censorship of Rosenthal's figures was prevented by
 "liberally-minded" community elements--artists and
 interested citizens--who formed the "Los Angeles
 Art Committee" to defend the attenuated, semi-ab-
 stract bronze. "With the help of public opinion
 throughout the nation," they blocked the attempt "to
 have the...work removed and melted down" (7, 1956:

567). (ILLUSTRATION 29)

1955, March 15	"The Public Affairs Luncheon Club, " a patriotic women's group of some four-hundred members-- described in the Dallas Morning News as "a power- ful women's group" (417 4:5-6 Ap 1956)--under the chairmanship of Mrs. Florence Rodgers, a past member of the Dallas Art Association, approved and released to newspapers a resolution declaring that the Dallas Museum was over-emphasizing "all phases of futuristic, modernistic, and non-objective painting and statuary, " and was "promoting the work of artists who have known Communist affiliations, to the neglect... of many orthodox artists, some of them Texans, whose patriotism... has never been questioned. " "A few of the most objectionable art- ists, " among those whose work the Club demanded the Museum cease sponsoring, were: Joseph Hirsch, Chaim Gross, George Grosz, Jo Davidson, Picasso, Rivera, Max Weber.

The Luncheon Club printed and circulated, in further releases, "information about the Communist art that has infiltrated our cultural front in Ameri- ca. " The "isms tagged specifically... as instruments of destruction" (quoted directly from Dondero's at- tack against modern art printed in the Congressional Record, but unacknowledged as a source):

> "Cubism aims to destroy by designed disorder;
> Futurism aims to destroy by the machine myth;
> Dadaism aims to destroy by ridicule;
> Expressionism aims to destroy by aping the
> primitive and the insane;
> Abstractionism aims to destroy by the creation
> of brainstorms;
> Surrealism aims to destroy by the denial of
> reason" (156).

1955, March 17	The Proteo Gallery in Mexico City opened its "first salon of free art, with works by Mexican and foreign resident artists who consider themselves independent of political propaganda in their output, " including such artists as: Rufino Tamayo, Pedro Coronel, Alberto Gironella, Jose Luis Cuevas, Geles Cabrera, Enrique Echeverria, Carlos Orozco Romero (7, 1956: 419).
1955, April	In answer to the Public Affairs Luncheon Club com- plaints of the previous month--March 15--the trus- tees of the Dallas Museum made a public statement:

> "that it was not Museum policy to knowingly ac-
> quire or exhibit work of a person known by them
> to be a Communist or of Communist-front affilia-
> tion; that they had obtained the Attorney-General's

list and would be glad to be guided by it; that
they found that the Museum owned ten other
paintings and one sculpture by artists against
whom the allegations had been made and would
look further into the matter; that they were re-
luctant to destroy work by artists accused of
subversion" (156:35, 54).

1955, April 8 Following the Islamic proscription against figural
art, "the Washington embassies of several Islamic
states were successful in their efforts to cause the
United States State Department to have a statue of
Mohammed removed" from the roof of the Appellate
Division Court House in New York City, "where it
had stood for fifty years as one of the ten statues
of famous lawgivers." The embassy censorship was
the result of Moslem protests.
 A divergent view of Islamic attitude toward art
was represented several years previously (1950-1951)
by "Ahmad 'Isa, librarian of the celebrated theologi-
cal university of al-Azhar in Cairo" when his article
in the official journal of the university "denied that
Islam opposes figural representations or even stat-
ues, since they can elevate the mind and answer an
undeniable human need" (179, VII:818; 410, Ap 9 1955
1:5).

1955, July 31 Firemen were called to remove poison ivy from a
statue of the "Venus de Milo" at a public park in
Winona Lake, Indiana. The foliage had been planted
by a local woman to cover the figure's nudity (410,
Ag 1 1930 5:5).

1955, Septem- The San Francisco Municipal Art Commission in
ber 16 organizing its latest Art Festival ordered removal
of a color lithography by Victor Arnautoff, Stanford
University instructor, because it depicted Vice-
President Nixon as "Dick McSmear." Nixon promptly
wired the Commission that the artist had "the right
to express contrary opinion," and that "the people
should not be denied a full opportunity to hear or
see his expression of that opinion" (Art News 54:7
0 1955; 410, S 17 1955 10:2; S 18 1955 74:8; S 21
1955 20:5).

1955, Novem- "In A Room," prizewinning watercolor by the Balti-
ber more artist Glenn Walker, was ordered removed
from the exhibition "Life in Baltimore" at the city-
supported Peale Museum in Baltimore by Mayor
Thomas D' Alesandro, Jr., a Museum trustee, who
charged that the picture was "obscene" and "morally
objectionable." A special trustee's committee "sub-
sequently qualified that the picture--depicting a nude

couple lying on a bed--could be shown only in the
Museum director's office. " Seven other artists rep-
resented in the exhibit removed their pictures on
December 3 in protest to this "overt censorship, "
which they viewed as a "threat to their creativity and
livelihoods. " Walker's banned picture "was sold to
an eager buyer as soon as the controversy became
public, " and over 300 people asked Museum director
Wilbur H. Hunter to see "In A Room. " Hunter com-
mented:

> "When they look decent and are over 21, I let them
> in" (21; 147).

1956, January China's centuries-old Brides' Books--"illustrated with
woodblock prints which many Westerners would con-
sider obscene, " handed down from generation to gen-
eration--as family treasures--and survivors of many
generations of recurrent censorship efforts, including
the book-fires of Shih Huang-ti, self-styled "First
Emperor" (c 246 B. C.) who ordered burned all books
written before his time, including the works of Con-
fucius--were the object of "a nationwide campaign"
launched by the Chinese Communists. Their reading
is interdicted by Communist authorities as "escapist"
and "reactionary. "

 Peking Worker's Daily tried to discourage reading
of Brides' Books by pointing out that the success of
the Five Year Plan was at stake:

> "These books and pictures seriously harm those
> workers who constantly looking at them can easily
> become degenerate in their thinking... pessimistic
> about their work. "

Not obscenity, but lack of Party Line, was what the
Chinese Communist leaders objected to in the tradi-
tional books (97 1:6 Mr 1956; 533:45).

1956, January The Dallas County Patriotic Council, representing
12 several local organizations "of patriotic purpose and
anti-subversive intent" including the American Legion,
Veterans of Foreign Wars, Daughters of the Ameri-
can Revolution, wrote to the Board of Trustees of the
Dallas Art Association--the sponsoring organization of
the Dallas Museum of Fine Arts, regarding the forth-
coming exhibit "Sport in Art. " The Council demanded
that the Association ban from the Museum works by
artists believed to have communist links:

> "We want you to do three things:
> 1. Take William Zorach's art out of the Museum;
> 2. Prevent the showing of Ben Shahn, Leon Kroll,
> Yasuo Kuniyoshi works in the Museum or any-
> where else under the sponsorship of the Mu-
> seum;
> 3. Redeclare publicly your policy not to buy or

show any works by persons who have Com-
munist-front records. Mr. Jerry Bywaters
(the Museum's director) has been furnished
a list of these artists' names. "

The "Sports in Art" show, sponsored by Time-Life
Corporation for its publication Sports Illustrated and
assembled by the American Federation of Arts, in-
cluded works by the four artists named in the Coun-
cil letter:

Leon Kroll. "The Park in Winter, " 26x48" oil,
1923, loaned by Cleveland Museum of Art. Shows
park in winter.

Yasuo Kuniyoshi. "Skaters, " 12x7" drawing, 1933,
loaned by Addison Gallery of American Art, And-
over, Massachusetts. Shows a boy and a girl
skating.

Ben Shahn. "National Pastime, " 36x40" drawing
1955, loaned by the artist. Shows baseball fig-
ures--batter, catcher and umpire--in motion.

William Zorach. "Fisherman, " 15x22" watercolor,
1927, loaned by Museum of Modern Art, New York
City. Shows a man fishing.

"Sports in Art" is scheduled for show in six cities in
the United States (Washington, D. C. , Louisville, Dal-
las, Denver, Los Angeles, San Francisco), and for
a final showing at the National Gallery of Victoria in
Melbourne, Australia, in connection with the Olympic
Games, with the United States Information Agency
sponsoring the overseas showing. The "unevaluated
files" of the un-American Activities Committee of the
United States House of Representatives are "bulky"
on the four named artists, according to report, but
none of the four is "listed as a Communist by the
Subversive Activities Control Board" (508:200-202).

1956, Febru- Trustees of the Dallas Art Association--considering
ary 11 the Dallas County Patriotic Council demands of Janu-
 ary 12, 1956--"reviewed the facts of the case, "
 found the charges of Communism against four artists
 (Kroll, Kuniyoshi, Shahn, Zorach) unfounded, were
 backed by the Dallas Park Board in their decision to
 show as scheduled the "Sports in Art" exhibit--banning
 no picture "on unproved political grounds" (156:55),
 and issued a 1500-word signed statement to declare
 publicly their policy on exhibiting and acquiring art,
 including declarations that:

"Democracy cannot survive if subjected to book
burning, thought control, condemnation without
trial, proclamation of guilt by association" (410,
F 12 1956 II, 15:3);

that

"it had become their policy that selection of
art would henceforth be made purely on artistic

grounds" (156:55);
and concluding:
> "It is important once and for all time to dissipate
> the nonsense that any single group in our com-
> munity is the custodian of the patriotism of the
> rest of us. We reject and resent the imputation
> that we are less patriotic than others and that
> because we hold a different opinion of the Museum
> operation that we and our Directors are 'dupes'"
> (410, F 12 1956 II, 15:3; F 19 1956 II, 8:3; 417 4:6
> Ap 1956; 4:2 Jy 1956).

1956, March 5 The Manchester Art Gallery Commission in England
called off the purchase of a bronze torso by England's
most famous contemporary sculptor, Henry Moore, as
a result of public criticism of the work, but after
considering the matter for several weeks decided to
buy the figure (410 Mr 6 1954 9:2; Mr 28 1954 II,
10:3).

1956, April 14 Diego Rivera painted out the offensive words in his
censored "Sunday" mural in the Del Prado Hotel,
Mexico City--by this erasure of the legend "God
Does Not Exist"--covered for nearly eight years--
insuring that the painting would be viewed by the pub-
lic (410, Ap 15 1956 19:1).

1956, May 25 Charges of "subversive" by the Dallas County Patri-
otic Council, a group of local organizations, caused
the United States Information Agency to cancel the
"Sports in Art" show scheduled for exhibit in Austral-
ia in connection with the Olympic Games. The ex-
hibit, arranged by the American Federation of Arts--
"an old and respected art organization"--under spon-
sorship of Sports Illustrated, the Time-Life magazine,
had already toured the United States, being exhibited
in six cities. Dallas Museum trustees and the Dallas
Park Board had held the exhibit at the Dallas Museum
as scheduled (February 1956), over the protest of
Col. Alvin M. Owsley, spokesman protesting the
show for the Dallas County Patriotic Council:
> "It is one of the basic premises of Communist
> doctrine that art could and should be used in the con-
> stant process of attempting to brain-wash and to create
> public attitudes that are soft toward Communism. "
According to Sports Illustrated, the four artists attacked
by the Council--Ben Shahn, Leon Kroll, William Zorach,
and Yasuo Kuniyoski--were at one time "members of front
groups, " but had never been connected with the "Com-
munist party and had never been called before any inves-
tigating body. "

graphs of sports as the cause for the cancellation,
and when questioned about the Dallas episode as a
cause of the "dropping" of "Sports in Art" replied:
"No comment. " Other actions taken during the year
by the United States State Department--through the
United States Information Agency, responsible for
government-sponsored international art exhibits, in-
clude:
1. Cancellation of the exhibit "100 American
 Artists of the Twentieth Century" on June
 21, 1956;
2. The banning of "American oil paintings dated
 after 1917 (the year of the Russian Revolu-
 tion) from its future traveling exhibitions"
 because an artist after this date "might be
 a communist or suspected of communist sym-
 pathies"--according to one commentator
 "political labels were used as a means of
 condemning works unpalatable to certain pa-
 rochial groups. " Watercolors, graphics, and
 photographs were exempt from the ban (7,
 1957:600; 156:34-35; 410, My 26 1956; My
 27 1956; 417 4:2 Jy 1956; 460:241).

1956, June 21 The United States Information Agency cancelled the
 second tour of American art--"100 American Artists
 of the Twentieth Century"--in as many months when
 it commented that ten of the artists in the show,
 half collected from museums and private collections
 over the United States, were "politically unacceptable, "
 "social hazards, " and "may be called pro-Communist"
 (410, Je 21 1956 33:1).
 Trustees of the American Federation of Arts, ac-
 tive in assemblying the exhibit, "voted unanimously
 not to go forward with the show if any paintings were
 to be barred" by the Information Agency, rejected
 "any political tests for its artists, " and quoted Presi-
 dent Eisenhower:
 "Freedom of the arts is a basic freedom, one of
 the pillars of liberty in our land... " (7, 1957:
 600; 156:34-35; 410 Je 22 1956 3:8, 22:2; Je 26
 1956 15:2; 417 4:2 Jy 1956).
 Director Streibert of the USIA said the agency "has
 a policy against the use of paintings by politically
 suspect artists" (410 Je 20 1956 21:3), but profes-
 sional artists, art critics, and art publications con-
 tinued in their criticism of the USIA "fiasco" in art
 (410, S 3 1956 14:6; S 11 1956 34:7).

1956, July Sculptor William Zorach had a check for $56,515
 (410 My 21 1956 27:4), and a giant seated nude wo-
 man, cast in bronze, in a foundry in Brooklyn. The
 figure had been commissioned by the Bank of the

Southwest in Houston, Texas, to adorn its facade as a large relief of three aluminum panels symbolic of Texas "rising out of struggle and war. "

Zorach's commission was cancelled by the bank-- not unmindful of the art controversy that raged in Dallas in 1955/56 when civic groups (particularly the American Legion and Women's Clubs) attacked artists whom they considered "too modern or too un-American"--and criticized Zorach, who was represented in the "Sports in Art" exhibit, on both counts. The bank sent the check as "consolation payment" after they announced that they preferred their facade "plain" (156:34-35; 193:93).

1956, July 5 After running off 13, 000 copies of their National Convention Program with a photograph of Auguste Rodin's sculpture "The Three Shadows" on the cover, the Republican Party, preparing for its Convention in San Francisco, rejected the program because of its cover design (410, Jy 6 1956 10:2; Jy 7 1956 6:7).

1956, July 12 Unidentified persons, carrying out a campaign of protest against the nudity of statues in Lima, Peru, have recently draped or painted bright red the undraped statues in Lima's parks and avenues. The National Association of Writers and Artists has issued a public statement denouncing the "false morality" of such censorship, and police are keeping a special watch to prevent future unwanted adornment of the city's public figures (410 Jy 22 1956 15:2).

1956, September The exhibitions prepared by the Communist countries at the 28th Biennale in Venice form a "kind of moving scale in degrees of freedom of expression. Russia... stops at the year 1900. Rumania goes as far as early Matisse. Poland, as far as Cubism and Klee. Yugoslavia ventures into the between-Wars period, through about 1935, with reminiscences of Surrealism and neo-prehistory" (214).

1956, October 22 Upon "complaints of townspeople, " police ordered copies of the October 22 issues of Life magazine removed from newsstands in the two Massachusetts towns of Fall River and Lowell, because the issue contained 14 photographs of famous statues and paintings of "nude or partly nude women" (417 5:1 D 1956).

1956, November Orleans Parish School Superintendent James F. Redmond ordered all copies of the booklet The Rabbit Brothers removed from the public schools, the New Orleans States reported on November 12. The book, issued by the Anti-Defamation League, had been attacked by the Citizens Council of New Orleans as a

"brainwash of racial integration." "The story concerns two twin white rabbits, almost identical" who differ in that one rabbit is "prejudiced." "I hate all rabbits who are not like me. Some days I have trouble liking myself," Prejudiced Rabbit says. The other rabbit answers, "I try to find some good in all rabbits." Asks the booklet, "Which rabbit are you"? The Chairman of the Citizens Council charged that the Anti-Defamation League was "under serious criticism as a possible Communist-front organization, an allegation denied by the League" (97 1:5 D 1956).

1956, November 29

Thomas Hart Benton, holding that art is a vocation and not a business, opposed the $25 Kansas City, Missouri, occupation tax levy, placed on him as an "artist-business," but within the month (on December 19) Benton paid the tax (410, N 30 1956 50:2; D 20 1956 40:3).

1957 (A)

Russian artist Ilya Glazunov was attacked, in a review of his exhibition at the Central House of Art Workers in Moscow, by Boris V. Ologanson, president of the Academy of Arts, as an "art student who had the conceit to declare himself a newly discovered genius and organize a personal show."

Glazunov, a graduate of the Leningrad Institute of Painting, Sculpture, and Architecture, painting in the style of icon painters of the fourteenth and fifteenth centuries--Theophanos the Greek and his pupil Andrei Rublev--with themes "ranging from Biblical to modern scenes" and portraits, produces work that falls outside the limits of officially acceptable Soviet art (410, Jy 8 1962 1:6).

1957 (B)

Cyril Brown's nude painting, "prominently displayed in a waterfront bar" in Sausalito, California, created a brief sensation when a police sergeant, acting on an anonymous complaint, "requested that the painting be turned to the wall until the Chief of Police returned to the city a few days later." Police Chief Louis Mountanos, upon viewing the painting, decided "that the nude was not lewd" (4:18).

1957 (C)

The "Roth Test" for obscenity stated by the United States Supreme Court in Roth v United States ("the test of obscenity is whether to the average person, applying contemporary community standards, the dominant theme of the material appeals to prurient interest"). As later amplified the "Roth Test" considered material obscene if it is "patently offensive," "utterly without redeeming social importance," and with the "dominant theme appealing to prurient interest" (501:15).

1957 (D) In official translation of three speeches, Nikita S.
 Khrushchev, Communist Party secretary, laid down
 the party line concerning art:
 "Literature and Art are organic parts of the gen-
 eral struggle of the people for communism";
 "The Russian people want works...of painting
 that mirror the pathos of labor...works they
 could understand";
 "Soviet artists and sculptors continue to be worthy
 sons of their Socialist homeland by using all the
 energies, their talents to glorify the heroic feats
 of our great people, the builders of Communist
 Society" (309:18).

1957, June 22 Peiping Daily described the Central Collection of Fine
 Arts moves in China--begun soon after the Commun-
 ists came to power--to destroy the traditional style
 of Chinese painting. Li Ku-chan and others, includ-
 ing Wang Ching-fang, were dismissed from their
 teaching posts at the Central Collection because they
 were "reactionary." Li Ku-chan, said by young
 cadres to be "unqualified" because of his style of
 painting to join the association of fine arts, had to
 earn his living in occupations outside the field of
 art (410, Je 23 1957 6:2).

1957, August "Once naughty, now nice" "September Morn," painted
27 by Paul Chabas, after forty some years of "prudery
 and press-agentry" was accepted to be exhibited in a
 place of honor in the Great Hall of the Metropolitan
 Museum of Art in New York City. Suppressed for
 years--even banned in reproduction from the mails
 by the United States Post Office--the bathing blond
 French peasant, widely viewed on "tinted calendars
 and barber shop chromos" after being catapulted into
 fame in 1913 by Reichenbach, "father of ballyhoo,"
 was first refused when donor William Coxe Wright
 offered her to the Philadelphia Museum of Art. Mu-
 seum president Robert Sturgis Ingersoll acknowledged
 the proferred gift: "declined because of no signifi-
 cance in the twentieth-century stream of art. A
 commonplace piece of work."
 Metropolitan Museum curator of painting Theodore
 Rousseau commented in his acceptance of "September
 Morn":
 "It has great appeal to the public. Chabas was
 fashionable in France fifty years ago, and it is
 interesting to see what everybody liked...Who
 knows what the taste in painting will be fifty
 years from now?" (391:22; 410 Ag 28 1957 29:6;
 S 1 1957 II, 8:5; S 15 1957 VI, p. 22).

1957, Septem- Oklahoma's three-man literature Commission, created
ber in 1957 to censor "objectionable" publications, re-
 ceived a letter demanding the banning of Time maga-
 zine for printing the painting "September Morn, " as
 reported in the Oklahoma City Times, September 20,
 1957 (417 6:6 D 1957).

1958 (A) The parishioners of Selby Abbey, Yorkshire, called
 Jacob Epstein's 11-ton, 10-foot marble figure of
 Christ, "Ecce Homo, " "ugly, " "heathen, " and got
 up a petition against it because their Rector has
 asked the sculptor to heave the figure to the Abbey
 in his will. Epstein was delighted with the request
 because "Ecce Homo" had stood in his studio since
 its one showing in 1935, when it was hated by "cri-
 tics and public alike" (410, Ja 10 1965 II, 21:1, 3).
 The Chancellor of the York diocese of the Church
 of England settled the question of Epstein's gift the
 following year, when he intervened in the controversy,
 and "refused to allow the Abbey to accept it" (67,
 1960:66).

1958 (B) In a further application of the United States Customs
 use of representation and utilitarianism in the classi-
 fication of objects of art for tariff purposes, the
 question of the classification of glass vases, sculpted
 by Dr. Lindstrand, Swedish artist--nonrepresentational
 and nonfigurative vases of "very heavy, blown, etched,
 and engraved glass"--was resolved when the Court
 (Ebeling & Reuss Co. v United States 40 Cust Ct 387
 (1958))--after ascertaining that Dr. Lindstrand was
 "a professional artist, " hearing the testimony of an
 expert (Director, Philadelphia Museum of Art) that
 the utilitarian aspect of the vases was "incidental"
 to the design, and considering persuasive "for de-
 termining a sculpture's status as a work of art in
 terms of the tendencies of Modern Art" Judge Bland's
 dissent in United States v Ehrich (1934) and the pre-
 cedent of the 1928 Brancusi decision--held "the non-
 representational Swedish glass vases to be legitimate
 works of art" (154:1244-1245).
 The problem of whether the work was done by an
 artist was paramount in this case. While Dr. Lind-
 strand did not personally color the vases (done by a
 glassblower using colored glass rods), and did not
 engrave the vases (engraved by a group of Dr. Lind-
 strand's students), the court found that Dr. Lindstrand
 exercised "sufficient control and supervision for the
 works to be called his own" (154:1244-1245).

1958 (C) The United States Government dropped its seven-year
 fight to bar some admittedly pornographic materials
 imported by Indiana University Institute for Sex Re-

search. Following an opinion of Federal District
Judge Edmund L. Palmieri that "what is obscenity
to one person is but a subject of scientific inquiry
to another, " the staff of the late Dr. Alfred Kinsey
will now be free to examine Chinese paintings, books,
statuettes, and "lavatory wall inscriptions" (3, 1957-
1958:11).

1958, April 9 A court in Ankara, Turkey, "ordered the principle
opposition newspaper, Ulus, to suspend publication
for one month and jailed its political cartoonist for
undermining the authority and prestige of the Turkish
government in his drawings" (7, 1959:770).

1958, May Museum directors censored an art exhibit at their
Grout Historical Museum, Waterloo, Iowa, when they
ordered removed from display a painting and a draw-
ing by Paul R. Smith, Associate Professor of Art at
Iowa State Teachers College, in the faculty art show.
 Two young mothers had protested to the Directors
that these nude pictures "were not fit for children, "
according to the Des Moines Register, May 8, 1958
(417 7:7 Je 1958).

1958, May 27 After conferring with museum officials and other in-
terested persons, Senator Jacob K. Javits (Republican,
New York) and Frank Thompson, Jr. (Democrat, New
Jersey) introduced identical bills in the United States
Senate and the House of Representatives to modernize
provisions of the 1930 Tariff Act concerning importa-
tion of modern works of art (410, My 27 1958 33:4;
My 28 1958 33:6).
 The law in force rules out as original works of
art: abstract sculptures, collages, lithographs,
primitive carvings, and in fact, any work not falling
within the law's limited, specific, and out-moded
definition of "art. " In the liberalized definition,
"work of art" for Customs purposes, will cover
works made of any material and in any form (410,
My 28 1958 33:6). Artists, importers, museum offi-
cials, and art collectors have been plagued for years
with the Customs' antiquated definitions of "art, "
tested in Customs court for restricting importation
of Brancusi's "Bird in Flight" (1928) and Albert
Burri's collage (1958). The Museum of Modern Art
in New York had to post a five-year bond to bring
into the country free Picasso's early collage "Man
with a Hat"--a charcoal, ink and pasted paper con-
struction--but it could not sell or even loan the work
to other museums without permission of the Customs
officials. Because its form did not fall within the
Customs definition of "art, " the sculptural relief by
English artist Ben Nicholson was allowed as an im-

port by the Museum, under bond, but a private col-
lector or dealer would have had to pay duty on the
work.

1958, Septem- The United States Customs Bureau ruled that four
ber 30 abstract sculptures by Spanish artist Jorge de Oteiza
 Embil were art and not dutiable, reversing the de-
 cision of the Customs appraiser in Baltimore, who
 had held, on September 26, that the works were duti-
 able as "manufactured metal" (410, S 27 1958 41:3;
 0 1 1958 31:3).

1958, Novem- A collage by Italian artist Alberto Burri was refused
ber 21 free entry, in May 1955, by the United States Cus-
 toms in New York City because its material and form
 --"several pieces of burlap sewn together and affixed
 to a board, stencilled with letters, and decorated with
 birds painted in oils"--fell outside the Customs defi-
 nition of "art." The Customs examiner "ruled that
 the importation was not a work of art," and that as
 a "manufacture of vegetable fibres" its chief value
 was in the vegetable fibre, or burlap sacking it con-
 tained. Donald Peters, owner of the collage, pro-
 tested the tax (410, Mr 10 1956 19:6) saying that if
 his import was "vegetable matter" it was worth $1--
 not the declared value of $450 as a work of art--and
 that as he owed the government 20% of declared value,
 the Customs fee was 20 cents, instead of the $90 duty
 levied.
 Alfred H. Barr, Jr., Director of the Museum of
 Modern Art, and Leo Castelli, owner of a New York
 City art gallery, both testified before the Customs
 Appeal Court (Peters v United States, C.D. 2042, 93
 Treas Dec No 48, at 35 (Cust Ct 1958)) that the col-
 lage was an original work of fine art by a major art-
 ist of post-war Italy, whose reputation was world-wide
 and whose work had been exhibited in major museums
 in the United States--including the Museum of Modern
 Art, Albright Gallery of Buffalo, Carnegie Museum
 in Pittsburgh.
 Finally, the United States Customs Court ruled
 that the collage was a work of art--although not a
 painting or sculpture--and dutiable at 20% of its $450
 value as art. Four years later Congress amended
 the Customs law to permit collages to be imported
 as duty-free art (154:1228, 1248; 410, My 27 1958
 33:4; N 22 1958 3:7; 626:228).

1959 (A) The Museum of Modern Art "Statement on Need for
 Bill to Liberalize the Tariff Laws for Works of Art,
 and Other Exhibition Material, and for Other Purposes"
 reported a case when the title of a sculpture carried
 "great weight with Customs officials" so that "free

entry for sculpture hinges entirely upon its title."
"Masque" was the title of this piece of sculpture im-
ported from France that was denied free entry by the
Customs on the grounds that a mask is not a "natu-
ral" object, but the object was later admitted as art
when it was shown that "Masque" may also be trans-
lated "Masker" or "Masquerader" and that this was
the correct rendering in the particular "case in hand"
(154:1243).

1959 (B) The Obscene Publications Act, an important landmark
in the history of English law relating to obscene pub-
lications, made it an offense to publish--which covers
the showing of pictures and sculpture--an obscene
article, whether or not for gain.

1959, Febru- The Federal Grand Jury in Phoenix, Arizona, indicted
ary 13 two local men--Frank N. Goldberg and Earl M. An-
derson, both members of the International Association
of Machinists--for publishing and distributing just be-
fore the November election last year "an anonymous
cartoon" that linked Arizona's Senator Barry Goldwater
with Josef Stalin, former USSR leader. The black-
and-white cartoon showed Stalin smiling, pipe in
mouth, asking, "Why not vote for Goldwater?" Fif-
teen thousand--of 50,000 printed copies--of the car-
toon were distributed in Phoenix, when Goldberg said
he stopped the distribution upon learning that "it was
illegal to distribute such anonymous cartoons."
 James H. Duffy, investigator from the United
States Senate Elections Committee came to Phoenix
(at the request of Ernest McFarland, Democratic
candidate opposing Goldwater in the Senate race won
by Republican Goldwater, and just completing his
second term as Governor of Arizona) to look into
the matter. Two days later he issued a statement
in which "he implied that Stephen Shadegg, Goldwater
campaign manager, had made the only widespread
distribution of the cartoon" (410, F 14 1959 10:3).

1959, May (A) Garth Williams' children's book The Rabbits' Wedding
had sold about 40,000 copies since it was published
in 1958 by the well-established firm, Harper, but--
because the boy bunny was black and the girl bunny
was white--an integrationist "intent" of the illustra-
tions in the book was pointed out in two areas of the
South--an Orlando, Florida, editor reported:
 "brainwashing... as soon as you pick up the book
 and open its pages you realize these rabbits are
 integrated";
The Home News, Montgomery, Alabama, "attacked
the bunny book as integrationist propaganda obviously
aimed at children in the formative years of from 3

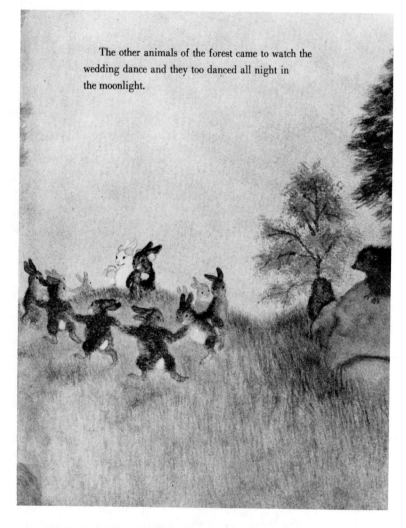

The other animals of the forest came to watch the
wedding dance and they too danced all night in
the moonlight.

30. 1959 May (A). Garth Williams. Wedding Dance, illustrations
from The Rabbits' Wedding

to 7. "

In the public library in Montgomery, <u>The Rabbits'</u>
<u>Wedding</u> was removed from the "Open" to the "Re-
serve" shelf (107:90). (ILLUSTRATION 30)

1959, May (B) The United States Customs inspector's classification
of a mosaic by Picasso, "Les Joutes," designated
the work as "bits of glass on stone. " While the
36x30" "varicolored mosaic"--showing a French har-
bor with two men in boats jostling with each other
with poles, was not classified as "art," it was
"taxed on its value as a work of art" (154:1228).

1959, May 14 The National Committee to Liberalize the United
States Tariff Laws for Art was formed, with R. S.
Ingersoll as chairman, to back the bill offered by
Senators Javits and Douglas, and Representative
Thompson in Congress, that was later--on Septem-
ber 14, 1959--signed into law (410, Mr 15 1959 7:2;
II, 18:3).

1959, May 18 "Close to sacrilegious," was the evaluation of some
viewers who examined Edolo Masci's painting "The
Annunciation," on exhibit in Rome's newest art gal-
lery--the basement of the church of St. Mary in the
Piazza del Popolo. One of a number of art works
in an exhibit on the theme "The Madonna in Contem-
porary Art, " Masci's controversial picture showed
the Virgin as a young girl in knee-length skirt, with
both Mary and the Angel Gabriel modeled as teenage
girls of Rome's slum belt (410, My 19 1959 1:5).

1959, June 3 In a Washington D. C. Committee on Un-American
(A) Activities hearing in the United States House of Rep-
resentatives, Ivan P. Bahriany, Ukranian writer and
artist who had escaped from Soviet Russia and is
president of a coalition of Ukranian democratic par-
ties in exile, testified concerning the "dangerous
features" of "so-called cultural exchanges and ex-
hibits" between the western nations and the Soviet
Union. Bahriany said that there is no freedom of
"artistic creativeness" under the "Socialist Realism"
art dictated by the Communist Party, and "recounted
the imprisonments and persecutions to which he was
subjected as a Ukranian writer and artist, and the
mass liquidations and terror inflicted on artists and
writers whose works are considered disloyal to the
Communist regime":
"The Soviet Government considers... every art
should be subordinate to political objectives...
Therefore, they are very much against modern
paintings"
and if any painter paints individually,

"he is considered a dangerous enemy to the Par-
ty. "

Bahriany commented on the American National Exhi-
bition in Moscow to open in July of this year, "at
which will be displayed the works of a number of
artists with extensive records of affiliation with the
Communist front movement in the United States":

> "The Soviet Government will certainly exploit to
> the fullest extent the very fact that the United
> States Government is sending exhibits by pro-
> Communist artists. They will say: 'You see,
> even the greatest capitalist country, America,
> has no one but Communist artists'" (591:1-2).

1959, June 3 The American National Exhibition in Moscow's Sokol-
(B) niki Park--containing "cultural, scientific, and tech-
 nological exhibits designed to further Soviet under-
 standing of life in America" (590)--saw "politics
 mixed with paint" when United States Congressman
 Francis E. Walter (Democrat, Pennsylvania)--chair-
 man of the House Committee on Un-American Activi-
 ties, in a speech before the Committee ("The Record
 of Certain Artists and an Appraisal of Their Works
 Selected for Display" at the American National Ex-
 hibition, Moscow") (590:895)--charged that "many of
 the 69 artists" represented in the exhibit "had rec-
 ords of affiliations with Communist fronts and
 causes. "

 President Eisenhower stood by the selection of
 American works of art that had been made for ex-
 hibit in Moscow. Although the controversial Ameri-
 can paintings--"largely nonobjective"--were not cen-
 sored by removal from the show, they were "diluted
 or submerged" by adding to the Exhibition a number
 of "traditional paintings from the "classic American
 repertoire" by Gilbert Stuart, Frederick Remington,
 Mary Cassatt, John Singer Sargent, John Singleton
 Copley (7, 1960:574; 250:2; 417 8:9 S 1959)

1959, Septem- President Dwight Eisenhower signed into United States
ber 14 law (Public Law 86-262), as amendment to paragraph
 1629 of the Tariff Act of 1930, liberalization of the
 tariff laws for works of art, including the free im-
 portation of art for exhibit, and the obliterating of
 antiquated laws that "placed a tax on culture" (154:
 1228, 1252; 410 S. 15 1959 14:2).

 This modification of the laws governing import
 tariffs on works of modern art (introduced in identi-
 cal bills in the United States Senate and the House of
 Representatives on May 27, 1958) permits free duty
 for all fine arts--made of any material and in any
 form--for exhibit, and eliminates the old restrictive
 definition of "high art" that had proved embarrassing

in a number of court cases to the United States Customs, especially in designation of abstract sculptures, collages, lithographs, and primitive carvings as "art," because they did not fall within the laws' outmoded definition of "art" (7, 1960:574; 626:228).

1959, September 25 The United States Customs Court continued to define "art" for items outside the scope of the new (1959) law, as when "a strongly divided court determined that a stained glass window was a work of art, and entitled to free entry" (154:1252).

1959, October 11 Today, when Simon Rodia's "Watts Towers"--the unique 100-foot-high sculptural structure built from scrap over a thirty-three year period--passed the "stress test," the Los Angeles City Building and Safety Commission reversed their advocated demolition of the Towers. The "anti-modern-art" controversy in Los Angeles over the spirals ceased, and four years later the Los Angeles Cultural Heritage Board declared the "Watts Towers" a cultural and historical monument, thus assuring them of preservation (410, My 31 1959 78:1; 0 12 1959 21:2; 528: 12).

1959, October 4 Goya's "Nude Maja" ("Maja Desnuda")--celebrated painting in Madrid's Prado Museum that had been distributed as a postage stamp series (1, 4, and 10 pesetas) by the Spanish government some years earlier (on June 15, 1930)--made headlines again when the United States Justice Department "scuttled" the Post Office Department case against the picture on a colored postcard by refusing to defend the ban against its mailing, and admitting that "the post cards at issue are neither obscene, lewd, lascivious, or filthy" (412:29-30; 410, 0 5 1959 61:2; 595:517).
 Last March United Artists motion picture company had mailed in New York City 2, 268 postcards picturing the "Nude Maja," with a "plug for the film on the other side of the card: "the most breathtaking canvas that ever came to life" (447:183), to publicize their new film of Goya's life, with the same title, "Nude Maja." The company was delighted with the stroke of good publicity when the Post Office declared the cards "unmailable" as "obscene" (410, Ap 9 1959 26:6). This decision was upheld by Examiner William A. Duvall in a 19-page judgment issued on April 8, criticizing the poor reproduction of the painting and concluding that the postcard "cannot be considered a masterpiece... In sum, it is simply a color picture of a nude woman," and since--generally speaking--"we live in a clothed civilization," a nude woman would strike the average person as indecent

410, My 6 1959 39:8; 417 8:2; Je 1959).

Postmaster Arthur Summerfield was not alone in postal problems with the "Naked Maja"--the postmaster of the Philippines had once held up all issues of Time magazine because there was a picture of the "Naked Maja" in the art section (94:93)--commenting on the incident:

"We are just the fall guys in a publicity campaign" (412:29-30).

Even when the Spanish stamp of the painting was issued in 1930, there was shocked comment over the picture, 132 years after it was created; one Swiss zealot wrote to Spanish authorities:

"You are corrupting the morals of millions of innocent children. " (ILLUSTRATION 31)

1959, November 2

Because of threatening telephone calls from irate residents, in the heighborhood of her Great Neck, Long Island art shop, Eva Lee, art shop keeper, moved the $6, 000-priced sculpture of a reclining nude couple, carved last summer from a fallen elm tree by New York City artist Ivan Fainmel, from her shop's front lawn to a safer location inside the gallery. Callers had promised to damage the figures if they were not removed from the view of passing school children (410, N 3 1963 59:1).

1959, December 27

Critic John Canaday spoke out against the "disasters" of the United States Information Agency cultural program abroad, mentioning the cancellation of sculpture exhibits under the direction of Yale University Art Gallery and Andrew Ritchie; the touring of the American art exhibit "Twenty-five Years of American Painting, 1933-1958" in Western Europe without any mention of the sponsors--the USIA; and the St. Louis Art Museum; plans for a large, world show of paintings loaned from the Ford Motor Company of works executed for Ford Times--indicating official United States acceptance of the USSR idea that "art must serve to illustrate and propagandize" (410, D 27 1959 II, 17:1).

1960's?

In Australia a bookseller was successfully prosecuted (In Re Jacobs, J. P. 235) for selling an art book containing reproductions of works of art--the main point in the case being "circumstances of sale" (118:39).

1960 (A)

An exhibition of the work of Paul Wunderlich, German graphic artist whose prints have been described as "sensuous and intellectual, erotic and macabre..." was closed by the Hamburg, Germany, police on a charge of "obscenity, " and some of the pictures

were confiscated. Officials found his "qui s'explique
... lithographs of lovemaking couples too explicit, "
even though the aesthetic merit of the exhibit was
guaranteed by the fact that Wunderlich was a teacher
at the Hamburg Academy of Fine Arts (33; 620:57).

1960 (B) The Civic Center Commission in Detroit, Michigan
 "ordered a bronze loincloth welded into place on
 Carl Milles' statue of a naked Indian, which had
 been placed in front of Cobo Hall (315 1:4 N 10 1970).

1960 (C) "Sadism" replaced "Sex" as a primary object of cen-
 sorship in books, plays, and visual arts. While in
 the nineteenth century, the "novel with its exposure
 of different classes to one another through serials
 and lending libraries... brought on Victorian censor-
 ship, " today "a similar impetus... has been provided
 by the paperback book" (327:88, 90).

1960, Febru- A "Guild Battle, " dating back to the 17th and 18th
ary 9 centuries "when artists in various places were often
 at loggerheads with the Painters' Guilds and other
 trade or labour unions" occurred in the dispute in
 Toronto between the Brotherhood of Painters, Deco-
 rators, and Paper Hangers of America and the Can-
 adian artist York Wilson about the execution of the
 mural paintings in the O'Keefe Arts Center. Wilson,
 designer of the murals, was painting them himself
 with the aid of two assistants, when the Brotherhood
 called on all three to stop their work "because it
 should be done by painters enrolled in the scenic
 artists division of the Brotherhood. "
 Artist Wilson refused to enroll in the Brotherhood
 or to limit his workers to union members:
 "Fine art is an individual and creative form of
 expression. I do not see how you can possibly
 unionize people who work as individuals" (316
 F 9 1960 14b).

1960, July 22 In the "imposed party line, " art in Communist China
 strengthens the Communist regime and culture (403:
 18, 19), and the Third Congress of Artistic and Liter-
 ary Workers laid down the principles governing art
 in China, exposing "the terrifying spectacle of the
 demoralization of the spirit and the degradation of
 morals" reflected by art of capitalist countries. The
 decisions of this Congress serve as a guide for the
 Communist Party in its reevaluation of foreign art
 works to be purged or banned "as contrary to Chinese
 Socialist ideology" (315, D 25 1964 F:1). Art, as
 well as literature, is regarded as "the nerve centre
 of the class struggle" (109:3), and since 1942 art
 has "served the workers, peasants and soldiers...

in the victory of Marxist-Leninist principles" (109: 7-8).

1960, September? In an "open letter," the presidents of nine national art organizations in the United States set forth their "considered opinion" that the selection of art for exhibition and for award should be made by juries composed of artists rather than of museum directors, critics, or art historians.

Among the organizations urging artists to boycott exhibitions where artists were not to be "judged by their peers, named in advance," are: National Academy of Design, Allied Artists of America, American Artists Professional League, American Watercolor Society, National Society of Mural Painters (340A).

1961 (A) Art--as considered in the American Law Institute's Model Penal Code proposed official draft--would fall into usual legal categories: sedition, libel, and obscenity--the latter treated under "Offenses Against Public Order and Decency" in Article 251. "Public Indecency." Section 4 (Evidence, Adjudication of Obscenity) provides for evidence admissible in any prosecution: character of audience for which the material was designed or to which directed, artistic merits and degree of public acceptance in the United States of the material, "appeal to prurient interest, or absence thereof, in advertising or other promotion of the material"; good repute of the artist, admissibility of testimony of the artist who created the work, and of expert testimony (6:238-239).

1961 (B) In the first definitive statement of Communist Party credo since 1919, Nikita Khrushchev's 47,000-word draft of a "new program" for the Soviet Communist Party discusses freedom in the role of the arts:
Arts "must be a source of happiness and inspiration to millions of people, must express their will... must enrich them ideologically and educate them morally" (Life Ag 11, 1961, p. 40).

1961 (C) Two "undraped youths wrestling"--life-size figures commissioned by the local council of the municipal borough Nuneaton in Warwickshire, England, twenty miles east of Birmingham, from sculptor Edward G. Hellawell, Head of Nuneaton School of Art, for the sum of £500--were rejected as indecent by the local council--after complaint from the town's Women's Guild. The sculpture will not be displayed on the river garden site it was purchased to occupy. Artist Hellawell commented:
"I've been asked to put the boys in shorts. I'm not going to, and the Corporation can

 put the statue where it likes" (342:12, 15).

1961 (D) "Siesta, " Sir Gerald Kelly's picture of a reclining
 nude, now touring England as part of a collection of
 the British artist's work, was "subject to veiling"
 while on exhibit at the Paisley Art Gallery in Scot-
 land, because visiting school children viewing the
 painting commented on the subject and laughed at it.
 Cyril Rock, Gallery director, defended his drap-
 ing:
 "We like the lads and lassies coming in, but
 we had the same sort of bother with a nude
 from the Tate Gallery some time ago, so we
 thought a curtain would be the best thing at
 this time (342:12, 14).

1961, March Bookseller James Sweet Shaw, was acquitted in a
 Los Angeles Municipal Court on charges of exhibiting
 pictures of "obscene Indian sculpture" in a display
 window. The pictures were photographs of sculpture
 accompanying an article by Mulk Raj Anand--Indian
 writer and artist--"The Great Delight, an Essay on
 the Spiritual Background of the Erotic Sculpture of
 Konarak, " which had appeared in the literary quarterly
 Evergreen Review, no 9, 1959.
 Shaw had been charged with "willfully and lewdly
 exhibiting, keeping for sale and selling allegedly ob-
 scene works" (417 9:7 D 1960), but Judge Parks Still-
 well ruled that the pictures in question "were within
 the area of free speech and free press provisions of
 the Constitution and protected thereby" (417 10:7 Mr
 1961), "since they did not have a tendency to corrupt
 and deprave the average person" (315 C:6 Mr 5 1961).

1961, March 17 "Even a machine wasn't allowed to commit suicide, "
 when Jean Tinguely's "Homage to New York"--a
 "splendid white structure, " one of the artist's "sar-
 donic metaphors on the world of the assembly line
 and conveyor belts"--broke itself into bits on "a cold,
 slushy evening" in the gardens of the Museum of
 Modern Art in New York City.
 The self-destroying sculpture was "aided in its act
 of non-being" by firemen, who "doused the burning
 piano and axed the big meta-matic" (530:10).

1961, Novem- Three sketches of nudes by British artist John J. Dunn
ber 8 were banned from his show at St. Mary's, women's
 college in Notre Dame, Indiana (410, N 9 1961 23:5).

1962 (A) An informative exhibit "Entartete Kunst: Bildersturm
 vor 25 Jahren" ("Degenerate Art: Destruction of Art
 25 Years Ago") was held in Munich in the Haus der
 Kunst--which in 1937, as Haus der deutschen Kunst,

had exhibited Hitler's exhibit of "True German"
"clean and healthy" art (620:58).

1962 (B) The Customs Act of India, Section II empowering
the Central Government of India to prohibit the im-
port and export of goods "for the purpose of the
maintenance of public order and standards of decency
and morality, " replaced the Sea Customs Act, 1878,
which prohibited the import into India of obscene
books and articles, including drawing, painting, rep-
resentation, figure (375:3).

1962 (C) On order of magistrates in Rome, four George Grosz
designs were destroyed, Dr. Gaspare del Corso, di-
rector of the Roman art gallery "L'Obelisco" was
sentenced to two months in prison and a $54 fine
for having published Grosz's pictures in a catalog.
The court also ordered destruction of 1, 500 catalogs
of the offending prints: "Society, " "Girl in a Night-
dress, "Easy Girl, " "The Psychoanalyst. " The
Italian magazine Mondo Nuovo (New World) was also
"sequestered" for having reproduced these same pic-
tures (315 Calendar:1 Mr 10 1963).

1962 (D) The United States Supreme Court clarified the Roth
ruling of 1957 by stating (Manual Enterprises v Day)
that a work must have the quality of "patent offensive-
ness, " as well as "prurient interest appeal" to be
considered obscene.

1962, Febru- The design for the Franklin Delano Roosevelt Memo-
ary 22 rial in Washington, D. C. --winner of a $50, 000 prize
in a nation-wide competition conducted by the Ameri-
can Institute of Architects--was rejected by the Na-
tional Fine Arts Commission "as inappropriate com-
pany for the Washington Monument and the Jefferson
and Lincoln memorials. " The award-winning work
was also turned down by the United States House of
Representatives and by the Roosevelt family (168:28-
29).

1962, March Pardoned by the President of Mexico after serving
10 four years of an eight-year term for agitating a
student rebellion and demonstrations on August 9,
1960, David Alfaro Siqueiros, 67-year old famed
Mexican muralist--"always a fiery Communist lead-
er"--was released from prison to complete some un-
finished murals, one of them at the government's
Chapultepec Castle museum in Mexico City.
Paintings by Siqueiros, known for their "blunt
interpretation of Marxist and Mexican revolutionary
themes" (108:506), had been destroyed or suppressed
in some instances in the United States, including one

mural censored in Los Angeles. (315 C:1 My 23 1971).

1962 Goya's "Nude Maja, " displayed in a 4 1/2-foot re-
 production in the men's room of the Host Internation-
 al restaurant at Los Angeles International Airport,
 was removed by the restaurant after a letter to Los
 Angeles city authorities complained that the painting
 was obscene.
 Placed some months later in the men's room of
 the Honolulu Airport Host International restaurant,
 the painting again evoked scathing comment, as re-
 ported by Harry Lyon in a Honolulu Advertiser arti-
 cle, "Is Naked Maja a Lewd Nude?" (617A).

1962, July Russian playwright Sergei S. Smirnov--"known main-
 ly for his interest in publicizing forgotten or lost
 causes"--attacked the Soviet Artists Union in an arti-
 cle in the literary newspaper, Literaturnaya Gazeta,
 as "seeking to impose its taste as 'absolute and
 rigid law, ' and of preventing the rise of young inno-
 vators. " The censorship of the work of Ilya Glaz-
 unov, Soviet artist painting in the icon style of Rus-
 sia's fourteenth and fifteenth century--far removed
 from the "photographic Socialist realism approved in
 the Soviet Union"--occasioned Smirnov's article,
 charging that Glazunov had not been admitted to full
 membership in the Artists Union, and had not had
 a show of his own since 1957 when his work was
 condemned for deviation from the party line by Un-
 ion officials. Smirnov described talent as a "na-
 tional property, " and labelled attempts to suppress
 it or to isolate it from the public:
 "just as anti-social and anti-state as an attempt
 to stop work without reason at a factory, or to
 let grain rot in the field" (410, Jy 8 1962 1:6).

1962, August An ultimatum "to restore the nudes within 24 hours
23 or they would close the exhibition" was given by the
 Arts Council of Great Britain to the corporation au-
 thority of Bradford, England.
 Conservative Alderman Horace Hird, aged 62,
 former Lord Mayor of Bradford and a member of
 the City Council since 1944, as Chairman of the Li-
 braries and Art Gallery Committee of the Bradford
 Council had ordered three nude paintings ("Nude"
 by Francis Hoyland, "The German Girl" by Euan
 Uglow, "Doreen" by Philip Sutton) taken out of the
 show)--selected by the Arts Council "for display in
 the provinces"--on display in Bradford's Cartwright
 Hall since August 11.
 The exhibition had already been shown without un-
 favorable reaction at Walsall, Cheltenham, and Cam-
 bridge. Hird refused to replace the pictures, and

in a letter to Peter Bird, director of the Art Gallery, stated that the pictures "were an affront to common decency. " "Wondering what the fuss was all about, " Hird's Committee viewed the questioned pictures on August 23, and, in a vote of 9 to 5, reversed their chairman's decision. They ordered the paintings, which had been banished to a locked room, returned to the exhibit, with Bradford's apology to the Arts Council.

Alderman Hird refrained from voting on the Committee question of the nude paintings, and said that he still thought the pictures "would corrupt minds" (316 Ag 21 1962 10:f; Ag 22 1962 8:g; Ag 24 1962 6:e; 410 Ag 24 1962 22:4).

1962, November 26

The Russian Academies of Art--"formed as instruments of the State...to direct art according to State policy"--guide artists "not arbitrarily by Diktat but by codifying a system of artistic rules which ensure the continuation of a traditional, homogeneous art reflecting State ideology" (41:22).

A semi-private exhibit--"avant garde by Moscow standards"--opened in the "barnlike studio of 38-year old art teacher Eli Belyutin" with about 75 canvases by his students done "in abstract and semi-abstract style" (294:7). The sculpture of Ernst Neizvestny--"a notorious, officially condemned, decadent and 'unpatriotic' sculptor" (41:19), for whom all applications from abroad to buy his work are turned down by the "Salon for the Sale of Art Objects" (41:79)--was included in the show. The exhibit, closed to the public, lasted only a few hours.

After some "western correspondents, Soviet cultural officials, " and several hundred "specially invited" Russians had been allowed to view the art works, the exhibit was closed (294:7).

1962, November 29

An exhibit of modern art scheduled to take place at the Yunost Hotel in Moscow was "mysteriously postponed" hours before it was to open. "Later, it was cancelled altogether" (294:7).

1962, December 1

"Thirty Years of Moscow Art, " an exhibit of 2, 000 works of painting and sculpture, was visited by Nikita Khrushchev when the show was held at the Manege Gallery in Moscow. He reported that the displayed works were "anti-Soviet" and "amoral" (545:93-95).

1962, December 2

Pravda, official newspaper in Russia, in its editorial "Art Belongs to the People" reaffirmed the Leninist policy that Soviet art should be partinost (characterized by "party-mindedness")--that is, "spring from

the life of the people and be comprehensible to the
people. " Russian artists who "have departed from
and betrayed the glorious traditions of Russian
realistic art" are officially condemned (545:96).

1962, Decem- Vladimir Aleksandrovich Serov, Russian painter of
ber 5 the Socialist Realism school, replaced Boris V. Iog-
 anson as President of the Soviet Arts Academy--
 Soviet Union of Artists. Apparently the Pravda edi-
 torial three days before--demanding discipline of
 artists and writers, and singling out avant garde
 painters and sculptors for particular critical atten-
 tion, foreshadowed this change (410, D 4 1962 1:6;
 D 6 1962 15:3).

1962, Decem- The right of an artist to draw and display figures of
ber 20 nudes was defended in the Appellate Department of
 the Superior Court in Los Angeles. Defendant in the
 case, Ernie A. Smith, had been convicted in Muni-
 cipal Court--and placed on three months' probation--
 for displaying drawings in his studio and shop, one
 of which, police testified, "went beyond the bounds
 of propriety, and could be seen plainly from the
 street. " Although Smith's probation period had ex-
 pired, both he and his attorney, A. L. Wirin of the
 American Civil Liberties Union, wanted to expunge
 Smith's conviction "as a matter of principle" (315, D
 21 1962).

1963 (A) An Indian Penal Code Amendment Bill, introduced in
 the Indian Parliament following the English Obscene
 Publications Act of 1959 and the trial concerning D.
 H. Lawrence's novel Lady Chatterley's Lover, in-
 serted a new Section 293A in the Code, providing ex-
 ception to Section 292 or Section 293 of the Penal
 Code for "any book, pamphlet, writing, drawing,
 painting, representation or figure meant for public
 good or for bonafide purpose of science, literature,
 art or any other branch of learning" (375:27).

1963 (B) The Publications and Entertainments Act, No. 26,
 was enacted by Parliament of South Africa to provide
 for control of publications, cinematograph films, en-
 tertainments, and "certain objects, " including paint-
 ings and exhibitions of sculpture. A Publications
 Control Board of nine members, appointed by the
 Minister of the Interior, scrutinizes and rules on
 the acceptability of "undesirable" publications. A
 publication may be deemed undesirable if it, or "any
 part of it, " is
 a. indecent or obscene or offensive or harmful to
 public morals,
 b. blasphemous or offensive to the religious con-

victions of any section of the inhabitants of
the Republic,
c. brings any section into ridicule or contempt,
d. harms relations between any sections, or
e. is prejudicial to the safety of the State, the
general welfare, or peace and good order
(358:131-132).
Under the Act, an art exhibition was closed in Dur-
ban because of nude studies on display, and "an art-
ist who portrayed an unconventional Christ was prose-
cuted for blasphemy, despite a strong protest by an
ordained member of the Anglican Church. "

1963 (C) "Many of Italy's established artists protested" against
the "research teams, " endowed with socio-political
ideology, proposed by Giulio Carlo Argan--Italy's
leading art critic, professor of modern art at the
University of Rome, and president of the Interna-
tional Association of Art Critics. These artists
"reaffirmed their faith in the personal statement
and the individual" in art, and rejected Argan's
thesis that "the individual in his solitude can no
longer exist in modern technological society and
produce significant works of art" (108:461).

1963 (D) The New Zealand Assembly passed legislation enab-
ling the New Zealand Indecent Publications Tribunal
--official censorship body operating since the begin-
ning of 1964--to decide whether or not a work is
"indecent" under the censorship provisions, and
whether or not the work should be restricted to
specified individuals or classes of persons, or for
particular purposes (397:1371).

1963, January Madrid police removed some of the paintings exhi-
bited by Australian artist Frank Hodgkinson from
the state-controlled Ateneo Gallery "because their
abstract biomorphic forms were considered too
erotic" for public display (410, Je 11 1967 II, 25:3).

1963, Febru- Premier Nikita Khrushchev in a speech, "The Great
ary Strength in Literature and Art Lies in High Ideologi-
cal and Artistic Standards, " delivered at a meeting
of Soviet artists, writers, and Communist Party
leaders, told artists that "their works are weapons
in the socialist movement, " and that there is no
place in the Soviet Union for such "bourgeois per-
versions" as Western abstract art (315, F 10 1963
A:13):
"It is the mission of Soviet literature and art
to recreate in vivid artistic imagery, the great
and heroic age of the building of Communism... "
(67, 1965:40).

1963, April 6 Jailed on a charge of desecrating the Confederate
 flag by "obscene and indecent words and phrases,"
 30-year old G. Ray Kerciu, assistant professor of
 art at the University of Mississippi was released
 on $500 bond. His offending canvas, "America the
 Beautiful"--"inspired by desegregation riots on the
 Oxford, Mississippi, campus in September 1962"
 (67, 1964:143)--had been removed the day before,
 along with four other paintings, from his one-man
 show of 56 canvases at the University of Fine Arts
 Center, at the order of Provost Charles Noyes, re-
 sponding to complaints of local White Citizens Coun-
 cil and the Daughters of the Confederacy (266:23).
 The censored "America the Beautiful," painted
 "in the New Realist idiom," pictures a large Stars
 and Bars--the flag of the Confederacy--plastered
 with social comments--slogans of the riots of last
 year: "Impeach JFK," "Would You Want Your Sister
 to Marry One?", "[scratched out word] the NAACP"
 (428:76-77).

1963, May On the opening day of the show, Colombian artist
 Fernando Botero's oil painting, "Cardinals Bathing"
 was removed--presumably for moral reasons--from
 the exhibit "Arte de America y España " organized
 by the Spanish government (410, Je 11 1967 II, 25:3).

1963, May 7 After an artists' mass at the Sistine Chapel, Pope
 Paul VI in a speech deplored the rift between art
 and religion, and while he scorned art that is incom-
 prehensible he asked pardon for the Roman Catholic
 Church efforts to impose sharp restrictions--"a
 cloak of lead"--on artistic expression (410, My 8
 1963 1:6; My 17 1964 II, 13:1).

1963, July 25 Detectives from Scotland Yard invaded the "Inner
 Temple," central London stronghold of Britain's
 lawyers where they have lived and worked for cen-
 turies, and carried off "a van load" of pictures and
 books they said were pornographic (Library Journal
 88:3041 S 1 1963).

1963, Septem- After a delay of a week, a visa to visit the United
ber 3 States was granted by the United States State Depart-
 ment to Mexican artist and architect Juan O'Gorman,
 whose best-known work is the mosaic mural on the
 Library Building of the University of Mexico.
 O'Gorman is to lecture as an art authority in the
 United States (410, Ag 29 1963 28:2; Ag 31 1963
 18:2; S 1 1963 48:7; S 4 1963 36:7).

1963, October Kashmir, India, banned the July 29 issue of Life,
22 International Edition, because the Prophet Mohammed

was depicted in the magazine (410, O 23 1963 7:1).

1963, October
31

The Roman Catholic Ecumenical Council meeting in
Rome approved--by a vote of 1, 838 for, 9 against,
and 94 in favor with reservations--the seventh chap-
ter of the schema on sacred liturgy dealing with
sacred art and furnishings. Amendments declared
that the Church gives "free scope" to contemporary
art, so long as it is "duly reverent, " and urged
"moderation" in number and display of pictures and
statues (410, N 1 1963 6:3).

1964 (A)

Danes--and the whole world--were shocked when "The
Little Mermaid"--bronze statue by Danish sculptor
Edvard Ericksen, inspired by Hans Christian Ander-
sen's tale, sitting on a rock overlooking Copenhagen's
harbor--was decapitated by vandals. The figure was
"fully restored, " and returned to her watch (7, 1965:
222).

1964 (B)

"The famous pornographic wall frescoes in Pompeii...
are shown only to male tourists on request, and then
only at the cost of a tip to the custodian" (279:10).
 The word "pornography, " derived from the Greek
pornographos ("the writing of harlots"), "connotes
description of the life, manners, and customs of
prostitutes and their patrons. "
 The editor of the Oxford English Dictionary re-
ferred to the Pompeii frescoes when he cited the
1864 Webster definition as an example of the word
"pornography":
 "licentious paintings employed to decorate the
 walls of rooms sacred to bacchanalian orgies,
 examples of which exist in Pompeii" (439).
Such paintings are represented in the book Roma
Amor, published in Switzerland, 1961, with an intro-
duction by Jean Marcade, Professor of Archaeology,
University of Bordeaux: "classical erotic imagery
in fresco, bronze, mosaic, and pictures from the
famous Secret Museum at Naples. "

1964 (C)

In further clarification of the Roth ruling of 1957,
the Supreme Court of the United States declared
(Jacobellis v Ohio) that obsceneity must be judged by
"national" community standards, not by individual
local standards, and emphasized that a work "cannot
be proscribed unless it is 'utterly' without social
importance. "

1964, January
13

University of Utah Board of Regents requested the
University's Union Board to remove a "controversial
art display, including several nude studies, " by three
artists--two of whom are instructors in the Univer-

sity's Art Department--from the Union Ballroom cor-
ridor.

"A number of complaints" from unidentified off-
campus visitors, who had viewed the controversial
works as they walked through the display corridor
to an exhibit of Hellenistic Culture--"Spotlight on
Greece, " with two nude statues among the sculptures
--caused the Regents' censorship (417 13:19 Mr 1964).

1964, Janu- The Liquor Control Board of Alberta Province in
ary 22 Canada barred fifty-one paintings, owned by Distillers
 Corporation-Seagram, from a show in Edmonton,
 capital city of the Province, on the grounds that the
 owner is a liquor company and liquor advertising is
 barred in Alberta (410, Ja 23 1964 51:3).

1964, April Certain art works are proscribed in the third revis-
(A) ion of the United States Customs Regulations (United
 States Bureau of Customs. Customs Regulations CR
 292--3rd revision, April 1964), which forbids import
 of:

> "Any obscene... print, picture, drawing or other
> representation, figure, or image on paper or
> other material, or any cast, instrument or other
> article which is obscene or immoral" (589).

1964, April The military regime which took power in Brazil es-
(B) tablished stringent censorship laws, by which "the
 authoritarian generals and colonels who run Brazil"
 control expression of ideas by prior police censor-
 ship of all books and periodicals, foreign and do-
 mestic.

 The initial censorship provisions were tightened
 by decree in February 1970 so that police are sup-
 posed to censor material "offensive to morals and
 good custom. " These decrees--infringing human
 liberty and easily stretched, according to the leader
 of Brazil's opposition party, to include political ideas
 --allow police censors 20 days to read a book, and
 two in which to read a magazine (315 F 18 1970 2:6).

1964, May 8 On Ascension Thursday, Pope Paul invited contem-
 porary artists to accept and "sign" the "new alliance"
 in the Vatican II Constitution on the Liturgy (464:704).

1964, June 15 Controversial Soviet painter Ilya Glazunov opened his
 first one-man show in seven years in Moscow under
 USSR Culture Ministry auspices, despite the Artists'
 Union objections (410, Je 16 1964 6:4), but the exhibit
 was later banned because "a nude portrait of the art-
 ist's wife... reportedly angered Soviet officials" (99
 2:54 O/N 1969).

1964, July 2 "Not Guilty," was the jury's verdict after a nine-day
 trial of Ed Muldoon, owner of the Vorpal Gallery of
 North Beach, San Francisco, and his salesman,
 charged with offering "lewd objects for sale"--11
 figures formed from junked automobile parts by Ron
 Boise, resident of Death Valley, California (159:464).
 The auto-fender-and-bumper figures, banned from
 public view because of indecency, were "engaged in
 various forms of sexual intercourse... graphically de-
 picted... either condemned completely by community
 taboos or reserved for wholly private enjoyment"
 (317:308). The defense, including several art au-
 thorities (University of California art historian Pro-
 fessor Walter V. Horn, and Mrs. Katherine Cald-
 well, Mills College lecturer in Oriental Art), ex-
 plained that this was "Kama Sutra sculpture," "de-
 picting forms and positions of lovemaking described
 in the Kama Sutra"--celebrated book of fourth cen-
 tury Western India of the Gupta Dynasty, originally
 written in Sanskrit, which has been "translated into
 most modern languages... and, after 1600 years,
 probably remains the fullest and most detailed so-
 cial and physiological treatise on the art of love
 (kama: sexual pleasure) which has ever been pro-
 duced" (279:90).
 Police efforts to suppress Boise's figures as
 pornographic were defeated by Professor Horn's
 evidence that erotic art has attracted talents of the
 best artists through the centuries, including Michel-
 angelo, Leonardo da Vinci, Rembrandt, Gauguin,
 and Picasso--supported by 45 photographs of works,
 well known to art students, "easily available in any
 first-rate library or bookstore," and by Mrs. Cald-
 well's statement that the Kama Sutra "is to the Indi-
 ans what a medical book on ideal family life would
 be to our own culture" (417 13:62 S 1964).
 Alan Watts, known for his writings on Zen, in a
 speech at Big Sur Hot Springs, evaluated these fig-
 ures as "pushing the line back" in the expression of
 "on-scene," rather than "off-scene" (or "obscene")
 expression of intimacy (612).
 From a legal standpoint, the judgment in the
 Boise case, "raises the question of whether the law
 may validly ban the public showing of any creative
 work without regard to its aesthetic appeal" (317:308).

1964, Septem- Venice Biennale detractors called the exhibit a "poi-
ber soning of the innocent" that had resulted in "heated
 debates, veto by the highest Catholic authorities, the
 sudden cancelation of the Italian president's partici-
 pation" in the show's inauguration. Attack was di-
 rected to the American Pavilion where "Pop Artists"
 were shown for the first time under official patronage

So he put on all his Fine
Clothes, and went out for
a walk in the Jungle. And
by and by he met a Tiger.
And the Tiger said to him,
"Little Black Sambo, I'm
going to eat you up!" And
Little Black Sambo said,
"Oh! Please Mr. Tiger,
don't eat me up, and I'll
give you my beautiful little

16

32. 1964, October 19. Hazel Bannerman. Little Black Sambo, illustration

of the United States government, including: "four
germinal" artists--Morris Louis, Kenneth Noland,
Robert Rauschenberg, Jasper Johns; and "four
younger" artists--John Chamberlain, Claes Olden-
burg, James Dine, and Frank Stella. Italian and
other European critics termed the American exhibi-
tors "impudent crooks"; "modern savages" whose
work produced with "frightening mental squalor"
"old and boring" results. Leading European painters
dismissed the show as "not-art," including Giorgio
de Chirico:
> "Pop Art cannot be judged because it has nothing
> to do with art. "

Before the Biennale opened, the patriarch of Venice
Cardinal Urbani had "deplored the 'moral disorder'
revealed by the 'disintegration of the human image,'
and banned the Exhibition for members and clerics
of all religious orders" (639:32-34).

1964, Octo- Little Black Sambo, fairy tale picture book by Hazel
ber 19 Bannerman, known to generations of children, was
 ordered removed from the Lincoln, Nebraska, Public
 School System by School Superintendent Steven N.
 Watkins, after a letter from the Lincoln Human Re-
 lations Council objected to the story of a Negro
 child pursued through the jungle by a tiger. Super-
 intendent Watkins' notice stated that while Little
 Black Sambo was "not a part of the instructional
 program, it will be available to those who want to
 read it as optional material" (315, 0 20 1964; 417
 14:12 Ja 1965). (ILLUSTRATION 32)

1964, Decem- William McVey's statue of Sir Winston Churchill,
ber ordered by the English Speaking Union as a $100,000
 memorial to be placed outside the British Embassy
 in Washington, D. C., was criticized by the Union--
 that had raised the purchase price for the nine-foot
 bronze figure--because a traditional Churchill out-
 sized cigar was shown between the first and second
 fingers of the figure's left hand, as it rested on a
 cane.
 The Union asked McVey to take out the cigar "on
 esthetic grounds. " Alexander Liggett, chairman of
 the committee in charge of the project, is sending
 letters to the Union's 30 branches across the United
 States to ask them whether they prefer Churchill
 with... or without...the cigar (315 D 7 1964 1:3).

1965 (A) Daniel Argimon, modern Spanish artist, had a col-
 lage including a woman's garterbelt, eliminated for
 moral reasons from an official art show in Spain
 (410, Je 11 1967 II, 25:3).

1965 (B) "Artists in Moscow were warned against so-called
 'progressive trends'" (67, 1966:453).

1965 (C) Lloyd Goodrich, director of the Whitney Museum of
 American Art, and painter Jimmy Ernst made state-
 ments on Freedom of the Arts, published in the Art
 Journal (179A; 233A).

1965, January An oil painting entitled "You Go Ahead, I Follow, "
 which won official approval in Communist China and
 was reproduced in the party magazine China Youth
 as the back cover of the last issue in 1964, was
 suddenly removed from view, all copies of the maga-
 zine were called in, and public discussion of the pic-
 ture was barred.
 Instead of propaganda for the Communist cause,
 the painting was discovered to contain "sharp anti-
 Communist propaganda. " In the cottonfield shown
 being harvested by young peasants, the tangled stalks
 of the cotton plants spelled out in Chinese charac-
 ters:
 "Long Live Chiang Kai-shek";
 and
 "Kill Communism" (410, Mr 7 1965 4:1).

1965, Febru- According to the United States Customs, "original"
ary 24 sculpture means the first ten castings of a work
 (410, F 26 1965 26:4).

1965, March 8 Dr. Charles Fraser Comfort, Director of the Na-
 tional Gallery of Canada, acting as advisor to the
 Canadian Custom's office, ruled that Pop Artist
 Andy Warhol's grocery cartons and tin cans are
 not "original sculpture, " so that under Canadian
 tariff regulations, the Toronto Gallery importing
 the works for an art show must pay a 20% "mer-
 chandise duty" (410, Mr 9 1965 31:1).

1965, May 15 The first obscenity charge ever brought against a
 local painter in the Los Angeles area (315 My 30
 1965 Calendar:17), ended in a court acquittal of
 Connor Everts, 36-year old Chouinard Art Institute
 instructor and president of the Los Angeles Print-
 making Society, by Beverly Hills Municipal Court
 Judge Andrew J. Weisz (410, My 16 1965 51:4).
 Everts had been arrested on three counts about
 a year ago when he displayed "genitally oriented"
 drawings "projecting the Kennedy assassination" of
 the previous year. He had been charged with: pre-
 paring and exhibiting obscene matter, possession of
 obscene matter, and commission of an act "which
 openly outrages public decency" (315 Je 25 1954
 1:22).

Michael J. Serio, Los Angeles County Sheriff of-
fice spokesman, said that the attention of the vice
squad was first attracted to the exhibit by a series
of telephone complaints. The artist insisted that
the sketch exhibited in the window of the Zora Gal-
lery--609 North La Cienega--"Study in Desparation, "
which represented in abstract form a human womb,
was an attempt to "depict the absolute horror of tak-
ing any life" (315 D 22 1964 2:2). The three char-
coal sketches in the window, and ten additional on
display in the Gallery, had been removed as obscene.
A fourteenth picture was also found to be obscene,
"but it was too big to move, " according to Deputy
Serio. This fourteenth drawing, "The Creature That
Bites Our Heels, " had been commissioned by the
Valley Unitarian Church--9550 Haskell Avenue,
Sepulveda. James J. Clancy, deputy district at-
torney in Los Angeles County--and also the attorney
for the organization Citizens for Decent Literature--
was quoted as telling the Gallery owner:
 "My mind is set like concrete against modern
 art" (315 N 22 1964 Calendar:1).
The first court hearing of the Everts' case in Decem-
ber 1964 ended in a mistrial--a hung jury. Argu-
ments for the second trial, heard May 14 on the
prior record, resulted in Judge Weisz's acquittal of
the artist, with the observation:
 "The question is, was it a work which had some-
 thing to say... " (417 14:67 S 1965).
While the clearing of Everts gave some "assurance
that creative artists" in the Los Angeles area "need
not fear extreme censorship movements" (315 Ja 21
1966 Calendar:13), the artist, although vindicated in
court, lost his job at Chouinard Art Institute (315
Ap 24 1966 Calendar:12).

1965, June "You can imagine how upset we were to learn
 that the French section (or Ecole de Paris) did
 not receive any prize... It would therefore be
 rather unpleasant for us to house an exhibition
 confirming such a failure in a government build-
 ing. The Minister for Cultural Affairs has writ-
 ten to me only today requesting me to forego
 this exhibition, "
so wrote Jean Cassou, director of Musée d'Art
Moderne in Paris, in refusing the request of the
Secretary-General of the Mazotto Prize Committee
for the use of a public gallery in Paris to exhibit
paintings of winners of the 1964 Mazotto Prize,
awarded in Italy to competing artists from different
nations.
 Cassou was French representative on the Mazotto
Prize jury, and after his refusal to exhibit the prize

paintings, the pictures were shown in Paris at a
private gallery (96 1 (no. 3):37 Summer 1965).

1965, June 11 San Francisco's Metro Transit Advertising Company
 advised Bantam Books that San Francisco municipal
 buses would not carry the Bantam poster advertise-
 ment (11x21"), an enlargement of the firm's cover
 for William Goldman's novel Boys and Girls To-
 gether, showing "the upper half of a nude boy and
 girl in embrace," with the additional copy reading
 "Everything Happens with 'Boys and Girls Together.'"
 Dale Sorensen, the advertising company's vice-
 president and general manager, had turned down the
 "Topless Ads," but the cover-poster, painted by
 Westport artist Bill Edwards, was cleared for bus
 display in seven other "target cities": New York,
 Chicago, Philadelphia, Cleveland, Baltimore, Minnea-
 polis, and Atlanta (517).

1965, June 13 The Reverend Robert T. Jenks, New York City
 Episcopal minister, exhibited in a sermon and de-
 fended a nude representation of Jesus, "Christ in
 a Coffin," a woodcut by Mark Berghash, banned
 from the second annual Chelsea Art Festival, that
 opened May 14 as a neighborhood art show in the
 basement of Jenk's church, St. Peter's Protestant
 Episcopal Church. Reverend Jenks criticized the
 selection committee of the Festival because they
 barred the controversial print--based on the theme
 The Last Temptation of Christ, novel by late Greek
 author Nikos Kazantzakis--which they considered in
 "poor taste" (410, Je 14 1965 39:4).

1965, July 31 The United States Customs Bureau declared the
 thread work of Czech artist, L. Krejc, to be art,
 reversing the decision of the Customs inspector in
 New York City that the work was not art and there-
 fore dutiable, and refunded the customs duty the
 artist had been required to pay in New York (410,
 Ag 1 1965 II, 19:4).

1965, Octo- The United States State Department acknowledged it
ber 13 had "expurgated" a display of surrealist paintings in
 its Exhibition Hall in Washington, D. C., and placed
 the paintings--which it found to be "vulgar" and
 "ghastly"--in its code vault for safe keeping.
 The pictures, part of an exhibit sponsored by
 the Belgian Embassy, were the work of the wife of
 the Embassy's first secretary, Herman Noppen, who
 paints under her maiden name of Maria de Mattels.
 Among the interpretations of anatomical subjects re-
 moved were: "Man with a Rose"--a male torso
 with a bouquet, instead of a fig leaf; "Callipygian"--

described by the Webster's dictionary definition of the word: "pertaining to or having shapely buttocks"; "The Birth of Venus"--a female breast emerging from a cracked egg; "Portrait of a Movie Star"-- bosoms suspended from a hook; "The Queen"--dis- robed mannequin-like woman's torso on a hatrack standing on a chessboard.

The State Department's stipulation against "com- mercialism" in the exhibits it displays also caused removal of price lists of the paintings, and business cards of a local art gallery (410, 0 14 1965 52:1, 2).

1965, Novem- Fresno District Fair officials refused to publicly show
ber two art works which had been accepted by a jury of
 four art experts for inclusion in the Fair art show:
 Charles Chestnut's "Female Nude," a drawing
 awarded second prize by the judges, was hung
 in an office where it could be viewed only on
 request;
 Arnold Jensen's "Bust," a sculpture painted
 with red, white, and blue stripes, and bearing
 a medallion of George Washington.
 Local artists sent a petition to California Governor
 Brown--with 1,000 signatures, contending that cen-
 sorship of art violates Constitutional guarantees of
 freedom of expression--requesting that the Governor
 take action "to see that the Fair directors refrain
 from exercising censorship over pieces of art se-
 lected by qualified judges for display in Fair art
 exhibits" (315 N 5 1965 1:32).

1965, Novem- "Not representative of art work at the College,"
ber 20 Mrs. Evelyn Field, dean of students at East Los
 Angeles College, commented when she ordered the
 doors of the Price Art Gallery closed on the art
 students' "The Changing Nude" art exhibit, and the
 pictures taken down. The exhibit--advertised by a
 poster that had occasioned unfavorable comment--
 consisted of student paintings copied from classic
 nudes by such masters as Titian, Rubens, and
 Modigliani, and was designed to show art "in pro-
 cess" by demonstrating paintings progressing from
 rough sketch to completed picture. "The Changing
 Nude" had opened earlier this month, and had been
 scheduled to run through January 1966 (315 N 21
 1965).

1965, Decem- Sculptor Elia Benvenuto of San Francisco claims that
ber (A) St. Luke's Catholic Church in Stockton accused him
 of "modernistic deviationism" when they removed his
 statue of St. Luke from the church and stored it in
 a nearby parking lot, chaining it to a utility pole.
 Benvenuto claims the church still owes him $3,900

of the $27, 000 he was supposed to receive for "St. Luke" (315 D 24 1965 1:3).

1965, December (B)

Chicago Public Library Librarian Gertrude Gscheidle supported the head of the Art Department in the Library, who had directed the removal of eight paintings by American artist George C. Kokines from an exhibit of his work in the Library. Several citizens and two members of the Library board (Reverend Bradley and Ralph Newman) spoke out against this banning, Pastor Bradley stating that he was "utterly opposed to any form of censorship in art. "

Librarian Gscheidle explained:

"We removed them (the paintings) because we felt they were suggestive. This was not censorship but a question of taste" (Library Journal 91:214 Ja 15 1966; 362).

1965, December 9

The United States State Department revoked the visa of Djanira da Motta e Silva, Brazilian artist planning a major show of her works in the United States, after she answered, "No, " to a form question asking if she had been a Communist Party member, but next day ordered a special exemption to permit her to visit the country (410, D 10 1965 24:6; D 11 1965 54:1).

1966 (A)

Modest Cuixart, Spanish artist, withdrew from the Spanish exhibit at the 33rd Venice Biennale because the Spanish Commissioner "intended to censor his work for moral reasons" (410, Je 11 1967 II, 25:3).

1966 (B)

When the proprietor of the gallery exhibiting "Erotic Art: 1966" viewed the sculpture American artist Larry Rivers had executed for the show--a Negro male and a white female having modeled for the figures--he declined to put the sculpture on display because he "decided that the work would be proscribed unless both statues were of the same race" (440:929).

1966, January 20

Czechoslovak artist Mia Munzer Le Comte, of Closter, New Jersey, after her painting of "two frolicking nude women" was banned from an exhibition at the Jersey City Museum, withdrew three other paintings from the show, commenting: "The Jersey City Museum is run by Philistines. " She also resigned from the Modern Artists Guild, the organization arranging the show, because the Guild, although it had protested the censorship of the Le Comte painting to the Museum, "felt obligated to continue with the exhibit" (410, Ja 21 1966 44:7).

1966, Febru- Police in Tarquinia, north of Rome and chief of
ary twelve ancient Etruscan cities, seized on the com-
plaint of the public prosecutor 5, 000 postcards from
newsstands and bookshops on the grounds that they
were obscene. The impounded postcards, reproduc-
ing sixth century B. C. Etruscan paintings of "unin-
hibited capers" of men and women, and scenes from
Etruscan mythology, have been on sale in Tarquinia
for the last fifty years, but will have their day in
court soon to determine whether the pictures are ob-
scene (410, F 4 1966 11:5).

1966, Febru- From the exhibit walls of the "sedate" Marlborough
ary 3 Gallery, Roman police removed eleven paintings and
drawings of unclothed women by two modern Austrian
artists--Egon Schiele and Gustav Klimt, after a Cus-
toms officer filed an anonymous complaint against the
pictures. A court hearing will decide whether the
works are obscene (410, F 4 1966 11:5).

1966, March 3 Six paintings of nudes have been removed, "from
where they hardly would be expected in the first
place"--the business offices of Stanford University.
The paintings by Ann Raymond of nearby Menlo Park
were installed last December, and came down this
week after complaints by "some administration offi-
cials and employees" (315 Mr 3 1966 1:2).

1966, March Although Los Angeles County Art Museum officials
22 refused to cancel the Edward Kienholz Exhibit--
March 30 to May 14--or to remove two "tableaux"
upon unanimous demand of the Los Angeles County
Board of Supervisors (7, 1967:81; 410, Mr 25 1966
36:2), who found them pornographic, the Museum
did establish for the show a "compromise": a
precedent-setting ban for viewers under 18 years of
age--unless accompanied by parent or teacher (410,
Mr 24 1966 47:1). Kienholz said that his works on
display "represented the human condition stripped of
sham and hypocrisy, and the conclusions to be drawn
from them are up to each individual" viewing his
assemblages. The Board of Supervisors and the
County Counsel found the exhibit: "revolting, "
"meaningless, " "pornographic, " "wholly repugnant, "
and "bad taste, " "blasphemous, " "beyond the limits
of public decency. " The two of the life-size three-
dimensional representations most censured were:
 "Back Seat Dodge--'38, " 1964 (240x144x60"),
 portraying lovers of the '30's;
 "Five Dollar Billy, from 'Roxy's'", 1963, mixed
 media, scene in a house of prostitution.
The Kienholz art--with its hallmarks of "violence
and shock in an effort to portray the 'brutality' of

the modern world" (315 Mr 23 1966 1:1; Mr 24 1966
1:1)--offended viewers who expected "Art" to be
"beautiful," in the 19th century concept of the word
(315 Ap 30 1966 1:21).

1966, April 14 Because a leader of the Student Union complained,
an adaptation of Whistler's painting popularly known
as "Whistler's Mother"--in this instance depicting
"a huge Negro woman"--was removed from an exhi-
bition of pictures at Florence State College in Ala-
bama, where it had been displayed near a portrait
of Alabama Governor Wallace. Student demands
that the painting be reinstated in the exhibit were
disregarded by school officials (410 Ap 15 1966 60:1).

1966, May Alfredo Cardinal Ottaviani told Vatican City's weekly
newspaper, L'Osservatore della Domenica, that the
Roman Catholic Index of Forbidden Books "now re-
mains not as an applicable and enforceable instru-
ment of censorship," but solely as a "historic docu-
ment." He explained that the last edition of the
centuries-old Index was published in 1948, and that
the Sacred Congregation for the Doctrine of the
Faith--that part of the Curia responsible for the
Index--is no longer "competent to judge the flood
of literature published today."
 The responsibility for evaluating literature to be
read--and not to be read--by Roman Catholics now
passes from the Curia to the Church's various na-
tional episcopal conferences, a change due to "sheer
bulk of printed material, and increasing maturity
and sophistication of Roman Catholic laymen." While
the agency that put censored books on the Index is
abolished--Communist publications are automatically
proscribed by canon law--it is replaced with the new
"Sacred Congregation of the Faith," which "will from
time to time publish lists of books not recommended
to Catholics." The Index--not renewed, will become
"a dead letter without the formal rescinding of au-
thority"--
 "has no juridical effect on Catholics, but the
 reading of such books is still sin" (410, F 9
 1966 3:7; Je 15 1966 12:6).

1966, May 1 Two "nude male and female studies" were taken by
Leeds police from an exhibition of works by Stassinos
Paraskos, Greek Cypriote artist, at the Leeds Insti-
tute Gallery in England, after a complaint that the
pictures were "indecent." Eric Taylor, principal of
Leeds College of Art, which artist Paraskos once at-
tended as a part-time student, commented on the
censorship of the allegedly obscene pictures--one a
painting entitled "Lost Love," the other a drawing:

"I would not regard them in any way as indecent
or obscene. It is a matter of appreciation of
art (316 My 2 1966 7:g).
The magistrate decided that the paintings were ob-
scene, within the meaning of the 1959 Obscene Pub-
lications Act, that is they "tended to deprave and
corrupt," and that their obscenity was not artistic
enough to be "for the public good" (505:924).

1966, June Soviet painter Oskar Rabin was attacked in the Rus-
sian press for displaying his paintings in London in
1965. His work was labeled "neurotic" and "para-
noid" and Sovietskaya Kultura, the Culture Ministry's
chief organ, described Rabin as "a miserable wretch
who had gone astray in his ideas and in his art,"
criticism that was another point of controversy in
"the continuing debate over proper and improper art
forms in the Soviet Union" (315 Ja 23 1967 1:6).

1966, June 23 The Ontario, Canada, Court of Appeals in a 4 to 1
decision (Regina v Cameron) found Dorothy Cameron,
manager of the Cameron Gallery--840 Yonge Street,
Ontario--guilty on each of the seven counts on which
she was charged with exposing obscene pictures to
public view, and fined her $50 on each count for ex-
hibition of drawings of "reputable artists" in her
commercial art gallery.
 The exhibition, "Eros '65," assembling 60 draw-
ings representing the work of 22 artists, had opened
May 21, 1965, for "Adults Only" viewers. Accord-
ing to defense evidence, the artists exhibited were
"professional craftsmen," and the accused's Gallery
"one of the best commercial galleries in the area."
An art expert testified that the exhibited works were
pictures with "a strong sexual connotation," and one
of the police officers who seized the seven pictures
from the Gallery described the drawings:
 "four of them... portrayed two or more nude
 female figures, and of these, three portrayed
 acts of Lesbianism, one portrayed a single nude
 female 'in an attitude of sexual invitation,' and
 two purported to show a male and a female fig-
 ure engaged in sexual acts or positions" (486:273).
Of the seven seized pictures, five were by Robert
Markle--best-known artist in the exhibit--whose work
has been acquired by the National Gallery of Canada,
the Toronto Art Gallery, and the Montreal Museum
of Fine Arts:
 1. "Lovers I," tempera. Robert Markle
 2. "Lovers I--The Kiss," charcoal. Markle
 3. "Lovers VI--The Kiss," tempera. Markle
 4. "Paramour," tempera. Markle
 5. "Lovers VII--The Kiss," tempera. Markle

6. "Lovers, " chalk drawing. Lawrence Chaplin
7. "Lovers, " red pencil. Fred Ross.
In the single dissenting opinion, Judge J. A. Laskin
held that:
"The human figure, singly or multiplied, expres-
sing love in any of its known forms, is a permis-
sible theme for a novel and for a picture" (486:
307).

1966, July Tia Vicenta, Buenos Aires humorous weekly, was
silenced by Enrique Green, brother-in-law of the
new President of Argentina, Lt. Gen. Juan Carlos
Ongania, who replaced President Arturo Illia when
the military took over the government.
Among more than two dozen publications banned
in one of the most sweeping reform movements in
Argentina's history, Tia Vicenta "was put on the
black list after the appearance of a cartoon depicting
the heavily-mustached Ongania as a walrus. " Ac-
cording to a government spokesman, this reflected
"disrespect toward authority and high government
office" (315 Jy 30 1966 1:9).

1966, August Robert Motherwell's abstract mural "New England
7 Elegy, " commemorating the assassination of Presi-
dent Kennedy "shocked and outraged" Bostonians
when they viewed the painting in the new John F.
Kennedy Federal Building. Public critics assailed
the 180-square-foot, $25, 000 mural, dominated by
black and white tones, labeling it "hideous" and "a
horror. " Motherwell defended his work as "not a
picture of the death scene, " but "an elegy which is
an expression of grief for someone dead, like a
requiem mass. "
Thomas N. Maytham, assistant curator of paint-
ings at Boston Museum of Fine Arts, professionally
appraised the painting:
"It emphasizes as powerfully as possible the
brutality of the moment" (315 Ag 13 1966 1:1;
410 Ag 13 1966 22:4).

1966, August Window shoppers' morals and taste were protected
10 from offense by London police when they seized
200 reproductions of some 40 drawings by Aubrey
Beardsley, from a shop window display, as "ob-
scene. " A few blocks away in the Victoria and
Albert Museum, the originals of the pictures--illus-
trations for an edition of Lysistrata--have been on
exhibit (315 Ag 16 1966 1:4; 410 Ag 11 1966 25:5).

1966, August Greek, Roman, and Chinese art works from Peking
26 Central Art Academy were destroyed by Communist
Chinese students and instructors at the Academy "in

an anti-bourgeois revolution" (410, Ag 27 1966 1:8).

1966, Septem-
ber
Statues of British kings and queens--sprinkled liber-
ally through Bombay, and other Indian cities, during
the long British rule--"are being hauled off gradually
to a secluded spot at Victoria Gardens at Bombay's
Zoo." Since India won its independence in 1947, the
statues have been defaced--if not demolished--"peri-
odically," and where a nose or an ear is missing, a
plaster replacement is "usually installed" on the fig-
ure. Since the outbreak of anti-British activity be-
ginning last September, "when many Indians accused
England of showing pro-Pakistani sentiment" in the
India-Pakistan war, severely disfigured statues are
hauled to the Gardens with greater frequency (315 S
15 1966 1:21).

1966, Septem-
ber 20
On a warrant under the Obscene Publications Act,
Scotland Yard took possession of 21 paintings and
drawings by American artist Jim Dine, pioneer of
the Pop Art movement, which were on exhibit at the
Robert Fraser Gallery in London, and also seized
the catalogues of the show. The confiscated works--
"the greater part of the show"--had been on exhibit
for a week, and were scheduled to be shown another
three weeks. The pictures, "mostly collages... in-
cluded anatomical drawings in the compositions."
Several collages represented collaborations between
Dine and British sculptor Eduardo Paolozzi, and a
number had been sold for prices ranging from 100
to 300 guineas, including one bought for the Leices-
tershire Education Committee.

As displayed in the gallery, and visible in part
from the street, "twelve compositions on one wall
depicted the male genital organ and three on the op-
posite wall showed the female genital organ." Dine
denied his "phallic and vaginal forms" were porno-
graphic, and said that "they reflect his feelings about
London." Gallery director Fraser said he was
"amazed at the police action":

"I consider these drawings to be about as porno-
graphic as Cezanne. They contain scatological
content but they are not erotic nor are they in-
tended to be so."

Action came to trial in Marlborough Court on Novem-
ber 28, in which Fraser was charged under the Va-
grancy Act of 1838, an amendment of the Vagrancy
Act of 1824, which "defines as rogues and vagrants,
fortune tellers and tramps, any person exposing his
person, or exposing in any public place any obscene
print or picture or any obscene object." The Va-
grancy Acts "do not allow the calling of expert evi-
dence about artistic merit" of seized art, and they

"deal with what is 'indecent,' a word that has at-
tracted less legal hairsplitting than the word 'ob-
scene'" (505:924).

John Aubrey Fletcher, Magistrate, "having viewed
the pictures and listened to the legal arguments"--
John Mathews, speaking for the Director of Public
Prosecutions, said that "although not obscene within
the definition of the Obscene Publications Act of
1959...the exhibition was crudely offensive and dis-
gusting"--decided that the Dine exhibition "had con-
travened Section 2 of the Vagrancy Act of 1838," al-
though the paintings were "individually not indecent,"
the display was "indecent by reason of arrangement."
Fraser was fined £20, and 50 guineas costs, for "will-
fully exposing or causing to be exposed to public view
an indecent exhibition," and the confiscated pictures
were "to remain in possession of the police for a
fortnight pending consideration of an appeal (7, 1967:
81; 23:62; 316 S 21 1966 9:b; 0 18 1966 10:c; N 29
1966 4:f; 410, S 21 1966 44:1; N 29 1966 38:1; 576:x).

1966, October
6

"Erotic Art '66," opened at the Sidney Janis Gallery
in New York City--after some weeks of preliminary
publicity "trying to establish it as a "cause célèbre
in anticipation of censorship"--a "chip on the shoul-
der" of "a segment of truculent painters and writ-
ers" that "the police were dared to knock off" (85:
34-35). The thirty works by 19 artists--dubbed
"Cop Art" ("a triple-entendre for copulation, pop
and op, and the minions of the law" (183:102))--had
been given advance build-up: nothing to be "fig-
leafed over," all works "in modern undress." Sid-
ney Janis explained the difference between porno-
graphy and eroticism:

"Pornography is done to arouse the carnal spirit,
while eroticism may be titillating, it has esthetic
interest first and foremost" (183:102).

At least one critic--John Canaday--considered "Ero-
tic Art '66" "a freak show that fails to deliver...as
it is neither erotic nor art," and that the exclusion
of viewers under eighteen eliminated "virtually the
entire audience that might find some stimulation" in
the show. He commented that the artists and "usu-
ally astute dealer" Janis, who staged the show, had
"failed to recognize a primary truth about eroti-
cism, which is that pictorial description of geni-
talia, the representation of intercourse, either
normal or perverse, and all the rest of the
physical and visual paraphernalia of sex, are
not erotic per se."

According to Canaday, such picturizations have as
much to do with the erotic impulse as "a photograph
of an airplane has to do with the principles of

flight" (85:34-35).

1966, Decem- Tass, official Soviet news agency, reported that
ber 29 Marc Chagall works were on display in a temporary
 exhibit in Moscow's main art showroom, Tretyakov
 Gallery, but for some "unexplained reason" the
 paintings were removed from the exhibit in a mat-
 ter of hours. Tass deleted Chagall's name from a
 revised news release, and a gallery official denied
 any plan to exhibit his works. No public exhibition
 of Russian-born Chagall's paintings has been held
 in Russia for decades, as his style--part of the
 avant garde of the early twentieth century--falling
 outside the narrative and didactic Socialist Realism
 prescribed in the USSR, has made him "the target
 of bitter official condemnation" (315 D 30 1966; S
 21 1967 1:17; 410, D 30 1966 7:2, 3).

1967 After a military coup, the Greek government re-
 quired artists to submit their work to censors before
 it could be published or exhibited. Not all writers
 and artists complied with this censorship require-
 ment. Among artists receiving a Ford Foundation
 grant--for 1970--was painter Demosthenes Kokkin-
 ides, one of more than a dozen artists and writers
 whose public criticism of the censorship policy of
 the military backed Greek regime had caused the
 publishing or showing of their works to be banned
 in Greece (315, Ja 3 1970 1:11).

1967, January In London the Home Secretary was asked by Ben
20 Whitaker if he would seek to amend the English law
 "to ensure that expert witnesses might be called in
 cases in which the owners of picture galleries were
 prosecuted for exhibiting pictures":
 "While there is a statutory right for the opinion
 of experts to be admitted in any proceedings
 under the Obscene Publications Acts, in order
 to assist the court in deciding whether the pub-
 lication was justified as being for the public good,
 there is no similar right in proceedings under
 the Vagrancy Acts, where the essence of the of-
 fense is wilful exposure of obscene pictures or
 indecent exhibitions to the public view" (316 Ja
 20 1967 14:c).

1967, January A Moscow art exhibition at a labor union hall called
27 Club Friendship by young Russian artists, scheduled
 to run for three days, was closed an hour after the
 gallery opened. The paintings exhibited went beyond
 the official bounds of art--Socialist Realism, "photo-
 graphic" art which carries a political or social mes-
 sage that must be "intelligible" to the masses--

because they ranged from "pure abstract to surreal-
ism--some works carrying strong religious motifs,
others weird distortions of human and animal fig-
ures, and still others were dark and even pessimis-
tic in tone" (315, Ja 23 1967 1:6).

1967, January Illustrations by Victorian artist Aubrey Beardsley
30 were declared "indecent" by an Edinburgh magistrate,
 Mrs. Margaret Ross, whose decision was not influ-
 enced by the catalogue from the Victoria and Albert
 Museum in London--presented in court by defense
 counsel K. J. Cameron--showing that the prints had
 been on public display in the Museum, and by the
 fact that the catalogue, illustrating at least one of
 the prints in question, was sold at the Stationery
 Office (the British Government Printer) in London,
 elsewhere in England and in Edinburgh.
 Jepson's Stores, Ltd., the defendant, pleaded
 "Not Guilty" to the charge of "selling and keeping
 for sale indecent prints in a shop"--the Bodkin, at
 North Bridge, Edinburgh--on August 30 and 31, 1966.
 In rendering judgment that fined Jepson's £20 and
 confiscated the prints, Mrs. Ross commented:
 "I have no doubt at all. I find the charge proved."
 Relief from this judgment failed--May 5, 1967--when
 the appeal was "rejected by the Judiciary Appeal
 Court in Edinburgh" (316, Ja 31 1967 9:b; F 2 1967
 11:e; My 6 1967 3:h).
 Defense evidence that the prints were "artistic"
 was disregarded as the charge was brought, not
 under the Obscene Publications Act claiming that
 the pictures were "obscene," but under a 1961
 Edinburgh Corporation bylaw prohibiting the display
 of "indecent or obscene books or pictures for sale"
 (505:924).

1967, March Spain's Chief of Audio Visual and Plastic Arts sec-
(A) tion of the Government's Ministry of Information and
 Tourism--angered by the portrait "Catholic Kings:
 Isabella and Fernando" by Norman Narotzky, Ameri-
 can painter living in Spain, showing Isabella "by the
 crucified Christ wearing a sanbenito and burning at
 the stake in an auto da fe" (which, according to the
 artist, expressed protest against all persecution in-
 cluding the Inquisition)--wrote in Nuestro Tempo that
 while Narotzky's canvases had been exhibited without
 banning, "clearly this will not happen again, because
 necessary measures have already been taken to pre-
 vent any attacks against our... history from slipping
 into any exhibition" (410, Je 11 1967 II, 25:3).

1967, March "Too blushing" for public viewing, the Chicago Art
(B) Institute told 27-year old artist Leanne Shreves,

when they returned, without having exhibited it, her
6x6' painting "Events," after awarding the picture
first prize--a medal and $1,500 money--in the 70th
Annual "Chicago and Vicinity Show." "Events" is
divided into 108 squares "which depict, unusual, in-
teresting--or what the Art Institute called shocking--
sexual activities among humankind."
 Charles C. Cunningham, Institute director, said
he felt the painting a bit "far out," and A. James
Speyer, curator of 20th-century art at the museum,
reportedly told the artist that he thought her paint-
ing a "happy and humorous thing," but that the Insti-
tute did not consider it appropriate for public medi-
tation. "In the interest of old-fashioned decency, the
prize-winner was barred from display" (315, Mr 12
1967 Calendar:9).

1967, March The memorial figure of leper missionary Father
30 Joseph Damien, who devoted his life to caring for
 lepers isolated in a government hospital on Molokai
 Island in Hawaii, completed by American artist Mari-
 sol (Marisol Escobar) stirred up such controversy
 that the Hawaiian State House rejected the work in
 favor of a more conventional representation of Father
 Damien by Nathan Cabot Hale (410, Mr 31 1967 29:1).

1967, April The Chicago Public Library banned a work of art
 from an invited exhibition of printmaker Letterio
 Calapai, when Librarian Gertrude Gscheidle demanded
 that the print, "Ozymandias"--representing a nude
 man and woman--be removed from the show. Cala-
 pais took down his entire exhibit in protest. Librar-
 ian Gscheidle commented that the print was "just not
 in keeping with the objectives of our Art Department
 display," and, although she would not categorize the
 picture as "lewd" or "obscene":
 "we have children, from small youngsters all
 the way up, and all kinds of people coming through
 the Library."
 Artist Calapai considered the offending print--a prize-
 winner--one of his most important works, and said
 that "to remove one print from a carefully planned
 exhibition of a body of my works is like tearing the
 page from a serious book" (105).

1967, April 10 Showing David Mayr's picture "St. George--Ten
 Minutes After Slaying the Dragon"--depicting a fully
 clothed male figure and a female nude--caused Doug-
 las Gallery in Vancouver, to be charged (under Sec-
 tion 150, Paragraph B of the Canadian Criminal
 Code) with exhibiting a painting that "was obscene
 or that a sexual theme was unduly exploited." Five
 witnesses for the defense were heard when the case

came to trial on May 30: Richard Simmins, art
consultant and critic; John Macdonald, Professor of
Romance Languages at the University of British Co-
lumbia; David Watmough, theology graduate student
from King's College; Jack Shadbolt, nationally-known
Canadian art teacher; Colleen Topping, freelance
writer and docent at the Vancouver Art Gallery.
 Magistrate Bernard Isman's judgment on July 7--
finding the painting in question "a serious work of
art by a serious artist, " that the Crown had failed
to establish "criminal intent, " and that the exhibition
would probably not have been questioned if held at
the Vancouver Art Gallery, rather than in a private
gallery--"Charge Dismissed" (543).

1967, April 26 Vatican sources announced that their Congregation
for the Doctrine of the Faith will soon publish a
quarterly magazine, Nuntius (Herald), "to help bish-
ops decide which books Roman Catholics in their
countries shouldn't read. " Nuntius will be "a guide
to replace the Index of forbidden books abolished in
February, 1965" (417 16:43 Jy 1967).

1967, May (A) The art works for exhibit in Barcelona's Salon de
Mayo were selected by Spain's National Ministry of
Information and Tourism in Madrid, and some works
submitted for showing were rejected with the notice:
 "The work is too social and political for accep-
 tance: (410, Je 11 1967 II, 25:3).

1967, May (B) "Too realistic, " vice squad detectives commented,
as they took down the painting of a nude woman in
the San Francisco Lounge, a Des Moines night club.
 William Morrissey, proprieter of the night club
had paid $750 for two murals and two nudes decorat-
ing his bar, and the artist, Carole Hedges, was the
wife of Reverend Robert Hedges, rector of St. Timo-
thy's Episcopal Church (417 16:46 Jy 1967).

1967, May 12 The Salk Institute for Biological Studies in La Jolla,
California, reopened its controversial art show,
closed after artists had withdrawn their works from
exhibition on May 1, when the Institute's president
Dr. Augustus Kinzel removed three works from the
show because he said that two works desecrated the
American flag, and one, a nude, he considered "of-
fensive. " The criticized works were hung in a sepa-
rate room, guarded by a Pinkerton detective, with
admission on an "Adults Only" basis--viewers restric-
ted to those over 18 years of age (417 16:46 Jy 1967).

1967, June The Danish Parliament "by overwhelming vote,
abolished all legal barriers against printed obscenity,

resulting in a startling decline in the circulation of pornography--more than 50%, according to some reports (61:xvii).

1967, September One of two nude gladiator figures, sculpted by Lamont Montyne, was charged with indecent exposure by an unidentified minister in Portland, Oregon. The 11-foot nude statue, with its companion figure a Sweepstakes Award winner in the 1963 Rose Festival parade, is located in front of the home of the sculptor, "who said he has no intention of clothing the gladiator" (315, S 14 1967 1A:7).

1967, October President Lyndon Johnson signed Public Law 90-100
3 (H. R. 10347) creating the Commission on Obscenity and Pornography, an eighteen-member Commission charged with four major responsibilities:
1. Analysis of current legislation regarding obscenity;
2. Assessment of the distribution and traffic in pornographic materials;
3. Study of the effect of obscenity and pornography on the public, especially minors, and the relationship between obscenity and crime;
4. Recommendation of action to regulate the traffic in pornographic materials

1967, October The petition for review of his conviction--with a fine
23 of $100--"for offering obscene images for sale" was denied Marcel Fort, French-born sculptor living in Miami, Florida, by the United States Supreme Court.
The sculptor had "displayed for sale in his yard, 50 to 75 feet from a busy highway," six life-sized statues of male and female nudes "entwined in erotic poses," and it was this public display that apparently disregarded the Court's warning in the Redrup case (Redrup v New York), an obscenity decision handed down earlier this year, when the Court found:
"Obtrusive publication of lewd material amounts to 'an assault upon individual privacy'" (410, 0 24 1967 36:1).

1968 (A) Much of the Venice Biennale was "forced to close down under the relentless blows of students, French as well as Italian, who had converged on Venice to overthrow what they regarded as the bourgeois capitalistic international art establishment." The Milan Triennale art exhibit and the Cannes Film Festival had already been shut down by students (170:177).

1968 (B) "Slippery pavement, not naked women" caused the traffic accidents, sculptor S. Moelgaard protested

in Copenhagen, when police ordered him to remove
his concrete statues of nudes from a high-accident
stretch of road (99 2:43 F/Mr 1969).

1968 (C) As part of the "New Left social rebellion against
bourgeois 'consumer' society," rebellious art and
architecture students in Paris seized the traditionally
academic Ecole des Beaux-Arts, labeling the building
"Ex-Beaux-Arts," and "hung the red flag and the
anarchist black flag in the courtyard." The rebels
under "student power" demanded a revision of the
school's regulations including:
> "elimination of entrance competitions and of that
> competition for the Grand Prix de Rome which
> had originally caused the alienation of David... in
> the eighteenth century" (170:377).

De Gaulle's regime "forcibly liberated the Ecole des
Beaux-Arts," but due to continuing student pressure
at the school, André Malraux, De Gaulle's Minister
of Culture, announced late in 1968 that the Ecole des
Beaux-Arts "would be decentralized," "bringing to an
end... official, centralized, academic education in
the arts established under Louis XIV, destroyed by
the Jacobin David, but revived later in the Revolu-
tion, and further centralized under Napoleon and
later governments essentially in the form in which
it continued until 1968" (170:378).

1968 (D) Michel Ragon, "resigned his post as Commissioner
of the French Pavillion at the Venice Biennale in
protest against the exclusion from the exhibit of
foreign artists residing in France" (91).

1968, January Sacramento Public Library, after "a few protests"
from viewers, removed some nude pictures by artist
Clifford Colver of Carmichael, California, from a
Library Art exhibit (417 17:21 Mr 1968).

1968, March An exhibition of 1,000 statuettes, vases, panels, and
scrolls "dedicated to the greater glory of the Chin-
ese People's Republic, opened in Hong Kong." With
"delicate figures titled 'Take Firm Hold of the Revo-
lution, Promote Production,'" the polemic sculpture,
following Chairman Mao's hard line--"In the world
today, all art is geared to definite political lines.
There is, in fact, no such thing as art for art's
sake"--included such "topical" carvings as "Guerilla"
(10:54).

1968, April Nicolae Ceausescu, General Secretary of the Com-
munist Party and President of the State Council in
Rumania, reiterated in a speech the "orthodox doc-
trine" that the principal function of art in Rumania

"is to spur the Communist cause" (410, My 9 1968 16:1).

1968, May (A) After weeks of preliminary publicity--"a Japanese poster of a couple frolicking in sexual intercourse... visible over much of Southern Sweden"--the 800-work display entitled "First International Exhibition of Erotic Art" opened at the Kronsthall in Lund, Sweden. "The nucleus of the show was drawn from the collection of Paris-based United States sexologists Phyllis and Eberhard Kronhausen," and expressed their announced explicit concern with mental health. "At the preview, a large coffinlike object, covered with black fur and with a slit across the lid, was rolled onto the museum floor. Out from the clearly vaginal opening of its pink, uterine interior stepped Phyllis Kronhausen, 39, dressed in a see-through minidress and nothing else," her appearance accompanied by a "stark-naked violinist."

Among the art objects on display were: "erotic Indian sculpture, a Guinea fertility goddess, a Rembrandt etching of the artist and his wife disporting in a four-poster bed, a Picasso engraving of a couple copulating, and a vast variety of dildos and phalli" (184:74).

The husband-and-wife Kronhausens--whose vocation (they use erotic art in their psychotherapy, and have cut a "how-to" sex record), as well as avocation (as judged by their 3,000-piece collection of erotic art) is sexual--plan to move the exhibit to Denmark, Germany, and the United States, where they hope to give it a permanent home in New York City.

The Kronhausens announced:

"This show is a protest against the whole rotten hypocritical bourgeois society and part of a cultural revolution that is under way" (185).

1968, May (B) People coming to the Police Headquarters in New Orleans are not "attuned to art," Police Chief Joseph L. Giarrusso announced, as he ordered the nude male statue standing in the lobby of the new Police Administration Building covered. The Chief said further that although he had no "artistic objections" to the sculpture, he felt that it belonged "in a museum rather than in a public building."

The figure, carrying an inscription denoting that "it symbolizes the defense and protective hands of the police" would remain in the lobby Architect Harry B. Smith announced, but to satisfy the Police Superintendent, he might ask the artist, Eldon Danhausen, to make certain "alterations" in the sculpture (99 1, No. 2:45).

1968, May 1 Mrs. N. W. Graham, sister of late artist Grant
 Wood, who posed for Wood's well-known painting
 "American Gothic" along with the family dentist,
 sued Johnny Carson, NBC, Playboy and Look maga-
 zines for $9,000,000, charging that caricatures of
 the painting published in the periodicals and shown
 on television place her in a "vile and obscene"
 light (410, My 2 1968 94:8).

1966, May 18 A group of seven taxpayers--Art Center members--
 in Des Moines, Iowa, filed suit "to declare null and
 void" the May 6 resolution of the Des Moines City
 Council, which in a 4 to 2 vote, stated that five
 pictures in the 20th Annual Iowa Artists Exhibition
 at the Des Moines Art Center were "obscene," and
 should be removed from the exhibit.
 The Art Center had agreed--by public statement
 of May 7--to put the five controversial pictures
 (paintings by Michael K. Meyers, "Prelude to F. F.'s
 Holiday"; Mark Peterson, "Discontented Nude"; and
 prints and drawings by Thomas Esser, "Evening";
 Leonard Lasansky, "Bridal Bouquet"--depicting a
 man and woman being married by a priest, with the
 woman beginning to give birth; James Nadel, "The
 Rape of the Mink") in a separate room, and to admit
 only adults to their viewing. The Center Trustees,
 in the statement, pointed out that while they recog-
 nized the City Council's concern
 "with respect to what may be viewed by children,
 particularly in light of recent rulings of the United
 States Supreme Court, establishing a distinction
 between what literature may be sold to children
 and adults,"
 they felt
 "a valid artist... deserves to be seen and heard
 and professionally judged by mature audiences
 without interference" (Des Moines Art Center.
 Letter, 0 13 1970).
 The suit of the Art Center members charged the Des
 Moines City Council with "restraint of freedom of
 speech," and with "unlawful censorship, suppression,
 and coercion." Critical councilmen had called the
 paintings "filthy, vile, and vicious," and one Coun-
 cil member said that if the pictures "were hung in
 a saloon, they would probably curdle the beer" (99
 1, No. 2:44).
 At hearing, the case was dismissed by the Judge,
 who ruled the Art Center members as plaintiffs were
 not "responsible people," that is, that the Board of
 Trustees of the Des Moines Art Center were plaintiffs
 who could have spoken legally against restriction of
 the art display (Des Moines Art Center. Letter, 0
 13 1970).

1968, May 27 California State College Chancellor Glenn S. Dumke
ordered "indefinite postponement" of a controversial
art exhibit at Long Beach State College--nude wax
and plaster figures by graduate student William
Spater "engaging in various sexual acts" (417 17:49
Jy 1968). College President Carl W. McIntosh had
announced on May 7 at a press conference that the
exhibition of life-size nudes--a master's thesis pro-
ject--"would be open to the public, but viewers of
the figures would be limited to 'adults,' presumably
meaning persons over 18 years old. " Sculptor Spater
described his work as "ten life-size figures dealing
with contemporary society, " but some viewers had
called the statues pornographic--the nude figures
"slouched in chairs... giving vulgar gestures, " "one
woman straddled an ironing board, " and one woman
stood in a washing machine, "her right hand holding
her breast, her left hand covering her genitals" (315
Ja 13 1970 1:3). Robert Tyndall, Dean of the School
of Arts at the College, had ruled January 30 that the
school would not exhibit Spater's work to "avoid
some bizarre happening" that would create a public
uproar damaging to the school, but changed his posi-
tion on displaying the sculptures "because the Art
Department faculty voted for a limited exhibition of
the figures" (315 Ja 13 1970 1:3; My 8 1968 2:8; Je
9 1968 Calendar:42).

A month later when Chancellor Dumke tried to
develop rules for "censorship for student efforts" in
a letter to State College administrators "seeking to
develop institutional policies to govern the display of
creative and related arts":
"The right to create does not necessarily equate
with the right to display publicly;
"Attention must be paid to the sensitivites of So-
ciety, "
Dr. John Stafford, English Professor at San Fernando
Valley State College, speaking as chairman of the
statewide Academic Senate, said that such inquiry
had "caused concern among faculty members" as an
"attack on academic freedom" and "the right of col-
lege faculties to make professional decisions" (315
Je 25 1968 2:1).

1968, May 30 Thirteen Argentine artists withdrew their works from
an exhibit at the Center of Visual Arts at the Insti-
tute Torguato di Tella, Buenos Aires leading modern
art gallery, to protest the censorship of a painting
by artist Roberto Plate. Jorge Romero Brest, di-
rector of the Center, explained the banning: The
controversial painting--depicting a public toilet--was
removed from the show because "the public began to
write graffiti on the work" (410, Je 1 1968 9:7).

1968, June A sculpture by Duane Hanson depicting the death of
 a teen-ager in a motorcycle accident was removed
 from a Miami, Florida, art show "so that children
 wouldn't see the sculpture, " although it had won
 second prize in a Sculptures of Florida Contest.
 The work, "Accident, " was banned by the director
 of the Bacardi Art Gallery, Albert Fernandez Pla,
 because of many school children attending the exhibit,
 which made display of the "violent sculpture" im-
 proper. Dr. August Freundlich, director of the
 Lowe Art Museum at the University of Miami, who
 had given the figure a prize in the Contest, took his
 teen-age son to see it (315 Je 18 1968 1:2).

1968, June 21 Nude statues in Brussels, Belgium, parks were
 found "dressed" in banners, as protest of a police
 action against painted nudes in galleries of the city
 (410, Je 22 1968 24:3), part of the increased se-
 verity of Belgian censorship against nudity in art,
 reportedly the result of Roman Catholic church pres-
 sure (410, Je 25 1968 6:1; Je 30 1968 IV, 6:1).

1968, July (A) Transit systems of four major cities in the United
 States--Los Angeles, San Francisco, Chicago, and
 Atlanta--canceled contracts with Bantam Books for
 advertising on city buses, when they refused to dis-
 play a full-color poster painting by New York City
 illustrator Bill Edwards for the novel Five Smooth
 Stones by Ann Fairbairn, showing a love scene be-
 tween a black man and a white girl.
 The picture--used on the cover of the book and
 accepted for display advertising in New York, Boston,
 Cleveland, Minneapolis, St. Paul, and Washington,
 D. C. --was not approved in Los Angeles "because of
 racial overtones. " San Francisco would display the
 painting if eight inches were cut off one end of the
 poster, and in Atlanta both the advertising company
 and the transit company felt that the copy was "too
 suggestive. "
 The City of Atlanta Community Relations Com-
 mission, upon Mayor Allen's order of its investiga-
 tion of the incident, reported that the cancellation
 related more to the advertising company policy "con-
 cerning censorship of sexual promiscuity than it did
 to racial overtones" (202:41).

1968, July (B) Art work, as well as plays and magazines, recently
 has been the target "in an active censorship drive
 in Belgium. A poster showing a naked, kneeling
 woman, which was advertising an art gallery exhibit,
 had black adhesive stuck over the breasts" by au-
 thorities, who say that their action complies with
 laws forbidding the exhibition of paintings "of an

indecent nature described as capable of exciting the
imagination of those less than 18 years old. "
　　The censorship drive indicated no change in offi-
cial policy, authorities say, but "police are being
asked to enforce existing laws. "　"Gallery owners
have formed a committee to study ways of dealing
with the police" (99 1, No 3:58).

1968, July 4　　Jean Cassou, art historian and critic, lead a com-
mittee of French artists and critics in condemning
the French Government's expulsion from France of
foreign artists who opposed the Government position
during the May-June strife in France (410, Jy 5
1968 22:4).

1968, July 5　　The Pan American Union in Washington, D. C. , can-
celled an exhibit of collages by Puerto Rican artist
Raphel Villamil, "after a Union official called the
art works pornographic and demanded that the show
be dismantled. "　The showing had been approved by
Cultural Affairs Director of the Union Dr. Rafael
Squerru, who insisted, after the criticism, that the
art works "were in good taste. "　Villamil commen-
ted:
　　"These battles were fought a long time ago, and
　　this seems ridiculous in the light of what is being
　　put in books and movies these days.　From ten
　　feet away, you can't even see the nudes.　They
　　are just a small part of the whole painting" (99 1,
　　No. 3:58).

1968, Septem-　Chiang Ching, wife of Chinese Communist leader Mao
ber 1　　　　Tse-tung, continues as "the arbiter of cultural taste"
in China.　Demonstrating the totalitarian politiciza-
tion of art, she praises works of art called by Hong
Kong newspaper art critics "hideous"--as the paint-
ing "Chairman Mao Goes to Anyuan, " showing a
youthful Mao bearing an umbrella on his walk to
organize the Anyuan coal miners--and refers to in-
ternationally famous Chinese painters--including Pan
Tien-shou--as "bad people, " because they are "re-
actionary" (410, S 22 1968 12:1).

1968, October　The Corcoran Gallery of Art in Washington, D. C.
23　　　　　　deleted the preface by art historian Jan Mladek from
the republished catalogue of their exhibition "Recent
Graphics from Prague. "　Critics charge that this
Gallery censorship was occasioned by the objection
of Czech officials to such words as "brainwashing"
in the text of the preface (99 2:43 F/Mr 1969).

1968, Decem-　Obscenity law of the State of Florida cannot be prin-
ber　　　　　ted, according to report, because of state restrictions

on obscenity of printed matter (Library Journal 93: 4464 D 1 1968). This restriction bears out George Bernard Shaw's assessment of censorship:
"It is impossible to explain obscenity without being obscene, 'since obscenity is its own prima facie case'" (410, S 8 1968 VI, p. 36).
A similar restraint is seen in several early court cases in the United States, which specifically excluded the visual art representations in question as obscene, from the official report of the case because of the necessity of maintaining "purity of the record."

1969 (A) The United States Supreme Court held--in the Stanley case--"that mere private possession of obscene material is protected by the United States Constitution" (455A).

1969 (B) Mediocrity alone in art is recognized by the Greek government of Colonel Papadopoulos, according to art historian Alexander Xydis, "because it alone is harmless, poses no problems, lacks impetus, looks backward..." During the three years (1967-1969) when art in Greece has been "suffocatingly controlled by ill-digested moral and aesthetic dogmas, or... by calculations of expediency," there has been a "slowing down or complete stoppage of exhibitions; the movement of artists and their works obstructed, both in Greece and on their way to other countries; prohibition of works, sometimes even names of certain artists..." (636:27-30).

1969, January The Chicago Art Institute exhibited "347 Gravures," latest outpouring of prints by 87-year old Pablo Picasso, and although 25 prints had been withheld from display as "unfit for public exhibition," the nudes and erotic subjects in the collection resulted in telephone calls to the Art Institute demanding the exhibit be removed (184A).

1969, January A New York State Civil Service Employees Associa-
23 tion-sponsored art exhibit in Albany state capitol came to special public attention when Mrs. Gabrielle Daly, a New York State Senate secretary, complained that one of the works shown was obscene. The offending work--a collage "Society" by the wife of a data processing supervisor in the Transportation Department--showed a brothel scene with the calligraphic legend, "My body can make me rich," "its focal point a soiled used foam-rubber 'falsie' glued to the canvas and pierced... by a brown wooden plug." The President of the local Employees Association refused to remove the picture, explaining,

"We try to take a liberal point of view" (99 2:59
Ag/S 1969).

1969, January
30

Harlem On My Mind, the paperbound catalog pub-
lished by Random House for the Metropolitan Mu-
seum art exhibit depicting Harlem life through the
years in photographs and phonograph records was
withdrawn "for revision" after it was denounced as
anti-Semitic because of a phrase in the introduction
written by a 16-year old Negro high school girl:
"Our contempt for the Jews makes us feel more
completely American in sharing a national preju-
dice" (99 2:37-38 Je/Jy 1969; 251A).

1969, Febru-
ary 7

Art, as well as films, for use in a student organiza-
tion sponsored conference on pornography and ob-
scenity at the University of Notre Dame in Indiana
was banned as "hard-core" pornography by the
school president, T. M. Hesburgh (410, F 8 1969
63:1).

1969, March
(A)

Los Angeles vice squad officers seized about 20
works--drawings, paintings, figurines--from an
"adults-only" art exhibit, "Erotic Art '69, " at
David Stuart's Gallery--807 North La Cienega
Boulevard--and charged Stuart with 16 misdemeanor
counts of displaying obscene art, including works
by such noted artists as George Grosz and Kenneth
Price.

After two trials, extending over 19 months, with
expert witnesses testifying at the second trial (Mu-
seum Curators Maurice Tuchman of the Los Angeles
County Museum of Art, Thomas Carver, and Jane
Livingston, and art critics John Coplans and Max
Kozloff), Stuart was acquitted of all charges (315 O
9 1970 1:2; O 25 1970 Calendar:60).

1969, March
(B)

Nationally known sculptor Clement Renzi of California
completed a memorial--"a semi-abstract work of
three unidentifiable nude men seated at a table with
an open book"--to honor three Fresno, California,
religious leaders of different faiths: Msgr. James
G. Dowling, Rabbi David L. Greenberg, and Dean
James M. Malloch, an Episcopalian. The commemo-
rative group was erected in Courthouse Park to
memorialize the religious leaders' promotion of
good will and better understanding among people of
all faiths, but the Fresno chapter of Americans
United--a group of from 300 to 400 members--op-
posed the site selected for the sculpture. They con-
tended that the County in approving a public site for
the memorial "is violating federal and state consti-
tutions, giving the stamp of approval to three speci-

fic religions, using public property improperly, and
setting a precedent for a 'graveyard of tombstones'
to other religious leaders in the Park." (315 Mr 2
1969 C:1).

1969, March While the "Impressionist and Post-Impressionist
18 periods have provided a story of heroic struggle
 against the tyrants and bullies of salons and official
 juries" in France, proscribed areas of art "left by
 the unofficial, but effective, censorship of partisans
 and historians" bans nineteenth century French aca-
 demic artists painting in the traditional manner,
 such as Adolphe William Bouguereau, Ernest Meis-
 sonier, and Edouard Detaille. In England, compa-
 rable censorship--in a "link between puritanism and
 adherence to strict criteria of form and colour apart
 from subject and association"--is demonstrated in
 Roger Fry's "excommunication" of British pompier
 Lawrence Alma-Tadema, painter of Graeco-Roman
 genre subjects (210).

1969, April 18 "Love, Not War," a student art exhibit was closed
 by the Dean of Students at Stanford University, Cali-
 fornia, following complaints from some college offi-
 cials and alumni. The pictures "showed nude men
 and women embracing a bizarre assortment of me-
 chanical devices, including vacuum cleaners, electric
 fans, and lamps." J. Michael Barnes, the artist,
 called the banning of his exhibit, "Censorship, some-
 thing the students and faculty should not allow to con-
 tinue" (99 1, No. 2:44).

1969, May 20 The Corcoran Gallery of Art, Washington, D.C.,
 gave warning to museum visitors viewing its current
 exhibition of "comic strip original drawings on drugs,
 violence, revolution, race and sex," from such un-
 derground papers as East Village Other, Haight-
 Ashbury Tribune, Realist, Zap Comics, to "proceed
 at their own risk" through the exhibit.
 Walter Hopps, Director of Special Services for
 the gallery, pointed out that the catalog described
 the show as "really heavy stuff," and that the gallery
 "rather than censor the artists... decided to warn the
 visitors. If their sense of decorum is offended by
 four-letter words or outrageous drawings, they ought
 to proceed at their own risk." "Refusing admission
 to children," according to Hopps, "serves no purpose,
 since youngsters throughout the country are already
 selling, buying, and helping to produce the publica-
 tions in which the comic strips appear" (99 2:59 Ag/
 S 1969). Zap Comics had tangled with the law in the
 San Francisco Bay area, on a charge of obscenity,
 and the museum curator testifying "in the liberation

of such pictures" commented:
> "It makes me laugh, and that's of redeeming
> social importance" (226:26).

1969, May 22 Upon complaints that an art show was obscene, San
Francisco police arrested Robert Albreaux for "ex-
hibiting obscene matter" in the Albreaux Gallery at
the Cannery, seizing more than a dozen paintings
and ceramic sculptures, which Police Inspector Peter
Maloney said "grotesquely pictured the sexual act."
Thomas Albright, covering the show's opening for
the San Francisco Chronicle, reported the works
"clearly an erotic joke," and described Gerald
Gooch's drawings in the exhibit as "deadpan realistic
drawings of Negro children playing sex games...
masterful illustrations of how unerotic erotica can
be." Michael Stephanian, defense attorney, discussed
Albreaux's release on $625 bail:
> "The public has to be taught to delineate between
> hard-core pornography and the legitimate develop-
> ment of art. Obscenity is only relative" (99 2:54
> 0/N 1969).

1969, June 5 "Puritanism" is charged in various Australian cen-
sorship moves against art--as well as films, theater,
and records (410 Je 6 1969 33:3), and the activity of
official banning, reviewing, and revising in Australia,
make it "statistically today one of the most censored
countries in the world" (315 Ag 18 1969).

1969, June 8 The Seoul, South Korea, businessman who was ar-
rested for selling water colors and pastels under the
signature "Picasso" was held for violating a South
Korean law "banning praise of Communists and their
causes" (410, Je 9 1969 8:1).

1969, June 18 A former United States Customs inspector, M. J.
Cassotta, was indicted for making false entries on
customs documents in 1967 to let pornography enter
the country marked "cups and saucers" (410 Je 19
1969 29:1).

1969, July (A) Po Yang, editor of a Taipei newspaper, was im-
prisoned by the Chinese Nationalist Government in
its effort to silence criticism of the regime.
 Author of many novels, Po Yang attributes his
arrest and the subsequent charge that he was a Com-
munist agent in Peking twenty years ago to his pub-
lication of a cartoon showing Chiang Kai-shek and
his son, Chiang Ching-kuo--newly designated Deputy
Premier--as "a father and son marooned on a tiny
island, with the father insisting on giving a speech
though there was no one but his son to hear" (99

2:52 O/N 1969).

1969, July (B) Dean Allen Weller, University of Illinois in Urbana,
ordered "four paintings of nude males" removed
from the lounge of a University building to "a non-
public area of the building. " The Fine Arts faculty
of the University had voted to display the paintings
publicly, and Weller clarified his order:
"This is not a case of censorship, but I think
the work should be exhibited in appropriate places
and with consideration for the public which sees
them" (99 2:59 Ag/S 1969).

1969, July 1 Denmark ended all legal barriers against visual
pornographic materials, including photographs and
films. Rules against displays of pornography in
shop windows and on stalls were strengthened and
the selling of pornographic materials to those under
17 years of age was made a crime (410, Jy 2 1969
4:4).

1969, July 15 The Arts Council report urged the British Parlia-
ment to repeal all of Great Britain's laws against
pornography except those protecting children and pro-
hibiting offensive public display (410, Jy 16 1969
11:1). The Report of the government-financed Coun-
cil, developed in a conference of prominent cultural
leaders in England, gave "overwhelming support...
urging the wholesale abolition of obscenity laws in
Britain for a five-year trial period, thus removing
the legal restraints against pornography. " The
eighteen cultural leaders in the working group, who
prepared the report over a year's time, "originally
considered reform of present obscenity laws, but
then came to the unanimous view that abolition was
preferable. " The report concluded:
"It is not for the state to prohibit private citizens
from choosing what they may or may not enjoy in
literature or art, unless there were uncontrover-
tible evidence that the result would be injurious
to society. There is no such evidence" (315 Jy
16 1969 1:27).
Economics of the question were presented when a
Soho studio proprieter specializing in erotic art
pointed out that the Danish and Swedish pornographers
were "siphoning" $60 million a year from a British
market, thus contributing to England's balance-of-
payments problem (315 Jy 16 1969 1:27). Among
the organizations that refused to give evidence at
hearings of the Arts Council of Great Britain Work-
ing Party on Obscenity Laws were: Scotland Yard,
Magistrates' Association, H. M. Customs and Excise
(316 Mr 20 1969 10:e).

1969, July 16 The United States art exhibit at the 10th Sao Paulo
Biennial in Brazil--largest of the international art
shows--was withdrawn after 9 of 23 artists refused
to participate in protest to the "repressive tactics"
of the Brazilian military regime. "Like the Venice
Biennal, with which it alternates, the Sao Paulo fair
offers prizes and prestige to competing artists. "
Since the Brazilian regime's "crackdown on civil
liberties"--including the arrest of 200 artists, intel-
lectuals and political suspects--two French delega-
tions, the Dutch, the Swedish, a group of Spaniards
and many Brazilian expatriates have refused to ex-
hibit their works in Brazil. An example of official
censorship of art in Brazil, was seen in the Biennal
officers' request to the art commissions in foreign
countries, selecting works for exhibit, not to send
"immoral" or "subversive" works (410, Jy 6 1969
II, 2:1; Jy 17 1969 24:1; Ag 3 1969 II, 22:5).

1969, July 19 A 22-foot-high marble copy of Michelangelo's
"David" is displayed at Forest Lawn Memorial Park
in Cypress, California, without a figleaf, for the
first time since 1937.
"Nudity is no longer something to be covered up, "
Park officials explained, because times and social
attitudes have changed. The protests against the un-
draped figure by a few residents in the suburban
Orange County community do not change the decision,
but similar statues in the company's Memorial Parks
in near-by Glendale and West Covina will keep their
coverings (410, Jy 20 1969 32:1).

1969, August The United States Customs Regulations were revised
to further admit fine arts free or at a reduced rate,
and to allow the evaluation of expert opinion in de-
ciding whether an object was "art" (589: Pt. 10).

1969, Septem- After fifty members of the Dutch Union of Artists
ber 16 and Sculptors picketed the Rijksmuseum and the Am-
sterdam Municipal Museum to protest Netherland's
cultural policy, and all the museums in Amsterdam
were closed for three days--September 14 through
16--to prevent demonstrating artists from occupying
them, Queen Juliana announced that the Netherlands
Government would meet "the demands of artists for
a bigger voice in cultural policy, and that the Govern-
ment will consult with the artists themselves" on
artistic questions (410, S 17 1969 9:1).

1969, Septem- "90 Days, " was the judgment of Circuit Court Judge
ber 19 Charles S. Russell, specifying the time to be allowed
Virginia architect Brockhurst C. Eustice to "tear
down his house or haul it away" because it "broached

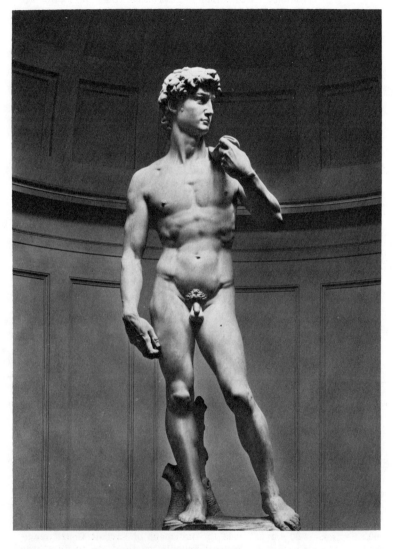

33. 1969, November. Michelangelo. David. Galleria dell'
Accademia, Florence, Italy

the local covenant governing residential design. "
Neighbors of Eustice had sued on the grounds
that the architect's house--two-story cubes connected
by a one-story corridor, and finished with plain ply-
wood panes with a cedar veneer--was "inharmonious"
with their own "ranch-style and crypto-colonial
homes" (94). Eustice is appealing the condemnation
of his $55,000 house located in Arlington, Virginia
(206A).

1969, Novem- Michelangelo's statue "David," depicted on a poster
ber displayed in a bookstore in Sydney, Australia, was
 seized by vice squad officers, and the bookstore
 manager was charged with obscenity. Curator of
 the New South Wales Art Museum, Daniel Thomas,
 called the action "incredible, utterly ridiculous,
 pointing out that "the statue of David has been stand-
 ing in an art gallery in a Roman Catholic city (Flo-
 rence, Italy) in full view of adults and children for
 over 500 years--and this is Sydney, 1969" (315, D
 1 1969 1:2).
 Several years ago a replica of the sculpture was
 seized by Beverly Hills police and removed from an
 art gallery "for appearing in public without a figleaf"
 (315, Mr 19 1966 1:3), and souvenir dealers in Flo-
 rence sell replicas of the famous figure with... or
 without... figleaf. (ILLUSTRATION 33)

1969, Novem- Journalists in Greece are using foreign cartoons to
ber 1 demonstrate their hostility to the Greek military
 regime in order to circumvent the government's of-
 ficial list of topics forbidden representation or com-
 ment in the press (410, N 2 1969 27:1).

1969, Novem- "Sculpture of the Month," the program of the New
ber 9 York City Parks Department, was criticized by the
 public, and some professional art critics, when they
 viewed the 32-foot silver-colored wooden sculpture
 on the Park Avenue Mall at 55th Street. "Tangential
 No. 32" by Paul von Ringelheim, the work occasion-
 ing comment, "was fun," according to the Parks De-
 partment, but one lay viewer said the figure was
 "Strictly Horsefeathers." Gilmore C. Clarke, for-
 mer chairman of the National Commission of Fine
 Arts, in a letter to New York City Mayor John V.
 Lindsay labeled the work "An insult." (315, N 10
 1969 1:2).

1969, Novem- Cuban Writers and Artists Union president Guillen
ber 16 warned artists in Cuba that they face punishment if
 they "fail to uphold the revolution" (410, N 17 1969
 10:4).

1969, Decem- "The questionable taste of politicians dictates the
ber visual image of government," according to art critic
 Wolf von Eckardt, and the most recent example of
 this is the scrapping of the modern seals designed
 for the United States Interior Department and the
 United States National Park Service by one of the
 leading graphic designers in the country, Chermayeff
 & Geismar Associates. Interior Secretary Stewart
 Udall commissioned the designs in 1968, but the
 present Interior Secretary Walter J. Hickel ordered
 the old buffalo emblem reinstated; and the National
 Park Service readopted its old arrow-head emblem.
 The change to the old symbols was made on the
 basis that the reinstated emblems are "traditional"--
 the Interior design was drawn up in 1929, and that
 of the Park Service in 1951 (superseding a sequoia
 cone, which in turn had replaced an eagle emblem).
 American Institute of Graphic Arts president Allen
 F. Hurlburt also criticized the replacement as a
 Gresham's law of art--"bad taste drives out good
 design"--stating that the government leaders "trust
 only 'hacks'" (315, D 14 1969 G:1).

1969, Decem- A Hartford University student, J. Hardy, was found
ber 13 guilty of libeling President Nixon with a cartoon pub-
 lished in the University newspaper in 1968. Federal
 Judge Ewing fined the defendant $50, but dismissed
 obscenity charges arising from the cartoons (410, D
 6 1969 22:3; D 7 1969 IV, 11:1; D 14 1969 IV, 13:1).

1970 "The end of traditional social alienation in the arts
 and of the traditional conception of avant-garde,"
 art historian Donald Egbert explained, shows why
 the "idea of avant-garde alienated from prevailing
 society...has essentially lost its traditional meaning."
 Today "outrage" is common, with the "Establish-
 ment seeking out and supporting the avant-garde as
 part of official culture." The alienated avant-garde
 is now fashionable and the alienated artist produces
 "mass art" for a "mass society" (170:741-745).
 "Art"--that is novelty, fashion, and entertainment--
 has ended in the bourgeois West, and in the USSR,
 too (170:744-745).
 Marcel Duchamp, painter of "Nude Descending
 Staircase," the picture that so shocked the critics,
 artists, and public at the Armory Show in 1913, fore-
 saw the "Death of the Avant-Garde" half a century
 after the famous Show, and explained to Henry Seldis,
 Los Angeles Times art critic, why he gave up art
 for chess:
 "In the final analysis, I probably stopped perform-
 ing as an artist because I did not want to be the
 victim of the integration of the artist into society.

> Though it may be fortunate that at this time
> (1963) the artist can live as a normal entity,
> it is unfortunate that everything any artist makes
> today is demanded, sought, and accepted by a
> growing public without criteria. This leads to
> mediocrity. You can't be <u>avant-garde</u> any more
> since there are millions of people around who
> will tell the artist trying to shock them that they
> accept his work before it is even made" (315,
> 2:8 0 3 1968).

1970, January
(A)

The office of the City Manager in Burbank, California,
made a survey directed to a question of removing
Hugo Ballin's "controversial" mural--which had been
installed in February 1943--from the Burbank City
Council Chamber in the City Hall. The twenty-two
foot long, eleven-foot high painting, "The Four Free-
doms" had been draped for many years ("since the
'50's"), because when the Mayor of Burbank was
seated in the presiding chair at City Council meet-
ings, an ass depicted in the mural was so positioned
that it appeared ass's ears grew from the Mayor's
head (Burbank Daily Review).

1970, January
(B)

In Sydney, Australia, "four men were arrested in a
bookshop for selling obscene publications"--"prints
of three drawings of nineteenth-century artist Aubrey
Beardsley and a print of a photograph of the statue
"David" by sixteenth-century sculptor Michelangelo."
 Other instances in the last few years, "when the
police in the Australian state of New South Wales
became arbiters of the visual arts," resulted in the
confiscations of "Sepik wood carvings, and the paint-
ings of Michael Brown" (328:45).

1970, January
4

Attorney Morris Ernst, noted civil-liberties champion
and long-time opponent of censorship, said in an in-
terview that he would not choose to live in a society
"without limits to freedom," and that he deplored
"utter freedom" if that meant "loose moral behavior
standards concerning sex on stage and on streets"
(410, Ja 5 1970 46:2).

1970, January
8

The Art Workers Coalition staged a "lie-in" before
Picasso's "Guernica" in the Museum of Modern Art
in New York City to protest the Museum's failure,
according to the demonstrators' charge, to keep a
promise to collaborate with the Coalition on a poster
protesting the massacre at Songmy, South Vietnam
(410, Ja 9 1970 36:1).

1970, January
20

When some South Viet Nam legislators suggested to
President Thieu that the 30-foot "grotesque" statue

of two United States Marines--one aiming a light machine gun at the Opera House 30 yards away, where the Assembly lower house sits--"had an un-savory symbolism, " he agreed to have the figures moved. After six weeks, the concrete and steel military statue still remains in place, and "has the Assembly well covered" (Time Mr 9 1970, p. 25).

1970, January 24
Although B'nai B'rith Anti-Defemation League chair-man Dore Schary urged President Nixon to bar the Federal funding of a road leading to the "Christ of the Ozarks Project" in Eureka Springs, Arkansas--because the project was promoted by Gerald L. K. Smith (whom Schary termed a "notorious anti-semite"), and would allegedly be used to spread religious ha-tred to Smith's profit--the United States Commerce Department approved the grant. According to the Department, the Project--among whose tourist at-tractions are a 7-story statue of Christ and a "Christ Only" Art Gallery--upon study had shown no link with Smith (410, Ja 25 1970 48:1).

1970, January 28
A panel of three federal judges in Los Angeles de-clared unconstitutional a portion of the United States Customs Regulation prohibiting importing of obscene materials. They held that the statute prohibits a person who may constitutionally view pictures of the right to receive them, by forbidding an adult from importing an obscene book or picture for private reading or viewing, an activity which is constitution-ally protected, violates the freedom of speech and press. This decision resulted from a suit filed by attorney Stanley Fleishman on behalf of Milton Luros, whose 37 photographs were confiscated last October 24 when he returned to the International Airport in Los Angeles from a European trip. Although Luros admitted that he intended to distribute the pictures commercially through the publication of a book, he could still claim constitutional protection, the Judges said, ordering the United States Customs to return the photographs and enjoining the Customs from en-forcing the statute (315, Ja 29 1970 1:29).

1970, January 29 (A)
"Hard-core pornography, " Prince George's Circuit Judge Roscoe Parker ruled the cartoon ("depicting sexual practice") in an issue of the Washington Free Press, an underground newspaper. Two "expert witnesses"--testifying that the cartoon was "a highly regarded work of art, " the original of which had been displayed at the Corcoran Gallery of Art--were disbelieved by the Judge who called the cartoon "a piece of trash which should be banned. " Marshall E. Woodruff, owner of Joint Possession, a leather

goods store, in College Park was convicted for sel-
ling the paper containing the cartoon (417 18:25 Mr
1970).

1970, January An exhibit of erotic art by Beatle John Lennon--
29 (B) closed by police in London the day after it opened
 there--went on public display at the Upstairs Gallery
 in Long Beach, California, after the show received
 the approval of the Long Beach Police Department.
 "Surrealistic sketches of intimate bedroom scenes"
 are included in the portfolio of 14 lithographic draw-
 ings and a poem, portraying Lennon and his bride,
 Yoko Ono (315, Ja 30 1970 1:2).

1970, Febru- The "past was removed from the future, " in prepara-
ary 17 tion of Guyana's becoming a republic on midnight,
 February 22, when the 73-year-old statue of Queen
 Victoria, once the ruling monarch of the British
 Empire, was hoisted from its place in front of the
 Supreme Court--known as the Victoria Law Court--
 in Georgetown "to a site in the Promenade Gardens"
 (Illustrated London News F 28 1970, p. 6; Time 95:
 42 Mr 2 1970). (ILLUSTRATION 34)

1970, Febru- An Appeals Court upheld the conviction of New York
ary 18 City art dealer Stephen Radich, in a five to two de-
 cision, for displaying 7 art works by Marc Morel in
 1966 in which the United States flag was used in a
 way held dishonouring to the flag--"to depict male
 sex organ and express antiwar themes. "
 The two judges who dissented from the ruling--
 that the right of free speech does not permit use of
 the flag in "dishonorable"--ways as a form of protest
 --described the majority ruling as "political censor-
 ship. " The New York Civil Liberties Union appeal
 of the case, asking that the United States Supreme
 Court declare use of the flag in artistic objects pro-
 tected by the First Amendment, was accepted on
 October 19 for hearing by the Supreme Court (410,
 F 19 1970 49:7; O 20 1970 24:4).

1970, March Customs Regulations of the United States Bureau of
 Customs concerning the importation of art were
 further modified, including provisions that:
 Declaration for United States Customs Inspection
 on duty free art works "shall show whether they
 are originals, replicas, reproductions, or copies";
 Sculpture to be admitted duty free must be "ori-
 ginal work or model or one of the first ten cast-
 ings, replicas, or reproductions made from the
 original work or model"; Included as art are
 "applied paper and other materials... such as
 are used in collages... " (589).

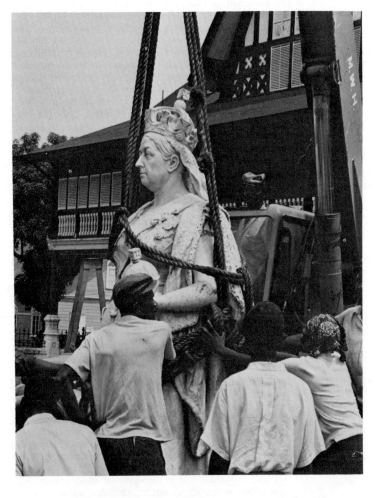

34. 1970 February 17. Queen Victoria. Georgetown
Prepares for Guyana Independence

1970, March 1
(A)

"I guess they didn't know that meant dirty pictures,"
psychologist Douglas Wallace commented concerning
his questionnaire requesting the reaction of a wide
range of groups to "pictorial erotic stimuli"--part
of a study to help define pornography for the Presi-
dential Commission on Obscenity and Pornography.
Because the language was "a little too academic,"
only one reply was received to Wallace's original
letter. It came "from an employment agency for
go-go girls," who said that they would try to round
up some girls to look at the pictures (315, Mr 2
1920 1:2).

1970, March
1 (B)

Two weeks after new decrees concerning censorship
of books and magazines in Brazil by police officers
had been attacked by publishers, writers and artists
with "scorn, indignation, ridicule, wit and sarcasm,"
Brazilian Justice Minister Alfred Buzaid announced
that he will not cancel the censorship order. Brazil's
most famous writers--including Erico Verissimo and
Jorge Amado--journalists, and artists "liken the cen-
sorship--which has been in effect since March 31,
1964 when the military regime took over--to the In-
quisition, and say it takes Brazil along the road trod
by Nazi Germany and Soviet Union. "
 Buzaid explained that the decree will be used only
against pornography, and has issued a later order
exempting from censorship scientific, technical, and
educational books. He also defended the ability of
the police to "make moral judgments on books," but
another Justice Ministry spokesman admitted that
the federal police were not "really qualified as cen-
sors," and that the government plans to hire at least
120 censors at salaries up to 1,400 new cruzeiros
(about $350) a month--"a high public service salary
in Brazil" (315, Mr 1 1970 F:8).

1970, March 5

Frank A. Kaufman, Federal Judge in Baltimore,
Maryland, opened the way by his decision for display
in the United States of a 200-work erotic art exhibit,
including works by Rembrandt, Picasso, and Chagall,
previously shown in Denmark and Sweden by Phyllis
and Eberhard Kronhausen. Judge Kaufman ruled that
ten "explicitly erotic paintings"--branded as obscene
by the United States Justice Department, who sought
permission to destroy them, and excluded from entry
into the country by the United States Customs in Bal-
timore on November 4, 1969--have "redeeming social
value," and cannot be kept out of the United States.
 The Kronhausens had shipped ten pictures to Bal-
timore to "test the reaction of federal officials" to
"the admittedly spicy contents" of this sample--with
representations by George Grosz, Hans Belman,

Karel Appel, and anonymous artists from Japan,
China, and India--from their International Exhibit of
Erotic Art, destined for display in New York City
(315, N 23 1969 A:26; N 28 1969 2:6; 410, N 23
1969 56:3; 417 My 1970, P. 40).

1970, March 16 "Jumping the gun" on the President's Commission
on Obscenity and Pornography, the United States
House of Representatives introduced a bill (H. R.
15693, drafted by the United States Civil Service
Commission) into the House carrying two proposals
contained in President Nixon's May, 1968, message
to Congress "requesting new laws 'to protect the
citizen from receipt of offensive material' in the
mails. "
 "The bill would make it a Federal crime to use
mails to deliver allegedly obscene materials to any-
one under the age of eighteen, " and provides for
extension "of the 1967 pandering law to permit any-
one to notify a postal authority if he does not wish
to receive obscene materials" (Publishers Weekly
Ap 20 1970, p. 39).

1970, March 21 Rio de Janeiro's hippie art fair reopened, after cen-
sorship by the "stern morality" of Brazil's military
regime, with bare breasts on fair murals covered
and distribution of the poster photograph of Michel-
angelo's statue of "David, " held up pending federal
police censor "revision" (315, Ap 13 1970 1:1; 410,
Mr 22 1970 23:1).

1970, March 23 Since July 1968 nearly $2 million has been spent by
the President's Commission on Obscenity in an at-
tempt to gauge what "the accepted standards of de-
cency" are in the United States. In addition to re-
search by staff members of the Commission, "40
federal research contracts have been farmed out,
from the UCLA campus to the wide-open pornography
bookstores of Denmark, and colleges, hospitals, and
prisons in between. "
 The wide concern with public morality standards
has been demonstrated by the more than 200 bills
relating to obscenity and pornography that have been
introduced in Congress. With respect to mailed
pornography, "under existing law, according to the
Post Office Department, more than 275,000 persons
have filed complaints against pornography" (315, Mr
23 1970 1:1).

1970, March 24 In a "nihilistic act against humanity and civilization"--
in the words of Cleveland Museum of Art director
Sherman E. Lee--Rodin's famous 900-pound cast
sculpture, "The Thinker, " was partially destroyed

by a dynamite bomb, cracking the face and shattering
the feet, of the figure that had stood on a pedestal
at the main entrance of the Museum since 1917.
"The Thinker" will be returned to its pedestal, but
in its damaged state, as "any repair attempt would
ruin what remains of the sculpture," according to
Lee (410, Jy 17 1970 19:3).

1970, April Obscenity in contemporary news pertains to violence
rather--as up to 1956--"matters related to sex or
the excremental functions." "In Britain, the courts
have extended the meaning of "obscenity" to include
violence, while the United States courts have refused
to do so, even when the legislature had expressly in-
tended it" (638:188, 199).

1970, April 1 The owner of the London Art Gallery exhibiting litho-
graphs of John Lennon, of Beatle fame, was sum-
moned to Magistrate's court for alleged indecency
of the display. The pictures, showing Lennon's
"love life," were printed in 300 copies each to sell
for $96 a copy, and were described by the defendant
as "pornographic, but not obscene" (410, Ap 2 1970
15:1).

1970, April 6 When the exhibit of Picasso's etchings and aquatints,
"347 Gravures," opened at the Art Gallery, Univer-
sity of California at Los Angeles, the images of
"playful eroticism" were "slightly bowdlerized" by
the deletion of 20 of the prints "presumably for the
sake of propriety" (315, Ap 19 1970 Calendar:45).

1970, April 18 The USSR continued to ban abstract art from exhibit
in Russian state-owned galleries. If such unofficial
art is displayed in Russia it must be shown in pri-
vate "underground" galleries (410, Ap 19 1970 II, 3:7).

1970, May 14 Thomas Forcade, American Library Association mem-
ber and projects co-ordinator for the Underground
Press Syndicate, "smashed a cream pie in the face
of a member of the National Commission on Obscenity
and Pornography," Otto N. Larsen, professor of so-
ciology at the University of Washington, Seattle, to
protest:
 "this unconstitutional, illegitimate, unlawful, pre-
 historic, obscene, absurd keystone committee"
 (American Libraries 1:635 Jy/Ag 1970).

1970, May 19 City officials in Newark, California, "censored four
nude drawings in a Newark Community Center art
exhibit." Assistant City Manager Thomas I. Smith
explained the action:
 "Not wanting to offend anyone, the staff decided

no nudity should be displayed at the Community Center" (417 19:72 S 1970).

1970, May 21 Sylvester and the Magic Pebble by William Steig-- awarded the Caldecott Medal by the American Library Association Children's Services Division as the most distinguished American picture book for 1969--was banned from Lincoln Nebraska Public School Libraries because among the picture of animals in the story, shown in human dress and following human occupations, is one that "portrays policemen as pigs" (417 19:73 S 1970).

1970, June 5 Twenty out of 44 United States artists selected to show their works in the United States pavilion at the 35th Venice Biennale withdrew their works "as an act of dissociation from the United States Government's sponsorship" using art as "cultural veneer to cover policies of ruthless aggression abroad and intolerable repression at home" (410, Je 6 1970 27:1).

By the first day of the official critics opening on June 22, twenty-four of the 47 American artists listed in the catalog had withdrawn their works from the show, in protest to the wars in Vietnam and Cambodia (410, Je 24 1970 38:1).

1970, June 8 The United States Appeal Court in New York City unanimously ruled that Section 305 of the Tariff Act, banning import of obscene materials for private use, is unconstitutional because it is an infringement of the First Amendment. The ruling did not touch on the Act's other sections barring commercial use of obscene materials (410, Je 9 1970 21:1).

1970, July "A Puritan plot," commented Mexican artist Rufino Tamayo upon learning that Smith College in Northhampton, Massachusetts, planned to sell or demolish its Tamayo mural, the first such painting he had completed on commission from the wife of the former United States Ambassador to Mexico, Dwight Murrow, who donated it to the College in 1943. At that time, Tamayo recalled, "the naked woman who symbolizes nature and fertility caused disgust among the puritans of New England," who tried to have the painting removed from Smith College. Now the mural is offered for sale; price: $15,000 (315, Jy 12 1970 B:1).

1970, July 16 In a decision reversing the Bethesda, Maryland, People's Court original jurisdiction and the county circuit court upholding the conviction on appeal, the Maryland Court of Special Appeals ruled "that a political cartoon depicting a judge sitting naked on a bench in a suggestive posture (i.e., masturbating)

is not obscene in a constitutional sense. "

The defendant, J. Brinton Dillingham, had been arrested in March 1968 for selling the controversial issue of an underground newspaper, the <u>Washington Free Press</u>, containing the cartoon, in front of the Montgomery County Police Station in Bethesda, Maryland.

The Special Appeals Court found that the cartoon, considered in relation to accompanying text on the same page of the paper, "is not utterly without redeeming social value" (417 19:74 S 1970).

1970, August 11 "Rigged, " was the only word Dr. Victor B. Cline, psychologist in Salt Lake City, could find to describe the draft report from the President's Commission on Pornography, in testimony before the United States House of Representatives Postal Operations Subcommittee. "The Report, " Cline said, "is a gross mixture of truth and error, part science fiction, and certainly a travesty on a scientific document, " as it was "full of selective use of statistics, biased conclusions on inadequate data, and... represented an almost Alice-in-Wonderland type of distortion of the actual evidence" (315, Ag 12 1970 1:10).

1970, August 20 "The sole Nixon appointee to the 18-man President's Commission on Pornography"--Charles H. Keating, Jr. , a Cincinnati lawyer, and founder of the Los Angeles-based Citizens for Decent Literature--told the Los Angeles County Commission on Obscenity and Pornography "that the federal panel's legal staff was so incompetent it 'erroneously stated the law in every page' of the law section of the report. "

"After hearing Keating, the County Commission passed a motion calling upon the Los Angeles County Board of Supervisors to request Mr. Nixon to fire all the Presidential Commission members not appointed by him, and form a new panel" (315, Ag 21 1970 2:1).

1970, August 27 A sculpture, "The Spirit of '76, " that judges had awarded an "honorable mention" was removed from an exhibition preview of the Art Show at the Minnesota State Fair in St. Paul because it included an American flag with a dynamite box, a molotov cocktail, and a red flag (410, Ag 30 1970 53:6).

1970, September 9 President Nixon's only member appointed to the Commission on Pornography, Charles H. Keating, Jr. , won a 10-day court order restraining publication of a Commission report recommending repeal of all adult censorship laws. Keating charged that the Commission had acted to "hinder, hamper, and

make it impossible" for him to write adequate dis-
senting views from the majority report, as he had
denied access to the nearly 10, 000 pages of the ma-
jority report, except for 150 pages given to him
(315, S 10 1970 1:4).

1970, Septem- The long-awaited 874-page report of the President's
ber 30 Commission on Obscenity and Pornography was issued
 at a news conference by the Commission's chairman,
 William B. Lockhart, Dean of the University of Min-
 nesota Law School. The Commission majority "pro-
 posed repeal of 114 state and federal laws that forbid
 importation, sale and display of pornography to
 adults, " as "such laws... are ineffective, are not
 supported by public opinion, and conflict with 'the
 right of each individual to determine for himself
 what books he wishes to read and what pictures or
 films he wishes to see. '" Also proposed by the ma-
 jority was "draft legislation for adoption at the state
 level forbidding distribution of erotic material with-
 out parental consent and prohibiting displaying of
 erotic pictures--but not books--in a manner visible
 to children. " Dissenters on the Commission said
 that the majority was "biased in favor of protecting
 the business of obscenity, " and that for $2 million
 of taxpayers' money the report was "a shoddy piece
 of scholarship that will be quoted ad nauseum by
 cultural polluters and their attorneys" (315, O 1 1970
 1:23).

1970, October The South Korea Supreme Court ruled that "art
 masterpiece or not" the nude picture violated the
 law against pornography and upheld fines for the
 printer and manufacturer of match boxes with re-
 productions of "The Nude Maja, " 18th century paint-
 ing by Francisco Goya (315, N 1 1970 A:A).

1970, October An explosion early in the day partially destroyed--
5 shearing it off at the knees--the bronze statue of a
 policeman, a Chicago memorial to police officers
 killed in the Haymarket Riot of 1886. A caller to
 the Chicago Tribune, identifying himself as "Mr.
 Weatherman, " said that Weathermen--an offshoot of
 the Students for a Democratic Society--had blown up
 the statue.
 The memorial figure was toppled from its stone
 pedestal by a similar blast on October 7, 1969, and
 Mayor Richard J. Daley, calling the bombing a
 "dastardly act, " said:
 "We are going to rebuild the statue again right
 where it is" (315, O 6 1970 1:6).

1970, October 11 Murals painted by some 20 youths enrolled in a fac-
tory training program of the Youth Ceramics Fac-
tory--depicting various aspects of "social upheavel"
--were ordered painted over by James T. Hughes,
chairman of the Area 11 Neighborhood Planning
Council, Washington, D. C., at the direction of
James L. Jones, the Mayor's advisor for Youth
Opportunity Programs. One of the Mayor's field
representatives had forwarded a critical account of
the series of murals painted at the factory which
had received $72,000 in Office of Economic Oppor-
tunity funds during its first year (417 20:5 Ja 1971).

1970, October 13 The United States Senate, which voted to create the
Presidential Commission on Obscenity and Porno-
graphy three years ago, overwhelmingly repudiated
it and its controversial findings by adopting a reso-
lution--vote 60 to 5--rejecting the Commission's
study and its call for repeal of laws restricting sale
of pornography to adults. Two of the charges in the
resolution were that the Commission was "unscien-
tific" and had ignored the long-term effects of expo-
sure to pornography (315, 0 14 1970 1:4).

1970, October 20 The United States Appeals Court in New York City
ruled that "consenting adults may send obscene ma-
terial to one another through the mail for their per-
sonal and private use." The decision, written by
Judge I. R. Kaufman and concurred in by Judges
L. P. Moore and S. R. Waterman, reverses the
December 1969 conviction of F. H. Dellapia of the
Bronx, and reinterprets the 97-year-old Comstock
Act in the light of recent United States Supreme
Court rulings, including the Stanley v Georgia de-
cision, which recognized the constitutional right of
adults to view pornography in their own homes (410,
0 21 1970 1:5).
 On October 12, the Supreme Court had agreed to
rule on the constitutionality of two Federal statutes
making it illegal to import obscene matter from
abroad or to send it through the mails, the question
in two cases--both brought in Los Angeles courts--
which ruled the statutes unconstitutional on the basis
of the Stanley v Georgia case (410, 0 13 1970 26:1).

1970, October 24 President Nixon in a 400-word statement rejected the
recommendations of the United States Commission on
Obscenity and Pornography as "morally bankrupt,"
and urged every state in the union to outlaw porno-
graphy (315, 0 25 1970 A:1).

1970, November Carl Milles sculpture, "God's Hand"--"a huge hand
of God holding a naked youth to show him the Uni-

verse"--was personally selected by Walter Reuther,
as late head of the United Auto Workers in 1959 to
honor Frank Murphy former Michigan governor, De-
troit mayor, and United States Supreme Court justice.
When the figure was placed at Detroit Recorder's
Criminal Court so that the judges, who could "clearly
view the naked backside of the statue from their win-
dows" were disturbed, Judge Robert J. Colombo,
pointing out that any coverup for the figure "would be
asinine, " gave his verdict:
> "I don't find anything personally offensive in it,
> but, of course, the only thing I've seen is the
> rear. And from the rear, I can tell you, it's
> not very becoming" (315, N 10 1970 1:4).

1970, Novem- Protests from City Hall and the Downtowners Associa-
ber 3 tion of Medford Merchants in Medford, Oregon,
 caused an exhibit by Ron Tore Janson, artist of
 Eugene, Oregon, to be "turned from street view"
 at the Rogue Gallery. The 27 charcoal nudes, alone
 and embracing, in the exhibit were "too much for
 Medford, " according to a spokesman for the Down-
 towners, merchants group (417 20:3 Ja 1971).

1970, Novem- The Brazilian satirical weekly O Pasquim (Satire,
ber 13 or Lampoon) used "humor... as a weapon of defense
 against government security forces, " to take the
 government to task for its "harsh security crack-
 down in which hundreds of persons have been arrested
 in the last few weeks. "
 The cartoons and writing--on the theme of the
 "fabled encounter between the wolf and the lamb"--
 were the work of staff members who were still at
 liberty and signing nearly every piece "Sig"--the
 cartoon rat symbol of Sergio Jaguaribe, O Pasquim's
 humor editor, a leading cartoonist in Brazil and now
 under arrest along with almost all of the other car-
 toonists and writers of the weekly (239).

1970, Novem- William Steig's Sylvester and the Magic Pebble, chil-
ber 18 dren's prize winning picture book, was removed from
 the Toledo, Ohio public school libraries by school of-
 ficials "because of a protest from James Caygill,
 president of the Toledo Police Patrolmen's Associa-
 tion, " "pending a review by school and public library
 representatives, " presumably because of the illustra-
 tions in this "animal story, " which include one pic-
 ture of pigs in policemen's uniforms (417 20:5 Ja
 1917).

1970, Novem- The children's book Sylvester and the Magic Pebble
ber 24 by William Steig, containing a picture of pigs in
 police uniforms, was ordered made available in all

elementary school libraries by a special 10-member
Prince George's County, Maryland, School Board
panel, with the ruling that the picture does not con-
tribute to the "development of negative attitudes to-
ward police officers." The investigation by the li-
brary committee panel had been prompted by protests
received from parents and complaints from law en-
forcement associations--including a letter from the
International Conference of Police Associations--
claiming 150,000 law enforcement members--pub-
lished in the local newspaper, stating that they de-
manded removal of the book from school libraries
because it put policemen in a bad light and lowered
respect for law enforcement officers (417 20:27 Ja
1971).

1970, Decem- "A 50-foot Dublin monument commemorating a visit
ber 6 by King George IV of England to Ireland in the 19th
 century was blown up in... a sign of defiance against
 the Irish government" (315 D 7 1971 1:11).

1971, Febru- The California State Supreme Court declined to re-
ary 10 view the libel suit of Mayor of Los Angeles Sam
 Yorty against the Los Angeles Times. Lower courts
 had dismissed the $2 million action brought over
 Paul Conrad's cartoon "depicting white-coated medi-
 cal orderlies preparing to take the mayor away in
 a straightjacket as he is saying on the telephone,
 "I've got to go now... I've been appointed Secretary
 of Defense, and the Secret Service men are here
 now" (315, F 11 1971 1:2).

1971, March The City Council of San Jose, California, agreed at
 its March meeting to place the children's book Sara
 Cone Bryant's Epaminondas and His Auntie on "re-
 serve" in San Jose Public Library.
 This restriction was made following a request in
 January from the local president of the National As-
 sociation for the Advancement of Colored People, T.
 J. Owens, to librarian Homer Fletcher that the book
 "be removed from the shelves because of its 'bad
 racial implications.'" (78A).

1971, March 8 Groton Public Library in Connecticut removed the
 February 1971 issue of Evergreen Review--contain-
 ing "drawings of sexual activities"--from its open
 shelves upon court order. In a four-month contro-
 versy between the Library and "municipal officials
 and self-appointed censors," the magazine had been
 placed on a "six-foot-high shelf... to keep it from
 short readers," but according to the order, the al-
 ternative to removal of the publication from the open
 shelves was "jail for the library Trustees" (242A).

1971, March Arraigned in Butler, Pennsylvania, on the summary
31 offense of blasphemy, which required no bond, John
 Sassone, 25, the owner of a boutique, was charged
 when he displayed for sale a picture of Christ with
 the legend:
 "Wanted for sedition, criminal anarchy, vagrancy,
 and conspiring to overthrow the established govern-
 ment. Dresses poorly. Said to be a carpenter
 by trade. Ill-nourished. Associates with common
 working people, the unemployed and bums. An
 alien, believed to be a Jew. "
 The arrest, made after "numerous complaints from
 older people in the community, " is set for magistrate's
 hearing on April 14, when some Butler clergymen
 are to testify against Sassone (315, Ap 2 1971 1:5).

1971, April The publishing group in the United States which
 brought out an illustrated edition of the federal
 government's Committee on Obscenity and Porno-
 graphy Report (cost $12. 50, as compared with the
 Government Printing Office official issue of the
 Report for $5. 50) was indicted in Dallas, Texas
 and San Diego, California. "charged with interstate
 shipment of obscene matter and with conspiring to
 send obscene matter through the mails. "
 The publisher, including three corporations and
 four individuals, named in the indictment are:
 Greenleaf Classics, Inc. ; Reed Enterprises, Inc. ;
 and Library Service, Inc. ; along with William L.
 Hamling, Shirley B. Wright, David L. Thomas, and
 Earl Kemp, officials of the three concerns (431A).

1971, May 3 The United States Supreme Court restored the curb
 on "importation of obscene material into the country
 for commercial use, " a law which had been voided
 by the Federal court in Los Angeles in the case of
 Milton Luros, in which the government attempted "to
 seize 37 photographs... from Europe for use in a
 book describing sexual positions" (315, My 4 1971
 1:1). Justice Byron R. White held in his opinion--
 for the seven-man majority--that forfeiture proceed-
 ings should "be completed within 60 days so that they
 do not become a form of censorship, " and that the
 1969 private possession decision "did not impair the
 government's power to remove obscene materials
 from the channels of commerce" (315, My 4 1971 1:1).

BIBLIOGRAPHY

1. Ackerman, James S. "Demise of the avant garde: Notes on the sociology of recent American art." Comparative Studies in Society and History 11:371-384, 398-412 O 1969

2. Alexander, Paul Julius. The Patriarch Nicephorus of Constantinople; ecclesiastical policy and image worship in the Byzantine Empire. Oxford, Clarendon Press, 1955.

3. American Civil Liberties Union. Annual Report. 1922-

4. American Civil Liberties Union of Northern California. Biennial Report, June 1956-June 1958.

5. American Federation of Arts. Statement on Artistic Freedom, adopted October 22, 1954.

6. American Law Institute. Model Penal Code. Proposed Official Draft. Philadelphia, 1961. Kept up to date by changes and corrections.

7. Americana Annual, 1925-1970. New York, Americana Corporation.

8. Anastos, Milton Vasil. "The ethical theory of images formulated by the iconoclasts in 754 and 815." In Dumbarton Oaks Papers, Cambridge, Mass., 1954. no. 8:151-160.

9. "And no ban for Danes." Time 91:37, 40 Ja 26 1968.

10. "And now, Mao-carve." Time 91:54 Mr 22 1968.

11. Anglo-French Art and Travel Society. Exhibition of a century of French caricature, 1750-1850, with some English caricatures of the Napoleonic period. New Burlington Galleries, London. 10th March-6th April, 1939.

12. "Angry art of the thirties." Fortune 51:88-91 Mr 1955.

13. "Argentine priest makes scandal of Buenos Aires' nude statues." Life 11:144-147 O 13 1941.

14. Aristotle. The politics, Book 7, 297. T. A. Sinclair, translator. N.Y., Penguin Books.

15. Arnold, Thomas W. Painting in Islam: A study of the place of pictorial art in Muslim culture. N. Y. , Dover, 1965.

16. "The Art Forum: Letter from Louis Muhlstock. " Canadian Art 4:134 My 1947

17. Art of the ancient Maya. N. Y. , Crowell 1959.

18. "Art within reason. " Art Digest 12:13 0 1 1937.

19. "The Arts and the Inquisition: The interrogation of Veronese, 1573. " Art News 52:36 S 1953.

20. "The artist and the Soviets: The interrogation of Nikritin, 1935. " Art News 52:37 S 1953.

21. Artists quit show over censorship. Baltimore, Peale Museum. Scrapbook of art and artists of Chicago. p. 106, p. 108. 1955.

22. The arts and man. Paris, UNESCO; Englewood Cliffs, N. J. , Prentice-Hall, 1969.

23. Arts Council of Great Britain. Working Party of Conference on Obscenity Laws. The Obscenity Laws, foreword by John Montgomerie. London, Andre Deutsch, 1969.

24. Ayrton, Michael. Golden sections. London, Methuen, 1957.

25. Baker, Elizabeth C. "Late Lachaise uncensored at last. " Art News 63:44-45 Mr 1964.

26. Barker, Ernest. The political thought of Plato and Aristotle. N. Y. , Dover, 1959.

27. Barr, Alfred H. "Is modern art Communistic?" New York Times Magazine D 14 1952, p. 22-23.

28. Bates, Ernest Sutherland. "Comstock stalks. " Scribner's Magazine 87:355-366 Ap 1930.

29. Baudouin, Frans. Middleheim. Berlin, Rembrandt Verlag, 1959.

30. Baur, John I. H. George Grosz, catalogue. N. Y. , Whitney Museum of American Art, 1954.

31. Bazin, Germain. The avant-garde in painting. N. Y. , Simon and Schuster, 1969.

32. ----- World history of sculpture. Greenwich, Ct. , New York Graphic Society, 1968.

33. "Beauty in the bizarre. " Time 95:79 Ap 27 1970.

34. Becker, Stephen. Comic art in America. N.Y., Simon and Schuster, 1959.

35. Bell, Clive. "Art and politics; attitude of the Russian government to art. " New Republic 24:261-263 N 10 1920.

36. Benedict, John. "Pornography a political weapon. " American Mercury 90:3-21 F 1960.

37. Benham, W. Gurney. Playing cards; the history and secrets of the pack. London, Ward, Lock, & Co., 1931.

38. Bennett, C. A. "Art as an antidote for morality. " International Journal of Ethics 30:160-171 Ja 1920.

39. Bennett, De Robigne Mortimer. Anthony Comstock: His career of cruelty and crime. 1970 reprint of the 1878 edition. N.Y., Da Capo Press, 1970.

40. Berenson, Bernard. Aesthetics and history in the visual arts. Garden City, N.Y., Pantheon, 1948.

41. Berger, John. Art and revolution. N.Y., Pantheon, 1969.

42. Berliner, Rudolf. "The freedom of Medieval art. " Gazette des Beaux-Arts (6th series) 28:263-288 N 1945.

43. Bernheimer, Richard. Religion and art. N.Y., Abrams, 1954.

44. Bevan, Edwyn R. Holy images. London, George Allen & Unwin, 1940.

45. "Biarritz has Eugenie trouble. " Life 31:163 N 19 1951.

46. Biddle, Francis. In brief authority. N.Y., Doubleday, 1962.

46A. A history of book illustration. 2nd rev. ed. Berkeley, University of California Press, 1969.

47. Blanshard, Paul. The right to read; The battle against censorship. Boston, Beacon Press, 1955.

48. "Blast from the North; Picasso banned by USSR. " Apollo 46:90 0 1947.

49. "Blushing Post Office and the Fine Arts, " editorial. Metropolitan Magazine (McFadden Fiction Lovers Magazine, N.Y.) March 6 1914. v. 39.

50. Boas, George and Lionel Trilling. "Art and morals; symposium excerpts. " Art Digest 27:19-20 My 15 1953.

51. Boeck, Wilhelm. Bilderverfolgung das Kunstwerk 819:65-68 1946/1947.

52. Boswell, Peyton. "Banned in Boston, ltd. Life Magazine and two reproductions by Doris Lee and Angelo di Benedetto. " Art Digest 21:3 D 1 1946.

53. ----- "Censorship: Miss Solomon and her sculpture, 'Lovers, ' recalled by National Association of Women Artists. " Art Digest 21:7 My 15 1947.

54. ----- "Cultural censorship: Life banned in Boston. " Art Digest 16:3 April 15 1942.

55. ----- "September Morn. " Art Digest 11:4 Je 1937.

56. Bowie, Henry P. On the laws of Japanese painting. N. Y. , Dover, 1952.

57. Bowie, Theodore, ed. The arts of Thailand. Bloomington, Indiana University, 1960.

58. Bowman, John F. Issues in art; a survey of controversies on art in society. Dubuque, Iowa, William C. Brown, 1965.

59. Boyd, E. Popular arts of Colonial New Mexico. Santa Fe, Museum of International Folk Art, 1959.

60. ----- Saints and saintmakers of New Mexico. Santa Fe, Laboratory of Anthropology, 1946.

61. Boyer, Paul S. Purity in print; the Vice-Society movement and book censorship in America. N. Y. , Scribner, 1968.

62. Bragdon, Claude. The frozen fountain. N. Y. , Knopf, 1932.

63. Bredt, Ernst Wilhelm. Sittliche oder unsittliche Kunst? Munchen, R. Piper, 1909.

64. Brenner, Hildegard. Die Kunstpolitik des Nazional Sozialismus. Reinbek bei Hamburg, Rowolt, 1963.

65. Brinton, Clarence Crane. A Decade of revolution: 1789-1799. N. Y. , Harper & Row, 1934.

66. ----- A history of western morals. N. Y. , Harcourt Brace, 1959.

67. Britannica Book of the Year, 1938-1970. Chicago, Encyclopaedia Britannica.

68. Broadley, Hugh T. Flemish painting in the National Gallery

of Art. Washington, D. C. , National Gallery of Art, 1960.

69. ----- German painting in the National Gallery of Art.
 Washington, D. C. , National Gallery of Art, 1960.

70. Brooklyn Institute of Arts and Sciences. Museum. The nude
 in American painting; a resume of the... [exhibition.
 Brooklyn, 1961].

71. Brooks, Robert C. "Lese majeste in Germany. " Bookman
 40:68-82 S 1914.

72. Broun, Heywood and Margaret Leech. Anthony Comstock,
 roundsman of the Lord. N. Y. , Boni, 1927.

73. Brown, Frank P. English art series, volume 3. London
 Sculpture. London, Pitman, 1933.

74. Brunetiere, Ferdinand. "Art and morality. " Living Age
 220:1-15 Ja 7 1899.

75. Bryston, Lyman. "Arts, the professions and the state. "
 Yale Review 36:no. 4: 631-642 Je 1947.

76. Burke, Redmond Ambrose. What is the Index? Milwaukee,
 Bruce, 1952.

77. Burland, C. A. Magic books in Mexico. Harmondsworth,
 Baltimore, Penguin Books, 1953.

78. Busch, Harald and Bernd Lohse. Romanesque sculpture.
 London, B. T. Batsford, 1962.

78A. "Busy paperhanger. " American Libraries 2:437 My 1971.

79. Butterfield, Roger. The American past. N. Y. , Simon and
 Schuster, 1948.

80. "Butterfly's Mummy. " Time 20:21 N 14 1932.

81. Cahn, Edmond Nathaniel. The moral decision; right and
 wrong in the light of American law. Bloomington, Indiana
 University Press, 1955.

82. Cairns, Huntington. The limits of art. Princeton, Princeton
 University Press, 1948.

83. Calverton, V. F. "Cultural barometer; art under modern
 dictatorships. " Current History 47:82-85 O 1937.

84. Canaday, John. Back to the nude. Horizon 5:90-96 S 1963.

85. ----- Culture gulch, notes on art and its public in the 1960's.

N. Y. , Farrar, 1969.

86. Canby, Harold S. "Agitated ladies; review of 'Sanity in Art' by J. H. Logan. " Saturday Review 15:8 Mr 27 1937.

87. "Caricature and the law of libel. " Law Notes (Law Times), Brooklyn, N. Y. 41:12-13 My 1937.

88. "Caricature and the law of libel. " 162 Law Times, London 89-90 July 31 1926.

89. Carter, Robert L. , et al. "Two thousand years of censorship; program and exhibit, History of Banned Books, at Enoch Pratt Free Library. " Library Journal 79:1003-1005 Je 1 1954.

90. Caso, Alfonso. Codex Becker.

91. Cassou, Jean. Art and confrontation: The arts in an age of change. N. Y. , New York Graphic Society, 1969.

92. Catalogue des ecrits, gravures et dessins condamnes depuis 1814 jusqu'a 1er janvier 1850. Suivi de la listse des individus condamnes pour delits de presse. Paris, Pillet fils aine, 1850.

93. Catholic Church. Councils. Disciplinary decrees of the general councils. St. Louis, B. Herder, 1937.

94. "C*ns*r *t w*rk. " Newsweek 73:90 Je 16 1969.

95. "Censorship. " Saturday Evening Post 202:26 Mr 29, 1930.

96. Censorship, a quarterly report on censorship of ideas and the arts. London 1964-1967.

97. Censorship Bulletin. New York, American Book Publishers Council. vol. 1, no. 1 D 1955-

98. "Censorship of foreign books. " Congressional Digest 9:33-57 F 1930.

99. Censorship today. vol. 1, no. 1 1968-

100. Chafee, Zechariah. Free speech in the United States. Cambridge, Harvard University Press, 1941.

101. Chambers, Frank P. Cycles of taste. N. Y. , Russell and Russell, 1928.

102. ----- The history of taste. N. Y. , Columbia University Press, 1932.

103. Chandos, John, ed. To deprave and corrupt... original
 studies in the nature and definition of obscenity. N. Y.,
 Association Press, 1962.

104. Cheney, Edward P., ed. "Freedom of inquiry and expres-
 sion." Annals of the American Academy of Political and
 Social Science. November 1938.

105. "Chicago Public Library bans art again." Library Journal
 92:1783 My 1 1967.

106. Chieh-tzu-yuan hua-chuan. The Tao of painting: a study
 of the ritual disposition of Chinese painting, with a trans-
 lation. N. Y., Pantheon Books, 1956.

107. "Children's book illustrations censored as integrationist propa-
 ganda." Life 46:90 Je 1 1959.

108. Chipp, Herschel B., comp. Theories of modern art.
 Berkeley, University of California Press, 1969.

109. Chou, Young. Path of socialist literature and art in China.
 China, 1960.

110. Christensen, Erwin O. Pictorial history of western art.
 N. Y., New American Library, 1964.

111. Clair, Colin. A chronology of printing. N. Y., Praeger,
 1969.

112. Clark, Eliot. History of the National Academy of Design,
 1825-1953. N. Y., Columbia University Press, 1954.

113. Clark, Kenneth. "The naked and the nude." Art News 53:
 18-21 0 1954.

114. ----- The nude: A study in ideal form. Garden City, N. Y.,
 Doubleday, 1956.

115. Cleeves, Janet. "Modern heresy." Catholic World 165:79-
 80 Ap 1947.

116. Codices Becker I/II. Museum fur Volkerkunde Wien, Inv Nr
 60306 and 60307. Graz, Austria, Akademische Druk-v.
 Verlagsanstalt, 1961.

117. "Coit Tower murals--yet again." Architect and Engineer
 146:10 S 1941

118. Coleman, Peter. Obscenity, blasphemy, sedition; censorship
 in Australia. Brisbane, Jacaranda Press, 1963.

119. Comstock, Anthony. "Indictable art." Household Guest (Our

Day) 1:44-48 1888.

120. ----- "Morals versus art." People's Library. January
 (extra), vol. 12, no. 406. N. Y. , Ogilvie Co. , 1888.

121. ----- Traps for the young, edited by Robert Bremner.
 Cambridge, Belknap Press of Harvard University, 1967.

122. "Comstockian: Anti-nude ruling by University of Southern
 California." Art Digest 14:27 F 1 1940.

123. "Comstockian Morals." Art Digest 12:10 My 15 1938.

124. "Confiscated picture." Mother Earth 1:34-38 Jy 1906.

125. Connolly, Cyril. "Surrealism." Art News Annual 21:133-162
 D 1952.

126. The contemporary scene, a symposium, March 28-30, 1952.
 N. Y. , Metropolitan Museum of Art, 1954.

127. Cooke, Hereward Lester. British painting in the National
 Gallery of Art. Washington, D. C. , National Gallery of
 Art, 1960.

128. ----- French painting of the 16th-18th centuries in the Na-
 tional Gallery of Art. Washington, D. C. , National Gal-
 lery of Art, 1959.

129. Coryell, John R. "Comstockery." Mother Earth 1:30-40
 Mr 1906.

130. Coulton, George Gordon. Art and the reformation. 2d ed.
 Cambridge, University Press, 1953.

131. ----- Five centuries of religion. 3 vols. Cambridge,
 University Press, 1923.

132. ----- From St. Francis to Dante; a translation of all that
 is of primary interest in the chronicle of the Franciscan
 Salimbene. London, Duckworth, 1908.

133. ----- Inquisition and liberty. Boston, Beacon Hill, 1959.

134. ----- "New Roman Index." Nineteenth Century 107:378-390
 Mr 1930.

135. Cowen, Z. "The artist in the courts of law." Australian
 Law Journal 19:112-113 Ag 1945.

136. Cowley, Malcolm. "There have to be censors; political
 censorship and works of art." New Republic 94:364-365
 Ap 27 1938.

137. Craig, Alec. Above all liberties. London, G. Allen & Unwin, 1942.

138. ----- The banned books of England and other countries; a study in the conception of literary obscenity. London, G. Allen & Unwin, 1962.

139. ----- Suppressed books, a history of the conception of literary obscenity. Cleveland, World Publishing, 1963.

140. Cram, Ralph Adams. The Catholic church and art. N. Y., Macmillan, 1930.

141. Craven, Thomas. Famous artists and their models. N. Y., Pocket Books, 1949.

142. Craven, Wayne. Sculpture in America. N. Y., Crowell, 1968.

143. Crehan, Hubert. "Lady Chatterley's painter: The banned pictures of D. H. Lawrence. " Art News 55:38-41 F 1957.

144. "Crimi disputes his fresco's destruction. " Art News 45:10 O 1946.

145. "Critic Hitler. " Time 30:46 Jy 26 1937; 30:32-33 Ag 2 1937.

146. Crowninshield, Frank. "The scandalous Armory Show of 1913. " Vogue 96:68-71, 114 S 15 1940.

147. "Curtain on a nude. " Newsweek 46:114 D 12 1955.

148. "Customs censorship. " Publishers Weekly 117:984:985 F 22 1930.

149. Dean, Joseph. Hatred, ridicule or contempt; a book of libel cases. N. Y., Macmillan, 1954.

150. Degler, Carl N. Out of our past, the forces that shaped modern America. N. Y., Harper, 1959.

151. de Grazia, Edward. Censorship landmarks. N. Y., Bowker, 1969.

152. Dejob, Charles. De l'influence du Concile de Trente sur la litterature et les beaux-arts chez les peuples catholiques. Paris, E. Thorin, 1884.

153. Dempsey, David. "The revolution in books. " Atlantic Monthly 191:76 Ja 1953.

154. Derenberg, Walter J. and Daniel Baum. "Congress rehabilitates modern art. " New York University Law Review

34:1228-1253 N 1959.

155. "Destruction of Crimi mural of the Rutgers Presbyterian
Church in New York. " American Artist 10:42 N 1946.

156. Devree, Charlotte. "The United States government vetoes
living art. " Art News 55:34-35 S 1956.

157. Dickson, Harold E. "The other orphan. " American Art
Journal 1:108-118 Fall 1969.

158. Didron, Adolphe Napoleon. Christian iconography; or, The
history of Christian art in the middle ages. 2 vols.
London, Bohn, 1851-1891

159. di Prima, Diana. "Fuzz's progress; harassment of the arts. "
Nation 198:463-465 My 4 1964.

160. Diringer, David. The hand produced book. London, Hut-
chinson's, 1953.

161. Ditchfield, Peter Hampson. Books fatal to their authors.
London, E. Stock, 1903.

161A. Dodd, Loring Holmes. Golden Age of American sculpture.
Boston, Chapman & Grimes, 1936.

162. "Dondero on the left. " Newsweek 33:84 Je 20 1949.

163. Downs, Robert Bingham, ed. The First Freedom: Liberty
and justice in the world of books and reading. Chicago,
American Library Association, 1960

164. Dows, Olin. "The New Deal's Treasury Art Programs. "
In Mark, Charles. Government and art. Madison,
Wisconsin, University of Wisconsin, Extension Division,
1963 (Arts in Society, vol 2, no. 4).

165. "Drapes marble limbs of Cupid; emissary of Purity Society
astonishes guests at Bellevue-Stratford. " Philadelphia
Inquirer My 1911.

166. Drujon, Fernand. Catalogue des ouvrages, ecrits, et des-
sins de toute nature pour suivis, supprimes, ou condamnes
depuis le 21 octobre 1814 jusqu'au 31 juillet 1879. Paris,
Rouveyre, 1879.

167. Eastman, Max. Artists in uniform; a study of literature and
bureaucratism. N.Y., Knopf, 1934.

168. Eckardt, Wolf von. "Monumental decision. " New Republic
146:28-29 Ap 2 1962.

169. Egbert, Donald Drew. "The idea of 'avant-garde' in art and politics. " American Historical Review 73:339-366 D 1967.

170. ----- Social radicalism and the arts. N. Y. , Knopf, 1970.

171. ----- Socialism and American art in the light of European Utopianism, Marxism, and Anarchism. Princeton, N. J. , Princeton University Press, 1967.

172. Eisenhower, Dwight D. Freedom of the arts, statement made on the occasion of the twenty-fifth anniversary of the Museum of Modern Art. October, 1954. American Federation of Arts.

173. Eliasberg, W. G. "Art: Immoral or immortal. " Journal of Criminal Law 45:274-278 S-O 1954.

174. Eliot, Alexander. Three hundred years of American painting. N. Y. , Time, 1957.

175. Elisseeff, Vadime. Two thousand years of Chinese painting. Paris, UNESCO, 1955.

176. Emde Boas, Coenrad van. Obsceniteit en pornografie anno 1966 [door] C van Emde Boas. 's-Gravenhage, NVSH, 1966.

177. Encyclopaedia Britannica. 24 vols. Chicago, Encyclopaedia Brittanica.

178. Encyclopedia of painting: Painters and painting of the world from prehistoric times to the present day. N. Y. , Crown, 1955.

179. Encyclopedia of world art. 15 vols. N. Y. , McGraw, 1959-1968.

179A. Ernst, Jimmy. "Freedom of expression in the arts. " Art Journal 25 no 1: 46-47 Fall 1965.

180. Ernst, Morris Leopold. The censor marches on: recent milestones in the administration of the obscenity law in the United States. N. Y. , Doubleday, 1940.

181. ----- Censorship: The search for the obscene. N. Y. , Macmillan, 1964.

182. ----- To the pure... a study of obscenity and the censor. N. Y. , Viking, 1928.

183. "Eros in polyester; show at Sidney Janis Gallery called Erotic Art 66. " Newsweek 68:102-103 O 10 1966.

184. "Eros in Sweden: First International Exhibition of Erotic Art. " Time 91:74 My 17 1968.

184A. "Erotica at 87. " Time Ja 31 1969, p. 66.

185. "Erotica on tour. " Newsweek 72:105 S 16 1968.

186. "Expression of thanks for support when 'Studio' was banned. " London Studio 17 (Studio 117):185 My 1939.

187. F. , W. H. , Jr. "Caricature involving no falsehood" [Burton v Crowell Publishing Co. , 82 F (2d) 154]. Texas Law Review 15:268-269 F 1937.

188. Fagg, William and Margaret Plass. African sculpture, an anthology. London, Studio; N. Y. , Dutton, 1964.

189. Faison, Samson Lane. Edouard Manet. N. Y. , Abrams, Pocket Books, 1954.

190. ----- Great paintings of the nude. N. Y. , Abrams, 1955.

191. Feinblatt, Ebria. German Expressionist prints. Los Angeles County Museum, 1954.

192. ----- Honore Daumier, exhibition of prints, drawings, watercolors, paintings, and sculpture. Los Angeles County Museum, November 1958.

193. "Female figure, symbol of Texas. " Life 41:93 Jy 23 1956.

194. "Fight kept up. " Boston Morning Herald S 18 1911.

195. Finley, M. I. "Must the artist rebel?" Horizon 10:50-55 Spring 1968.

196. "Florida prudes. " Art Digest 8:9 F 15 1934.

197. Forbidden art in the Third Reich; paintings by German artists whose work was banned from museums and forbidden to exhibit. [8]p. 1945?

198. "Forbidden Lehmbruck 'Kneeling Woman. '" Life 7:55 0 30 1939.

199. "Forbidden prints. " Art Digest 6:21 Ja 1 1932.

200. Foster, Henry H. "'Comstock Load': Obscenity and the Law. " Journal of Criminal Law 48:245-258 1957.

201. "Fountain dei Termini, Rome. " Magazine of Art 25:422-424 Jy 1901.

202. "Four major cities refuse Bantam poster for 'Stones.'" Publishers' Weekly 194:41 Jl 22 1968.

203. "Francesco Ferrer and Anthony Comstock," editorial. Mother Earth 5:277-278 N 1910.

204. Franco, Jean. The modern culture of Latin America, society and the artist. N.Y., Praeger, 1967.

205. Frankfurter, Alfred. "Editorial." Art News:54:17 Ap 1955.

206. Friedlaender, Walter F. Caravaggio studies. Princeton, Princeton University Press, 1955.

206A. "From dream to nightmare." Time 94:50 S 26 1969.

207. Fryer, Peter. Mrs. Grundy; studies in English prudery. N.Y., London House & Maxwell, 1963.

208. Furst, Herbert. "Art and temperament." Apollo 34:84-86 O/N 1941.

209. Gardner, Helen. Art through the ages. 4th ed. N.Y., Harcourt, Brace, 1959.

210. Gaunt, William. "Censored celebrities of painting." London Times Mr 18 1969 15d.

211. ----- Etty and the nude. Leigh-on-Sea, Essex, England, F. Lewis, 1943.

212. ----- Everyman's dictionary of pictorial art. 2 vols. London, Dent; N.Y., Dutton, 1962.

213. Genauer, Emily. "Still life with red herring." Harper 199:88-92 S 1949.

214. Gendel, Milton. "The iron curtain in the glass-factory." Art News 55:23-25 S 1956.

215. Gentry, Helen and David Greenhood. Chronology of books and printing. San Francisco, Helen Gentry, 1933.

216. George, Mary Dorothy. English political caricature: a study of opinion and propaganda. 2 vols. Oxford, Clarendon Press, 1959.

217. Gerber, Albert B. Sex, pornography, and justice. N.Y., L. Stuart, 1965.

218. "German declaration of independence." Literary Digest 60: 27-28 Ja 4 1919.

219. Getlein, Frank. The bite of the print; satire and irony in
 woodcuts, engravings, etchings, lithographs, and serigraphs.
 N. Y. , Potter, 1963.

220. ----- "Pope strikes back. " New Republic 150:22-24 My 23
 1964.

221. Giedion, Siegfried. "On the force of esthetic values. "
 Architectural Record 101:84-86 Je 1947.

222. Gilfond, Duff. "The Customs men keep us pure. " New
 Republic 59:176-177 Jy 3 1929.

223. Gillett, Charles Ripley. Burned books; neglected chapters
 in British history and literature. 2 vols. N. Y. , Colum-
 bia University Press, 1932.

224. Gillray, James. Works of James Gillray: 582 plates and a
 supplement containing the 45 so-called "Suppressed Plates. "
 N. Y. , Blom, reprint.

225. Gimpel, Jean. The cult of art; against art and artists.
 N. Y. , Stein & Day, 1969.

226. Gold, Herbert. "The end of pornography. " Saturday Review
 53:25-26 0 31 1970.

227. Goldscheider, Ludwig. Roman portraits. N. Y. , Oxford
 University Press, 1940.

228. Goldsmith, Elizabeth Edwards. Sacred symbols in art. 2d
 ed. London, Putnam, 1912.

229. Goldwater, Robert. Artists on art; from the fourteenth to
 the twentieth century. 3d ed. N. Y. , Pantheon, 1958.

230. Gombrich, Ernst Hans Josef. Art and illusion; a study in
 the psychology of pictorial representation. Princeton,
 Princeton University Press, 1961.

231. ----- Story of art. 11th ed. London, Phaidon; N. Y. , New
 York Graphic Society, 1966.

232. Gomez Moreno, Manuel. The Golden Age of Spanish sculp-
 ture. Greenwich, Ct. , New York Graphic Society, 1963.

233. Goodrich, Lloyd. "Art in democracies. " In The contemporary
 scene, a symposium, March 28-30, 1952. N. Y. , Metro-
 politan Museum of Art, 1954.

233A. ----- "Freedom of expression in the arts. " Art Journal 25
 no 1:44-45 Fall 1965.

234. ----- Winslow Homer. N. Y. , Braziller, 1959.

235. Grabar, Andre. Byzantine painting. Geneva, Skira, 1953.

236. Grant, Judith. A pillage of art. London, Roder & Yale, 1966.

237. Greenberg, Clement. Art and culture. Boston, Beacon Press, 1961.

238. Greenleaf, Richard E. The Mexican inquisition of the sixteenth century. Albuquerque, New Mexico University Press, 1969.

239. Greenwood, Leonard. "Satirical weekly hits crackdown in Brazil. " Los Angeles Times Nov 14 1970 1:11.

240. Grimal, Pierre. The civilization of Rome. N. Y. , Simon and Schuster, 1963.

241. Grindel, Carl W. , ed. Concept of freedom. Chicago, Regnery, 1955.

242. Griswold, Alexander B. , et al. Art of Burma, Korea, Tibet. N. Y. , Crown, 1964.

242A. "Groton censors win: Trustees back down." Library Journal 96:1318 Ap 15 1971.

243. Gueron, E. "Turkey tightens censorship grip. " Christian Century 52:585 My 1 1935.

244. Hagen, Oskar F. L. Art epochs and their leaders. N. Y. , Scribner, 1927.

245. Haight, Anne Lyon. Banned books. 2d ed. N. Y. , Bowker, 1955.

246. ----- Banned books. 3d ed. N. Y. , Bowker, 1970.

247. Hallgren, Mauritz Alfred. Landscape of freedom: The story of American liberty and bigotry. N. Y. , Howell, 1941.

248. Hallis, Frederick. The law and obscenity. London, Desmond Harmsworth, 1932.

249. Hamilton, George Heard. Manet and his critics. New Haven, Yale University Press, 1954.

250. Haney, Robert W. Comstockery in America; patterns of censorship and social control. Boston, Beacon Press, 1960.

251. Hannay, Howard. Roger Fry, and other essays. London, G. Allen & Unwin, 1937.

251A. "Harlem catalog raises racist, censorship issues." Library Journal 94:1282-1284 Mr 15 1969.

252. Harris, Neil. The artist in American society; the formative years, 1790-1800. N. Y., Braziller, 1966.

253. Hartford, Huntington. Art or anarchy? How the extremists and exploiters have reduced the fine arts to chaos and commercialism. Greenwich, N. Y., Doubleday, 1964.

254. Hartt, Frederick. Sandro Botticelli. N. Y., Abrams, Pocket Books, 1953.

254A. Harvey, James A. Librarians, censorship, and intellectual freedom, an annotated bibliography, 1968-1969. Chicago, American Library Association, 1970.

255. Harvey, Richard S. "Law and humor of newspaper libel." Georgetown Law Journal 11:30-43 N 1921.

256. Haskell, Francis. Patrons and painters: A study in the relation between Italian art and society in the Age of the Baroque. N. Y., Knopf, 1963.

257. Hauser, Arnold. The social history of art (reprint, 4 vols). N. Y., Vintage, 1957-1958.

258. Hays, Arthur Garfield. Let freedom ring. N. Y., Liveright, 1937.

259. Hazeltine, Charles, ed. Narcissus scrap book. 1873.

260. Hefele, Karl Joseph von. A history of the councils of the church from the original documents. 5 vols. Edinburgh, Clark, 1876-1896.

261. Henderson, Ernest Flagg. Symbol and satire in the French Revolution. N. Y., Putnam, 1912.

262. Henderson, Helen W. The Pennsylvania Academy of Fine Arts. Boston, Page, 1911.

263. Henkin, Louis. "Morals and the Constitution: The sin of obscenity." Columbia Law Review 63:391-414 1963.

264. Herbert, Eugenia W. The artist and social reform, France and Belgium, 1885-1898. New Haven, Yale University Press, 1961.

265. Hess, Stephen and Milton Kaplan. The ungentlemanly art:

A history of American political cartoons. N. Y. , Macmillan, 1968.

266. Hess, Thomas B. "Them damn pictures. " Art News 62:23 My 1963.

267. Heywood, Angela F. T. Sex-symbolism--The Attucks Shaft (Leaflet Literature). Princeton, Mass. , Word Office

268. Hightower, John B. "From the class art to mass art. " Art in America 58:25 S 19 1970.

269. Hill, Draper. Mr. Gillray, the caricaturist. Greenwich, Ct. , Phaidon, distributed by New York Graphic Society, 1965.

270. Hitler, Adolf. Mein Kampf. N. Y. , Reynal & Hitchcock, 1939.

271. "Hitler purges German art. " Life 3:72 Ag 18 1937.

272. Hobbs, Perry. "Dirty hand, a federal customs officer looks at art. " New Republic 62:189-190 Ap 2 1930.

273. Hofmann, Werner, Caricature from Leonardo to Picasso. N. Y. , Crown, 1957.

274. Hollander, Barnett. The international law of art for lawyers, collectors, and artists. London, Bowes & Bowes, 1959.

275. Holt, Elizabeth Basye. Documentary history of art. 3 vols. N. Y. , Doubleday, 1957-1966.

276. ----- Literary sources of art history. Princeton, Princeton University Press, 1947.

277. Houston, Texas. University of Saint Thomas. Art Department. Builders and humanists: The Renaissance popes as patrons of the arts. Houston, 1966.

278. Huyghe, Rene. Art treasures of the Louvre. N. Y. , Abrams, 1960.

279. Hyde, Hartford Montgomery. A history of pornography. N. Y. , Farrar, 1965.

280. Illustrated history of the Reformation. St. Louis, London, Concordia Publishing House, 1967.

281. Imhoof-Blumer, F. W. and Percy Gardner. Ancient coins illustrating lost masterpieces of Greek art. 1885/1887, revised reprint. Chicago, Argonaut.

282. International Conference of Artists, Venice, 1958. The art-
ist in modern society (essays and statements collected by
UNESCO). Paris, UNESCO, 1954.

283. "International Convention for the suppression and circulation
of and traffic in obscene publications. " American Journal
of International Law 20:sup 178-191 0 1926.

284. "Is it 'Beautiful' or 'Shocking'?--public divided. " Chicago Sun-
Times Jy 1 1951. In Scrapbook of Art and Artists of
Chicago, p. 27, 1951.

285. Iversen, Erik. Canon and proportions in Egyptian art. Lon-
don, Sidgwick & Jackson, 1955.

286. Ivins, Willima M. , Jr. Art and geometry; a study in space
intuitions. Cambridge, Harvard University Press, 1936
Dover reprint.

287. Jackson, Naomi C. W. "Ernst Barlach: Gothick Modern. "
Art News 54:38-41 D 1955.

288. James, Henry. William Wetmore story. 2 vols. N. Y. ,
Crowell, 1957.

289. Jameson, Anna Brownell. Sacred and legendary art. 3d ed.
2 vols. Boston, Houghton, 1900.

290. Janson, H. W. The pleasures of painting. N. Y. , Abrams,
1953.

291. Jarrett, Bede. Social theories of the Middle Ages, 1200-
1500. Boston, Little Brown, 1926.

292. Jedin, Hubert. Ecumenical councils of the Catholic Church;
an historical survey. N. Y. , Herder and Herder, 1960.

293. Jenkins, Iredell. "The laissez-faire theory of artistic cen-
sorship. " Journal of the History of Ideas 1:71-90 Ja
1944.

294. Johnson, Priscilla. Khruschchev and the arts; the politics
of Soviet culture, 1962-1964. Cambridge, Mass. , M. I. T.
Press, 1970.

295. Joint Committee on Continuing Legal Education of the Ameri-
can Law Institute and the American Bar Association.
The problem of drafting an obscenity statute. Philadelphia,
The Committee, 1961.

296. Jones, Henry Stuart. Select passages from ancient writers
illustrative of the history of Greek sculpture. enlarged
ed. reprint. Chicago, Argonaut, 1966.

297. Joosten, Ellen. The Kroller-Muller Museum. N. Y., Shor-
 wood Publications, 1965.

298. Josephson, Matthew. "Vandals are here." Nation 177:244-
 248 S 26 1953.

299. Kallen, Horace M. Art and freedom; a historical and bio-
 graphical interpretation of the relations between the ideas
 of beauty, use, and freedom in western civilization from
 the Greeks to the present day. 2 vols. N. Y., Duell,
 Sloan and Pearce, 1942.

300. ----- Freedom in the modern world. N. Y., Coward-Mc-
 Cann, 1928.

301. ----- "Freedom of the arts." Gazette des Beaux-Arts (6th
 series) 28:5-26 Jy 1945.

302. ----- Indecency and the seven arts. N. Y., Liveright, 1930.

303. ----- "Of democracy and the arts." Journal of Aesthetics
 3:137 No. 9-10

304. Kamen, Henry Arthur Francis. The Spanish inquisition.
 N. Y., New American Library, 1965.

305. Kampf, Avram. Contemporary synagogue art. N. Y., Uni-
 versity of American Hebrew Congregations, 1966.

306. Kansas. University. Libraries. He who destroyes a good
 booke, kills reason it selfe; an exhibition of books which
 have survived fire, sword, and the censors. Lawrence,
 1955.

307. Kelley, Charles E. "Rights of artists and authors outside
 the copyright law." Cornell Law Quarterly (Ithaca, N. Y.)
 5:48-57 1919.

308. Kent. Norman. "No nudes is poor news for artists."
 American Artist 24:3 My 1960.

309. Khrushchev, N. S. "Krushchev lays down the line on the
 arts." New York Times Magazine p. 18 S 29 1957.

310. Kielland, Else Christie. Geometry in Egyptian art. London,
 Tiranti, 1955.

311. Knoedler and Company, New York. Classics of the nude...
 Loan exhibition, Polaiuolo to Picasso. April 10 to April
 29, 1939. N. Y.

312. Koefoed-Petersen, Otto. Egyptian sculpture in the Ny Carls-
 berg Glyptothek. Copenhagen, Bianco Lunos Bogtrykkeri,
 1962.

313. Komroff, Manuel. "Putting modern art in its place; Radio City Music Hall." Creative Art 12:37-49 Ja 1933.

314. Kroeber, Alfred Louis. Style and civilization. Ithaca, N. Y., Cornell University Press, 1957.

315. LAT: Los Angeles Times

316. LT: London Times

317. Kuh, Richard H. Foolish figleaves? Pornography in-and out of-court. N. Y., Macmillan, 1967.

318. La Barre, Weston. "Obscenity: An anthropological appraisal." Law and Contemporary Problems 20:533-543 1955.

319. La Farge, Henry, ed. Lost treasures of Europe. N. Y., Pantheon, 1940.

320. Lamont, Corliss. Freedom is as freedom does; civil liberties today. N. Y., Horizon, 1963.

321. Lane, Barbara Miller. Architecture and politics in Germany, 1918-1945. Cambridge, Mass., Harvard University Press, 1968.

322. Lange, Kurt and Max Hirmer. Egypt. 3d rev ed. London, Phaidon, 1961.

323. Langsner, Jules. "Art news from Los Angeles." Art News 53:54 S 1954.

324. ----- "Art news from Los Angeles." Art News 53:56 0 1954.

325. ----- "Art summoned before the Inquisition." Arts and Architecture 68:18 D 1951.

326. Larkin, Oliver W. Art and life in America. N. Y., Rinehart, 1949.

327. Larrabee, Eric. "Pornography is not enough." Harper's 221:87-88 N 1960.

328. Larter, Richard, et al. "Police action in Australia." Studio 179:45 F 1970.

329. "Lawlessness in art." Century 86:150 My 1913.

330. Lawrence, A. W. Classical sculpture. London, Jonathan Cape, 1929.

331. Lawrence, David Herbert. "Art and morality; what makes a picture really good." Living Age 327:681-685 D 26 1925.

332.　----- The portable D. H. Lawrence. N. Y., Viking, 1947.

333.　----- Sex, literature and censorship; essays. London, Heinemann, 1955.

334.　Lea, Henry Charles. A history of the Inquisition of the Middle Ages. 3 vols. N. Y., Harper, 1887.

335.　"Left about, Face! Backward March! Hep! Epstein's Day retouched." Art Digest 4:5 0 1 1929.

336.　Legman, Gershon. Love and death: A study in censorship. N. Y., Breaking Point, 1949.

337.　Lehmann-Haupt. Hellmut. Art under a dictatorship. N. Y., Oxford University Press, 1954.

338.　----- "Art under Totalitarianism." In The contemporary scene, a symposium, March 28-30, 1952. N. Y., Metropolitan Museum of Art, 1954.

339.　----- "German art behind the iron curtain." Magazine of Art 44:83-88 Mr 1951.

340.　Leith, James Andress. The idea of art as propaganda in France, 1750-1799. (Romance Series, No. 8). Toronto, University of Toronto, 1965.

340A. "Letters." Sculpture Review 9:26 Fall 1960.

341.　"Letting in light." Arts 7:303-304 Je 1925.

342.　Levy, Mervyn. "The naked and the prude." Studio 162:12-15 Jy 1961.

343.　-----, ed. Paintings of D. H. Lawrence. London, Cory, Adams, & Mackay, 1964.

344.　"Libel in a cartoon." Solicitors' Journal and Weekly Reporter, London 74:446 Jy 12 1930.

345.　"Liberalism since 1893." Art Digest 9:13 Ag 1935.

346.　"Life on the newsfronts of the world: Al Hirschfeld's 'Reclining Figure' drawing." Life 37:42 0 25 1954.

347.　Lipchitz, Jacques. Amedeo Modigliani. N. Y., Abrams, 1954.

348.　Lippmann, Walter. A preface to morals. N. Y., Macmillan, 1929.

349.　Lockhart, William B. and Robert C. McClure. "Censorship

405

and obscenity: The developing Constitutional standards. "
Minnesota Law Review 45:5-121 1960.

350. Logan, Josephine Hancock. Sanity in art. Chicago, A.
Kroch, 1937.

351. London. County Council. Sculpture 1850-1950. Exhibition
at Holland Park, London. May to September 1957. Lon-
don, The Council, 1957.

351A. Long Beach Independent Press Telegram.

352. Los Angeles Art Calendar. June/August 1969.

353. "Los Angeles bumps bump dancer out of show. " Art Digest
16:12 Mr 1 1942.

354. Los Angeles County Museum. The arts of the T'ang Dynasty,
a loan exhibition organized by the Museum from collec-
tions in America, the Orient and Europe. January 9-
February 7, 1957. Los Angeles, The Museum, 1957.

355. Loth, David Goldsmith. The erotic in literature. N. Y.,
Messner, 1961.

356. Low, Will H and Kenyon Cox. "Nude in art. " Scribner's
Magazine 12:741-749 D 1892.

357. Lullies, Reinhard and Max Hirmer. Greek sculpture. rev
ed. N. Y., Abrams, 1960.

358. Lunn, Betty. "From whitest Africa--a dark tale of censor-
ship. " Library Journal 95:131-133 Ja 15 1970.

359. Lynd, Robert. "Bounds of decency. " Atlantic 139:748-759
Je 1927.

360. Lynes, Russell. The tastemakers. N. Y., Harper, 1954.

361. Maas, Jeremy. Victorian painters. N. Y., Putnam, 1969.

362. McCoy, Ralph Edward. "The ABC's of Illinois censorship,
1965. " Illinois Libraries 48:372-377 My 1966.

363. ----- Freedom of the press; an annotated bibliography.
Carbondale, Southern Illinois University Press, 1968.

364. McDermott, John Francis and Kendall B. Taft. Sex in the
arts; a symposium. N. Y., Harper, 1932.

365. MacDougall, Curtis Daniel. Hoaxes. 2d ed. N. Y., Dover,
1958.

366. "McDougall shows Pusey the fatal weakness of his anti-cartoon bill and hurls defiance at him. " Philadelphia North American Ja 30 1903.

367. McKeon, Richard. The freedom to read: perspective and program. Published for The National Book Committee, New York, R. R. Bowker, 1957.

368. McLanathan, Richard B. K. "Art in the Soviet Union. " Atlantic 205:74-84 Je 1960.

369. Macneil, Sayre. "Some pictures come to court. " In Harvard legal essays written in honor of and presented to Joseph Henry Beale and Samuel Williston, 1934. Cambridge, Mass. , Harvard University Press, 1934.

370. McWilliams, Carey. Witch hunt: The revival of heresy. N. Y. , Little, Brown, 1950.

371. Maillard, Robert. Dictionary of modern sculpture. N. Y. , Tudor, 1960.

372. "Maine mural: Kennebunkport's angry citizens get ready to remove unwanted art. " Life 18:34 Ap 2 1945.

373. Male, Emile. The Gothic image: Religious art in France in the thirteenth century. N. Y. , Harper, 1958.

374. ----- Religious art from the twelfth to the eighteenth century. London, Routlege, N. Y. , Farrar, 1963.

375. Mallik, Jyotsna Nath. Law of obscenity in India. Calcutta, Eastern Law House, 1966.

376. Mangravite, Peppino. "Freedom of expression; excerpts from an address delivered before the annual meeting of the American Federation of Arts, New York, May 1947. " American Artist 11:47 S 1947.

377. Mankowitz, W. The Portland vase. London, Deutsch, 1952.

378. Maritain, Jacques. The responsibility of the artist. N. Y. , Scribner, 1960.

379. Markun, Leo. Mrs. Grundy: a history of four centuries of morals intended to illuminate present problems in Great Britain and the United States. N. Y. , London, D. Appleton, 1930.

380. Mathew, Gervase. Byzantine aesthetics. N. Y. , Viking, 1963.

381. "Matter of principle in New Mexico's capitol. " Time 56:25

0 16 1950.

382. Matthews, John F. El Greco. N.Y., Abrams, 1953.

383. Maurice, Arthur Bartlett and Frederic Taber Cooper. The history of the nineteenth century in caricature. N.Y., Dodd, Mead, 1904.

384. Maxwell, Everett C. "Value of the nude in art." Fine Arts Journal 24:2-11 1911.

385. Mayor, A. Hyatt. Callot and Daumier. N.Y., Print Council of America.

386. Mertz, Barbara. Temples, tombs and hieroglyphs. N.Y., Coward-McCann, 1964.

387. Metropolitan Museum of Art. American sculpture, a catalogue of the collection of the Metropolitan Museum of Art, by Albert Ten Eyck Gardner. N.Y., The Museum; distributed by New York Graphic Society, 1965.

388. ----- Art treasures of the Metropolitan. N.Y., Abrams, 1952.

389. Middleton, Lamar. "Chamberlain's bumbershoot; British cannot lampoon officials but the law is silent about umbrellas." Current History 50:30-31 Ap 1939.

390. "Mr. Comstock and the nude in art." Current Literature 41: 286-287 S 1906

391. Mitgang, Herbert. "As the visitors see Miss S. Morn." New York Times Magazine, p. 22 S 15 1957.

392. Mitsch, Erwin. Egon Schiele. 2d ed. Salzburg, Verlag Galerie Welz, 1967.

393. "Mitzi Solomon's sculpture 'Lovers' withdrawn from the National Association of Women Artists Exhibition." Art News 46:6 My 13 1947.

394. "Model undresses at University of Southern California." Art Digest 14:27 F 15 1940.

395. "Modigliani's series of reclining nudes." Life 45:87-93 N 24 1958.

396. Moody, Howard. "Toward a new definition of obscenity." Christianity and Crisis 24:284-288 Ja 25 1965.

397. Moon, Eric. "'A social experiment': Indecent Publications Tribunal." Library Journal 91:1371 Mr 15 1966.

398. Morley, Sylvanus Griswold. The ancient Maya. Stanford, Stanford University Press, 1947.

399. Morris European and American Express Co. v United States (1898) 85 Fed Rep 964--Cir Ct So Dist N. Y.

400. Morrow, Irving W. "Coit Tower murals again." Architect and Engineer 146:12 Ag 1941.

401. Mott, Frank Luther. American journalism. N. Y., Macmillan, 1950.

402. Muhlstock, Louis. "An excess of prudery." Canadian Art 5, No. 2:75-79 Autumn 1947.

403. Munro, Thomas. The arts and their interrelations. N. Y., Liberal Arts Press, 1949.

404. Murphy, Terence J. Censorship: Government and obscenity. Baltimore, Helicon Press, 1963.

405. Museum of Modern Art. German art of the twentieth century. N. Y., The Museum, 1957.

406. ----- The new decade; 22 European painters and sculptors, edited by Andrew Carnduff Ritchie. N. Y., The Museum, 1955.

407. Myers, Bernard S. Art and civilization. N. Y., McGraw, 1957.

408. NYH: New York Herald.

409. NYHT: New York Herald Tribune.

410. NYT: New York Times

411. NYW: New York World

412. "Naked Maja." Time 74:29-30 O 19 1959.

413. Neilson, William Allen. "The theory of censorship." Atlantic Monthly 145:13-16 Ja 1930.

414. Nelson, Harold L. Freedom of the press from Hamilton to the Warren Court. Indianapolis, Bobbs-Merrill, 1967.

415. ----- Law of mass communications: Freedom and control of print and broadcast media. Mineola, N. Y., Foundation Press, 1969.

416. New Catholic encyclopedia. 15 vols. N. Y., McGraw-Hill, 1967.

417. Newsletter on Intellectual Freedom. vol. 1, no. 1- . 1955-

418. "Newsworthy nude; September Morn." American Artist 21:6
N 1957.

419. Newton, Eric. "Art for Marx's sake in Russia." New York
Times 0 19 1947, VI, p. 8. "Letters of comment." N 2
1947, VI, 2:5; N 9 1947, VI, 4:5.

420. ----- Arts of man. Greenwich, Ct., New York Graphic
Society, 1960.

421. ----- Masterpieces of European sculpture. London, Thames
and Hudson, 1959.

422. Nicolson, Benedict. "The 'Raft' from the point of view of
subject matter." Burlington Magazine 96:241-249 Ag
1954.

423. Northrup, Filmer Stuart Cuckow. The complexity of legal
and ethical experience; studies in the methods of norma-
tive subjects. Boston, Little, Brown, 1959.

423A. "Nostalgia." Time 59:76 Mr 24 1952.

424. "Nude in Art" (review). Athenaeum (London) 110:459 0 2
1897.

425. "Nude in art; legitimate and illegitimate use discussed by
Professor Charles H. Moore, Harvard, and Charles
Henry South, Professor of American History, Yale."
Outlook 83:870-872 Ag 18 1906.

426. "The nude in museums." Atlantic 88:286-288 Ag 1901.

427. "O, Susanna!" Art Digest 6:17 N 1 1931.

428. "Obscene and indecent." Time 81:76-77 Ap 19 1963.

429. "Obscene literature and pictures" (editorial). American
Journal of Dermatology 15:442.

430. "Obscene prints." Justice of the Peace (England) 116:710-
711 N 8 1952.

431. "Obscenity in the arts." Law and Contemporary Problems
vol 20 Fall 1955.

431A. "Obscenity study brings indictments." Library Journal 96:
1312 Ap 15 1971.

432. Ogden, Robert Morris. The psychology of art. N. Y.,
Scribner's, 1938.

433. "One hundred years of Town and Country." Life 21:90 D 23 1946.

434. O'Neil, F. R. Social value in art. London, Kegan Paul, Trench, Trubner, 1939.

435. Oppe, A. Paul. "Art." In Young, G. M. Early Victorian England. London, Oxford University Press, 1934.

436. "Others didn't dare to destroy 'The Nightmare of 1934.'" Art Digest 9:12 O 15 1934.

437. Ott, Sieghart. Kunst und Staat. Der Kunstler zwischen Freiheit und Zensum. Munchen, Deutscher Taschenbuch-Verlag, 1968.

438. Overmyer, Grace. Government and the arts. N. Y., Norton, 1939.

439. Oxford English dictionary. 12 vols. Oxford, Oxford University Press, 1933.

440. "A panel discussion on censorship and pornography." Wilson Library Bulletin. 42:926-929 My 1 1968.

441. Panizo, Alfredo. Address on arts and morals at the opening exercises of the academic year 1954-1955, University of Santo Tomas, the Catholic University of the Philippines, Manila. Manila, University of Santo Tomas, 1954.

442. Panofsky, Erwin. Meaning in the visual arts. Garden City, N. Y., Doubleday, 1955.

443. "Papal puritanism." Art Digest 11:13 N 15 1936.

444. Parton, James. Caricature and other comic art in all times and many lands. N. Y., Harper, 1877.

445. Pattison, James William. "Public censorship of art." Fine Arts Journal 28:243-244 Ja/Je 1913

446. Paul VI, Pope. "The phenomenon of art in the light of faith." Liturgical Arts 32:38-39 F 1964.

447. Paul, James C. N. and Murray L. Schwartz. Federal censorship; obscenity in the mail. Glencoe, Ill., Free Press, 1961.

448. Paul Kantor Gallery. E. L. Kirchner. April 8-May 3, 1957. Los Angeles, The Gallery.

449. Pearson, Ralph M. Modern Renaissance in American art. N. Y., Harper, 1954.

411

450. Peckham, Morse. Art and pornography. N. Y., Basic, 1969.

451. Pelles, Geraldine. Art, artists and society: Origins of a modern dilemma; painting in England and France, 1750-1850. Englewood Cliffs, N. J., Prentice-Hall, 1963.

452. Perry, Ralph Barton. Puritanism and democracy. N. Y., Vanguard, 1944.

453. Petrazhitskii, Lev Iosifovich. Law and morality. Cambridge, Mass., Harvard University Press, 1955.

454. Pevsner, Nikolaus. Academies of art, past and present. Cambridge, Cambridge University Press, 1940.

455. Pickford, Ralph William. The psychology of cultural change in painting. Cambridge, Cambridge University Press, 1943.

455A. Pilpel, Harriet F. "But can you do that?" Publishers' Weekly 198:16-17 N 30 1970.

456. "Plaster pants for nude; Kankakee." Magazine of Art 30:450 Jy 1937.

457. Plato. Dialogues. 2 vols. translated by B. Jowett. N. Y., Random, 1937.

458. Plinius Secundus, Gaius. The Elder Pliny's chapters on history of art, translated by K. J. Blake. reprint. Chicago, Argonaut, 1968.

459. "Pocahontas vs. wildlife experts at Louisiana State Museum." Life 34:61-62 Je 15 1953.

460. "Political critics of art." Commonweal 64:241 Je 8 1956.

461. Pond, Irving K. "Art in a straight-jacket." Western Architect 32:2-6 Ja 1923.

462. Ponente, Nello. The structures of the modern world, 1850-1900. Geneva, Skira; distributed in the United States by World Publishing Co, Chicago, 1965.

463. "Poor policy: Jersey City Museum Association refuses to hang Ward Mount's 'Freedom from Dogma.'" Art Digest 26:5 Je 1952; discussion. 26:4 Jy 1952.

464. "Pope and the artists" (editorial). America 110:704 My 23 1964.

465. Pope-Hennessy, John. Introduction to Italian sculpture. vol. 1. Italian Gothic sculpture. London, Phaidon; Greenwich, Ct., New York Graphic Society, 1955.

466. "Prudery in medicine, in law, and in the fine arts." Medical Brief 32:852-855 0 1904.

467. "Prudish Bostonians ban nudist show now in San Francisco Museum." Architect and Engineer 152:4-5 F 1943.

468. Purcell, Ralph. Government and art, a study of American experience. Washington, D. C., Public Affairs Press, 1956.

469. "Puritanism edits the 'Spirit of Freedom,' Romano painting for Trenton Branch of the U. S. O." Art Digest 18:15 N 1 1943.

470. "Puritans; annual exhibition of Van Emburgh School of Art." Art Digest 7:21 Je 1933.

471. Putnam, George Haven. "Censorship in European history." Congressional Digest 9:34-35 F 1930.

472. "Putting art in its place." Nation 136:519 My 10 1933.

473. "A question of nudity; sculpture for San Francisco's 1939 Golden Gate Exposition." Art Digest 12:8 Mr 15 1938.

474. Raab, Clement. The twenty ecumenical councils of the Catholic Church. London, Longmans, 1937.

475. Raglan, Fitzroy Somerset. The temple and the house. N. Y., Norton, 1964.

476. Raphael, Max. The demands of art. Princeton, Princeton University Press, 1968.

477. Rau, Catherine. Art and society; a reinterpretation of Plato. N. Y., Smith, 1951.

478. Rave, Paul Ortwin. Kunst Diktatur im Dritten Reich. Hamburg, Gebr Mann, 1949.

479. Read, Herbert Edward. Art and alienation; the role of the artist in society. N. Y., Horizon, 1967.

480. ----- Art and society. new and rev ed. London, Faber & Faber, 1945.

481. ----- Concise history of modern sculpture. N. Y., Praeger, 1954.

482. ----- The grass roots of art; lectures on the social aspects of art in an industrial age. N. Y., Wittenborn, 1955.

483. ----- "The necessity of art." Saturday Review 52:24-27 D

413

6 1969.

484. Reau, Louis. Les monuments detruits de l'art francais; histoire du vandalisme. 2 vols. Paris, Hachette, 1959.

485. Reed, Alma. Orozco. N. Y. , Oxford University Press, 1956.

486. "Regina v Cameron" [1966] IV Canadian Criminal Cases 273-316.

487. Reith, Adolf. Monuments to the victims of tyranny. N. Y. , Praeger, 1968.

488. "The rejected picture. " New World (New York) VI:545-546 My 6 1843; VI:577 My 13 1843; VI:604-605 My 20 1843.

489. Renoir. Los Angeles, Los Angeles County Museum, 1955.

490. "Resolution on freedom. " Milwaukee Art Institute Bulletin 14:3 Mr 1940.

491. Rex, John. "Institutions and men. " The Listener 66:905-906 N 30 1961.

492. Rice, David Talbot. Art of the Byzantine era. N. Y. , Praeger, 1963.

493. Rice, Tamara Talbot. Ancient arts of Central Asia. London, Thames & Hudson; N. Y. , Praeger, 1965.

494. Rich, Daniel Catton. Edgar-Hilaire-Germain Degas. N. Y. , Abrams 1953.

495. Richardson, Edgar P. Painting in America, N. Y. , Crowell, 1965.

496. ----- The way of western art, 1776-1914. Cambridge, Mass. , Harvard University Press, 1939.

497. Richter, Giselle. A handbook of Greek art. 4th ed. London, Phaidon, 1965.

498. Richter, Hans. Dada: Art and anti-art. N. Y. , McGraw-Hill, 1965.

499. Rickards, M. , ed. Banned posters. London, Evelyn, Adams & Mckay, 1969.

499A. ----- Posters of protest and revolution. N. Y. , Walker, 1970.

500. Ripley, Elizabeth. Gainsborough, a biography. N. Y. , Lippincott, 1964.

501. Roberts, Edwin A. The smut rakers; a report in depth on obscenity and the censors. Silver Springs, Md. , National Observer, 1966.

502. Roemberg. "Satan, book jacket. " Life 32:96 Ap 14, 1952.

503. Rogers, W. G. Mightier than the sword: Cartoon, caricature, social comment. N.Y. , Harcourt, Brace & World, 1969.

504. Rolph, C. H. "Backward glance at the age of obscenity. " Encounter 32:19-28 Je 1969.

505. ----- "The literary censorship in England. " Wilson Library Bulletin 42:912-925 My 1968.

506. The romance of playing cards. Association of American Playing Card Manufacturers.

507. Rooses, Max. Art in Flanders. N.Y. , Scribners, 1931.

508. Rosenfeld, John. "Vigilantes riding. " Southwest Review 41: vi, 198-203 Spring/Summer 1956.

509. Roth, Cecil. Jewish art. N.Y. , McGraw-Hill, 1961.

510. ----- The Spanish Inquisition. N.Y. , Norton, 1964.

511. Rothenstein, John. British art since 1900. N.Y. , Phaidon, 1962.

512. Rothschild, Lincoln. Sculpture through the ages. N.Y. , McGraw-Hill, 1942.

512A. Saarinen, Aline. The proud possessors. N.Y. , Random, 1958.

513. St. John-Stevas, Norman. Obscenity and the law. London, Secker & Warburg, 1956.

514. Sakanishi, Shio. Spirit of the brush. N.Y. , Dutton, 1939.

515. Salinger, Margaretta. Michelangelo: the Last Judgment. N.Y. , Abrams, 1954.

516. Saltus, J. Sanford and Walter E. Tisne. Statues of New York. N.Y. , Putnam, 1922.

517. "San Francisco censors Bantam books cover. " Publishers' Weekly 187:54 Je 28 1965.

518. Sargeaunt, G. M. "Plato's quarrel with art. " Nineteenth Century 106:230-242 Ag 1929.

519. Scherer, Margaret R. Marvels of ancient Rome. N. Y.,
 Phaidon, 1956.

520. Schroeder, Theodore. Free speech bibliography: including
 every discovered attitude toward the problem, covering
 every method of transmitting ideas and of abridging their
 promulgation upon every subject matter. N. Y., Wilson,
 1922.

521. ----- "Obscene" literature and Constitutional law. N. Y.,
 privately printed, 1911.

522. ----- "Our prudish censorship." Forum 53:87-99 Ja 1915.

523. ----- "Varieties of official modesty." Albany Law Journal
 70:226 1908.

524. Schwarz, Karl. Jewish sculptors. Tell-Aviv, Jerusalem
 Art Publishers, 1954.

525. Scott, George Ryley. "Into whose hands"; examination of
 obscene libel in its legal, sociological and literary as-
 pects. London, Swan, 1945.

526. "Sculpture for 1939 Golden Gate Exposition, San Francisco,
 starts cultural storm." Life 4:14 F 21 1938.

527. Seldis, Henry J. "The biggest threat facing modern art."
 Los Angeles Times. Calendar:13 F 10 1963.

528. ----- "Lesson to be learned: Art and politics don't mix."
 Los Angeles Times. Calendar:12 Ap 24 1966.

529. ----- "Roualt prints: A memorable exhibition." Los
 Angeles Times. Calendar:28 0 29 1961.

530. Selz, Peter. Directions in kinetic sculpture. Berkeley,
 University of California Art Museum, 1965.

531. Seuphor, Michel. Sculpture of this century. N. Y., Brazil-
 ler, 1959.

532. Sewall, John Ives. History of western art. rev ed. N. Y.,
 Holt, 1961.

533. "Sex and the party line." Newsweek 47:45 Ja 23 1956.

534. Seznec, Jean. Survival of the pagan gods. N. Y., Pantheon,
 1935.

535. Shahn, Ben. "Nonconformity." Atlantic 200:36-41 S 1957.

536. Shapley, Fern Rush. Early Italian painting in the National

Gallery of Art. Washington, D. C., National Gallery of Art, 1959.

537. Sherman, George V. "Dick Nixon: Art commisar." Nation 176:20 Ja 10 1953.

538. Shikes, Ralph E. The indignant eye, the artist as social critic in prints and drawings, from the fifteenth century to Picasso. Boston, Beacon Press, 1969.

539. Short, Ernest Henry. The painter in the story. London, Hollis, 1948.

540. Showerman, Grant. "Art and decency." Yale Review, n. s. 11:304-314 Ja 1922.

541. Shufeldt, R. W. "Science and Art Protective Society." Medico-Legal Journal 37:3-6 Ja 1920.

542. Sigler, Jay A. "Custom censorship." Cleveland-Marshall Law Review 15:58-74 Ja 1966.

543. Simmins, Richard. "Police fail to prove obscenity charge against Douglas Christmas, owner of Douglas Gallery, Vancouver." Artscanada 24 [sup]:1-2 Spring/Summer 1967.

544. Sixty years of living architecture: The work of Frank Lloyd Wright. Los Angeles, Los Angeles Art Commission, 1954.

545. Sjoklocha, Paul and Igor Mead. Unofficial art in the Soviet Union. Berkeley, University of California Press, 1967.

546. "Skirts for statues." Art Digest 8:15 S 1934.

547. "Slime: Whistler and Zorn etchings: Painting by Ferstadt." Art Digest 6:12 D 1 1931.

548. Slocombe, George. Rebels of art. N. Y., McBride, 1939.

549. Smyth, Henry D. "The place of science in a free society." American Scientist 38:426-436 Jy 1950.

550. Soby, James Thrall. "Art as propaganda." Saturday Review of Literature 32:30-31 My 7 1949.

551. ----- "Regimes and reaction." Magazine of Art 44:82 Mr 1951.

552. ----- Salvador Dali. N. Y., Museum of Modern Art; distributed by Simon and Schuster, 1946.

553. Social meaning of legal concepts, No. 5. Protection of public morals through censorship. N. Y., New York Univer-

sity Law School, 1953.

554. Soper, Alexander Coburn. "Early Buddhist attitudes toward the art of painting." Art Bulletin 32:147-151 Je 1950.

555. Spelman, Leslie P. "Calvin and the arts." Journal of Aesthetics and Art Criticism 6:246-252 Mr 1948.

556. Spingarn, J. H. "Huntington Cairns, federal censor." American Mercury 68:683-691 Je 1949.

557. "Spirit of Detroit." Time 21:26 Ap 3 1933.

557A. "A spurned sculptor triumphs." Life 33:65-66 N 3 1952.

558. Staley, John Edgcumbe. The guilds of Florence. 2d ed. London, Methuen, 1906.

558A. Steichen, Edward. "Brancusi vs. United States." Art in America 50 no 1: 56-57 1962.

559. Stone, J. M. Reformation and Renaissance. N. Y., Dutton, 1906.

560. "Story behind the painting: Cranach: The impish nudes." Look 23:64-65 Ja 20 1959.

561. Strong, D. E. Roman Imperial sculpture. London, Tiranti, 1961.

562. Stuart, Evelyn Marie. "Inconsistency of censors." Fine Arts Journal 31:347-350 Jy /O 1914.

563. "Studio narrowly avoids censorship." Publishers' Weekly 135:1127 Mr 18 1939.

564. Sullivan, Michael. An introduction to Chinese art. London, Faber, 1961.

565. Sumner, John S. "Decency crisis." Good Housekeeping 107: 26-27 Ag 1938.

566. "Sumner's insult." Art Digest 6:16 N 15 1931.

567. Symposium on the artist in tribal society. London, Routledge, 1961.

568. Taft, Lorado. History of American sculpture. N. Y., Macmillan, 1930.

569. Taylor, Francis Henry. Fifty centuries of art. N. Y., Harper, 1954.

570. ----- Taste of angels. Boston, Little, Brown, 1948.

571. Taylor, Harold. Art and intellect; moral values and the ex-
 perience of art. N.Y., Published for the National Com-
 mittee on Art Education by the Museum of Modern Art;
 distributed by Doubleday, Garden City, N.Y., 1960.

572. Taylor, John Francis Adams. The masks of society. N.Y.,
 Appleton, 1966.

573. Taylor, Robert Lewis. Vessel of wrath: the life and times
 of Carrie Nation. N.Y., New American Library, 1966.

574. "Texas insists that its pioneers be clothed and decent."
 Newsweek 7:48 Ap 18 1936.

575. Thomas, Donald. "Fat men on thin ice." Studio 175:224-
 230 Ap 1968.

576. ----- A long time burning: the history of literary censor-
 ship in England. N.Y., Praeger, 1969.

577. Thomas, John Lilburn. Lotteries, frauds and obscenity in
 the mails. Columbia, Mo., Press of E. W. Stephens,
 1900.

578. Thorp, Margaret Farrand. "Rediscovery, a lost chapter in
 the history of nineteenth-century taste: The nudo and the
 Greek Slave." Art in America 49:46-47 1961.

579. Time Magazine. Time Capsule. N.Y., Time-Life Books,
 1967/68-1923, 1925, 1927, 1929, 1932, 1933, 1939-45, 1950,
 1956, 1959, 1968.

580. Tolstoy, Leo. What is art? and essays on art. London,
 Oxford University Press, 1930.

581. Tomars, Adolph S. "Class system and the arts." In
 Cahnman, Werner Jacob and Alvin Boskoff, eds. Socio-
 logy and history. N.Y., Free Press, 1964.

582. Tompkins, Calvin. Merchants and masterpieces: the story
 of the Metropolitan Museum of Art. N.Y., Dutton, 1970.

583. Traquair, Ramsay. "Cult of the rebel." Atlantic 152:357-
 365 S 1933.

583A. Treue, Wilhelm. Art plunder, the fate of works of art in
 war and unrest. N.Y., John Day, 1960.

584. Trobridge, George. "Nude in art and semi-nude in society."
 Westminster Review 164:303-310 S 1905.

585. Tuberville, Arthur Stanley. The Spanish Inquisition. London, N. Y. , Oxford University Press, 1932.

586. "Tyomies Publishing Company v United States. " 211 Federal Reporter 385 1914.

587. "Unconsecrated church: Too unorthodox for use by the Catholics, it is now a Brazilian national monument. " Life 25: 76-77 Jy 4 1949.

588. Unger, Giselle D'. "Censorship, U. S. " American Art News 11:10 Mr 29 1913.

589. United States Bureau of Customs. Customs regulations of the United States, 1969; with revised pages to Customs Regulations through June 3, 1970. Washington, D. C. , United States Government Printing Office, 1969-

590. United States Congress. House Committee on Un-American Activities. The American National Exhibition, Moscow, July 1959 (The Record of Certain Artists and an Appraisal of Their Works Selected for Display). Hearings, July 1, 1959. 86th Congress, 1st Session. Washington, D. C. , Government Printing Office, 1959.

591. ----- Control of the Arts in the Communist Empire, consultation with Ivan P. Bahriany, June 3, 1959. 86th Congress, 1st Session. Washington, D. C. , Government Printing Office, 1959.

592. United States Customs Court. 3d Division. Sculptures, works of art, originals. C. Brancusi vs United States. 1928.

593. United States v. One Unbound Volume of a Portfolio of 113 Prints Entitled "Die Erotik der Antike in Kleinkunst und Keramik. " 128 F. Supp. 280 (D. D. Maryland) (1955).

594. United States v. Three Cases of Toys. 28 Fed Cas 112, No. 16499 S. D. N. Y. (1843).

595. "Unmailable 'Naked Maja, ' and Spanish postage stamp. " Illustrated London News 234:517 Mr 28 1959.

596. "An Un-P. O. etic view. " Art Digest 18:19 F 1 1944.

597. Upjohn, Everard M. History of world art. 2d ed. N. Y. , Oxford University Press, 1958.

598. Vaillant, George Clapp. The Aztecs of Mexico. N. Y. , Penguin, 1950.

599. "Vandalisme legal. La separation de l'Eglise et de l'Etat. "

Revue de l'Art Chretien 55:213-214, 280-282 My, Jy 1905.

600. Vandier, Jacques. "Egypt." Courier 7:23-29 F 1955.

601. Vasari, Giorgio. Lives of seventy of the most eminent painters, sculptors and architects. 4 vols. N.Y., Scribner's, 1911.

602. Vasiliev, Alexander Alexandrovich. "The iconoclastic edict of Caliph Yazid II, A.D. 721." Dumbarton Oaks Papers No. 9-10:23-47 1956.

603. Vaudoyer, Jean Louis. The female nude in European painting, from pre-history to the present day. N.Y., Abrams, 1957.

604. Vellinghausen, Albert Schulze. "Art as evidence of freedom." Atlantic 19:127 Mr 1957.

605. Veth, Cornelis. Comic art in England. London, Goldston, 1930.

606. Villard, Oswald Garrison. "Sex, art, truth, and magazines." Atlantic Monthly 137:388-398 Mr 1926.

607. Vincent, Howard P. Daumier and his world. Evanston, Northwestern University Press, 1968.

608. Vincent, Jean Anne. History of art. N.Y., Barnes & Noble, 1955.

609. Waldberg, Patricia. Surrealism. Cleveland, World, 1962.

610. Watson, Bruce Allen. "The social control aspects of art, with reference to painting, sculpture, and architecture." University of Southern California thesis (typewritten), Sociology, 1955.

611. Watson, Ernest W. "Vandals are here," reply to M. Josephson. American Artist 17:3 N 1953.

612. Watts, Alan. "Sculpture by Ron Boise: The Kama Sutra theme." Evergreen Review 9 (no. 36):64-65 Je 1965.

613. Webber, George. "Art and the law." Solicitor (England) 27:170, 172-173 Je 1960.

614. Weber, Max. Protestant ethic and the spirit of capitalism. London, Gallen & Unwin, 1930.

615. Wechsler, Herman J. French Impressionists and their circle. N.Y., Abrams, 1953.

616. Weeks, Edward. "The practice of censorship. Atlantic

Monthly 145:17-25 Ja 1930.

617. Wegner, Max. Greek masterworks of art. N.Y., Braziller, 1961.

617A. Weinstock, Matt. "Travels of a naked lady." Los Angeles Times G:7 Ag 16 1964.

618. Weisberg, David B. Guild structure and political allegiance in early Aechaemenid Mesopotamia. New Haven, Yale University Press, 1967.

619. Werner, Alfred. "Eternal Olympia." American Artist 29: 48-53 Ap 1965.

620. ----- "Hitler's Kampf against modern art: a retrospect." Antioch Review 26:56-67 Spring 1966.

620A. ----- Maurice Utrillo. N.Y., Pocket Books, 1953.

621. "What shall we do with the nude in art" (Sunday Tribune, Chicago). Fine Art Journal 23:321-328 D 1910.

622. "When is a nude? 'Studio' banned from the mails." Art Digest 13:56 Mr 15 1939.

623. Whinney, Margaret. Sculpture in Britain, 1530-1830. Baltimore, Penguin, 1964.

624. Whipple, Leon. The story of civil liberty in the United States. N.Y., Da Capo, reprint of 1927 ed.

625. White, Harrison C. and Cynthia A. White. Canvases and careers; institutional change in the French painting world. N.Y., Wiley, 1965.

626. Whitehead, Don. Border guard; the story of the United States Customs Service. N.Y., McGraw-Hill, 1963.

627. Whitley, William T. Art in England, 1800-1820. Cambridge, Cambridge University Press, 1928.

628. Wight, Frederick S. Goya. N.Y., Abrams, 1954.

629. ----- "The revulsions of Goya." Journal of Aesthetics 5:3 S 1946.

630. Wilenski, Reginald H. English painting. Boston, Hale, Cushman and Flint, 1937.

631. "Will Texas Miss: William Zorach's model for monument to pioneer women." American Magazine of Art 29:413 Je 1936.

632. Wind, Edgar. Art and anarchy. N. Y., Random, 1969.

633. Woldring, Irmgard. Art of Egypt. N. Y., Crown, 1963.

634. Wood, A. L. S. "Keeping the Puritans pure." American Mercury 6:74-78 S 1925.

635. "Would nude statues, pure as a dew-drop, debauch Roxy's public." Art Digest 7:7 Ja 1 1933.

636. Y (Theodorakis). "Greece: Cultural freedom in the gangster state." New York Review of Books My 21 1970 p. 27-30.

637. Zahar, Marcel. Gustave Courbet. N. Y., Harper, 1950.

638. Zellick, Graham. "Violence as pornography." Criminal Law Review (England) Ap 1970 p. 188.

639. Zevi, Tullia. "The Biennale: How evil is pop art?" New Republic 151:32-34 S 19 1964.

640. Zigrosser, Carl. Kaethe Kollwitz. N. Y., Bittner, 1946.

641. Zuckman, Harvey Lyle. "Obscenity in the mails." Southern California Law Review 33:171-188 1960.

Index references are to date of listing in the Chronology of Censored Art. Listings are arranged in order of date from general to specific, as:

century	19th c.
range of decades	1860's-1870's
decade	1860
range of years within decade	1860-1867
approximate year	c 1860 (or 1860?)
year	1860
month	1860 My
day	1860 My 1

Identical dates are distinguished by letters in parenthesis following the date, as:

1860 My 1 (A)
1860 My 1 (B)
1860 My 1 (C)

"Academie des Dames"
 destroyed in Paris, as ob-
 scene 1822 N 16 (A)
Academie Francaise
 Carner caricature of, banned
 1931 Ja 29
Academies of Art
 Artists trained as professionals
 16th c (B)
 China, founded 1125 (B)
 England, Royal Academy
 opened 1769 Ja 2
 Florence, established 1563
 Ja 13
 Guild restrictions inapplicable
 to members 1773 (A)
 Paris, foundation meeting 1648
 F 1
 Russian artists revolt against
 St. Petersburg Academy
 1862
 Vienna members exempt from
 Guild 1726 (A)
Accademia del Disegno, Florence
 Ammanati letter to, censor-
 ing own nudes 1582 Ag 22
Accademia di San Luca, Rome
 Petitioned Clement VIII not to
 destroy Michelangelo "Last
 Judgment" 1596
 Ruled against non-academic
 artists 1714
Act of 1734 for the Encouragement
 of the Arts of Designing,
 Engraving and Etching His-
 torical and Other Prints 1734
L'Action Catholique, Quebec
 Bonnard "Buste de Femme,"
 censored 1947 F 11
"L'Action Enchainee." Maillol
 1905 (B)
"Actualities." Vernier 1851 Ap 17
Ada, Ohio
 Normal School "Apollo,"
 draped 1922 Ap 9 (B)
"Adam." Epstein 1939 Je (B)
"Adam and Eve." Bandinelli
 Censured 1549
 Removed from Florence
 Cathedral 1488
"Advancing American Art" 1947 Ap
Advertiser, Montgomery, Alabama
 Spangler "Cartoon Mirror,"

 anti-cartoon legislation
 drawing 1915 F 3
Advertising Art See also Signs
 and Signboards; Transit
 Advertising
 "Love Nest," advertising figures,
 censored 1922 Ap 9 (A)
 Paintings owned by liquor com-
 pany, banned as liquor ad-
 vertising 1964 Ja 22
Aesthetics See Esthetics
"After the Bath." Wencker 1884
 O 7
"L'Age d'Arain." Rodin 1875 (A)
"L'Age d'Or." Dali and Bunuel
 1928 (B); 1931 (C)
"Age of Bronze." Rodin 1875 (A)
"Age of Steel." Rivera 1952 Mr 24
Agnellus, Brother
 Defrocked for pulpit pictures
 1083?
Agnus Dei
 Efficacy as charm 1471
Agorakritos
 Lost Athens prize, as
 foreigner 453-448 B.C.
"Aida," Vienna memorial figure,
 draped 1934 Je 15
Aitken, Robert Ingersoll
 Brancusi "Bird in Space,"
 expert witness 1928 N 26
Ajanta Cave Paintings c 200 B.C.-
 500 A.D.
al-Hilli
 Mohammedan proscription of
 pictures 1270's
al-'Umari
 Mohammedan proscription of
 zoological illustration c 1340
Alabama
 Anti-cartoon legislation attempt
 1915 F 3
 "Whistler's Mother," parody de-
 picting Negro, banned 1966
 Ap 14
Alaric
 Plundered Rome 410 Ag 24
Albany, New York
 Daly "Society," censured 1969
 Ja 23
Alberti, Leon Battista
 De Re Aedificatoria 1485
 Della Pittura 1436

Albigenses
 Iconoclasm 16th c (E)
Albreaux, Robert 1969 My 22
Albright, Thomas 1969 My 22
Albright-Knox Art Gallery,
 Buffalo
 Classic nudes, ordered draped
 or segregated 1911 Mr 6
 (ILLUS 20)
"Album Anecdotique, n. 16"
 Destroyed in Paris 1833 Ap 23
"Album Heretique"
 Destroyed in Paris 1842 Ap 9
 (A)
Alcamenes
 Hephaestus statue 440? B.C.
 Won Athens prize over foreign-
 er 453-448 B.C.
Alcoholism in Art See Intoxication
 and Liquor
Alesandro, Thomas D. 1955 N
Alexander the Great
 Official artists 328-325 B.C.
 Plunder of Persepolis 330 B.C.
Alien and Sedition Acts, United
 States
 Forbade criticism of govern-
 ment 1798-1800
Alien Registration Act, United
 States 1940 (B)
"All Art Must be Propaganda,"
 Stalin dictat 1932 Ap 23
Allegory in Art
 Church art 1563 D 4
 Libel, England 1729
 McMonnies "Civic Virtue,"
 censured 1922 Mr
Allied Artists of America
 Urged art juries be composed
 of artists 1960 S?
Alma-Tadema, Lawrence
 Expert witness 1892 Ap 27
 Fry criticized 1969 Mr 18
Alphabet
 Piero della Francesca
 described in human figure
 proportions 1591
Altars and Reredos
 Cistercians prescribed
 carving 1240
 U.S. Customs, ruled "not art"
 1898 (D)

Alvarez, Enrique
 "The Family," removed from
 Municipal Courts Bldg
 1951 Mr 7
Amandola
 Iconoclasm 1568
"L'Amant Heureux," engraving
 Destroyed in Paris, as obscene
 1822 Ja 14 (E)
"L'Amant Pressant," engraving
 Destroyed in Paris, as obscene
 1822 Ja 14 (E)
"Les Amants Surpris," engraving
 Destroyed in Paris, as obscene
 1822 Ja 14 (E)
Amen
 Name and representation erased
 1375-1358 B.C.
 Statues destroyed 1200 B.C.
"America the Beautfful." Kerciu
 1963 Ap 6
American, New York City
 Fisher "Mutt and Jeff" suit
 1916 (C)
American Aphrodite 1898 (B)
American Artists Congress
 Criticized censorship 1937 D 19
 Organized to bring artists into
 trade union 1936 F
American Artists Professional
 League, United States
 Censured U.S. State Dept
 touring exhibits 1947 Ap
 Dondero demanded Communist
 members be expelled 1949
 Mr-O
 Lobbied for protective tariff on
 contemporary foreign art
 works 1929 (A)
 Lobbied to require only Ameri-
 can artists paint U.S. official
 portraits 1931 (A)
 Obtained legislation requiring
 artists decorating U.S.
 buildings be American
 citizens 1933
 Urged art juries be composed
 of artists 1960 S?
American Association of Museums
 Clarification of U.S. Customs
 law on import of abstrac-
 tions sought 1950 Ap 30

Amphitriatroff, M.
Issued copies of Russian censored art 1906 Mr 10
Amsterdam
Minne "Mother and Child," censured 1938 My 16
Amulets See Charms and Amulets
Anand, Mulk Raj
Illustrations for his article on Konarek erotic sculpture, not obscene 1961 Mr
Anathema
Germanus anathematized as "wood worshipper" 754 Ag 27
Iconoclasts against 867
Iconodules, Council of Hieriea 754 Ag 27
Painters anathematized forbidden to paint church images 869-870
Anatomy See also Life Classes
Restrictions on study, for woman art student 1850 (A)
Anderson, Earl M. 1959 F 13
Anderson, William H.
Caricatured in Prohibition satire 1924 N 29
Andrieu, Jean Bertrand
Engraver of "official pattern" of playing cards in France 1810 (B)
Angeles Temple, Los Angeles
Miller. Apparition Over Los Angeles," removed from exhibit 1932 Ap 17
Angels in Art
Borglum, G., destroyed his angels branded heretical c 1914
Improper in Bible illustrations 17th c (E)
Michelangelo misinterpreted in "Last Judgment" 1564
Angiviller, Comte d'
Official French view of Art: Teach Moral Lesson 1774 (B)
Aniconism See God in Art; Iconoclasm
Animals, Imaginery, in Art
Bernard of Clairvaux censured

1125 (A)
Chinese color code 1679
Animals in Art See also Dogs; Pigs
Anti-Defamation League Rabbit Brothers, removed from public schools 1956 N
Ballin "Four Freedoms" mural, draped to conceal ass's ears 1970 Ja (A)
Bovil bull poster, censored 1894 D 1
Brancusi "Bird in Space," U. S. Customs suit 1928 N 26
Dove, forbidden as Holy Ghost symbol 313
Jewish proscription 13th c. B. C.
Mohammedan encyclopedia abstained from zoology illustration c 1340
Mohammedan proscription 622?
Mohammedans destroy mosaic representations 721 Jy
Pusey, proposed anti-cartoon bill, forbade depicting men as animals or birds 1902 0 19
Rabbi Meir proscribed prayer book illumination 13th c (A)
Tia Vicenta, banned for walrus caricature of Argentine president 1966 Jy
Williams The Rabbits Wedding, censored 1959 My (A)
Annals of the American Academy of Political and Social Sciences
Report considered freedom in visual arts 1938 N
"The Annunciation." Masci 1959 My 18
Anthropometry and Anatomy for Artists
Banned by U. S. Postoffice 1954 (A)
Anti-Caricature Legislation See Caricatures and Cartoons
Anti-Cartoon Legislation See Caricatures and Cartoons

Anti-Clericalism See Clergy in
 Art
Anti-Defamation League
 Arkansas project protested
 1970 Ja 24
 Rabbit Brothers, ordered re-
 moved from public schools
 1956 N
Anti-Luxury Laws See Sumptuary
 Laws
Anti-Papism See Pope in Art
Antiquities, Rome
 Destroyed 1448
 Paul III edict allowed destruc-
 tion 1540 Jy 22
 Protected by papal bull 1462
 Ap 28
 Raphael reproved Leo X De-
 struction 1514?
 Urban VIII destruction 1623-
 1644
Anti-Semiticism See also Art and
 Race; Jews
 Bauhaus, Dessau, dispersed as
 "Jewish-Marxist" center
 1932 0 1
 "Christ of Ozarks Project, "
 protested 1970 Ja 24
 Harlem On My Mind, catalog
 censored 1969 Ja 30
Antoninus, Saint
 Condemned errors of artists
 1477?
Apel, Karel
 Work in Kronhausen erotic art
 exhibit, admitted to U. S.
 1970 Mr 5
Apelles
 Official portrait painter to
 Alexander the Great 328-325
 B. C.
Aphrodite
 Praxiteles nude Cnidian Aphro-
 dite, refused by Cos 364-
 361 B. C.
 Siena statue, banished 1357 N
 7
"Apocalypse. " Gill 1939 F
"Apollo"
 Ada, Ohio, Normal School,
 draped 1922 Ap 9 (B)
 Buffalo censured nudity 1911

Mr 6
 Greek convention 5th c B. C.
"Apollo and Daphne. " Bernini
 1624?
"Apollo Belvedere"
 Everett censorship 1836-1840
 Objected to in Royal Academy
 Galleries, London 1796?
"Apotheose de Bonaparte, " en-
 graving
 Destroyed in Paris, as sedi-
 tious 1823 Ag 26 (A)
"Apotheose des Quatre Condamnes
 de la Rochelle, " engraving
 Destroyed in Paris, as sedi-
 tious Ag 26 (B)
"Apotheosis of Hoche. " Gillray
 1817
"Apparition Over Los Angeles, "
 Miller 1932 Ap 17
Applied Arts See "Fine" Arts vs.
 "Mechanical" Arts
Apprenticeship See also Guilds
 Genoa Guild statutes 1590
 (B)
"Les Apprets du Bel, " engraving
 Destroyed in Paris 1824 Ap
 9 (B)
"The Archer. " Geiger 1913 S
Archipenko, Alexander
 Works proscribed by Nazis
 1937 Jy 8; 1937 Jy 18
Architectural Symbolism
 Church porches 13th c (B)
 Churches, 13th c. 1286
Architects
 Nazis dismissed public and
 professional officers 1933
 Mr 12
 Royal Architect Ledoux, im-
 prisoned 1773 (C)
Architects' Handbooks and Manu-
 als
 Alberti. De Re Aedificatoria
 1485
 Lomazzo. Tratto dell'Arte
 pittura, scultura, ed archi-
 tettura 1584 (A)
 Vitruvius 1st c. B. C.
Architecture See also Bauhaus;
 Golden Section
 Architect Eustice home, banned
 1969 S 19

"International Style, " banned
by Nazis 1930's (A); con-
demned by Russia 1930's (C)
Nazis destroyed work not meet-
ing their standard 1930 (C)
Netherlands freed from Guild
1773 (D)
Reproductions of erotic art
obscene 1952 (C)
Too advanced Maillart bridges,
censored 1917-1940
U. S. Customs ruled "not art"
1898 (D)
Wright refused building permit
1921

Architecture--Orders
Vitruvius prescribed for speci-
fic Temples 1st c. B. C.

Architecture, Classical
Notre Dame gothic arches
made classical for Napoleon
coronation 1804 (A)

Architecture, Mayan
Hieratic prescriptions 300-900

Architecture, Roman
Classical Canons, abandoned
4th c. (A)

Architecture and State
Plato required state enforce-
ment of rules for c 387
B. C.

Architecture As a Profession
German professional organiza-
tion excluded members on
racial and political grounds
1933 S
Licensure requirements criti-
cized 1923 Ja

Arco, Duke d'
Charged Torrigiano with sacri-
lege for smashing Madonna
statue 1522

"Ardlamont Mystery"
Tussaud wax figure, a libel
1894 Ja

"L'Aretin Francais, " book with
engravings
Ordered destroyed 1825 F 25 (B)

Aretino, Pietro
Attacked Michelangelo "Last
Judgment" as licentious
1541 0 31
Sonetti Lussuriosi, suppressed

1527 (B)
Wrote Michelangelo re Gregory
the Great pagan art destruc-
tion 590-604

Aretino's Postures
Raimondi, from suppressed
Giulio Romano "Posizioni"
1527 (B)

Arezzo
Tarlati Monument, defaced
1341

Argan, Giulio Carlo
Socio-political ideology dis-
counts individual in art
1963 (C)

Argentina
Communist art proscribed
1943 S
Plate painting banned, to
avoid graffiti 1968 My 30

Argentine National Prize
Government banned award to
Berni 1943 S

Argimon, Daniel
Collage with garter belt,
banned 1965 (A)

"Ariadne. " Vanderlyn 1815

Aristotle
"Unseemly pictures" 335-322
B. C.

Aristophanes. Lysistrata
Beardsley erotic illustrations,
censured 1898 (B);
indecent 1967 Ja 30;
seized 1966 Ag 10
Lindsay illustration, charged
obscene by U. S. Postoffice
1954 Ag

Arlington, Virginia
Architect Eustice home,
banned 1969 S 19

Armenia
Iconoclasm c 600

Armory Show
Chicago 1913 Je?
Dondero labeled "red plot"
1949 Mr-0
New York City 1913 F 17-Mr
15

Arnautoff, Victor
"Dick McSmear, " Nixon,
caricature, banned 1955 S
16

downfall 1870 (B)
Nazi official policy: Criticism
a political question 1937 Mr
15
Powers "Greek Slave, " com-
mentary on Turkish-Greek
war 1847-1851
Rivera mural, deleted from
exhibit of Mexican art for
Paris display 1952 My
Salon de Mayo, Barcelona,
works rejected 1967 My (A)
Stadler's poster advocating
votes for women, suppressed
1914 Mr 8
U. S. State Department, re-
called touring exhibits 1947
Ap
Art and Race See also Jews;
Nazis; Negroes
American Artists Congress,
attacked discrimination
against Negro artists 1937
D 19
Anti-Defamation League Rabbit
Brothers, removed from
public schools 1956 N
Bannerman Little Black Sambo,
removed from public schools
1964 0 19
Bauhaus styles, charged "Ori-
ental-Jewish-Bolshevist"
1933 Ap 11
British refuse German invita-
tion to Berlin exhibit with
racial and political restric-
tions 1937 (B)
Comic strip exhibit, under-
ground press 1969 My 20
Czech artists group demanded
proof of Aryanism 1938 D
Edwards poster for Fairbain's
Five Smooth Stones, banned
1968 Jy (A)
Georgia, reportedly demanded
Klansmen be included in
"Confederate Memorial"
1925 (D)
German architects professional
organization had racial and
political requirements 1933
S
German monopolistic Art Cham-

ber, excluded "racially in-
ferior artists" 1933 My
Harlem On My Mind, cen-
sored 1969 Ja 30
Hitler comment 1930 (C)
Rivers sculpture, banned
1966 (B)
Schultze-Naumberg Art and
Race, Nazi aesthetics 1928
(A); official Nazi doctrine
1930 (B); 1930 (C)
Stzydowski Aryan art views
1910-1940
Williams Rabbits Wedding,
censored 1959 My (A)
Art and Race. Schultze-Naum-
berg 1928 (A); 1930 (B);
1930 (C)
Art and Religion
France voted to remove pub-
lic crosses and religious
figures 1950 Je 9
Renzi sculpture, censured
1969 Mr (B)
Art and Science
American Journal of Derma-
tology, suppressed for
scrotal surgery illustra-
tions 1911 Je
Anthropometry and Anatomy
for Artists, banned from
U. S. mails 1954 (A)
Brazil exempted scientific,
technical and educational
books from censor 1970
Mr 1 (B)
Covington, archaeologist, sen-
tenced for obscene pictures
in home 1922 My 8
Indian obscenity law, exempted
works for professional study
1963 (A)
Moens tried for possessing
ethnological nudes 1919
Pronographic Chinese art, ad-
mitted to U. S. for scientific
study 1958 (C)
U. S. Customs detained Field
Museum imports as obscene
1909 (B)
Art and Society See also names
of artists, as Courbet;
Daumier; Gericault: Goya;

Art Patronage
 Alexander limited his represen-
 tation to appointed artists
 328-325 B. C.
 Queen Elizabeth, England, for-
 bade Hilliard to shadow
 portraits 1570's
Art Promotion
 Censorship, effective publicity
 1940 Ag
 Chabas "September Morn, "
 famous from Reichenbach
 promotion 1913 My 14
 "Erotic Art '66" 1966 0 6
 Kronhausen "First Interna-
 tional Exhibition of Erotic
 Art" 1968 My (A)
 Radio City Music Hall censor-
 ing of nude statues, charged
 publicity stunt 1932 D 12
 United Artists motion picture
 "Nude Maja" 1959 0 4
Art Reproductions See Repro-
 ductions of Works of Art
Art Sales and Prices
 Art acceptable in art collec-
 tion, may be "unfit for
 sale" 1931 N
 Degenerate art commerce,
 forbidden by Nazi 1937 Ag
 4
 El Greco won suit against
 Hospital de la Caridad for
 altar payment 1607 My
 France, Painters' Guild mem-
 bers alone could sell paint-
 ings 1600 (B)
 Germany forbade banned art-
 ists to sell works 1933 My
 Hague limited art sale during
 Fairs to Pictura members
 1655
 Hungarian paintings are priced
 by size and number of per-
 sons in canvas 1953 Ag 29
 Mohammedan proscription of
 picture buying or selling
 1270's
 Nude, sale potential 1952 Mr
 Paris Academy of Art limited
 member sales of art 1648
 F 1
 Rivera rights to Rockefeller

Center Mural, terminated
 with sale 1933 My 22
 Rogers "Slave Auction, " re-
 fused shop sale 1859 (A)
 Seller of book with art repro-
 ductions guilty, by "cir-
 cumstances of sale" 1960's
 Torrigiano smashed Madonna
 to protest low payment for
 work 1522
 U. S. State Department banned
 commercialism in Exhibi-
 tion Hall 1965 0 13
Art Schools See also Bauhaus;
 Art Education
 Academies of Art, profession-
 al training 16th c. (B)
 Artists regulated by Italy
 Guilds 1400-1430
 Florence Guild regulation 1339
 Hosmer study of anatomy in
 U. S. 1850 (A)
 Madrid School of Fine Arts,
 Dali as pupil 1924 (C)
 Van Emburgh School of Art
 Exhibit, nude censored
 1933 Ap 30
 Vienna Academy of Art, re-
 fused Hitler as student
 1930 (B)
Art Students' League, New York
 City
 Comstock confiscated official
 magazine 1906 Ag 2
 Grosz teaching assignment
 controversy 1932
 Life classes discontinued
 1890 My 9
Art Themes See Subject Matter
 in Art
Art Theory
 Dufresnoy. De Arte Graphica
 1673
 Felibien. Conversations on
 the Lives and Works of the
 Most Eminent Painters 1666
 France, freed from Academy
 1737
Art Trade See Art as a Business;
 Importation and Exportation
 of Works of Art
Art Viewers See also Class Dis-
 tinctions in Art; Exhibitions

Ap 11

Baumeister, Willy
Works proscribed by Nazis as
degenerate art 1937 Jy 8

Bavarian National Exhibition
Poster. Riemerschmid
1896 (A)

Bayer, Herbert
Nazis dispersed Bauhaus, Ber-
lin, caused emigration to
U. S. 1933 Ap 11

Baylinson, A. S.
Trial for display of Prohibi-
tion satire 1924 N 29

Bearbaiting
Macaulay's epigram on Puri-
tan censor 1601-1625

Beardsley, Aubrey
Drawings, seized 1970 Ja (B)
Illustrations, indecent in
Edinburgh 1967 Ja 30
Lysistrata illustrations, seized
as obscene 1966 Ag 10
Requested publisher destroy
Lysistrata and other ob-
scene drawings 1898 (B)
"Venus and Tannhauser, "
cited as obscene in U. S.
Roth case 1898 (B)
Wilde Salome illustrations,
censored by publisher 1894

Beatty, Director
removed Parker "La Paresse"
1914

Beauty
Aristotelian-Thomistic view
1955 (B)
Kienholz realistic reporting,
beauty obsolete in viewing
1966 Mr 22
Liturgical images must avoid
1563 D 4
"Polykleitos Canon, " mathe-
matical demonstration, in
human form c 440 B. C.
Proportions in "The Canon"
c 440 B. C.
Puritans hostile to in art
1601-1625
Townsend decision, found in
utilitarian altar and reredos
1898 (D)
Zeising, Golden Section article

1855 (A)

"Beauty and the Beast. " DuBost
1810 D 6

Becker, Regnier, Parisian car-
penter-print dealer
Prints destroyed 1842 Ag 9
(A); -- (G); -- (I); -- (J)

Beckett, Welton 1955 Mr

Beckmann, Max
Works proscribed in Nazi
degenerate art drive 1937
Jy 8; 1937 Jy 18

Beemer, Edwin F.
"Bubble Girl, " removed from
exhibit 1936 D 16

Beham, Barthel and Hans Sebald
Beham Banished from
Nuremberg 1525 (C)

Belgium
Censorship activities 1968 Jy
(B)
Refused Meunier "Monument
au Travail" 1906 (B)

"La Belle et la Bete. " Du-
Bost 1810 D 6

Bello, Gianno di. Ordinamente
della Giustizia 1293

Bellows, George
"Nude Girl with Shawl, " cen-
sured 1922 F 10

Bells
Cistercians limited church
bells and bell towers 1240

Belman, Hans
Work in Kronhausen erotic art
exhibit admitted to U. S.
1970 Mr 5

Belo Horizonte
Niemeyer church, unacceptable
to Catholic officials 1946
(C)

Belt v Lawes, England
Libel case against sculptors
1882

Belyutin, Eli
Abstract exhibit of students,
closed in Moscow 1962 N
26

Benbow, William
"The Brightest Star..., " and
"The Royal Cock and Chick-
ens..., " suit against as
seditious libel 1821 (B)

Beskin, Russian critic
Comment on Mikritin painting
1935 Ap 10
Bethesda, Maryland
Washington Free Press nude
cartoon of judge, not ob-
scene 1970 Jy 16
Beverly Hills, California
Michelangelo "David," replica
seized 1969 N
Biarritz
Cousino figure, refused 1951 N
Bible
Council of Trent decreed art
conformity 1563 D 4
Illustrated censured 17th c.
(E)
Jewish figural proscription
13th c. B. C.
Luther's Bible, anti-papal
illustrations 1522 S
Nude illustrations proscribed
1564
Nude illustrations proscribed,
even in following stories
15th c. (A)
Veronese before Inquisition
for extraneous figures in
Bible story painting 1573
Jy 18
"Bible of Art"
Byzantine painters' manual
10-11th c.
"Bible of the Illiterate"
Council of Trent art decrees
1563 D 4
Bibliotheca historica. Diodorus
Siculus 6th c. B. C.
"Bibliotheque des Romans," en-
gravings
Destroyed in Paris, as ob-
scene 1843 Ap 11 (A)
Biddle, George
Justice Department mural
sketches, disapproved 1934
(E)
Mexican government commis-
sioned Supreme Court of
Justice mural 1941 S
Scored U.S. government se-
curity check of artists
awarded Federal commis-
sions 1954 N 16

Biddle, Judge
Comstock seized art in Phila-
delphia, ruled not obscene
1888 Ja 24
Bignon, Jacques
Engravings sold, destroyed as
obscene 1820 Ap 27
Bignou Galleries, New York City
Destination of Nazi looted art
shipment 1940 0 7
"Le Bijou de Societe," engraving
Destroyed in Paris, as ob-
scene 1815 My 19 (A)
"The Binders." Millet 1857 (A)
Bird, Peter 1962 Ag 23
"Bird in Space" ("Bird in
Flight"). 1928 N 26;
1950 Ap 30
Birds in Art See Animals in Art
"The Birth of Venus." Mattels
1965 0 13
"Birthday of Prudery"
Council of Trend art decrees
1563 D 4
Bishops
Must approve unusual liturgical
images 1563 D 4
Bjanthorson, Asgeir
Icelandic painter, forbidden to
sell work in England 1947
Ag 12
Black, Harold 1952 My 10
Bland, Judge 1958 (B)
Blanqui, Louis Auguste
Maillol figure memorial, con-
cealed 1905 (B)
Blashfield, Edwin Howland
Criticized as outmoded in
National Academy of Design
1925 My 7
Blasphemy See also Sacrilege
Artist of "unconventional
Christ," prosecuted for
blasphemy 1963 (B)
Display of Christ picture,
charged blasphemy 1971
Mr 31
Grosz Hintergrund, artist and
publisher convicted of blas-
phemy 1928 D 10
Kaufman "Marriage of Cana,"
not a crime in New York
1924 N 29

Bovril Bull
 Poster, unsuitable 1894 D 1
Bowman, Mrs. Lawrence M.
 1933 Ap 30
Boxall, William 1872
Boys and Girls Together. Gold-
 man 1965 Je 11
Bradford, England
 Arts Council ordered nudes re-
 turned to traveling exhibit
 1962 Ag 23
Bradlaugh v Queen, England
 "Chastity of Records, " refused
 acceptance in England 1815
 Mr 1
Brancusi, Constantin
 "Bird in Space" trial, U. S.
 Customs classification as
 art 1928 N 26;
 case cited 1950 Ap 30
 (ILLUS 25)
 Duchamp comment on sculp-
 ture, as art 1927 F 26
 English Customs questioned
 art status of sculpture 1938
 Jy
 "Fish, " U. S. Customs classi-
 fication as art 1950 Ap 30
 "The Kiss, " Armory Show,
 poem 1913 F 17-Mr 15
 "Princess X, " removed from
 Salon 1920 (A)
 Sculptures ruled dutiable by
 U. S. Customs 1927 F 23
Brancusi v United States
 "Bird in Space, " judged art,
 for U. S. Customs 1928 N
 26; precedent cited 1958
 (B)
Brandt
 "News from the Camp of the
 Heavenly Hosts, " cartoon
 censored 1898 (E)
Brandt, Rex
 "Surge of the Sea, " censored
 for "hammer and sickle"
 1951 N 6 (B)
Braques, Georges
 Nazis proscribed works as de-
 generate 1937 Jy 18
Braun & Company, New York City
 Displayed Chabas "September
 Morn" 1913 My 14

Brazen Serpent of Moses
 Broken by Hezekiah 720-692
 B. C.
Brazil
 Art Censorship 1969 Jy 16
 Censorship decrees 1970 Mr
 1 (B)
 Censorship law stringent 1964
 Ap (B)
 Pasquim cartoons, censored
 1970 N 13
"The Breeches-Maker" 1558 (B)
Brest, Jorge Romero 1968 My 30
Breton, Andre
 Manifesto, to free art for the
 Revolution 1938 (B)
Breuer, Marcel
 Nazis dispersed Bauhaus,
 causing emigration to U. S.
 1933 Ap 11
Breughel, Pieter, the Elder
 "The Wedding Dance, " Time,
 banned 1951 D 1
Brewster, Customs Solicitor
 1933 F 14
"Bridal Boquet. " Lasansky 1966
 My 18
Brides' Books
 Proscribed by Communist
 Party in China, as lacking
 Party line 1956 Ja
Bridges
 Maillart bridges, censored as
 too advanced 1917-1940
"The Brightest Star... Benbow
 1821 (B)
Brink, Louis van
 Obscene picture display trial
 1921 Ap 21
"Britannia"
 British Industries Fair poster,
 censored 1933 Ja 28
British Industries Fair
 Poster censored for Near East
 1933 Ja 28
British Museum
 Admission restrictions 1784
 (C)
 Admission rules revised 1810
 (A)
 Sunday opening vetoed in Com-
 mons 1855 (B)
Broadway

draped 1970 Ja (A)

Burckhart, Emerson
mural, whitewashed 1943 (A)

Bureau of Censure, Paris
Touchatout portrait, censored
1874-1877

"The Burghers of Calais." Rodin
1895

Berleson, A. R.
Suppressed The Masses under
Espionage Act 1917 Ag-S

Burnett, Frederick 1936 Mr 19

Burri, Alberto
Collage, ruled art, but dutiable
1958 N 21

Burroughs, Bryson
"The Explorers," ordered re-
moved from window display
1905 (A)

Buses See Transit Advertising

"Buste de Femme." Bonnard
1947 F 11

Butler, Benjamin Franklin
Recommended abolishing
school for life classes
1882-1884

Butler, Reg
"Unknown Political Prisoner,"
destroyed 1953 Mr 15

Butler, Pennsylvania
Display of Christ picture,
charged blasphemy 1971 Mr
31

"Buy American" 1933

Buzaid, Alfred 1970 Mr 1 (B)

Bywaters, Jerry 1956 Ja 12

C. P. S. U. 1932 Ap 23

Cabanel, Alexandre 1888 Mr 23

Cabrera, Geles
Exhibited Mexican salon of
"free art" 1955 Mr 17

Cadmus, Paul
"Sailors and Floosies," re-
moved from Corcoran Gal-
lery exhibit 1934 (H); Re-
moved from Golden Gate
International Exposition
1940 Ag

Caffin, Charles H.
Story of American Painting,
scored avoidance of nude in
art book illustration 1907

(B)

Cagliari, Paolo See Veronese

Cairns, Huntington
Freedom and Obscenity in
visual arts 1938 N
U. S. Customs art advisor
1934 (D)

Calais
Hogarth arrested for sketch
1747
Rodin "Burghers of Calais,"
censured 1895

Calapai, Letterio
"Ozymandias," banned 1967
Ap

"Calavera Huertista." Posada
1913 (D)

Caldecott Medal
Winner, censored 1970 My 21;
1970 N 18

Calder, A. S.
Vogue, sued by model for
Calder nude figure 1923
Ag 24

Calder, Alexander
English Customs question art
status of sculpture 1938 Jy

Calderon, Philip
"St. Elizabeth of Hungary,"
nude from translation error
1891 My 16

Caldwell, Katherine
Boise case expert witness
1964 Jy 2

California
Anti-caricature legislation
passed 1899 (A);
repealed 1915 (C)
Refregier California history
murals, charged offensive
and inaccurate 1953 My 1

California, University of, Berke-
ley
Sather Gate nudes, rumored
censored 1911 (C)

California, University of, Los
Angeles
Picasso "347 Gravures,"
censored 1970 Ap 6

California State College, Long
Beach
Spater sculpture exhibit,
banned 1968 My 27

destroyed 1934 S
Spangler "Cartoon Mirror,"
reported Alabama anti-car-
toon legislation 1915 F 3
Tia Vicenta, banned for walrus
caricature of Argentine
president 1966 Jy
Turkish political cartoons, cen-
sored 1958 Ap 9
U. S. Bureau of Cartoons, con-
trolled 1917 (E)
Washington Free Press cartoon,
judged pornographic 1970 Ja
29 (A); nude cartoon of
judge, not obscene 1970 Jy
16
Wood "American Gothic,"
parody charged libel 1968
My 1
Young "Having Their Fling,"
exhibit at Espionage Act
trial 1917 Ag-S
Carillo Puerto, Felipe
Orozco mural 1931 Ja 19;
1953 My 21
Carlier, Jean Francois, lock-
smith
Engravings sold, destroyed as
obscene 1820 My 25
Carmody, John Michael 1939 (A)
Carnegie Institute, Pittsburgh
Parker "La Paresse," banned
1914
Carner, Anne Marie
"Second Childhood," banned
1931 Ja 29
Carpeaux, Jean Baptiste
"The Dance," censured as im-
moral 1869
Carpenter
Censored for obscene art 19th
c. (B)
"Carpenter Shop." Millais 1850
(D)
Carr, W. P.
Scrotal surgery article illus-
trations, suppressed 1911
Je
Carrefour, magazine
Bonnard "Buste de Femme,"
censored in Quebec 1947 F
11
Carroll, Earl

Vanities poster, jailed 1924
N 10
Carta Caritatis 1115
"Cartoon Mirror." Spangler
1915 F 3
Cartoons See Caricatures and
Cartoons
Carucci, Jacopo See Pontormo,
J. da.
Carver, Thomas 1969 Mr (A)
Casaurano, Puig 1923 (B)
Cassotta, M. J. 1969 Je 18
Cassou, Jean
Mazotto Prize Committee,
refused use of Paris pub-
lic gallery 1965 Je
Protested France's expulsion
foreign anti-government
artists 1968 Jy 4
Castagna, Edward
Eames "nude chair" contro-
versy 1951 Je 24
Castelli, Leo
Burri collage, testified work
of art 1958 N 21
Catacombs, Rome
Paintings avoided representa-
tion of Christ c 200
Cathedrals See Church Architec-
ture
Cather, Willa
Death Comes for the Arch-
bishop 1851 (C)
Catholic Centre Party
Nude Christ child picture,
indicted 1927 My 17
Catholic Church See also Coun-
cils, as Nicaea; Trent; and
names of Popes, as Gregory;
Pius; and names of Orders,
as Cistercians; Franciscan
Catholic Church schema on
sacred art approved 1963
O 31
Codex of Canon Law, art pro-
visions 1917 My 27
Religious art attitude 1570
Summary of laws re church
building and decoration
1952 (D)
"Catholic Kings: Isabella and
Fernando." Narotzky 1967

censured for realism 1917
(D)
Beer Garden sign, censured
1832 (B)
Powers "Greek Slave, " ap-
proved for exhibit 1847-1851
Cinquini, Auguste, art dealer,
Paris
"Italy, " nude plaster figure,
censored 1853 Ap 24
"Circus Girl. " Kuniyoshi 1947 Ap
Cistercians
Building restrictions 1192
Forbade all images, except
crucifix 1213
Pavement, tesselated, destroyed
1235
Proscription of church art 1115
Reredos, carved, proscribed
1240
Citizens Council of New Orleans
Anti-Defamation League
Rabbit Brothers, charged
integration propaganda 1956
N
Citizens for Decent Literature
1965 My 15; 1970 Ag 20
Civic Center Commission, De-
troit
Milles nude Indian, clothed
1960 (B)
"Civic Virtue. " MacMonnies
1922 Mr
Clancy, James J. 1965 My 15
Clapp, William H.
Oakland Public Library re-
quired pre-censorship of
art works 1928 Ja
Claremont, California
Orozco "Prometheus, " cen-
sured 1930 Ap
Clarke, Gilmore C. 1969 N 9
Clarke, Father
Calderon "St. Elizabeth of
Hungary, " censured 1891
My 16
Clarkson v McCarthy, New
Zealand
Giorgione "Sleeping Venus, "
photograph indecent as shop
display 1917 (C)
Class Distinctions See also Art
and Society; Satire; Slaves

in Art
Art subjects, Greece 5th c.
B. C.
Art study, Greece 5th c. B. C.
Artists admitted to dining hall
as equals 1462 Ap 28
Censor office, Rome 443 B. C.
Clothing and hair style in
Massachusetts 1651
Comstock Morals vs. Art,
condemned exhibit and sale
of art to uncultivated 1888
(B)
Comstock on nude art 1874
(B)
England, Frenchman's com-
ment on 1819 (C)
Medieval dress 1400
Reproductions of art acceptable
in original setting, may be
obscene 1952 (C)
Rome office of Censor, for
Patricians only 443 B. C. ;
plebians admitted 351 B. C.
Society for Suppression of
Vice action 1802
Vatican Museum legend 1505
(A)
Classic Art See also Ladies Day
Albright Art Gallery nudes,
ordered draped or segre-
gated 1911 Mr 6
Nude sculpture casts, should
be exhibited in "Reserve
Room" 1901 (B)
"Classiques"
Gericault "Raft of the Medusa"
1819 (A)
Claudius as "Censor" 22 B. C.
Clayton, Herbert 1916 (A)
Cleland, John
Memoirs of a Woman of
Pleasure, effected U. S.
Postoffice obscenity law
1865
Clemenceau, Georges
Ordered Louvre to hang Manet
"Olympia" 1907 Ja
Clemens, Samuel L.
Life on the Mississippi, plate
deleted 1884 (B)
"Million Pound Note" 1954 (D)
Clement VII, Pope

Suppressed Aretino <u>Sonetti
Lussuriosi</u> 1527 (B)
Clement VIII, Pope
Considered destroying Michel-
angelo "Last Judgment, " as
obscene 1596
Clement XIII, Pope
Covered nude art, including
Michelangelo "Last Judgment"
1758-1769
Clement of Alexandria
Iconoclasm 190-203
"Cleopatra at the Bath. " Noble
1900 D 27
"Cleopatra's Arrival in Cilicia. "
Etty 1821 (A)
Clergy in Art
Courbet "Return From the
Meeting, " censored 1863
(A)
Goya Los <u>Caprichos</u>, satirized
1799 F 6
Rosa "Fortune, " anti-clerical
1662 (A)
Cleveland Museum of Art
Rodin "The Thinker, " bombed
1970 Mr 24
"The Climax. " Plummer 1942 Mr
(B)
Cline, Genevieve R. , Judge
Brancusi "Bird in Space, "
judged art 1928 N 26
Cline, Victor B. 1970 Ag 11
"Clothes Horsley" 1885
Clothing Proscribed <u>See</u> Costume
Proscribed
Club Friendship, Moscow 1967
Ja 27
Club of Revolutionary Artists
1790 S 29
Cluny, Order of
Bernard of Clairvaux, con-
demned 1115
Cnidian Aprhodite. Praxiteles
364-361 B. C.
Coats of Arms
Jewish proscription of family
crest with lion 16th c. (G)
Coblenz
Wine Auction figures, cen-
sored 1925 Ag 15
Cobo Hall, Detroit
Milles nude Indian, clothed

1960 (B)
Cockburn, Alexander
"Hicklin Rule, " stated 1868
(B)
Cocteau, Jean
Drawings for London exhibit,
restricted by English Cus-
toms 1938 Ja
<u>Code of Canon Law</u> 1917 My 27
<u>Codex Dresdensis</u> 1560's
<u>Codex Juris Canonica</u> 1917 My 27
<u>Codex Peresianus</u> 1560's
<u>Codex Tro-Cortesianus</u> 1560's
Codices
Maya 1560's
<u>Codices Becker</u>, Mixtec 16th c.
(C)
(ILLUS 3)
Coins and Currency
Ancient, melted by Nicholas
V 1448
Hasmonaean Kings discontin-
ued likenesses on coins
2nd-1st c. B. C. (A)
"Million Pound Note" poster,
illegal 1954 (D)
Mohammedan prohibition of
figural designs 695
Coit Tower, San Francisco
Murals, censured as Commu-
nistic 1941 Ag 28
Colbert, Jean
Art Academy in France,
founded 1648 F 1
Coleridge, Lord, Chief Justice
Tussaud wax figure, libelous
1894 Ja
Colin, Marcel
Satirical posters, banned 1954
Ag 31
Collages
Burri collages, rulled art but
dutiable by U. S. Customs
1958 N 21
U. S. Customs law, recognized
as art 1959 S 14; 1970 Mr
<u>The Collector and Art Critic</u>
1900 Ja 24
College Park, Maryland
<u>Washington Free Press,</u>
cartoon judged pornography
1970 Ja 29 (A)
Collette, Felix Alexander, pub-

refused by patron 1870's-
1880's
"Io," destroyed for nudity 18th
c.
"Jupiter and Antiope," obscene
according to English law
1857 (D)
Parma Cathedral, cancel con-
tract 1526-1530
Corrigan, Joseph E.
Destroyed nude picture 1921
Ap 28
Cortissoz, Royal
Comment on Armory Show
1913 F 17-Mr 15
Cos
Rejected Praxiteles nude
Aphrodite 364-361 B. C.
Cossiers, Jan
"Golgotha," Guild refused to
allow installation 1662 (B)
Costume in Art See also Color;
Iconography
Cheyenne Indians censored mu-
ral for Navajo clothing 1941
Je
Classical dress in English
historical painting 1769 (B)
Greenough "George Washington,"
criticized 1843 (B)
Reynolds prescribed for West
"Death of Wolfe" 1769 (B)
Reynolds rules 1768-1790
Costume Prescribed
"Cato the Censor" in Rome
184 B. C.
Colors for clergy 1400
French Revolution 1790 S 29
Massachusetts to designate So-
cial Class 1651
Rome 3rd-4th c.
Solon, Athens c 549 B. C.
Coughlin, John
Censored Chabas "September
Morn" 1913 (A)
Council of... See designation, as
Constantinople; Ephesus,
Nicaea, Trent
Counter-Reformation
Art decrees of Council of
Trent 1563 D 4
Effect on art 1560's-1650's
Prudery emphasized 1582 Ag

22
"Le Coup de Vent," engraving
Destroyed in Paris, as ob-
scene 1842 Ag 9 (D)
Courbet, Gustave
"Bathers," censured 1853 (D)
Convicted of Vendome Column
destruction 1871 My 16
"Funeral at Ornans," criti-
cized 1850 (B)
"Return From the Meeting,"
censored 1863 (A)
Cousino, Juan Luis
"Virgin Mary," refused 1951
N
Covington, Lorenzo Dow
Archaelogist imprisoned for
obscene picture collection
1922 My 8
Cowan, Elsie
Nude paintings, censured 1934
F
Cox, Kenyon
Nudes, censured 1891 Mr 15
Crafts, Reverend W. J.
Censured MacMonnies
"Baccante" 1897 0
The Craftsman's Handbook.
Cennini 1370 (A)
Craftsmen's Charter, Uruk c 529
Cranach, Lucas
Antipapal illustrations of Lu-
ther's Bible 1522 S
Ceased painting nudes 1505
(B)
Cranmer, Thomas
Destroyed church art in
England 1552
"The Creature That Bites Our
Heels." Everts 1965 My
15
Credi, Lorenzo di
Burned paintings in "Bonfire
of Vanities" 1498
Creel, George
Urged repeal of censorship
laws 1923 D 16
Cresti, Domenico
Exiled as heretic 1581
Crests See Coats of Arms
Crimi, Alfred D.
"Christ," painted over 1949
F 1

Crimi v Rutgers Presbyterian
 Church, U. S.
 "Christ, " painted over, in-
 volved no artists' rights
 1949 F 1
"Criminal Libels Act, " England
 Press and cartoon control 1819
 D 30
Critchfield, Justice
 Ruled Leighton "Bath of
 Psyche" reproductions, im-
 moral 1905 Mr 4
"Criticism and Self-Criticism"
 Russian artists guide 1939 (D)
Cromwell, Oliver
 Depicted on treasonable playing
 Cards 1653-1658
Cropp v Tilney, England
 Libel defined 1693
Crowninshield, Frank
 Brancusi "Bird in Space, "
 expert witness 1928 N 26
 Vanity Fair draped Kent nude
 1924 My
Crucifixes
 Dimensions and details pro-
 scribed 16th c. (A)
 Forbidden in Cortona 1569 (B)
"Cruelty. " Sterne 1939 (A)
"Cruikshank, American" 1819 (B)
Cruikshank, George
 "The Dandy of Sixty..., " cari-
 cature of Geroge IV, pur-
 chased by King to suppress
 1820 My
 (ILLUS 10)
Crusades
 Fourth Crusade destroyed
 classical sculptures 1203 D
 Fourth Crusade sacked Con-
 stantinople 1204 Ap 12
Crystal Palace Exhibition, London
 Powers "Greek Slave, " exhibi-
 ted 1847-1851; criticized
 for bound wrists 1851 My 1
Cuba
 Art Policy 1969 N 16
Cuban Writers and Artists Union
 1969 N 16
Cubism
 Both Russia and U. S. demand
 censorship 1949 S 11
 Chicago Art Institute Director

French, evaluation 1913
 Je?
Dondero in Congressional
 speech listed in modern
 art "role of infamy" 1949
 Mr-O
 Nazis proscribed 1937 Jy 18
Cuevas, Jose Luis
 Exhibited first Mexican salon
 of "free art" 1955 Mr 17
Cuixart, Modest
 Withdrew from Venice Bien-
 nale, to avoid censor 1966
 (A)
Cultural Exchange
 Ukranian exile testified of
 U. S. -Soviet exchange dan-
 gers 1959 Je 3 (A)
Cummings, Earl
 Sather Gate, Berkeley, nudes,
 rumored censored 1911 (C)
Cunningham, Charles C. 1967
 Mr (B)
"Cupid. " Story 1911 My
"Cupid and Psyche. " Page 1843
 My
Le Cupidon, magazine
 Articles and drawings from
 caused publisher's imprison-
 ment 1926
Cura Morum
 Rome censor control 443 B. C.
Curl
 Exhibited corrupting pictures
 1726 (B)
Curley, J. M.
 Banned Copley Society Exhibit,
 as insult to church 1946 0
 2
Currency See Coins and Currency
Curry, John Steuart
 Kansas State Capital mural,
 specifications 1937 S;
 repainted pigs tails after
 public criticism 1942 (B)
Customs Administration--Aus-
 tralia
 Norton illustrated book, banned
 1952 (B)
Customs Administration--Canada
 Warhol "Pop Art" held, on
 expert advice, not art and
 dutiable 1965 Mr 8

banned 1929 (B); 1951 (C)
Pape illustrations for Rabelais
Gargantua and Pantegruel,
banned 1930 (H)
Picasso "Les Joutes, " mosaic,
refused art classification
1959 My (B)
Picasso "Man with a Hat, "
ruled not art 1958 My 27
Regulations specified pro-
scribed art 1964 Ap (A)
Rouault ceramic plaques and
jars, refused art classifica-
tion 1915 (B)
Royal Museum of Naples cata-
log, destroyed 1857 (D)
Sculpture, definition 1928 N 26
Sculpture "original, " defined
1965 F 24
Sculpture (marble font, boxes,
stands, seats), refused en-
try as art 1916 (D)
Stained glass window, admitted
as art 1959 S 25
United States v Perry, fine art
defined for Customs purpose
1892
United States v Three Cases of
Toys, first case under Tar-
iff Law of 1842 1843 (A)
Utrillo paintings, denied entry
as art, as done with aid of
picture postcards 1959?
Cypress, California
Michelangelo "David" 1969 Jy
19
Cyprus Tourist Office
"Venus de Milo" poster, banned
in Kuwait 1952 D
Cyrus, King of Persia
Craftsmen's Charter c 529
Czarnecki, Anthony
U.S. Customs banned Zorn
and Whistler etchings 1931 N
Czechoslovakia
Announced official art policy
1939 Mr 18
Anti-German caricatures, cen-
sored 1937 O 14
Artists group demanded proof
of members' Aryanism 1938
D
Censured caricatures 1939 F

Protests effected catalog cen-
sorship 1968 0 23

"Dada-Fair, " Cologne 1920 Ap
20
Dadaism
Armory Show works, cen-
sured 1913 F 17-Mr 15
Cologne "Dada-Fair, " closed
1920 Ap 20
Dondero listed in modern art
"role of infamy" 1949 Mr-
O;
quoted by Dallas citizen
group 1955 Mr 15
"First International Art Fair, "
artists tried 1921 My 21
Daguerreographs
U.S. Tariff Law, 1842,
amendment added to allow
Customs seizure 1857 (C)
Daily Mirror, London
Zec cartoon, caused official
warning 1942 (A)
Daily Worker, London
Suppressed for anti-war car-
toon 1941 Ja 21
Daley, Richard J. 1970 0 5
Dali, Salvadore
Art school attendance 1924 (C)
"L'Age d'Or, " closed by Paris
police 1931 (C)
"Un Chien Andalou" and "L'
Age d'Or, " caused riots
1928 (B)
Dallas, Texas
Illustrated edition of U.S.
Commission on Obscenity
and Pornography report,
indicted as obscene 1971
Ap
Dallas Art Association See Dallas
Museum of Fine Arts
Dallas County Patriotic Council
Dallas Museum art policy
statement, answered
charges 1956 F 11
Dallas Museum controversy
over Communistic arts and
"Sports in Art" 1956 Ja
12;
USIA cancelled 1956 My 25
Dallas Museum of Fine Arts

De Arte Graphica. Dufresnoy
 1673
De Diuersis Artibus. Theophilus
 10th c.
De divina proportione. Pacioli
 1591
De Picturis et Imaginibus sacris.
 Molanus 1570
De Re Aedificatoria. Alberti
 1485
Dean, Abner
 It's a Long Way to Heaven,
 nudes censored 1946 (A)
 Nudes caused PM ban by Post
 Office 1939?
Death in Art See also Violence
 Lynes "One for the Road"
 safety poster, showing skull,
 banned 1953 (A)
 Lysoform Antiseptic poster,
 criticized for skeleton
 symbolizing Death c 1910
 (A)
"Death of the Virgin. " Caravag-
 gio 1607
"Death of Wolfe. " West
 Clothing prescribed by Rey-
 nolds 1769 (B)
"Decadent Art"
 Nazi banned art 1937 Jy 18
"The Declaration of Independence. "
 Trumbull 1818 (A)
Decollete
 Bellows "Nude Girl With
 Shawl, " critized 1922 F 10
 Sargent "Madame X, " cen-
 sured 1884 (A)
Decorative Arts
 Cistercians proscribed 1115
Degas, Edgar
 "Absinthe, " censured for al-
 coholism 1873 (C)
Degenerate Art
 Hitler ordered proscribed art
 privately owned, but pub-
 licly exhibited, confiscated
 without compensation 1938
 Je 3
 Nazi drive to eliminate 1937
 Jy 8
 Nazis auctioned in Lucerne
 1939 Je 30
 Nazis burned in Berlin 1939

Je 30
 Nazis ordered removed from
 museums 1937 Ag 4
 Nazis exhibit of 1937 Jy 18
 Retrospective exhibit after
 25 years 1962 (A)
"Degenerate Art"
 Schultze-Naumberg Art and
 Race concept for Nazi
 aesthetics 1928 (A)
"Degenerate Art, " Munich
 Nazi exhibit 1937 Jy 18
"Dejeuner sur l'herbe. " Manet
 1863 (B)
Delacroix, Eugene
 "Liberty Leading the People, "
 exhibit suppressed 1831
 (B)
Delaporte, lithographer, Paris
 Tried for Daumier "Gargan-
 tua" 1830 F 23
del Corso, Gaspare 1962 (C)
"Delilah. " Story 1911 My
Dellapia, F. H. 1970 0 20
Della Pittura. Alberti 1436
Demetrios of Phaleron
 Sumptuary legislation 317-307
 B. C.
Democracy in America. Tocque-
 ville 1913 F 17-Mr 15
Dempsey, David 1953 Ja
Denmark
 Printed obscenity laws for
 adults, abolished 1967 Je
 Visual pornography laws,
 modified 1969 Jy 1
Denver
 Speer Memorial commission,
 withdrawn from Mestrovic,
 as foreign artist 1934 (C)
"The Deposition. " Pontormo
 Charged blasphemous 1523 (B)
Derain, Andre
 Works proscribed by Nazis
 1937 Jy 8
"Descriptive Perspective"
 Egyptian art 3400-2900 B. C.
Deshayes, Louis Victor, and
 wife Goin
 Guilty of obscene print sale
 1845 N 28
"Design for Today's Living"
 Eames "nude chair, " cen-

censorship c 1898 (B)
Fibonacci Numbers
 Zeising Golden Section article
 1855 (A)
Field, Evelyn 1967 N 20
Field Museum, Chicago
 U. S. Customs, detained Chin-
 ese art objects for, as ob-
 scene 1909 (B)
Fifth Avenue Playhouse
 Bonge paintings in lounge,
 seized 1928 Jy 9
Fig Leaves
 Choubrac shows vine leaves
 c 1889 (B)
 Clement XIII ordered fig
 leaves for Belvedere statues
 1758-1769
 French variant of fig leaves:
 vine leaves c 1898 (B)
 Ingham resolution placing fig
 leaves on National Academy
 of Design figures 1832 (A)
 Ladies' Academy of Art, Cin-
 cinnati, hired Fazzi to fig
 leaf statues 1865-1867
 Michelangelo "David, " dis-
 played in fig leaf copy 1939
 Je 22
 Origin of term c 1889 (B)
"Fighter of the Spirit. " Barlach
 1927 (B)
Filinov, P.
 Censured in Russia 1920's (A)
Fin de Siecle, Parisian journal
 Choubrac cover, censored c
 1898 (B)
"Fine Arts" vs. "Mechanical
 Arts" See also Academies
 of Art; Customs Adminis-
 tration--U. S.
 Academies organized to sepa-
 rate 1648 F 1
 Academy instruction distin-
 guished 16th c. (B)
 Antwerp Academy of Fine Arts,
 separated 1664
 Artist admitted to great dining
 hall, as equal 1462 Ap 28
 Cennini Libro dell'Arte, dis-
 tinguished 1370 (A)
 Marie Therese ordinance, sepa-
 rated 1773 (D)

"First Dada Event, " Cologne
 1920 Ap 20
First International Congress of
 Catholic Artists, Pius XII,
 on Catholic art and morals
 1950 S 3
"First International Dada Fair,"
 Berlin 1921 My 21
"First International Exhibition of
 Erotic Art" 1968 My (A)
"Fish. " Brancusi 1950 Ap 30
Fisher, "Bud" (Harry C.)
 Rights to "Mutt and Jeff"
 cartoon, exceed copyright
 1916 (C)
Fisher, Mrs. Harry C.
 Ferstadt "Friendship, " cen-
 sured 1931 N 21
"Fisherman. " Zorach 1956 Ja 12
"Five Dollar Billy, from
 'Roxy's'. " Kienholz 1966
 Mr 22
Five Smooth Stones. Fairbairn
 1968 Jy (A)
Flagellation
 Gillray indecent prints, in-
 cluded flagellation 1850
 (C)
 Poster showing cat-o'-nine-
 tails, banned 1902
Flags
 Kerciu "America the Beauti-
 ful, " charged desecration
 1963 Ap 16
 Morel works, dishonored U. S.
 flag 1970 F 18
 Salk Institute art exhibit,
 desecrated American flag
 1967 My 12
 Sculpture showing U. S. flag
 with explosives, banned
 1970 Ag 27
Fleishman, Stanley 1970 Ja 28
Fletcher, Homer 1971 Mr
Fletcher, John Aubrey 1966 S 20
Les Fleurs du Mal. Baudelaire
 Rouault illustrations, banned
 1857 (B)
Florence
 Academy of Art, established
 1563 Ja 13
 Guilds of painters, in Guild
 of Doctors and Apothecar-

French, Chester Daniel
 MacMonnies "Baccante" con-
 troversy 1896 (F)
French Academy
 Caricature of member, cen-
 sored 1931 Ja 29
French Academy of Art
 Life drawing 1840's (C)
 Membership compulsory for
 court painters 1663 F 8
 Membership gives exemption
 from military service 1655
 Je 23
 Rules registered 1655 Je 23
 Revolution dissolved Academy
 1790 S 29
Fresno, California
 Renzi religious memorial, cen-
 sored 1969 Mr (B)
Fresno District Fair
 Censored works accepted by
 art experts 1965 N
Freundlich, August 1968 Je
Freundlich, Otto
 "New Man, " on Nazi degener-
 ate art exhibit catalog cover
 1937 Jy 18
Friedlander, Leo
 Rosenthal "The Family, " cen-
 sured 1955 Mr
"Friendship. " Ferstadt 1931 N 21
Fry, Roger
 Criticized Alma-Tadema 1969
 Mr 18
Fulda, O.
 Comstock confiscated postcards,
 after case against them dis-
 missed 1912 O
"Funeral at Ornans. " Courbet
 1850 (B)
Furniture
 Eames chair, censured for
 Steinberg outline drawing
 of nude 1951 Je 24
 Legs covered, in England
 1851 (B)
Futurism
 Dondero listed in "role of in-
 famy" of modern art 1949
 Mr-O;
 Quoted by Dallas citizen
 group 1955 My 15
 Nazis proscribed 1937 Jy 18

Futurist Manifesto 1910 F 11

Gabo, Naum
 English Customs, questioned
 art status of sculpture
 1938 Jy
 USSR expelled from Central
 Soviet of Artists 1930's (C)
Gainsborough, Thomas
 "Henry, Third Duke of Buc-
 cleuch, " rejected by Aca-
 demy, Edinburgh, too in-
 formal with dog 1770
 (ILLUS 7)
 "Lady Waldegrave, " censored
 for character of subject
 1782
Galanis, Demetrios
 "Three Graces, " nude in
 Studio, banned by U. S.
 Post Office 1939 F
"Galerie des Gardes Francaises, "
 drawings
 Destroyed in Paris 1842 Ag 9
 (E)
"Gallery of Wheels"
 Banned as Communistic 1949
 (C)
 Dondero criticized 1949 Mr-O
Gann, Mrs. Harry M.
 Nude painting removed from
 window display 1934 Ag
"Gargantua. " Daumier 1832 F 23
Gargantua and Pantegruel. Rabe-
 lais 1930 (H)
Garnier, Jules
 Rabelais illustrations, cen-
 sored in London 1890 N 8-
 14
Gassner, Mordi
 Mural, charged obscene 1936
 F 28
"Gate of Calais. " Hogarth 1747
"Gate of Hell. " Rodin 1880-1888
Gauguin, Paul
 Boise case expert witnesses
 testify on erotic art 1964
 Jy 2
 Cane, with two lovers, de-
 stroyed as indecent 1903 My 9
 "Vision After the Sermon, "
 refused c 1889 (A)
 Works proscribed by Nazis

graving 1828 N 22 (A);
1828 N 22 (B)

Grand Prix de Rome
New Left, demanded abolishment 1968 (C)

Grandville (Jean Gerard)
La Caricature work 1831 My 5
"Le Poire," in manner of
1831 N 19

Grant, Gordon
Kennebunkport, Maine, post
office mural, replaced
banned painting 1945 Mr

Graphic Arts See Prints

Grave Reliefs
Forbidden in Athens by Solon
549 B. C. ;
by Demetrios of Phaleron
317-307 B. C.

"Graven Images"
Cistercians forbade 1115
Jewish proscription 13th c.
B. C.

Great Neck, Long Island
Fainmel nudes, censured 1959
N 2

"The Great Strength in Literature
and Art Lies in High Ideological and Artistic Standards"
Khrushchev speech 1963 F

Greater Berlin Propaganda Council
Censored Kollwitz poster 1913?

Greco, El
"Espolio," refused by Toledo
Cathedral 1579
"Martyrdom of St. Maurice and
the Theban Legion," refused
for Escorial chapel 1582
Sued Hospital de la Caridad
1607 My
Urged destruction of Michelangelo "Last Judgment"
1566 (A)

Greece
Art restrictions 1969 (B)
Issued list of forbidden cartoon topics 1969 N 1
Kokkinides forbidden to exhibit
1967
Prior censorship required for
art works 1967

"The Greek Slave." Powers 1847-

1851; 1851 My 1

Green, Enrique 1966 Jy

Greenberg, David L. 1969 Mr
(B)

Greenleaf Classics, Inc. 1971 Ap

Greenough, Horatio
"Chanting Cherubs," condemned for nudity 1831 (A)
1832 (A)
"George Washington," undraped
torso scandal 1843 (B)

Greenwood, Lawrence B.
Criticized Boston Museum of
Fine Arts nudes exhibited
1911 S

Gregory III, Pope
Protected church images 731
N 1

Gregory the Great, Pope
Destroyed Rome's pagan art
590-604
Rebuked Bishop for image removal 590-604

Grids See Transfer Patterns and
Grids

Gritton, John
Condemned art viewing 1896
(B)

Gropius, Walter
Nazis banned architecture
1930's (A)
Nazis destroyed Weimar memorial 1930 (C)
Nazis takeover, caused emigration to U. S. 1933 Mr 12

Gropper, William
"Japan Emperor Getting the
Nobel Peace Prize," Vanity
Fair banned in Japan 1935
Ag

Gros, Antoine Jean
Napoleonic canvases banned by
Restoration 1814-1829

Gross, Chaim
Dallas citizens group, objected
to Dallas Museum sponsorship 1955 Mr 15

"The Gross Clinic." Eakins 1875
(B)

Grosse deutsche Kunstausstellung
Nazi art show 1937 Jy 7

Grosz, George
Art labelled obscene 1969 Mr

Gunn, James
 "Elizabeth II, " state portrait
 criticized 1953 (B)
Gunnison, Walter B.
 Defended nude in art 1914 Mr 11
Gustrow, Germany
 Barlach "Hovering Angel, " de-
 stroyed 1927 (B)
"Gutter Art" 1898 (F)
Gutzon, Borglum
 "Confederate Memorial" suit
 1925 (D)
Guyana
 Victoria statue, removed 1970
 F 17 (ILLUS 34)

Habusoneb
 Memory obliterated 1481-1447
 B. C.
Hadith 9th c. (A)
Hadrian I
 Christian imagery, proscribed
 787 0 13
Haight-Ashbury Tribune 1969
 My 20
Haines, Fred 1932 Ag 17
Hairdress
 Puritans accepted long hair
 for men of upper class 1651
 Puritans' style 1645-1649
Hairdressers' Model Busts
 Inquisition ordered draped or
 removed from window dis-
 play 1650-1680
Hall, Lee
 Nude drawing in Corradi, cen-
 sured 1954 D 17
Hallam, W. W.
 Comment on Chabas "Septem-
 ber Morn" 1913 (A)
Hamburg
 Barlach "Mourning Mother and
 Child, " removed 1927 (B)
 Wunderluch print exhibit,
 closed as obscene 1960 (A)
Hamling, William L. 1971 Ap
Hammurabi, Code of
 Seal design regulation 1900
 B. C. ?
Hance, Myrtle G.
 Labeling as subversive of
 Moby Dick and Canturbury
 Tales, demanded because

illustrated by Rockwell Kent
 1863-1955
Hand, Learned
 Ruled The Masses could mail
 as periodical 1917 Ag-S
Hannegan v Esquire
 U. S. requiring art conform to
 prescribed norm, alien to
 American ideology 1946 (B)
Hanson, Duane
 "Accident, " banned for vio-
 lence 1968 Je
Harby, Harold
 Los Angeles Municipal Art
 Exhibition, charged com-
 munistic and blasphemous
 1951 N 6
 Rosenthal "The Family, " cen-
 sured 1955 Mr
Harding, Stephen, St.
 Proscription of art 1115
Hardy, J.
 Nixon cartoon, libel 1969 D
 13
Harlem On My Mind 1969 Ja 30
Harnoncourt, Rene d'
 Manifesto on Modern Art, de-
 manded "free speech" for
 artists 1950 Mr 27
Harper's Weekly
 Nast cartoons 1870 (B)
Harris (May Ormerod) Hall 1940 Ja
Harrisburg, Pennsylvania
 Barnard symbolic nudes on
 State Capitol, ordered
 draped 1909-1910?
Harrison, Alexander
 Nudes, censored 1891 Mr 15
Harrison, Carter, Mayor of
 Chicago
 Comment on Art Institute of
 Chicago students fountain
 1899 Je 16
Harry Levinson v Arthur E. Sum-
 merfield
 Lindsay illustrations for Aris.
 tophanes Lysistrata, charged
 obscene by U. S. Post Office
 1954 Ag
Hart, Joel Tanner
 "The Triumph of Chastity, "
 title change 1865-1867
Hartford, Huntington

Art or Anarchy?, Abstract
　　Impressionism held a Com-
　　munist plot 1934 (F)
Hartford, Connecticut
　　Gann nude painting, removed
　　from window display 1934 Ag
Hartford School of Fine Arts
　　1934 Ag
Hartford University 1969 D 13
Hartley, Jonathan Scott
　　Expert witness 1898 (D)
Harvard Lampoon
　　Censored 1870's?
Hasek, Jaroslav
　　The Good Soldier Schweik
　　1928 D 10
Hasmonaean Kings
　　Coin likenesses, discontinued
　　2nd-1st c. B. C. (A)
Hatshepsut
　　Memory obliterated 1481-1447
　　B. C.
Hauptmann, Gerhart
　　German censorship restric-
　　tions opposed 1929 Mr 11
Haus der deutschen Kunst,
　　Munich
　　Nazi art exhibit 1937 Jy 7
Haus der Kunst, Munich
　　Retrospect exhibit of Nazi art
　　1962 (A)
"Have You Seen Stella?" 1915 (A)
"Having Their Fling." Young 1917
　　Ag-S
Hawaii
　　Marisol. Father Damien memo-
　　rial, rejected 1967 Mr 30
Hawthorne, Nathaniel
　　Marble Faun, comment on
　　nude 1860 (A)
Hazeltine, Charles
　　Nude statue owned by, seized
　　1873 (A)
Hazlitt, William
　　Dismissed from Morning
　　Chronicle, London, for cri-
　　ticism of Lawrence painting
　　1814 My 3
Hearst's Magazine
　　Censored 1916 F-Ap
Heckel, Erich
　　Works proscribed by Nazis
　　1937 Jy 18

Hector
　　Playing card Knave of Dia-
　　monds 1576
Hedges, Carole 1967 My (B)
Heil, Walter
　　Censured Cadmus "Sailors and
　　Floosies" 1940 Ag
Heine, Thomas Theodore
　　Gestapo queried 1940 (A)
Hellawell, Edward G.
　　Commissioned wrestlers, un-
　　displayed as nude 1961 (C)
Henner, Jean Jacques 1888 Mr 23
Henry VIII, King of England
　　Church art destroyed 1552
　　Destruction of English Gothic
　　painting 1509
　　Ten Articles, condemned
　　church art 1536 (B)
Henry III, King of France
　　Playing cards satirizing,
　　treasonable 1581 Ja 15
"Henry, Third Duke of Buccleuch."
　　Gainsborough 1770
Hephaestus
　　Alcamenes, statue 440? B. C.
Herald, Vatican 1967 Ap 26
Herbert, Justice
　　Sentenced archaeologist for
　　possessing obscene pictures
　　1922 My 8
Hercules
　　Statue buried as pagan art
　　1370 (B)
Heresy See also Blasphemy;
　　Sacrilege
　　Aztec manuscripts, burned as
　　heresy 1528-1533
　　Inquisition evolved to cope
　　with heresy 1545-1564
　　Modern Heresy, defined blas-
　　phemy in art 1947 (G)
　　Nudity disapproved as induce-
　　ment to heresy 364-361
　　B. C.
　　Passignano exiled for heresy
　　1581
　　Pontormo "Last Judgment,"
　　charged with heresy 1546-
　　1556
　　Renata di Francia, imprisoned
　　by Inquisition for heresy c
　　1554

England 1890's?
<u>Hogarth's Act</u> 1734
Holbein, Hans
 Portrait painting, avoided re-
 ligious subjects c 1536
Hollander, Edward D. 1954 Ag 31
Holmes, Bryan 1939 F
Holmes, Edward Jackson 1933 Ap
 24
Holmes, Peter
 <u>Commonwealth v Holmes</u>, U. S.
 obscene matter omitted from
 indictment, to preserve
 "chastity of the records"
 1821 (C)
Holt, Chief Justice
 Defined libel, <u>Cropp v Tilney</u>
 1693
Holy Ghost
 Dove symbol prescribed 313
"Homage to New York." Tinguely
 1961 Mr 17
"Homeless After a Japanese Raid"
 Japan banned 1941 Jy 2
Homer, Winslow
 "High Tide," too risque in de-
 picting sea bathing 1870 (A)
Hone, William
 Libels, acquitted of, London
 1817
Hong Kong
 Chinese realistic art 1968 Mr
Honolulu Airport
 Goys. "Nude Maja," removed
 from display 1962
<u>Hooey</u>
 Cartoon, subject of Duchess of
 Marlborough libel suit 1935
 (C)
Hooper, Franklin W. 1914 Mr 11
Hope, Thomas, and Mrs. Hope
 Caricatured in Du Bost "La
 Belle et la Bete" 1810 D 6
Hopps, Walter 1969 My 20
Horn, Walter V.
 Boise case expert witnesses
 testify on erotic art 1964
 Jy 2
Horsley, J. C.
 Anti-nude painting 1885
Hosmer, Harriet
 Instruction to learn anatomy
 1850 (A)

Hospital de la Caridad, Illescas
 El Greco, suit for altar pay-
 ment 1607 My
Hotel del Prado, Mexico City
 Rivera "Sunday in the Al-
 meda," censored for athe-
 istic phrase 1948 N 19;
 phrase painted out 1956
 Ap 14
Hotel Marguery, New York City
 Ferstadt "Friendship," re-
 moved from exhibit 1931
 N 21
Hotel Reforma, Mexico City
 Rivera murals, changed with-
 out artist's knowledge 1936
 N 21
 Rivera murals, political theme
 1930 (A)
House of German Art, Munich
 Nazi art show 1937 Jy 7
Houston
 Zorach bank facade, com-
 mission cancelled 1956 Jy
"Hovering Angel." Barlach 1927
 (B)
<u>How to Paint the Cloud Terrace</u>
 <u>Mountain.</u>
 Ku K'ai-Chih 4th c. B. C.
Howard, Cecil
 Repudiated National Sculpture
 Society minority attack
 1952 (A)
Hoyland, Francis
 Arts Council, ordered nude
 returned to travelling ex-
 hibit 1962 Ag 23
Hoyle, R. Larco. <u>Checan</u>
 Publication pictures restricted
 pre-Columbian erotic art
 1955 (A)
Hsieh Ho
 "Six Canons of Chinese Paint-
 ing" 500
Hudson, William Henry
 Epstein "Rima," memorial,
 censured 1925 (A)
Huerta, Victoriana
 Posada "Calavera Huertista,"
 caricature censored 1913
 (A)
Hughes, James T. 1970 O 11
Hughes-Stanton, Blair

Isman, Bernard 1967 Ap 10
Italy
 Art critic discounts individual
 as artist 1963 (C)
 Central "Pornographic Office,"
 proposed as censor 1927
 Mr 23
 Fascists dominate Venice
 Biennale 1940 Je 12
 Regulations absorbed artist
 into corporate state 1935 (A)
 Venturi self-exiled, when he
 refused Fascist loyalty oath
 1931 (B)
"Italy," nude figure 1853 Ap 24
It's a Long Way to Heaven. Dean
 1946 (A)
Ivan the Terrible
 Destruction of Russian secular
 art 1551

Jacobellis v Ohio
 "Roth Test," clarification
 1964 (C)
Jaguaribe, Sergio 1970 N 13
James I, King of England
 Puritanism effect on art 1601-
 1625
Janis Gallery, New York City
 "Erotic Art '66" 1966 O 6
Janson, Rone Tore
 Janson nudes, removed from
 street view 1970 N 3
Japan
 Gropper "Japan Emperor Get-
 ting the Nobel Peace Prize,"
 banned Vanity Fair 1935 Ag
 New York Times Sunday maga-
 zine, banned for Chinese
 War art 1941 Jy 2
 Perry expedition official artist
 scene of Japanese bathing,
 suppressed in U.S. 1854
 (A)
"Japan Emperor Getting the Nobel
 Peace Prize." Gropper
 1935 Ag
Javits, Jacob K.
 Congress bill introduced to
 modernize U.S. Customs
 definition of art 1958 My 27;
 Eisenhower signed into law
 1959 S 14

Opposed Dondero attacks on
 modern art 1949 Mr-O
Jawlensky, Alexej von
 Works proscribed by Nazis
 1937 Jy 18
Jendov, Alexander
 Bulgaria expelled from Art-
 ists Union and Communist
 Party 1951 (A)
Jenks, Robert T.
 Defended Berghash "Christ in
 a Coffin," banned print
 1965 Je 13
Jensen, Arnold
 "Bust," censored by Fresno
 District Fair 1965 N
Jepson's Stores, Ltd., Edinburgh
 1967 Ja 30
Jersey City
 "Radio," Marconi memorial
 figure, refused 1954 D (A)
Jersey City Museum
 Le Comte nude painting,
 banned 1966 Ja 20
Jersey City Museum Association
 Mount "Freedom from Dogma,"
 unhung as attack on church
 1951 My 10
Jesus Christ in Art
 Artist representing "unconven-
 tional Christ," prosecuted
 for blasphemy 1963 (B)
 Berghash "Christ in a Coffin,"
 banned 1965 Je 13
 Christ, picture, charged blas-
 phemy 1971 Mr 31
 Christian Catacombs, Rome,
 painting restricted c 200
 Color convention, Byzantine
 10-12th c.
 Color prescribed for after
 Resurrection portraits 313
 Crimi "Christ," painted over
 1949 F 1
 Epstein "Ecce Homo," re-
 jected as gift 1958 (A)
 Lamb symbol, forbidden 692
 Michelangelo misrepresented
 in "Last Judgment" 1564
 Narbonne Cathedral, naked
 Christ, covered 590's
 Portraying prescribed 787 O
 13

Rivera "Vaccination Panel,"
 censured 1933 Mr
Jesus-Marie, Bruno de
 Satan, book jacket censored
 1952 Ap
Jessup, Morris K. 1873 My 16
Jewell, Edward Alden 1932 D 12
"Jewish-Democratic" Art
 Nazis proscribed 1937 Jy 18
Jews See also Art, Jewish
 Moravian Artists Association,
 forbade Jewish members to
 exhibit 1938 D
 Nazis confiscated Munich art
 1938 N 17
 Nazis decreed Jews must
 register property, includ-
 ing art 1938 N 17
 Nazis established "pawn-bro-
 kerage" offices to buy
 Jewish-owned art 1938 N 26
John, Augustus Edwin
 Lawrence painting hearing, re-
 fused as expert witness
 1929 Jy 5
John of Damascus, Saint
 Iconodule controversialist 843
 Mr
John Reed Clubs
 Motto: "Art as a class
 weapon" 1930 N
John the Evangelist, Saint
 Color of portraits, prescribed
 313
Johnson, Andrew
 Censured nude capitol lamp-
 posts 1859 (B)
Johnson, Lyndon
 Created Commission on Ob-
 scenity and Pornography
 1967 0 3
Johnson, Samuel
 Asked Reynolds not to work
 on Sabbath 1784 (B)
Johnston, David Calypoole
 Caricatures, libellous 1819 (B)
Joint Committee for the Promo-
 tion and Protection of Art
 and Literature 1923 D 16
Jones, Albertus E. 1934 Ag
Jones, James L. 1970 0 11

Jones, Thomas H.
 Brancusi "Bird in Space,"
 expert witness 1928 N 26
"Le Jour et La Nuit," engrav-
 ings
 Destroyed in Paris, as ob-
 scene 1843 Ap 11 (B)
"Les Joutes." Picasso 1959 My
 (B)
Joyce, James
 Ulysses trial, "Hicklin Test,"
 rejected 1934 (A)
"Jupiter and Antiope." Corregio
 1857 (D)

Kaiser Friedrich Museum, Berlin
 Vatican condemned exhibit
 1940 Ap 3
Kalogynomia, or the Laws of
 Female Beauty
 Illustrations, suppressed 1899
 (B)
Kama Sutra
 Boise erotic sculpture, de-
 fended as illustrating Kama
 Sutra 1964 Jy 2
Kandinsky, Wassily
 Works proscribed by Nazis
 1937 Jy 18
Kankakee, Illinois
 Barnard nude statues, high
 school gift, censored 1937
 Jy
Kansas City, Missouri
 Benton protested art-business
 tax 1956 N 29
Kansas State Art Commission
 Curry mural specifications
 1937 S; Curry repainted
 pigs 1942 (B)
Karlstadt
 Burned pictures of Saints 1521
Karnak
 Obelisks sheathed 1481-1447
 B. C.
Kashmir, India
 Life, banned for depicting Mo-
 hammed 1963 0 22
Kaufman, Frank A. 1970 Mr 5
Kaufman, I. R. 1970 0 20
Kaufman, J. Francois

Law of Numbers See Golden Section

Lawrence, D. H.
 Paintings at Warren Gallery, London, seized 1929 Jy 5 (ILLUS 27)
 Paintings, banned by U. S. Customs 1929 (B); 1951 (C) (ILLUS 27)

Lawrence, Thomas
 Hazlitt's criticism of Lawrence painting, caused dismissal as Morning Chronicle critic 1814 My 3
 Social limitations on printing or exhibiting complete portfolios of works 1938 N

League of Nations
 Obscenity proscribed 1924 Ag 7

Le Brun, Charles. Methode pour apprendre a dessiner 1698
 Prescribed art role for Academy, Paris 1648 F 1

Lecht
 Comment on Nikritin painting 1935 Ap 10

Le Comte, Mia Munzer
 Nude painting, banned 1966 Ja 20

"Leda" 1822 Je

"Leda." Michelangelo
 Burned at French court 17th c. (B)

Ledoux, Claude Nicolas
 Royal Architect to Louis XV, France, imprisoned 1773 (C)

Lee, Doris
 Life, with "Noon" reproduction, banned 1946 N 25
 "Thanksgiving Day," Logan Prize award, censured 1935 N 7

Lee, Eva 1959 N 2

Lee, Sherman E.
 Comment on bombing of Rodin "The Thinker" 1970 Mr 24

Leeds Institute Gallery, England
 Paraskos nudes, censored 1966 My 1

Lefebvre, Jules Joseph 1888 Mr 23

Lefort (Agnes) Gallery, Montreal
 Roussil sculpture, destroyed by indignant visitors 1951 (B)

"Legend of St. Stephen," tapestry
 Removed from Auxerre Church, as too fanciful 1777

Legenda Aurea
 Saints emblems 1275

Legman, Gershon
 Love and Death, censored 1951 Je?

Lehmbruck, Wilhelm
 Berlin Academy, removed work from exhibit 1936 (B)
 "Kneeling Woman," proscribed by Nazis 1939 0
 Works proscribed by Nazis 1937 Jy 8; 1937 Jy 18

Leicestershire Education Committee 1966 S 20

Leighton, Frederick
 "Bath of Psyche," hung in Tate Gallery, reproductions ruled immoral in Richmond, Virginia 1905 Mr 4

Lend-Lease Program
 Colin satirical posters on, removed 1954 Ag 31

Lenin, Nicolai
 Defined art role in Communism 1930 (F)
 Portrayed in Orozco "Table of Brotherhood" mural 1931 Ja 19
 Portrayed in censored Rivera Rockefeller Center mural 1933 My 22

Lennon, John
 London exhibit closed 1970 Ap 1; Long Beach, California, showed exhibit closed in London 1970 Ja 29 (B)

Lens, Andreas Cornelis
 Influenced artists freedom in Austrian Netherlands 1773 (D)

Lens, Cornelis
 Guild proscribed for gilding own picture frames 1773 (D)

Mohammed 1963 0 22
New York Times printed un-
draped Hirschfeld advertis-
ing drawing, after Life
showed 1954 0 (A)
The Life and Opinions of Herr
Piepmeyer. Schroedter
1848 (C)
Life Classes
Art Students League, New York
City, discontinued Life
classes 1890 My 9
Budapest Art Academy forbade
nude models 1932 S 23
Comstock confiscated Art Stu-
dents' League magazine de-
picting student life sketches
1906 Ag 2
Eakins resigned from Pennsyl-
vania Academy of Art post,
over nude model controversy
1886 (A)
English Royal Academy, pre-
scribed 1769 Ja 2
French Academy control of
nude life class models
1840's (C)
German censorship bill banned
life classes for students
under 18 years 1927 My 17
Germany banned nude models
at Weimar art school 1930
Ag 9
Massachusetts Governor criti-
cized State Normal Art
School for life classes 1882-
1884
Paris life classes a monopoly
of the Academy 1648 F 1;
1655 Je 23
Pennsylvania Academy of Fine
Arts proposal for life
classes, censured 1805
Peters The Student Question,
anti-nudery pamphlet 1854
Jy 8
Royal College of Art, London,
and other Academies use of
life classes 1893 (A)
Slade's School of Art, London,
criticized for life classes
1881 Ap
University of Southern Cali-

fornia banned nude models
1940 Ja
Vatican banned nude models
1954 (C)
Vienna Academy monopoly of
life classes 1726 (A)
"Life in Baltimore"
Walker "In a Room, " Peale
Museum, restricted view-
ing 1955 N
Life on the Mississippi. Clemens
1884 (B)
Liggett, Alexander 1964 D
Ligny et Dupaix, publisher,
Paris
Indecent lithograph, destroyed
1832 N 27
Lin ts'iuan Rao che. Kuo Hi 11th
c.
Lincoln, Abraham
Barnard "Abraham Lincoln, "
censured for realism 1917
(D)
Lincoln, Nebraska
Bannerman Little Black Sambo,
removed from public school
system 1964 0 19
Steig Sylvester and the Magic
Pebble, banned in public
school libraries 1970 My 21
Lind, Mrs. Therese
Sued Vogue for publication of
nude statue, she modeled
for 1923 Ag 24
Lindsay, Norman
Lysistrata illustrations,
charged obscene 1954 Ag
Art in Australia paintings,
banned 1930 D; case dis-
missed 1931 Je 30
Lindstrand, Dr.
Nonrepresentational glass
vases, judged art for U. S.
Customs 1958 (B)
Liquor Control Board, Alberta
Province
Paintings owned by liquor com-
pany, banned as liquor ad-
vertising 1964 Ja 22
Literature and Revolution. Trot-
sky 1924 (B)
Literature Commission, Oklahoma
Time, banning demanded for

Chabas "September Morn"
 1957 S
Literaturnaya Gazeta
 Smirnov scored Soviet Artists
 Union for rigid art law
 stifling innovation 1962 Jy
"The Lithograph Case"
 Whistler forced du Maurier to
 alter Selby, pictured in
 Trilby, as libel 1897 Ap
Lithographs
 U. S. Customs, recognized as
 art 1959 S 14
Little Black Sambo. Bannerman
 1964 0 19
"The Little Mermaid. " Ericksen
 1964 (A)
Livingston, Jane 1969 Mr (A)
Lockhart, William B. 1970 S 30
Lodi, New Jersey
 "Radio, " Marconi memorial
 figure, refused as gift 1954
 D (A)
Logan, Josephine Hancock
 Sanity in Art, attacked "mod-
 ern" art 1935 N 7;
 published against "modernist
 humbug" 1938 My
Lollards
 Iconoclasm 16th c. (E)
Lomazzo, Giovanni Paolo. Idea
 del tempio della pittura 1590
 (C)
 Tratto dell Arte... 1584 (A)
London
 Beardsley Lysistrata illustra-
 tions, seized as obscene
 1966 Ag 10
 Dine and Paolozzi exhibit, in-
 decent 1966 S 20
 Lawrence paintings, seized
 1929 Jy 5
 Lawyers' "Inner Temple" pic-
 tures, removed as porno-
 graphic 1963 Jy 25
 "Million Pound Note" poster,
 illegal as reproduced bank
 note 1954 (D)
London Art Gallery
 Lennon pictures, seized 1970
 Ap 1
London Contemporary Art Institute
 1953 Mr 15

Long Beach, California
 Eames chair, censured for
 Steinberg outline drawing
 of nude 1951 Je 24
 Lennon exhibit, closed in Lon-
 don, shown 1970 Ja 29 (B)
 Spater sculpture exhibit,
 banned 1968 My 27
Long Beach Municipal Art Com-
 mittee
 Eames chair, censured for
 Steinberg outline drawing
 of nude 1951 Je 24
Long Buckby
 Tombstone inscriptions cen-
 sured 1954 Ag 25
Longchamps Restaurant, New
 York City
 Reiss forced to join Mural
 Artists Guild to finish
 restaurant mural 1937 (A)
Longley, William
 "Mother Earth's Fertility, "
 removed from New Mexico
 State Capitol 1950 0 6
Looting See Vandalism and Plun-
 der
"Lord Campbell's Act, " England
 Enacted 1857 (D)
Lord's-Day Society, England
 Sabbatarian activities 1896 (B)
 Sabbatarian objection to Sunday
 opening of Museums 1880
Los Angeles
 U. S. Customs regulation pro-
 hibiting import of obscene
 materials, held unconstitu-
 tional 1970 Ja 28;
 decision reversed by Su-
 preme Court 1971 My 3
 East Los Angeles College art
 exhibit, closed 1965 N 20
 Edwards poster for Fairbairn's
 Five Smooth Stones, banned
 1968 Jy (A)
 Evergreen Review display by
 Shaw, held not obscene 1961
 Mr
 Everts abstract figures, found
 not obscene 1965 My 15
 Federal Art Project, ordered
 to paint war subjects, suit-
 able for army camps 1941

lutionary Art
Proposed to free art for the
Revolution 1938 (B)
Mannequins
Garment Maker's wax figure,
censored by Comstock 1874
(E)
Inquisition ordered hairdresser's
model draped 1650-1680
Tussaud Wax figure, censored
as libel 1894 Ja
Mannerism
Iconography 1584 (A)
Mannheim
Nazi drive to eliminate degen-
erate art 1937 Jy 8
"Venus de Milo, " censored for
nudity 1853 (A)
Manship, Paul
"Playfulness, " suppressed 1914
Mr 6
Repudiated National Sculpture
Society minority attack on
modern sculpture 1952 (A)
Manson, James Bolivar
Advised English Customs re-
garding contemporary sculp-
ture as art 1938 Jy
Mantle of the Virgin, color code
1400
Manual Enterprises v Day,
United States
"Roth Rule" of obscenity,
clarified 1962 (D)
Manuel de ministros de Indios...
Serna 17th c. (A)
Manufacture des Meubles de la
Couronne 1667
"Manufacture of Metal"
Brancusi "Bird in Space" 1928
N 26
Manufacture Royale des Gobelins
1667
Manuscripts
Aztec manuscripts, destroyed
by Zumarraga 1528-1533
Manichaean manuscripts, de-
stroyed as unholy c 1897
Maya books, burned by Landa
1560's
Private library allowed only
manuscripts, no printed
books 1480's
Puritans proscribed illumi-

nated manuscripts in England
16th c. (E)
Mao Tse-tung
Chinese art line set 1968 Mr
"Maple Leaf" baby, trademark
Quebec ordered draped in ad-
vertising poster 1947 (F)
Maratto, Carlo
Draped Reni's "Virgin Quiri-
nal, " at Innocent XI order
1676?
Marble Faun. Hawthorne 1860 (A)
Marc, Franz
Works proscribed by Nazis
1937 Jy 8; 1937 Jy 18
Marcade, Jean
Roma Amor, pictured Naples
Museum erotic art 1964 (B)
Marcellus
Sacked Syracuse 212 (A)
Marchal, couple
Obscene drawings, destroyed
in Paris 1814 Je 23
Marcus, Debora 1954 D 17
Marechal, Claude Balthaser Manuel
Fined and imprisoned for sale
of obscene graphic works
1845 Ap 29 (B)
Marescalco, Il
Tried for not depicting purga-
tory 1572
Maria del Fiore, Florence
Bandinelli "Adam and Eve, "
censured 1549
Maria della Scala, Trastevere
Caravaggio "Death of the Vir-
gin, " rejected 1607
Maria Theresa
Freed artists from Guild in
Netherlands 1773 (D)
Marisol (Marisol Escobar)
Father Damien memorial, re-
jected 1967 Mr 30
Marius
Denounced art 88
Markle, Robert
Art works, judged obscene
1966 Je 23
Marlborough, Duchess of
Hooey rose cartoon, claimed
libellous 1935 (C)
Marlborough Gallery, Rome
Schiele and Klimt nudes,
seized as obscene 1966 F 3

Ziegler title from critics 1937
 Jy 8
Matare, Ewald
 Nazis proscribed work 1933
 My
Matchboxes
 Goys "Nude Maja," ruled
 pornographic 1937 O
"Mater Dolorosa." Burkhard 1933
 Ap 24
"Maternity." Duncan 1923 F 10
"Maternity." Orozco 1923 (B)
Mathews, John 1966 S 20
Mathias of Janow
 Proscribed church art 1389
Matisse
 Armory Show nudes, con-
 demned 1913 Je?
 Burned in effigy by Art Insti-
 tute of Chicago students for
 "Blue Nude" 1913 Je?
 "Hindu Rose," nude in Studio
 cited by U.S. Post Office
 in censorship 1939 F
 "Three Women," auctioned by
 Nazis as degenerate art
 1930 Je 30
Matsys, Quintin. "Margarete"
 Book jacket, banned by book-
 seller 1920 Ap 5
Mattels, Maria de
 U.S. State Department exhibit,
 censored 1965 O 13
Mauldin, Bill
 Patton censured Stars and
 Stripes prize-winning car-
 toons 1945 (B)
Maya
 Art prescribed by priests 300-
 900
 Books burned by Landa 1560's
 Codices surviving censorship
 1560's
Mayer, print seller, Paris
 Engravings, destroyed as ob-
 scene 1843 Ap 11 (A)-(D);
 1843 Ag 11
 "Saint-Simoniens," engraving,
 destroyed as obscene 1842
 Ag 9 (H)
Mayr, David
 "St. George--Ten Minutes
 After Slaying the Dragon"

1967 Ap 10
Maytham, Thomas N. 1966 Ag 7
Mazotto Prize Committee
 Committee refused use of
 public gallery in Paris, as
 French awarded no prize
 1965 Je
Mead, Frederick
 Judged Lawrence paintings
 obscene 1929 Jy 5
Mechanical Arts See "Fine" Arts
 vs. "Mechanical" Arts
Medals
 French censored medals 1835
 Saint-Gaudens Columbian Ex-
 position prize medal cen-
 sored 1890-1893
Medford, Oregon
 Janson nudes, removed from
 street view 1970 N 3
Mediator Dei
 Official Catholic attitude to-
 ward modern Christian art
 1947 (C)
Medici, Cosimo de'
 Florence Academy of Art,
 established 1563 Ja 13
Medici Palace, Florence
 Sacked 1494
"Medusa"
 Gericault. "Raft of the Me-
 dusa" 1819 (A)
Meilleraye, Duke de la
 Male statues, mutilated 1661
 (A)
Meir of Rothberg, Rabbi
 Prohibited illumination of fes-
 tive prayer books 13th c.
 (A)
Meissonier, Ernest
 Censored by art fashion 1969
 Mr 18
Melbourne University
 Norton paintings, charged ob-
 scene 1951 Ag
Memmi, Simone
 S. Spirito, fresco destroyed
 1560
Memoirs of a Woman of Pleasure.
 Cleland 1865
Mendelsohn, Erich
 Nazis takeover, caused emi-
 gration to U.S. 1933 My

Mixtec
 Codices Becker, damaged by
 intentional erasure 16th c.
 (C)
Mladik, Jan
 Art catalog, censored 1968 O
 23
Moby Dick. Melville 1953-1955
Model Penal Code. American
 Law Institute 1961 (A)
Models, Nude See also Life
 Classes
 Rush "Schuylkill River, " use
 of scandalous 1809 (A);
 Eakins picture, showed
 chaperon 1809 (A)
Modern Art See Art, Modern
"Modern Art as Communist
 Heresy"
 Dondero speech, U. S. Congress
 1949 Mr-O
"Modern Art Shackled to Commu-
 nism"
 Dondero speech, U. S. Congress
 1949 Mr-O
Modern Artists Guild
 Le Comte resigned over cen-
 sorship 1966 Ja 20
Modigliani, Amedeo
 Nudes displayed in Paris, re-
 moved from window 1917
 (F)
"Modistus"
 Greenough "Chanting Cherubs, "
 criticized for nudity 1832
 (A)
Moelgaard, S.
 Nude statues, banned as traf-
 fic hazard 1968 (B)
Moens, N. M. Berthelot
 Tried for possessing ethnolo-
 gical nudes 1919
"Les Moeurs de Paris per Arron-
 dissement, " drawings
 Destroyed in Paris, as inde-
 cent 1842 Ag 9 (F)
Mohammedans See also Art, Mo-
 hammedan
 Buddha at Bamiyan, damaged
 by Mohammedans 5th c.
 Courthouse statue of Moham-
 med, removed in New York
 City 1958 Ap 8

Life, banned in Kashmir for
 depicting Mohammed 1963
 O 22
Moholy-Nagy, Laszlo
 Nazis dispersal of Bauhaus,
 caused emigration to U. S.
 1933 Ap 11
Molanus, Johannes. De Picturis
 et Imaginibus Sacris 1570
Mondo Nuovo
 Sequestered for Grosz prints
 1962 (C)
Monkeys in Art
 Veronese "Feast in the House
 of Levi, " interrogated by
 Inquisition 1573 Jy 18
Monks See also Cistercians;
 Franciscan Order
 Destroyed Martini fresco 1560
 Icon sale controlled 730
 Pictures on pulpit, caused de-
 frocking 1083?
 Tibetan painter iconography
 17th c. (D)
Monnier, Henri
 La Caricature work 1831 My 5
Monopoly in Art See also Trade
 Unions
 Florence Guild required Brun-
 ellesco membership 1434
 French Academy of Art, re-
 quired court painters to
 join 1663 F 8
 Paris Academy, controlled
 life drawing instruction
 1648 F 1; 1655 Je 23
 Paris Art Guild, reluctant to
 give up monopoly 1648 F 1
 Uruk Guilds c 529
Monotheism See also Art, Jewish;
 Art, Mohammedan
 Egyptian "Amarna Period" art
 1375-1358 B. C.
Monson, Alfred John
 Tussaud wax figure, libelled
 1894 Ja
Monson v Tussaud, England
 Tussaud wax figure, censored
 as libel 1894 Ja
Montalto, Cardinal
 Allowed separate guild for
 painters in Bologna 1598
 D 28

Closed shop controlled New
York World's Fair mural
and sculpture work 1938 (A)
Reiss forced to join to complete
Longchamps mural 1937 (A)
Murano
Glassworkers forbidden to
leave 16th c. (D)
Murcia
Venus and Adonis statue, cen-
sured 1796?
Murillo, Bartolome
Spanish Inquisition rebuked for
showing Madonna's toes c 1660
Murphy, Frank 1970 N
Murphy, Timothy 1930 (D)
Murray, David Christie
Expert witness 1892 Ap 27
Musawwir 622?
Museo Barbonica Reale
U. S. Customs, destroyed
catalog 1857 (D)
Museum Art Policy
Dallas Museum of Fine Arts
1956 F 11
Institute of Contemporary Art,
Boston 1950 Mr 27
Milwaukee Art Institute 1940
Ja 25
Museum of Modern Art, New
York City 1950 Mr 27
Whitney Museum of American
Art 1950 Mr 27
Museum of Modern Art, New York
Art Workers Coalition demon-
strated 1970 Ja 8
Dondero attacked for "degener-
ate" modern art displays
1949 Mr-O
Eisenhower address stated
principles of Freedom of
the Arts 1954 O (B)
Lachaise erotic sculpture, with-
held from exhibit 1935 (D)
Manifesto on Modern Art, de-
manded "free speech" for
artists 1950 Mr 27
Museum Art Policy 1950 Mr 27
Nicholson sculptural relief,
refused art classification
by U. S. Customs 1958 My 27
Picasso "Man with a Hat," held
not art by U. S. Customs

1958 Mr 27
Problems in importing abstract
art, not recognized as art by
by U. S. Customs 1950 Ap 30
Roosevelt speech on Freedom
in Art 1939 (C)
Statement on need to liberalize
Tariff Laws for works of art
1959 (A)
Tinguely "Homage to New York,"
self-destroying sculpture
1961 Mr 17
Museum of Modern Western Art,
Moscow
Collection exhibited to public
1953 (C)
Museums and Art Galleries See
Blue Laws; Class Distinction;
and names of museums, as
British Museum, Chicago Art
Institute, Louvre, Metropoli-
tan Museum of Art, Museum
of Modern Art, Pennsylvania
Academy of Art
Muskett, Herbert G. 1929 Jy 5
Mussolini, Benito
Vied with Vatican as censor of
morals 1927 Mr 7
Mustaches
French Revolution fashion
1790 S 29
Mustard Seed Garden Manual of
Painting
Mai-mai Sze 1679
"Mutt and Jeff," cartoon. Fisher
1916 (B)
Mynn, Ilkade c 1895 (B)
Myth of the Twentieth Century.
Rosenberg 1930 (B)
Myths and Fables in Art
Charon ferry in Michelangelo
"Last Judgment," proscribed
as myth 1564
Chautauquan, faun cover cen-
sored 1914 F
Mythological art removed from
papal palaces 1600 (A)
Myths in wall papers, cen-
sured by Buenos Aires In-
quisition 1796
Nudity permitted in liturgical
art with myth theme 1563
D 4

Orozco "Prometheus" mural,
censured 1930 Ap
Paleotto Discorso intorno alle
immagini..., censured myths
in art 1584 (B)
Rousseau attacked myth motifs
in art in France 1750
Der Mythus des 20. Jahrhunderts.
Rosenberg 1930 (B)

Naples Art Academy
Life models begun in 1870
1893 (A)
Naples Museum
Marcade Roma Amor, pictures
erotic works 1964 (B)
Royal Museum catalog, de-
stroyed by U. S. Customs
1857 (D)
Napoleon
Gros paintings of Napoleon ex-
ploits, banned by Restora-
tion 1814-1829
Notre Dame gothic arches rep-
resented as classical for
coronation 1804 (A)
Napoleon III
Courbet "Bathers," censured
1853 (D)
Manet "Luncheon on the Grass,"
shocked 1863 (B)
Narbonne Cathedral
Nude Christ, covered 590's
Nari Nari, magazine
Reproductions of erotic art may
be obscene when removed
from original setting 1952 (C)
Narodnost 1931 (E)
Narotzky, Norman
"Catholic Kings: Isabella and
Fernando," censured 1967
Mr (A)
Nashville, Tennessee
Capitol lampposts, nudes cen-
sored 1859 (B)
Nast, Thomas
Cartoons affected Tweed down-
fall 1870 (B)
Nation, Carry
Noble "Cleopatra at the Bath,"
destroyed 1900 D 27
(ILLUS 18)
National Academy of Design, New

York City
Artist sued over unadvantageous
exhibit of work 1835
Censored exhibits, dictatcd art
style, charged 1925 My 7
Dondero demanded Communist
members be expelled 1949
Mr-O
Greenough "Chanting Cherubs,"
criticized for nudity 1832
(A)
Page "Cupid and Psyche,"
banned 1943 My
Solomon "Lovers," banned
1947 My
Urged art juries be composed
of artists 1960 S?
National Alliance of Art and In-
dustry, U. S. 1932 N (B)
National Arts Club Exhibit
Bellows "Nude Girl with
Shawl," censored 1922 F 10
National Association for the Ad-
vancement of Colored People
1971 Mr
National Association of Women
Artists
Solomon "Lovers," banned
1947 My
National Commission to Advance
American Art
Promoted American art 1933
Je
National Committee to Liberalize
the United States Tariff
Laws for Art
Formed 1959 My 14
National Council for the Protec-
tion of Literature and the
Arts, U. S.
Opposed all censorship 1925
F 4
National Council to Protect the
Freedom of the Arts, U. S.
Urged repeal of censorship
laws 1923 D 16
National Fine Arts Commission,
U. S.
Rejected Roosevelt Memorial
design 1962 F 22
National Gallery, London
Sunday opening vetoed in Com-
mons 1855 (B)

removed by police 1927 (C)

PM, banned by U.S. Post Office
for Dean and Arno nudes
1939?

Paleotto censured nudes 1584 (B)

Paleotto ordered reworking of
church art nudes 1594

Paraskos nudes, censored 1966
My 1

Parker "La Paresse," removed
from exhibit 1914

Pennsylvania Academy of Design
exhibits of nude, protested
1891 Mr 15

"Pocahontas," nude to waist,
removed from exhibit 1953
Je

Pocket Book of Old Masters,
banned for nudes 1953 Ja

Polasek "Sower," exhibit place
changed 1916 (B)

Portland Vase, figures draped
1839

Praxiteles Cnidian Aphrodite,
first Greek representation
of female nude 364-361 B.C.

Price poster, censored c 1910
(B)

Privacy assaulted by obtrusive
display of nude 1967 O 23

Queen Christina, removed
drapery from statues 1655?

Queen Victoria approved Mul-
ready nude 1853 (C)

Radio City Music Hall, nudes
censored 1932 D 12

"Radio," Marconi memorial
figure, refused as gift 1954
D (A)

Raymond nudes, banned 1966
F 3

Regli "Stella," sensation of
Panama Pacific Exposition
1915 (A)

Removal of church nudes 1600
(A)

Riemerschmid poster, censored
1896 (A)

Rio de Janeiro Hippie Fair art,
censored 1970 Mr 21

Rivolta nudes, removed from
park display 1933 Ap 20

Romano "Spirit of Freedom,"

refused by Trenton USO
1943 O

Rosen Broadway illustrations,
judged obscene 1896 (D)

Roussil sculpture, destroyed
by viewers 1951 (B)

Russell painting banned in
Toronto 1932 Ag 17

Saint-Gaudens Columbian Ex-
position prize medal, cen-
sored 1889 Je

Saint-Gaudens "Diana," cen-
sured 1932 Mr 26

Salk Institute art exhibit, re-
stricted 1967 My 12

Savonarola proscribed nude art
1498

Schiele and Klimt nudes, seized
1966 F 3

Smith, E. A., convicted for
display of his nude drawings
1962 D 20

Smith, Matthew, nude banned
1947 (A)

Smith, Paul, works removed
from exhibit 1958 My

Spanish painters forbidden to
paint nude c 1657

Steinlein White Slave Traffic
cover, censored c 1895 (A)

Student paintings, removed
1969 Jy (B)

Studio, banned by U.S. Post
Office 1939 F

Tableaux Vivants 1840's (A)

Tamayo mural, removal 1970
Jy

Tennessee Capitol lampposts,
censured 1859 (B)

Tintoretto "Susanna," cen-
sured 1931 O 22

U.S. art books, self-imposed
ban on nude 1907 (B)

U.S. attitude toward nude
1870's-1880's

Vanderlyn "Ariadne," cen-
sured 1815

Vanderlyn copy of Corregio
"Antiope," refused by patron
1870's-1880's

Van Emburgh School of Art
nudes, censored 1933 Ap 30

Vanities poster, jailed Carroll

Pennsylvania Academy of Design
 Rejected moral criticism of ex-
 hibits 1891 Mr 15
Pennsylvania Academy of Fine
 Arts
 Eakins resigned over nude mod-
 el in life class 1886 (A)
 Ladies Day, nude antique sta-
 tues draped 1806 Mr;
 nude statues draped 1840's
 (B)
 Life Classes proposal, cen-
 sored by students 1805
 Nudes, censured 1932 Mr 26
 Peale fought to exhibit classic
 nude casts 1805
 Society of Artists, Philadelphia,
 censured classic nude dis-
 play 1807 Ap
Pennypacker, Samuel W., Gover-
 nor of Pennsylvania
 Sponsored Pusey anti-cartoon
 bill 1902 O 19
 Told Pennsylvania legislature
 political caricature once was
 capital offense in England
 1903
People of the State of New York v
 August Muller
 Convicted for selling obscene
 picture 1884 O 7
People v Baylinson
 Suit for exhibit of Prohibition
 satire, dismissed 1924 N 29
People's Artist 1913?
Pericles
 Athena shield by Phidias, rep-
 resented 438 B. C.
Perrault, Leon Jean Baile
 "La Baigneuse" 1884 O 7
Perry, James
 Dismissed art critic Hazlitt for
 criticizing Lawrence painting
 1814 My 3
Perry, Matthew Galbraith
 Perry expedition picture of
 Japanese bathing, suppressed
 1854 (A)
Perry, Walker Scott
 Demanded Brooklyn Society of
 Artists censor pictures 1921
 D 13
Perry decision, 1892 1934 (G)

Persepolis
 Alexander the Great, plun-
 dered 330 B. C.
Perspective
 Alberti Della Pittura 1436
 Egyptian art 3400-2900 B. C.
 Mannerist 1584 (A)
Pertine, General
 Removed director of Buenos
 Aires Municipal Art Gallery
 1943 S
Peru, Victor, street peddler,
 Paris
 Engravings sold, destroyed as
 obscene 1842 Mr 4
Peru
 Ancient Peruvian erotic sculp-
 ture, viewing restricted to
 "qualified" 1955 (A);
 Hoyle Checan, pictured 1955
 (A)
 Lima nude public statues,
 guarded by police to pre-
 vent draping and painting
 1956 Jy 12
Peter, Saint
 Byzantine color convention 10-
 12th c.
Peters, Donald 1958 N 21
Peters, William
 The Student Question..., anti-
 nudery pamphlet protested
 life class models 1854 Jy 8
Peters v United States
 Burri collage, ruled art, but
 dutiable by U. S. Customs
 1958 N 21
Peterson, Mark
 "Discontented Nude" 1966 My
 18
Pevsner, Antoine
 English Customs questioned art
 status of sculpture 1938 Jy
 Russia expelled from Central
 Soviet of Artists 1920's (C)
Phidias
 Tried for peculation and im-
 piety over Athena Parthenos
 438 B. C.
 (ILLUS 2)
Philadelphia
 Comstock censorship case,
 dismissed 1888 Ja 24

as art 1959 O 11

Rodin, Auguste
 "L'Age d'Arain, " criticism
 forced removal from exhibit
 1875 (A)
 "Balzac, " censured as non-
 representational 1895;
 work refused 1898 (G)
 "The Burghers of Calais, "
 censured as too realistic
 1895
 "Gate of Hell, " commission
 cancelled by French govern-
 ment 1880-1888
 "The Kiss, " censured as ob-
 scene 1895;
 draped in Lewes 1913 (E)
 "The Thinker, " bombed 1970
 Mr 24
 "The Three Shadows, " deleted
 from Republican Party Na-
 tional Convention program
 cover 1956 Jy 5
Rodman, Hugh
 Cadmus "Sailors and Floosies, "
 censured 1934 (H)
Roemberg, Cornelius van
 Satan book jacket, censored
 1952 Ap
Rogers, John
 "The Slave Auction, " refused
 shop sale in New York City
 1859 (A)
Rogue Gallery
 Janson nudes, removed from
 street view 1970 N 3
"Le Roi Bourgeois" 1831 N 19
"Rokeby Venus. " Velazquez c
 1657
Roland Fureiux
 Illustrations proscribed 1596
"Rolla" 1888 Mr 23
Roma Amor. Marcade 1964 (B)
Roman Nose, Chief of the Chey-
 enne 1941 Je
Romano, Giulio See Giulio Ro-
 mano
Romano, Umberto
 "The Spirit of Freedom, "
 refused by Trenton USO, as
 nude 1943 O
"Romantiques"
 Gericault. "Raft of the Medusa"

1819 (A)

Rome
 Alaric plundered 410 Ag 24
 Antiquities destroyed 1623-
 1644
 Censor office instituted 443
 B. C.;
 censor office opened to
 Plebians 351 B. C. ;
 last censor elected 22 B. C.
 Decline of Rome, influenced
 by art 212 (A)
 Forum statues removed 158
 B. C.
 Fountain dei Termini, nude
 naiads censured by church
 as indecent 1901 (A)
 Grosz prints, destroyed as
 obscene 1962 (C)
 Leo X destroyed Roman anti-
 quities 1514?
 Masci "The Annunciation, "
 criticized 1959 My 18
 Monuments destroyed for
 lime 1426
 Pantheon exhibit paintings,
 removed as indecent 1680
 Mr 19
 Sacked, with bonfires in Sis-
 tine Chapel 1527 (A)
 Schiele and Klimt nudes,
 seized as obscene 1966 F
 3
 Vandals sacked 455
Ronnebeck, Arnold
 Speer Memorial commission,
 awarded as a local artist
 1934 (C)
Roosevelt, Franklin Delano
 Caricature, "The Nightmare
 of 1934, " destroyed 1934 S
 Freedom in Art, speech 1939
 (C)
 Roosevelt Memorial, winning
 design from American Insti-
 tute of Architects competi-
 tion, rejected 1962 F 22
Rops, Felicien
 Poster, censored 1896 (E)
Rose Cartoon, libel suit 1935 (C)
Rose Festival Parade, Oregon
 1967 S
"La Rosee, " engraving

Heresy; Inquisition

Benvenuto "St. Luke," banned
by church 1965 D (A)

Burkhard "Mater Dolorosa,"
removed from exhibit 1933
Ap 24

Copley Society Exhibit, banned
in Boston as insult to church
1946 O 2

Grosz Hintergrund trial, artist
and publisher convicted of
sacrilege 1928 D 10

Kaufman "Marriage of Cana,"
charged sacrilege 1924 N 29

Mount "Freedom from Dogma,"
unhung as attack on church
1952 My 10

Orozco "Maternity," charged
sacrilege 1923 (B)

Phidias accused of sacrilege
for putting his portrait and
Pericles on Shield of
Athena Parthenos 438 B. C.

Rivera "Sunday in the Almeda,"
censored for atheistic
phrase 1948 N 19;
phrase painted out 1956 Ap
14

Rivera "Vaccination Panel,"
charged sacrilegious parody
1933 Mr

Rivera Virgin of Guadalupe mu-
ral, charged sacrilege 1953
F 6

Vatican condemned German art
exhibit 1940 Ap 3

Veronese "Feast in the House
of Levi," charged sacrilege
by Inquisition 1573 Jy 18

Sadism See also Violence
Sadism replaced sex as censor-
ship object 1960 (C)

Saigon
U. S. Marine war statue, cri-
ticized 1970 Ja 20

Sailboat Emblem
Painting charged Communistic
for "hammer and sickle"
emblem 1951 N 6

"Sailors and Floosies." Cadmus
1934 (H); 1940 Ag

St. Albans Naval Hospital, Long
Island

"Gallery of Wheels," banned
as Communistic 1949 (C) 1
Dondero criticized 1940
Mr-O

"St. Elizabeth of Hungary."
Calderon 1891 My 16

"St. Eucharius Sets His Foot
Upon a Naked Woman in
Labor"
Vatican condemned 1940 Ap 3

"St. Francis Preaching to the
Birds" 1946 (C)

Saint-Gaudens, Augustus
Columbian Exposition medal,
censored 1889 Je

"Diana," censured as nude
for Philadelphia site 1932
Mr 26

Expert witness 1898 (D)

Life Drawing course, discon-
tinued 1890 My 9

MacMonnies "Baccante," made
no statement when consul-
ted as to merit 1896 (F)

"St. George--Ten Minutes After
Slaying the Dragon." Mayr.
1967 Ap 10

St. Louis Art Museum
Ford Times art 1959 D 27

"St. Luke." Benvenuto 1965 D
(A)

St. Mary's, Notre Dame, Indiana
Dunn nude sketches, banned
from his show 1961 N 8

"St. Matthew and the Angel."
Caravaggio 1590-1593

St. Paul, Minnesota
Sculpture showing U. S. flag
with explosives, banned
1970 Ag 27

St. Paul's Cathedral, London
Picture decoration scheme for
St. Paul's, rejected 1773
(B)
Wren's design, modified 1675

St. Petersburg Academy
Artists revolt against academic
standards 1862

"Saint-Simoniens," engravings
Destroyed in Paris, as ob-
scene 1842 Ag 9 (H)

Saints in Art See also names of
Saints

sculpture and primitive carvings 1959 S 14

Rouault ceramics entry as art, refused 1915 (B)

Sculpture definition 1916 (D); 1928 N 26

Sculpture "original" definition 1965 F 24

Sculpture (Brancusi "Bird in Space") refused as art 1928 N 26

Sculpture (marble font, boxes, stands, seats) refused as art 1916 (D)

U. S. Tariff Law of 1842 Amendment, allowed Customs seizure of indecent items 1857 (C)

"Venus" statue, censored, Murcia Spain 1796?

"Sculpture of the Month, " New York City 1969 N 9

Sculptures of Florida Contest 1968 Je

Seals

Hammurabi Code regulated seal design 1900 B. C. ?

Jewish figure proscription, excepted intaglio rings 13th c. B. C.

Talmud allowed signet ring c 400

U. S. government, scrapped new designs 1969 D

Seasons

Chinese colors symbolizing 1679

Thornycroft "Queen Victoria's Children as Seasons, " criticized for associating "Autumn" with wine 1840 (B)

Sebah, Shiek Abdullah al Salimal 1952 D

"Second Childhood, " Carner 1931 Ja 29

Section Doree See Golden Section

Section of Fine Arts See United States Section of Fine Arts

Sedition See Treason and Sedition

Selby, Joe

du Maurier Trilby illustrations of character "Selby, " ordered altered as libel on

Whistler 1897 Ap

Selby Abbey, Yorkshire

Epstein "Ecce Homo, " rejected as gift 1958 (A)

Seldis, Henry 1970

Self-Censorship

Ammanati censured own nudes 1582 Ag 22

Ammanati requested permission to clothe early nude figures 1590 (A)

Beardsley requested publisher destroy his Lysistrata and other obscene drawings 1898 (B)

Borglum destroyed his angels, labeled heretical c 1914

Pater suppressed his Studies in the History of the Renaissance 1873 (B)

Pisano, Giovanni, commented on his Pisa Cathedral pulpit 1304

Rivera "Portrait of America" panels, suppressed by artist 1949 (B)

Russia required self-censorship in artists 1939 (D)

Russian artists censured own art 1948 F 25

Self-Destroying Sculpture

Tinguely "Homage to New York, " aided in self-destruction 1961 Mr 17

Senate populaire et republicaine des Arts 1794 (B)

Senmut, memory obliterated 1481-1447 B. C.

Sentiments des plus habiles peintres... Testelin 1680

"Les Sentinelles en Default, " engravings

Destroyed in Paris, as obscene 1821 S 14 (A)

Seoul

Picasso pictures, banned as Communist 1969 Je 8

Sepher ha-Hinnukh. Aaron of Barcelona 13th c. (D)

Sepher Hassidim 12th c. (B)

Sepik Wood Carvings 1970 Ja (B)

"September Laws, " France 1835 S 9

Hsieh Ho 500

"Skaters. " Kuniyoshi 1956 Ja 12

Skin Formation
Thai art, Buddha footprint of
108 symbols 1850's (A)

Skolov-Skalya
Comment on Nikritin painting
1935 Ap 10

Slade's School of Art, London
Life classes, criticized 1881
Ap

"The Slave Auction. " Rogers
Refused shop sale, New York
City 1859 (A)

Slaves in Art
Greek subjects prescribed
scale 5th c. B. C.
Louis XIV statue, chained
slaves removed by French
Revolution order 1790 Je
Rogers "Slave Auction, " re-
fused shop sale, New York
City 1859 (A)

"Sleeping Venus. " Giorgione 1917
(C); 1929?

Slivka, David
Nude sculpture, censured 1938
F

Sloan, John
Defended Longley "Mother
Earth's Fertility" 1950 O 6
Refused to remove Prohibition
satire from exhibit 1924 N
29
Resigned as president Art Stu-
dent's League, over Grosz
teaching cancellation 1932

"Slop, Dr. " 1820

Smirnov, Sergei S.
Scored Soviet Artists Union for
rigid laws preventing innova-
tion 1962 Jy

Smith, Ernie A.
Convicted for displaying his
nude drawings in shop 1962
D 20

Smith, Gerald L. K. 1970 Ja 24

Smith, Harry B. 1968 My (B)

Smith, Matthew
Nude painting in Massey Col-
lection, banned in Canadian
galleries 1947 (A)

Smith, Paul R.

Works removed from exhibit
1958 My

Smith, Sidney
Society for Suppression of
Vice, description 1802

Smith, Sydney Ure 1931 Je 30

"Smith Act, " United States 1940
(B)

Smith College
Tamayo mural removal 1970
Jy

Smithers, Leonard Charles
Beardsley requested him to
destroy Lysistrata drawings
1898 (B)

Smiuski, John
Destroyed "Nightmare of 1934, "
caricature of President
Roosevelt 1934 S

Smoot Amendment
Decision on art obscenity and
immorality, removed from
Customs court 1930 Mr 18

Snedeker v Warring, U. S.
George Washington statue, did
not turn "chattel to land"
1854 (B)

Snuff Boxes
Inquisition, Spanish, inspected
1650-1680
U. S. v Three Cases of Toys,
judged paintings on snuff
boxes obscene 1843 (A)

"Soap Bubbles. " Philipon 1831
My 5

Social Class See Class Distinction

Social Protest in Art See Art
and Society

Social Purity Section, Civic
Foundation, Chicago
Censured Chicago Art Institute
students fountain 1899 Je 16

Social Realism
Club Friendship exhibit,
closed 1967 Ja 27
Germany, East, rules for
1947 N
Russian official art style
1932 Ap 23; 1947 (E);
Stalin enforced standard
1948 (A)

Social Reform League, United
States

Earth's Fertility" 1950
O 6
Pennsylvania State Capitol,
Barnard nudes, ordered
draped 1909-1910?
Tennessee Capitol lampposts,
censured 1859 (B)
State Law: or, The Doctrine of
Libels Discussed and Ex-
amined 1729
"Stateless Book"
Norton book refused admittance
to U. S. , and rejected for
return by Australia 1952 (B)
"Statement on Need for Bill to
Liberalize the Tariff Laws
for Works of Art. " Museum
of Modern Art 1959 (A)
Stationery Office, London 1967 Ja
30
Statler Hotel, Washington, D. C.
Colin satirical posters on poli-
tical subjects at Legion's
National Security Commission
meeting, removed 1954 Ag 31
Steichen, Edward
Brancusi "Bird in Space, "
owner and expert witness
1928 N 26
Steig, William
Sylvester and the Magic Pebble,
banned Lincoln, Nebraska,
public school libraries 1970
My 21;
banned Toledo, Ohio, public
school libraries 1970 N
18;
ordered available in Mary-
land county 1970 N 24
Steinberg, Saul
Eames chair, censured for
Steinberg outline drawing
of nude 1951 Je 24
Steinlein, Theophile
Le Journal cover, The White
Slave Traffic, censored c
1895 (A)
"Stella. " Regli 1915 (A)
Stepanian, Michael 1969 My 22
Sterilization
Nazis threat for degenerate
artists 1937 Jy 18
Sterne, Maurice

"Cruelty" panel of "Struggle
for Justice" mural, cen-
sured for Inquisition scene
1939 (A)
Stockholm
Academy members freed from
Guilds 1773 (A)
Stockholm Art Academy
Life models begun in 1839
1893 (A)
Stockton, California
Benvenuto "St. Luke, "
banned by church 1965 D
(A)
Stoddart, John
Constitutional Organization,
founded 1820
Stone Mountain, Georgia
Borglum sued by Georgia for
destroying designs and mod-
els of "Confederate Memori-
al" 1925 (D)
Story, William Wetmore
"Cupid" and "Delilah, " at-
tempted draping by Purity
Society 1911 My
Strasbourg
Religious statues destroyed
1794 N 24
Streiberg, USIA Director 1956
Je 21
Strohm Case
Violence in publications con-
sidered by U. S. Supreme
Court 1948 Mr 29
"The Struggle for Justice. "
Sterne 1939 (A)
Stuart, David
Exhibit of obscenity charge,
dismissed 1969 Mr (A)
Student Art
Barnes "Love, Not War" ex-
hibit, banned 1969 Ap 18
California State College stu-
dent art display policy
1968 My 21
Chicago Art Institute, fountain
censured 1899 Je 16
East Los Angeles College art
exhibit, closed 1965 N 20
Hardy cartoon, libel 1969 D 13
Illinois, University of, paint-
ings, removed 1969 Jy (B)

Lee Nude in Corradi, censored 1954 F 17

Scenes of student life at University of Paris, concealed from public view 1250-1260

Spater sculpture exhibit, postponed 1968 My 27

Student Power
Paris students change Ecole des Beaux-Arts 1968 (C)

The Student Question... .
Peters 1854 Jy 8

Studies in the History of the Renaissance. Pater 1873 (B)

Studio
Banned for nudes by U. S. Post Office 1939 F

Stzygowski, Josef
Racist view of art, favored Aryan 1910-1940

Subject Matter in Art See also Art and Communism; and types of subjects, as Animals in Art; Human Figure in Art; Iconography; Plants in Art; Portraits; Symbolism

Eakins "Gross Clinic," censured 1875 (B)

Felibien set painting scale of values for subjects 1666

French Academy prescribed subject matter 1648 F 1

French Revolution prescribed subject matter 1790 Je; 1791 N

Greek restrictions on subjects of art 5th c. B. C.

Russian artists revolted against classical subjects 1862

U. S. wartime control in cartoons 1917 (E)

U. S. wartime restrictions on subject matter 1941 D 7; 1942 Ap 15

U. S. S. R. set subjects to show Socialist improvement 1939 (D)

"Subjective Anarchy" 1947 (E)

Subversive Activities Control Board, U. S.

Artists as Communists 1956 Ja 12

Sukanta Halder v State, India
Reproductions of erotic art may be obscene, although acceptable in original setting 1952 (C)

"Sukhodaya Footprints," of Buddha
Thai art symbol 1850's (A)

Sulla
Corrupted Roman soldiers with art 88 B. C.
Destroyed city of Piraeus 87 B. C.

Sullivan, John P.
Buffalo Alderman ordered Albright Art Gallery classic nudes draped or segregated 1911 Mr 6

Sullivan, Leo
Complained Coit Tower murals Communistic 1941 Ag 28

Sully, Thomas
"Washington at the Passage of the Delaware," refused by North Carolina legislature 1818 (B)

Summer Palace, Peking
Looted 1860 (B)

Sumner, John S.
Bonge paintings, seized 1928 Jy 9

Complained against Brink obscene picture display 1921 Ap 21

Covington, archaeologist, convicted for obscene pictures in home 1922 My 8

Murphy, charge of exhibiting indecent pictures, dismissed 1930 (D)

Prohibition, moral backwash makes "indecent art" display convictions difficult 1922 F 11

Published article explaining anti-vice campaign: "Morals, Not Art" 1938 Ag

Tintoretto "Susanna," censured 1931 O 22

Sumptuary Laws

"Cato the Censor" 184 B. C.
Demetrios of Phaleron 317-307
 B. C.
Massachusetts 1651
Solon c 549 B. C.
Sun
 Symbol of Surya 406
"Sun Flowers. " van Gogh 1913
 My 14
Sunday Activities See Blue Laws
"Sunday in the Almeda. " Rivera
 1948 N 19; 1956 Ap 14
Superstition See Art and Magic
"Surge of the Sea. " Brandt 1951
 N 6 (B)
"The Surprise, " removed from
 exhibit 1905?
Surrealism
 Cinema, caused Paris riots
 1928 (B); police closed 1931
 (C)
 Club Friendship, Moscow, ex-
 hibit closed 1967 Ja 27
 Dondero listed in "role of in-
 famy" of modern art 1949
 Mr-O;
 Dallas citizens group
 quoted Dondero 1955 Mr
 15
 Logan Sanity in Art, cen-
 sured Surrealism 1938 My
"Susanna. " Tintoretto 1931 O 22
Sutton, Philip
 "Doreen, " nude ordered re-
 turned to traveling exhibit
 1962 Ag 23
Sweden
 "First International Exhibition
 of Erotic Art" 1968 My (A)
Sweeney, James Johnson 1950 Ap
Switzerland
 Maillart bridges, censored as
 too advanced 1917-1940
Sydenham, John. Baal Durotrigen-
 sis 1842
Sydney, Australia
 Beardsley prints, censored
 1970 Ja (B)
 Lindsay nude paintings in Art
 in Australia, seized; case
 dismissed 1931 Je 30
 Michelangelo "David, " poster
 seized 1969 N;

reproduction in photograph,
 seized 1970 Ja (B)
Sylvester, Major
 Draped Barney nude sculpture
 1910 (C)
Sylvester and the Maggic Pebble
 See Steig, William
Synod of Elvira 306
Syracuse
 Marcellus sacked 212 (A)
Syria
 British Industries Fair poster,
 censored 1933 Ja 28
System of Squares
 Egyptian art technique 3400-
 2900 B. C.
Symbolism See also Architectural
 Symbolism; Color; God in
 Art; Iconography; Mudra
 Aten, Sun God 1375-1358 B. C.
 Attucks Memorial, Boston,
 officially censored 1888 (A)
 Brancusi "Princess X, " re-
 moved from Salon 1920 (A)
 Buddha, symbolized as foot-
 prints 404
 Chinese painting symbolism
 1679
 Christ, as Lamb, forbidden
 692
 Diplomats urged destruction
 of belligerent State Depart-
 ment mural 1952 Jy 7
 Dove, Holy Ghost symbol 313
 Egyptian art symbolism 3400-
 2900 B. C.
 Los Angeles Municipal Art
 Exhibition, charged Com-
 munistic and blasphemous
 1951 N 6
 Thai art, Buddha footprint of
 108 symbols 1850's (A)
 Umbrella, symbol of appease-
 ment in English cartoons
 1938 O
Szilvassy, L.
 Butler "Unknown Political
 Prisoner, " destroyed 1953
 Mr 15

Table of Rules, Testelin 1680
Tableaux Vivants 1840's (A)
Taft, Lorado

Labor," figure, condemned
by Vatican 1940 Ap 3
Trilby. du Maurier 1897 Ap
Trinity in Art
 Benedict XIV proscribed rep-
 resentation 1745
 Gerson criticized inaccurate
 representation c 1400
 St. Antonius, condemned
 three-headed representation
 1477?
 Urban VIII, prescription 1628
 Wycliffe, forbade representa-
 tion 1377-1384
"The Triumph of Charles the
 Fifth." Makart 1887-1893?
"The Triumph of Chastity." Hart
 1865-1867
Trollope, Frances
 Domestic Manners of the
 Americans 1832 (B)
Trotsky, Leon
 History of the Russian Revolu-
 tion commented on art 1930
 (F)
 Literature and Revolution, so-
 cial utility of art 1924 (B)
 Manifesto, to free art for the
 Revolution 1938 (B)
Trotter, Mr. and Mrs. Philip
 1929 Jy 5
"True German" Art Exhibit 1937
 Jy 7
Trullan Council 692
Truman, Harry
 Colin satirical posters on poli-
 tical subjects, removed 1954
 Ag 31
 Commented on Kuniyoshi paint-
 ing in exhibit recalled by
 U. S. State Department 1947
 Ap
Trumbull, John
 "Declaration of Independence,"
 commission for Capitol
 rotunda, withheld 1818 (A)
Truth in Libel 1952 (E)
Tsao Hsiang Liang-tu Ching
 Iconography rules 1748
Tuchman, Maurice 1969 Mr (A)
Tun-huang
 Buddhist art, destroyed 445-
 452

Turin International Exhibition of
 Industry and Labor
 Poster, restricted in London
 1911 (B)
Turkey
 British Industries Fair poster,
 censored 1933 Ja 28
 Political cartoons caused news-
 paper suspension 1958 Ap 9
"The Turkish Bath." Ingres 1863
 (C)
Turner, Joseph Mallord William
 Erotic paintings, reportedly
 burned 1860-1880
Tussaud, Mme.
 Monson wax figure, judged a
 libel 1894 Ja
Tutankhamon
 Figure mutilated 1200 B. C.
Twain, Mark See Clemens,
 Samuel L.
Tweed, William Marcy
 Nast cartoons, exposed graft
 1870 (B)
"Tweed Ring" 1870 (B)
"Twenty-Five Years of American
 Painting, 1933-1958"
 Toured without USIA identified
 as sponsor 1959 D 27
"Two Harlequins." Picasso 1930
 Je 30
"The Two Orphans" (MacMonnies
 "Baccante") 1897 O
Tyndall, Robert 1968 My 27
Tyomies Publishing Company
 Lapatossu caricatures, judged
 obscene 1914 Mr 3
Typis Polyglottis Vaticanus
 Last Index, issued 1948 (B)

UNESCO 1952 S
USIA See United States Informa-
 tion Agency
U. S. O. 1943 O
Uglow, Euan
 "The German Girl," ordered
 returned to traveling exhibit
 1962 Ag 23
Ugly Duchess. Feuchtwanger
 1929 Ap 5
Uhlmann, Hans
 Nazis proscribed works 1933
 My

tated by British soldiers
1776 N

Vandalisme Legal
France ordered removal of
public crosses and religious
statues 1905 Je 9

Vandals
Sacked Rome 455

Vanderlyn, John
"Ariadne," censured as ob-
scene 1815
Corregio "Antiope" copy, re-
fused by patron as nude
1870's-1880's

Vanderveer Park Taxpayer's
Association
Demanded sequestering of
Museum's nudes 1914 Mr 11

Van Emburgh School of Art
Plainfield, New Jersey, Public
Library, censored nudes
1933 Ap 30

Van Gogh, Vincent
Self-portrait, auctioned by
Nazis as degenerate art
1930 Je 30
"Sunflowers," U.S. popular
art 1913 My 14
Works proscribed by Nazis
1937 Jy 18

Vanities
Nude poster, jailed Carroll
1924 N 10

"Vanity." Williamson 1939 F

Vanity Fair
Gropper "Japan Emperor Get-
ting the Nobel Peace Prize,"
banned in Japan 1935 Ag
Kent picture, once draped,
published undraped 1924 My

The Various Arts. Theophilus
10th c.

"Varnishing Days"
Discrimination favored Royal
Academy, England, mem-
bers 1809 (B)

Vases
Lindstrand nonrepresentational
glass vases, judged art
1958 (B)
Portland Vase, figures draped
in Victorian England 1839

Vatican See also Sistine Chapel

Caravaggio "Madonna of the
Serpent," removed from
Basilica 1605
Cautioned against "corrupt and
errant" church art 1952 Jy
19
"Cnidian Aphrodite," draped
364-361 B. C.
Museum motto: "Let the igno-
rant stay away" 1505 (A)
Nude models, banned 1954
(C)

Vatican II Constitution on the
Liturgy
Artists invited to sign al-
liance 1964 My 8

Vchutemas, Moscow
Art school, closed 1920's (B)

"Une Veille de Jeune Fille,"
engraving
Destroyed in Paris, as licen-
tious 1842 Ag 9 (J)

Velazquez, Diego
"Venus and Cupid" ("Rokeby
Venus"), only nude painted,
due to restrictions c 1657

Vendome Column, Paris
Courbet charged with de-
struction 1872 My 16

Venice Biennale d'Arte
Church urged boycott of Bi-
ennale 1930 My 6
Closed by students 1968 (A)
Communist exhibits measure
of free expression 1956 S
Cuixart withdrew from Span-
ish exhibit 1966 (A)
Foreign artists residing in
France, excluded from
French Pavillion 1968 (D)
U. S. artists withdrew works
1970 Je 5
U. S. withdrew from Fascist
dominated Biennale 1940
Je 12

Venturi, Leonello
Self-exiled when he refused
Fascist oath of loyalty
1931 (B)

"Venus." Botticelli
Burned in "Bonfire of Vani-
ties" 1498

"Venus." Hart 1865-1867

Williams, Garth
 The Rabbits Wedding, attacked
 in South as integrationist
 1959 My (A);
 Montgomery Public Library,
 sequestered 1959 My (A)
 (ILLUS 30)
Williams, Wheeler
 National Sculpture Society at-
 tack on contemporary Ameri-
 can sculpture, approved
 1952 (A)
Williamson, H. M.
 "Vanity" and "Toilet," nudes
 in Studio, cited in U. S.
 Post Office censorship 1939
 F
Wilson, John M.
 Watts "Love and Life," unhung
 in White House 1894 O 22
Wilson, York
 Muralist, refused to join
 scenic artists union 1960
 F 9
Wilton, Joseph
 "George III," equestrian fig-
 ure, destroyed by American
 colonists 1776 Jy 9
 "William Pitt," destroyed by
 British soldiers 1776 N
Wind
 Michelangelo "Last Judgment,"
 misrepresented 1564
Windows See Glass Painting and
 Staining
Wine See Intoxication and Liquor
Wine Auction Building, Coblenz
 Nude wine symbols, censored
 1925 Ag 15
Winnipeg Art Gallery
 Smith (Matthew), nude paint-
 ing, banned 1947 (A)
Winona Lake, Indiana
 "Venus de Milo," freed from
 poison ivy planted to cover
 nudity 1955 Jy 31
Winship, Blanton 1938 Ag 22
Winter, Fritz
 Nazis prescribed work 1933 My
Winter Beerhouse 1920 Ap 20
Winters case
 Violence in publication, con-
 sidered by U. S. Supreme

Court 1948 Mr 29
Wirin, A. L.
 Smith case, Los Angeles 1962
 D 20
Witnesses See Art Experts as
 Witnesses
"The Wolf" (Victoriano Huerta)
 1913 (D)
"Woman Triumphant." Hart 1865-
 1867
Women Artists See Artists,
 Women
Women in Art
 MacMonnies "Civic Virtue,"
 charged degrading to wo-
 manhood 1922 Mr
 Nazi art policy, favored
 women in art 1939 O
 Vatican condemned German
 exhibit 1940 Ap 3
Women's Christian Temperance
 Union
 Censured Chicago Art Institute
 students fountain 1899 Je 16
 Censured Cowan nude paintings
 1934 F
 Criticized MacMonnies "Bac-
 cante" 1896 (F); 1897 O
 Criticized MacMonnies "Civic
 Virtue" 1922 Mr
Wood, Grant
 American Legion, Cedar
 Rapids, refused stained
 glass window, as made in
 Germany 1927 (A)
 Parody of "American Gothic,"
 suit 1968 My 1
Wood & Perot, Philadelphia
 Tennessee Capitol lampposts,
 censored 1859 (B)
"Wood Nymph Dance." Manship
 1914 Mr 6
"Wood Worshiper"
 Patriarch Germanus, anathema
 754 Ag 27
Woodcuts
 Forbidden in Montefeltro li-
 brary 1480's
 Imprimature considered for,
 in Spain 1502
Woodruff, Marshall E. 1970 Ja
 29 (A)
The Word of God (Koran) 622?